ARAB WOMEN IN ARAB NEWS

OLD STEREOTYPES AND NEW MEDIA

ARAB WOMEN
IN ARAB NEWS

OLD STEREOTYPES AND NEW MEDIA

Amal Mohammed Al-Malki

David Kaufer

Suguru Ishizaki

Kira Dreher

دار بلومزبري - مؤسسة قطر للنشر
BLOOMSBURY
QATAR FOUNDATION
PUBLISHING

مؤسسة قطر
Qatar Foundation

First published in 2012 by

Bloomsbury Qatar Foundation Publishing
Qatar FoundationVilla 3, Education City
PO Box 5825 Doha, Qatar
www.bqfp.com.qa
Copyright © Amal Al-Malki and David Kaufer, 2012
The moral right of the authors has been asserted

ISBN 9789992179116

Cover design by Jamie Winder

Typeset by Hewer Text UK Ltd, Edinburgh

Printed in Great Britain by Clays Ltd, St Ives plc

Sponsorship for this research was generously granted by the Qatar
National Research Priority Fund to lead investigator Dr Amal Mohammed
Al-Malki. The views expressed herein are the authors' alone. Any
errors or omissions are the sole responsibility of the authors.

This book is dedicated to
Her Highness Sheikha Moza Bint Nasser:
A visionary for women worldwide

Contents

Preface

This book reports the first comprehensive[1] survey of Arab women in Arab news – a picture of peaks, valleys, and troughs where the achievements, challenges, and day-to-day realities of Arab women are portrayed. The vast majority of media studies on Arab women thus far undertaken are Western-based. They study the effect of Western stereotypes in Western media depictions of Arab women. A sprawling literature traces Western stereotypes of Arab women from medieval times to the present. From 1800, the dominant Western stereotype of Arab women depicts them as passive and oppressed. Thirty years of social science media research in the West has shown that media images of Arab women reinforce this 200-year-old stereotype. Much of this research has studied silent "image bites" of Arab women, in which women are pictured in veils and their own voices are replaced by Western captions or voice-overs.

Today, the Internet and satellite communications allow the world to share around-the-clock news, and global news services permit one part of the world to read the news produced in other parts of the world. These recent developments make it possible to broach two never-before-asked research questions:

- If we could draw a statistically representative sample of Arab women in Arab news, would the sample reinforce or disconfirm Western stereotypes of Arab women as passive?
- If we could take a census of Arab women in our representative sample, and if we could come to know them as human beings, and benchmark their experiences against the experiences of women worldwide, what would our census reveal?

This book sets out to answer both questions, with Part I tackling the first question and Part II the second. Part I, entitled 'Coding Arab Females in Arab News', describes our pursuit of question one. To answer the first question, we embarked on a media study of Arab women in Arab news. We contracted with a global news service based in the Middle East to collect and translate a sample of news summaries issued between September 2005 and June 2007 (twenty-two months) by 100 Arab media sources belonging to twenty Arab countries. Filtering for summaries that contained one or more female keywords (e.g., woman, mother, aunt, sister) yielded 2,014 summaries. Using a variety of sampling methods, we arrived at a sample of 178 summaries from four leading pan-Arab media sources where Arab females are mentioned in the highest concentrations. One of the striking findings of our sampling of Arab news is that media sources that are liberal and pro-women are much more likely to mention women in their stories, while media sources that are not advocates of women are likely to deprive women not only of headlines, but even of mentions, in hard news. They don't disparage women. They simply make references to them that are too sparse and scattered to be noticed. Of all the mentions of women in our twenty-two-month corpus from 100 Arab media sources,[2] 44% were concentrated in just four liberal pan-Arab sources based in London.

The journalism in much of our sample is thus driven by a liberal vision largely unknown to or ignored by the West. Almost a decade after 9/11, one of America's two most venerable and most widely read news weeklies, *Newsweek* (Zakaria, February 22, 2010), considered that its American readership still needed to be made aware of the existence of a liberal Arab press and progressive Arab thought-leaders who advocate the rights of women.

After creating a concentrated sample of Arab females in Arab news, we constructed and validated a coding scheme to measure active vs. passive behavior in news. Our coding study found that Arab women in Arab news display a wider range of "active" behaviors than previous studies had found for Arab women in Western media. This finding struck us as being, on the face of it, good news for media representations of Arab women in the Arab press. But Part I left us with many unanswered questions about the detail behind the good news. Our

coding study counted the mentions of Arab women in news, but kept their names, identities, and biographical details anonymized in sterile numbers. Furthermore, our coding study left historical and cultural issues underpinning the surface of the news stories unexamined.

Part II, entitled 'Canvassing Arab Females in Arab News,' describes our pursuit of question two. We returned to our corpus but we now removed the narrow lens of our coding study to take a more comprehensive and in-depth look at the Arab females in Arab news. We sought richer interpretive readings of the news summaries coded in Part I and these readings were informed by a voluminous scholarship on gender, human rights, and other related literatures. In Part II, we meet the Arab women we coded in Part I as individuals living in distinct countries with distinct biographies. We meet Arab women who are sometimes outstripping men, sometimes keeping pace, and sometimes falling behind. We meet Arab women of achievement who hold titles and set trends. We meet Arab women who are victims of economic blight, ravaged by war, poverty, ineffective leaders, and brutal politics. We meet women who are empowered and women who are detained or imprisoned, and forced to endure everyday insults and indignities within practices of sexism or misogyny. However, unlike the Western stereotype, Arab women in Arab news are not stigmatized as helpless creatures incapable of fending for themselves. Rather, as we have seen, the appearance of Arab women in hard news is concentrated in the liberal media that are transnational. This concentration means that, when an Arab media source mentions Arab women in hard news, the odds are that the source takes a pro-women editorial stance, takes an interest in reporting on Arab women as a way of spotlighting their imagination, ingenuity, suffering, or marginalization, seeks to expose shortcomings in the Arab societies that leave women at the periphery, and operates at a safe distance from the countries it reports on.

The analysis in Part II makes it clear that the active-passive binary so often used to frame Arab women is a Western filter, and a prejudicial one, that does little to actually describe Arab women in Arab news. Part II explodes the concepts of "active" and "passive" into atoms of more operational concepts (e.g. literacy, education, employment, fear, threat, etc.) that are descriptive of both the Arab context and, as we document from the literature on gender and human rights, the global

context as well. In Part II, we show that the concepts of active and passive, stripped of their Western biases, are not dichotomous but overlapping categories. Arab women, like women worldwide, are constantly monitoring the passive constraints of their cultures to learn about and test boundaries and to step across them when possible and appropriate. Arab women, like women worldwide, have learned to see passivity less as an insurmountable barrier than as a reality check and a measure against which to mark their own advancement. This book shows that Arab women in Arab news can be identified with significant achievements in the struggle for equality and significant challenges ahead.

Introduction

From coding to canvassing Arab women in Arab news: the journey of this book

The poet, critic and documentary writer Vicki Karp once shared perceptive words about writing and its difference from reading: "When we read, we start at the beginning and continue until we reach the end. When we write, we start in the middle and fight our way out" (cited in Ross & Collier 2010, 98). This process describes the genesis of this book. We started writing one book and then found ourselves in the middle of writing another. The trick was to "fight our way out" of the middle of the second book so that it could flow seamlessly from the book we had begun.

The first book, the book we originally planned, was a media study of Arab women in Arab news. The premise of that study relied on the following historical narrative. From the 1980s, there has been a spate of empirical media studies showing that Arab women (and Arabs generally) are represented in Western media in a negative light. These empirical studies confirmed anti-Arab stereotypes that scholars have documented for hundreds of years in the West. The identification of Arab women as passive in the Western imagination has an estimated birth around the turn of the nineteenth century, with the confluence of colonialism and romanticism. Western stereotypes of Arab women evolved from pre-colonial images of shrewish harassing women (Kahf 1999) to colonial and post-colonial images of Arab women as oppressed, submissive, and passive slaves to men (Yegenoglu 1988; Schick 1990; Mabro 1991; Abu Odeh 1993; Kahf 1999; Greenberg & Gottchalk 2008). Kahf (1999) calls this transition in the Western imagination toward Arab women a shift from termagants (old scolds) to odalisques (nubile harem women).

With the image of the compliant and come-hither odalisque burned into the Western psyche, the representation of Arab women has coursed through a steady stream of media, including the word of mouth of travelers (Mabro 1991), theater and literature (Kahf 1999), staged photography and Hollywood movies (Graham-Brown 1988), vintage postcards (Vivian 1999), journalism (Greenberg & Gottchalk 2008), contemporary art (Bailey & Tawadros 2003), fashion (Tarlo 2010), the rise of "hijab chic" (Cherribi 2006; Nomani n.d.), pious performance art (Mahmood 2005) and cultural and historical semiotics (Abu Odeh 1993; Stack 2007; Heath 2008).

The impetus for our study was that previous media studies had tracked Arab women in news on Western soil and our interest was to track them in their own news. Our research question was simple: Would Arab women take on a different appearance in home-grown news outside a Western cultural bias? And if so, what was that appearance? Because Western negative stereotypes of Arab women often spill over to Muslim women in general, this research question could be asked for Muslim women in the news of Muslim countries. For reasons of limited resources and the need to focus our project, we decided to restrict our focus primarily to Arab women. Because the lead researcher is a native Arabic speaker, and because we had no speakers of Farsi, Tamil, Urdu or other languages widely spoken in Muslim countries, we decided to restrict our scope to Arab media and to references to Arab women. We thus eliminated news from Iran, Pakistan, Afghanistan and other majority Muslim countries from the scope of our study. In addition, attempting to cover the press coming out of all Muslim countries would have made the scope of our project intractable.

Because we had expertise in the Arabic language on our research team, we could, in principle, have pursued our research question with Arabic news in Arabic. However, this path posed two insurmountable hurdles. First, we chose a research design that required a wide sampling across Arab media sources and we knew of no comprehensive archive of Arabic news in Arabic that would be easy to construct. Second, we knew our corpus of news briefs had to be sufficiently large to require text-analysis software to help with the analysis. Our research team had developed such technology, but only with the ability to cover English.

And we could find no technologies adequate for parsing Arabic script to meet our requirements.

This seemed to bring our choice set down to two options. We could aim at a research design that built a corpus of Arab news that publishes in English (e.g., *Arab News*, an English newspaper based in Saudi Arabia, which bills itself as "The Middle East's Leading English Language Daily" and which is published by the Saudi Research & Publishing Company (SRPC); or a research design that built a corpus of Arabic news that offered a parallel English version (e.g. the English version of *Al Hayat*, a media source that is Saudi-owned and based in London). However, we eventually rejected both options because we also wanted to conduct a *comprehensive* census of Arab women in Arab news. This meant we wanted to start from a sample that represented multiple Arab media sources with varying geographies, ownership structures (government-owned or independent), political and religious affiliations, and editorial philosophies (Rugh 2003; Sakr 2007).[1]

After careful weighing of options, we licensed a database that provided us with twenty-two months (from September 2005 to June 2007) of translated news briefs from mideastwire.com, an Internet translation service based in Beirut. Mideastwire.com is a daily service that translates briefs from over 100 media sources originating from dozens of countries, including twenty Arab countries, reporting on the Middle East. The service makes its news briefs available to subscribers by email and through its website. Given the significant volume and variety of media sources and non-English source languages it translates from, mideastwire.com provides its subscribers with a wide assortment of Middle-East focused foreign news that reflects, in range, timeliness, and depth, the newspaper-reading habits of a native speaker.

How did we know our twenty-two-month sample would contain any news about Arab women? As part of our licensing arrangement, mideastwire.com filtered the briefs they licensed to us to include only those containing at least one "female" keyword (e.g., "mother," "aunt," "sister," etc.). Our initial corpus of the twenty-two-month sample contained 2,323 news briefs, and, as we explain in later chapters, we winnowed this down to a much smaller number of briefs (237 briefs in Part I and 178 in Part II) that represented from our sample the most extended accounts of Arab women and their lives in Arab news. In Part

I, we report a study where we coded Arab women in Arab news for their levels of "activity" or "passivity" as participants in Arab news stories. One of our early findings was the widespread erasure of Arab women in Arab news, replicating and expanding in effect Skalli's (2011) recent findings for the erasure of Moroccan female leaders in Moroccan news. The big headline is that Arab women in Arab news are neither active nor passive; they are unseen. Another headline is that the press with an international reach is more likely to include women in their news than local presses. Skalli (2011) cites the lament of the venerable Moroccan leader, Halima Embarek Warzasi, with a record of serving the UN and the cause of human rights for over 50 years thusly: "I was cited in all the papers around the world, but I have remained unknown in my own country" (473). Consistent with this lament, we found that four media sources from the liberal pan-Arab press accounted for over 40% of the female keywords and the news briefs in our sample of 100 media sources.

To track the state of Arab women in Arab news, we decided to restrict our coding study to these four pan-Arab media. Within the scope of these media, we found that Arab women are significantly more "active" than U.S. social science had found Arab women to be in pre-Internet U.S. news. However, these results are not particularly earth-shattering when one considers the datedness of these US studies and the fact they took as their primary object of study visual images of Arab women from photo-journalism (Abu-Lughod 2002). In these images, Arab women are typically exotic-looking, veiled and have no speaking parts. When they were given words to speak, the words were typically supplied by Western caption writers. By contrast, in the sample of pan-Arab news we coded, we found that Arab women are often quoted, so their voices contribute constructively to the story. And this phenomenon alone, what we call the "source effect" (chapters 3 and 4), makes Arab women more "active" in Arab news in a way that already exceeds most pre-Internet Western coverage.

We had originally designed our media study to be about East-West comparisons: Arab women as they have been studied in Western news vs. Arab women in Arab news. However, in the course of implementing the media study and analyzing the data, we discovered that we were in the midst of writing a second book, a book within the book. The

book within, we discovered to our surprise, began turning some of the key assumptions of the original book on their head. As we struggled to analyze the data in our corpus, the East-West comparisons receded in importance. Rather than an unbiased lens to study East-West differences, we began to recognize that the simple active-passive dichotomy was more an iconic than an investigative category (Greenberg & Gottchalk 2008), more a marker of Western prejudice than an unbiased framework for describing the empirical reality of Arab women. We began to wonder what it might mean to call an Arab woman "active" when Western feminism was no longer the standard of judgment. And we began to wonder what it might mean to call an Arab woman "passive" when there was no Western myth in the background of a dark woman who is veiled, withdrawn, and silent. What struck us in studying Arab women in their own media was the way their achievements and challenges appeared similar, not different from, the achievements and challenges of Western women, indeed of women worldwide.

We had originally designed our media study so that all the Arab women we coded could remain anonymized and aggregated in a statistical analysis. For the purposes of science, we wanted to stay at arm's length from these women and we considered acquaintance with them a form of contamination. We had designed the media study to be as descriptive as possible and to pay no heed to normative theory, social policy, cultural analysis, or human rights. However, as we struggled to make sense of our findings, we realized we could not derive deeper meaning from our coding results without coming to know the women in our corpus as intimately as possible and from the deep background provided by the best and latest global research on the status of women. We realized our framework of study needed to shift from the mainly quantitative to the mainly qualitative. In Part II, we turned to grounded analysis and close reading to arrive at a conceptual synthesis of how Arab women appear in Arab news. We thought of ourselves now less as number crunchers than as census-takers, conducting a census of the circumstances under which Arab women appear in Arab news. And we recognized that to understand better the women we were meeting in these news briefs and to evaluate their circumstances, we needed the

insights uncovered from the latest research in gender, human rights, and women's studies to guide us.

We recognized, in sum, that we could start with the unexamined active-passive dichotomy used to frame Arab women in the West, but we could not end there. We would need to mine the unexamined divide between active and passive for a range of more precise concepts to describe the appearances of the Arab women we were uncovering in our corpus of Arab news. True to Karp's aphoristic warnings about writing, we had discovered ourselves in the midst of a book we never intended to write. And true to her aphoristic solution, we wondered whether we could "fight our way out" to a single seamless book?

Fortunately, we could. We needed the original book project – the media study and its requirements – to achieve a sampling systematic enough to be confident that the 237 news briefs we ended up coding in Part I and the 178 briefs we employed for our "census-taking" in Part II were the best window possible (from our larger sample) for tracking Arab women in Arab news.

Part I reports on the media study, the book we first planned to write. There we discuss the theoretical motivation behind a coding scheme classifying active and passive Arab women (chapter 2), the scheme itself, our sampling criteria, other methodological concerns (chapter 3), and finally the statistical results that followed from applying our scheme to our sample of news briefs (chapter 4). Beyond these aggregate and coarse results, there were limits to what the coding study could tell us. A study that relies on the numerical coding of Arab women can rarely, like a good novel, bring us deeper into the lives of particular women. Such studies yield numerical tallies of anonymized persons, not rich observer portraits of individualized Arab women in all walks of life, expressing unique personalities, filling their days, nursing their fears, and dreaming about their futures with a variety meant to be savored more than counted.

Part II moves to this book within the book, where we transition from coding Arab women in Arab news to canvassing their reality from a wider research lens. Part II provided us – and provides you – with the opportunity to meet up close the Arab women we had anonymously coded in the coding study. Chapter 5 narrates the transition we made

in our procedures and thinking as we segued from the coding study (of 237 news briefs) to a more qualitative canvassing of a slightly smaller number (178) of the same set of briefs for the circumstances and roles of Arab women in Arab news.

Chapters 6–13 elaborate the various concepts that expand and complicate a cultural frame of female activity in Arab news. Chapters 14–19 perform the same elaborations and conceptual refinements for a cultural frame of female passivity. We conclude by discussing how the portrait of Arab women in Arab news constructed in our research helps us project some of the important roads ahead for Arab women and women worldwide in their struggle for equality.

Methods

The coding study reported in Part I relied on standard content-analytic methods (Neuendorf 2002). The canvassing and census-taking of Arab women in Arab news reported in Part II combined two methods: grounded theory and text-analysis technologies. Grounded theory (Glaser & Strauss 1967) is a technique for discovering latent concepts from textual data and refining the concepts iteratively so that the concepts continue to fit the textual data and the texts continue to fit the concepts with increasing refinement and precision. Textual analysis covers a large family of computational techniques (Feldman & Sanger 2006) used to access and harvest information from texts that would be hard, if not impossible, for human readers to find or collect in systematic fashion. The need for computerized text analysis is self-evident when the corpus of texts in question runs in the high hundreds and thousands of texts, beyond the comfortable reading capacity of a single human reader on a single project. Our final sample was smaller and more modest – 178 news briefs – so the need for textual analysis requires further explanation.

We required computer supported text-analysis methods for two reasons. First, to get the most comprehensive look at Arab women possible, we needed to scour the peripheries of briefs as well as the headlines. We did not want to limit our search to briefs where "Arab women" can easily be skimmed from the headline of the story or

because the news brief is already classified as a "women's" story. There is substantial evidence that "women's briefs" give a skewed view of the world of females, not only in Arab cultures but across all cultures. According to the *Initiative for an Open Arab Internet*, the electronic magazine *Elaph*, founded in 2001, is a leader in the Arab world for carrying a daily stream of news about women who occupy high positions and champion women's rights.[2]

Yet, as the *Initiative* points out, should one try to find these women via *Elaph's* search engine using the keyword "women," one is more likely to be bombarded by a torrent of briefs about female fashion, entertainment, pop stardom, celebrities, and gossip, intended to draw in young male and female readers.[3] Restricting a study of Arab women in news to so-called "women's news," is to use too narrow a lens on Arab women. To cast the broadest net possible over Arab culture while still training our sights on Arab women, we had to design a way of sampling news briefs that would involve Arab women at the periphery of the brief as well as in the headlines.

Second, we needed text-analysis methods because Arab women (like any other type of person) fill multiple roles, create multiple layers of impressions, and are therefore associated with multiple concepts in one and the same brief. Furthermore, active and passive behaviors are not mutually exclusive. When Arab women are active in a news brief, they are often active in multiple ways and not infrequently active in some ways and passive in others. Text analysis methods are helpful and arguably necessary to keep track of the various roles the Arab woman can fulfill and the various layers of impressions she can convey in these roles. We employed text-analysis methods developed by our own research group (Kaufer et al. 2004; Ishizaki & Kaufer 2012) that are specifically designed to mine texts qualitatively as well as quantitatively in association with a grounded theory approach to category development.[4] Employing grounded theory and computational text-analysis methods within an integrated methodological framework, we were able to meet at intimate depth many of the Arab women in the second phase of our research who were coded anonymously in the first phase.

What We Don't Address in this Study:
The Effect of Translation

Although translation is a mature area of academic research, the study of translation practices in the context of global news remains a relatively recent subfield of translation studies. Bielsa and Bassnett (2009) provide the first book devoted to the history and practices of global new agencies (see Bassnett 2002; and Baker 2006 for extended treatments of news). The mission of such agencies, beginning with the Paris-based *Agence France-Presse* in the 1830s and later the London-based *Reuters* in the 1850s, is to supply international content to newspapers worldwide. These agencies hire legions of translators in order to produce news with transnational mobility. Mideastwire.com, an independent news agency that provides news directly to subscribers, also relies on the skill of translators translating from Middle Eastern languages (primarily Arabic) into English. Our corpus consists of translations and so an obvious question to raise is, do the translations forming our corpus do justice to the news as presented in the original Arabic? Or might the fingerprints of the translators obscure and distort important source meanings beyond acceptable thresholds?

As Bielsa and Bassnett (2009) note, some news agencies distributing international content to media are beginning to ask these important questions and, in their estimation, all news agencies with translation services should be asking them. Throughout the industry, news agencies are becoming increasingly aware of translation as an academic field whose mission is to theorize and systematize into predictable approaches the many contingencies that crop up in the course of translation (Bassnett 2002; Baker 2006). Bielsa and Bassnett (2009) devote chapter 5 of their book to the profound differences a particular translation can make to the reader's experience of foreign news. These differences are tolerable when they are deliberate, systematic, informed by theory and stem from different approaches to translation. However, they are less than desirable when they are caused by hidden bias, oversight, and error (a particular concern of Baker [2006], who shows how ideological bias can creep into translation). The traditional staffing model for news agencies was to hire multi-lingual journalists with no academic background in translation as a field of study. This traditional

model has more recently been thrown into competition with the hiring of translation experts, individuals with formal degrees in translation, trained in the various approaches to translation, and cognizant that different translation situations make different approaches appropriate (Bielsa and Bassnett 2009, chapter 4).

When we first conceived this research project, long before Bielsa and Bassnet's book appeared, we had envisioned making our own independent translations of all of the news briefs so that we could test just how far the English reader's window on Arab news resembled the window of the Arab reader. We reluctantly concluded that the matter of translation practices was significant enough to require a book in its own right, and that it would not be the present book. In the present book, our focus is on the English reader's immersive experience with Arab news in translation. We do not test the veracity of that experience against the original Arabic. We focus on what happens to the old stereotypes of Arab women from the vantage point of an English reader who has paid a subscription fee to become steeped in Arab news in translation but reads not a word of Arabic. Our research design does not permit us to infer anything about the impressions of Arab women conveyed to the reader of the Arabic story; nor does it permit us to make comparative claims about the correspondence or gaps in the impressions formed about Arab women between readers of the original Arabic sources and the English translations.

Why Our Sample Remains Text-based and Excludes Multi-Media

Translation maps the syntax, semantics, and pragmatics of one language into those of another. The process is difficult enough when we are dealing with language alone. Multi-media sources of news provide a much harder challenge for the translator because more than linguistic meanings are at stake. In multi-media communications, especially broadcast or satellite radio or television, the semantics of the language are synchronized with sound and visuals. There is often no single narrator but distributed source authorities filling multiple roles. There are news presenters, field reporters, eyewitnesses, studio experts, analysts, pundits locking horns, and moderators seeking to ensure that

the pundits' locked horns keep pace with viewer attention and interest. While mideastwire.com does translate from original radio and TV broadcasts as well as from print and Internet news, its entries for the former are typically restricted to monologic interviews where one interview subject dominates the floor. Its translators – at least in the 2005–2007 sample we analyzed – do not take on briefs in which visual imagery, voice-overs, and lively, sometimes heated, studio exchanges are requirements for the story-telling. The briefs it translates follow the linear structure of a newspaper article. There is a single writer (the reporter) who is the author of a continuous narrative and the translator adapts the narrative script of the reporter's story to Western news conventions. There are no abrupt shifts of source authorities to throw off the translator. There are no concerns about synchronizing the verbal narrative with visual and auditory feeds. The news product is restricted to translations that are dominantly textual narratives, newspaper briefs in essence, that are not integrated with the multi-media effect (viz., radio, television, photojournalism, and video streaming).

In some known cases, the impact of multi-media on the depiction of Arab women in Arab news has proven significant. For example, between mid-2002 and April 2005, Sam Cherribi (2006) counted 282 television programs on Al Jazeera Arabic that covered the debate in France to ban the veil from public schools and the reverberations of that debate across Arab countries. Al Jazeera TV adopted a strong editorial policy against the ban and produced one story after another on Arab officials and ordinary citizens condemning France's policy-makers. Within this same time interval, in November 2003, one of Al Jazeera's star reporters, Khadija bin Gana, a native Algerian, decided to adopt the veil herself. Stately, dignified, and with a perfect command of French, a veiled bin Gana created riveting and iconic television when she was seen on Al Jazeera interviewing France's Minister of Foreign Affairs, Dominque de Villepin, about why he thought the veil threatened public education in France. For Al Jazeera viewers, according to Cherribi (2006), bin Gana's poise and aplomb functioned as a visual repudiation of France's policy. From her appearances, and from the appearance of many similarly veiled erudite women on Al Jazeera's programs, the station sought to elevate the veil into a "sign of distinction and cultural and religious belonging to the imagined community,

the Umma" (Cherribi 2006, 129). But key to Cherribi's argument is that Al Jazeera could not have made this point through words alone. The network's argument for linking the veil to a positive global conception of Islam, as Cherribi saw it, depended on the "visual language" conveyed by the sophisticated, educated, and well-spoken veiled women Al Jazeera paraded before its cameras between 2002 and 2005. To the extent that a story about Arab women in Arab news relied on the sounds and cadences of radio and the aural-visual codes of television to make its point, our corpus of Arab news, based on translations, was not tailored to catch it.

This is unfortunate, but only up to a point. Visual and aural channels add emotional weight and vividness to verbal narratives and in many if not most cases, like the Al Jazeera case study above, television news integrates these senses to enhance the viewer's experience. Exactly *how* the integration of senses through multi-media works to enhance the language of news and advertising has been an active area of research in Europe and the US for over a decade. Researchers (Kress & Van Leeuwen 2001), including those from our own research group (Ishizaki 2009), have made significant progress analyzing visual information and its potential to command attention and convey experiences to audiences in ways that both parallel and integrate with verbal channels. However, most of this work has remained at the stage of theory development and has not yet been refined into consensual methodological frameworks. Methodologies for transcribing multi-media artifacts (Baldry & Thibault 2006) are promising but still in their infancy and theoretical frameworks for analyzing them (O'Halloran & Smith 2011) are multiple and not yet well-synthesized. Furthermore, the transcription systems and analytic frameworks developed to date for multi-media tend to cover single specimens at a time, without apparatus for studying large volumes of artifacts simultaneously or as a collection. In light of these concerns, the challenge of amassing a corpus of television or radio news dedicated to our specific subject matter (Arab women in Arab news) was beyond our capabilities. Yet despite the important enhancements that multi-media brings to news, we concluded that restricting our analysis of news to the written *language* of news – the linear narratives easiest for translators of news to translate – was justified by the simple fact that the written language

remains central in carrying a news narrative, and in focusing and coor-
dinating attention around the narrative (Oakley 2009). Written
language captures levels of subtlety, nuance, and variation that we
required most to analyze each story under microscopic conditions.
Our corpus, within certain idealized assumptions,[5] contained the major
story lines involving Arab women that an avid newspaper reader of
Arab news would have tracked during the twenty-two-month time
frame of our sample. And while the television watcher or radio listener
would have undoubtedly received enhanced information about these
story lines through images and sounds, we had a reasoned basis for
believing that the linguistic spine of these multi-media briefs was
captured in our sample.

Scope of this Research

We present a media-based coding study followed by a research-based
canvassing of Arab women in Arab news. From the point of view of the
coding study, we were able to study the effects of Internet translation
services providing immersive experiences in foreign news to readers of
another language and culture. Such immersive experiences can help
readers gain a greater awareness of the cultural biases that influence
their home media. From the point of view of the canvassing study, we
discovered that news can be a useful repository from which to take a
conceptual census of persons. We discovered that the Arab women
who appeared in our limited sample were often covered in many other
news sources. Thus, with appropriate background research, we could
establish a deeper acquaintance with these women even if their appear-
ance in our sample was fleeting and clipped.

Our study of Arab women in Arab news provided a comprehensive
picture of individual Arab women and networks of such women in
Arab news. We took special note of the achievements marking their
progress to date and the challenges they must overcome for further
progress to be made. At one pole is a hopeful and privileged elite
woman, educated as never before, willing to network and compete in a
man's world on assumptions of gender equality. This female demo-
graphic emerges predominantly in the richly capitalized Arab Gulf,
spilling generously across Europe and stretching into North America,

but she can also be found in major cities across North Africa and the Middle East. She is raised in a supportive family that believes in gender equality and regards a university education and achievements outside the home as rites of passage for women. This Arab woman represents a rising cosmopolitan class and both the East and the West compete for her attention in the name of global development or the upholding of Muslim/Arab family tradition, and frequently both. At the other extreme are the still mostly silenced voices of Arab women who have yet to attain hope and who struggle, like many women worldwide, beyond anyone's radar, East or West, fighting patriarchy, poverty, corruption, and war. These weaker voices do not seek rescue from the West but the rights, aid, and assistance on their own soil that might transform hopeless futures into more hopeful ones. Using the methods employed in this book, we were able to take a systematic census of Arab women in Arab news from both poles and many points in between.

Part I:

Coding Arab Females in Arab News

1: Searching for Arab Females in Arab News

WHY WOMEN IN HARD NEWS ARE HARD TO FIND

The Arab woman is a flesh-and-blood human being living in twenty-two countries and territories among some 340 million people spanning northern Africa and western Asia (CIA 2007). She is illiterate and lives in abject poverty. She is blessed with unimaginable wealth enjoying near universal literacy. She lives under the rule of governments that are oppressive and governments that are more enlightened. She is a sister, wife, mother, daughter, grandmother, aunt, and cousin. She is the vital tissue binding her immediate and extended family together. She is educated, with doctoral and medical degrees. She holds titles in universities and labors on the streets. She works as a teacher, in commerce and the crafts, and also in science, engineering, technology, banking, literature, journalism, and the arts. She is an uneducated housewife and an educated one. She is an exhausted modern professional wife and mother balancing family and work. She is a destitute divorcee and widow with little family support. She is a divorcee or widow who enjoys overwhelming family support. She is a young schoolgirl who leaves for school each day with hope and confidence in what she can be. She is a young schoolgirl who must bring courage and resolve to the classroom because her educational rights are ignored and sometimes attacked. She lives in rich families and poor families and families facing cultural, political and psychological pressures. She is politically quiet and politically aware and active. Her womanhood makes little difference to her identity in the world. Her womanhood makes a great deal of difference. She cares passionately about the future of her children. The Arab woman is no different from women everywhere.

The Arab woman is also an historical construct of culture and media, an image to the world. The imagistic Arab woman is not a unique individual to know but a quick stereotype to nourish the illusion of acquaintance. The illusion is powerful because in very short order it lends the feel of insider understanding to perfect strangers. The illusion is dangerous because it can delude these same strangers, consumers of her image, into a false confidence that they know her without knowing her at all. Governments commonly exploit this false confidence by using stereotypical images of Arab and Muslim[1] women and often, mistakenly, conflating both to rally support for their policies. British colonialists, with the help of the British press, circulated stories in the nineteenth century of the "oppressed Arab woman" to add legitimacy to the claim that Arab men were not fit to rule their own lands (Ahmed 1992).

In a perfect world, we would all have the curiosity and time to know people as they are and where they live. We would learn their mother tongue, read their native literature, and even travel, like anthropologists, among them until their culture seemed as natural as our own. The world is not perfect. Walter Lippman (1922) observed at the dawn of modern journalism in the early twentieth century that advances in communication technologies were – even then – making every corner of the world increasingly aware of the other corners. Consumers of media had no choice but to trust the knowledge and judgments of other peoples that they acquired from fast-moving and easy-to-grab images, filtered through their own cultural lens. The mass media produce and circulate these images and, because of the influence these images exert on intercultural perception and policy, media images of various groups, including Arab women, have emerged as a legitimate and important area of academic study. Western social scientists of media employing empirical coding schemes of Arab women (Wilkins 1995; Falah 2005) and Arab populations generally (Suleiman 1965; Terry 1971; Mishra 1979; Jarrar 1983; Al-Qazzaz 1983; Lendenmann 1983; Shaheen 1983; Michalak 1988; Haque 1995; Hashem 1995; Kamalipour 1995; Palmer 1995; Nacos & Torres-Reyna 2007) in Western media, along with studies by Arab social scientists of Arab women in Egyptian media (El-Hadidy 1977; Rizk 1988; Agwa 2000 – all cited in Allam 2008) have found a

strong and consistent tendency to depict Arab women as passive, powerless, and culturally subordinate to men. In order to make generalizations of this kind reliably, such studies must be carefully designed. Researchers must decide on the universe of media to be sampled, how sampling will take place and the sampling biases to be addressed and avoided, how the specimens drawn from the sample will be categorized, how the categorized specimens will be tabulated and analyzed into results, and how the results will be interpreted (Riffe, Lacy & Fico 2005). Whereas we believe the studies cited above were well-executed and permit adequate generalizations within their sampling frame, most of the Western research cited above chose a frame where orientalist (Said 1979; Yegenoglu 1988) assumptions about the "passive Arab women" dominate. Indeed, a clearly articulated intent of most of these Western studies was to test the pervasiveness of Said's (1979) orientalist stereotypes of Arabs in Western media. Toward that end, these studies selected the appropriate sampling frame for their research question.

The research in this book took a different direction. We set out to understand whether depictions of Arab women in the emerging medium of "same-day"[2] translation services provides English readers worldwide with less stereotypical views of Arab women. This research direction, to our knowledge, has not been taken by others. And but for one recent exception (Skalli 2011), it has not been taken with the methodological focus on the textual analysis of Arab news that we employ.

English readers by and large cannot speak or read Arabic. So it stands to reason that Arab women in Western media are not likely to be shown to mass audiences who speak or think in their native tongue. Westerners have predominantly glimpsed Arab women in media where their words and actions are interpreted through third-person narrative accounts or image bites (Grabe & Bucy 2009). Image bites of Arab women expose them in photojournalism with their voices silenced and with captions, or voice-over commentary that is not their own.[3] Made known in the West largely through image bites, Arab women in Western media have been the subalterns who did not speak but were spoken for (Spivak 1988). Image bites serve ideological functions because of their plasticity and hence manipulability as a vehicle of

reference. Key to the signifying power of the image bite is the severa-bility of the verbal commentary and the image, which allows audiences "to reach conclusions from incomplete or partial information" (Grabe & Bucy 2009, 270). The de-contextualization of the image becomes morally problematic when it causes the image to be "staged" for blatant audience manipulation, the stock-in-trade of the tabloid press and much popular cinema. From 1850 to the present day, much of the West's imagery of the Arab woman was staged in Western photogra-phy and film in an effort to capture the "exotic" Arab woman (Graham-Brown 1988), much as a *National Geographic* crew would be sent out to capture for Western markets the sight of a rare animal species on a remote island. To cater to many Western readers' curios-ity for the mysterious and the "other," the Arab woman was historically eroticized and her harem reimagined as a brothel. Visuals within the image bite served as substantiations of the verbal channel. Mountains of images of silent and veiled Arab women in staged and compliant poses were used to support the cultural stereotype that Arab women were preternaturally passive.[4]

The important research from the West that has studied Arab women in media has concentrated on Arab women in image bites. The single most cited empirical study to date on Arab women in American news (Wilkins 1995) uses journalistic image bites as the coding unit of her study. Wilkins surveyed the *New York Times* index from July 1991 to June 1993 to gather an inventory of photographs of people in news associated with the Middle East. She gathered 230 captioned photo-graphs ranging across Israel (42%), Gaza Strip and West Bank (20%), Lebanon (10%), Syria (5%), Egypt (4%), Jordan (4%), and Iraq (4%). The remaining 11% of photographs captioned a smattering of women from Iran, Kuwait, Pakistan, Turkey, Algeria, and Libya. Using multi-ple raters, she coded every appearance of a male and female in the photographs and what the captions said about them. She found that 75% of the images were male and only 13% were female, a point we return to when we discuss the general invisibility of women in hard news. The majority of women who did appear (63%) were veiled[5] and she found that the veil erased not only the woman's face but, to an alarming degree, her identity. A veiled woman, she found, was signifi-cantly less likely than an unveiled woman to be identified by her name

and position, and would be more likely to be identified by her religious affiliation only. She also analyzed the captions beneath the photographs, providing description and commentary on the images. She found that men were significantly more likely to be cast in roles of agents who made news – soldiers, police, protesters, lawbreakers, working professionals, and politicians. Indeed, virtually all the politicians in Wilkins' sample were male and none were Muslim. The lone female politician in her sample was not Muslim and, tellingly, the caption made a point of contrasting her with Muslims. The woman in question, Hanan Ashrawi, was captioned as a "hard-working" woman and a "Christian in a largely Muslim world" (Wilkins 1995, 60). Wilkins found that the women in her sample were significantly more likely than men to appear at the periphery of the story, in collective, generic, supportive and victim roles. Women were not individuals making news but were part of the societal fabric impacted when news was made. Wilkins found that women were significantly more likely than men to be captioned as family members (e.g., wives, mothers) and religious worshippers. They were six times more likely than men to be cast as victims (42% to 7%), and significantly more likely than men to be captioned in war scenes where they were mourning, suffering, and witnessing the effects of war from the sidelines. In sum, Wilkins' study, within the constraints of her sample and research design, produced clear evidence that women from the Middle East conveyed through image bites in Western news appear less frequently and in less central news-making roles than Middle Eastern men.

Globalization and Foreign News:
Arab Women in Arab News

Wilkins' (1995) study was designed to provide a fair test of whether orientalist assumptions pervaded Western image bites of Arab women and she found they did. Her work focused on one Western media source (*The New York Times*) targeted at Western readers. Her study design did not try to counterbalance for sources and readerships outside the West and it is perfectly understandable why she did not seek such balance. She conducted her study prior to the explosion of

the Internet, at a time when Western readers did not have the expo-
sure they now have via their computers to non-Western sources.
One of the leveling influences of the Internet has been to reduce
geographical/cultural distance in news as never before. British soci-
ologist Anthony Giddens (1991) has argued that this reduction of
geographical/cultural distance has accelerated as each media tech-
nology has given way to more advanced successors. In pre-modern
times, news makers and news readers were connected by a common
"here" as well as "now". With print of the fifteenth century, and the
steam press and telegraphy of the nineteenth century, the newsmaker
and news reader became less reliant on a connection with the "here."
Timely news could reach audiences at greater geographical distances
in the same span of time (Kaufer & Carley 1993). Giddens called this
separation of the "here" in mass communication the "disembedding"
of social systems (Giddens 1991, 17–20; also cited in Bielsa & Bassnett
2009, 21), which allowed the news of one region and culture to be
extracted out of its local context and shared with another culture.
With the growing sophistication of communication technologies,
the process of extracting information from one culture to another
became increasingly fast but not increasingly problem-free. Unless
the consumers of news were schooled in the language of the foreign
culture, they were still dependent on the art of translation to make
foreign news accessible. Translation from one language to another
was and remains endlessly vulnerable to error, omission, and
distortion.[6]

While translation and the distortions it can cause are not a theme
of the present book (see the introduction), disruptive innovations that
whet consumer appetite for foreign news is one of our central themes.
The theory of disruptive innovation was first conceived by Clayton
M. Christensen and first introduced in an article he co-wrote with
Joseph Bower for the *Harvard Business Review* in 1995 (Bower &
Christensen 1995) and later developed in a two-book series, *The
Innovator's Dilemma* (Christensen 1997) and *The Innovator's Solution*
(Christensen & Raynor 2003). Christensen defined a disruptive inno-
vation as an innovation that takes a market by surprise and ultimately
displaces leading incumbent products by producing a transformative
change in consumer preferences that had not been anticipated. Before

Henry Ford's Model-T, cars were considered high-end luxury items that did not compete with horses. By producing inexpensive Model-Ts that could redefine the car from a "luxury" item to an everyday "necessity" for the masses, Ford was able to disrupt the current transportation market with his "horseless carriage." New market disruptions explain how desktop publishing came to overthrow traditional publishing; how digital photography came to overthrow chemical photography; how personal computers came to overthrow mini-computers; how telephones overthrew telegraphy; and, much earlier, how paper overthrew parchment.

Our research was made possible because of long-simmering disruptions in the foreign news business. One such disruption was the liberation of foreign news from the nationalist policies of states.[7] Historically, the foreign news citizens were able to read was wrapped in their government's foreign policy interests and briefings. With globalization and the increasing interconnectedness between developed and developing nations, this model of foreign news became unserviceable for cosmopolitan readers concerned with the development of civil society worldwide. New markets of cosmopolitans, including policy-makers, decision-makers, diplomats, academics, think-tanks, NGOs, and foundations, required premium transnational news perspectives that traditional news services such as Reuters were not providing (Bielsa & Bassnett 2009). Inter Press Service (IPS), headquartered in Rome, was founded in 1964 to address this new cosmopolitan reader of foreign news and it has grown, in its self-description, as the world's leading news agency today on issues of development, environment, human rights, civil society, and gender. IPS represents a global news service that might be called "news without borders," focusing on how globalization policies of the developed world have impacted the economies and civil societies of the global south. Such services afford readers the opportunity to follow foreign news through the wide lens of empathic conflict (placing the reader in the shoes of global underdogs rather than global elites) as an alternative to the narrow lens of hegemony (we elites vs. those alien others who stand in the way of modern civilization and progress). With this transnational perspective, IPS breaks down the traditional walls between foreign and domestic news, and seeks to build capacity for

new generations of journalists and translators who are professionally committed to reaching across borders.[8]

Market innovations in foreign news may also be the by-product of disruptive events. Our research was also made possible because of a disruptive event that called attention to the high price readers paid when their news agencies failed to provide adequate in-depth reporting of foreign news. That disruptive event was 9/11. In the Christensen model of disruptive innovation (Bower & Christensen 1995; Christensen 1997; Christensen & Raynor 2003), new market disruptions open up because the incumbent products are not keeping pace with the realities that drive consumer demand and because new "innovative" products come on the scene that make consumers mindful of what they are missing. Nine/eleven made American intellectuals mindful of how little reliable reporting US-produced news had been providing about Arab countries and cultures. Nine/eleven aroused in America's educated class a general disdain for the way their news services had failed to help them anticipate or respond to this event. Mainstream American journalism responded to 9/11 with rage more than enlightened analysis. It rallied Americans for blood, attacked the patriotism of skeptics of US foreign policy (McChesney 2002), and through its jingoism fueled the flames of prejudice against Arabs (Navasky 2002; Waisbord 2002).

The failure of the American press to anticipate 9/11 was a matter of economics as much as editorial slant. Having written off average American news readers as apathetic to foreign news, and with foreign news bureaus expensive to operate, American news agencies in the years leading up to 9/11 had closed foreign bureaus and fired foreign correspondents (Volkmer 2002; Karim 2002). These cutbacks compromised quality news-reporting; they made it all but impossible, even for Americans with the curiosity, to seek a deeper understanding of news with an Arab lens to find it; and they predictably exposed mainstream American journalism to embarrassing gaps of coverage. There was little in-depth historical reporting on the background of colonialism and twentieth-century British and French foreign policy, which had carved the Middle East into European spheres of influence with little regard for their viability as sustainable political states; little in-depth reporting on a Washington foreign policy that had stationed

troops near the holiest cities of Islam, roiling the anger of Muslims; little in-depth reporting on how America had been all too happy to support unpopular dictatorships in the Middle East in return for cheap oil (Glain 2004); and little in-depth reporting on how the very foe America, post-9/11, now branded the largest threat to global stability had been in the 1980s funded and trained to fight the Soviets in Afghanistan by none other than the American government (Haq 2008). Pre-9/11 American journalism remained mostly silent on this constellation of facts, the exposure of which could have avoided the ahistorical innocence ("Why do they hate us?") with which the mainstream American press ended up framing 9/11 for its readers (Karim 2002).[9] Non-Arabic-speaking intellectuals from America and Europe with an immersive and wide-ranging interest in Arab news from an Arab perspective were left in the cold. It was only a matter of time before Arab news services would rush in to fill this market gap.

The rise of these post 9/11 news services from the Arab world provided us with the incentive and opportunity to study representations of Arab women in Arab news afresh. Were these innovations in foreign news from the Arab world disruptive events that would change the historical coverage of Arab women in news? Or would they continue to reinforce the old historical stereotypes across new Internet services?

Launched on November 15, 2006, Al Jazeera English TV channel became a possible source of our study. However, Al Jazeera is one media conglomerate with many tentacles and does not represent the spectrum of reporting and editorial commentary across the Arab press. We wanted to sample Arab women broadly across Arab news and so we decided that we needed a news service that tapped into a broad cross-section of Arab media sources. Even before Al Jazeera English, on June 15, 2005 a subscription email service and website from the Middle East, mideastwire.com,[10] became operational. Founded by Majdoline Hatoum, David Munir Nabti, Maha Al-Azar and Nicholas Noe, all Lebanese, American or both, mideastwire.com sends to subscribers a daily email newsletter with that morning's headlines (translated and summarized) from the leading Arabic and Iranian newspapers. The service is operated from Beirut, which gives the

correspondents and editors a full workday to complete the newsletter and have it in the inboxes of American subscribers by mid-morning across the US. Nicholas Noe, Editor-in-Chief, is a 2006 recipient of the MPhil from Cambridge University's Centre for International Studies, editor of *Voice of Hezbollah: The Statements of Sayyid Hassan Nasrallah* (London and New York 2007) and the 2008 Century Foundation white paper, *Re-Imaging the Lebanon Track: Toward a New US Policy*.

On its website, mideastwire.com announces that its mission is to meet the need that non-Arabic-speaking Arabs or Westerners have felt for an "affordable" and "timely" translation service for news from the Arab press. While the Internet makes certain select articles in translation available on an à la carte or pay-as-you-go basis, there was, according to mideastwire.com's marketing plan, no existing service that allowed a subscriber to pay an annual subscription rate that provided him or her with open access to more than 500 Arabic and Iranian news outlets. As a result, mideastwire.com promises a disruptive innovation for high-end users in both the Arab world and the West – the ability to immerse oneself firsthand in the way the Middle East covers news from every walk of life and from every geographical angle – local, national, regional and international. In its first months of daily operation, according to its website, the service had recruited 1,700 paid subscribers. The website reports that most subscribers live in the US but a good number are also Arabs living in the Middle East.

The service has received favorable reviews from independent assessors. In a review for *The Electronic Intifada*, Najla Said wrote that mideastwire.com has a successful new concept in cross-cultural news distribution because its newsletters are "thorough" and because the articles it translates cut against a wide cross-section of Arab life, in stark contrast with the more narrow Israeli-owned MEMRI (The Middle East Media Research Institute) subscription service, which tends to cover Arab extremist movements (Whitaker 2002; see note 10). Said concludes that "Mideastwire.com is a remarkable service that is long overdue" (Said 2005). In a review for the *Library Journal*, Laguardia (2006) remarks on how a librarian would use it to support a patron interested in a single day of reporting from the Arab news.

Accessing the daily briefing for June 22, 2006, she notes that one will find thirty-four translated short reports, datelined "Algeria, Egypt, Iran, Iraq, Israel, Jordan, Kuwait, Lebanon, Morocco, Palestine, Saudi Arabia, Somalia, and Syria." The headlines are eclectic and wide-ranging from "Participation Front conference discusses Islam and modernity" to news from the independent daily *Al Quds Al Arabi* on "News about a mini Arab summit in Riyadh." Laguardia is impressed that the service is unique: She writes: "This is information you are not going to find elsewhere – at least not in English – and not this fast after events happen." She also notes that the news briefs are not stripped down bullets but offer substantial reading that varies in length but runs up to 2,500 words, sufficient for in-depth coverage. She concludes that the service is "a highly practicable means of delivering valuable content in a remarkably timely way." She goes on to say: "I don't know of any other source that can deliver content from this area of the world this quickly." Her bottom line is that the service is an "essential resource" for libraries supporting researchers in global and Middle Eastern studies. While mideastwire.com reports only briefs of news articles (translations of the full article are available at an additional charge), the genre of the original news article is explicitly identified in the translation and the translated news brief typically retains enough discourse cues for the English reader to discern at least some traces of the original genre at work. The articles translated cover news (*khabar*) and commentary (*maqāl* or *maqāla*), as well as the major subcategories of commentary, including the editorial (*iftit hiyya*), which often covers an issue and its historical context, columns (*'am'ād*), which may be serious or humorous, often served up in a sarcastic tone and generally political in nature, and news analysis (*bahth sahaf*), which tends to go into more depth to explain issues (Mellor 2005, chapter 5). While the genre of the original news article is often cited in the English translation as a service to the English-reading customer, the articles themselves are translated overall in the register of Western news, with a focus on information stripped of religious reference and other Arabic news idioms and colloquialisms that might be standard for Arab news reporting but infelicitous for the English news reader (Hatim & Mason 1990, chapter 3). Baker's (2006, chapter 4) theory of "translation as narrative" argues that

translations must be contextualized as narratives in order to be under-
stood. Such contextualization includes the selection of detail to fit a
coherent narrative – what Baker calls "selective appropriation" (Baker
2006, 71). While it is clear that mideastwire.com stories are selec-
tively appropriated to fit a Western news model, they are not
selectively appropriated to fit one particular ideological mindset in
Middle East reporting. Some Arab news briefs cater to the Western
reader's pre-existing categories, while others challenge them.[11]

Searching for Arab Women in News
between Scylla and Charybdis

In the *Odyssey*, Homer describes Ulysses caught at sea between two
devastating forces, the monster Scylla, who devoured sailors, and
the menace Charybdis, a whirlpool that sucked a ship down to the
bottom of the ocean. Studies of Arab women in media have been
caught between the Scylla of unholy myth and the Charybdis of
regrettable fact. The Scylla in this case is the Western myth of
"rescue" (Abu-Lughod 2002), the belief that Arab women, veiled
and secluded, must be saved from their own cultures. As we have
already noted, this myth has been pervasive throughout the West
since 1800 and has a long and unhappy history. The myth predates
the era of European colonization of Arab territories and was certainly
a contributing factor to it (Yegenoglu 1988; Mabro 1991; Kahf 1999;
Mernissi 2001). Both during colonization and even after, the myth
has been reinforced and commoditized, we have seen, across all
manner of artifacts, from postcard images of Algerian women sold as
kitsch trinkets to French tourists (Alloula 1986; Vivian 1999); to
editorial cartoons mocking women in veils (Shick 1990; Greenberg
& Gottchalk 2008); to staged photography of Western models
posing as "harem women" in the formative days of Hollywood
(Graham-Brown 1988); to depictions of Arab women submitting
willingly to male domination in modern Hollywood movies (Esposito
& Mogahed 2008). As we have also seen, studies of depictions of
Arab women in Western media (Wilkins 1995; Falah 2005) have
replicated variations of the rescue myth, showing Arab women to be
unassertive, compliant, and voiceless.

New research designs with the potential to explode this myth cannot evolve without media samples and sampling procedures that yield better sight-lines into the day-to-day reality of Arab women. This may mean, as it meant for us, avoiding the clutches of the Scylla myth by relocating our research question East and turning to the study of media representations of Arab women outside the West, where Arab women in fact live. To be sure, we discovered, to relocate the research question Eastward can provide fresh samples for analysis; alas, however, we also discovered that it does not necessarily provide less contaminated examples from the perspective of fair sampling. This is because, as we move East, or globally for that matter, we confront Charybdis, which is the hard fact of the media "invisibility" of women worldwide. No matter how far we travel beyond the prejudiced eyes of the West to see Arab women, we discover that, even in their own lands, Arab women, compared with men, like women around the world, are mostly unseen in the media. According to the Global Media Monitoring Project (2005), monitoring coverage of women in the news across seventy-six countries, women made up only 22% of all news subjects and even lower percentages when the reporting turned to the economy, politics and government. As the "gender wire" division of the IPS news agency aphoristically explains it, "Half the world's population, but not with half the share of wealth, wellbeing and opportunity. And certainly, women do not get half of media attention, or an equal voice in expression – only 22 percent of the voices you hear and read in the news today are women's" (IPS 2011).

Western scholarship since the 1970s has confirmed the same invisibility of women in media. In 1978, Tuchman (1978) introduced the concept in an article entitled *The Symbolic Annihilation of Women by the Mass Media* and the title seems as alive today as it was then. Numerous studies of the portrayal of men and women throughout the 1980s and 1990s have illustrated the low ratio of women to men represented in media and how even those few women who were represented tended to be trivialized or dismissed (Miller 1975; Blackwood 1983; Luebke 1989). Middle Eastern women are even harder to find in Western news. In her study of Middle East women in *New York Times* image bites described above, Wilkins (1995) found that 10% of photographs

showed women and men, 75% were photographs that showed only men while only 13% showed exclusively women. Overall, men outnumbered women in front page images by 75 to 17, a ratio of 4.4:1 and images on inside pages by 397/67, a ratio of close to 6:1.

Arab women holding leadership positions have been difficult to locate in Arab news. In a recent study looking at the representation of female political leaders in Moroccan media, Loubna H. Skalli (2011) of American University sampled 1,738 articles from major sections (cover, editorial, politics, nation/news) of three of Morocco's leading Arabic and two of its leading French newspapers from February 1, 2009 to May 31, 2009. She found over this three-month period that only 84 articles, less than one half of one percent (.04%), referenced a female Moroccan leader and none referenced Morocco's rising generation of young female leaders. And when any of these Moroccan newspapers did manage to reference one of Morocco's female political leaders, their reference tended to be brief; it tended to omit quotes from the woman; it tended to focus on her background as a woman more than on her achievements; and it tended to question her credibility and qualifications rather than take her professional competence as an established fact. Skalli (2011) further found that these tendencies increased significantly when the reporter was male.[12]

The worldwide phenomenon of female invisibility in media lives side-by-side with a parallel worldwide media phenomenon that genuflects to women's growing purchasing power even in the face of their stagnant political power: the growth of media niches targeted mainly to women. The emerging "women's" market in media, exaggerating women's visibility in a world scrubbed for woman-friendliness, rises from the ashes as a gendered counterforce to women's overall media invisibility (Minic 2008). In this parallel universe of women's media, media producers take pains to develop programming content that caters to women, that promotes their identity politics, that divides women against men or women against themselves, and that showcases women at the leading edge of trends in work or leisure (Minic 2008). The Middle East and North Africa are no exception to this worldwide trend. The *Middle East and North Africa Media Guide* (Smalley 2007, 90-98) shows that women's publications are an important and growing

sector of consumer publications, featuring not only publications marked for women, but emerging niche lifestyle markets that are weighted heavily toward female interests, such as fashion and shopping, bridal magazines, food and cooking, and parenting and childcare. The same niche markets have grown in Arab radio and newspapers and now feature ubiquitous on-air programming and print sections devoted to women's concerns (Smalley 2007).[13] While this market segment may seem a step forward for gender advancement, it is in fact held in deep suspicion by various media experts as an unsatisfactory, even counter-productive, response to the overall problem of female invisibility in media (Sakr 2007, chapter 4, footnote 65). Sakr (2007, 101) has dubbed it a form of "ghettoization" of women's media in the Arab world and, in the worst case, a permanent surrender to the fight for mainstream visibility. As Sakr (2007, 106) sees it, the rise of a "woman's media" could "actually have the effect of masking women's absence from other positions" in media.

Media that fashion a woman's world apart from men cannot help but promote women who play up their differences from males. This tendency, in turn, can lead to women's programming that places women in roles that replicate the worst cultural stereotypes of the feminine. This tendency is in fact a documented empirical trend in much of Arab media. The Center of Arab Women for Training and Research (CAWTAR) and the United Nations Development Fund for Women (UNIFEM) state as much in their 2006 report titled *Arab Women Development Report: Arab Women and the Media, Analytic Survey for Women Research Studies from 1995–2005*. The report covers a decade of research on media images of Arab women in Arab media. It reviews twenty-three studies on the image of women in Arab drama, the movies, and TV series. The studies found that 79% of the images of women were negative, focusing on women as sex objects, unintelligent, inexperienced, materialistic, manipulative, opportunistic, child-like, weak and dependent. Studies on Egyptian media conducted by the University of Cairo over two decades examined the same range of media in Egypt but in addition included the coverage of Egyptian women in hard-print news. The findings of the Egyptian studies echoed those of the CAWTAR/UN studies. In magazines and news, radio and film, Egyptian women were underrepresented compared

with men, and poor rural women were underrepresented compared with upper-class and cosmopolitan urban women. Across all classes, Egyptian women were widely depicted as requiring a man to make rational decisions for them and as being economically dependent on men. In the Egyptian magazine market, the media sector most gender segmented, portrayals of women were disproportionately relegated to the domestic domains of "cooking, cosmetics, and gossip" (Allam 2008). In the Egyptian newspaper market, the market most likely to portray women in realistic roles and settings, only two recently launched newspapers, *Nahdat Misr* and *Al-Masry Al-Youm*, were found to report discrimination against women in hard news. However, even these newspapers were found to provide no coverage of the conditions of the Egyptian working poor, primarily women; nor did they address as concerns the scant participation of Egyptian women in the political and economic life of Egypt (Allam 2008).

These studies of Arab women in media conducted in both the West and the East deeply challenged and informed our own study design. The prospect of keeping our study rooted in Western media made us wary of reproducing the Western myth of rescue. Yet in light of the Eastern findings, relocating Eastwards put us in jeopardy of reproducing segregated female stereotypes of the Arab woman that serve consumer culture and studiously escape the realpolitik that affects Arab women. If we had thought our way around Scylla by moving East, Charybdis remained untamed and unconquered.

Each step of a research design to study media images is fraught with challenges. Our challenge was to study media images of Arab women beyond Western eyes, stepping gingerly around the myth of rescue. At the same time, to dodge Charybdis, we needed to avoid sampling media where women were somehow programmed to "perform" within the limited stereotype of "the woman" within so-called women's media, a media used to sell products consumed by women. We wanted in other words to make sure we sampled widely across women in news and not just a fantasy universe created to open women's purse strings. We chose hard-news reporting because, as mentioned above, that is the market sector where one has the best chance of finding realistic portrayals of Arab women in everyday life.

Selecting Arab News from a Web Service for our Research

Since 9/11, international interest in news emerging from the Arab world has accelerated at a rapid rate and commercial translation services, such as mideastwire.com,[14] have sprung up to meet the demand. These services translate, daily, a cross-section of timely news articles and TV transcripts from the Middle East for international subscribers, A substantial cross-section of these articles derives from Arab countries and Arab media sources. By focusing our attention on Arab media focused on Arab countries translated into English, we wanted to learn whether Western readers who subscribe to these translation services might obtain a more realistic and well-rounded view of Arab women than the limited portrait Western and, as it turns out, much Arab media furnish. Would Arab media in translation offer a dramatically different picture of Arab women from the one that research on Western media has produced? Studying the genre of translated news might ensure that we would be looking at media representations of Arab women that were linguistically rich, crafted outside the West, but still accessible to Western readers. Studying Arab news in the English language would ensure that we could use text-analysis software that, unfortunately, has not yet been written to parse Arabic script. Our research question and its scope of application now seemed to be crystallizing. Would coverage of Arab women in Arab news prove less stereotypical than research on pre-Internet media had shown Western coverage to be? In preparation for this research, we obtained a license from mideastwire.com to conduct research on the representation of Arab women over a large sample of news articles indexed across a wide cross-section of Arab media sources.

Finding Arab Female Needles in Predominantly Male Haystacks

Mideastwire.com classifies its translated news briefs for subscribers and one of the classification categories is "women." For research purposes, we could not rely on mideastwire.com's classification scheme for two important reasons. First, their classification system

was proprietary and so we could not replicate it even if we wanted to. Second, and more importantly, any classification scheme relying on a third party could contain hidden biases that we would not have been able to control. We required a classification scheme that we could build from the ground up, without the possibility of introducing a third-party bias. And to build this scheme required that we have at our disposal any appearances that Arab women were making in Arab news, thematic or cameo. We required objective guidelines to assure that each translated brief in our corpus of news briefs included the presence of a female subject. We reasoned that a story containing one or more female keywords (e.g., girl, woman, female, mother, sister, daughter, etc.) would ensure that a woman had been referenced in the brief with no further bias as to her role. As part of our research agreement with mideastwire.com, we requested that the database of news briefs from September 2005 to June 2007 (twenty-two months) be filtered so as to contain at least one occurrence from a pool of eleven female-specific keywords (viz., woman, female, wife, girl, mother, sister, daughter, lady, aunt, niece, grandmother) along with their plural forms. Through the analysis of news briefs that included these keywords, we believed we could more realistically approximate how an English reader, interested in Arab news generally (not Arab women's news), might form impressions of how Arab women participate in Arab news.

The news briefs obtained from our license totaled over 2,323 briefs located in thirty-seven different geographic regions. From this sample, we removed 309 briefs (13.3%) originating from 15 non-Arab territories.[15] This left us with 2,014 (86.7%) news briefs from twenty Arab countries.[16]

In addition to the twenty Arab countries, our sample of 2,014 "Arab" news briefs included news with two non-Arab country codes. The first was a general "Middle East" code that covered one or another Arab country or Arab region. The second, and more interesting, was the country code signified as "Israel." The status of Israel as a "non-Arab" country lies at the heart of the biggest controversy in Arab media and politics. As researchers on gender and Arab women in Arab news and not Palestine/Israel, we did not want to have to enter this latter issue as a condition for conducting our

research. Nonetheless, from the Arab news perspective, it is simply the case that Arab news originating from Israel inherits the framing of Israel as occupied Palestine. Further, much compelling coverage of Palestinian women within Arab news would have to be discarded from our study – arbitrarily and unjustifiably we felt – if we eliminated news briefs on Arab women solely because they originated from a country code with a non-Arab designation (Israel). We wanted to avoid politics in our study, but we came to the sobering judgment that it would be more political (and arbitrary) to eliminate from our analysis Arab news stories about Arab women originating from within land the Arab press widely considers to be occupied Palestine. To take one dramatic example of what we would lose – all news briefs in our 2005–2006 sample about Arab female suicide bombers originate from the country code of Israel.

Each of the briefs in our sample of Arab news ranged from approximately 250 words to 2,000 words though some briefs exceeded 4,000 words. We decided to use the 2007 briefs (518 briefs; 26% of our Arab news sample) to develop and validate our coding scheme and train the coders; and to use the 2005–2006 sample (1,496 briefs; 74% of our Arab news sample) as the experimental sample, the sample we would code and tabulate results for once our coding scheme was developed and validated.

These decisions yielded a proposed study with an experimental sample of 1,496 Arab news briefs from a hundred media sources[17] that included at least one female keyword.[18] The rest of Part I reports the procedures and results of the coding study.

Conclusion

In Western media, the voices of Arab women have been muffled, scripted, or staged by others. In media worldwide, women are either eclipsed in hard news or fantasized in "women's media" as seeking perfection as mothers and wives, inveterate shoppers, fashionistas, celebrity watchers, or gossip-mongers, all images cultivated to feed an advertising industry selling non-stop to women. These trends make a fair study of Arab women in Arab news a sizable challenge. By sampling media stories across a wide cross-section of Arab media sources where

an Arab woman's presence was signaled by a mere female keyword or keywords, we sought to guarantee a sample of hard news that came with the barest hint of an Arab female or females without any further assumptions about them.

2: *Thinking Through a Coding Scheme*

CAN WE MEASURE ACTIVE AND PASSIVE BEHAVIOR IN NEWS?

That Arab women are "passive" in their own cultures has been a meme of Western thought since the eighteenth-century colonization of Arab territories (Ahmed 1992). One implication of the passive stereotype afflicting Arab women is that Western women must be somehow "active" in their cultures in ways that Arab women are not. Despite the popularity of the meme in Western thinking, one would be hard-pressed to find definitions of "active" and "passive" that pin down precisely what the dichotomy is supposed to mean in relation to the stereotype "passive Arab women." In both West and East, the active-passive dichotomy seems to refer to a female's claim to power rather than to the levels of energy she expends. In the West, the pervasive stereotype of the "homebound" woman has been the subject of feminist criticism since Mary Wollstonecraft's *A Vindication of the Rights of Women* (1997) and John Stuart Mill's *The Subjection of Women* (1997). Both treatises call attention to the wrongs of failing to educate women and restricting them to domestic affairs. However, neither Wollstonecraft nor Mill dared suggest that homebound women, saddled with the exhausting tasks of home maintenance and child-rearing, might be lethargic or inactive (see also Friedman 2005). The issue for them, as for many modern feminists, is not the lives women lead as much as their rights to choose that life and to ensure their choices are their own.

The definition of "passive" in the stereotype "passive Arab women," it appears, seems rooted in a Western myth that the powerlessness of Arab women must be a congenital condition of Arab/Islamic culture. To be sure, Arab territories have offenders when it comes to the rights

of women. In 2010, Yemen ranked last in the World Economic
Forum's global gender gap index (Kristof 2010). Nujood Ali, a Yemeni
girl became a best-selling author at the tender age of twelve for her
memoir, *I am Nujood, Age 10 and Divorced* (Ali & Minoui 2010) where
she wrote of her homeland: "In our country it's the men who give the
orders and the women who follow them" (quoted in Kristof 2010,
A27). However, like most negative stereotypes, correlation is mistaken
for causation and samplings are skewed to fit preconceived prejudices.
To assume that Nujood's experience is an irreversible and congenital
aspect of Yemeni culture is to violate her a second time.

These considerations speak to the power of the stereotype and the
damage done by those who circulate them. However, they do not yet
speak to the study of stereotypes from a disinterested perspective. To
conduct research on the stereotype of the passive Arab woman in new
vs. old news media, we needed operational definitions of active and
passive behavior in news obtained at a dispassionate arm's length from
the stereotype itself. We had to have non-fuzzy answers to the fuzzy
question: What does it mean to say a woman (or a human being for
that matter) is active or passive in news? How can we reliably associate
words and phrases in Arab news briefs with active and passive
behaviors?

Because we did not want to speculate too deeply about the stereo-
type itself that we were trying to understand, we had to start our quest
for operational definitions of active and passive behavior in news
through the most objective means available to us – the fundamentals of
grammar. To what extent can judgments of activity and passivity be
related to the grammatical relations of words in sentences? In the
sentence "Miriam hit the chair," Miriam is the active subject. In the sentence
"The chair hit Miriam," she is the object, and implicitly the passive
object. How reliably can judgments about the grammatical structure of
news spill over into coding judgments about active and passive Arab
women?

In this chapter, we review the thinking that informed a coding
scheme to capture definitions of active and passive behavior in news.
The following chapter reviews the coding scheme itself and the experi-
mental sample of Arab news stories to code. A coding scheme is a
method of quantification. It allows us to count and tally instances of

active and passive behavior in news inter-subjectively and for statistical purposes. The coding scheme, in turn, allows us to code these behaviors in our corpus of Arab news with scientific rigor. But why count what we can already read and infer? To explain our decision to quantify active and passive behaviors in news as objectively as we could (through a coding scheme), we begin with a justification of why we decided in the first place to develop a coding scheme for active and passive behavior of Arab women in Arab news.

The Importance of Quantitative Analysis

The literary critic and academic Stanley Fish published a book entitled, *Is there a text in this class?* (1982). As a university professor, Fish clearly knew the answer to his own question. Yes, there was a text in his class. And since he was a professor of literature, there were many. The meaning of his title was that, as he taught literary texts and as he and his students read and discussed them, it often *felt* as if there was no common text that everyone had read. Both Professor Fish and his students came up with so many and varied interpretations of what any single text meant that they were led to wonder whether everyone's eyes had indeed visited the exact same words of the author in the exact same order. How can one and the same text lead to so many different interpretations?

The answer to this question is that a text is not the same thing as a specific reading of a text. A text, once published, is unchangeable. Unchanging words live in unchanging sentences, paragraphs and chapters. However, readings of a text depend upon the background, interests, focus of attention and identity of the person reading it. A person who identifies as a conservative will read Adam Smith and Karl Marx differently from a person who identifies as a liberal. Readings are variable from one reader to the next because readers bring different histories of experience to the texts they read. Readings change, even within the same individual, because of changes in life experience. Reading *Hamlet* as a teenager is not the same experience as reading *Hamlet* in mid-life or in old age. Texts by themselves say nothing about who we are. However, our readings of texts say everything about who we are.

The fact that our readings are subjective indicators of identity is a very good thing that richly repays the investment we put into reading. However, it is not such a good thing for trying to make reliable generalizations about bias in media. Were one to claim that an Arab woman was treated "badly" on a particular hour-long television show, how would one substantiate it? One would first need to define what it means to be treated badly. Was she hit? Was she ignored? Did someone fail to smile when passing her in a hallway? When did these actions occur? An hour leaves plenty of time for a person to be on the receiving end of many kinds of treatment. How do we know that being treated 'badly' is the best generalization for what happened to the woman during the entire hour? What if the woman was spoken to abusively in one scene, but lavished with honors in another? What would prevent a person with a bias toward seeing 'mistreatment' to selectively remember the scene in which she was abused and selectively forget the scene in which she was honored? We cannot be precise about generalization if we do not take further precautions to break down our observations so that others can share and agree with them. There are many ways to take such precautions. One would be to break down the hour into uniform intervals of time and record our observations within those intervals. However, that still leaves open the question of when treatment becomes mistreatment. In some cases we can agree on the definition of mistreatment but not on whether the definition fits the observed behavior. Suppose we can agree that to hit a woman is to mistreat her. We still need to agree in a scene where a woman appears to have been hit that she was in fact hit and not accidentally bumped. In other cases, we might not even agree on the definition of mistreatment. Is being ignored a form of mistreatment? Is failing to be smiled at mistreatment? One could counter that these do not fit an objective definition of mistreatment at all but rather reveal that the person making the definition has unrealistically high expectations of the behavior of others. Was she truly made to endure an unsmiling face in the hallway and, if so, will everyone agree that this makes her the victim of mistreatment, or is she merely suffering from hypersensitivity and a too-thin skin?

The likelihood of this range of variability being in play when

television shows are viewed or texts are read is sufficiently high for us to be skeptical of researchers who report on media content without sharing their methodology. Developing a coding scheme about active vs. passive Arab women forced us to confront and clarify our own conceptual confusions about active vs. passive behavior in media. The value of a validated coding scheme is that it ensures that these confusions have been identified and eliminated *before* the actual coding of the study begins. Because of our special focus on the *language* of active vs. passive behavior in news, our study is distinct from many previous and well-executed studies that have found Arab women to be "passive" in the Western orientalist media. In Western media, the dominant image of the Arab woman since 1800 has been one of a silent female form, covered head to toe, standing motionless, arms frozen at her side, being gazed upon and not herself gazing outward. Chronicling over 100 years of photographic images of Middle Eastern women (from the mid-nineteenth to the mid-twentieth century) consumed by the west, Graham-Brown notes that the photographs typically "make the subjects seem passive" (1988, 64), give the impression that "women were entirely passive or helpless" (ibid., 80) and project women "as completely passive victims" (ibid., 243).

By turning to "same day" Arab news in translation on the Internet, we had a way of studying contact zones between the English reader and Arab news. Given the sample of Arab news in our corpus, we would have systematic access to the language spoken by Arab women, or about Arab women in Arab news. Our sample also provided us with a way to study Arab news in a language (English) for which we had sophisticated text-mining tools. To obtain an initial baseline of how Arab women might appear actively or passively in Arab news, we needed to obtain an initial baseline of how any agent, regardless of demographic characteristic or the geographical source of the news, may exhibit active or passive characteristics. Once we had that baseline embodied in a coding scheme and verified across coders, we reasoned, we could apply it to our sample of Arab women in news.

Three Measures for Marking the Active/Passive Distinction in News

We arrived at three measures that appeared to give us traction for distinguishing active vs. passive behavior in news. The first measure had to do with the linguistic notion of transitivity. The second and third had to do with the genre conventions of news reporting in English. We discuss each of these measures in turn.

Measure 1: Transitivity in Language

Transitivity is a refinement of the grammatical notion that a verb may or may not "act upon" its object. When we say "X hit the ball," there is the sense that the verb (hit) acts upon the object (ball). When we say "Y felt ill," there is no sense that an entity called "feeling" is acting upon another entity called "illness." The semantics even suggest other-wise – that the illness produces some negative feeling that has overcome Y. Verbs that "act upon" their objects (like "hit") are transitive. Verbs that do not (like "felt") are intransitive.

This is the simple intuition that underlies the concept of transitivity. However, the concept of transitivity is more elusive than this simple definition because a verb may "act upon" its object in a variety of ways and may fail to act upon its object in a variety of ways. Transitivity is a scaled and not a simple either/or judgment. Rather, determining whether a verb is transitive or not depends upon looking at the whole sentence context and then determining *how transitive* it is. On a scale of 1–100, a verb in context may have a transitivity score of 100 or 75, or 50. It may score 0 or even 38 or 92, depending on our scoring system. The relative transitivity of verbs has become a deep issue in the theo-retical linguistics of grammar (Hopper & Thompson 1980).

Transitive verbs such as "throw" and "rushed" (e.g. he *threw* the missile, he *rushed* the fortress) project action outward onto the envi-ronment. They indicate the agentive power of the subject. Intransitive verbs and verbal phrases such as "stand" and "keep watch"[1] (e.g. she *stood* still, she *kept watch*) exert no outward projective force onto the environment. Hopper & Thompson make the additional observation that transitivity has important discourse functions in story-telling. The

heroes of our stories, the characters who bask in the limelight of visi-bility, disproportionately act through transitive verbs. The minor characters in our stories, those who toil in the shadows and who help push the main characters into the limelight, disproportionately act through intransitive verbs. Based on the short examples above, we can tell a stereotypical gendered story about heroes and minor characters: "As she *stood* and *kept watch*, he *threw* the grenade and *rushed* the fortress." When this story is reported in the press, the man's transitive action may be honored and commemorated as a symbol of courage in warfare while the intransitive verbs attending the woman cues her secondary involvement.

The continuous use of transitive verbs in speech or writing can make the grammatical subject of these sentences appear to be an effec-tive manager capable of conquering the world through decisive action. Hariman (1995), analyzing the stylistics of political discourse, notes that (mostly male) chief executives rely on a straight-ahead unblinking discourse of command and conquest, what Hariman (13–50) calls the Machiavellian style.[2] Hariman also notes that mid- and low-level managers within bureaucracies rely on a weak and shapeless discourse, a discourse intended to exert authority and gain compliance while shirking responsibility and accountability. He calls this the bureau-cratic style (141–6). Using a corpus of American CEO communications to represent Machiavellian discourse and a corpus of tax code state-ments issued by the American Internal Revenue Service to represent bureaucratic discourse, Kaufer and Hariman (2008) found that Machiavellian discourse is strongly marked by transitive verbs, espe-cially transitive verbs of transformation (e.g., *strengthen, reduce, raise, lower, command, exert, crystallize, dominate, change*) while bureaucratic discourse is strongly shaped by weak intransitive auxiliary verbs (e.g., *is, was*) and single verbs (e.g., *defined, constituted*) and verb phrases (e.g., *defined as, constituted by*) of definition. Based on these findings, there seems a strong *prima facie* case for tracking the active/passive distinction along the transitive/intransitive distinction.

Unfortunately, things are not so simple. Were transitivity fully expressed by the simple grammatical formulas students of English learn in school ("verb + direct object"), we could have written a simple computer program to decide between active and passive Arab women

in print news. Hopper and Thompson (1980) show, however, that surface syntax is only the tip of the iceberg with regard to how we make judgments about transitivity (and indirectly activity and passivity) and that our judgments fall along not one but nine continua of hidden semantic considerations.

First, Hopper and Thompson show that to enhance the judgment of transitivity, it helps to have two participants in the situation: the agent projecting force onto the environment and a discrete object, or objects, in the environment impacted by that force. In the sentence above, consider how the presence of "grenade" and "fortress" contribute to the sense of the man's agency. Had we just described the man as throwing and rushing, we would have removed him from his unique historical circumstances (the circumstances of heroes) and made the description indistinct from that of an ordinary football player or athlete exercising in the gym (e.g., We watched the man throwing and rushing during his exercises).

Second, Hopper and Thompson show that transitivity is enhanced by a sense of kinesis or action. Only actions can be transferred as forces onto the environment, not states. Imagine the diminished status of our hero had he been described only as 'looking at' the grenade and the fortress. He would have exerted whatever weak projective force an eyewitness can exert, but this seems much weaker than the force exerted by a doer, whose actions ripple into the environment and leave imprints. And doing, kinesis, appears fundamental to making a difference that observers, and readers, pay attention to.

Third, they show that transitivity is enhanced when the action in question is completed and no longer ongoing. Throwing the grenade implies that it has been successfully thrown. Rushing the fortress implies that it has been successfully rushed. Imagine the fall in stature of our hero had the description been that "he was contemplating a way to throw the grenade and rush the fortress." We may have admired his effort but without action and results there are no medals, nor real transitivity.

Fourth, they show that transitivity is enhanced when there is no interruption between the start and completion of the action. Had our hero stopped contemplating and begun to throw the grenade and rush the fortress, there would be a serious loss of energy and impact were he

described merely as "beginning to throw the grenade and rush the fortress." Like impatient and fickle sports fans, transitivity is results-oriented.

Fifth, they show that transitivity is enhanced when the action is instigated of the agent's free volition. When our hero throws the grenade and rushes the fortress, the implication is that he is acting according to his own free will in doing so. Transitivity discourages reluctant heroes, as in descriptions like "he was forced to throw the grenade and rush the fortress."

Sixth, they show that transitivity is enhanced when the action is affirmative rather than negative. Our man of action could have been described as "refusing to throw the grenade and rush the fortress", in which case his action is active inaction. His resistance, in many circumstances, might be as admirable as the affirmative action, and in some circumstances (refusing to commit evil) even more admirable. Nonetheless, according to Hopper and Thompson's theory, negative action and positive inaction lose some points on transitivity as action in the world because the outward force on the world is either compromised (negative action) or suppressed altogether (positive inaction) by inward resistance.

Seventh, Hopper and Thompson show that transitivity is enhanced when the action is real and not simply hypothetical or contingent. Everyone is a hero in his or her imagination. That is why a man who "could/might have thrown the grenade and rushed the fortress" is seriously compromised as an actor in the world.

Eighth, they show that transitivity is enhanced when the outward force derives from human agency. Imagine finding that a tornado "threw" the grenade and rushed the fortress. The tornado carries the force of a transitive army but it is an anonymous force of nature and judgments of transitivity favor the unique historical forces of human volitional action.

Ninth, they show that transitivity is enhanced when the objects acted upon are individuated and bear effects that are traceable to the action. Transitivity increases when "he rushed the fortress" is revised to "he rushed the fortress until the walls came tumbling down." The revision makes us eyewitnesses to the effects of the action as well to as the action itself and tracks the efficacy of the action as a force in the

world. Similarly, "he rushed the fortress" has higher transitivity than "he rushed the bill through Congress" because "fortress" is an individuated object while "Congress" is not. Transitivity favors witnessable action because witnessable action can be experienced firsthand in the reader's mind's eye. To know that he rushed a bill through Congress becomes a turn of phrase to indicate he was insistent and forceful in his actions, yet the actions about which he is insistent and forceful remain abstract, unseen and unknown.

It is crucial to note that, for Hopper and Thompson, not every verbal expression needs to be high on all nine continua in order to qualify as transitive. In the broad universe of verb phrases, only a small percentage can be described as scoring high on all nine continua at once. For Hopper and Thompson, transitivity is a "how much" rather than an "either-or" judgment. Verb phrases scoring high on five or six of these continua will be judged more transitive than verb phrases scoring high on only one or two. We have relied on central aspects of Hopper and Thompson's transitivity theory as one important anchor point for our understanding of "active behavior" in news. For example, we found that women as agents of transitive verbs were often depicted in "active" roles outside the home – roles in which girls and women followed aspirations, took the initiative, or pursued education, employment, achievement and roles of empowerment. These "active" roles for Arab women are developed and discussed in Part II.

We adapted Hopper and Thompson's scheme for as far as it took us. However, we found that news reporting in English also relies on two additional considerations that go beyond considerations of transitivity. We have labeled these considerations the "source effect" and the "agent reference effect."

Measure 2: News Sources as Active Contributors to News Stories: The Source Effect

Grammar is not the only measure we found that could be used as an objective basis for the active-passive stereotype. We employed a second measure that involved the institutional context of news. By definition, "news" is a public genre restricted to the newsworthy. There are ample instances of active and passive behaviors in life that are not "news."

The verb "hit" in the sentence "The little sister hit her brother" meets most of the strong requirements of transitivity within Hopper and Thompson's theory, but lacks public value as news. News captures only the fraction of life that is deemed newsworthy. While what is newsworthy is a debatable question, newsworthiness imposes a constraint that judgments based on transitivity cannot directly capture. News deals with public contexts, including government, business, social organizations, political parties, and so on. When it deals with private contexts, there are typically cultural and policy implications in the background that make it newsworthy. "The president had his gall bladder removed" is newsworthy even though the event is private and the verb intransitive. It is newsworthy because the action is happening to a public figure and anything that happens to a public figure may be news.

Everyone has his or her 15 minutes of fame. And the spotlight of fame may shine on anyone who provides credible source information for news. Even private individuals experience some positive notoriety when they become credible sources of news. An eyewitness to a hurricane need not be a public figure – simply providing credible eyewitness testimony about the hurricane may be sufficient for him or her to be counted an active source of news. The words of the source help shape the news story and the news story, in turn, shapes the public record of the news. When interviewed by the media, a direct quotation from the eyewitness helps toward the construction of the news story. We may also report the words of the eyewitness indirectly, by noting that the eyewitness said the storm was devastating. This indirect quotation confers upon the eyewitness source credibility and fashions her, arguably, as an active source of news. We call this measure of activity the "active source effect" (or "source effect" for short) and we have considered it a second measure of activity beyond the transitivity measure. Many intransitive verbs of source citation play an active role in the development of news within English-language conventions. The verb "said" in the sentence, "She said the earthquake left her homeless," lacks most of the strong requirements of transitivity within Hopper and Thompson's framework. Yet in conventions of English news reporting, it can elevate the woman to an active source, engaged in her own form of active behavior in the sourcing of the story. With regard

to the domain of Arab women, the Arab woman is active if her cited words become a collaborative voice, helping to tell the story the journalist wishes to tell. The phrases for establishing a source effect may be as simple as "she said that," or "she thought that," along with various families of speech act verbs (Searle 1969) along with our own construal of how classes of speech acts map onto the representation of power in news.

Measure 3: Agents whose Acts Compose the News Story: The Agent Reference Effect

In addition to the source effect, there is a third measure of active behavior in news we call the "agent reference effect". The agent reference effect occurs when the journalist includes the plans or deeds of a person referenced as part of the official news narrative. Common phrases to express this effect are "she planned that" or "she X-ed that," where "X" is a verb, transitive or intransitive, that creates a central plot element of the news narrative. The source effect grants the source active standing because her words are helping affirm the story the journalist is telling. The agent reference effect grants the agent active standing because her referenced plans and deeds are helping affirm the story the journalist is telling.

Strong Speech Acts and Powerful Actions

Our three measures of activity in news worked for us like huge shovels that helped us to scoop out large families of verbs from English and categorize them as passive or active. Using our three measures, a thesaurus of journalistic verbs and verb phrases, and texts in our training sample, as our starting points, our initial coding categories for active behavior in news began to take shape as follows:

- Strong Speech Acts: e.g., *asserted, announced, decided, confirmed, insisted, declared.* Strong speech acts exhibit some qualities of transitivity by indicating action that is uninterrupted, completed, volitional, real and affirmative. Just as importantly for the institutional context of news, agents must typically have standing and recognized entitlement

with others to instigate speech acts of the types expressed in these examples. These speech acts also tend to do double duty as strong source effects.

- Strong Speech Acts of Opposition: e.g., *denied, refused, condemned, vetoed, prohibited, complained.* Strong speech acts of opposition enjoy transitivity in all the aspects of strong speech acts with the exception of affirmativeness. They also strongly co-occur as source effects.
- Powerful Actions: e.g., *initiated, studied, led, organized, rallied, graduated, ran for, elected to, appointed to, nominated, led prayer, cooperated, coordinated, distributed, volunteered.* These actions take activity out of the realm of words into the realm of deeds and either build up to or presuppose material achievement and empowerment outside the home. Powerful actions manifest some qualities of transitivity but also, even more importantly, confer cultural agency upon the subject of the action whether used in a transitive context or not.

To test the robustness of these categories in helping us formulate a theory of "activeness" in news, we split our sample of news briefs into a training sample and an experimental sample. We designated the 518 briefs from the first half of 2007 as our training sample. We designated the 1,496 briefs from 2005–2006 as our experimental sample. We employed the training sample to develop and evaluate our coding categories for both theoretical coherence and inter-rater reliability. To meet the standard of theoretical coherence, we needed to know that our categories made sense. In this chapter, we only discuss our explorations for coherence. The next chapter discusses our efforts, and ultimate success, in obtaining inter-rater reliability.

The first step of coherence-testing with our training sample was to look through our briefs and determine whether we could systematically expand our entries of transitive verbs in each of our three categories of activity (namely, strong speech acts, strong speech acts of opposition, and powerful actions). We had some preliminary ideas about the verbs that exemplified each of these categories, but we knew that once we started coding actual text, we would discover many more verbs matching these categories that we had not anticipated. Members of the research team individually read through brief after brief,

checking over the wide variation of verbs they encountered, and seeing whether the verbs made easy fits with our pre-existing categories of activity. These readings forced us to clarify our thinking and helped us better understand, refine, and justify the categories we were develop-ing for coding. For many months, we held weekly meetings to discuss our and our coders' different experiences in classifying these verbs. We were often surprised at how often we disagreed with each other, and how much constructive thinking and theoretical work we needed to do in order to arrive at consistent agreement.[3]

We eventually came to recognize a large family of speech-related verbs that seemed regularly to function as strong speech acts. The family consists of verb phrases headed by verbs such as "declare," "insist," "support the claim," "dedicate to," "indicate," "confirm," "clarify," "decide," "advise," "assure," and "agree to." Each of these verbs showed considerable consistency as strong speech acts across a range of contexts in our sample. This does not mean there could not be exceptions. We knew that, whatever coding scheme we devised, our coders would need to use measured discretion at every decision point before deciding how to code it.

As we examined stockpiles of verbs from our training sample of briefs, we began to appreciate systematic patterns connecting various verbs of citation and the source effect that portrayed the source as a credible co-constructor of the journalist's story. We began to unpack hidden reader assumptions about how the English reporter (or the translator hewing to the conventions of English reporting) associates certain verbs citing a source with the tacit authorization of the source's perspective.[4] To illustrate these linkages, imagine a reporter assigning a woman a speaking role in a news story and in the context of quoting or paraphrasing her words, the reporter describes her as committing one of a possible number of cited speech acts. Consider how these various cited acts, though different, all tacitly authorize her perspective.

- When the reporter describes her as having "declared" something or having "made a declaration", she is portrayed as having honed a confi-dent message with a bid on being heard far and wide.
- When the reporter describes her as "insisting" on something, it is often

the case that she has a track record of turning her personal forcefulness into action.

- When the reporter describes her as "supporting claims" she is presented as an active reason-giver, who cultivates an environment where reason-giving is expected and rewarded.
- When the reporter describes her as "dedicating" something to another person or "making a dedication," she is depicted as someone with public standing, whose credentials and achievement are likely to have been supported by those to whom she makes the dedication.[5]

These diverse verbs all constitute *strong speech acts* – and levels of active-ness through the source effect – in news because, unless they are explicitly overridden, they imply the agency of anyone who is reported performing them. Through strong speech acts, the press allocates agency to characters in news stories. Though they may lack some features of transitivity, they tend to be volitional and affirmative, completed and uninterrupted.

Let us now turn more briefly to *strong speech acts of opposition*. We can be briefer here because strong speech acts of opposition are simply strong speech acts but bereft of the transitive property of affirmation. Like strong affirmative speech acts, strong speech acts of opposition presuppose the active standing of the agents who participate in them. One article in our sample describes a young Egyptian Arab student, Ala , who was punished because she criticized American foreign policy during the administration of George W. Bush. The verb "criticize" is volitional, completed and uninterrupted and would transform into the verb "praise" were we simply to reverse the polarity from oppositional to affirmative. In the institutional context of the story, Ala is opposing, rather than affirming the Bush foreign policy. A similar analysis applies to the verb "deny," another strong speech act of opposition, whose affirmative twin is "assert." The verb "condemned" is a third example of a strong speech act of opposition, whose affirmative equivalent is something like "supported," "endorsed," or, more subjectively and positively, "gushed over." Strong speech acts of opposition cover a wide range of verbs with affirmative partners: attack/defend, prohibit/permit, refuse/accept, and so on. All strong speech acts of opposition seek to counter a previous or anticipated positive action.

Let us finally turn to the last category of active behavior, which we call *powerful actions*. Powerful actions are defined as actions whose effective outcome is inherent in the meaning of the action. Unlike strong speech acts, which focus on what characters in news *say*, powerful actions focus on what characters *do* and *accomplish* as demonstrated enactments of power. To be reported as taking a powerful action is to be reported as having already made an impact on other participants. As mentioned above, powerful actions may exhibit many of the transitive features of strong speech acts (of affirmation and opposition) but, in addition, they more directly make manifest institutional participants and how they are affected.

Straightforward examples of powerful actions are achievements reported as biographical milestones. Verb phrases such as "received a bachelor's degree," "graduated from Qatar University," "earned a paralegal certificate" are examples. While these phrases seldom explicate impact on the surface, they are understood culturally to be powerful entitlements affecting the disposition of others with regard to respect, deference, and employment.

While few powerful actions are also speech acts, there are, on occasion, speech acts that function as powerful actions. This is true in the English phrase "call on" in extended verb phrases such as "call on the media to have stricter standards." In such contexts, the call is made by a person of public authority who exercises moral, if not hierarchical, authority over the entities addressed. The call is a strong speech action to be sure. But unlike strong speech acts, which invite effects without expecting them and without building the expectation into the speech itself, the authority "calling upon" the other participant is not only inviting action, but expecting it. The "calling upon" is an enactment of presumptive power over the participants summoned.

Other powerful actions speak to elective opportunities for women. One article in our corpus of Arab news reports on an Arab woman who "registered her name in the electoral lists." We classified this as a powerful action because it makes a permanent imprint on her standing to run for office. The same is true for the verb phrase "nominated herself in the parliamentary elections which forced her into debates about the political circumstances in the country." The extended verb phrase captures both the institutional fact of her nomination and the

immediate social impact. Still another example reports a candidate for elective office, Aisha Al-Rasheid, as having "said in statements issued" various facts about her positions. This is not the simple [strong speech act] "say" of a source of the story. Aisha Al-Rasheid is not the source of the story but its subject. The verb phrase highlights her campaign organization and the fact that she campaigns by issuing official statements to the press. In offering this highlighting, the verb phrase is putting the power she wields on display.

Still other powerful actions express achievements in diplomacy. Take the case of an Iraqi woman who is described as having "met with an envoy of the commander of the multinational forces General George Casey and the political advisor to the American embassy as well as other military leaders." Participation in such a high-powered meeting indicated to us the enactment of power. The same Iraqi woman is described as someone who "will play a real and key role" and who "will prove herself" in negotiations with the Americans. What makes the categorization of these specific phrases as powerful actions slightly questionable is their irrealis nature, the fact that the verb phrases in question are inflected to indicate that the action being described is a hypothetical and not an established fact. The above verb phrases, more specifically, describe an unrealized future rather than a realized present. Nonetheless, we concluded, the woman's impact – and so her power – in the negotiations is being featured, even if that power remains a potential more than a foregone actuality.

A similar irrealis verb phrase and a similar categorization apply in a story about Abla Saadat, a human resources manager in the Palestinian Ministry of Labor. Saadat was in transit to Tokyo at Ben Gurion airport in Tel Aviv when she was detained by airport security. She is described as having "intended to participate in a human resource training course." The story clarifies her occupation as a manager and the verb phrase clarifies her occupational involvement as a participant in an international conference. That involvement is anticipated, however, and never came to fruition because of her detention. Nonetheless, the poignancy of the story rests on the dramatic tension between the positive and non-threatening power she wields in her position as a human resources manager and the fact that she is still made to suffer indignities at odds with her standing and professional effectiveness.

Some powerful actions arise because they describe a transformation whose effects are visible merely in the description of the action. Consider a story about a group of Arab women who work in car dealerships in Saudi Arabia. It is reported that the women "underwent training sessions to get them more acquainted with the various characteristics of the cars and various car brands." The fact that they underwent training speaks to the fact that they are now trained. The reporting of the action coincides with a statement about their newly-achieved capacities in the workforce. Other verbs or verb phrases that imply successful transformation are "coordinate," "lead the prayers," "distribute bread, flour and cereals to the displaced," "contacted," "run in the elections," and "volunteer at the headquarters of the female ballot boxes." The occurrence of the verbal form coincides with accomplishments having already affected other participants in the situation.

We have spent a good deal of space reviewing how our coding team reasoned about the *language* of activity in news because this language has been, in our view, under-studied and under-theorized. We catalogued the language of activity in terms of strong speech acts, strong speech acts of opposition, and powerful actions. The first two types of acts are verbal acts, or what Searle (1969) calls speech acts. They are acts accomplished by saying things. Powerful actions are depicted by verbs denoting non-verbal actions and accomplishments.

Coding Passive Behavior in Arab News

Through our three measures of active behavior in news, we had arrived at some systematic classifications of activeness. Could we do the same for passive behavior? What does passive behavior mean *in terms of linguistic representation* and how can we code for it? As with active roles, we sought to answer this question in the most general terms possible. Note that active behaviors fell into categories associated with strength (strong speech acts) and potency (powerful actions). To be active, the verb or verb phrase must signal the capacity of the agent to make a difference to the external environment. Analogously, we found, passive behaviors must signify some blockage, obstruction, resistance or inhibition that prevents an agent from making such a difference. In the

work with our training sample, we uncovered two major categories of passivity.

- Physical Passivity: e.g., *beaten, assaulted, forced, suffered, confined.* Physical passivity blocks bodies from exerting force on the outside environment in a way that might be considered human and natural.
- Social Passivity: e.g., *embarrassed, humiliated, pressured.* Social passivity describes psychological restrictions or institutional engagements that limit decision-making.

Physical passivity refers to restrictions on a woman's body. Physical passivity is evident when a journalist, like Abir Al Askari, from the weekly Egyptian opposition newspaper *Al Dostour*, complains that she was "beaten and sexually harassed" by the police. It is evident when a woman in war-torn Iraq claimed she "didn't feel safe in her own bedroom." It is evident when an eyewitness reports an armed group of males "beating up on one of the female students" for not wearing a headscarf. It is evident when a woman is reported as being "forced to flee" in disgrace because a man who had sex with her and was picked up for fornication told the police in his defense that he had entered into a *muta'a* marriage with her (a Shi'i Muslim tradition that may be translated as "pleasure marriage" or "temporary marriage"). It is evident when a woman complains that her employment opportunities are restricted because she "cannot move about like a man or work in dangerous fields including services [i.e. the armed forces] and security." It is evident when a report on the state of Palestinian women from the Office of the UN High Commissioner for Refugees accuses occupation soldiers of "sexually harass[ing]" Palestinian women and leaving them "regularly exposed to threats when they pass military checkpoints that the occupation forces place [i.e. position] in the West Bank."[6]

Social passivity arises in many cases when the physical threat has withdrawn and the only threat in evidence has become internalized or institutionalized. Threats of this kind are commonly reported in the workplace, where women may not feel the same protections as men. This was evident in a story about Manal al-Sharif, a Saudi journalist who works for the newspaper *Al Watan*. Al-Sharif complained that her

government needed to look into all Saudi press houses, as the rights of women journalists "are ignored" and "they do not receive the recognition they deserve." In this case, the fear derives from institutional failures to treat people equally. In other cases, the fear constitutes some mixture of the personal and the professional. In one article, a woman was promoted to a higher office but she "feared that her promotion might be explained through her status as the party leader's wife." Here the woman fears that her own actions may have violated the principle of equal treatment in the workplace and she worries about how the repercussions of these violations will affect her.

Other stories exemplifying social passivity speak of fears that arise from longstanding political conflicts in war zones, such as suffering in Palestine-Israel and Iraq. One article covering Arab women's anxiety mentions that: "The Arab women are living today in an insecure environment;" the Arab woman "suffers from many problems" and cannot "succeed and become productive while internal and external peace and security are lacking." Another article describes how a Palestinian student started wearing the headscarf when the Israelis started invading the cities and refugee camps of the West Bank after the second Intifada and she felt "humiliated and oppressed" about not being able to help the victims most directly affected. These stories are examples of the fear of powerlessness in hopelessly complicated geopolitical situations.

Still other stories illustrating social passivity arise from the fear of institutions and cultural traditions that restrict one's decision-making. The institution of arranged marriage is a case in point. One article cites a survey showing that the majority of marriage officials "do not ask the bride" whether she approves of the marriage or accepts the conditions of marriage. The officials report that asking the bride for her opinion would be a violation of custom and an embarrassment to the bride and her family, even though, they admit, the lack of such consultation violates Islamic law, which requires the bride's active consent. The institution of forced marriage in some parts of the Islamic world is a second case in point. An article about fifteen-year-old Khansaa, an Iraqi girl, whose father was killed by the American armed forces, tells a story about the economics of forced marriages. Her family being destitute, she was "forced to marry" a religious cleric in

Fallujah who was old enough to be her grandfather. The cultural traditions prohibiting women from driving in Saudi Arabia is a third case in point. An article from Saudi Arabia points out the irony that the demand for buying and owning cars among Saudi women is skyrocketing, even though they "are not allowed to drive them yet."

Social passivity may be, but need not be, associated with a woman's self-censorship and sacrifice. A woman may report that she is happy only to keep up appearances. Social passivity in these instances has no connection with fear or perceived suffering. One article in this vein mentions that a girl will wear hijab either out of her own personal beliefs or because she "is influenced by what she reads or hears on the subject from religious scholars who are spreading on satellite channels." In this case, the girl wears hijab out of social expectation and personal choice. She is dependent on cultural expectation but she independently chooses such dependence. And in other cases, women may make social passivity a matter of choosing the lesser of two evils. She may comply with some social expectations in return for circumventing others. In 2000, Egyptian wives were, for the first time, granted the right to apply for *khula* [no-fault divorce] as a way to end their marriages. However, as an article covering this event mentions, the introduction of this right meant that Egyptian women who exercised it "must agree to forfeit their financial rights and repay the dowry given to them by their husbands upon marriage."

In some cases, social passivity can appear as a background context for describing efforts of reform. As we have seen before and will see again, active Arab women are constantly monitoring institutions that enforce social and physical passivity as a way to measure their progress against them. One article acknowledges that women in Saudi Arabia face "restrictive regulations" on their lives, "are forced to live under" a repressive government, and face obstacles in "obtaining capital and getting loans, as well as institutional and social disadvantages such as access to education." But the story's hopeful point is that this situation might be changing, as the "unprecedented openness on state-owned television channels" is, for the first time, allowing Saudi women "to voice their grievances and frustration." Passive cultural barriers need not be brick walls for Arab women. Active Arab women can see openings and opportunities in them.

Conventions enforcing social passivity are typically designed to force women to censor their own behavior in compliance with family and social custom. Failing to adhere to prescribed norms can leave them vulnerable to forces of physical passivity, where the restraints are imposed from without. The institution of honor killing, in life and as reported in the news, is a case in point. An article in our corpus noted that in Jordan 90% of the female prison population had been detained for their own protection because they had run away from arranged marriages or had sex outside marriage and now their fathers and brothers had contracts out on their lives. In this case, women are sandwiched between two institutions of physical passivity, one seeking to end their life and the other seeking to protect it.

Conclusion

We have discussed three measures we used to define active behavior in Arab news. First, we employed Hopper and Thompson's notion of transitivity. Second, we assumed that sources taken as high in source credibility who help construct a story are active (the source effect). Third, we assumed that agents whose plans and deeds reference part of the story narrative are also active (the agent reference effect). Using these measures as a heuristic for classifying large quanta of verbal passages in Arab news, we arrived at a classification of active behaviors in terms of strong speech acts of affirmation and opposition and powerful actions. We were able to define passive behaviors in news through verb phrases that expressed forces inhibiting rather than activating an agent's effect on the environment. These definitions of active and passive behavior in news became necessary input into our coding scheme of active and passive behavior. As we shall see in the next chapter, they were not quite sufficient and more was needed to finalize and verify our coding scheme.[7]

3: The Coding Scheme and Experimental Sample

HOW WE CODED ARAB WOMEN AND WHERE WE LOOKED

In the previous chapter, we overviewed the thinking that went into distinguishing active from passive behavior in news. We needed to think rigorously about this distinction in order to conduct a study to determine whether the Western stereotype of "passive Arab women" held up in news from the East. Would English readers consuming Arab news in translation encounter the Western stereotype with the same frequency as that which infiltrated pre-Internet media from the West? We could not answer this question without objective ways of breaking down the negative stereotype (passive Arab women) and the anti-stereotype (active Arab women) into more descriptive, operational and researchable concepts.

We relied on one measure – transitivity, and developed two others – source effect, agent-reference effect – to help us classify verbs and verb phrases appearing in news into active (*strong speech acts of affirmation, strong speech acts of opposition, powerful actions*) and passive (*physical passivity, social passivity*). Using these measures, we were able to organize large collections of verbs and verb phrases into active and passive categories. This effort gave us the apparatus we needed for a coding scheme, but did not yet give us the coding scheme itself. A coding scheme for our purposes had to be set out in a manual that could teach anyone who was properly trained to classify active and passive behaviors in news and to do so with a high level of agreement with any other similarly trained coder.[1]

In this chapter, we review how we progressed from our thinking toward a coding scheme to the finished coding scheme itself. There are gaps between the two, and we caught one of our first glimpses of those gaps when we realized that not all verbs in news easily fit along an

active-passive axis of interpretation. We discovered we had conflated two of Osgood's[2] core continua – active/passive and positive/negative. We had erroneously assumed (based on our not-so-hidden liberal bias) that an Arab female who is active will be taking positive action and an Arab female who is passive will suffer negative action. These cultural assumptions, however, proved erroneous because they failed to explain female behaviors that seemed both active and negative (e.g., females involved in committing crime, abusing family members, or acting as suicide bombers). They also failed to explain female behaviors that hinted at passivity without hinting at negativity. A woman described as "curled up on a couch watching TV" appears passive without appearing negative. Such descriptions of a woman seemed more fairly neutral than passive, making us realize we needed a category for neutral behavior that filled the gaps between active, passive and negative characterizations.

We further recognized that we had not yet taken into sufficient account the vital distinction between the behavior of an Arab woman in news and the editorial perspective toward her behavior. Consider the ambiguous sentence, "Fortunately, she was able to take care of her younger siblings." Does the woman referenced deem her ability to care for her younger siblings fortunate? Or is it the journalist's overlaying a positive commentary on the situation responsible for the adverb "fortunately"? Or are both parties responsible for the commentary?[3] Because of the need to manage two viewpoints in reported news, we asked our coders to make two judgments about every action of an Arab woman referenced in our training samples. We asked them to make a judgment about the female behavior itself and then, if possible, about the journalist's attitude toward the behavior. We called the first judgment the "power" judgment because it sought to capture whether the woman herself was being described as active or passive. We called the second judgment the "viewpoint" judgment because it was meant to capture the viewpoint of the story from the story maker's, or journalist's, perspective.

There are predictable combinations of judgments of power and judgments of viewpoint. Suppose a woman is judged to be active and the journalist reporting the story is pro-woman and pro-activist. The journalist's viewpoint will tend to affirm the woman's active behavior. Conversely, a conservative journalist's viewpoint would tend to applaud situations where women remain in passive roles and to frown on

women engaged in active behaviors that stretch convention. Furthermore, a journalist striving for an objective tone would work hard to suppress overt indications of his or her viewpoint and when the journalist struck us as succeeding at suppressing any subjective framing we coded the viewpoint as neutral.

Dimension 1: The Power/Viewpoint Dimension

We called the dual judgments of power/viewpoint "dimension 1" of our coding scheme. For the power judgment, there were four possible codings: active, passive, negative, and neutral. For the viewpoint judgment, there were three possible codings: positive, negative and neutral. In light of these options, there were a total of eleven possible coding combinations[4] on dimension 1: active/positive, active/negative, active/neutral, passive/positive, passive/negative, passive/neutral, negative/negative, negative/neutral, neutral/positive, neutral/negative, neutral/neutral.

Dimension 1 posed the greatest challenge for getting our coders to read and code the Arab news briefs independently while achieving strong agreement across coders. In the summer and fall of 2007, we tested our coders' independent agreement on dimension 1. At the beginning of each week, we assigned our two coders a random assortment of Arab news briefs from our corpus. The briefs were marked with fifty to a hundred instances where a woman – or women in the plural – was mentioned. The task of each coder was to assign each of these marked instances one of the eleven possible codings of dimension 1. Half-way through the week, the coders submitted their judgments and we ran their codes through a computer program to compute the level of agreement between them. The program computed a statistical measure of agreement known as Cohen's Kappa (Cohen 1960). We then met with the coders at the end of the week to brief them on the level of agreement they had achieved that week, and went over with them ways they could increase their level of agreement for the next week. In the early weeks of this venture, the Cohen's Kappa score was quite low and each week we looked forward to making it higher. On the basis of our weekly discussion, we revised the coding scheme and sent the revisions to the coders for their review, approval, and use for the next week's coding. Our coding scheme developed and

grew significantly from these weekly discussions. This weekly process continued uninterrupted for ten weeks until, on October 8, 2007, we achieved a Cohen Kappa score on dimension 1 that the literature defines as "substantial" or "excellent" agreement.[5] The final scheme appears in Appendix 1.

Dimensions 2, 3, 4: Demographic Dimensions

We next turned to other coding dimensions, which we used for demographic purposes. Do the Arab women mentioned in the news briefs share common demographics? Do they work for a living? Do they stay at home? Do they have strong ties outside the home? To what organizations do they belong? Answers to these questions comprised dimensions 2–4. Of course, we could only code this information in the briefs if it was mentioned, which was often the case. When it was not explicitly mentioned, these dimensions were coded as "unclear."

Dimension 2: Occupational Status

Dimension 2 covered the occupation of the Arab women to be coded. Were the women employed or homemakers? Were they students? Were they professional or non-professional workers? Were they office-holders or government candidates? Once again, we coded this information only if it was provided and otherwise we called it "unclear."

Dimension 3: Personal Status

Dimension 3 covered the personal status of the woman referenced if it was discernible in the brief. Personal status could include the fact that she had never been married; that she was divorced and not currently remarried; divorced and remarried; or married and widowed. A brief could also indicate that the woman had children but made no mention of her current marital status. In that case, the woman was coded as a "mother" without committing further to her marital status. If none of this personal status information was available in the brief, we coded personal status as "unclear."

Dimension 4: Social Status

Dimension 4 covered the social role of the woman, "social role" being understood to include a woman's civic, social or political affiliations beyond her employment. Do the Arab women found in Arab news belong to groups outside the home or office? If they belong to outside groups, what are those groups? Are they liberal-progressive groups seeking to question cultural conventions, or more traditional groups seeking to reinforce established practices?

Obtaining Coder Agreement on Dimensions 1–4

We have referred to the weekly regimen employed to secure high agreement on dimension 1. Agreement on dimensions 2–4 was more straightforward and achieved with relative speed. Within a month of attaining acceptable agreement on dimension 1, we had obtained what the literature defines as "substantial" or "excellent" agreement on dimension 2, and what the literature defines as "near perfect" agreement on dimensions 3 and 4.[6]

Sampling Strategies for the Actual Study on the Experimental Data

Having achieved inter-coder agreement on all four dimensions, we turned to the experimental data, the corpus of 1,496 news briefs from 2005–2006 for the actual coding experiment. We now had to ensure we were sampling enough news briefs and the right assortment of briefs to give a fair answer to our research question, namely: Do depictions of Arab women in Arab news provide representations substantially more balanced than what legacy research literature had found was the case when Arab women were depicted in Western news?

To keep the coding manageable, we decided to limit the coding judgments to 1,000 keywords or less; yet the 1,496 news briefs that made up our experimental sample of briefs from Arab countries (see chapter 1) contained almost ten times that number: 9,751 female keywords. We initially reasoned that we would need a stratified random sample (proportional to the distributions of keywords and media

sources) to choose the most representative 1,000 keywords to code from the larger population of keywords. But after inspecting the distri- bution of keywords and media sources in our sample, we recognized a simpler way to sample than stratified sampling.

First we discovered that, in our sample at least, female keywords were not distributed equally. Of the 9,751 female keywords that appeared overall, 3,669 or nearly 38% appear as female pronouns, *she*, *her*, *hers* or *herself*. 3,611 keywords or nearly 37% of the keywords show up as the word *woman*. This means that of all the female references, a full three-quarters (75%), reference a female presence either in the most generic sense possible (keyword: "woman" or "women") or in the most particularistic sense possible (keywords: "she", "her" "hers" or "herself").[7]

By way of contrast, no other female keyword had an overall occur- rence rate higher than 6% ("female": 6%; "wife": 5%; "girl": 5%; "mother"; 4%; "sister": 3%; "daughter": 2%; with the keywords "lady", "aunt", "niece" and "grandmother" all with an occurrence rate of less than 1%; see Table 3.1 for a complete breakdown).

Female Keywords	Total Occurrences	% of Total
In the 2005-6 Corpus		
"she," "her"	3,669	38%
"woman"	3,611	37%
"female"	603	6%
"wife"	461	5%
"girl"	460	5%
"mother"	364	4%
"sister"	266	3%
"daughter"	216	2%
"lady"	86	1%
"aunt"	12	0%
"niece"	3	0%
"grandmother"	0	0%

Table 3.1 Distribution of female keywords in the 2005–2006 corpus.

With regard to the fact that our original research question was whether Arab women are stereotyped in Arab news in the manner that the Western press has been known to stereotype them, this distribution of female keywords quickly answered this question for us. Extended references to individual Arab women by use of the pronoun "she" (e.g., Salima Najm, an owner of one of the salons, announced that *she* had to shut it down after *she* received a pamphlet threatening to kill her if *she* did not close it down [*Al Hayat*, June 5, 2006, Headline: "Ba quba tribes pledge to fight the extremists . . ." Country Tag: Iraq, emphasis ours]) formed a basis, we discovered, for non-stereotypical historical reference.[8] Any woman referred to as "she" in a brief had previously been mentioned, and the pronoun "she" marks what linguists (Givon 1979) call a "persistent reference" and an indicator of a unique historical individual rather than a generic category or stereotype. Referencing a female as a historical individual and not a stereotype is the first step toward what fiction writers call a rounded character (Novacovich 1995), who can learn, grow, reflect on, and respond to her environment. In a media source that seeks to elaborate women as historical individuals beyond stereotypes, we would expect females to be referenced as unique individuals (e.g., Salima Najm) comparatively more than they are referenced generically (e.g., female hygiene; women's fashion; women's health).[9]

By way of contrast, usages of the singular word "woman" and its plural form "women," we discovered,[10] are more indicative of stereotypical reference to females as a category rather than as unique persons. In our corpus of Arab news, reference to the singular generic female ("woman") was predominantly employed as a social and demographic category (e.g. the good woman, veiled woman, Egyptian woman, Muslim woman, single woman, married woman, the woman of the family, kidnapping of a woman, young woman, old woman, unemployed woman). In addition, in a substantial number of news briefs, the plural form "women" does not reference a generic female category but only a gendered label (e.g., women's conference, women's organization, women's entrance, women's clothing). Females referenced as labels can tell us much about gendered divisions within a society but little about the historical experience of one or several unique females.

The mere fact that female keywords in our sample of Arab news

were dominated by the least stereotypical female reference ("she") and the most stereotypical ("woman") suggested, at least at first glance, that the depictions of Arab women in our corpus of Arab news was considerably more balanced than the images of generic "veiled women" deprived of unique historical identities found so dominantly in pre-Internet Western media.

We also discovered that a very small fraction of media sources accounted for a very high percentage of all female keywords – both stereotypical and non-stereotypical references – in our corpus. Although our experimental sample contained 1,496 briefs ranging across some one hundred media sources, the top four sources in terms of frequency of briefs (*Al Hayat*, *Al Quds Al Arabi*, *Asharq Al Awsat*, and *Elaph*) contributed 649 (43%) of the total number of briefs and 3,978 (41%) of the overall number of keywords. All four publications were among the top seven publications ranked by number of female keywords. Of the 9,751 female keywords across all 2005–2006 briefs, in order of the size of their contribution: *Asharq Al Awsat* came first, contributing 1,500 (15%) of the total of female keywords; *Al Hayat* came third, contributing 1,001 (10%); *Elaph* came fifth, contributing 757 (8%); and *Al Quds Al Arabi* was ranked seventh, contributing 720 (slightly over 7%). The only two publications ranked higher than some of these four were a women's magazine (*Sayidaty:* ranked second), whose stories not only consistently mentioned females (1,173 [12%] of the female keywords) but were deliberately focused on women, and *Al-Watan*, a Saudi-based reformist and pro-women newspaper, ranked third with 899 (slightly over 9%) of the total number of female keywords. Al Jazeera, with thirty-one texts in our sample coming mainly from its website,[11] ranked thirteenth with 118 (1%) of the total female keywords contributed.[12] Unlike *Al Hayat*, *Al Quds Al Arabi*, and *Asharq Al Awsat*, which are all pan-Arab publications headquartered in London, and *Elaph*, a website with a large, youthful, and Internet-savvy pan-Arab audience, *Sayidaty* has a gender-focused market and *Al-Watan* a regionally-focused market (Rugh 2003). Because of the lack of balance of female references in Arab media sources taken from our sample, we were unable to say that *Al Hayat*, *Al Quds Al Arabi*, *Asharq Al Awsat*, *Elaph*, *Sayidaty*, and *Al Watan* offered a "representative" window on females in Arab news. On the contrary – because

these six media sources were so rich in female references, collectively containing 63% of all female references over our sample of one hundred media sources, we had to judge that they were not representative of the larger pool of media in our sample. Indeed, if we wanted to draw a truly representative sample of the one hundred media sources in our sample, we would have discarded the six "female-rich" media sources as outliers and focused instead on the ninety remaining media sources, which together accounted for less than 1% of all female references. And we would have concluded, on the basis of representativeness, that Arab media sources, at least by the evidence of our sample, are by and large silent about women.

Because we wanted to keep our research focus on Arab women in Arab media, we needed to jettison the idea that we were sampling for statistical representativeness. We rather found we needed to sample for highly-concentrated "clusters" of Arab women within Arab news and the six publications that caught our attention for this purpose were the four pan-Arab publications, plus *Sayidaty* and *Al-Watan*. After further consideration, we decided not to use *Sayidaty* and *Al-Watan* in our sample. Because *Sayidaty* focuses on "women's news," we were concerned that keeping *Sayidaty* in our sample would tilt the center of gravity to "women's stories" in the limiting context of "women's media" discussed in chapter 1. Because *Al-Watan* is a Saudi newspaper, we were concerned that adding the sixty-two news briefs from *Al-Watan* to our sample would over-represent Saudi Arabia at the expense of other Arab countries. Adding *Al-Watan* would have boosted Saudi Arabia's representation in our corpus from 12% (28/237) to 30% (90/299) of the Arab news briefs sampled.

Because of their high level of representativeness in briefs and female keywords, both the stereotypical reference ("woman") and the non-stereotypical reference ("she"), along with their pan-Arab and digital reach, we determined that we would lose little in sampling accuracy and gain a great deal in simplicity if we restricted our experimental sample study to the four largest pan-Arab print and web sources: *Al Hayat, Al Quds Al Arabi, Asharq Al Awsat*, and *Elaph*. By restricting our study to these four pan-Arab media sources, we were still accounting for 44% of the news briefs through a small and manageable window.[13] These decisions ensured that we would be tapping the center of gravity

of our sample where females were most densely referenced, both as stereotypical categories and as persons. It also ensured that each of our media sources had a pan-Arab reach that would be less likely to over-sample one or another Arab country.

Each of the four pan-Arab media sources we retained for our sample is a leader in its market niches. Founded in 1946, *Al Hayat* is the oldest and leading liberal pan-Arab newspaper, owned by the Saudi Prince Khaled Bin Sultan, and distinctive for bringing leading thinkers to its editorial pages. It has a circulation of some 190,000 readers by some estimates (Allied Media on *Al Hayat* 2010a; Freebase on *Al Hayat* 2010). Over 100,000 of those readers are based in Saudi Arabia. Its readership is 67% male and 77% of its readership are between the ages of 24 and 44. Its readers are highly educated, with over 80% of readers having some university education or a university degree (Allied Media on *Al Hayat* 2010a). Founded in 1978, *Al Quds Al Arabi* is the leading independent pan-Arab newspaper and is Palestinian-owned. Because of its lack of affiliation with a state, it tends to exercise less self-censor-ship than government-owned news media. It champions Arab and Islamic causes and often takes an anti-Western perspective. Its editor-in-chief, Abdel Bari Atwan, rose from the refugee camps to become a best-selling author and a familiar face on satellite television. It has a circulation of 50,000 (Allied Media on *Al Quds* 2010b). Marc Lynch (2009) of *Foreign Policy* magazine has called *Al Quds* the most "popu-list" of the pan-Arab newspapers because of its hard-line stance against Israel. Founded in 1978, *Al Sharq Al Awsat* has a reported daily circula-tion of 237,000 (Allied Media on *Al-Sharq* 2010c). Of the pan-Arab dailies, it is the most exhaustive in its coverage of political news across Arab regions, most of which comes from non-Arabic news agency wire services, which it translates into Arabic. Founded in 2001, *Elaph* is one of the first Arabic-language electronic magazines. Based in London, it enjoys among the largest international readerships of any Arab-language news site. It is owned by the Elaph Holdings Company in the United Kingdom and Elaph Publishing House in Saudi Arabia. The CEO and editor-in-chief is Othman al-Omeir. According to the Initiative for an Open Arab Internet (Open Arab Internet 2009), an organization committed to an open Internet in the Arab world, *Elaph* is a leader in promoting human rights and calling attention to human

rights violations against minorities, refugees, and women, publishing on average 1.6 articles per day related to that topic. Its explicit editorial policy is to promote human dignity, equality, and democracy, and it champions the causes of oppressed minorities, be they Kurds in Iraq, Copts in Egypt, or Lebanese Christians (Arab Press Network 2009). As a website, *Elaph* commands a reader base that reached an average of 5 million visitors a month in 2008, with readers scattered across the Middle East, Europe, and the United States. Indeed in 2008, readers from the US (with a significantly smaller percentage of Arabic-language speakers) constituted 8% of its readership, second in country percentages only to Egypt (11.4%) and Saudi Arabia (8.3%) (Arab Press Network 2009). As one might expect, readers of *Elaph* skew younger than the readers of the other pan-Arab media, with 90% aged between 18 and 34 (Bialek 2010). Because of its uncensored editorial policy and commitment to human rights, *Elaph* has been called the most "respected" Arab electronic daily in the Arab world (Jackson 2010). *Elaph* accommodates its youth market by featuring women in politically-mixed roles, both as victims of rights violations and also as objects of desire, in sections marketed to youth-oriented readers drawn to stories featuring women and fashion, celebrity news, gossip, and glossy photography (Open Arab Internet 2009).

Despite differences in the demographics and markets of these four pan-Arab media sources, it should be obvious that their readership, in comparison with the average Arab citizen, is highly literate and educated. It should also be clear that, compared with the average Arab reader, the readership of these four pan-Arab media sources is globally aware and interested in news beyond their own town, region, and state. The fact that 44% of all female keywords appear in 4/100 or about 4% of the media sources indexed by mideastwire.com is astonishing. Assuming that mideastwire.com's propriety indexing service seeks to approximate a representative sample of stories about females in the Arab media,[14] then one arrives at an astounding conclusion. Should one want to find Arab women in Arab news in concentrated numbers and without relying on women-themed publications (*Sayidaty*), one had better look to liberal-progressive sources and, typically, sources with an international reach, to find them.

In hindsight, skeptical readers might wonder whether we might not

have been better off just starting with the four pan-Arab media sources and analyzing them. The attractiveness of this alternative became apparent to us when, well into our research, both *Al Hayat* and *Asharq Al Awsat* started English-language versions on their website. Could we not have saved ourselves time and trouble by simply focusing from the start on a select few Arab media sources that already produced English editions? The short answer is no. Had we started with a restricted corpus, we could only legitimately claim to be studying mentions of Arab women in *these* media but not in Arab print media as a whole.[15] Yes, we end up with four media sources that share similarities – they covet readers with transnational awareness and all take a relatively pro-women editorial stance. Our sample clearly over-represents young liberal readers who like to read beyond their local or national context. However, does that mean our sample over-represents or is skewed to these four sources? No. These four sources, after all, capture nearly half the briefs and nearly half the female mentions in our sample of 100 media sources. These findings reflect an important empirical truth about women in Arab news.[16] Close to home, Arab women's appearances in local, regional and even national news remain neither stereotypical nor non-stereotypical. They are rather sparse and scattered (see also Skalli 2011 on this point for print media in Morocco).

Conversely, in the liberal Arab press, where women are accorded more attention, both stereotypical and non-stereotypical, we discovered that females fall into stereotypical categories but are often accorded more rounded potential, even at the peripheries of stories. In response to the question of whether Arab women are stereotyped in Arab news, we were at this juncture able to answer that Arab women both fit into types and are described as unique individuals beyond types. They are both stereotyped and not stereotyped. Once this finding began to emerge, we decided it would be most fruitful to continue to track the non-stereotypical references, the mentions where Arab females are referenced as particular individuals ("she") and not as cultural categories or labels ("woman"). We also decided we wanted to code Arab females who entered the news as flesh and blood individuals through persistent reference, whose lives were developed across clauses and sentences and not dropped in the same language unit in which they were introduced. As discussed above, particularistic and persistent

reference to females is accurately signaled by the female pronoun (viz., "she", "her", and the female plural – "they"). We decided to focus our keywords on the singular female nominative pronoun "she" (which is more persistent across clauses than the accusative "her") and on the plural female nominative pronoun "they" (which coincides with the male plural and requires a human editor to distinguish by gender). We decided as a result only to sample occurrences of "she" and the plural "they."[17]

These decisions substantially reduced our sample of briefs. By restricting our corpus to the four pan-Arab media sources, our corpus was reduced from 1,496 to 649 Arab news briefs. We then filtered these 649 briefs down to briefs that contained either the female keyword "she" or the female keyword "they." This reduced our sample size of briefs to 237 briefs. The final coding scheme and the coding study, presented in the next two chapters, are based on these 237 briefs. Starting with the 2,323 briefs we originally received from mideastwire. com, through a series of methodical filtering steps, we had filtered our way down to 237 briefs. And in the process we discovered much about our sample. When we partitioned our sample by keywords, we found that the dominant keywords reference either particular females (e.g., she, her) or social categories designated by gender (viz., woman). When we partitioned our sample by media source, we found that liberal pan-Arab sources dominate both stereotypical and non-stereo-typical references to women. The reality for the majority of Arab sources in our sample toward females was not stereotyping but erasure. Restricting our sample to the four pan-Arab sources ensured we would be studying media where Arab women, stereotyped or not, are not erased. Restricting our coding sample to the non-stereotypical and persistent female keywords "she" and [female] "they," ensured that we would be looking at the subset of our sample featuring historically specific Arab females whose lives were accorded at least some persist-ent exposure in Arab news. We required this sustained exposure to get the best fix on how Arab females might appear active or passive in Arab news. Having now fixed our coding scheme and our sampling strategy, we could at long last be precise about not only *how* we would code, but *what* we would code. In the scientific terminology of coding schemes, there are two terms of art worth noting. One is called the "coding unit"

and the other, the "contextual unit" (Riffe, Lacy & Fico 2005, 56; Geisler 2004). Coding units are the actual entities in the stream of language to be coded. They are typically fixed units, such as words, clauses, sentences, or paragraphs. Contextual units are the surrounding areas of text and context to which one appeals in order to justify one's specific coding decision (e.g. active vs. passive) regarding the coding units. We established that our coding units would be every mention of the female keywords "she" and "they." We established that our contextual units, insofar as they were textually based, would be the nearest verb phrases on the left or right of the female keyword (Table 3.2).

Coding Units	Contextual Units
she (singular female pronoun) they (plural female pronoun)	Nearest verb phrase providing the controlling semantic frame of the female pronoun; English new-reporting conventions

Table 3.2 The coding and contextual units for our coding study. Our coders coded every occurrence of the female nominal pronoun, the singular "she" or the plural "they." They judged this occurrence as "active" or "passive" based on the nearest controlling verb phrase and on English news-reporting conventions. Thus, the full apparatus fell into place for settling on our contextual unit, as discussed in chapter 2.

The important decisions about our coding scheme, both the appropriate coding unit and contextual unit, evolved, as we acquired more information about our corpus of study. We could not have predicted that the verbal system of English was insufficient to distinguish active-passive behaviors until we tested it on hundreds of examples and found it required supplementation from English reporting conventions. We could not have predicted that a coding unit limited to female pronouns (she, they) made sense until we had a chance to study the distribution of references to females across our entire corpus of news. In sum, we discovered that, in order to conduct research of this nature, nimble and informed adjustments along the way were an absolute necessity.

Conclusion

As we recounted in the last chapter, we employed three measures – grammatical transitivity, the source effect, and the agent-reference effect – to calibrate levels of behavioral activity in news. Using these measures, we were able to divide the English verbal system into strong speech acts of affirmation, strong speech acts of opposition, and powerful actions. This chapter has reviewed our progress from this delineation of a coding apparatus to a fully deployed coding scheme. To move from coding apparatus to coding scheme, we recognized that every reported behavior in news may be regarded from two possibly divergent points of view: the point of view of the Arab female in news herself, and the point of view of the writer reporting on that female.[18] These two insights led to the first dimension of our coding scheme, the power/viewpoint dimension. The remaining three dimensions covered demographic information about the Arab women or girls reported on. These decisions determined how we were to code, but not what. After analyzing our corpus of news in greater statistical depth, we recognized we could get maximal leverage by limiting our coding to four pan-Arab media sources and coding the female nominative pronouns, "she" and the plural female "they." The coding scheme now filled in, and the coding and contextual units about what to code now decided, we were ready to conduct the study and await the results. The results are the business of the next chapter.

4: Results of the Coding Study

BREAKDOWNS OF ARAB WOMEN IN ARAB NEWS

This chapter reviews the coding results after we applied our coding scheme to the 237 briefs of Arab news on each of the four coding dimensions.

Results of Dimension 1. Power/Viewpoint

Table 4.1 enumerates the breakdown of codings of Arab women in our sample of Arab news across 888 female pronoun occurrences in 237 briefs.

Active	Passive	Neutral	Negative	Non-Arab
44%	10%	22%	3%	21%

Table 4.1. Coding breakdown of 936 mentions of Arab women across 237 briefs.

Contrary to previous coding schemes used to study Arab women in Western print media, which found them to be disproportionately passive, we found that 44% of the time Arab women were referenced in Arab news, they were referenced in an active context. They were referenced as passive 10% of the time, referenced in a neutral context 22% of the time, and in a negative context 3% of the time, and almost 21% of the time the women referenced were not coded because they were not Arab.[1] Of the 237 news briefs, fifty-nine contained at least one mention of a non-Arab woman or women. This would prove an important finding when we turned to the

qualitative analysis in Part II. We wanted to make sure that the news briefs carried over into the qualitative study dealt exclusively with females who were Arab. For the qualitative study of Part II, we thus eliminated all briefs that included a "she" or "they" that referenced a non-Arab woman or non-Arab women respectively. This resulted in the elimination of fifty-nine briefs, reducing our corpus of Arab news briefs to 178 briefs (237–59).

Why did our coding results, finding Arab women so apparently active in Arab news, differ so dramatically from previous studies of Arab women in pre-Internet Western media? The single largest contributor appeared to be the source effect. Arab women were assigned active speaking roles that allowed them to formulate assertions about their environment, even in the face of challenges it presented them. Arab women in these stories take on active socio-cognitive stances toward others, resulting in speech acts of asserting, demanding, denying, maintaining, and insisting. They take on active social behaviors, such as directing, supporting, organizing, advocating, or rallying others, either within the family or outside the home. Our study revealed that regarding Arab women as active pillars of Arab society is a truism that stands side-by-side with the seemingly contradictory cultural stereotype that they are passive. As we have previously argued, in traditional [pre-Internet] Western media, Arab women were typically aliens, given no words of their own to speak but spoken for in images and captions; in Arab media and in their native tongue, Arab women rise from being detached subjects of news to involved sources. On their own soil, their thoughts, words, and deeds contribute constructively to news narratives.

The prevalence of the source effect and the agent-reference effect was palpable, as indicated in Table 4.2. The source effect was evident in ninety-two out of 178 briefs, or slightly over half (52%), of our corpus of Arab news. Recall that the agent-reference effect occurs when the actions or plans, if not the quoted words, of an Arab woman form part of the news narrative. The agent-reference effect is evident in locutions such as "she planned," "she discovered that," "she traveled to Mecca," or some other discrete action or plan that contributes to the narrative arc of the news story. The agent-reference effect

was much weaker than the source effect, accounting for just thirty-one out of 178 (17%) of the overall briefs. In our sample, it is common for stories to use Arab women both as a source and as an agent-reference. In fact, Arab women are much more likely to be agent-referents in a story when their words are also quoted. In twenty-three of thirty-one cases (74%) where an Arab woman provides a source for a story, she also provides an agent-reference. And when the words of an Arab woman are not quoted as sources of the story, their chances of having their plans and actions referenced tail off considerably. Only in eight of thirty-one (26%) cases does an Arab woman provide an agent-reference without being a source. This means that across our 178 briefs, 92 + 8 = 100 briefs (56%) carried either an Arab female source effect or Arab female agent-reference effect or both.

Two Effects Affecting Active Behavior in News	Definition	Number of Briefs in Which Effect Occurs	Overall % of 178 Briefs
Source Effect	*Female is active source whose quotes help construct the story*	92	51%
Agent-Reference Effect	*Female's plans/actions form a basis for the news narrative*	31	17%
Combined Effects (eliminating duplicates)	*At least one of the above*	100	56%

Table 4.2. A majority of briefs in our corpus that mention Arab women based the news narrative on what women were saying (source effect) or planning and doing (agent-reference effect). Overall, ninety-two (51%) articles contained source effects while thirty-one (17%) articles contained agent-reference effects. When we do not double-count articles with both effects, a hundred of the 178 (56%) articles contained one or the other effect, or both. These references were all coded as active in the coding study, and provide a strong reason why our counts for Arab women demonstrating "activity" in news was so high.

We coded not only the active/passive levels of Arab women (what we have called the "power dimension"), but also the viewpoint of the story toward that power. Table 4.3 breaks down the active codings by the editorial viewpoint (neutral, positive, negative) that accompanies them.

Active/Neutral	Active/Positive	Active/Negative
338 (86%)	44 (11%)	12 (3%)

Table 4.3. Coding breakdown by editorial viewpoint of the 398 judgments found to depict an Arab woman's active behavior. Active/neutral means that the woman is described as active and the writer/translator adds no further commentary. Active/positive means that the woman is described as active and the writer/translator offers a positive slant on that fact. Active/negative means that the woman is described as active and the writer/translator offers a negative slant on that fact.

As Table 4.3 indicates, in the 398 instances where Arab women exhibited an active power, the story writer (or translator) in 338 (86%) of these stories took a neutral stance toward that power. The story writer (or translator) took a positive stance forty-four times (11%), meaning that the woman was exerting active power and the story writer (or translator) commended it. In only twelve cases (3%), did we find evidence of a misogynous story writer (or translator) who showed a critical attitude towards the woman's active stance. A similar finding revealed itself in the editorial viewpoint on the relatively few (ninety-three [11%]) cases when women were shown to take a passive stance, either through passive cognition and speech (e.g., begging, wailing); through expressions of loss, helplessness, or hopelessness; through feeling at the mercy of other persons or forces beyond their control; or through the fact of having to wait upon others or on external circumstances before they could act. Consider Table 4.4.

Passive/Neutral	Passive/Positive	Passive/Negative
42 (45%)	0 (0%)	51 (55%)

Table 4.4. Coding breakdown by editorial viewpoint of the ninety-eight references found to depict an Arab woman's passive behavior. Passive/neutral

means that the woman is described as passive and the writer/translator adds no further commentary. Passive/positive means that the woman is described as passive and the writer/translator offers a positive slant on that fact. Passive/negative means that the woman is described as passive and the writer/translator offers a negative slant on that fact.

In forty-two of these cases (45%), the story writer (translator) employed a neutral tone. In the remaining fifty-two cases (55%), the story writer (translator) employed a negative tone, indicating empathy for the woman who found herself hemmed in by the situation. In no cases did we find a misogynous attitude, with the story writer (translator) responding positively to a woman caught in circumstances that rendered her passive. These relatively progressive views toward women were very likely a particular feature artifact of the pro-women cosmopolitan news sources we sampled.[2]

Results of the Demographic Dimensions 2, 3, 4

We now report the results of the demographic dimensions 2, 3, and 4.

Results of Dimension 2. Occupation

Table 4.5 presents the results of the occupations held by the females coded in our sample. We start with those females whose employment status is unclear, irrelevant because of age, clearly unemployed, or specified as employed with no further information about the nature of their employment.

Employment status unclear or inapplicable	Schoolgirl/ Student	Unemployed	Employed without further specification
464 (52%)	85 (10%)	21 (2%)	52 (6%)

Table 4.5. Coding breakdown by occupation: employment status unclear or inapplicable; irrelevant because of age; unemployed; employed but occupation unspecified.

As Table 4.5 shows, in 464 (52%) of the coding opportunities, the employment status of the women was not clear or not applicable because the reference to "she" was to a non-Arab. In eighty-five of the cases (10%), the female was a girl or a student not eligible for the workforce. This leaves the remainder in the employment range. What was their status? Twenty-one (2%) were referred to as unemployed, and another fifty-two (6%) as employed but with no further clarification about the nature of the employment.

What about employment breakdowns when employment was specified? These results are displayed in Table 4.6.

Non-professionals	Professionals	Candidates for public office	Public office-holders
13 (1%)	162 (18%)	41 (5%)	50 (6%)

Table 4.6. Coding breakdown by occupation if the female's occupational status is specified. In over 70% of the Arab female mentions it was not specified.Of those whose employment was specified, thirteen (1%) women were identified as non-professional workers while 162 (18%) were professionals. Another forty-one (5%) were identified as candidates for public office and fifty (6%) were described as office holders. These statistics suggest, and we shall see confirmed later, that Arab women in pockets of these stories exerted influence as substantive cultural agents well beyond the formal agency inherited from the source and agent-reference effects.

Results of Dimension 3: Personal Status

What was the personal status of the Arab women coded? Table 4.7 provides some answers.

Unclear or inapplicable	Married	Unmarried	Widowed	Mothers	Divorced	Remarried
587 (66%)	128 (14%)	109 (12%)	28 (3%)	21 (2%)	15 (2%)	0 (0%)

Table 4.7. Coding breakdown of marital status of the females coded.

As Table 4.7 makes clear, in 587 (66%) of the cases, the marital status of the women was either unclear or not applicable (the woman's

marital status was either not described or she was a non-Arab); 128 (14%) were referenced as married and 109 (12%) as unmarried; twenty-eight (3%) were described as widows and twenty-one (2%) only as mothers whose marital status was unclear; fifteen (2%) were described as divorced. No women were described as remarried. The absence of women in this category may suggest that remarriage occurs too infrequently to be referred to in news, or that the marital history of Arab women is simply not mentioned.

Results of Dimension 4: Social Status

This dimension refers to the role the woman coded occupied in the wider culture. Is she portrayed in the home with family, or outside the home? Is she in school or employed? Is she an activist who has entered the world of politics with a secular or religious agenda? If so, is she working in isolation or as a member of a group? Is she a leader of such a group? Is she a progressive seeking to change the status quo or a religious conservative seeking to strengthen it or even return to a more pious era? Table 4.8 tabulates the Arab women coded who either clearly did not occupy activist roles or who could not be confirmed as doing so.

Unclear or inapplicable	Employed	Students	Girls living at home
433 (49%)	153 (17%)	56 (6%)	24 (3%)

Table 4.8. Coding breakdown of Arab women who were not playing an activist role outside the home or who could not be confirmed as doing so.

Table 4.8 reveals that 433 (49%) of the codings came with no available information about the cultural role played by the female in question; 153 (17%) described her as unemployed, while another fifty-six (6%) described her only as a student, and twenty-four (3%) described her as a girl living at home.

Table 4.9, by contrast, breaks down women who either have already stepped into activist roles or seem on the cusp of doing so.

Women with liberal-progressive agendas	Women with conservative agendas	Members of women-related activist organizations	Activists with unspecified politics	Activist leaders with unspecified politics	Women seeking to become religious role models
112 (13%)	3 (1%)	11 (1%)	28 (3%)	61 (7%)	7 (1%)

Table 4.9. Coding breakdown of Arab women who were either playing an activist role outside the home or who appeared on the cusp of doing so.

As Table 4.9 shows, 112 (13%) of the women mentioned were activist women with liberal-progressive agendas, and three (1%) were activist women with a conservative agenda; eleven (1%) were members of women-related activist organizations but not necessarily leaders; twenty-eight (3%) were activists whose affiliations or politics were not related to women, and sixty-one (7%) were activist leaders whose politics were not directly related to women. Seven (1%) were seeking to become Muslim religious role models with no specified interest in making their religious practice into a public agenda. As we shall see from our further analysis below, the many instances of Arab women with progressive political agendas helps explain our qualitative discussion of feminist agendas among Arab women. The fewer references to women as religious leaders prefigures a similar later discussion of female Islamic movements.

Conclusion

This chapter reports the results of our coding analysis. The chief finding is that Arab women referenced in news from their own cultures play more active roles than has been found by previous studies that have examined references to Arab women in Western-based pre-Internet print media. We attribute this macro finding in large measure to the source effect and to a much lesser extent the agent-reference effect. In older print media, Arab women are predominantly depicted in image bites (Wilkins 1995), where they have no lines to speak and no face to reveal. In pre-Internet print media, where Arab women appear without their own voices, their minds tend to be even more veiled than their faces. It is not so much the obliteration of her face

that has caused historical offense to the Arab woman, we surmise. It is rather the erasure of her mind from the Western imagination, as evidenced from the absence of speaking roles for her. In older print media, the Western adage, "out of sight, out of mind" reframed as "out of speaking roles, out of mind" seems to have applied literally. Our linguistically-based coding scheme was designed, in part, to recover traces of her language as a window into her mind insofar as such traces were there to be found in Arab news. As it happens, in the Arab press, when Arab women are referenced in news they are routinely quoted, and that in itself appears a notable change from pre-Internet print media from the West.

Our finding of Arab women's greater "activeness" in Arab news is in one sense heartening. It offers the possibility for English-speaking/Western readers to approach the complicated reality of Arab women more closely than ever before. But even within the terms of the present study, this general finding is limited to claims about aggregates rather than individuals. We recognized even before completing the coding study that pure numerical counts of aggregate classes would be insufficient to gain access to all the knowledge that our corpus of news briefs afforded. We decided to leave strict numerical analysis behind in favor of a richer and more openly interpretative approach that would allow us to canvass the women we had coded in a more intimate and culturally informed way. The grounds for this decision are explained more fully in the next chapter.

Part II:

Canvassing Arab Females in Arab News

5: *Females up Close*

FROM PROPORTIONS TO PERSONS

Our coding study found a dominant set of active behaviors of Arab women, based to a large degree on the source effect discussed in the previous two chapters. The findings we reported in the last chapter are sufficient to let us know that the stereotype of the "passive" Arab woman, so often found dominant in studies of how Arab women are depicted in pre-Internet Western media, do not dominate the representations in our sample of Arab news briefs. Arab women in the news of their own soil have voices that form the constructive basis of news narratives. These findings alone might be revealing enough to call the study successful, and only in need of follow-up and replication. However, the findings of the coding study remain incomplete.

The coding study left us with a count of female pronouns deprived of any hint of even a name, much less a culturally-embedded flesh and blood human being. It left us with verb phrases extracted from the rich cultural and historical context. For a precise coding study, we had no other choice. To first validate and then administer a coding scheme as carefully as possible, we had to straitjacket our coder into doing very narrow readings, focusing solely on the local verb phrase or on conventions of news reporting as described in chapter 2. This meant that the coding of Arab women in our media study would be narrowly precise yet missing many elements of the larger picture when the entire brief and its overall context were assessed.

Our coding study provided us with descriptions of active vs. passive Arab female behavior that, albeit linguistically well-grounded, remained culturally shallow. We created a coding scheme that gave us

enough depth to test the presence of Arab female activity/passivity in Arab news, but not a sliver more depth than that. Our finding that Arab women are more active than passive, as we have seen, was owed in large measure to the source effect. We should not underestimate the importance of this finding. Even when the news originates from a female's own backyard, we should not underestimate the importance of the news being crafted from *her* thoughts, voices, and deeds (see Skalli 2011 on this point). That said, we must also acknowledge that the status of a news source, whether male or female, is hardly a reliable indicator of cultural empowerment or even presence. A rape victim who is interviewed on condition of anonymity may be a credible news source, but surely not an icon of cultural empowerment. With the wisdom of hindsight, we recognized that, hard as we had tried to build a coding scheme describing active and passive behavior in news free of cultural bias, a cultural bias had nonetheless seeped into our coding scheme. We had been so influenced by previous, mainly pre-Internet, studies of Western media that linked Arab female silence to passivity that we had been misled into assuming that a news source can exercise cultural agency simply by opening her mouth.

The source effect, we recognized, is a real but culturally limited form of agency that Arab women play in Arab news. After bracketing off the source effect from our analysis, we discovered much unexplored territory in our corpus of Arab news briefs that could be further mined. Such further exploration depended on asking three new questions.

First, if a purely linguistic lens is too narrow to capture the active-passive distinction as it pertains to Arab women in Arab news, what literatures are available to help us build a more explanatory cultural lens? Second, assuming such literatures and cultural lens are available, how beyond functioning as active sources of news might Arab women exhibit agency in Arab news? Third, if not the Western stereotype of Arab female passivity, through what theoretical lens can we look to help understand Arab female passivity in Arab news?

The rest of this book pursues these three questions for answers. We embark on answers to these first two questions in chapters 6–13. We take up answers to the third question in chapters 14–19.

In order to answer these questions, we changed our methodology

from coding Arab women in news briefs to canvassing these same women using a richer variety of methods and external scholarship. We thought of ourselves as census workers canvassing households, except that, instead of counting family members, our census would be concept-based, designed to understand the major concepts associated with Arab women in our sample of Arab news briefs.

To proceed with canvassing Arab women in our sample, we turned to a combination of grounded theory (Glaser & Strauss 1967) and text-analysis methods (Ishizaki & Kaufer 2011). We adapted grounded theory to help us acquire concepts for cataloguing Arab women in the briefs in terms more refined than active or passive. Text-analysis methods were designed to help us count the recurrence of these concepts throughout the corpus, so that we could trace their statistical frequency.

Grounded theory is a qualitative data analysis method that seeks to find "emergent" concepts from large samples of data, especially textual data (Glaser 1992; Clarke 2005; Charmaz 2006). Grounded theory in Glaser's formulation also accommodates numerical data analysis, as it treats statistics as another form of data. Grounded theory relies on the back-and-forth exploration of texts for their points of convergence with higher-level concepts, and the exploration of concepts for their congruence with fine-grained textual data. The method of grounded theory thus proceeds as an iteration between top-down (conceptual) and bottom-up (textual) classification, as the emergent concepts derived at the top must account for the lowest textual detail at the bottom and vice versa.[1]

We wanted to canvass all 178 briefs as comprehensively as we could. This meant we had to be as systematic in our coding as we had tried to be in the first phase of the study.[2] But it also meant that the concepts we would be using to categorize Arab women in Arab news would be open-ended interpretative concepts, and concepts with as many rich links as possible to the extant scholarship on the worldwide status of women.

We wanted, in sum, to turn to qualitative interpretation and a comprehensive scholarly documentation of our corpus from those interpretative categories without leaving behind the advantages of numerical analysis. To achieve the best combination of conceptual and

numerical analysis of our briefs, we made use of a computer-aided text-analysis tool developed by our research group at Carnegie Mellon, called DocuScope (Ishizaki & Kaufer 2011; Kaufer et al. 2004; Kaufer et al. 2005; Kaufer & Ishizaki 2006; Kaufer & Hariman 2008).[3] In this particular study, we employed the DocuScope environment as a tool within which to wed grounded theory and textual analysis on the 178 briefs of Arab women in Arab news. Using the combination of grounded theory and computer-supported textual analysis, we read through all the briefs and began developing customized concept dictionaries, organizing the language patterns found in the 178 briefs into hierarchical conceptual categories. These emergent categories provided a comprehensive look into what it meant to be an Arab woman involved in Arab news within the universe of our corpus. We eventually arrived at a customized dictionary of 1,196 patterns categorized into fourteen categories and layered into hierarchies reflective of the four major divisions (active, passive, negative, neutral) of Arab female behavior.[4]

In our coding study of Part I, the only identifying trace of an Arab woman had been a reference to a "she" or a female "they." In the qualitative study of Part II, we had the opportunity to meet in much greater depth and background context the Arab women we had coded in Part I as anonymized "she-s" and "they-s." Because of our software's automatic pattern-matching and visualization environment, we were able to isolate and call attention to hard-to-notice patterns, especially the small stories-within-the-story about Arab women in these briefs that would have remained beyond the systematic reach of even an attentive reader. Arab women often show up in these stories as they show up in life – so deeply integrated with many other cultural categories that they were often camouflaged by them. Employing our methods of close reading augmented by software methods, we took pains in the qualitative phase of our study to strip away the camouflage.

The coding study of Part I had found substantial evidence of active and passive Arab women in Arab news. We knew nothing about these women except that they fell into a statistical pile of active and passive behaviors that had not been sorted out. By turning to grounded theory and computer-based text-analysis, we had a

chance to learn more about these Arab women in the 178 news briefs. But even when we carefully examined the language patterns found in these briefs comprehensively by the computer, we found we still could not answer many of the questions about these women being revealed to us. We recognized that we needed extensive background research on these women – on gender, human rights, and many other scholarly literatures related to the make-up and status of women – to provide us with a deeper understanding of how these females came to appear in news, the significance of their appearance, what their appearance in news meant more broadly for the status of Arab women in their region of the world and, ultimately, the deeper implications of their appearance in news for the status of women in other regions.

The remaining chapters present our conceptual census of Arab women in Arab news based on grounded theory and text-analysis, our background research on these women, and our synthesis of many research literatures relevant to benchmarking the experience of these women against the experiences of women worldwide. We encounter for the first time flesh and blood Arab women, and experience first-hand the concepts that contribute to the overall impression of female involvement in Arab news. The concepts we introduce and explore in the following chapters were derived over months of sifting the briefs from a grounded theory and text-analysis perspective. The result, we believe, was to acquire more culturally-rich and scholarly-informed handles for gaining the acquaintance of the Arab women coded anonymously in the coding study.

Before turning to the canvassing study of Part II, let us take an overview of the geographical territories covered by it. Table 5.1 breaks down the countries that provided sources of news across the 178 news briefs used in our canvassing sample, listing these countries in descending order of appearance. Not surprisingly, Iraq, an intensely hot war zone in 2005–2006, contributed thirty-six news briefs and over 20% of sample. Table 5.1 reveals that the final corpus for our canvassing study in the chapters that follow covered sixteen Arab countries, one regional code applicable to multiple Arab territories [Middle East] and one country code [Israel] framed by the Arab press to describe Palestinian women living in "occupied Palestine."

Country Code	# of News Briefs 2005–2006 sample	% of News Briefs (of 178)
Iraq	36	20.2
Saudi Arabia	25	14.0
Palestine	20	11.2
Egypt	19	10.7
Middle East	16	9.0
Lebanon	14	7.9
Jordan	8	4.5
Bahrain	7	3.9
Israel	7	3.9
Kuwait	6	3.4
Syria	6	3.4
Morocco	4	2.2
Yemen	3	1.7
Sudan	2	1.1
UAE	2	1.1
Algeria	1	.6
Mauritania	1	.6
Tunisia	1	.6
Total	**178**	

Table 5.1.Final sample of news briefs used in Part II broken down by number and percentage of briefs (out of 178) per country. Note that Arab females in Iraq received the most coverage in our sample of 2005–2006. Briefs with the county code "Middle East" are regional Arab stories. Briefs with the country code "Israel" represent coverage of Arab women from the framing of occupied Palestine.

Conclusion

This chapter presents the transitions we made from studying Arab women in Arab news as statistical proportions to studying them as unique historical individuals. This transition required combing the corpus as close readers, classifying the females according to cultural categories consistent with the external scholarship, and making sure

our cultural categories made the best fit with the small detail of the news briefs. In this way we hoped to move from narrowly linguistic to more culturally rich and scholarly informed ways of describing Arab females in Arab news.

6: *Anger & Resistance*

Well-behaved women seldom make history.

Laurel Ulrich (2007)

The truth will set you free. But first, it will piss you off.

Gloria Steinem (cited in Levine 2010)

Our focus in this chapter and the next is on concepts associated with individual determinants of Arab female activity. What constitutes the individual make-up of an Arab woman perceived as active in Arab news? As we shall see in this chapter, it starts with a fire in her belly to make a difference and create change. We operationalized this "fire in the belly" concept as an emotional frame of mind for inspiring cultural change. We coined the term anger/resistance, also known as retributive anger, a compound of anger and resistance. But while retributive anger can be directed at individuals in pursuit of personal vengeance and revenge, anger/resistance, as we defined it, is high-minded and fights for principles, not just for the vanquishing of an opponent. It is directed at an unjust status quo and is in search of justice.

This compound, or something roughly equivalent, was first recorded by Aristotle (1378b-1380a) who conjured that anger for retribution "must always be attended by a certain pleasure, that which arises from the expectation of revenge." The pleasure of retributive anger comes from envisioning a sweet future where justice sweeps in to correct injustice. The retribution is sweet, according to Aristotle, "sweeter it is by far than the honeycomb dripping with sweetness." Aristotle recognized that this envisionment of a future vindicated by justice becomes contagious as the anger for retribution "spreads

through the hearts of men" and moves individuals to act collectively (Aristotle 2004) [1]

The Aristotelian conception of retributive anger and its positive ties to social justice have been validated recently in the laboratories of Lerner and her associates (Lerner & Tiedens 2006; Litvak et al. 2009). Lerner found that retributive anger can focus an individual's concentration and sustain optimism for the future for extended periods of time. Retributive anger is among the most patient of emotions, as it is an anger that waits with humility and reserve for justice to prevail. In Lerner's terms, it is an anger that provides "fuel for the fire" for the person seeking justice over the long term. And retributive anger not only waits for lady justice to make her ruling in one situation; it perseveres to await her arrival across many situations. Lerner showed in controlled studies that anger for retribution is not only contagious across persons but transferable across situations. Subjects whom she primed for anger about one unjust situation retained that anger as surplus "fuel" with "carryover to subsequent judgments and decisions" (Lerner & Tiedens 2006, 119).

What does retributive anger have to do with the well-known "angry man" syndrome (Hegstrom 2004), thought to explain males who habitually abuse their wives and children verbally or physically? The anger of the chronic abuser is a blind (or white) rage and it is a species of anger apart from retributive anger. Lerner's research distinguished retributive anger, which she found to be a productive and optimistic emotion, from blind rage, which is neither. Retributive anger arouses an internal flame that burns steadily and under control with a clear cognitive focus; it provides a shelter of calm determination while one waits for lady justice to turn the tables on injustice. Blind rage, by contrast, is impulsive and myopic. It rushes in unexpectedly, forcibly, and uncontrollably, like an explosive thunderstorm. It bludgeons the body rather than focusing it. It causes one's face to redden, veins to pulsate, jaws to tremble and muscles to shake and it steals one's attentiveness and concentration until it passes over. Rather than being characterized by the emotional reserve to wait for lady justice, blind rage causes recklessness and, instead of awaiting and celebrating her arrival, more often than not tramples over her. [2]

In several cases in our corpus, female anger is aligned with the seeking of retributive justice, but the awaited justice is not gender equality. Some of these expressions of female anger are darker and cross political motivation with nihilist rage, as expressed in female suicide bombing, a topic saved for chapter 19. Others of these expressions of female anger are more pointedly geopolitical and partisan and rooted in seeking retributive justice for Palestine. Indeed, as we might predict, many expressions of female anger in our corpus are directed against American and Israeli foreign policy. It is a political anger that, both in our corpus and in reality, widely unifies Arab men and women rather than divides them. In a July 7, 2006 *Asharq Al Awsat* brief, a Lebanese wife is described as grief-stricken at the Israeli bombing of residents of Beirut, and her "growing temper" is likened by her husband to a Raad-2 missile. We also find stories of Arab women who do not exhibit anger but seek to incite it for political purposes. A July 26, 2006 brief from *Asharq Al Awsat* is a case in point. Seeking to rally world support against the Israeli incursions against Lebanon, Rein Abu Azza discusses how she came upon [images] of "the young Israeli girls signing their names on the missiles headed for Lebanon."

Retributive Anger and Feminist Movements

Retributive anger for gender equality has lain at the heart of progressive movements for women throughout history. Feminist social reformers in the West, including the British and American suffragettes of the nineteenth and twentieth centuries, relied on retributive anger to win the right to vote. Susan B. Anthony (1820-1906), one of the leaders of the suffragette movement in America, understood that society frowned upon women who indulged their anger because of cultural mores that made the emotion of anger "unbecoming" for a woman and "unladylike." She understood that "proper" women were obsessed with their reputation, and girls and young ladies were taught that keeping their anger under wraps was an essential differentiator between being a lady of high repute and being a tramp. Anthony understood that she would have to confront these mores to recruit women into the

suffrage movement. And so she famously warned her female audiences that "cautious, careful people" bent at all costs to "preserve their reputation or social standards never can bring about reform" (quoted in Sherr 1996, 48). Retributive anger also became a central construct behind Downing and Roush's (1985) five-stage model[3] to describe the personal journeys of second-wave feminists of the 1960s. These women all experienced a common phenomenon: they all reported one day "waking up" to a culture ruled by males and holding them back. Their awakening left them energized, alert, angry, and determined to fight back. Although Downing and Roush's five stages of female awakening are sometimes alleged to carry a Western bias, there is recent scholarship to suggest that some, if not all, stages, including the stage of retributive anger, apply to female reformers outside the West (Murray & Farmer 2008).

As already noted, women who have historically dared to display their anger on behalf of gender equality break the veneer of social decorum and have risked negative judgments from society. But they also earned the admiration of women and men who shared a vision of unfulfilled justice for women. Had our sample of Arab news extended into the 2011 "Arab Spring" for women, we would have uncovered numerous examples of courageous Arab women heroes risking not only their reputation but also their physical safety for the sake of reform. Samia al-Aghbari, a Yemeni journalist on the frontline of the 2011 protests in Sana'a, was memorialized in poetry for her valor. At one point she was pushed to the ground by police and one Yemeni bystander was so moved by her bravery that he dedicated a poem to her entitled "Revolution of the Green Hijab . . . To Samia al-Aghbari and all the other revolutionaries." The poem enjoyed wide circulation on the Arabic Internet (Hackman 2011). Furthermore, during the Arab Spring of 2011, Arab leaders learned the hard way they risked the wrath of women if they played the religious card to block women's rights. On April 16, 2011, thousands of enraged Yemeni women filled the streets of Sana'a and other cities to protest against President Ali Abdullah Saleh's pronouncement that "it was against Islam for women to join men in the demonstrations aimed at toppling his regime" (Peninsula 2011).

Quantitative summary of female anger/resistance

Reference to female retributive anger directed at a male-dominated culture occurred a significant number of times in our sample of Arab news. More than 25% (forty-five) of the 178 briefs on Arab women dealt in some central or peripheral way with women displaying such anger against male domination.[4] We have noted that in our sampling procedures (chapter 3), we found that one must go to the liberal Arab press to find females mentioned in any consistent way, let alone in ways that invited a narrative elaboration of their character as individuals. This is why we found that little would be lost in restricting our sample to four pan-Arab media sources and, because of our sampling decisions, we were not surprised to find in our corpus a high concentration of female retributive anger raised to call for gender equality. The four pan-Arab media sources that made up our sample take an overall pro-woman editorial stance; they cultivate educated and liberal-minded Arab women for their readership; they commonly cover Arab women who exhibit anger toward and resistance against a male-dominated status quo; and their editorial stance often sympathizes with struggles for gender equality.

Qualitative analysis of female anger/resistance

Let us take a brief look at some of the stories that focused on women and retributive anger seeking gender equality. A brief from an *Al Hayat* editorial on June 28, 2005 is headlined "Arab women are suffering" and goes on to denounce the fact that in most Arab countries, women remain "second class citizens." A brief of an *Asharq Al Awsat* article from August 15, 2005, dateline Saudi Arabia, reports in its headline that Saudi women "demand greater roles in professions [and] public life." A range of Saudi academics, physicians and businesswomen were interviewed for the story and all express a litany of hope that the status of the women in the Kingdom "will be enhanced." In an *Asharq Al-Awsat* brief two days later, Iraqi secularist and women's rights activist Hawzan Mahmoud openly expressed her fear that the strengthening of Islamic law in Iraq would create "disaster to women and society as a whole." She cautioned, "We do not want to go hundreds of years back

to the middle ages where religion dominated over society. It will be a period where women are second-class citizens." She complained that the religious sects in Iraq were perpetrating violence against women every day; she accused various of these sects of exploiting the American occupation as a pretext for forcing conservative religious views down women's throats; and she charged the Iraqi police and the occupation forces with showing not the slightest interest in solving the problem.

Less than a month later, on September 13, 2005, a brief of an *Elaph* piece by Ahlam Akram, another well-known women's rights activist who often speaks out against Islamic fundamentalism, insisted on the necessity of promoting human rights for women across the Arab world. Akram averred that, without enforceable human rights policies, it had been too convenient for fundamentalists to misinterpret Qur'anic doctrine for their own foul purposes. She reckoned that the ease with which fundamentalists were able to pervert Islamic teachings was the result of the lack of critical thinking across the mainstream Arab populace, asserting bitterly that "Arab societies were not prepared to think and use their minds." Akram called for the eradication of the backward thinking that refuses to acknowledge human rights and the bigotry that ranks Muslims above non-Muslims and men above women. Two days later, an *Al Hayat* brief from August 19, 2005 critically observed that Arab women, if they expect to marry and raise children, were under intense pressure to avoid certain professions. The article blamed sexism within the family for this pressure, because "[unlike the mother], the father is free to choose whatever profession since he is not obliged to take care of a child."

A brief from *Asharq Al Awsat* on November 29, 2006 quoted Suzanne Mubarak, then First Lady of Egypt, speaking at a conference for Arab women in Bahrain. Mubarak called upon the United Nations and "all the Arab countries" to help address the problems faced by Arab women, especially those women suffering in war-torn Iraq, Lebanon, Palestine, and Darfur. She expressed dissatisfaction with the political rights of women in her own country and noted that Egyptian women, through their distinguished history of contributions to Egyptian culture, deserved more political enfranchisement rights than they currently enjoyed. Curiously enough, the angry women of the January 25, 2011 revolution in Tahrir Square who helped overthrow Hosni Mubarak

would also come to renounce Suzanne Mubarak as a "step-backward" for women's rights in Egypt. They alleged she had been a First Lady who championed woman's rights more for the international headlines than for meaningful structural change at home or abroad (Azzi 2011).[5]

In some briefs, Arab women professionals put their retributive anger on display against political leaders who treat foreign professional women with more respect than they themselves are treated. In a December 15, 2005 brief from *Elaph*, a Saudi female journalist railed at the inconsistency of Saudi officials who were only too willing to grant Western female journalists direct access to male Saudi newsmakers and yet denied the very same access to female journalists who were Saudi citizens. Simmering, one Saudi female journalist interviewed for the story raised the perfectly reasonable question: "I simply find it difficult to understand why a Western female journalist is able to interview Saudi officials and local female journalists are not." The government's apparent but not directly expressed line of defense was that, unlike Western women, Saudi women were too pure to mingle with the likes of strange men, even if the women were journalists and even if the men were important newsmakers. The writer of the *Elaph* piece contributes to the anger of the story by sardonically wondering why, in the interests of maintaining the full purity of Saudi women, the Saudi government has stopped at simply creating separate check-in lines for men and women at airports. Why stop there? Is not the purity of the Saudi woman worth creating whole fleets of airlines and terminal buildings just for women? We could enumerate from our corpus many similar stories about women expressing their anger at gender inequality. But they follow in the same vein as the stories we have already chronicled. The largest class of retributive anger stories that do not overlap with the stories we have thus far reviewed concern the retributive anger of women in election campaigns.

Retributive Anger Fueling Female Candidates in Kuwait and Bahrain

Political elections are cultural occasions on which candidates conventionally express retributive anger. Candidates may run for election in order to change a status quo that angers them, or to defend a status

quo from forces of change that anger them and which they seek to resist, or, often, they run on a platform of both change and stability. In the time period of our sample, 2005–2006, Kuwait (June 2006) and Bahrain (December 2006) held elections in which female candidates were involved. These elections were milestones for women because females had never before had the right to vote or to run for office in either country. And in both elections, female candidates were aware that they were running not only on the issues of concern to the voters, but also on the fundamental principle that women were capable of holding elective office.[6]

Kuwait: Female candidates angry at a dysfunctional government

Kuwaiti women waited for a long time to get the vote. On December 15, 1971, Nooriyyah Assaddaani, chairwoman of the Arab Women's Day Committee in Kuwait, first recommended to the Kuwaiti National Assembly that Kuwaiti women should have the right to vote and the right to run for elected office. In late 1973, the petition was rejected on the grounds that it violated religious and certain civil laws. On May 22, 1999, Emir Sheikh Jaber al-Ahmed al-Sabah issued Decree No. 9/1999, which proposed amending existing law to give Kuwaiti women the right to vote and the right to run for elected office. Six months later, in November 1999 the National Assembly voted on this proposal and it was defeated by two votes. Prior to its defeat, on June 22, 1999, Al-Ra'i Al-'Aam newspaper published the results of a survey of 400 randomly selected Kuwaiti men and woman, which showed that a slight majority of Kuwaiti men and women favored the Emir's proposal. However, the majority of respondents also drew a hard line between family and politics, which called into question how deep the overall support for the proposal ran. The majority of respondents felt that women were not ready to enter the world of politics and almost half thought that giving women a presence in politics would upset the balance of power in families, which they believed was sacred and fixed by religious principles. Half also believed that granting women a presence in politics would have no positive effects on Kuwait's social, political or economic development. A third of the sample believed that

Shari'a and human rights were conflicting value systems and that to grant Kuwaiti women human rights from a perspective of universal moralism would be a direct repudiation of the sacred holding of women in Muslim law (Al Awadi, Al Mubarak & Al Attawi 2009). Despite this skepticism regarding Kuwaiti women in politics, on May 16, 2005, the Kuwaiti National Assembly did finally approve the rights of Kuwaiti women to vote and run for elective office. This brief narrative shows that the history of elected female candidates in Kuwait has been surprisingly short but also sparked with controversy.

The 2006 elections would be the first to include Kuwaiti women as both candidates and voters. A brief of an *Al Quds Al Arabi* editorial of May 26, 2006, more than one month before the election, was optimistic about the rising power of women in Kuwait. It spoke of Kuwaiti women now "breaking the chains" that had kept them out of politics, quoting a UN report that cited the "absence of women's efficient participation in society" as the root cause for the "retardation" and "downfall" of the region. Recent efforts to guarantee political rights to Kuwaiti women, the editorial went on, had been a "positive correction of this huge mistake." The brief called women's entry into political life a "major turning point" not only for Kuwait but for the entire Gulf region.

That major turning point would be tested one month later – election day, June 29, 2006. The Kuwaiti female candidates were determined to win. An *Al Hayat* brief from May 26 noted that five women had thrown their hats into the ring, anticipating breaking a forty-three-year-old male monopoly on political candidacy in Kuwait. These women understood their role as pioneers and were resolved to beat any man every step of the way in the election cycle, including beating their male opponents to the candidate registration line. The brief notes that:

> It was noteworthy yesterday that the five female candidates came to the headquarters of the elections department even before they were open for business. And they came focused for the task at hand. Rola Dashti, Aesha Al-Rashid, Tayibah Al-Ibrahim, Khalidah Al-Khodr, and Ghuleima Al-Haidar presented their nominations, each in her electoral province, within the first 15 minutes of the registration.

However, no female candidates won in that June election in Kuwait. Women were up against strong sitting candidates from conservative parties who had long been in office and were sustained by the attitudes revealed in the 1999 *Al-Ra'i Al-'Aam* survey. In light of these opposing forces, the 2006 defeat of female candidates in Kuwait could hardly be a surprise. Readers of the 2005–2007 corpus of mideastwire.com briefs would have read hopeful stories predicting a "major turning point" for Kuwaiti women in politics, and stories that cited even the losing women as secure in the knowledge that they were standing on the right side of history. But would these briefs have steered the reader in the right direction? The answer, it turns out, is "yes," although a dramatic reversal of fortune for Kuwaiti female candidates would be three years coming. On May 9, 2009, four women were elected to the Kuwaiti Parliament. The candidates had many similarities (all educated in the United States, all holders of a PhD in either political science, economics or education) and just as many differences (one was married to a non-Kuwaiti, one divorced, one single, one with a Lebanese mother; Ahelbarra 2009a). The women were Massuma al-Mubarak, a traditionalist who won her race by a wide margin, and three liberal candidates, Aseel al-Awadhi, Rola Dashti and Salwa al-Jassar. The contests fought by al-Awadhi and Dashti attracted most interest because both women ran against what Al Jazeera English had described as "charismatic" Islamist and Salafist candidates who had "dominated political life in Kuwait over the last ten years" (Ahelbarra 2009a). A video accompanying the Al Jazeera story illustrated how the victory left the liberal women of Kuwait breathless. The reporter Hashem Ahelbarra framed the story in these bold words: "It's a day women in Kuwait will remember for generations to come." Amani Abu Al-Hassan, a young female voter croaked in a voice hoarse from celebrating, "It's history . . . I mean . . . we all wanted one but four . . . it's mind blowing . . . We were almost hopeless." Aseel al-Awadhi explained that in the aftermath of this election, "women will be perceived different." Rola Dashti wasted no time hammering out the women's agenda for the Parliament: "And we're going to move the country forward, on various issues, economic, jobs, education, health, curbing corruption, making our good governance, we're gonna move forward, bringing solutions to the challenges confronting us." Ahelbarra closes the story

by warning of the key challenge awaiting the four women: "Once in the Parliament, one of the first things women need to overcome is the perceptions by Islamists and conservative colleagues that they are not fit for this tough job" (Ahelbarra 2009b).

While Ahelbarra's point is certainly well-taken, the evidence also suggests that Kuwaiti voters had lost confidence in the fitness of many Islamist and conservative incumbents to lead. Parliament had for a long time been a dysfunctional institution. The election that swept the women to power in May 2009 occurred shortly after Emir Sheikh Sabah al-Ahmad al-Sabah dissolved Parliament in March because of its ineffectiveness – the second time he had done so in two years. (The first time was in March 2008, when he scheduled new elections for May 2008, but the 2008 elections did not involve female candidates.) The government's capacity to function had become a public issue and, by March 2009, an international embarrassment. In April 2009 the *Financial Times* covered the dysfunction of the Kuwaiti government and the severe economic repercussions of that dysfunction (England 2009). Like its richer neighbors, Saudi Arabia and Qatar, Kuwait looked to spend its petrodollars to refashion itself as a world center of trade and finance. It had retained the best advisors and consultants, including the World Bank, McKinsey, and even Tony Blair, to chart its future direction. It had drawn up a twenty-five-year master plan with over 1,000 projects requiring meticulous coordination to build a self-sustaining and versatile economy (England 2009). However, unlike his neighboring rulers, Kuwait's Emir did not have autocratic powers to push ahead his policies by fiat. The constitutional traditions of Kuwait had developed a government that resembled a democracy more than in any other Arab country. As in a true constitutional monarchy, the Kuwaiti Parliament could exercise oversight over the monarch and the members of the royal family who filled cabinet positions. But as Kuwait-observer Nathan Brown wrote in *Foreign Affairs* magazine (Brown 2009), just after the Kuwaiti Emir dissolved Parliament in March 2009, Kuwait's experiment in democratic government was endangered. Parliament and the royal family found it increasingly difficult to set common agendas and the government became increasingly deadlocked.It was a ripe time for female political candidates to show what they could do.

Gridlock hit Kuwait's government, leaving its development plans far behind those of its neighbors. Despite its natural resources and financial clout, by spring of March 2009, the Kuwaiti government had left many financial analysts worldwide seriously doubting its leaders' fitness to govern. Unlike most Gulf countries, Kuwait's investment industries were negatively impacted by the world recession and Kuwait required an effective government to respond to these vulnerabilities. The rifts between Kuwait's ruling family and the Parliament impaired Kuwait's capacity for international business. Lucrative joint ventures, including a multi-billion dollar deal with Dow Chemical, fell through. The country was in desperate need of creating private-sector jobs and attracting investment but by March 2009 it did not have a government up to the task (England 2009).

Such was the political and economic climate that helped sweep four Kuwaiti women into Parliament. The campaign agendas of all four dealt with strategies for getting the government moving again. Like the constituencies who supported them, the female candidates were angry at a government unable to get its act together and, after they were elected, hopes that the government would come unstuck rose significantly. Moments after the election results were finalized, Al Jazeera reported, "The resounding victory [of four women] may offer hope that the political infighting that has frozen development will ease" (Ahelbarra 2009a).

Early in their term, the new Kuwaiti women parliamentarians appeared to be scoring victories and, at the same time, creating a back-lash. In October 2009, Kuwait's highest court ruled that women could obtain passports without the consent of their husbands. That same month, one of the liberal parliamentarians, Rola Dashti, submitted a petition to the court to rescind a vague 2005 law that had required women to abide by Shari'a law. Sensing its turf violated, the Fatwa Department of the government counter-acted, asserting that all four parliamentarians were required to wear hijab (neither Dashti nor Aseel al-Awadhi wore religious apparel). Dashti called the fatwa non-binding and in violation of the guarantee of gender equality in Kuwait's constitution. She claimed that it was a breach of the Kuwaiti constitution to include Shari'a regulations in electoral law ('Malika' 2009) and the court agreed with her. Dashti next turned her attention to other

major issues for women: housing for women and a woman's right to pass on citizenship to her children (McKee 2009). But the achievements of the women parliamentarians were not confined only to issues of primary interest to women. Within a year of the 2009 election, the Parliament had passed a five-year plan enumerating vital economic and social reform policies that would promote "engagement" over "entitlement" and "productivity" over "consumerism;" it also passed laws strengthening the equity market, the labor market, and the treatment of special needs (disabled) citizens. All told, the new female parliamentarians seemed to be performing positively to get the country moving again (Dunne 2010).

Nonetheless, almost two years later, when Kuwait celebrated its fiftieth birthday in 2011, it had become clear that Kuwait still faced many unsolved challenges and that the country was still gazing "inward" and focusing on shoring up its stagnant economy (Valanka 2011). Some local news in in 2011 was upbeat, trumpeting the fact that, despite a slow growth curve, Kuwait's economy was on the rebound (Garcia 2011), but the record overall was mixed and even in 2011, as we write this, it was still too early to assess the cumulative impact of four women in the Kuwaiti Parliament and the impact they have made and will make on Kuwaiti politics. Nevertheless, it is not too early to assess the wider issue for women everywhere about whether including women in Parliament or any deliberative body might be a step in the right direction. We can turn to science for that assessment.

A US-based assessment was published in September 2010 in *Science*, a leading scientific journal (Woolsey et al. 2010). The lead author was Anita Williams Woolsey of the Tepper School of Business at Carnegie Mellon and her co-authors were from the Sloan School of Business at MIT. The study looked at the existence of group intelligence. We all know we have an individual IQ score. Men such as Alfred Binet (1857–1911) and Charles Spearman (1863–1945) pioneered the IQ test as we know it today. That test examined the intelligence of individuals. More controversial has been whether there is such a thing as group intelligence. Is there a capacity to make groups effective at tasks and is this capacity a stable trait in individuals, like the individual IQ? Does each of us stand in possession of a group intelligence that can be measured?

And if so, how does our group intelligence compare with our individual IQ?

IQ tests, or tests of individual intelligence, were carried out by observing people perform on a battery of intellectual tasks and then correlating their performance across these tasks. Before the Carnegie Mellon/MIT study, no one had systematically tried to measure group intelligence in exactly the same way, by placing individuals in different groups, asking them to solve different group tasks, and then correlating each individual's performance based on the success of the group across all the groups in which the individual had participated in order to calculate (for each individual) a general score of group intelligence. Woolsey and her colleagues worked with a population of 699 men and women and each of these individuals was administered a standard IQ test and a standard test for social sensitivity, a test to determine an individual's skill at imagining him or herself in the shoes of another person. The participants were then assigned to different groups of two to five people. The groups were given a battery of different group tasks to solve and the performance of the group was measured. While working in their groups, each individual was monitored for the amount of time they were talking and the amount they were listening. A group intelligence score for each individual was calculated based on his or her performance across all the groups in which he or she participated and the overall success of each group. Individuals who were consistently part of successful groups accumulated higher group intelligence scores.

Woolsey and her team found that group intelligence was not strongly correlated with traditional IQ. Very smart people may be very "dumb" at making groups effective. However, Woolsey and her colleagues found that group intelligence was strongly correlated with three things. First, the higher the score of an individual on the social sensitivity test, the higher that individual's group intelligence. Being able to put yourself in the shoes of others proved a strong factor in making groups successful and assigning an individual a high group intelligence score. Second, the more evenly balanced a person's turn-taking behavior (i.e. the greater one's ability to share the floor with others by speaking and listening in equal proportions), the higher one's group intelligence. Third, and the most surprising

result to the investigators, the simple fact of having a female member increases the odds, on average, that the group to which she belongs will succeed at group tasks. Woolsey explained this finding in part from the fact that, on average, females in the population score higher in social sensitivity behaviors than males. On average, women put themselves in the shoes of other people better. The results also indicate, though not conclusively, that women may enjoy listening more than men. And inasmuch as they listen more, the collective talent of the group is more likely to be tapped when women are members. The practical implications of Woolsey's study are clear and she spells them out:

> If you're a headhunter looking for someone to work in a group, you might want to stop chasing down the most intelligent candidates. Group intelligence depends less on how smart individuals are and more on their social sensitivity, ability to take turns speaking, and the number of women in the group (Frankel 2010).

The Kuwaiti royal family and Parliament were not operating as a successful group. It is unfair to say, without measuring them, that all the men had low social sensitivity, were unable to put themselves in the shoes of others and preferred hearing themselves talk to listening to what others had to say. It is equally unfair to say, without measuring them, that all four female candidates who entered the Kuwaiti Parliament in 2009 are high in social sensitivity. Many females in the population score low on social sensitivity just as many males score high. So what should you do if sensitivity measures are not available? Woolsey has sound practice advice for us and, in retrospect, for the voters of Kuwait and any other state skeptical of female candidates. "If you don't know the social sensitivity of a group, it is a better bet to include females than not" (Frankel, October 1, 2010). For this reason, if no other, women should have been welcomed into the Kuwaiti Parliament as soon as they had the right to hold office – especially if they were angry about the dysfunction of government and felt they could put Kuwait back on track.

Bahrain: Female candidates angry at conservatism, tokenism, and chaos

Political women in Bahrain were angry and struck out at multiple targets. One target was long-held conservative beliefs that women are unfit to govern; a second target was tokenism – the belief that some women were placed in appointed or elected positions merely to earn the government some public relations points; a third target, which came to a head in 2011, is what we call the political chaos of Bahrain, a tangled skein of sectarian conflicts between Sunni and Shi'a and political conflicts between the citizens of Bahrain and the ruling monarchy, which buried women's voices and divided women's votes.

Female Anger at conservatism

Bahrain's history with the female franchise is only slightly longer than Kuwait's and, from the female point of view, just as frustrating. In 1971, shortly after it gained independence from Britain, Bahraini men were given the right to vote and to be represented in parliamentary councils. The following year, women activists organized and petitioned Bahraini Emir Isa bin Salman al-Khalifa to grant the same rights to women, but the petition was indefinitely deferred. In 2002, three years after Isa's death, King Hamad bin Isa al-Khalifa, Isa's son, launched a reform project granting women the right to participate in municipal and parliamentary councils. Thirty-one women ran for municipal elections that year. None won. Then came the parliamentary elections of October 2002, the first national elections held since 1975, when Emir Isa had declared a state of emergency that suspended national elections in Bahrain. The 2002 elections were the first national elections in which women were able to run for office as well as vote. No woman won a seat.

Days prior to the 2006 elections in Bahrain, a brief of an *Al Quds Al Arabi* article of November 27 observed that Bahraini women candidates were using the upcoming elections as a test case for women, as a way to "prove their presence and role" in Bahraini society. Just as they had in 2002, the female candidates of Bahrain in both the municipal and parliamentary elections were defeated, but the article suggests

they did prove their fortitude, as the women candidates had to stand up to harassment and threats by organized conservative and Islamist movements. As in Kuwait, it was often conservative women in Bahrain who were the staunchest opponents of women running for office. "In the Gulf, women are not women's best friends," blared the headline of Lebanon's English-language *The Daily Star* article that had previewed the national elections in both Kuwait and Bahrain (Janardhan 2005). The elections in both Bahrain's municipal and parliamentary races had attracted a large turnout of conservative women voters who made it a top priority to vote down the female candidates. Nonetheless, the defeated women reported feeling a fierce sense of pride at being pioneers fighting not just for themselves but for their daughters and granddaughters. And these proud candidates also felt angry in defeat towards the elements in society who continued to believe, against all the evidence, that women were unfit to govern. One Bahraini female candidate, Dr Jamilah al-Sammak, quoted in the November 27 brief, criticized Islamist groups who, in the name of religion, "assault" the freedom of women and "belittle" their roles. Another candidate, Aminah Abbas, complained that most national parties that solicited candidates had "no faith in women's ability and competence." Partly in spite of and partly because of these obstacles, the brief applauded the grace and courage of the female candidates in Bahrain for refusing to wilt under the pressures of the campaign.

Just days before the December 2 elections, on November 27, 2006, an *Al Quds* brief had taken a bird's-eye view of the adaptive strategies of the Bahraini female candidates. The brief notes by way of background that Bahraini women were still smarting from the disappointment of running thirty-four female candidates in 2002 and suffering thirty-four losses. This time around, in 2006, the female candidate pool had shrunk by almost 30%, to nineteen candidates running for parliament and five in the municipal elections. The women, it turns out, had learned from the pain of 2002 to be more strategic, realistic and coordinated in their efforts. They were hopeful of winning at least two or three parliamentary victories and a comparable number of municipal seats. And just who set these collective expectations for female victories in the elections? None other, the brief reveals, than Bahrain's First Lady, Sheikha Sabeeka herself. One Bahraini female candidate, at long

last, did taste electoral victory in 2006. Latifah Al Gaood, a director in the Ministry of Finance, won by default in the unpopulated Hawar Islands without rival candidates, making her the first woman in the Arabian Gulf to be elected to her country's parliament, albeit without opponents or constituents (Jamsheer 2006).

In 2010, elections were held once again. This time, eighteen women ran for parliament and five for the municipal council. Mariam Al Ruwai, the best known of the female candidates and the president of the Bahrain Women's Union, a network of liberal women's organizations, ran on a progressive platform seeking to promote jobs, shrink poverty, and expand services. At one of her rallies, she accused her male opponent of inviting government officials to his campaign headquarters so as to give the false impression that he was the government's preferred choice. A woman supporter in the audience shouted that Bahrain sorely needed to "try women for real changes." Another supporter chimed in that voters should not opt for candidates who buy their vote, only to forget about them once elected. Al Ruwai ran under the theme "With Your Vote We Build the Nation" (Women Gateway 2010). Despite her stature as a candidate, Al Ruwai failed to survive even the first round of the parliamentary elections. However, Fatima Salman, who had worked as a volunteer for the Red Crescent for thirty-five years, did win a seat on the municipal council, thus bringing to two (Latifah Al Gaood was re-elected in 2010 without opposition and, again, in a mainly uninhabited district) the number of women holding elective office in Bahrain. Even more promising for women, Fatima Salman served a real voter base and not an uninhabited region like Al Gaood.

Anger at female tokenism

To cover the dearth of women in elected positions after the disastrous 2002 elections, the Bahraini government began to place women in highly visible appointed positions. In 2004, Dr Nada Haffadh was appointed Health Minister. In 2005, Alees Samaan was appointed chair of a Shura Council. In 2006, Bahrain was elected head of the UN General Assembly and the government appointed Haya bint Rashid al-Khalifa to serve as the Assembly's President. Haya al-Khalifa would

be the first Arab woman and only the third woman ever to hold this position (*The Malaysia Star Online* 2006). The appointment of Bahraini women to prominent titles and positions may have seemed a significant advance for Bahraini women, but not all Bahraini women agreed. Human rights activist Ghada Jamsheer, well known in Western governments and media (Macleod 2006), alleged that the women appointees were tokens, chosen solely for their loyalty to the ruling family. These women are "like candles on the cake – to make lights in front of the world that we have women's rights," offered Ms Jamsheer (Hameed 2006). As Jamsheer saw it, the government needed token females because behind the scenes it had already doomed women who wanted to hold office on a progressive platform of change. She accused the government of brokering backroom deals with the conservative Shi'a majority to gerrymander election districts to prevent liberal women from ever winning an election (Chan'ad Bahraini 2006).

Jamsheer took the fact that the only woman then serving in parliament (Ms Al Gaood) had no constituents as helping make her case and remained underwhelmed by Ms Al Gaood's victory. In an address to the House of Lords in the UK just days after the 2006 election, Jamsheer alleged "The government arranged for her to be the only candidate in Hawar Islands where hardly anybody lives" (Jamsheer 2006). Although Jamsheer's attitudes may have seemed unduly harsh and ungracious, her understanding of the poor treatment of women in Bahrain and the temptation of Bahraini officials to use tokenism to mask the problem was informed by years of dogged research. Jamsheer had spent time in Bahrain's family courts watching anguished mothers collapse and bang their heads on floors after losing custody of their children in divorce proceedings. As a mother, Jamsheer knew firsthand what it had meant to be on the lucky side of capricious judges in the family courts. She too had gone through a divorce and managed somehow to retain custody of her daughter. She vowed to work to standardize the family law of Bahrain and make the courts that enforced it friendlier to the interests of women. In 2000, she began a grassroots organization called the Women's Petition Committee, whose mission was to battle Bahrain's Shari'a court system by compiling hundreds of stories about the mistreatment of women in the family courts. While collecting stories, she discovered that the majority of Shi'a families

struggled financially because of an inequitable distribution system based on sectarian and class difference. Corruption catapulted by these differences had destabilized the housing market, weakened family structures, increased divorce rates, and left unprecedented numbers of Shi'a women and their children vulnerable to the whim of the family courts. One in three marriages in Bahrain had been ending in divorce, and poor housing conditions were a commonly cited contributory factor. Marital break-up gave the family courts enormous influence over the lives of thousands of Bahraini families. More than 45,000 families had been waiting for as long as twelve years for government loans to lease houses.

Jamsheer vowed to fight the corrupt patronage system, create one uniform code for family law, secularize the courts, and provide standard training for family judges based on judicial merit. These goals remain a work in progress. The clerics in charge of the family courts retaliated by claiming that Islam should control all aspects of marriage, maintaining that it would be nothing short of blasphemy to combine Sunni and Shi'a family law into one standard code. After all, Sunnis and Shi'a had relied on different codes of family law for centuries. On whose authority could Jamsheer and her followers be permitted to change all that? Counteraction came from the Bahraini government, which played the clerics and the female reformers off against each other. In official publications, the government hailed the rights of women to consistent treatment in the family courts and called for a uniform family code enforced by trained and qualified judges (Supreme Council of Women 2009), though there was acknowledgement that reform could be difficult in the face of entrenched political and religious factions (Al Awadi, Al Mubarak & Al Attawi 2009).

Two days after the 2006 election, on December 4, a brief appeared from *Elaph* of an interview with the first elected female parliamentarian from Bahrain, Latifah Al Gaood, the woman some had hailed as a groundbreaker and others, like Jamsheer, had criticized as a hapless token. The brief went into some detail about her platform for governance. Al Gaood, who brought together no constituents of her own, vowed to govern on a unity platform. She declared, "We must strive to be Bahrainis who are not divided by sect or doctrine." She asserted that she did not wish to be a candidate for women or for men but for both:

"My home is open to all voters, both men and women, from the differ-
ent parts of Bahrain because I represent them all." Her multiple-point
platform consisted of fighting corruption, extending and improving
health care, attracting more foreign investment to Bahrain, helping
the business community, modernizing infrastructure, improving
housing services, restructuring the public sector as an employer,
combating poverty, strengthening charities and public welfare, and
supporting youth recreation and education. She "demands that the
social status of women be improved" so that women can rise to their
rightful place in the process of national development and homeland
service.

A December 4, 2006 brief from *Elaph* returned to Latifah Al Gaood
in greater depth. A British-educated employee of Bahrain's Ministry of
Finance, Al Gaood may have been elected in peculiar circumstances,
but her token status cannot erase what appears to be a genuine aptitude
for tactical leadership. During her campaign, she admitted that she
had to face down many male colleagues from the Islamist party who
were not afraid to tell her to her face that women did not belong in
elective politics. Al Gaood plotted a resourceful counter-strategy that
kept her in the game. She imagined the parliamentary dome as a home
where women were the equals of men, and associated the symbols of
home with decorum, unity, and inclusiveness. From these premises,
she was able to develop a governing philosophy that exposed the men
as falling short in their duties of home maintenance. A home needs
harmony and attentive care but, having created a circus of warring
sectarian blocs, the men had despoiled their home and left it in disar-
ray. Sectarianism was the culprit and Al Gaood vowed she would fight
sectarianism at every turn. She stressed that "sectarianism is a grave
threat that must be uprooted, and we must pursue national unity . . . We
must strive to be Bahrainis who are not divided by sect or doctrine."
And to Al Gaood, this imperative set out responsibilities for her to
assume. It meant she needed to cultivate an image as an unapologetic
non-partisan. She would rebuff alignment with any one bloc. She
would be the coalition builder to whom all blocs would look for
support. She would pursue committees that allowed her to grow as a
non-partisan (e.g., the Financial and Economic Committee) and
eschew assignments that required partisanship (e.g., speaker). Al

Gaood's responses outline a canny political office holder whom Jamsheer may have underestimated. She may have been elected as a token, but she did not govern as one.

Anger at becoming invisible amidst the political chaos

Bahrain is an archipelago of thirty-three islands in the Arabian Gulf whose small size belies the complexity of its politics (Davidson & Coates Ulrichsen 2010). It is a three-ring mix of clashing political alliances, in which female candidates and their causes can easily be lost in the scuffle. In one ring, there is the familiar tension between liberal women who champion female equality and Islamists who believe that the tenets of Islam support the subservience of women. In a second ring, there is a sectarian and class tension between Bahrain's Sunni population, who make up about 30% of the native population and include the ruling family and most of the country's elite professional class, and the remaining 70% who are Shi'a. There is a significant economic divide between these sects and, as Thomas Friedman noted in his *New York Times* op-ed column, technology has increased social awareness of this chasm. Shi'ites can now look on Google Earth and zoom in on the tiny, cramped dwellings in the southern district where they live and then find and zoom in on the spacious estates and palaces of the al-Khalifa family and the Sunni elite (Friedman 2011). The second ring is also affected by the first ring. Sunni women face one set of obstacles set up by Islamists because of their gender; Shi'a women face sectarian and class obstacles as well as gender issues.

In a third ring lies what we might call the geopolitical "chaos" of Bahrain. As Davidson and Coates Ulrichsen (2010) noted on the eve of Bahrain's 2010 election, Bahrain hosted simmering tensions between its Sunni and Shi'a populations that would, of course, erupt into violence in 2011.

Amidst these sectarian tensions in Bahraini society, there was no easy place for female candidates to rally the public. The Islamic sectors were unresponsive and sharply divided. The democracy movement did not unify in Bahrain as it had in Egypt. Shi'a women largely cast in their lot with the democracy movement, but Sunni women for the most part closed ranks with the government. None of these alignments

gave visibility to Bahraini women as a unified bloc with shared inter-
ests. Women had become invisible in Bahraini politics. On February
22, 2011, Sana Mohammed Bou Hamoud, a Bahraini lawyer and activ-
ist, was moved to write an article for *Common Ground News Service*
whose title – "Amidst chaos, don't forget Bahraini women" – put its
finger on the problem facing political women in Bahrain. In the article,
Hamoud strategizes how, as they look forward to the 2014 elections,
Bahraini female candidates might reclaim their political visibility. She
writes: "Bahraini women must not lose sight of their goals amidst the
current chaos but instead use the opportunity to set their sights on
seats in parliament in 2014." She advocates that the government should
set quotas for female candidates, and she believes that women must
press the government to do so. She urges the UN to be called in to
combat conservative groups who refuse to endorse female candidates
or who gerrymander constituencies to kill female candidacies. The
UN's Convention on the Elimination of All Forms of Discrimination
Against Women (CEDAW) condemns such election practices and the
government of Bahrain has ratified these CEDAW resolutions. She
finally exhorts the government to support secular political organiza-
tions that champion female candidates. One such organization, Awal,
mobilizes awareness campaigns about the right of women to hold
office and the benefits of their doing so. Another organization, Fatat
al-Reef, combats stereotypical notions of women in media, such as the
insinuation that women are too emotional for rational decision-
making. Only an aggressive campaign against Bahrain's current state
of chaos can, in Hamoud's view, bring women candidates back to visi-
bility in the elections of 2014.

Conclusion

In this chapter, we have reviewed anger/resistance (or retributive
anger) as a key determinant for judging female activity in our corpus of
Arab news. Both in our corpus and in research extending beyond it,
Arab women display their retributive anger in a wide variety of politi-
cal venues and direct it at a wide variety of targets. In our corpus,
female anger is often focused on issues that unite Arabs (such as
Palestine) and do not divide men from women or women from one

another. We were most concerned in this chapter with female retribu-tive anger that squarely confronts male domination as a target. The highest proportion of instances in our corpus associates female retributive anger with a liberal critique of male dominance. This is followed by a subclass of the liberal critique as it applies in stories where progressive women who are out to correct male dominance vote and run in elections. Our corpus was rich in stories of this kind because landmark elections involving progressive women candidates in Kuwait and Bahrain took place in 2006. In election campaigns, retributive anger tends to reflect the anger of women whose political talents have been systematically overlooked and whose political participation has been systematically excluded. Given their edge in group intelligence and the importance of such intelligence for making and mobilizing groups for positive social change, and given their historical marginali-zation in politics and campaigning, it is little wonder that Arab female candidates in our corpus would work tirelessly to see the denial of their gender equality both in and outside elections avenged.

7: *Aspiration & Drive*

Women who seek equality with men lack ambition.

Timothy Leary (cited in Byrne 1988, 272)

Women throughout legend and folklore fall on the wrong side of ambition. The likes of Cleopatra (Schiff 2010) and other remarkable women of ambition notwithstanding, cultural commonplaces make ambition a male trait. Frank Harris (1856–1931), the Irish-born American publisher and journalist known for his risqué writing, had one of his female characters quip in his 1910 fiction collection *Montes the Matador and Other Stories*: "A man without ambition is like a woman without looks." The phrase became viral and was repeated so often it became proverbial.

Women in the West who have historically yearned for equality face great cultural pressure to temper their ambition with modesty. They are socialized to seek equality demurely, without ruffling their femininity. The writer, Harvard psychologist, and 1960s iconoclast Timothy Leary, author of the 1976 novel *What Does Woman Want*, warned that modesty and restraint can be debilitating for an ambitious woman. Should she assert her equality with too much deference, she will be misunderstood as making a joke or, worse, making fun of the very idea of gender equality. At the same time, because of discrimination, women who saw gender equality as aiming only as high as men and working only as hard would fall short. Women had to set their sights twice as high and work twice as hard in order to attain the same result. Leary framed an aphorism (the epigraph of this chapter) to scold women for their meekness, and to remind them that gender equality required more than a level playing field with men. A woman who understood ambition as a man does would be aiming too low. The

Leary saying became an important part of the feminist vernacular of 1970s America (cited in Byrne 1988).

What about the pressures on ambitious Arab women to temper their ambition with modesty? In some ways, these pressures are not much different from those felt by ambitious women in the West. Suha Sabbagh, a Palestinian writer, edited a volume (Sabbagh 1996) in which ambitious Arab women writers from a wide spectrum testify to the tightrope they walk between defiance and restraint. In other ways, however, the terms of defiance and restraint for women can vary between East and West. In the West, female ambition is likely to be secular and defiant of religious authority; in Arab territories, female ambition is likely to be defiant of a Western secularism that seeks to expand ambition at the expense of religion (Sabbagh 1996, xxiv).

What forms does Arab female ambition take in our corpus of Arab news? How does it square with legend and lore? In this chapter, we continue the discussion from the last chapter on individual determinants of Arab female activity in Arab news, but now our specific focus turns to Arab women and the concepts related to female ambition, including the Arab female's aspirations, capabilities, choices, drive, and determination.

Aspiration, Capability & Choice

Aspiration

Aspiration is the hopeful longing to fulfill a vision of future success on the part of an individual woman, or a group of women who have managed to coordinate their individual aspirations into a collective desire. Tied to retributive anger, aspiration can be a means of projecting a future that rights previous wrongs. Had our corpus extended into 2011, we would no doubt have had many stories to report on the collective aspiration of women in Tunisia, Egypt, Yemen, and other Arab countries. As it stands, our corpus represents collective aspiration as we found it in our 2005–2007 corpus of Arab news. However, at one point, we will indulge in a brief peek ahead to a Yemeni woman who entered the news after our corpus expired and was singled out for her superior collective vision for that country in 2011.

Quantitative summary of female aspiration

Of the 178 news briefs in our corpus, seventeen (or 9%) convey information about an Arab woman's aspirations.

Qualitative analysis of female aspiration

Female aspiration in our corpus falls into two categories. The first is collective aspiration, the aspiration of individual Arab women who pool their aspirations in order to rise higher than each could rise on her own. The "collectivist" stories about female aspiration in our corpus tend to originate in the wealthy Gulf region, and shine the spotlight on women who are well-resourced and well-networked. They are typically, but not always, stories of optimism. The second category of female aspirational news story is individualistic and relates the aspirations of an isolated Arab woman dreaming about an individual life of success and achievement; the woman in this second type of story is usually cognizant that her aspirations are frighteningly dependent on uncertain external circumstances that may dash her hopes and cause her fear and insecurity. News briefs involving individual aspiration appear mainly, but not exclusively, outside the Gulf. In addition to their difference in geography, news summaries about individual and collective female aspiration differ in tone. News briefs about collective aspiration tend in most, but not all, cases to be hopeful about a better future for women as they build their nation-state, while stories about individual aspiration tend to be more negative, and raise concerns that a girl or young woman may not attain a future she has longed for and, on the merits, deserves.

Collective female aspiration

Besides the 2006 Bahraini elections (chapter 6), a second event in Bahrain in late 2006 dominated stories in our corpus about collective female aspiration. This was the first summit of the Arab Women Organization (AWO), held on November 13–15 in the capital, Manama, six years after the organization's founding in 2000. The

goals of the organization are to help Arab women regain rights of which they have been deprived, and also to make them aware of the civic and national responsibilities that follow from these rights. An *Al Hayat* article of November 14, 2006 interviewed the Bahraini First Lady, Sheikha Sabeeka, on the occasion of her hosting the summit. In the brief, Sheikha Sabeeka reviews AWO's assumptions and aspirations, and the audiences that it wishes to reach, rehearsing the reasons for the organization's founding. Arab women, she cautions, live in an environment that is "unsafe and vulnerable to threats," and they must organize to insist on their rights in male-dominated societies. AWO is particularly mindful of reaching the Arab women who live in war-torn Palestine and Iraq. For these war-stricken women, the Sheikha extends the "hope that there will be peace so that the women in Palestine and Iraq could keep up with the wheel of development and advance." She continues that AWO is also interested in raising the consciousness of Western women, who carry extraneous Western cultural stereotypes about Arab women. The Sheikha "expressed her hope" that the first conference of the AWO "will contribute in changing the stereotype for Arab women in the west."

An *Asharq Al Awsat* brief published the next day, November 15, 2006, covered the AWO conference. Suzanne Mubarak, the wife of the then president of Egypt, Hosni Mubarak, and the primary interview subject, says the problems faced by Arab women, and especially those living in war zones, are of special importance to AWO. Like Sheikha Sabeeka in the November 14 *Al Hayat* piece, the Egyptian First Lady articulated a common aspiration for AWO: "Women must preserve their rights and continue working to obtain all of their demands."

Saudi Arabia demonstrated its own version of female collectivism, but one that links aspiration more to outrage than to optimism. An *Asharq Al Awsat* brief dated August 15, 2005 reports on the rising aspirations of Saudi female opinion leaders, invigorated by the prospect of a new sovereign, King Abdullah. According to these female leaders, Saudi women in academe, medicine, and law have been laboring against a myriad of obstacles that they believe can and should be lifted under the new King, Adbullah. Hala al-Mu'ajjal, a

lecturer at King Saud University's College of Administrative Sciences, expressed the desire that more women would be admitted to Saudi universities and more areas of academic study would be opened up to women. Dr Islam Khujah, a consultant surgeon and head of the vascular surgery unit at King Fahd General Hospital in Medina, stressed the need to eliminate stereotypes that disparage the competence of female doctors in the Kingdom. She condemned university overseas scholarships programs that eliminated female applicants preemptively, on the untested assumption that a woman would not be able to accept a scholarship even if offered. Why? The expenses of her male guardians are not included in the scholarship and, on the basis of the paternalistic thinking of stewards of the scholarship program, no respectable woman could accept a scholarship without expenses for a guardian to accompany her. Zayn al-Abidin, an expert in law, noted the cruel discrimination Saudi women face by being granted the right to study law but not the right to practice it. She complained about how poorly Saudi women are represented under the laws of the Kingdom because they cannot count on sympathetic legal representation in family courts and because lawyers representing them typically communicate only with their guardians and not with their female clients directly. Manal al-Sharif, a journalist who works for the *Al Watan* newspaper, aspires to see equality among Saudi journalists. She expresses regret that female journalists in Saudi Arabia receive lower pay and less professional respect than their male colleagues.

An *Elaph* brief appearing two months later, on October 20, 2005, covers a Gulf Women's Business Forum in the Kingdom that is less plaintive than the *Asharq Al Awsat* article of August 15. Women organizers and attendees express optimism at the growing involvement of Saudi female entrepreneurs in the private sector. Two months after that, *Asharq Al Awsat* provided an extended example of one sector where Saudi women were beginning to enter private enterprise – car dealerships. Entering the private sector has traditionally been a precarious venture for a Saudi woman. The public sector, but not the private, has long guaranteed a female-only workplace that avoids the need for her to interact with men outside her family circle. Segregation laws are strictly enforced in the public

sector fields of education and health and this makes these public sector environments comfortable workspaces for Saudi women. So few Saudi women have traditionally worked in the private sector that it has not been as carefully developed to protect the privacy of women from males. Nonetheless, employment in the private sector remains a collective aspiration for some Saudi women. The brief quotes Maha Najoud Al-Hazyan, a sales manager for a private car dealership experimenting with "women-only" dealerships, who expressed the aspiration that the Saudi private business sector be opened up to many more women, acknowledging that this in turn required the development of more "women-only" private enterprises in the Kingdom.

A final example of collective female aspiration comes from an *Al Quds Al Arabi* brief of December 6, 2005, which describes the political aspirations of Soumaya Ali Raja, a Yemeni woman who lives in Paris and is the Director of the Yemeni-French Cultural Forum. She has nominated herself for the unlikely position of Yemen's next president. The fact that she has nominated herself for a position she is not likely to attain makes her candidacy more symbolic than realistic. Nonetheless, she can be tentatively included in a collective aspiration category because she seeks to speak on behalf of the aspirations of Yemeni women. The brief reports that Ali Raja declared herself a candidate just in case President Ali Abdullah Saleh made good on his promise not to run again. Raja noted that her self-nomination as a woman would make Yemen a "pioneer" in the region. Her administration, she declares, would transform the "ambitions and hopes" of Yemeni women "from words to actions." She would work for women's rights and "make the level of participation of women in different fields rise in addition to showing a more civilized side of the Yemeni society." Her platform would come straight from the concluding declarations of the women's rights conference recently held in Sana'a. These declarations, if implemented, would help Yemeni women to enjoy their full legal and constitutional rights, increase their participation in the professions, and strive to achieve a "more civilized side" of Yemeni society.

A postscript to this story: Ali Abdullah Saleh remained in power in 2005, of course, and Ali Raja's improbable candidacy never got off the

ground. Our sample of news briefs made no mention of the Yemeni women who would rise to lead the January 2011 revolt in Sana'a, or of a particular Yemeni woman whose collective aspiration some thought would make her the most realistic candidate thus far to become Yemen's first female president (Hackman 2011). Her name is Tawakkul Karman and long before the 2011 revolt, she had been feted as a staunch defender of human rights in Yemen and showered with attention by the North American press, including the *Washington Post*, *Time* magazine, and the *Toronto Star*. In an interview with Al Jazeera in January 2010, she enumerated a list of abuses by the Yemeni government that would come to a head a year later, including detaining journalists, tyrannizing the residents of Ibb, and providing a fertile new ground for al-Qaeda, a prescient observation made months before *WikiLeaks* uncovered and leaked that same fact. According to one profile by *Common Ground News Service*, what gave Karman the stature of a president-in-the-making was her visionary capturing of the common aspirations of all Yemenis, focusing especially on curtailing corruption and unemployment. She was not simply a voice for Yemeni women, marveled the profiler, but a woman's voice for all Yemenis (Hackman 2011).

Individual female aspiration

Unlike collective aspiration, individual aspiration remains confined within the framework of a single life and identity. In some cases, individual aspirations shrink into isolated aspirations that go unshared, unsupported, and bereft of sponsors and followers. In even sadder cases, a girl's aspirations may be strangled by a malevolent guardian, made more tragic by the innocence and future promise of the girl and the malice of the guardian. This tragic pathos peaks in an *Elaph* brief from Lebanon dated December 6, 2005, an opinion piece authored by Charbel Baayni about why fathers rape their daughters. It introduces a forty-nine-year-old father jailed for seven years for sexually abusing two of his daughters and tells the tale from the father's point of view. Why did he start raping his eldest daughter when she turned eleven? Because, according to the brief, he matter-of-factly "wanted to teach her life" and so he "violated her with

hair-bristling [sic] brutality . . . seven times in one night." The father persisted in his assaults night after night until his daughter turned fourteen. Not having been caught, his predatory attention turned to his second daughter. As with the first daughter, the attacks on the second daughter continued nightly. At some point, his wife finally realized what was happening and called the authorities before her husband had a chance to go after his third daughter. To capture the ignominy of the father's action, the brief lets us know that he understood the depth of his crime in all its cold-bloodedness. When describing the father making his way to the bedroom of his eldest daughter for his first assault, the brief makes clear that the father saw more than a daughter to molest. He saw a "small angel, dreaming about her studies and her success at school." The father feared a future when his daughters would be strong and successful and he would become increasingly enfeebled and shunted aside. He wanted to assault that future by desecrating not only his daughters' bodies but their dreams. Few things inspire hope more than an innocent girl's anticipation of a fulfilling future. Few things can be more tragic than the brutal ending of her dreams.

Thankfully, individual aspiration can also be redemptive. It can rescue hope from the jaws of despair. We see this redemptive female aspiration in an *Al Quds Al-Arabi* brief from Gaza dated August 8, 2006 that describes the return of residents of the rural village of al-Shawka to the remains of their homes and farms after the withdrawal of Israeli troops. The Israelis had driven tanks over their homes and destroyed the irrigation systems used to water their fields. One of the Gazans interviewed was a female resident named Karima, described as "over 50 years old," whose home had been leveled by an Israeli tank. In tears, Karima tells the reporter that just days before the Israeli operation in al-Shawka, she and her family had rushed for safety to a school inside the city of Rafah. They had just returned to al-Shawka and found themselves homeless. Inconsolable, she curses the feckless Arab leaders who allowed this to happen but, quickly recovering her composure and confidence, assures the reporter that "she, along with her family, will rebuild the house again." They will hold on to their land and nurse it back to health, because the land is "as dear to her as her own child."

Capability

To aspire is to strive for an unrealized positive future. Aspirations remain unrealized, however, without the capacity to realize them.

Quantitative summary of female capability

Of the 178 briefs in our news corpus, ten (or 5%) convey information about an Arab woman's capabilities.

Qualitative analysis of female capability

As with aspiration, female capability appears in shadings that eluded the black and white of the coding study of Part I. Female capability exists within both active and passive cultural frames. Nonetheless, despite the Ying-Yang overlap of active and passive capability, we can still separate them in concept, if not always in practice.

Active capabilities

Active capabilities, in our conceptual analysis, referred to the capabilities a woman exercises outside the home. The icon of Arab female capability in our corpus is a twenty-nine-year-old Harvard-educated lawyer by the name of Reem Al Habib, who is introduced in an *Al Hayat* brief from March 29, 2006. We shall revisit Reem many times along the road and from various perspectives. For now, we simply take note of the brief's references to her capabilities. Reem is such an impeccably skilled and fair-minded lawyer committed to the rule of law that the daughter of Saddam Hussein had hand-picked her for her father's defense team. The brief alludes to Reem's capabilities in several pointed phrases to explain why she had caught the attention of Saddam's daughter. It says that Reem would take Saddam's defense strategy "a step forward considering her capacities," and that working on Saddam's defense team would give Reem a chance to "prove herself" as she had proven herself so many times before. Reem herself in the brief thanks Saddam's daughter, Raghad, for "her confidence in me." Reem confides that she carries this confidence inside her. She says she

accepted the challenge of representing Saddam because "I felt I could do justice in this case." Reem shows she understands that what is at stake is not only her legal competence, fairness, and integrity, but the competence, fairness, and integrity of the legal profession she represents. As she remarks: "As a law graduate, I felt that the status of the court that is handling President Saddam Hussein's case calls for interference, in accordance with the laws of international court." When it seemed that no one in Iraq was capable of giving Saddam a fair defense, Reem stepped in to fill the capability vacuum.

In our corpus, there was a weak but nonetheless positive correlation (.1) between female aspiration and active female capability. That is to say, stories about female aspiration do not as a rule overlap with stories about female capability. Nevertheless, some overlap is evident, and one example comes in an August 15, 2005 *Asharq Al Awsat* article describing the hopes of female intellectual leaders in Saudi Arabia. They hope to persuade King Abdullah to take Saudi women to new heights of educational, professional and civic advancement. Now, it is one thing for a Saudi woman to nurse her aspirations privately, another to avow them publicly, and yet another for her to solicit her government to fund her aspirations outright. Hala al-Mu'ajjal, whom we encountered above, understood that pleading her and her female colleagues' capability to be productive citizens outside the home was as good a reason as any to persuade her sponsor to invest in Saudi women. And, true to this understanding, she makes a plea that the Saudi government "be aware of women's ability to be productive citizens."

Passive capabilities

Passive capabilities are a negative capability that relegates women to "what women are good at doing" within traditional domestic boundaries. A woman capable of giving birth and tending to the home and her family's needs shows capability, but it remains passive capability if it is confined within the domestic sphere of life, or within traditional career paths for women, and does not extend into the professional and public spheres typically dominated by men. Sometimes, a pioneering Arab woman with active capability decides she has stepped too far outside her safe boundaries and retreats to traditional roles. A Lebanese

woman trained as a mechanical engineer, identified only as Amal in an August 19, 2005 opinion piece from *Al Hayat*, refused her mother's advice to become a teacher. Her mother knew that teachers, an occupation friendly to females, could remain in their jobs even while raising children. As a single woman, Amal had originally snubbed teaching because she saw it as a safe option that did not give her enough challenge. Wanting to push her capabilities beyond traditional boundaries, Amal decided to enter a male profession – engineering. However, once married and expecting her first child, according to the brief, Amal found herself bereft of role models. She knew of no female engineers who continued to work while raising a family. Feeling isolated, Amal eventually recognized her mother's wisdom and decided to shift to a teaching career. She was mostly at peace with her decision but still could not help wondering whether the time she had spent training as an engineer had been a waste. Her return to her "traditional capabilities" was a retreat to passive capabilities, designed to fall back on rather than to strive for.

Passive capabilities are often imposed by men but they are also routinely policed by women. One of the favorite back-handed compliments of some male-dominated societies is to relegate to women one, and only one, kind of expertise – and that is the "expertise" of being a woman. According to this gender illogic, being a woman is such a time-consuming matter that someone burdened with female chromosomes has no time to study anything but her womanhood and the responsibilities genetically conferred by it. Such expressions of passive capability are evident in an *Asharq Al Awsat* brief dated January 2, 2006 from Saudi Arabia. The brief explains that earlier reports had announced that the Shura Council (Saudi Arabia's legislature) had instituted a Woman's Committee and had named its members. Later reports from the Shura Council, however, had denied the earlier reports. *Asharq Al Awsat* had contacted the women named and none admitted knowing anything about such a committee. Abdul Rahman al-Sughayyar, the Director of the Shura Council's public relations and press department, acknowledged that the Shura Council had from time to time invited in women experts to hear their views on various issues faced by women, and had in fact conducted one preliminary meeting where the idea of a permanent committee on women's issues

was raised, but such talk was tentative and not pursued further with any seriousness. At no point, al-Sughayyar insisted, had the Council made the appointment of a standing committee on women a matter of serious deliberation. Had the Council ever entertained placing a woman directly on the Shura Council? Al-Sughayyar sniffed that it was "absolutely out of the question," while nevertheless throwing a sop to Saudi women. He offered that the reason for inviting women to testify on women's matters was because "the woman is the one that can give an opinion on such issues." He thus made clear that Saudi women are experts on being women and fulfilling women's obligations – a field of expertise to be sure, but one that keeps a woman's know-how confined to her biology. Unlike Saudi women, Saudi men are permitted to be experts in matters other than their masculinity. Saudi women struggle for the same recognition.

Choice

Aspiration and capability mean little to the Arab woman if she cannot exercise the free choice to fulfill her dreams.

Quantitative summary of female choice

Of the 178 briefs, five (3%) include surface discourse information about an Arab woman's choice.

Qualitative analysis of female choice

As with aspirations and capabilities, choice falls into active and passive cultural frames. Active choices are made from leverage and opportunity. Active choices are "free choices" because the alternative is the status quo. If active choices are not made, the chooser will continue to experience life as she knows it. Passive choices are not "free choices" but are made from necessity, constraint, and from the lack of leverage to maintain the status quo if the passive choice is turned down. If a passive choice is not made, the chooser risks a life even worse than the status quo. A passive choice may feel like compulsion rather than choice. Unlike active choices, passive choices are joyless and do not

expand freedom but, compared to some alternatives, they are never-theless typically "safer" than the worst alternatives and often "the best alternative under the circumstances" when the circumstances are bad all around.

Veiling: active or passive choice?

Veiling is a complex sartorial practice of women in the Arab world, and claims a long history predating Islam and the delineating of Arab lands. The practice varies widely across nations, regions, villages, tribes, and social classes. Age-old custom across many ancient cultures linked wealth to female seclusion (Chamberlin 2006). The banalities of life, work, and trade require mingling with strangers and the woman with means and leisure could avoid that humiliation. For women-on-the-go, veiling provided seclusion without the loss of mobility (Abu Lughod 2002). Since the individualist turn in modern-ist and post-modernist thought, veiling has increasingly come to signify, in addition to religion, complex identity markers of personal choice and taste (Lewis 1995, 2004; Tarlo 2010). The practice of veiling has a voluminous and growing literature (Mernissi 1987; Barthel & Mule 1992; Abu Odeh 1993; Hoodfar 1997; Duval 1998; El-Guindi 1999; Shirazi 2001; Bullock 2002; Scott 2007; Heath 2008), and there is now a recent and expanding literature on the acceleration of veiling practices in the Middle East, Europe, and America post 9/11 (Haddad 2007; Ahmed 2011; Wright 2011). Post 9/11, be it an established symbol of modesty and tradition; an emerg-ing symbol of national assimilation or resistance; a beacon of democracy, social justice, or feminism; or an accessory of the social and artistic counter-cultures that came to world attention during the Arab Spring (Wright 2011), there now seem to be as many reasons advanced for veiling as there are women who veil.

A perennial question about veiling as an institution is the extent to which it lies within the bounds of an Arab woman's active choice (Read & Bartowski 2000). A lengthy brief from a December 1, 2006 edition of *Asharq Al Awsat* that delves into the practice of veiling in Egypt speaks to this matter, at least between the lines. The context for the article is the growing popularity of veiling among Muslim women

since the Six-Day War of 1967 and the Iranian Revolution of 1979. Since those events, veiling as a practice among Muslim women has grown significantly both across the Middle East and in Europe. In chapter 8, we discuss this *Asharq Al Awsat* article in greater depth with reference to female education and open-mindedness. In the present context, we simply wish to note that, on several occasions, the brief makes indirect reference to veiling as an active choice among Arab women.

In one passage, the news brief mentions that in the rural provinces of Egypt, donning hijab is a naturalized rite of passage for girls past the age of twelve. These rural girls are said to embrace the veil "without any persuasion." The phrase "without any persuasion" implies (to the English reader associating the word "persuasion" with free will) that, were the girl to balk at the practice, she would be given reasons to change her mind, and that, if the reasons still failed to persuade her, her right either to embrace or reject veiling would be respected. This would be the correct way of narrating the story were veiling a matter of her active choice. This "active choice" narrative, however, misses two volcanic pressures in Egyptian society that speak to why veiling might also reasonably flow from "passive choice" narratives. First, the brief notes that a veiled woman presents to many families as better marriage material than an unveiled woman. This makes wearing the veil a necessary choice for a woman who hopes to enhance her prospects and avoid spinsterdom, which in 2005 had reached a record high of 9 million Egyptian young women. Second, during the decade preceding the article, the veil itself had become increasingly stylized and part of designer fashion wear. So, apart from a strategic choice for marriage, hijab was providing Egyptian women with an increasingly important fashion identity, one from which they arguably had less freedom to turn away.

Of course, these "active choice" and "passive choice" narratives are not mutually exclusive, and, without probing into the heart of a woman more deeply than even she probably can, sorting the truth across these narratives is more an academic than an empirical exercise. The decision to veil or not to veil may turn on many reasons, none of which needs be exclusive. One may be simply that "it suits me personally." There is no contradiction between calling a choice both "religious"

and "suitable to me." It may be both my own choice and more than my own choice.

This is essentially the testimony offered by a second-year mass communications student at Cairo University, identified in the brief only as Shaimaa, as to why she wears hijab. The news brief mentions that Shaimaa "was veiled by her own accord since the second year of secondary school." Shaimaa denies being pressured by her family to cover and, in the words of the brief, she "supports her claim by saying that her older sister, two years her senior, is not veiled." Shaimaa was freely persuaded into wearing the veil by what the brief describes as "her decision." She recalls listening to the tapes of the young preacher Amr Khaled on hijab and its religious importance, and, influenced but not coerced by Khaled, freely made up her own mind that hijab was important to her too. The brief wants us to know that Shaimaa exercised both a choice beyond her and a choice within. It was a religious choice but still a choice she owned. Were her choice not her own, it is doubtful that she could have been so relaxed about her sister not following her path. The brief supports the interpretation that Shaimaa made both passive and active choices simultaneously. It was a choice suited to her religion and suited to her.

A less ambiguous example of active female choice in the corpus involves politics rather than religion and comes from an *Al Quds Al-Arabi* story from Egypt, published November 28, 2005. Egypt had just held its parliamentary elections and the Muslim Brotherhood had cried foul. The Brotherhood claimed that ballots in support of the government's own party (the National Democratic Party [NDP]) had been forged and that Brotherhood candidates had been denied seats as a result. Dr Jamal Hishmat, along with two other male Brotherhood candidates, vigorously disputed their losses and threatened to appeal to the "Human Rights Commission at the UN". By contrast, Dr Makarim al-Deiri, the only female Brotherhood candidate to run for election and to lose, broke ranks with her male colleagues. She said she would postpone any decision to make an international case of her situation for at least a few days; and with that decision to postpone, she made an active choice about how to respond publicly to her situation that caused her, respectfully, to stand apart from her male peers.

One brief provides an interesting case study of how an active

religious choice can open up an active personal choice. This unusual example comes from an *Asharq Al Awsat* brief from Sudan dated May 22, 2006. There, a Muslim Sudanese woman chose to marry a Christian man on the basis of a local fatwa (religious legal opinion) that permitted a Muslim woman to marry a Christian. The woman entered this mixed marital arrangement because she was given the choice under religious authority. Notice that the fatwa gave the woman an active choice within her religion. Freely embracing the opportunity opened by that religious ruling, the woman faced a second free choice, namely whether to exercise her option to participate in the option opened by the first choice. Unlike most religious dicta that command adherence, the fatwa functioned as a stock option that the woman was free to exercise or not, as she chose fit.

Passive choice

Western individualism typically associates greater choice with greater freedom and happiness, and superior prospects. This is why the default for choice in the West leans toward positive, free active choice – choice that preserves the status quo if it is declined. In passive choice, a woman faces bad alternatives and the best she can do is choose the least evil. There are two clear examples of passive choice confronting Arab women in the corpus. The first involves no-fault divorce (*khula*) in Egypt. A March 30, 2006 *Elaph* brief reports that, since 2000, Egypt has allowed *khula*, and the brief explains how it works. The woman seeking a no-fault divorce must agree to repay her dowry[1] upon petitioning for such a divorce. Unlike a regular divorce, she does not need to prove spousal abuse or any other harm inflicted on her during the marriage. *Khula* divorce is less protracted than a regular divorce, which is a plus for both divorcing spouses. Despite its apparent attractions, however, *khula* has been controversial on the Egyptian street and has more detractors than supporters. Its supporters say it gives women a quicker exit from a bad marriage and helps her land on her feet. Its detractors claim that *khula* shatters a time-honored cultural belief about marriage in Egypt, namely that any husband, no matter how bad, is still a gift to a woman. An Egyptian proverb says: "[any woman would prefer] the shadow of a man [to the] the shadow of a wall."

Driven by such conventional wisdom, opponents of *khula* worry that it may change the balance of power in marriage. In the worst case, they fear, it allows scheming women with money the opportunity to dump their husbands on a whim. Intisar Badr, a researcher from a woman's organization called Women's Advancement and Development, which provides counseling services for female heads of households, found both parties to the debate to be wrong. Affluent women, Badr discovered, were not using *khula* flippantly to rid themselves of good husbands. But neither were women who were exercising the *khula* option landing on their feet in the way proponents claimed. The reality was different: poor women were using *khula* to rid themselves of their abusive husbands as quickly as they could – and were finding themselves out on the streets at an alarming rate. Why? Divorce by *khula* deprives the wife of claims to the marital home. *Khula* gives poor women the choice between marriage and homelessness, and many were choosing homelessness. Badr found that 80% of separation cases in Egypt involved domestic violence, and so the choice many Egyptian women faced was between homelessness and beatings. Badr's research showed that, rather than extending active female choice, *khula* was only strengthening Egyptian women's passive choice to "choose their freedom rather than live with a man in hell."

Within assumptions of patriarchy, a woman takes her direction from her male guardian. Her choice is his choice. Her best choice is what the men in her life choose for her. If she fails to accept that, she has no choice at all. Given these assumptions, her best choice is passive choice. A dutiful wife does not choose her own political candidates. She takes direction on this matter from her man. But what if the woman rebels and insists on a political candidate different from her husband's choice? This question emerges at the periphery of an *Asharq Al Awsat* brief of June 13, 2006. The author of the original Arabic piece, Mshari Al-Zaydi, *Asharq Al Awsat's* opinion page editor, writes about the inconsistent rhetorical practices among the warring ethnic and religious factions in Lebanon – Sunnis, Shi'a, and the various factions of Christians. Each faction assumes that the others are driven by corrupt politics while their sect alone is motivated by religious sanctity. Each faction assumes that their attacks on the others are protected by an open public sphere guaranteeing free speech, and each assumes

that the others' attacks on them are blasphemies and calumnies that are not protected speech. According to the editorial, Hassan Nasrallah, the Secretary General and leader of Hezbollah, is a master practitioner of this asymmetrical style of argumentation and has no qualms about mocking his adversaries under the umbrella of political speech while condemning his opponents for sacrilege when he and Hezbollah are mocked.

Al-Zaydi writes from the intellectual high ground of a non-partisan. He wants to improve the level of civil argument in Lebanon across all the factions. He believes that each faction has allowed the realm of the religious to loom too large in their public discourse and the realm of the political to grow too small. He maintains that a healthy public sphere requires open argument and criticism, which needs to be as free-flowing as possible. This means that all factions need to learn to take criticism from the other factions as well as direct criticism back to them. And he believes that this give-and-take can happen only if public figures across all sects agree to leave the absolutism of religion out of their public discourse. Public figures, he urges, should rely on political discourse, which is fallible, open to endless criticism, and makes no claim of religious immunity for itself. Al-Zaydi wonders aloud, "Can a politician legitimately demand the immunity reserved for religious symbols?" He answers his own question with a resounding no, and attributes any other view to Lebanon's weak national identity. He finds Lebanon's brittle public sphere to be a sad statement about a country once known as the "beacon of pluralism" in the Middle East.

What does Al-Zaydi's writing have to do with passive choice for women? Consider the question of a woman's right to choose a political candidate independently of her husband's choice. In what realm – political or religious – would you guess Al-Zaydi classifies debate about this right? If you were a betting person and a secular reader from the West, you would probably think he calls a woman's right to choose her own political candidate, free of her husband's influence, a political choice and so open to further debate and criticism in the public sphere. After all, we are talking about electing political candidates and not religious clerics, and we are talking about a writer (Al-Zaydi) who wants to see political debate expand in Lebanon's public life and religious debate contract.

But, if you predicted along these lines, you would be wrong. Al-Zaydi, the champion of open debate in Lebanon, classifies the argument that a woman should choose her own political candidates as a blasphemy that should never see the light of day. So when Dr Mohammed al Tabtabai, Dean of the Faculty of Islamic studies and Shari'a in Kuwait, dared issue a fatwa respecting a woman's choice on these matters, he was, according to Al-Zaydi, not expressing his political opinion. He was violating Islam and should be silenced. A woman's choices for candidates are, as Al-Zaydi sees it, her husband's. That is her best alternative to having no choice at all.

In the coding study of Part I, where the coding context was the local verb phrase and not the holistic meaning of the text, we kept active and passive categories distinct. In the canvassing and conceptual census-taking of Arab women in Part II, we find that Arab women, like everyone, are caught between active and passive cultural frames that not only co-exist but are mutually defining. The active Arab woman faces passive constraints but uses those constraints to measure her progress against them. Active women find that indignation at the status quo, aspiration toward a better future, and the capacity and choice to move forward, are parts of a working whole. If women lack a present to resist and a future to fight for, there can be no hope, and if they lack the capacities to compete for such a future, there can be no choice. Lacking the choice to make the most of their vision and capacities, they will find themselves tailoring a life to everyone's decision-making but their own. The woman demanding active choice will identify these deficits with an unsatisfactory life and seek more. The woman content with passive choice will acquiesce in, if not embrace, a life within familiar boundaries, built for her, but not of her making.

Personal Discipline/Drive

Aspiration, capability and choice are not abstractions to be admired. They are tools of living to be implemented each day. When a devout Arab woman was once asked by a Westerner why she drank so much coffee, she replied, "Because I have my responsibilities." People must have the personal discipline/drive to implement their aspirations,

abilities, and choices in their daily living. The active Arab woman runs on drive to make sure she actualizes her potential. In his magisterial 1807 treatise *Phänomenologie des Geistes* (Phenomenology of Mind), the nineteenth-century German philosopher Georg Wilhelm Friedrich Hegel (1967) was struck by the yawning gulf between aspiration and drive. He called this gap "the beautiful soul," the soul that frames aspiration much as a connoisseur of art frames a fresco on a living room wall. It is aspiration reified into a faraway vision too beautiful in concept, too avoidant of ugly detail, ever to be actualized into an earthly plan. The beautiful soul would rather harbor 1,000 perfect aspirations than dare take even one imperfect step toward bringing one of them into the harsh light of reality.

In what follows, we break down discipline/drive into three subcategories: pride, insistence, and initiative. Pride refers to the self-respect with which an Arab woman carries herself and her loyalty to and identification with other women and their progress. Insistence refers to her persistence and confidence in her planning and thought. Initiative refers to her readiness and assertiveness to transform ideas into actions. Below, we provide a quantitative summary followed by a qualitative analysis of each of these concepts as they appeared in our corpus.

Pride

Pride reflects respect and loyalties to self and groups and, for our purposes, it especially reflects a woman's pride in the common destiny of women to influence society as a collective. The Danish writer Suzanne Brogger has written eloquently about female pride in this special sense: "If a woman can only succeed by emulating men, I think it is a great loss and not a success. The aim is not only for a woman to succeed, but to keep her womanhood and let her womanhood influence society" (cited in Doyle 2001, 169).

Quantitative summary of female pride

Of the 178 briefs, only one (.05%) makes reference to an Arab woman's pride.

Qualitative analysis of female pride

The lone brief involving female pride comes from an *Al Hayat* report from Bahrain dated June 7, 2006. The headline of the brief in question reads: "Precedent in Arab Gulf countries: Woman appointed judge in Bahrain." The brief describes how the King of Bahrain, Sheikh Hamad Bin Isa al-Khalifa, made a historic appointment of a Bahraini woman, Muna Jassim Muhammad Al-Kawari, to serve as a judge in the supreme civil court. Judge Al-Kawari is given space to express what the appointment means for her and for Bahraini women. She is quoted as saying: "I feel proud as the first woman judge in Bahrain"; "I hope to live up to the expectations . . . without any doubt, I feel proud, [the] same as every other Bahraini woman . . . there is no surprise for me because his majesty the King always encouraged women since the start of his reform program."

Insistence

Insistence registers the confidence and conviction with which ideas are held and expressed. An insistent woman knows her mind and can stand her ground in the face of resistance. The confidence and conviction may indicate a desired reality that has been achieved or a reality that remains an aspiration.

Quantitative summary of female insistence

Of the 178 briefs, seventeen (9%) make direct reference to an Arab woman's insistence.

Qualitative analysis of female insistence

Arab women are stereotyped in the West as relying on male guardians for their decision-making. According to the stereotype, an Arab woman's opinions are uncertain and tentative. She depends on men as lodestars for her guiding principles. The possibility of Arab female insistence counters this negative stereotype by suggesting that Arab women can form beliefs and principles for action autonomously,

persistently, and confidently. Arab females can be a force of change unto themselves, the originating source of historic action and direction-setting. The corpus of news briefs provides substantial evidence of Arab women who bring insistent voices to visions for the future.

One insistent and plaintive voice in our corpus belongs to Leila Tallab. In a June 28, 2005 editorial from *Al Hayat*, headlined, "Arab women are suffering," Tallab observes that: "Although we are entering the 21st century, the Arab woman is an example of women in developing countries suffering from the control of men." She complains that "intellectuals and NGOs" routinely call for "women's freedom," but few policies ever seem to be implemented to flesh out these calls into effective action. She notes that, in Arab countries, women remain second-class citizens and lead marginalized roles in "decision making and drawing the political map of the state." She points the finger at the Arab family and declares "No family can develop except with equality among its members."

In mild competition with the insistence on equality between males and females is the conventional worldwide belief that women play a more equal role than men when it comes to care for and attention to family matters, particularly the welfare of children. This conventional belief has recently been supported, in some respects, by research on the neurochemistry of the female brain, which has shown that mothers bond with their babies in the womb (Brooks 2011) and exhibit uncanny skills in relation to their children that fathers do not exhibit. For example, among other tricks of maternal magic, mothers can successfully localize their baby's smell with 90% accuracy from an environment emitting a 360-degree range of human odors (Brizendine 2006, 102). This and many other neurological advantages that mothers have in relation to their offspring, the stuff of much folk wisdom about mothers long before it received scientific attention, has tended to beget the cultural belief that women merit being given a more insistent voice of authority within the home when it comes to the care of children. Speaking on behalf of the woman's special powers within the Muslim home, Jamila Ibrahim, head of a delegation for the International Federation of Red Cross and Red Crescent societies in Afghanistan, once noted that, when you peer into the Islamic home, you soon see that the women are the leaders, responsible for the health and welfare

of the family. Women, she argues, enjoy an inbuilt training inherited from their mothers and aunts that allows them to take on the leadership role at home (quoted in Hayward 2004, 18).

A woman's special claim to an insistent voice of authority within the home is made evident in an *Elaph* brief of February 28, 2006 reporting fears arising in Gaza about food shortages resulting from Israeli blockades. As a result of these fears, the brief reports, Palestinian residents of Gaza were making runs on stores for legumes, canned food, and frozen and fresh food stuffs. Anxieties were running high, "especially amongst women" that their children would suffer from a shortage of milk and food. A Gaza citizen, Mahmoud Omar Hakoumi, is quoted in the story as saying that "while he was shopping for his family," he felt "obliged to store some products because his wife insisted and his children are afraid." It is interesting, but not altogether surprising, that a husband would defer to his wife as the stronger and more insistent voice of the family when it came to attending to matters of family well-being and welfare.

Another poignant example of the special power of a mother's insistence on monitoring and maintaining the bonds of family surfaces in an *Al Hayat* brief of November 21, 2006 from Saudi Arabia. The brief reports on the "phenomenon" of young Saudi men leaving for Iraq to fight the Americans. The story features twenty-eight-year-old Khaled Abdul-Rahman, from the Al-Jawf region, who left for Iraq in the middle of Ramadan, telling his family he was going on hajj to Mecca. After only a few weeks in Iraq, Khaled was killed during a military operation against American soldiers. Relevant for our purposes is the contrasting behavior of Abdul-Rahman Al-Khalidi, Khaled's father, and Khaled's unnamed mother, whenever Khaled called home during the brief time he was in Iraq. The brief quotes the father as having "refused to talk to Khaled whenever he called his family from Iraq because he did not approve of him going there." Khaled's refusal to obey his father's wishes had cut him off from the family. But his mother never failed to pick up the phone and each time she did, the story reports, she "insisted" he return home "at the closest possible time." The story goes on to quote the father that "Khaled's mother has been passing through a terrible emotional state since she received news about his death in Iraq. She is extremely pained and sad at the death of

our eldest son." Note well that the father can speak for the family but not to it, while the opposite is the case for the mother. Her power to insist and then impose her will on behalf of family unity is sovereign, implacable, and impervious to whatever her husband lays down.

In addition to the woman's special voice of insistence within the family, the Arab woman's voice of insistence may project outward, to the society and nation. This projection of the maternal voice outside the home can influence directions for national policy, directions bold enough to dare propose revising the views propounded by male sovereigns. A September 19, 2006 *Al Quds Al-Arabi* story from Mauritania noted that women of that country were relieved to learn that the government had apportioned 20% of electoral seats to women. The Mauritanian President Ali Ould Mohammed Vall had opined that Mauritanian women were "neglected" and needed to be involved in government affairs on a wider scale. But then the brief goes on to quote two Mauritanian women from different backgrounds with insistent voices who beg to differ with the President, who think his plans do not go far enough for the long term and who fret that he may be offering a political façade to avoid real change for Mauritanian women. Siham Sayyed Muhammad, a radio journalist, is quoted. She gives a weak acknowledgement of the presidential initiative but thinks it needs to be thought through further because women's quotas "ought to be increased" and involve "a real percentage and not just a move made for political purposes." A tradeswoman, Nasirah Allah Bint Al Hassan, greets the President's directive with skepticism and laments that "women in Mauritania were doomed to be inferior." She confidently counterproposes that "the percentage [of electoral seats to women] be raised to 40% or 50%, since there [is] no difference between women and men, in terms of assuming public responsibilities." These two women seek to push the same "equality at home" argument (the nation is home and women's equality at home must scale outward to the nation) in Mauritania that Latifah Al Gaood pushed in Bahrain.

Efforts to insist on "equality at home" on a national scale spill over into female voices seeking to rein in foreign occupiers. An *Al Hayat* brief of August 15, 2006 from Iraq reports on such a story, saying that Iraq's Minister for Women's Affairs, Faten Abdul-Rahman Mahmud, had "demanded that the Iraqi side be allowed to participate in the

ongoing investigations into the crimes committed by American soldiers against Iraqi citizens." According to Mahmud, the Americans should not be allowed to prosecute their own soldiers because they would use "soldier stress" as an excuse. Iraqis should be part of the prosecution team so that the Americans would not be able to extend leniency to criminal soldiers or avert their eyes from the magnitude of the wrong-doing perpetrated by American soldiers.

One area in which the insistent voices of Arab women tend consistently to take the lead is in the arena of human rights. An *Al Quds Al-Arabi* brief of May 26, 2006 documents the effectiveness of the insistent voices of Palestinian women in reminding the Israeli government to enforce its own human rights laws. The brief reports that the Israeli Prison Authority, without prior notice or explanation, had recently closed the bank accounts of Palestinian political detainees. A Commission for Citizens' Rights had appealed to an Israeli judicial advisor to intervene and to force the Prison Authority to reopen the detainees' bank accounts. The Commission for Citizens' Rights finally agreed to act on this appeal because of the "complaints" of one Sana Shehade, a female detainee in the Sharon prison who, in partnership with Taghrid Jahchan, organized a women's association for the rights of female detainees. Jahchan had been aware of and sympathetic to Shehade's situation and that of other detainees whose bank accounts in the Al Barid Bank had been abruptly closed by the Prison Authority. Together, these women worked with Attorney Sonia Boulos from the Commission. Boulos had studied the law and determined that Israeli law "stipulated that the Prison Authority had to provide an account for the detainees to deposit their money or money sent by their families, or to transfer money they earned working in the prison home." Attorney Boulos conceded that the prison guidelines did authorize the Prison Authority to exercise some limits on the use of a detainee's account, but in no case, she argued, did Israeli law allow the Prison Authority to close down an account outright or without notice.

At times, insistence reflects impatience with a reality that does not keep pace with expectations. Such insistence is the product of frustration. At other times, insistence affirms that reality has caught up with expectations. Such insistence is the product of satisfaction. We see this ambiguity between insistence-as-frustration and insistence-as-satisfaction in the

English expressions "it is high time that" (insistence-as-frustration) and "the time has finally arrived when" (insistence-as-satisfaction). Our corpus of Arab news has examples of both kinds of expressions.

An example of female insistence-as-frustration is evident in an *Elaph* brief from Syria on November 7, 2005, which details how the respected Syrian opposition leader Riyad al-Turk appeared on satellite television calling for Syrian President Bashar Assad to resign and accusing Assad of continuing his late father's dictatorial policies. In retaliation, the Assad administration accused al-Turk of ties to US and Israeli foreign policy interests. The female activist Suhayr Al-Atasi came to al-Turk's defense, endorsed his call for Assad's resignation, and accused Assad of slandering al-Turk's good name. Al-Atasi was then questioned as to whether her views reflected those of the broad Syrian population or a small elite of dissident intellectuals. She admits that her group is less involved with ordinary Syrian citizens than it should be, but vows "that it was high time it was involved." The reality lags behind. Her insistence keeps alive a future that has yet to arrive.

Yet there are other cases of female insistence-as-satisfaction, where reality has indeed caught up and the hoped-for future has arrived. We have discussed above (see the section on Pride) evidence from a June 7, 2006 *Al Hayat* story of women in Bahrain expressing joyous pride in their appointment as judges, and, in particular, the historic appointment of Muna Jassim Muhammad Al-Kawari to the supreme civil court. The general secretary for the Supreme Women's Council in Bahrain, Lulu Al-Awadi, registers with satisfaction: "The time has [now] come for women's rights [in Bahrain] to be translated into reality." Of course, insistence-as-frustration and insistence-as-satisfaction both influence the trajectory of policy and planning. The impatient insistence of women, with enough persistence and luck, can deliver and satisfy.

As one 2005 *Asharq Al Awsat* brief we have seen before makes clear, insistent voices can often be heard from the Gulf, and Saudi women, in particular, register their frustration and their concern to raise the profile of Saudi women in the professions and public life. The brief is headlined "Saudi women demand greater roles in [the] professions [and in] public life." Accomplished women – such as businesswomen, academics, and physicians – go on record in this brief with their high

expectations for the new era under King Abdullah. The insistence referred to in the brief comes into play early in the planning trajectory on an impatient note – still in the "it's high time for" rather than "the time has finally arrived" spectrum, indicating frustration in in the maddening wait for satisfaction.

Thus far, the voices of Arab female insistence we have heard are not only active but noble. They have been cries for "equality at home" for women and extensions of that equality into public life. For pro-women advocates, whether the female insistence for equality be in the early (frustration) or late (satisfaction) phases, the planning trajectory that spans both phases includes plans worth supporting. But insistent female voices in our corpus may also be ignoble and unflattering. They may spring from vanity and be unleashed from the mood swings of a diva who cannot be pleased or appeased. She may use her insistence to elevate personal whim into a public cause célèbre and seek to pass off her caprice as legitimate social purpose. Our corpus gave us a glimpse of one of these *grandes dames* among Arab women.

A June 5, 2006 *Asharq Al Awsat* brief written by Tariq Alhomayed, the editor-in-chief of that publication, excoriates one young diva, the Egyptian actress Hanan Turk, who in 2006 began to wear hijab. The brief respects her opinion to make that personal choice. However, it takes her to task for demanding that the Egyptian cinema should imitate the Iranian cinema. Alhomayed accuses Turk of turning a blind eye to the repressive practices of the Iranian film industry, which forces dissident film-makers underground and often requires men to play women's roles. According to Alhomayed, Turk exploits the freedom of Egyptian cinema to attack that very freedom. As Alhomayed sees it, Turk has publicly wished "to be repressed and shackled." She has exploited her celebrity to make demands that are whimsical and self-indulgent. She has tried to make her personal religious conversion into public policy – with disastrous consequences for Egyptian cinema.

Sometimes female insistence is perceived to falsely support a woman's undeserved status as a victim. In a June 26, 2006 brief of an opinion piece from *Asharq Al Awsat*, Alhomayed attacks the US-based Egyptian secular activist and journalist, Mona Eltahawy. Eltahawy had written a column for the *International Herald Tribune* accusing *Asharq Al Awsat* of firing her on instructions from the Mubarak government

because she had written too many columns for that paper that crossed lines. Alhomayed uses his June 26 editorial to address Eltahawy's allegations against his paper, and, in particular, Eltahawy's charge that *Asharq Al Awsat* censors itself to stay on the right side of Mubarak. Alhomayed retorts that if his newspaper were truly trying to avoid risk, it was making a poor job of it, claiming that "We receive death threats and extremists denounce us as infidels on a daily basis" and that "Eltahawy was wrong . . . to portray herself as the victim."

Initiative

Initiative is pride and insistence channeled and refined into deeds. An Arab woman with initiative seizes opportunities to turn ideas into action without having to be prompted or cued.

Quantitative summary of female initiative

Of the 178 briefs, eleven (6%) make direct reference to the initiative of an Arab woman.

Qualitative analysis of female initiative

Our sample of new briefs is replete with examples of Arab women showing initiative in small ways and large. An *Al-Quds Al-Arabi* brief from January 31, 2006 tells an interesting tale of the initiative of Jordanian women responding to the rising price of gold and the devastating effect this was having on the provision of marriage dowries by middle- and lower-class suitors. As the brief describes, Jordanian women had long established unspoken understandings about how much gold was required to purchase their hand in marriage. These understandings were visibly demonstrated on the person – the ring finger to be exact – of the bride as part of the wedding ceremony. The rising price of gold was compromising marital contracts, as brides were either pricing themselves out of the marriage market or feeling coerced into accepting the shame of selling their hand for less than convention approved. In some cases, to save face, brides would resort to fake or borrowed gold – a risky strategy if exposed. The business of becoming

a bride in Jordan was sputtering and spinsterhood was spiking as never before. In response to this unhappy situation, enterprising Jordanian women took ingenious action. They collectively changed the social conventions of marriage by redefining the common currency of marital transactions from pure gold to a combination of alloyed gold, cash, and low-risk stock options. To keep the marriage economy moving briskly, brides in Jordan had simply, in the words of the story, "come up with new alternatives to . . . gold."

Because of heavy capitalization in the Gulf and the availability of large quantities of investment capital to Gulf women, several briefs report on the many initiatives taken by Gulf women, particularly Saudis, to organize and educate themselves about investment opportunities. These initiatives have led to the institution of a "business women's division" of the Gulf Cooperation Council (GCC). One brief from *Elaph*, dated October 20, 2005, reviews the many initiatives undertaken by Saudi women in business on behalf of Saudi women, including forums on investment and estate management that have attracted hundreds of women at a time, conventions showcasing women-to-women businesses, and educational trips to business centers such as Dubai, where businesswomen conduct and take seminars and workshops in investment opportunities. Workshops are also offered that help educate Saudi businesswomen on common obstacles to investment, such as the limitations on access to business education for women, and the difficulty Saudi women experience in obtaining the low-cost loans that are required to form new women-owned and -managed businesses. The brief also quotes from leading Saudi businesswomen about the important and growing role that "businesswomen's councils and committees" will play in the overall national economy.

Other briefs that mention Saudi women only at the periphery imply in small but still perceptible ways the enthusiasm of some Saudi women to rise in the world of business. Saudi women know they must work harder than men to be taken seriously and a brief from *Al Hayat* columnist, Jihad el-Khazen, writing on the World Economic Forum, makes the point emphatically with but two words of English – "before us." El-Khazen captures in this phrase co-chairperson Lulua al-Faisal's unfailing punctuality, preparedness, and readiness at the Forum,

taking note of how she consistently arrived "before us" at each morning's session.

One sure indicator that a woman has the power to seize the initiative is to catch her denying that she intends to exercise her power to do so. An Arab woman put in exactly that position is the subject of an *Asharq Al Awsat* brief of January 30, 2006 out of Palestine. The headline reads: "Hamas: Religious coercion is not a part of our program." The brief quotes Maryam Farhat, popularly known as Umm Nidal (mother of Nidal), who ran for and was eventually elected to the Palestinian Legislative Council (PLC) in 2006 as a representative of Hamas. Prior to her election, Umm Nidal had gained worldwide attention for sending three of her six sons (Nidal being the oldest) on suicide attacks against Israel. The brief notes that Umm Nidal had denied reports that she had been "undertaking initiatives to enact rules that impose the Hijab on women." Umm Nidal rather explained that "The Hamas Islamic movement is open and . . . will never restrict people's freedoms," adding that "Islamic teachings guarantee the freedom of all people."

Finally, briefs can be found of courageous Arab women taking initiatives on behalf of the displaced victims of war in Lebanon during the summer of 2006. An *Asharq Al Awsat* brief of July 27, 2006 reports on the heroic efforts to help victims of war-torn Beirut, which opened the hearts of many of Beirut's youth, who are said to have "turned away from their everyday interests [to help] . . . the displaced." One woman in particular, Patricia Mashaalani, is singled out in the brief, as a hero who "has taken it upon herself to distribute bread, flour and cereals to the displaced in the regions [and] who have found some tents, [along with] abandoned or partially destroyed hotels to live in." A brief from the same newspaper, appearing just the day before, focused on how women-led groups took to Internet forums to rally world support for the suffering Lebanese. Rein Abu Azza, a founder of the movement, was quoted as saying the project started as a "private initiative" in chat rooms and she noted how important it was to give those who work for Western media a perspective on the war different from what they typically see or report on. Abu Azza went on to explain that her digital initiative to marshal support for Lebanon had taken invaluable lessons from the Zionist lobbies of 1947 and 1948 that sent almost 50,000

letters to the White House petitioning for the state of Israel and almost a million additional letters of support to influential associations and institutions in the West. Abu Azza proudly reported that her initiative had thus far garnered 150,000 signatures of support in America and Canada.

Conclusion

Anger/resistance prefigures an emotional response conducive to seeing injustice and correcting it with justice, but this emotion goes undeveloped and the turnover from injustice to justice goes unfulfilled if it is not accompanied by other important individual characteristics, such as capability, choice, discipline, and drive. This chapter has reviewed the occurrence of references to these last concepts in our corpus of Arab news. We reviewed capability and choice and found that, despite their contributions to a woman's cultural frame of activity, both have strong definitions within passive as well as active cultural frames. We broke down discipline and drive into more specific concepts, namely pride, insistence, and initiative. Women who exhibited these various concepts in our sample of Arab news did so for reasons that were admirable and sympathetic and also for reasons that were less so.

Along with the concept of retributive anger discussed in the previous chapter, the concepts discussed in the current chapter complete our review of the individual determinants of female activeness in our sample of Arab news. These determinants in turn provide important building blocks for a woman's participation in and contributions to her nation's education and employment sectors. In the next two chapters, we move from the individual determinants of cultural activity addressed in this and the previous chapter to the institutional determinants of education and employment.

8: Education

[In]the tribal areas [of Afghanistan] men saw it as an insult to be told by the government . . . that their daughters had to leave home, attend school, and work alongside men. God forbid that should happen!

Khaled Hosseini (2007, 121)

Educated girls and women are less vulnerable to HIV infection, human trafficking and other forms of exploitation, are more likely to marry later, raise fewer children who are more likely to go to school, and make important contributions to family income.

World Education (2011)

During my tenure as Chief Economist of the World Bank, I have become convinced that . . . investment in the education of girls may well be the highest return investment available in the developing world.

Lawrence Summers (cited in Foreword of King & Hill 1993, v)

Just as in the West and most regions of the world, education in Arab territories is the great social equalizer between the sexes, providing women with the best chance to compete with men for socio-economic status, opportunity, income and all the life rewards that such advantages collectively bring with them. Furthermore, education supplies an Arab woman with her best tool for resisting forces of cultural patriarchy that are often mistaken for Islamic doctrine. Educational credentials enhance a woman's visibility, mobility, and public recognition in conservative cultures that seek to repress women's levels of activity. On the home front, the education of women is well-known to increase the odds of maintaining intact families, decreasing domestic violence, and advancing the

nutritional and mental health of children (Kristof & WuDunn 2009).

In the last chapter we examined discipline and drive as individual manifestations of an active Arab women. Discipline and drive have institutional manifestations too, which play out most visibly in the institutions of school and work. In this chapter, we tease out the relationship between education and Arab women as suggested in our corpus of news briefs.

Quantitative summary of female education

A sizable number (twenty-four of 179), or 13%, of the briefs in our corpus of Arab news address issues of education for Arab women in various ways, both thematically and in passing.

Qualitative analysis of female education

As a driver pushing women to achieve more than their mothers, education promotes increased levels of female cultural activity. However, while many educated Arab women pursue such goals, they find themselves vulnerable to cultural counter-forces that may react to educated women as a nuisance if not a threat. Under conditions of war, political instability, social upheaval and general cultural conservatism, educated women and their priorities may be the first to be dismissed or targeted. Many of the briefs in our corpus of Arab news focus on the cultural push-back against educated Arab women as much as they focus on the push-ahead for society of seeing both sexes educated equally. Education makes Arab women a source of family pride and also society's first victims when war, instability, and social upheaval turn the social clock backwards.

Nothing advances the education of Arab women more than literacy. And nothing destroys life's opportunities for a woman more than illiteracy. One brief in the Arab news corpus, an *Elaph* summary from October 19, 2005, from Algeria, headlined "A generation whose slogan is: keep the book away from you . . . at all costs," puts a spotlight on some aspects of the problem. The writer, Nour al-Houda Ghawly, narrates that she was in Al Arabi Ben Mahdi library in

Algiers when she spotted a young girl reaching for a children's book. The mother scolded her, asking "What do you want to do with this story?" and pulled her daughter out of the library. Why would a mother do such a thing? Ghawly answers her own question by citing statistics indicating that two decades ago 35% of the adult population in Algeria avidly read for pleasure but that the number has now dropped to an alarming 8%. Why had the number of active readers in Algeria dropped so precipitously? Ghawly offers two explanations. First, the "harsh" economic conditions in Algeria have made book buying an expensive habit. Second, there is competition among the leisure reading market between French-based and Arabic-based literature. According to Ghawly, French-speaking Algerians, considering themselves more cultured than those who speak only Arabic, have more enthusiasm for French reading materials than for Arabic. Ghawly reports hearing that the Al Arabi Ben Mahdi library had recently closed.

Cultivating the reading habit, of course, depends on first cultivating literacy. Education starts with literacy and the more one sees education as a driver for advancement, the more one will welcome being recruited into literacy as a first step. Worldwide, male literacy rates exceed female literacy rates by an average of 15.9%. As of 2000, the Arab region had the widest male-female gap in the world, at 23.9% more literate males than females (Arab Fund for Economic & Social Development, 2005, 143). This gap has been steadily shrinking over the past twenty years. In 1980, every Arab country had a significantly higher literacy rate for males than for females. By 2000, female literacy was steadily catching up with male literacy and in three Gulf countries (UAE, Kuwait, and Qatar) surpassed it (Arab Fund for Economic & Social Development, 2005, 144). Nonetheless, even with this progress, the Arab region is challenged with "some of the world's lowest adult literacy rates," with only 62.2% of the region's population aged fifteen and over able to read and write, far below the world average of 76.4% (Hammoud 2005).

There is an unsurprising relationship between a country's scoring at the bottom of the World Economic Forum's Global Gender Gap Index and tolerating appallingly high levels of female illiteracy. Yemen, which consistently ranks at the bottom of this index,

tolerates a female illiteracy rate of 67% (Hackman 2011). The inability to read means that a woman will never know through books worlds broader than her own, but it also means she will be handicapped in everyday life, fending for her own and her family's basic nutritional, health, and political needs and rights. In Yemen, one in three suffer from malnutrition, most families have limited access to healthcare, and despite there being two female parliamentarians, Yemeni women, on average, do not participate in politics. It does not help when Yemeni men believe that maintaining their dominance over women requires that reading should be restricted to males. In May 2010, educators came to Dhamar, a rural governorate south of Sana a, and advertised a course in "illiteracy eradication." Excited women flocked home to ask their husbands and brothers for permission to attend. The organizers of the course were inundated by calls from enraged males wondering why strangers would be putting such corrupt ideas into the heads of their women (Hackman 2011).

Concurrent with these broader statistical trends, rural Morocco has produced a startling gender statistic about the female appetite for literacy. Learning to read may give a Moroccan girl her only escape from the house. Moroccan girls for this reason tend to be more drawn to literacy programs than boys. Nowhere is this trend better illustrated than in a January 5, 2006 *Asharq Al Awsat* brief under the headline, "Women in Morocco are more eager to eradicate illiteracy." The latest statistics for Morocco, according to the brief, indicate that upwards of eleven million out of a total population of some thirty million people are, to all intents and purposes, illiterate. In 2000, the female illiteracy rate was 65% while male illiteracy stood at 40% (Sabh 2005). The Moroccan government's current literacy program was launched in 2002 and has sought to bring literacy rates up to 80% by 2015. Meeting this national goal has meant maintaining an annual target of bringing 1 million citizens into literacy. However, Morocco has been falling well behind that target, training less than half that number, and – more to the point – failing to recruit boys and men. What is worse, this was not a new story. The 2002 literacy campaign was only the latest in a series of failed campaigns the Moroccan government has sponsored since 1957. Each previous campaign had failed because of what the

brief cites as the lack of proper funding, skilled help, and continuity, with new initiatives to raise literacy rates not learning from previous mistakes.

Every initiative had to start afresh, and without the consistent support or participation of men. The brief quotes Latifa Arousi, who attests to that: "Women in Morocco represent 80 percent of the participants in the illiteracy eradication program." In a deliberate dig at Moroccan men, she goes on to say, "This high number reflects the women's will and desire to learn more than men." While illiterate boys and men in the cities and villages are recruited to participate in these programs in equal numbers with girls and women, it is the illiterate girls and women who are flocking to the programs in a steady stream. The unidentified *Asharq Al Awsat* reporter interviewed some girls and women in one Moroccan literacy program and concluded that women held deeply religious or deeply practical reasons for wanting to read: they wanted to memorize passages from the holy Qur'an, read bus signs and their electricity and water bills, better follow television programs, including news, and help their children with their lessons. Not unlike literacy programs in the West, which are deeply gendered and marginalized as "women's work" and under-supported (Gere 1997), literacy programs in Morocco are considered spaces for women, and underfunded as a result. The brief follows one teacher, identified only as Fatima, who bewails the poor sanitary and hygiene conditions in the center, the "filthy" walls and floor and the lack of decent light-ing, with even light bulbs missing. These facilities are meant to serve men and women of all ages, but they are mainly supported by females and not by men. The *Asharq Al-Awsat* reporter asked Fatima why this was so, and she responded that she considered men to be cursed either with laziness, or with pride so that they did not want to admit that they could improve. Women by contrast, she explained, see literacy programs as a way to "leave the house" and to take a step forward toward their independence, mobility, and freedom. Worldwide, female literacy is viewed as the first step in female empowerment. Unfortunately, even if it is accomplished, it is all too often a woman's last step. Literacy campaigns were part of the Moroccan struggle for national independence and remain an important part of that country's feminist agenda.

In her acclaimed 1983 novella, *Year of the Elephant: A Moroccan Woman's Journey Toward Independence*, whose English translation appeared in 1989, Leila Abouzeid tells the tale of the Moroccan war of independence through the barely literate character of Zahra. Zahra learned to read and write during the war and helped the war effort by organizing courses for illiterate women. Her literacy, however, failed to emancipate her and she was left divorced and destitute soon after the war's end. The "diploma from the literacy campaign," as she sarcastically refers to her war-time education (Abouzeid 1989, 53), offered her no better life in a state that had defeated French domination, only to replace it with a new ruling order where Moroccan men sought to act like Frenchmen (Kozma 1999).

Despite the experience of Abouzeid's fictional character, literacy and the educational credentials it helps to support can provide an Arab woman with some semblance of credibility should she dare trailblaze across red lines in a repressive state. Such pioneering women are frequently profiled in news: witness a brief of an *Elaph* article in a July 27, 2005 profile of the first female Saudi television announcer, Buthaynah al-Nasr. Al-Nasr emerged in a Saudi society where the appearance of a woman on screen was denounced as a sign of decadent liberalism. The brief describes Buthaynah al-Nasr as she started her maiden newscast as an announcer on the Saudi Al-Ikhbariyah Space Channel. To a society that says a woman can't, a woman must perform, al-Nasr suggests, and show she can. And if she is not given the chance to let her actions speak for her, her education gives her credentials to hold up as a card to play against blind prejudice. Saudi society has historically made it difficult for women to play this card because they were not accepted into media programs in Saudi Arabia when al-Nasr was in college, but the education card can still be played and it seems to help if it rivals a man's degree and is not just a degree in the traditional female majors of literature, teaching, or nursing. The profile made sure to refer to the fact that al-Nasr obtained her "bachelor's degree from the Administrative Sciences College of the King Saud University in Riyadh three years ago, majoring in quantitative methodology." To the thrust of prejudice against women, educational qualifications provide at least one considerable parry.

An educational pedigree is an important part of an Arab woman's armor when she seeks to break glass ceilings. An *Asharq Al Awsat* brief of March 24, 2006, out of Syria, announces the appointment of Najah Attar to be the first Arab woman to hold the position of vice-president and deputy to the Syrian President, Bashar Assad. Like the profile of Buthaynah al-Nasr, Attar's profile ends with her educational credentials: "She received her baccalaureate degree in 1950 and graduated from the University of Damascus with a diploma in education in 1955." She then, according to the brief, continued her doctoral studies and received her PhD in Britain. Once again, the educational qualification provides an Arab female pioneer with the standing from which to plan her entry into a man's world.

There is no doubt that Arab women, like everyone else, are given a significant career boost through their education, but gendered divisions in the Arab world mean that education gives Arab women a smaller boost than it gives to women in other regions. A report from the World Bank on women in the MENA (Middle East and North Africa) region in 2004 (Chamlou 2004) uncovered the so-called MENA paradox – that over the past thirty years, all the social indicators for a rise in the female impact on economic development, more years of schooling, marrying at a later age, and raising fewer children, have become realities for Arab women as they have for women worldwide. However, these leading indicators of workforce impact for women have not affected the fortunes of Arab women as decisively as in other parts of the developed world. That is, Arab women have not made the same impact on their countries' economic growth as women in other regions. The World Bank estimated that Arab women represented 32.2% of the Arab labor force during the period covered in its report, the lowest percentage of female input in any developed region of the world (Chamlou 2004; Chamlou & Yared 2005; Chamlou 2008). The United Nations Development Programme of 2005 put the percentage slightly higher, at 33.3% (Arab Human Development Report, 2005, 88).

Generally speaking, one finds two dominant situations for Arab women in the MENA region. First, there are the relatively "poor" Arab regions, where women's education levels are low but workplace participation is high because of economic necessity. Women's work is

unskilled and wages are low. These are uneducated women who work to survive and not to be major contributors to their national economies. Women in Yemen and Sudan best fit this profile, followed by Morocco, Syria, Algeria, Tunisia, Egypt, and Mauritania. Second, there are the more "prosperous" Arab regions, where women's educational levels are high and so their capacity for non-menial labor is also high. Nevertheless, their workplace participation remains low. Women in Kuwait, Qatar, Bahrain, and the UAE best fit this profile but women in Lebanon, Jordan, Libya, Saudi Arabia, and Oman are not far behind (Arab Fund for Economic & Social Development 2005). In these more prosperous regions, the paradox that education and employment are not fully related is striking. More education does not, for a woman, purchase more economic leverage.

What causes the paradox in these Arab regions? Many answers have been offered. The influx of foreign workers is one. The fact that women are primarily educated in the humanities and arts rather than in business is another. Family pressure not to work in high-stress jobs is a third. Whatever the causes, the MENA paradox finds many Arab women educating themselves to extend their experience outside the home, but with no intention of turning their education into a career investment. To be sure, with or without a career, education brings invaluable life benefits: the non-working mother who has educated herself brings that learning to her child-rearing and her children benefit. But this still limits the woman to building her nation's economy exclusively through her children rather than through involvements that can impact many more people at the same time.

The Educated Female as Target

The briefs reviewed thus far describe education as a driver pushing women forward and helping girls and women go places and rise into positions they could not otherwise access or attain. However, other briefs make clear that societal stresses often target girls in school and educated Arab women. Under conditions of war, foreign occupation, and political upheaval, Arab girls in school and Arab women professionals are among the first to experience threat and loss.

Warfare is especially harrowing for school girls and professional women in war-torn Iraq, as an April 21, 2006 brief from *Asharq Al Awsat* vividly portrays. Wars are not kind to men but they have ways of punishing women even more. They restrict their physical mobility, keeping girls from school, and women from their workplace. Security issues make the streets unsafe for women and making them harder to employ, unless, as we shall see in chapter 19, they are willing to transport bombs under their abayas. In war, normal jobs are at a premium and there is rising demand for jobs in the security and arms sectors, which favor the hiring of men. As we saw with literacy programs in Morocco, school provides girls with their best way of securing mobility outside the home. But in times of war, even this basic mobility disappears. Parents are more reluctant to let their daughters out on the streets, even if just for school. Fathers and husbands are more reluctant to let their adult women out of the house, even if it is just to work. An unidentified female graduate from Baghdad University is quoted as saying that the war has deprived her of her freedom of movement and so also of her job prospects.

A May 24, 2006 *Al Hayat* brief from Iraq describes in grave terms what it meant for an Iraqi student to live in a war zone through the spring final examination period. Just before the final exams were to begin, the head in charge of administering examinations for Baghdad schools was killed. Parents had already been paying for security guards to escort their girls safely to and from school. The chaos of the final examination period and the increased threats of violence meant the cost of security for girls' mobility was skyrocketing. Religious insurgents in a war zone who want to prove they have control of the streets make stamping out the movement of girls and women, especially those who fail to wear hijab, their highest priority. One girl, Rim Mahmoud, said regretfully, "my school received flyers that threatened female students who are not veiled with death if they go to the examination." Girls are prime targets for kidnapping and Rim said sadly, "my mum would accompany me for fear of kidnapping operations." Desperate and exasperated, Rim laments, "Is there any hope for me to go back to school? Who is responsible for all the years of studying I've wasted?"

An *Al Hayat* brief of October 3, 2006 updates the security situation

in Baghdad schools at the start of the next school year. Increasing numbers of parents insist on keeping their children at home. More than 4,000 university students have requested transfers to universities outside Baghdad. A female student identified as Abir, close to finishing her master's degree, has had to abandon her studies after her brother was killed by a militant group. A student identified as Sara complains that the chaos of war gives any religious zealot a perfect excuse to bully her and her friends. A junior studying philosophy, Sara, wonders how "female students [can] continue their studies amidst threats that they must wear the Islamic headscarf and stay away from all sorts of makeup?" Sara has personally witnessed female students being beaten up "for not wearing the headscarf." She did not want this to happen to her so she has decided to leave school for a year.

Outside the context of war, less violent but still restrictive cultural constraints can cause a successful professional Arab woman to repeat Rim's complaint, "Who is responsible for all the years of studying I've wasted?" A woman we have already met (chapter 7, page 112), Amal, the Lebanese woman trained as a mechanical engineer in the August 19, 2005 *Al Hayat* brief, could well have asked Rim's question though not with Rim's urgent desperation. Amal, we may recall, had been devoted to engineering as a career, until she married and was on the verge of having her first child. Although her mother had always encouraged her to enter teaching as a good career path for women, Amal had dismissed her mother's advice, but she had now come to recognize the sense in her mother's words. Amal recognized that she had no female role models for the life she was living; she knew no female engineers with children who had continued working – but she knew plenty of teachers with children who continued to teach. So Amal decided to become a teacher, a decision tinged with bitterness about all the years learning to become an engineer that seemed to have gone to waste. Evon El Helo, the author of the *Al Hayat* story profiling Amal, used her as an example to show that society harbors a basic unfairness that keeps certain high-ranking professions off limits to women merely because they are the primary care-givers of children. Amal's situation puts a personal face to a cultural prejudice discussed in a CAWTAR report (2001), which notes that Arab women are undervalued for their economic contribution to society and overvalued for their reproductive contribution.

We have seen the forward push of educational drivers moving Arab women forward and the reactive forces pushing them back. The Western stereotypical perception that active and passive are simple dichotomies is belied by the fact that, worldwide, women who are high educational achievers and on the upper rungs of the employment ladder are on the front line with regard to targeting by reactive forces. Accomplished women throughout the world have the farthest to fall when conservative societal norms and political upheavals shake their pedestals.

Educational Values and Open-Mindedness

When studied below the sociological surface, however, the issues of women and education that are touched on in our corpus look to be even deeper than gender. They also involve considerations of class and, perhaps more importantly, the conflict between a value system that prizes liberal education, critical thinking, and open-mindedness, and a value system that prizes conservative beliefs that are resistant to critical thinking or progressive change. A lengthy brief from a December 1, 2006 edition of *Asharq Al Awsat* from Egypt dramatically illustrates the contrasts in these value systems when it comes to the practice of veiling. The brief reports that 80% of Egyptian women have now made the veil (i.e., hijab) their "uniform." After the 1979 Iranian revolution, the wearing of the veil may have been a symbol of resistance to late nineteenth- and twentieth-century secularism; but since veiling is now so ubiquitous, the brief suggests, one must consider each woman individually concerning the reason she has decided to wear the veil. Middle- and upper-class women tend to view veiling as a personal choice and an extension of female expression that has gained inspiration from the emergence of a female piety movement in Egypt (Mahmood, 2005). For these women, the brief suggests, the veil may be either shapeless or fashioned to a woman's tastes. It can be used to counter the latest fashion trends or to complement and extend them. The poor and less tolerant, represented in the brief by a young woman named Sanaa, barely twenty years old, see it very differently. Sanaa lives in a poor neighborhood with a number of mosques where the imams speak of the

veil as a way to "counteract the prevailing disintegration in society." The *Asharq* brief reports that Sanaa accepts the imams' view with "her total conviction".

Now the brief does not mention binaries such as tolerance/intolerance, open-mindedness/close-mindedness, and receptive-to-new-ideas/non-receptive in so many words, but they are clearly at stake there. Consider the contrast between two female fine arts students who are interviewed. Nermine is a student of the fine arts who does not veil. Asked why she does not veil, her answer is surprising: "I cannot take such a step now because the veil is not simply a headscarf. I must reach a state of complete piety so that my veil would be representative of my essence as well, not just an appearance." Although Nermine does not veil, her attitude toward veiling is positive and religious. Only a person with an open mind about veiling, as Nermine seems to have, could articulate the subtle belief that a woman who does not veil still aspires to the piety she believes must be attained to justify veiling. Contrast Nermine with a second-year fine arts student who veils, and who chooses to remain nameless in the brief. This student declares that she holds in contempt women who wear the veil as "a fashion trend," and even has to restrain her anger with them, accusing them of defaming Islam as a whole. But how can this student know in advance who is wearing the veil only as a fashion statement and who is not? Only someone with a closed mind toward veiling could fail to conceive that a woman who wears a veil that looks fashionable may also be wearing it for more than that reason.

The nameless student may well seem to the Western reader like a religious bigot, but the briefs make clear that religious women have no monopoly on bigotry and closed-mindedness. A December 30, 2005 brief from *Al Hayat* out of Egypt discusses the appointment of Aicha Abdelhadi to the post of Minister of Labor, the first veiled minister in an Egyptian cabinet post and, indeed, the first veiled woman to hold a government position in the history of Egyptian politics. The brief goes on to mention the societal "obstacles" veiled women face simply because they wear the veil. We should not be tempted to think that secularist thought is necessarily liberal and open-minded. There are plenty of bigots among those who attack veils, as well as plenty among those who wear them.

What about fundamentalism and closed-mindedness? Is Sanaa's attitude toward veiling also closed-minded? Because she relies with "her total conviction" on the imams, her attitude arguably goes beyond being closed-minded. The position she freely takes might be called no-mindedness about veiling. She does not think for herself, but defers to what the imams think. Paying attention only to what the imams say, without considering what her own thoughts might be, she accepts that a woman who does not veil is causing the disintegration of society. Sanaa's views on veiling might be called pre-modern. Nermine and the anonymous student's views are modern, though one is open-minded and the other closed-minded.

One of the deepest principles underlying a general liberal arts education is open-mindedness and its mission to combat no-mindedness and closed-mindedness. To value liberal education is to commit to open-mindedness; to value open-mindedness is to commit to liberal education. This brief on the sociology of the veil in Egypt makes abundantly clear that Arab girls and women, just like Arab boys and men, may exemplify the whole spectrum of no-mindedness, closed-mindedness, and open-mindedness. Thus, while the briefs we have reviewed so far have described education as a driver pushing Arab girls and women ahead in their societies, not all Arab girls and women agree to acknowledge the power of this driver, or wish to bring it into play on their own behalf. They have the freedom to remain closed-minded to the value of education, or no-minded about it, deferring to what others think. We nevertheless maintain that an Arab woman who is open-minded about her situation will see education as a way to attract improved life chances. And because of the inequalities between men and women, it will be reasonable for her to perceive that her life chances will improve with education to a greater extent than men will expect to be the case for them. Assuming that a considerable number of Arab women think like this, we can better understand why literacy programs in Morocco, for example, are likely to remain predominantly female for a long time to come. Education is the beacon of hope for Arab women – and for women in most regions of the world. It is the first step out of everything bad and into everything good for women. This stark fact makes few things more poignant than to read about acid thrown on the faces of little girls in Afghanistan just because they wish

to learn. Or to read, as in a brief from *Al Quds Al Arabi* of November 18, 2005, about an Israeli military court that acquitted an officer who "emptied a machine gun" into a thirteen-year-old Palestinian girl for getting too close to a military checkpoint on her way to school.

To close this discussion on education, we turn briefly to gender-segregated education, which is the dominant form of education in the Arab world and a minority option in the West. Our sample of Arab news contained no briefs[1] about the widespread separation of girls and boy in the Arab school system and, pondering why, the best explanation we could arrive at was that gender-segregated education remains less controversial, and so perhaps less newsworthy, in the Arab world than in the West. However, after reviewing the scholarship extensively, we were surprised to find that even Western research on same-sex education suggests that Arab thinking on segregated schooling has more merit than popular opinion in the West tends to give it credit for. Lee and Bryk (1986), Shmurak (1998) and Wall, Covell and MacIntyre (1999) have found that teacher support and motivation play a critical role in girls' perceptions of their career opportunities and expectations, and it appears that girls in same-sex schools can often count on more support and motivation than girls in mixed-sex environments. Sampling hundreds of schoolgirls in the San Francisco Bay area in both same-sex and mixed-sex school environments, Watson, Quatman and Edler (2002) found that girls from single-sex schools at all achievement levels looked to more prestigious jobs in both their ideal (ideally, what would you like to do when you grow up?) and realistic (realistically, what would you like to do when you grow up?) career aspirations than girls in mixed-sex schools. Girls in same-sex schools were less likely to lower their career aspirations from the freshman to senior years than girls in mixed-sex schools, where girls were under tremendous peer pressure to lower their career sights in order to win popularity with boys. In mixed-sex schools, puberty often turned girls from thoughts of learning to thoughts of playing up their physical attractiveness and playing down their intelligence with the boys they targeted for interaction. Girls in same-sex schools were relieved of this pressure. Visiting some same-sex schools, the researchers report there being "camaraderie" among the girls and between the

girls and school administrators that was less in evidence in mixed-sex schools. They also took note of the teachers' and students' greater "freedom" to discuss sensitive sex-related topics confronting women, which are likely to go unaddressed in formal settings in mixed schools (Watson, Quatman & Edler 2002).

Pressure for same-sex schools has grown in America, Europe and Asia for an additional and surprising reason. Boys are lagging behind in classrooms as never before and are losing in the competition with girls. Boys need their own classrooms, arguably, so that teachers can focus on their gender-specific learning challenges. As Kindlon and Thompson (2000) wrote in their best-selling book, *Raising Cain: Protecting the Emotional Life of Boys*, boys are more physically active, less developmentally mature, more impulsive, and more easily distracted, and bring shorter attention spans to the classroom than girls. Most school tasks reward quiet sitting and prolonged attention to texts, and boys consistently earn fewer classroom rewards as a result. Boys draw more classroom attention than girls but it is often negative attention that can do great harm when "girl behavior is treated as the gold standard" and "boys are treated like defective girls" (Kindlon & Thompson 2000; cited in Tyre 2006). Struggling to sit still and focus, boys are twice as likely as girls to be diagnosed with learning disabilities and routed to special education classrooms (Tyre 2006). In response to these alarming trends, researchers have called for more all-boys classes and schools (Rosin 2010). Boys learn from what psychologists now call the "'boy brain' – the kinetic, disorganized, maddening and on occasion brilliant behaviors" (Tyre 2006), which collectively require learning environments more suited to movement and structured competition than the learning environments required by girls (Kindlon & Thompson 2000).

Beyond their biology, boys struggle with cultural myths about boyhood. They inherit myths that they should be obsessed with sex, cars, violence, and sports and that they will grow up to dominate women and become their providers. William Pollack (1999), a psychiatrist from the Harvard Medical School, has found that boys struggle hard to live up to these myths, whether they believe them or not. And yet their struggle with the myths can impede their creativity in the classroom, deplete their self-esteem, and force them to deal with the

humiliating reality (since the 1990s) that the girls in the class are leaving them in the dust.

That boys are falling behind at every level of schooling is a worldwide phenomenon. Statistics from the US tell the story dramatically: High-school boys are losing ground to girls on standardized writing tests. The average eleventh-grade boy writes as well as the average eighth-grade girl (Kaplan 2011; Snow 2011). "Thirty years ago men represented 58 percent of the undergraduate student body. Now they're a minority at 44 percent" (Tyre 2006). US women constitute 70% of the high school valedictorians, and earn 60% of all bachelor's and master's degrees conferred (Rosin 2010). Educational policy-makers have called for sex-segregated classrooms to accommodate boys' unique ways of learning so they can close the gap with girls (Pollack 1999).

In sum, sex-segregation in the classroom, taken for granted in Arab regions, is less controversial in the West than we might first expect and is likely to become more accepted in the West over time. It is certainly less controversial than another practice that is taken for granted in Arab regions: sex-segregation in the workplace, a topic we examine in the next chapter.

Conclusion

The MENA gender paradox, as we have seen, shows a divide in the Arab world between female education and the meaningful employment of females. In this chapter, we have focused on what the briefs say about the first side of the divide – Arab female education. In the next chapter, we turn to what our corpus and research have to say about the second side of the divide – Arab female employment. We have learned in this chapter that education is a girl's first step toward upward mobility and gender equality, but that very mobility and equality are among the very first targets when war and social upheavals descend on a society. The issues are not simply a matter of girls in the classroom; they concern the values of open-mindedness and gender equality that a valuing of education, for both girls and boys, upholds. In chapter 14, we shall review a substantial literature that shows the systemic connections between social unrest and the targeting of

females by societal forces that repudiate these values. Conservative forces in the Arab world and worldwide are offended by the claim to gender equality that the education of girls signifies. There is no symbol that is a bigger anathema to champions of male dominance than girls in the classroom; there is no greater insult to the closed-minded male ego than the harsh truth that the girls are out-competing the boys. Yet, this picture of girls out in front in the classroom is now increasingly true of classrooms around the world.

9: Employment

No lady could work for payment without losing her genteel status.

(Howarth 1988)

Women aren't supposed to work. They're supposed to be married.

(Tillmon 1972)

When women arrive in the workplace, the gendered expectation is that they will still perform [a] caretaking role.

(Wildman 1996, 37)

Women globally contribute two-thirds of the world's work hours, for which . . . they globally earn only one-tenth of what men do and own a mere one-hundredth of the world's property.

(Data used to help launch the UN Decade for Women in 1975; cited in Riane T. Eisler 1995, 339)

Sarah Emily Davies (1830-1921) was best known as a pioneer and tireless advocate for women's education in England. She fought for the rights of girls to be admitted into Britain's elite and male-only secondary schools and universities, including the Universities of London, Oxford and Cambridge. Her single greatest achievement was to lead the founding of Girton College in Hertfordshire in 1869, which moved to the city of Cambridge in 1873.[1] Girton was the first English college to admit women and Davies remained connected to it until the end of her life. In 1866, Davies mobilized support for John Stuart Mill's 1866 petition to Parliament seeking women's suffrage and she would carry that torch well into her later years. In the same year, she authored the book *The Higher Education*

of Women, which exemplified her life-long effort to see British women educated.

The first quotation at the head of this chapter – "No lady could work for payment without losing her genteel status" – was in fact an eighteenth-century commonplace that defined British women as the guardians of "domestic manners, morals, and comforts" and, as such, too burdened with that cultural responsibility to work outside the home (Howarth 1988, x). Men's education stressed mental toughness and technical learning. Women's education, reserved for the upper classes, stressed mastering the gentility of the domestic sphere. Outside forces, however, were breaking down these parallel educational tracks for even well-to-do British men and women. There was a surplus of girls in mid-nineteenth century British society– too many to marry off – and a shaky economy made it impossible for British families to support their unmarried daughters indefinitely. The feminist tradition inherited from the writings of Mary Wollstonecraft (1792; 1997) advocated self-actualization outside the home for women, and the influential Anglican Church preached a strong work ethic and a life of service for British women beyond the confines of domesticity. Sizing up the economic crisis and influenced by the feminism and Anglicanism of the day, Davies noted that "the modern girl . . . has fallen upon an age in which idleness is accounted disgraceful" (Howarth 1988, xv).

Davies fought to have women of well-placed families, intellectual curiosity, and high character matriculate into liberal arts college programs. But she was also adamant that these women, once graduated, seek out and take jobs. In the conclusion of *The Higher Education of Women* from 1866, Davies offered a spirited rebuttal to those who feared that for every woman added to the workforce a man would be removed. In this passage, she characterizes the concerns of her opponents:

> If women take to doing men's work, what are men to do? (167) Will not the intrusion of women into professions and trades already overcrowded, lower the current rate of wages . . . and by thus making men less able to support their families – in the long run, do more harm than good? (Davies 1988, 167–8)

And she provided three rebuttals. First, she argued that women who did not work still spent money: "To keep [women] from earning money does not prevent their spending it," she noted (Davies 1988, 169). And so, she reasoned, men were paying a steep price to keep their women out of the workforce. Second, she countered that every male who lost family income because of an influx of working women would find his lost income returning to the household with the paychecks of his wife and eventually his daughters. Third, she made the larger policy argument that "it can never be for the interest of society . . . to keep any class of its members in idleness." We would regard a man as a "lunatic," she affirmed, were he permanently to keep his right arm in a sling simply to strengthen his left arm. But the same lunacy applies to British society, she explained, when one gender remains permanently unemployed merely to give an artificial boost to the employment status of the other (Davies 1988, 173–8). Davies' arguments exposing the economic and political folly of keeping women out of the workforce in nineteenth-century Britain parallel almost verbatim twenty-first-century World Bank arguments exposing employment gaps for Arab women in Arab lands (Chamlou 2004; 2008). Davies' legacy in Britain reminds us that employment discrimination against women has been historically and geographically pervasive. Though we find employment discrimination against women in Arab countries today, such discrimination is hardly an Arab, Middle Eastern, or recent problem.

Discrimination against women in the workplace takes on complexions that vary by class. There have always been historical tensions between the uneducated female working poor and the female in a monied family with better prospects for a "respectable" life. "Respectable" women had the luxury of shunning employment as a dirty enterprise. By contrast, women who made up the working poor had to accept whatever conditions of labor they could get without looking a gift horse in the mouth. From prostitutes to dishwashers, from housemaids to menial laborers, the focus of labor for the female working poor in the West had been on sustenance over public respect and dignity, on what women could earn rather than how they had to earn it. Capitalism helped elevate the female working poor to a more respectable female working class and afforded women, in principle if

not practice, more shared power with their working-class husbands. Frederick Engels (1884/1972) noted that, as capitalism was moving proletarian women out of the household into the factory, their husbands were losing all rights to their claim of supremacy as bread-winners. To maintain their hold on power in the family, Engels clinically observed, the husbands' only recourse was to fall back on their "brutality toward women that has spread since the introduction of monogamy" (1972, 135). For the working class, female work could emasculate the men of the household.

Yet, even farther down the socio-economic ladder, African-American women trapped in poverty and repressed by racial discrimination from one generation to the next, were finding that the compulsory work requirements of the US welfare system were banishing the men of their households. When the African-American welfare activist and Executive Director of the National Welfare Rights Organization (NWRO) Johnnie Tillmon (1972) uttered the quotable words in the second quotation at the head of this chapter, "Women aren't supposed to work. They're supposed to be married," she was not attacking husbands who refuse to let their wives work. She was attacking a double standard that found it de rigueur for rich white women to marry and stay home and raise their children while poor uneducated black women could do the same only if they could prove "there [was] no man around" to help support the family. Publishing her essay, "Welfare is a Women's Issue," in the debut edition[2] of *Ms. Magazine* in 1972, she noted that "Ninety-nine percent of welfare families [in the US] are headed by women," and "in half those states . . . AFDC (Aid to Families With Dependent Children) says if there is an 'able-bodied' man around, then you can't be on welfare." The sad result is that, "If the kids are going to eat, and the man can't get a [decent-paying] job, then he's got to go." Since most women on welfare cannot earn more than the person they would pay to watch their own children, working outside the home for the woman in such straitened circumstances can seem futile. Better to stay at home and raise one's own kids. But if a welfare mother wants to do that, she must kick out a husband who cannot support her in order to invite in a state that can. Said Tillmon: "You trade in a man for the man."

But even for professional women who manage to find work outside the home at a living wage, there is evidence that the expectations of care-giving that are placed on them within the home travel with them into the workplace. Stephanie Wildman, a Professor of Public Interest Law at Santa Clara University[3] has observed that women within the home are expected to "meet . . . [the] needs [of others] and keep . . . people happy" (Wildman 1996, 37). Wildman, who has made a study of systems of privilege in the workplace, found that women entering the workforce run into two hard realities. First, they discover that there are strong workplace expectations for them to function as care-givers, providing assistance, support, and extending service to others. Second, they discover that as they meet these expectations, they are confronted by the fact there is little reward or recognition waiting for them. As Wildman explains: "Caring for people is a significant aspect of work that is not valued in many workplaces" (37). Caring is especially undervalued financially. Caring is the labor of women and, compared to men, caring is poorly compensated. As the fourth quotation at the head of this chapter makes clear, statistics from the UN on the wages of female labor worldwide found that women work far more hours for far less pay than men.

Women not only put in more hours outside the home for less pay; they put in more hours inside the home for less societal reward. Women are expected to play the dominant care-taker role in the family both at home and at the worksite. Naomi Cahn (2000), a Professor of Law at George Washington University, studied records of parent involvement of nearly 17,000 American children and found that within two-parent families, fathers were only half as likely to be involved in their children's schools as their mothers. Cahn calls for a societal empowering of the care-giving role, both within the home and the workplace. She believes that exalting care-giving would lead to more equitable pay for women in the workplace and more cultural incentive for fathers to join mothers as primary care-givers within the home. Empowering care-giving, she further believes, would help policy makers recognize the long-term societal benefits of paying welfare mothers to stay home and raise their own children rather than the children of strangers for the same or less pay.

We have strayed far from the genteel world of Sarah Emily Davies

and the women from well-to-do families whose employment she championed. Davies, as we have seen, had to combat a traditional attitude among the affluent that a woman working bred scandal and humiliation for her family. The feminist author Charlotte Perkins Gilman, writing on the economics of female labor, captured this historical tension between female work and wealth nicely when she noted that, "The women who do the most work get the least money, and the women who have the most money do the least work" (Gilman 1898). Thanks to pioneers like Davies, the stigma of women from privileged classes leaving the home to work has gradually diminished. In the late nineteenth century, the educational and employment opportunities for well-do-to women increased, especially in the still-emerging female professions (e.g., teaching, nursing, social welfare, and the arts). These growing late nineteenth-century opportunities were launched as part of the long and complex process of professionalization (Abbott 1988) that saw the reorganization of work into domains of expertise requiring peer networking and credentialing (Collins 1979). Professionalization in the West brought about a growing convergence of work and respectability for women and, despite structurally low pay compared to men, the idea of raising a daughter who would grow into a "modern professional woman" became, very slowly and very gradually, an increasingly attractive idea for Western women and their families.

Arab Female Employment

This sweeping panorama of female employment in the West provides a comparative context for turning to female employment in Arab regions based on our corpus of Arab news briefs. Arab female employment across our corpus falls into two categories. First, there are a woman's basic *conditions* of employment. Second, there are her organizational and societal *achievements*, and career *empowerments* that frequently arise from her education and employment. In this chapter, we review only what our corpus of Arab news reveals about the bare conditions of employment in which Arab women participate. We leave for the next chapters what the briefs say about Arab female achievement and empowerment.

Quantitative summary of female employment

Of the 178 briefs, only one (< 1%) dealt with women's determination
on the job and, as we will see below, this was in reference to Palestinian
women working harder than Palestinian men for less reward. We had
to relax our criterion in order to identify just eight briefs (4%) of the
corpus that referred to female employment.

Qualitative analysis of female employment

The MENA paradox described in the last chapter predicts that the
employment situation for Arab women across the expanse of twenty-
two Arab countries will seem sparse and patchy. This indeed is borne
out in our corpus. Coverage of the "working lives" of women in our
sample of Arab news was slim unless seen through a tendentious
geopolitical lens. For example, a March 7, 2006 brief from *Al Quds Al
Arabi* reports that the Islamic Jihad movement sent a letter to the
Moroccan embassy in Palestine and to the Islamic Tawhid and Islah
movement in Morocco to alert them about 600 Moroccan women who
were "working as prostitutes" in Israel. According to the allegations in
the letter, these 600 women migrated to work in illegal Jewish settle-
ments by day and "in Jewish whorehouses and brothels by night." The
letter calls for restoring "Arab Muslim honor" by freeing these women
from "the lust and coveting of the Jews," that is, if the Jews have not
yet made them into spies.

The sole example in our corpus of Arab women in the workplace
that was not used for geopolitical point-scoring came from a
November 16, 2006 *Al Hayat* brief that covered wage discrimination
against Palestinian women working for the Palestinian Authority. On
January 31, 2006, Israel announced it would suspend monthly tax
payments to the Palestinian Authority in light of Hamas's unexpected
election victory. By February 27, the tax payments had been cut off,
and the International Envoy James Wolfensohn predicted that the
Palestinian Authority would suffer imminent financial collapse. The
brief points out that, during this financial crisis, now lingering into
November, leaders of the Authority were cutting women's salaries
and benefits at a higher rate than men's, despite the fact that an

earlier poll had shown that during this critical period when just about all the Authority's employees worked without salaries, it was the female employees, constituting some 35% of the Authority's workforce, who remained focused on their jobs and kept the key institutions and services of the Authority running. Beyond this one example where working women are mentioned in the context of gender inequality, we found no examples of news describing Arab women in their everyday lives on the job.

Fortunately, we had in our sample a thoughtful and challenging opinion piece by the famed Lebanese journalist and novelist, Samir Attallah, who offered a perspective on the dearth of "working lives" coverage in the Arab press. In a brief from *Asharq Al Awsat* of September 18, 2006, headlined, "The crushing but crushed majority," Attallah opines on a report in an Egyptian magazine (*Rose Al-Youssef*) that had sought to capture the "life of the simple folk in Egypt." *Rose Al-Youssef* had interviewed Hajja Nadia, the breadwinner of a small family, who cleans women's bathrooms in a commercial center in Cairo. *Rose Al-Youssef* asked her if her monthly income of 300 Egyptian pounds (about US$50) was a sufficient living wage. Her reply? Not bad, unless you want an allowance for your children and new clothes on more than rare occasions and you are happy using up more than a month of your salary buying one lady's shoe because you can't afford two. Attallah continues in a slightly sardonic tone: "The *Rose Al-Youssef* published a 'nice' report on the 12th of September about the life of the simple folk in Egypt. Why do I call it 'nice' when it contains all that poverty and misery?" Because, Attallah suggests, the interview expresses "accurately" and "simply" the life of the poor in Egypt, and, in a quick turn on the press itself, he condemns "our newspapers and magazines" for not having "paid any attention to people and life in a long time." He accuses the Arab press of focusing obsessively on politics at the expense of ordinary lives and their ordinary challenges. He then turns his critical eye on the "Arab human being" for supporting this obsessive focus by trusting the lives of ordinary people, including their own, "to Allah" and setting aside the significant victories and losses in their own lives to give prominence to what is happening in Afghanistan, Somalia, and Madrid. He salutes the *Rose Al-Youssef* report as representing all the unreported stories of ordinary working lives, especially those of the

poor and struggling, not only in Egypt but in Lebanon, Iraq, Syria, Palestine, Jordan, Morocco, Algeria, Tunis, Libya, and all the other Arab League member states, including the Comoros Islands. We do nothing for them, he complains. They are born and then go away "left to Allah."

To find visible examples of female working lives in our sample, we had to leave behind the working poor that Attallah so fervently championed and turn to the other end of the financial spectrum, east to the rich Gulf region, where women, through their families, if not entirely in their own right, control significant capital and where Gulf governments spare no expense to ensure female honor and respectability in government-controlled workplaces that segregate the working environments of males and females. Although Saudi Arabia is the country most Westerners associate with gender seclusion and suppression, it is also, from our sample at least, the country that produces the greatest pride and visibility for its women in business and entrepreneurship. From a total of 339 briefs in our corpus that mideastwire.com had classified[4] as "women's" stories, the largest cluster (27) were about Saudi businesswomen. An October 20, 2005 brief from *Elaph*, previously reviewed above, reports on the busy agenda of a Saudi Businesswomen's Forum that would, in the month ahead, host 500 businesswomen from across the Gulf at a two-day meeting on investment strategies, options, and creating new business start-ups. In previous months the Forum had sponsored a delegation of Saudi businesswomen to visit Dubai so that they could return to brief Saudi women entrepreneurs on investment options and economic development in the UAE. An *Al Hayat* brief of December 29 of that same year heralds the election of a Saudi woman, Nadia Bakhraji, to the board of directors of the Saudi engineers' association. Bakhraji promises to use her position to lure back Saudi women engineers who have left the Kingdom for better opportunities.

What about Saudi women with a more traditional (female) education who are considering employment in the Kingdom? Mona AlMunajjed (1997), who has tracked the employment situation for Saudi women for years, has some answers. She found that Saudi women are under increasing pressure to pursue employment options as a result of the government's effort to become less dependent on

foreign labor. She interviewed a hundred Saudi women in the city of Jeddah, split evenly between women with at least a high school degree and women without one and between women who were currently working and women who were not. She found that a substantial number of educated women worried that employment would bring them into unwelcome contact with men outside their family circle men. While 60% of those she interviewed did not mind boys and girls learning together in the classroom, a larger proportion did mind sharing a workplace with men. They feared male harassment and explained that, even if they had no such fears, their male guardians at home would never allow them to work with men to whom they were not related.

Unsurprisingly, AlMunajjed reports that women's work in the Kingdom has been most successful in areas of the economy (e.g., nursing, teaching, welfare services, health, and niches of the banking industry) where the government can ensure female-only worksites (see also Calvert & Al-Shetaiwi 2002). At the time AlMunajjed conducted her study, it was estimated that 62% of working Saudi women were employed as teachers. Saudi women working in the private sector tended to run small businesses that catered to a female clientele, including bakeries, boutiques, and stores devoted to fashion, cosmetics, and tailoring. The one place where Saudi women were able to work in proximity to men at the time of her study was the Saudi Aramco or Saudi Arabian Oil Company (ARAMCO), which is staffed mainly by non-citizen residents.. At the time of the study, ARAMCO employed 3,000 women of whom only 300 were Saudi nationals.

When wealthy Saudi women start businesses that require heavy capitalization, such as restaurants, banks, large retail outlets, or real estate and investment firms, they typically obtain the backing of male financiers. These financiers are typically their male guardians (e.g., their father, brother, husband, uncle) or outside connections managed by their male guardians. In Saudi Arabia and much of the Arabian Gulf, collective life for nationals is still organized along the lines of families and tribes as much as by the abstract rights and obligations defining citizenship in nation states. Family connections remain the most important lifeline for the individual seeking access to work (see

Altorki 2000). While women in the West also no doubt rely on family connections for employment options, this does not have the same importance as in the Arab world and the Arabian Gulf in particular, steeped as they are in tribal traditions.

In both West and East, women are viewed as the physically weaker sex and the idea that men "protect" them is not overtly offensive. Both West and East understand and respect codes of male chivalry and deference to females. Where West and the Arab East begin to divide is over whether and, especially, the extent to which social rules of gender segregation are appropriate expressions of female protection. Living in the aftermath of the 1954 Brown vs. Board of Education ruling and the US moral revulsion toward apartheid policy in South Africa, Westerners, and particularly US citizens, take it as a commonplace that racial segregation is a form of racial discrimination. While Westerners arguably do not link segregation and discrimination as strongly in the context of gender as in the context of race, Westerners do tend to think that segregating women in matters involving employment opportunity in a field dominated by men is a form of discrimination against them. Why?

In the Western ideal, advancement in opportunity and employment necessitates freedom of movement. To rise and advance outside the home, the woman, as well as the man, must be "out and about."[5] More than a decade of research conducted in the West on female career advancement has rested on the premise that cultural equality, including equality of access, is the positive dream of "enlightened" women. Such research, seeking to explain the "glass ceiling" that holds women down (Ragins, Townsend & Mattis 1998; Oakley 2000) came to lay the blame for Western women's arrested career advancement on their limited access to well-connected men (Kanter 1977; Morrison, White & Van Velsor 1987; Moore 1990; Ibarra 1993; 1997). While men network with other men for both emotional and tactical reasons, women tend to seek out other women for tactical and emotional support. A 1991 study reported in the *Wall Street Journal* (cited in Karsten 1994, ch. 10) indicates that women resorting to an exclusively "old girl network" for tactical and emotional support tend to stall in lower prestige and lower paying professions. More successful women, by contrast, resort to a

mixed gender networking strategy, seeking out powerful male mentors for tactical support and women for emotional support. This mixed gender strategy, whatever its proven strengths for women on the rise, tends to inhibit the growth of senior female mentors (Chow & Ng 2007), despite a literature (Ragins & Cotton 1991; Ragins & Scandura 1994; Feldman, Folks & Turnley 1999) that cites the desperate need for more senior female mentors within organizations.

Other literature in the West has shown that it is not solely the gender of the mentor that makes a difference. It is also the diversity of a woman's mentors and contacts, what the sociologist Peter Blau (1977) has called "heterogeneous" networks – contacts that vary widely in background, schooling, and expertise. Granovetter (1973) has found that successful entrepreneurs rely on heterogeneous networks because the more diverse one's network, the more one can be assured of obtaining timely assistance, know-how, and advice on the widest range of challenges that may confront the entrepreneur. Compared with networks that remain small and homogenous, it is large diverse networks that benefit entrepreneurs more (Burt 1992). A family network is a prototype of a closed and homogenous network, and the research would predict that entrepreneurs (men or women) who rely too heavily on family networks for their upward mobility are at a decided disadvantage. Fischer & Oliker (1983) and Hurlbert (1991) independently confirm this prediction. Kinship connections, they have found, bathe the entrepreneur in emotional support that becomes superfluous and deprives the entrepreneur of quality information that is objective, honest, and necessary for making progress. Other researchers (Marsden 1987; Moore 1990) have empirically compared the social networks American female entrepreneurs tend to build with those built by American male entrepreneurs, and found that American women do indeed rely more than American men on relatives and close personal ties for their core professional networks.

Renzulli, Aldrich and Moody (2000) wondered whether the alleged "problem" of relying too much on kinship ties was inherent in being a woman or simply the product of the networks women built. Are professional networks limited because it is a woman who

is trying to build them? Or would a woman who managed to build professional networks like a man succeed like a man?[6] In seeking to answer this question, Renzulli, Aldrich, and Moody surveyed 659 aspiring entrepreneurs, both men and women, in the North Carolina Research Triangle, to learn about their networks for starting a business. Months later, they did a follow-up survey of 328 of them to determine who had in fact started a business. They found, in line with previous research, that aspiring entrepreneurs who relied on diverse networks beyond family were more likely to start a business. They also found that women entrepreneurs in their sample, as expected, tended on average to rely more than their male counterparts on kin and friendship networks. Significantly, however, they found that the subset of women who did manage to build diverse networks of advisors, like the networks built by successful men, achieved the same success rate as men at starting a business. Renzulli, Aldrich and Moody conclude that it is not being a woman per se that creates a handicap for advancement in business. Rather, what holds women back is that most are not sufficiently "out there" networking in the manner in of men.

Note well that these Western studies, and the questions they frame, not to mention the findings they collect, affirm a Western individualist ideal, assuming that the most important difference between men and women is the *cultural* environment. Culture in the West tends to trump so-called "universal" truths handed down over generations from religion and biology. Unlike religion and biology, culture is malleable and can be bent to accommodate social change. From such a mindset, strongly represented if not dominant in the West, the freedom of the female to move as she pleases, within the bounds of acceptable risk, is a more powerful factor than the attraction of retaining security within her family and tradition.

Such mindsets are less evident in Arab countries. A monograph-length World Bank report (Chamlou 2004) documents cultural restrictions on Arab women's work and mobility and its impact on employment. The collection of articles edited by Lobban and Fernea (1998) explores a feminized "invisible economy" (3) in which Arab women build livelihoods in workspaces that remain tethered to home and kin. These invisible economies of the Middle East involve

extensions of domestic labor that leave women close enough to home to remain hidden from the public economy; but with just enough distance from domestic labor to bring in a living. The invisible or informal economies include everything from farm labor to the production of food, textiles, and crafts made in the home and sold in the streets, to child-care and health-care services for women. The informal economy allows Arab women control over their working environment, which is highly valued. Jacques Charmes tried to measure the size and growth of female participation in the informal economies of Arab countries since measures started being taken in the 1990s, and concluded there had been no significant growth (CAWTAR 2001; also cited in Moghadam 2005, 112).

Growing or not, the informal economy affords Arab women a more gender segregated and, arguably, protected environment. Survey data in Jordan cited by World Bank and United Nations Population Fund researchers reported that 16% of educated female respondents who were qualified to work in information technology would not do so if it required a mixed work environment (cited in Chamlou & Yared 2005, 54; Benhadid 2005, 113). Not all restrictions in a woman's occupational networking are of her choosing. Much is imposed by men and by the legal systems they write. Women's occupational networking is hampered in some Arab countries, for example, because women are not regarded as legal agents. A woman in Jordan and Bahrain must secure her husband's signature for a business loan even if all the assets standing as collateral are in her name and even if it is known that the husband's backing would not add any monetary value to her loan application (Chamlou & Yared 2005).

In Arab territories, researchers from the World Bank found that women's visibility in the workforce is impeded by irrational fears that women workers displace men (Chamlou & Yared 2005, 59). The researchers found that this fear was baseless and even contradictory to the truth. Regions of the Arab world where women have the greatest economic impact also have the least overall (male and female) unemployment. Of all Arab regions, it is in Kuwait that women have the highest per capita labor force participation and the lowest unemployment rate in a country with a low unemployment rate overall; yet in Palestine (West Bank/Gaza) and Algeria, women have the lowest per

capita labor force participation and the highest unemployment rate (Chamlou & Yared 2005, 58–60).[7] Where Arab women work, Arab men work too.

We take the time to cite this research on female employment East and West because it provides important background for understanding why the Western reader of Arab news might instinctively, viscerally, and uncritically react to gender segregation in Arab regions as a form of gender discrimination. The Western reader would be challenged to imagine how restricting a woman's networking options could expand her overall horizons. Consequently, the Western reader would be surprised by a December 12, 2006 *Asharq Al Awsat* brief from Saudi Arabia, reporting on the Kingdom's exploration of ways to increase overall female employment by *increasing* segregated spaces in the private sector. The brief explains how car dealerships designed exclusively for women in the Kingdom were now "rescuing" Saudi females from the unemployment lines. Despite the fact that women cannot legally drive in Saudi Arabia, they have their own purchasing power to buy cars, and the demand among Saudi women to use their purchasing power has been growing. This rising demand had caused a number of dealers to change their practices when it came to selling cars to women. The practice had been to specify certain days in certain dealerships when a female sales force would be in place and prepared to receive women customers. In order to achieve this, dealerships had to have female staff trained in all aspects of the car retail business and able to work across various departments, including sales, credit, and customer service. Najoud Al-Hazyan, who has been working for a dealership for ten months in such a capacity, was quoted as saying that she heard criticism from family and friends when she first took the job, but now received only positive feedback from her family and from the community after she had settled in. The job for her had become perfectly reputable.

However, that role was now being phased out. New jobs for Saudi women in car dealerships would be to staff dealerships with an exclusively female clientele. This new practice extends female segregation into the private sector and opens up considerably more job opportunities for Saudi women as a result. Al-Hazyan is quoted once again, expressing the hope that her work in car dealerships would become

one among many shining examples of private sector work that finds a way to extend the veil of segregation to open more spaces for Saudi women. In the Saudi context, the family remains the hub of women's employment social networks, and commercial enterprises make an effort to respect these homogenous networks. In the Saudi context, extending segregation into private enterprise is seen – incredibly to the Western mindset – as a way of empowering female influence over purchasing decisions. Maha Al-Hassan, the marketing director of the first dealership in Riyadh to serve only women, is quoted as estimating that some 25% of the cars sold by the dealership are bought with the purchasing power of Saudi women. Yet even when the car is bought with a woman's money, it is her husband or her son, according to Al-Hassan, who will insist on the final decision of type and brand. Al-Hassan, however, is hopeful that the all-female dealerships will, over time, embolden Saudi women to stand up for their purchasing choices and, as Al-Hassan puts it, "rais[e] the awareness among women about the money in their hands."

This story is restricted to car dealerships and may seem remote from central commercial trends in Arab regions, but it is not. Because of both the disproportionate unemployment rate of females in MENA labor markets and widespread gender segregation practices, the World Bank economists cited above (Chamlou & Yared 2005, 44) predicted that the extension of female, rather than male, entrepreneurship into the private sector was a more promising indicator for lowering unemployment overall in Arab countries. On this prediction, Saudi Arabia's economic growth depends on bifurcating private enterprise into separate male and female spaces. This economic prediction, however, lives in tension with the recognition that, in an era of globalization, women will need to cooperate and compete head-to-head with men in order to fulfill the human capital potential they bring to their nations. And such head-to-head gender cooperation and competition, for better or worse, requires cross-gender networks that extend beyond the reach of families.

The predictions of globalization may be winning out, slowly, especially with the educated class. This is because professional knowledge is not gendered and female lawyers and pharmacists with ambition to compete must train to be the best in their profession and not the best

women in their profession. They must set their sights higher than gender. In the previous chapter, we saw evidence that Saudi professional women think segregation laws in the Kingdom are too restrictive. Furthermore, if half of your professionals compete with the world and the other half compete only within their own gender, you are dividing the aggregate strength of your professional class by half. Bill Gates tells a story of addressing a room of Saudis, four-fifths of whom were men seated on the left and one fifth veiled women seated on the right, with a partition between them. A questioner asked Gates if the Saudi plan to break into the top ten technology countries by 2010 was realistic. Gates replied, "Well, if you're not fully utilizing half the talent in the country, you're not going to get too close to the top ten." At that moment, the tiny group to the right "erupted in wild cheering," while the large group to the left clapped "tepidly" (cited in Kristof & WuDunn 2009). Even in Qatar, Rand researchers found a startling change in the attitudes of female Qatari high-school students toward the attractiveness of mixed-gender work environments. Females who had graduated from high school in 1998 reported that a single-gender work environment was very important to them. Yet females graduating in 2006 reported the opposite attitude – that a mixed-gender work environment would be an extremely important feature of the workplace they hoped to join (Felder & Vuollo 2008; based on the general survey of Stasz, Eide & Martorell (2007).

The realities of a globalized workforce mean cutting back on gender segregation. The realities of Arab tradition mean extending gender segregation on grounds of religion and custom, even if it means turning one's back on the pressures of globalization. In the years 2001 to 2007, Gallup researchers (Esposito & Mogahed 2008) conducted tens of thousands of hour-long phone calls and thousands of face-to-face interviews with Muslims around the world. While the Gallup poll found that Muslim women admired the West's notion of legal equality for all and gender equality, the Gallup researchers reported that:

> [W]e expected a high percentage to associate the statement, "adopting Western values will help in their progress" with Arab and Muslim nations. However, the exact opposite turned out to be case. (Esposito & Mogahed 2008, 107)

Under Islam, men and women are assigned equally vital but nonethe-less distinctive roles within the family. To confuse these roles is to undermine the central position of the family in Islamic life. The American Constitution makes no mention of the family as a building block of American society, while the modern Constitution of Saudi Arabia (1992) makes four central references to it, the first being: "The family is the kernel of Saudi society, and its members shall be brought up on the basis of the Islamic faith."[8] To emphasize the indi-vidual over the family would be to upset this balance. In the historiography of the West, a medieval world that offered no rights to individuals became a modern world that did offer such rights. In the historiography of Islam, a pre-Islamic world that was oppressive to women turned into Muslim lands that offered women unprece-dented respect, responsibilities, honors and rewards within a supportive family network (Khan 2004).

Muslims in the Gallup poll widely rejected a modernist gender blindness that would dismiss the essential differences between men and women and the special advantages conferred on women in the family because of that difference. The Gallup survey found that, while Muslims admire many aspects of Western personal freedoms, they nonetheless assess the overall costs of these freedoms as too high (Esposito & Mogahed 2008). Muslim women may be modern in their thinking, seek to educate themselves to their fullest potential, and aspire to professions once dominated by men. However, they cannot embrace a modernism that elevates the individual above the family without compromising their identity as Muslims.

The Gallup poll found that Muslim women did not see themselves as the damsels in need of rescue that the West often makes them out to be. And while Muslim women in the poll were concerned about clitoridectomies, honor killings, and reproductive rights, they felt that these concerns reflected more the sensationalist trade of Western headlines than their own immediate priorities. Their more pressing priorities, as revealed in the Gallup poll (Esposito & Mogahed 2008, 125–30), were not difficult for Westerners to understand. Muslim women wanted peace, education for their children, and prosperity for their families and their neighbors, and to see overall political reform in their region to eliminate the corruption that crowds out

merit-based political growth. They were committed to their family-based Islamic culture where the differences between men and women are not only noticed but revered. While the West has long held to the myth that Muslim women are helpless and oppressed, Muslim women's responses to the Gallup interviewers indicate that they see Western-style individualism and gender blindness as a force of destruction for them, not a force for rescue. Cultural equality applied indiscriminately and arbitrarily between men and women represents a nightmare for most Muslims, not a dream. Nonetheless, many feminists in the Islamic world would also insist that Islam does not discriminate between men and women with regard to their fundamental capacities, including the capacity to achieve and gain public recognition outside the home.

These facts are relevant background for trying to understand the briefs in our sample that depict Arab women in gender-segregated workplaces. Let us turn to four briefs that overview official Saudi policy about women as employment assets in a conservative Islamic country. The first consists of a posthumous consideration of King Fahad's legacy written by Souhayla Hammad on behalf of women. The original article from which this brief was taken appeared in *Al Hayat* just two days after the king's death, on August 3, 2005. Part eulogy, part encomium, the brief commemorates King Fahad's beneficence toward Saudi women during his active years of rule (1982–1995) and ties that beneficence to his devotion to Islam. Hammad writes that Fahad "gave special care to women because Islam honors women." Each day of his life, she continues, he had lived the Prophet's words: "The good of you are good to [your] women, and I am good to my women." It was King Fahad who added Article 9, about the family, to the Saudi constitution, which posits the Saudi family as the nucleus of Saudi society. He was also responsible for Article 10, about equality, which observes that equality and justice must be practiced within the family in order for human rights to be observed according to Shari'a law. According to Hammad, forty-five years previously, during the reign of King Faisal, Fahad was championing the right of females to an education and, as king, he never wavered on that commitment. As Hammad sees it, Saudi women can thank King Fahad for having their own universities today

and for being able to take their education into civil society associations and NGOs. Most relevant to the discussion, Fahad believed in women participating in the private sector of business as investors, if not entrepreneurs. During his rule, Hammad offers, 20% of commercial and trade companies were registered in the names of women and 40% of Saudi money in worldwide banks was invested by Saudi women. All this came about, Hammad asserts, because King Fahad believed in women's rights.

In 1995, King Fahad suffered a debilitating stroke and his half-brother, Abdullah, served as regent until the king's death in 2005, when Abdullah was enthroned as King Abdullah. The second brief we review, dated August 1, 2005, appeared on the day King Fahad died and two days prior to Abdullah's accession to the throne. The brief comes from *Asharq Al Awsat* and discusses a previously released report called *The Eighth Saudi Development Plan: Twenty Steps to Allow Women to Work*. The report announces the female unemployment rate as of 2002 to be 12.8%, which its authors consider unacceptably high. The report goes on to suggest that the reason it is so high is that the Saudi education system has tended to discourage women from pursuing majors with a market demand. It is true that there is evidence that a university education gives Saudi women a broader interest in career-seeking, as 50.6% of the women who are looking for work have a university degree, compared with only 17.8% with high-school certificates. However, the true culprit to which the report points is the large non-competitive public sector, particularly the Ministries of Education and Health, which hires an astounding 88.4% of working Saudi women into a mostly non-competitive workforce. Saudi Arabia's twenty-step plan seeks to make women more aware of, and interested in taking, more competitive private-sector jobs.

The third brief, taken from *Elaph* on June 27, 2006, appeared almost a year after the first two, just days before the first anniversary of King Abdullah's accession to the throne. It reports on the reforms King Abdullah has been pushing during his first year as monarch on behalf of Saudi women, and some of the conservative reaction to his reforms. On the reform side, the brief reports on the "remarkable transformation that is unprecedented in the history of the

conservative Kingdom." Development for women takes many forms and King Abdullah realized that one of the first steps towards making women an asset in the workplace is to make them visible participants in the culture. Women should be seen, Abdullah surmised, to participate in public contract-signings, ceremonies, and conferences. They should be allowed to be photographed and in the news. To permit them be seen is to help them have impact. Before Abdullah, images of Saudi women did not appear on the news or in the media and women were banned from being newscasters. Even if female members of the royal family traveled on official visits, the cameras were forbidden to focus on them. Now everything had changed. As the brief notes, "The first pages of the eight official newspapers are no longer monopolized by men but are now full of daily images of Saudi women wearing their veils." The four official Saudi channels now put women before the camera routinely. This change, according to the report, was silently signaled when Abdullah took female delegates with him on state visits to India and China.

On the pushback side, six months into Abdullah's first year, in February 2006, Shura Council member Mohammad Al Zalfa had produced a report advocating the right of females to drive. The report was mysteriously "lost" before it could be distributed to the Council. For taking the blasphemous position that it should be legal for women to drive, Al Zalfa came under relentless personal attack by other Council members. They called him an infidel who had "opened the doors of hell" with his proposal. Calls on his private cell phone accused him of trying to turn Saudi women into prostitutes. Rumors were spread that he had no daughters (he has two daughters), as that, according to his enemies, could be the only explanation why the morals and modesty of Saudi women were of no concern to him (Al Nafjan 2008). Al Zalfa stood his ground and the Council's acrimonious exchanges were picked up by the press.

The public concern, according to the brief, influenced Abdullah to ease censorship and allow for more open discussion of sensitive topics affecting women, but the brief questions whether the country was ready for such discussion. It reports that young Saudi men liked the new availability of women in images, but only so long as their wives and female relatives were not the ones to appear before the camera.

The brief also mentions that the majority of women in Saudi Arabia are devout conservatives, do not seek increased liberties, and believe that the ban on their driving is justified on religious grounds. When he first assumed the throne, the brief notes, King Abdullah was visited by 500 conservative women who requested that he insulate the Kingdom from Western influences and uphold the ban on female driving.

A fourth brief, from *Asharq Al Awsat* on August 3, 2006, offers another year-end progress report on King Abdullah's record. Like the third, it starts positively but, unlike the previous brief, it also ends positively. It enthuses about the difference a year can make and over-views King Abdullah's "gradualist" vision for female reform in the Kingdom, which even in a short year has produced some impressive employment statistics for women. Under King Abdullah's term, the brief boasts, "the percentage of women in the Saudi workforce has reached 19% and 38% of this force now work in the private sector." Abdullah has been pushing for women's greater participation in the private sector, it says, and has also given particular emphasis to their role as voters and candidates for positions with local chambers of commerce. Under his watch, the brief asserts, two women had been elected and two others appointed to chamber positions and one of the women elected is quoted as saying that "after years of being marginalized," she has Abdullah to thank for her opportunity and her current office. Under Abdullah's reign, the brief goes on, more Saudi women than ever before are independently managing investment portfolios and attracting foreign money from Saudi women abroad to fund local projects.

In a thinly veiled reference to the conservative counter-pressures the king faces, Al-Youssef, one of Abdullah's six advisors, is quoted as saying, "King Abdullah's vision for gradual reform has been described by many as 'wise and in keeping with the values of Saudi society.'" Further commenting on the king's gradualist vision, the brief cites a previous interview with Princess Adila Bint Abdullah, who affirms: "Changing a society's ideas comes gradually. This doesn't mean it should be slow. We have to remember we are dealing with people and not machines." Although calling Abdullah's gradualist vision slow and steady, the brief presents a whirlwind of precedent-setting "firsts" that

Abdullah has achieved on behalf of Saudi women in one short year. In January, he made an official tour of China and India and, for the first time, six Saudi women were included as part of the public delegation. The brief heralds this act of media visibility for Saudi women as a solid "achievement" in its own right. Faten Bandaqji, one of the women in the delegation on the Indian leg, is interviewed and confirms that "women played an important role" during the trip to India. Abdullah permitted Bandaqji to be photographed at his side, allowing Saudi girls at home to see for the first time images of a Saudi woman participating at the center of power rather than in the wings with the floral decorations. The brief goes on to say that Bandaqji's photograph was "celebrated in all Saudi newspapers." But Bandaqji's was not the only precedent to be set. In his first year on the throne, King Abdullah made a point of having himself photographed while meeting with a delegation of women teachers and later with a delegation of female writers and intellectuals from across the spectrum of Saudi society. One writer in the delegation, Siham al Qahtani, marveled that the meeting with Abdullah "legitimizes our work and effective role in Saudi society." The brief goes on to praise Abdullah for creating precedent-setting opportunities for women at the university level. In 2005, with Abdullah's blessing, the Law Faculty at King Saud University in Riyadh instituted a women's department. For the first time, a media studies curriculum was created for women. And, under Abdullah's authority, a technical college for women, another "first of its kind," was established.

On the basis of these briefs, the fair-minded Western reader of these new media accounts may conclude that Arab women have legitimate avenues of advancement within a gender-segregated society, even within Saudi Arabia and may learn from this that not all forms of gender segregation need be forms of discrimination.

This lesson is reinforced in yet another brief from Saudi Arabia, which, not surprisingly, makes segregation policies an unquestioned *positive* condition of women's work. A January 18, 2006 brief from *Asharq Al Awsat* covers the opening of women's recruiting agencies in three cities in the Kingdom. In Riyadh, Dammam and Jeddah, agencies were recently opened whose mission it is to put women seeking jobs and companies with vacant positions in touch with one another.

Hattab Al Anzi, Head of Public Relations and Communication at the Ministry of Labour, is cited in the brief as indicating that these agencies are meant to address the recurrent unemployment problem of Saudi women. Currently, Al Anzi notes, the immediate focus is on training the ten female counselors who will be staffing each agency and making the arrangements between the women clients and the companies. The counselors will need to interview the women and assess their qualifications and the needs of the company, and make the best match. The counselors will also need to ensure that the conditions for hiring are clearly spelled out by the company, and understood by the job seeker, and then mutually agreed on and committed to by both before a final match is made. These conditions of employment, the brief spells out, include state regulations that women in the Kingdom must be allowed to work under conditions "suitable for their nature" according to Islamic Shari'a, including the guarantee that the work "will be hidden from men and will not [require] interacting with them." The Western reader with an anthropological sensibility may not understand how Arab women can thrive under such segregation rules, but may still cultivate the attitude: "If the natives aren't complaining, why should I?"

But what if the natives do complain? Is there a procedure for deciding when segregation is unwelcome discrimination and when it is not? Is there a procedure for determining *who* should be the decision-makers at the table to make the decision? If we let traditionalists decide, we shall discover, as the World Bank, the Arab Fund for Economic & Social Development and other international watchdogs have discovered, that traditional practices in Arab governments may unfairly defend discriminatory practices against women under the mantle of "time-honored practices." On the other hand, if we let international monitors from outside the region decide, then some truly hallowed traditions of Arab society that do not discriminate (even if they seem to from the naïve outsider's perspective) may come into jeopardy. If we invite both to the table, there is the likelihood of a structural impasse that will bring the decision-making process to a grinding halt.

These are below-the-surface questions that haunt some of the briefs. A September 9, 2005 *Al Hayat* brief covers the struggle of Yemeni

women to enter private businesses while fighting traditional segrega-
tion norms and constraints. According to World Bank data (Chamlou
& Yared 2005), Yemeni businesswomen experience cultural constraints
in entrepreneurship because of restrictions on their mobility and busi-
ness networks. The brief cites a field study from the Women and
Development Research Institution in Sana'a University that provides
a status report on women entrepreneurs in Yemen. The study makes
clear that we are not talking about aggressive Western women with Ivy
League MBAs and Wall Street ambitions, but about modest Yemeni
women seeking to improve the meager living standards of their fami-
lies by finding a place for themselves in private commerce and
investment. The study found Yemeni businesswomen to be young, on
average between twenty and forty years of age. The study also reports
that the percentage of Yemeni women seeking and finding jobs in the
private sector is on the rise. However, because of existing social and
cultural norms that mitigate against women working outside the home,
the number of such women remains a low percentage of Yemeni
women overall – only 25.6% in rural areas of Yemen and an even lower
11.5% in urban areas. Unlike in the richer Gulf countries, Yemeni
women experience a public sector that is poorly resourced and an
unreliable employer. The study also reports the obstacles Yemeni
women face in finding their way into business and the handicaps
imposed by gender segregation. One woman, Sahar Al Zabhani, who
owns a fashion boutique, is quoted in the brief as saying that her inabil-
ity to travel outside the country without a male escort to purchase
imports or attend workshops poses a serious problem for her business.
She also feels encumbered because her family warned her against
"dealing with men in ministries, institutions, and markets," echoing
the findings of the Western research, cited above, that women without
privilege who cannot travel in circles far beyond their family will not
travel far.

Another brief, dated August 15, 2005, from *Asharq Al Awsat*,
Saudi Arabia, shows more restless natives, women who lived unhap-
pily during the reigns of Kings Fahad and Abdullah. We have
already mined this article for the angry and insistent voices of Saudi
women of accomplishment who expressed their displeasure at being
excluded from key roles in the professions they represent. In chapter

11, we shall explore the sense in which the women in this brief are raising a "feminist" voice. For now, we note how they take it upon themselves, not simply following tradition, to judge that certain segregation practices in the Kingdom discriminate against women. The Saudi professional women in this brief are not opponents of gender segregation, but they are angry and impatient with some expressions of gender discrimination, which, in their eyes, masquerade as "women-friendly" segregation. As Hala al-Mu'ajjal, a lecturer at King Saud University's College of Administrative Sciences, puts it, female students need to be able to count on having the same range of subjects to study and facilities in which to study them as their male counterparts, but this is not currently the case. Dr Islam Khujah, consultant surgeon and female head of the vascular surgery unit at King Fahad General Hospital, complains that female physicians are not accorded the same respect as male doctors and insists that that situation needs to be corrected. She further identifies the problem that women's scholarships for travel and study abroad are often canceled preemptively because the scholarship does not cover the costs of a close male relative to chaperone her. She argues that women deserve equality with men and the segregation rules she sees women facing are not protecting that equality. A December 15, 2005 brief from *Elaph* reports that Saudi women complained even more openly and forcefully against segregation during a three-day Fifth National Dialogue Forum, entitled "Us and Others," where Saudi women vented their anger against segregation rules they saw as discriminatory.

Conclusion

In this chapter, we have reviewed some of the challenging conditions of employment for Arab women. We have seen that the Arab press, based on our sample at least, does not give extensive coverage to the day-to-day work environment of Arab women. Stories in our sample that refer to female employment are associated with stories about female capitalization and the Gulf region, mentioning particularly the women of Saudi Arabia. This led us into a discussion of female employment and gender segregation and the Western research that

cites gender segregation as a marked disadvantage, if not an outright form of discrimination, for women in the work force. We also saw that, in most Arab regions, including Saudi Arabia, there are traditional pressures to bend employment patterns to maintain the sanctity of the family. These pressures produce results such as car dealerships in Saudi Arabia run exclusively by women. Counter-pressures from globalization are similarly at work to bend Arab employment patterns to worldwide patterns that favor a gender-integrated labor force where men and women cooperate face-to-face and compete head to head. After the Arab Spring of 2011, Arab women in Tunisia, Egypt, and Yemen were calling for new freedoms, but these new freedoms were being defined differently within the orbits of these competing pressures. The Egyptian women in Tahrir Square reported enjoying full integration and equality with men for eighteen days in January and February. They hoped to push this gender equality and integration out into the life and work patterns of greater Egypt. However, on the official website of the Muslim Brotherhood, Iman Isma'il interprets the "Arab Spring" for women as leading to the formation of women-only transportation systems to protect women from verbal and physical harassment on their commute to work. She argues there is a good chance that women "will jump at the idea in an unprecedented way" (Isma'il 2011) because a woman's first duty is to protect her modesty and separation allows her to fulfill that duty comfortably, without exhausting herself. Under the pressure of globalization, the product of a woman's work and the power of her direct networks comes first. Under the pressure of Islam, her modesty, protection, and physical comfort come first. The future of employment spaces in Arab regions depends on which set of priorities ultimately prevails, but, more realistically, it will depend on negotiating a framework of acceptable compromises across the pull of these competing priorities.

Thus far, we have been discussing conditions of Arab female employment, and employment is not empowerment. Employed Arab women often remain stuck in ruts of menial labor with no hope of transforming their labor into leverage. Empowerment, the magical watershed by which labor rises to become leverage, lies on the other side of the coveted development rainbow. In chapters 11 and 12, we turn from

female employment to empowerment, but before that, in the next chapter, we take stock of what we have learned thus far about Arab women in Arab news and try to rank the concepts most commonly associated with the perception of their being active.

10: Ranking Activeness

WHAT MAKES A READER OF NEWS JUDGE
A WOMAN TO BE ACTIVE?

The news briefs we have covered thus far in our corpus of Arab news bear witness to Arab women exhibiting a dominant frame of active-ness[1] by leveraging their retributive anger, their capabilities, their choice-making, their pride, insistence, initiative, and aspirations, and their involvement at school and work. The minds of these women are not veiled, no matter what their choice of fashion. They do not need to be rescued within the terms of any simple Western supremacist fantasy. But they do deserve to be listened to. And when we listen, we find that, like women across the world, they face many challenges; but as women with their own minds, their responses to whatever challenges they face are just as important as the challenges themselves, if not more so.

In some respects, these conclusions about Arab women in Arab news are subtle and liberating. In other ways, they may simply say more about the traditional one-dimensionality of Western news sources on Arab women than about the women in Arab regions per se. The real story here may not even be about what is going on in these Arab news stories; it may rather be the realization that the historical power of "image bite" media from the West has so caricatured Arab women that "realistic" stories about them in Arab news appear, to the Western reader, revelatory.

Significantly, our coding study focused exclusively on the female nominative pronoun and the surrounding verb phrase as context. It took no account of a human reader's macro-impressions of dominant active or dominant passive female behavior in the news brief, nor of

how the concepts we had discovered through grounded theory/text-mining (e.g., anger/resistance, capability, etc.) might have contributed to these macro-impressions. To explore these macro-impressions of dominant active or dominant passive behavior, imagine putting a news brief referencing an Arab woman before the eyes of a human reader, and administering the following instructions:

> *Dear Reader. We want you to read this news brief, which you will find involves an Arab woman or Arab women at the center of the story or in the background. After reading the story, we want you to make a judgment about whether the Arab woman or women involved in the story strike you as active or passive. Don't worry about defining active and passive. That's up to you. Don't worry if you think that the Arab women in the story are both active and passive; or that some women are more active or more passive than others. Please focus on the whole story and not simply the characters. We want you to make an intuitive judgment about your dominant impression of the Arab women in the story based on the story as a whole. Is your dominant impression formed from reading the story that Arab women are active? Or is your dominant impression that they are passive? Don't wrestle too much with this decision. Go with your gut. If your gut tells you that you can't decide that's fine too. Just say you can't form a decisive judgment. We are only concerned when your gut feeling is clear one way or the other.*

We recruited a (Western) coder from our study to be our human reader and we gave her exactly these instructions – except that, rather than having her read just one news brief and going with her gut about whether the story gave her the impression that Arab women were active or passive, we had her go with her gut for all 178 news briefs. Of the 178 briefs in our corpus, our reader classified fifty-seven as conveying an overall impression of "active Arab women," and sixty-two as conveying an overall impression of "passive Arab women." She found that the remaining sixty briefs did not give her a definitive gut impression either way and we did not consider them further.

Our reader's judgments gave us 119 news stories in two piles; one pile of fifty-seven stories that had given her gut impressions of Arab female activity, and a second pile of sixty-two stories that had given her gut impressions of Arab female passivity. Focusing on the fifty-seven

stories that had produced an impression of Arab female activity, we ran a statistical procedure called multiple analysis of variance (MANOVA) to determine how the various concepts associated with a dominant frame of activeness (e.g., aspiration, capability, initiative, etc.) might have ranked in contributing to this gut impression. Table 10.1[2] enumerates the rankings in descending order.

Concept of Activeness	P-value for identifying the relationship between the active concept (on the left) and a dominant impression of Arab female activity as judged by a human reader
Female Capabilities	F = 5.08; p < .026*
Female Drive**	F = 4.37; p < .039*
Female Anger/Resistance	F = 3.61; p < .06***
Female Aspirations	F = 3.19; p < .07***
Female Initiative	F = 2.28; p < .134
Female Employment	F= 2.13; p < .147
Female Education	F = 1.36; p < .245
Female Insistence	F = .43 p < .511

* = statistically significant at .05 level
** = drive was calculated as the sum of insistence + initiative + education + employment
*** = close to statistical significance at .05 level

Table 10.1. How different "active" concepts differentially contribute to dominant macro- impressions of Arab female activity. The table presents MANOVA analyses of the 57 news briefs our reader judged to put Arab women in dominant active frames. These results are suggestive of how the various "active" concepts we have discussed (chapters 6–9) may contribute to a dominant active frame. For example, briefs mentioning female capabilities and drive appear most central to our reader's "gut" judgment of activeness; female anger/resistance and female aspiration were very close to statistical significance at the .05 level and also seemed to contribute positively to the reader's judgment of female activeness. The remaining concepts, on their own, were not statistically related to a dominant macro-impression of activeness.

As Table 10.1 shows, the MANOVA results revealed that news briefs that gave prominence to female active capabilities were the strongest contributor to the reader's overall impression of activeness (F = 5.08; $p < .026$), closely followed by female drive (summing female insistence, initiative, education, and employment) (F = 4.37; $p < 039$). Female anger/resistance approached significance at the .05 level (F = 3.61; $p < .06$), as did female aspirations (F = 3.19; $p < .07$). Female initiative on its own provided a statistically insignificant (weaker) signal for activeness (F = 2.28; $p < .134$), as did female employment (F= 2.13; $p < .147$), female education (F = 1.36; $p < .245$), and female insistence (F = .43; $p < .511$).

Because we did not employ multiple independent readers, these numbers are suggestive and no more than ball-park estimates. Nonetheless, we could verify them independently by turning to the textual record. For example, as Table 10.1 makes clear, female initiative seemed to be a weak indicator of female activeness. This squares with the textual record, for in several news briefs where Arab females show initiative, the broader story context emphasizes Arab female powerlessness. A case in point is the resourceful Lebanese woman we have met twice before (pages 80, 131), Rein Abu Azza. We have already noticed her special initiative in setting up a global digital petition campaign against Israeli aggression during the Lebanon bombings of 2006. However, the brief applauding her singular initiative commits many more words to describing the masses of Lebanese women and children who are victims of Israeli bombs. Our reader probably did not miss Azza's initiative, but it simply did not dominate her overall impression of Arab females in the story.

Female employment provided a still weaker signal of activeness (F= 2.13; $p < .147$; see Table 10.1) than other concepts. Again, we had textual evidence to make sense of this finding. In various news briefs, such as the one about discrimination against Palestinian women in the workplace (page 156), Palestinian women were employed, but subject to unfair working practices. Female education, surprisingly, proved an even weaker signal for activeness (F = 1.36; $p < .245$; see Table 10.1). And again, this finding too made tragic sense when we reread the stories that describe the threat of war to college women in Iraq. As two *Al Hayat* briefs from Iraq (*Al Hayat*,

May 24, 2006; October 3, 2006) had made crystal clear, war makes educated women a prime target.

None of the concepts of insistence, initiative, education, or employment on its own provided a strong signal for dominant female activeness; yet when summed together to create a composite concept of female drive, the composite did decisively tilt the scales for our reader in favor of a dominant judgment of female activeness. A prime example of insistence and initiative aligning with education and employment is evident in the news brief from *Elaph*, dated October 20, 2005, which describes educated Saudi women involved in business holding forums to advance their career prospects (pages 107, 130 and 158). Our reader readily interpreted this and similar briefs illustrating female drive pertaining to Saudi businesswomen, and registered a gut impression of Arab women in these briefs being active.

By far the weakest signal for activeness was female insistence (F = .43 p < .511; see Table 10.1). As we saw in chapter 7, a woman's insistence may reflect confidence in her positions, and even an optimistic sense that reality has finally caught up with expectation ("the time has finally come . . ."). However, insistence may also reflect that reality lags behind expectations ("it is high time that") and then insistence aligns with frustration and feelings of weakness. Leila Tallab, whom we have met before (page 123) championing female equality in the home and who is reported in the *Al Hayat* news brief of June 28, 2005 as saying, "No family can develop except with equality among its members," arguably represents the intersection of insistence, frustration, and weakness. In this context, Tallab is insisting on norms of equality *that she knows she is helpless to enforce*. She pleads for equality against the dominant reality of Arab women's experience of inequality. Tallab's insistence is not an act of power but a cry from a stance of powerlessness.

Conclusion

Focusing on fifty-seven news briefs that a reader judged to convey a dominant impression of active Arab women, we were able to rank many of the "active" concepts discussed in chapters 6–9 according to their overall contribution to the dominant frame of Arab female

activeness. The most important concepts contributing to a dominant macro-impression of female activity were female capability, drive, anger/resistance, and aspiration. We were also able to confirm many of these rankings independently, through the textual evidence.[3]

11: *Empowerment*

The term gender empowerment . . . refers to arming or endowing a woman with instruments (power and authority) to take control over her own life.

(Roy, Blomqvist & Clark 2008, 24)

In the past few chapters, we have discussed how the corpus of Arab news reveals the attributes of an active Arab woman in terms of her feelings of anger about and resistance to the status quo, her aspirations, capacities, choices, and drive and determination for education and employment. Using statistical analysis to assess the different contributions of these concepts to the overall perception of active Arab women, we have found that some of these concepts[1] individually contribute positively to the overall impression of an active Arab female and all of them contribute to a greater or lesser extent in combination with others.[2]

These findings are consistent with the inventory of attributes that Sen (1993) and Nussbaum (2000) associate with what they call a "capabilities approach" to human rights and development with respect to women worldwide. On a capabilities approach, human development is viewed as more than investing in an individual's food, shelter, health, and other staples of survival. A capabilities approach extends the common understanding of "the human basics" to cover the minimum essentials that all human beings require in order to become positive contributors to their economies. A capabilities approach to human development changes the fundamental question of public welfare from "What can we do to keep people alive?" to "What can we do to help people thrive as human capital contributing to the societies in which they live?"

In this chapter, we turn to these active capabilities as they play out

in our sample of Arab news at the organizational and societal level. We meet not only women outside the home in situations of education and employment, but also women who are effective and empowered achievers: leaders, innovators, pioneers, entrepreneurs, representatives, and spokespersons. These are women who take control over their own lives and in addition accept institutional responsibility for the well-being of others outside the home. The Arab women discussed in this chapter merit public recognition and societal power and influence. Taken in the aggregate, their actions are capable of being society-changing. They can be seen as changing the course of history *because* they live the lives they live. The Arab women in this chapter live lives of achievement, authority, and pioneering. They inspire new generations of Arab females as role models.

Achievement, Authority and Pioneering

The concepts of achievement, authority, and pioneering emerged from our grounded analysis to form a close-knit triad of female empowerment. In this chapter, we define these concepts and focus mainly on achievement. In chapter 13, we rank these concepts on the basis of the differential contributions each makes to an understanding of female empowerment.

Achievement

"Achievement" refers to admired actions that an Arab woman may undertake to increase her access and claim to organizational and societal empowerment. Achievement often coincides with authority and pioneering, but it is distinctively merit-focused, such that the achiever can point to her own efforts to use her mental and physical capabilities to achieve status or become a pioneer. Achievement may be recognized in news stories by the use of a variety of verbs such as *earned, won, took-first-place, took-first-prize, elected, graduated, nominated, advanced, appointed, promoted to, awarded, recognized-for, presented with, organized, instituted, developed, invented, honored, discovered, authored, published, ascended to,* and so on. Any woman in our corpus associated with these

and other expressions was classified under the heading: Arab women of achievement.

Quantitative summary of female achievement

Of the 178 news briefs, thirty-two (18%) refer to Arab females of achievement.

Authority

"Authority" is defined as the status and title conferred on a power-holder (e.g., *president, queen, sheikha, vice president, senior administrator, cultural advisor, expert, doctor, professor, chairwoman, minister, parliamentarian, leader, director, supervisor, superintendent, division head, officer*) and other honorifics of power-holding. We classified any Arab woman described by any of these titles or honorifics under the heading "Arab women of authority." The authority an Arab woman holds may be achievement-based, in the sense that she earns authority from the accumulation of her background, education, and actions. But authority need not be achievement-based. She may inherit, or marry or be widowed into her authority. She may fall into authority in circumstances not of her own making.

Quantitative summary of female authority

Of the 178 news briefs, thirty-eight (21%) reference Arab women who hold public titles of authority in the workplace or civil society.

Pioneering

"Pioneering" refers to the attainment of a woman who is first to achieve what no woman has achieved before, or who rises to a title and position of authority that no woman has hitherto occupied. Female pioneers break precedents and set new precedents for others to break. Female pioneers are usually associated with positive empowerments, with a strong emphasis on being the first at something. In our corpus of Arab news, we find Arab women achieving the following firsts: *first female*

judge in Bahrain; first female parliamentary seat in Bahrain; first Kuwait elections in which women have participated; first female Saudi TV announcer; first veiled labor minister in Egypt; first female vice-president in the Syrian cabinet; first female to run for the presidency of Yemen. Any woman in our corpus of Arab news described in the language of precedent-breaking was classified under the heading: female Arab pioneer. We also found rarer instances in our corpus of negative pioneering and so negative empowerment (e.g., the first female suicide bomber) that lack prestige. We restricted the reference of female pioneering only to positive empowerments.

Quantitative summary of female pioneering

Of the 178 news briefs, fifteen (8%) make mention of an Arab female pioneer.

For reasons that will become apparent in chapter 13, we shall focus the rest of this chapter on female achievement, the relationship of achievement to empowerment, and the relationship of achievement to other concepts derived from the research literature, such as female role models and critical mass.

Awakening Female Achievement through Role Models

Female empowerment is a primary goal of economic, if not political, development across many Arab regions and worldwide. Female empowerment means putting education, authority, decision-making, capital, prestige, and influence in the hands of women. Because examples of female empowerment remain relatively sparse in the Arab world and worldwide, the concept of *female role models* takes on increased importance as a means to inspire new generations of females to strive for achievement and empowerment.

Achievement, as we have said, refers to admired actions that an Arab woman may undertake to increase her access and claim to organizational and societal empowerment. Achievement covers actions in school, the professions, business, and civic life that imply a high level of challenge and a sustained effort to rise to it. In a fair and rational world, achievement leads to power, wealth, and influence outside the

home. Language patterns in the news briefs typical of school achievement are: *among the best in her school, earned top grades, won honors, earned the PhD.* Patterns typical of professional and civic achievement are: *promoted, appointed, elected to, advanced to the position of,* and more.

Achievement must be distinguished from simple employment. As we saw in chapter 10, female employment alone is not an indicator of female activeness, much less empowerment. Women worldwide, even educated women, are underemployed and underpaid when compared with men. In the US, where women have worked in numbers almost equal to men since the 1980s, they have held a disproportionate share of low-paying, low-prestige jobs (Reis 1987; Shapiro & Crowley 1982). The mere fact of female employment does not by itself advance the cause of females as power-holders. What does advance it? One might think it starts with girls having high aspirations and showing the willingness, when necessary, to resist cultural pressures that dichotomize educational achievement and femininity (Hawley 1972). In a 1980s study of middle-class US teenagers, Danzinger (1983) found that, by the end of high school, adolescent boys put a premium on achievement whereas girls were found to choose their career interests only after determining an image of themselves as females and assessing the family-work balance they were seeking consistent with that image (see also Corder & Stephan 1984). However, US-based studies in the 1990s began to find these assumptions dramatically changing with regard to girls. Researchers found a surge in female career aspirations in the US, often equaling those of boys (e.g., Stevens et al. 1992) and not infrequently surpassing boys (Dunnell & Bakken 1991). What spurs aspiration? A popular belief is that girls who aspire ultimately achieve. While this view has merit, the research (Fox & Zimmerman 1985; Hay & Bakken 1991) on the subject, all US based, has found, at least for high female achievers, the causal evidence flowing more in the opposite direction: achievement spurs aspiration. Adolescent girls who are high-achieving have been found "to have higher career aspirations than their lower achieving counterparts" (Watson, Quatman & Edler, 2002, 234). A focus on achievement stimulates confidence and confidence seems to give girls the boost to set their sights even higher (Danzinger 1983). A focus on achievement is the one great equalizer between girls and boys when it comes to career aspirations (Watson,

Quatman & Edler 2002). Not all aspiring girls become power-holding women, but it is hard to find a successful power-holding woman of merit who did not at some point in her early schooling and adolescence feel continually invigorated and fueled by a drive toward achievement.

After 9/11, a generation of intellectuals in the Arab world, knowingly or otherwise, brought many of these research insights[3] about the development of women to the diagnosis of how to improve Arab societies. In a series from 2002 to the present, the United Nations Development Programme and the Arab Fund for Economic & Social Development, a Kuwait based, pan-Arab development finance institute with assets of $7.3 billion as of 2003, commissioned intellectuals across the Arab world to address global trends and concerns affecting the Arab countries and their competitive standing in the world economy. All its reports, called the Arab Human Development Reports, have mentioned the lack of power-holding among Arab women as a key deficit limiting the competitiveness of Arab countries. The 2002 report spoke of three major deficits confronting the Arab world: the knowledge deficit, the freedom deficit, and the deficit of female empowerment. Using a global index, called the Gender Empowerment Measure (GEM), which measures the "participation of women in economic, professional and political activities using the indicators of income per capita" (*Arab Human Development Report 2002*, 28, footnote), the report states that, apart from women in sub-Saharan Africa, Arab women lag behind the women of all other regions of the world in terms of gender empowerment (*Arab Human Development Report 2002*, 28).

The 2003 report, focusing primarily on the knowledge deficit, presents data from a World Values Survey conducted that same year, which measured Arab public opinion against public opinion in other regions of the world on the knowledge, freedom, and gender empowerment deficits. Arab public opinion was found to rank highest in taking seriously the devastating effects of the knowledge and freedom deficits on economic and social development. However, unlike most other regions of the world, Arab public opinion reacted equivocally to the female empowerment gap. Arab public opinion championed the idea that boys and girls have equal rights to an education but, unlike

most regions of the world, it rejected the idea that men and women have equal rights to employment (*Arab Human Development Report 2003*, 19).

Could Islam be the problem behind this patriarchal thinking? Or is the problem the entrenched patriarchal beliefs of Arab societies, which may be failing to live up to Islamic principles of gender equality? An important study tried to answer these questions by comparing Arab Muslims with non-Arab Muslims. Drawing from the same 2003 World Values Survey, Rizzo, Abdel-Latif, and Meyer (2007) compared the views of respondents from Arab Muslim and respondents from non-Arab Muslim countries on the relationship between gender equality and the rise of democracy. The researchers found that non-Arab Muslims saw a significant relationship between gender equality and political freedom, holding that their societies overall could be made more free *only if* their women were made more free. Failure to move women ahead meant, for them, failure to move society ahead. However, public opinion in Arab countries made no such linkage between making their societies freer and making their women freer. Arab respondents on the survey who championed more freedom in their countries did not see championing more freedom for women as a necessary first step. Rizzo, Abdel-Latif, and Meyer concluded that they had identified an important blind spot in the dominant cultural thinking of many Arab countries on the relationship between advancing democracy and advancing the rights of women. On the basis of their results, they argued that, if the Arab countries were truly to become more democratic and free, their leaders would have to take this blind spot toward gender empowerment into account by inaugurating laws championing the freedoms of women and the infrastructure to enforce them. Rizzo, Abdel-Latif, and Meyer's study suggests that Islam is perfectly compatible with gender equality, but that patriarchal cultural assumptions still prevalent in many Arab societies remain committed, regrettably, to gender inequality.

The *Arab Human Development Report 2004*, focusing on the freedom deficit, noted that Arab women were doubly excluded from state freedoms. In addition to the freedom deficits faced by men in non-democratic Arab states, women were found to face additional restrictions on their freedoms. They were often limited in their right to vote or run for office, often lacked legal protections against domestic violence, and

tended to have fewer rights in divorce, child custody, and passing their citizenship to their children when marrying foreigners (*Arab Human Development Report 2004*, 10). The report does chronicle some singular gains for women in Morocco, Kuwait, Jordan, Oman, Saudi Arabia, Mauritania, Algeria, Lebanon, Bahrain, Tunisia, and Egypt, but notes that these gains, welcome as they are, have been few and far between and should not mask a political environment for women in these countries that remains unwelcoming toward the advancement of women overall. The report notes that that Arab women's freedom and ascension to power roles in their societies "will remain inadequate so long as the vast majority of women are not allowed to develop their capabilities and use them in various fields" (42–3).

The *Arab Human Development Report 2005* is of most direct relevance to our analysis because it focused exclusively on the gender empowerment deficit. It is subtitled "Toward the Rise of Women in the Arab World." As if to start with a frontal assault on the thinking that there is no linkage between achieving greater freedom in Arab countries and extending greater freedoms to women, Abdel Latif Youseff El Hamed, Director General and Chairman of the Board of Directors of the Arab Fund for Economic & Social Development, asserts straightaway in the foreword that the rights of Arab women and improving their status "are not a luxury or a subject for mere theorizing." They are rather "a fundamental component of the rights of humankind" (*Arab Human Development Report 2005*, vi). El Hamed further contends that the "long hoped-for Arab 'renaissance' cannot and will not be accomplished unless the obstacles preventing women from enjoying their human rights and contributing more fully to development are eliminated and replaced with greater access to the 'tools' of development, including education and healthcare" (*Arab Human Development Report 2005*, I).

While previous reports focused on the factors that prevent Arab women from rising in their societies, the 2005 report focuses mainly on the single factor that can promote their rise. In a word, that factor is achievement. Paralleling the Western findings reviewed above, the report suggests that promoting the inclusion of women in their economies requires raising the aspirations of women when they are still girls and raising their aspirations through a focus on achievement. Yet this

leaves a most crucial question unanswered: how does one raise women's focus on achievement?

The simple answer: female role models. Women can more easily enter a culture of achievement when, from their youngest memories as girls, such a culture is already visible for them to enter. There seem to be two kinds of such role models, which we shall call individualized and strategic role models. Individualized role models are women who may inspire girls without providing models that are easy for others to emulate. Their achievement may be leveraged through wealth, social position, inheritance, or lucky circumstances that ordinary girls cannot reproduce. Strategic role models are women of achievement whose success is reproducible through instruction and training. Strategic role models make the roots of their success visible and reproducible for the next generation of women.

The *Arab Human Development Report 2005* on the rise of Arab women puts some stock in the individualized role model. As El Hamed writes in the foreword, the achievements of individual Arab women "must be the starting point for Arab development efforts" (VI). While the report pays homage to the traditional role women have played in "family and social structures," it seeks to balance that role against newly emerging non-traditional roles of women achievers across the spectrum of professions, in institutions of civil society, and in political and emancipatory movements. The report goes on to discuss the cultural barriers, cited in previous reports, that must be lifted for Arab women to achieve their full potential. The impetus for lifting these barriers comes from the understanding of Arab women's achievement potential and the huge cost to society, as well as to each woman personally, when they are not allowed to live up to it. The report then goes on to profile the achievements of individual Arab women in literature, arts, cinema, the social and natural sciences, athletics, and entrepreneurship.

The Limits of Individualized Female Role Models

The 2005 report recognizes that female empowerment programs that are too individualized have certain limitations. Role models cut too close to the lives of specific individuals may turn into tokens, idols, and celebrities rather than true role models. The danger of role models

that are too individualized is that they may encourage tokenism prac-
tices, bringing cosmetic solutions to longstanding and deeply-rooted
societal problems. Herminia Ibarra (1993) of the Harvard Business
School found that women and racial minorities in predominantly white
male organizations face contradictory lose-lose pressures when they
come across as role models to the outside world but live as tokens
within the organization. They face pressures to turn away from their
fellow women or minority co-workers for fear they will appear disloyal
and out of step with the dominant white male culture of the organiza-
tion, and the dominant culture subjects them to constant reminders
they are "different" and sends them constant challenges to "overcome"
that difference (Kanter 1977). However, at the same time, they face
rebuke and ostracism from their female and minority colleagues should
they appear to have sacrificed their minority identity at the altar of the
"the men" or "the white boys." Women working in predominantly
male organizations often feel rootless and distrusting of any organiza-
tional network they are asked to join. And while they may become
respected role models for women outside the organization, their very
status as a role model may be become seriously compromised if they
have no true secure place within the organization. The promise they
offer to other young women and minorities ("you can make it here
too") may be a hollow one.

Strategic role models, by contrast, inspire study, emulation, and
admiration, but not celebrity worship, or adulation. The 2005 report
addresses the limits of role models for Arab women that have become
too individualized. It asserts that reducing the gender empowerment
deficit in the Arab world calls for more than a "symbolic makeover"
that lets a few Arab women advance at the expense of the many. The
report advocates "strategic" thinking about Arab women's empower-
ment at the societal level, by which it means finding ways for Arab
women to attain a "critical mass" in positions of leadership and power.
But what might such a strategy be? The report divides its answers to
this question into two parts. The first part is to ensure the short-term
legal enforcement of Arab women's rights so that all barriers to devel-
oping their capabilities to their full potential are removed. To this end,
the report calls for the protection of women's rights in the home and
beyond and the guarantee of legal and institutional changes in

compliance with the UN Convention on the Elimination of All Forms of Discrimination against Women (CEDAW). It further calls for affirmative action practices in the hiring of Arab women, at least until women reach a critical mass that would make such policy unnecessary. The second part, even more ambitious, calls for a radical longer-term shift in societal thinking that would ensure that Arab women, competitively educated and trained, would be accorded fair access to leadership positions systemically, as an unexceptional cultural group rather than as a "one-token-at-a-time" cultural exception. Planning for such a seismic shift calls for a new ideology about women in Arab societies and new social movements to help spread it. These new social movements would depend, according to the report, on networks of women and men working at the national and trans-national level across the Middle East and North Africa. Individual female role models can certainly fit into this strategic planning but, in order to do so, their personal example must be accompanied by strategic thinking. In contrast to individualized female role models, which present Arab women of achievement to younger Arab women without strategies for reproducing their success, strategic female role models seek to unify personal examples with the replication strategies required to build critical mass.

Our corpus of 178 news briefs includes twenty-four that reference Arab female role models. Table 11.1 breaks these briefs down between individualized and strategic role models.

Number of Role Model Stories	Number of Individualized Role Model Stories	Number of Strategic Role Model Stories
24	6	16

Table 11.1 Breakdown of role model stories between women presented as individual vs. strategic role models. This breakdown does not account for the two "role model" stories (discussed below), in which Arab women are presented as role models for audiences other than Arab women.

As Table 11.1 indicates, six of the twenty-four (25%) "role model" news briefs refer to individualized role models. They present a female achiever whose exploits cannot easily clone other females in her image.

Females who remain individualized role models can certainly be deserving of admiration and be rightfully inspiring to young women. We do not mean to criticize individualized female role models as a category, but simply to call attention to the lack of a strategic connection between their personal example and well-thought-out pathways for generations of women to follow. The following section presents examples of the strengths and limits of the individualized Arab female role model.

Individualized Female Role Models

Sometimes a female earns recognition as a role model on the basis of factors that are easy to admire but hard for younger women to emulate. A good example is a woman who is promoted into a new position because of continuous years of competent and faithful service. The reasons why she is recognized may seem beyond younger women seeking to break in. A case in point is a news brief from *Asharq Al Awsat*, out of Syria March 24, 2006, that discusses the appointment of Najah Attar as the first Arab woman in Syria to reach the position of vice-president. Syrian President Bashar Assad had recently issued a decree naming Dr Attar to that position, which authorizes her to administer certain cultural policies under his direction. On the positive side for projecting a career path for masses of younger women to follow, Dr Attar seems to have risen through the ranks without strong family connections. She is identified as the sister of Sheikh Issam Attar, who headed the controversial Muslim Brotherhood in Syria in 1961 and has lived in exile for decades. She has exceptional educational credentials, especially for a woman of her generation, having received her baccalaureate degree in 1950 and being later awarded a PhD in Arabic literature from Edinburgh University. Nonetheless, she is hardly a new face on the scene, taking up a brand new challenge. While the title of vice president may be new, Dr Attar's promotion appears to be an award for loyalty and longevity more than an opportunity for upward mobility. She had been Minister of Culture for the past twenty-four years. And despite the reference to her being a pioneer (viz, first Arab woman to reach vice president), she was seventy-three years old at the time of her promotion, not an age that new generations of women

might aspire to wait for in order to begin setting trends. Even if one acknowledges that her career trajectory is admirable and even inspirational, one must wonder how a record of twenty-four years of service will seem imitable to younger generations of Arab women with not one day of work experience.

Female role models may also fail to generalize their experience to younger women because of factors that lie at the other end of the continuum. Rather than focusing on the day-to-day competencies required to land a high-profile position and discharge its responsibilities flawlessly each day, press attention may tend to focus on the woman's celebrity status, giving the appearance that she was "cast" for a role rather than recruited from a large anonymous pool that remains available for future recruitment. Earlier, we met Buthaynah al-Nasr in an *Elaph* news brief (pages 138–39) that profiled her as the first Saudi newscaster on Al-Ikhbariyah TV. There, we made a point of how the brief's reference to Ms al-Nasr's educational credentials helped justify her appointment to a new role for Saudi women. Here, we point out that the brief fails to present her as a woman of achievement with transparent and transferable competencies that younger women can learn and practice. There is no talk of why Ms al-Nasr was chosen for the position, or of how her selection can open regular routes of entry for future Saudi female newscasters. There is, however, more tabloid-like talk of her "black head-dress cover[ing] her shoulders," the way she places her hands "in a semi-circle" on the table, and her "confident eyes and serious features", which clearly captivate the reporter covering her story. The brief notes that her on-air appearance represented "official recognition" of female television announcers by the Saudi government, but this shifts the focus from her personal accomplishment to the official decision-making of the Saudi government, which may have its own public relations interest in manufacturing a "first for women." As the Saudi government is given no voice of its own in this brief, it is impossible for the English reader to know whether Ms al-Nasr's appointment indicates a real policy change or whether the government has agreed to let her slip through as a token celebrity so that it can put a stop to the criticism that it bans female newscasters while still, for all practical purposes, banning (most of) them.

Female role models may also fail to generalize their experience to younger women when their achievement feeds off of family connections and nepotism, even if the role model protests to the contrary. A brief of an *Asharq Al-Awsat* article from September 28, 2006 from Egypt, reports that Ayman Nour, head of the Egyptian opposition party, Al Ghad, and a critic of President Mubarak, and who had been jailed on accusations of forgery, has been reprieved for health reasons and was scheduled to be released from prison at the end of the Ramadan holiday. The brief points out that the pardon coincided with Al Ghad's recent softening of its criticisms of the Mubarak government, but also came at a time when there were deep frictions within Al Ghad itself. In particular, several officials within the party had attacked Nour's wife, Jamilah Isma'il, who holds the position of assistant secretary general of Al Ghad and whose name had recently been put forward for the higher and more prestigious post of deputy head of the party. To fend off accusations of nepotism, Isma'il explained that she had refused the position when she had been asked to take it several times previously, because of her lack of experience and because she "feared that her promotion might be explained as because of her status as the party leader's wife." She further agrees to stand for the position in an open election, which, she explains, is the method by which she took her current position.

Sometimes female role models leave little to imitate because they owe their success to happenstance more than to achievement. This case is apparent in an *Elaph* brief of October 25, 2006 out of Bahrain that discusses the November elections in that Gulf state. The brief describes the intense jockeying for provision of candidates among the Sunni tribes in the Southern Governorate. The six constituencies of the Southern Governorate, controlled by the Arab tribes, had put forward twenty-six candidates, all affiliated to Islamic societies. Latifah Al Gaood, whom we met in chapter 6, (page 95) became a woman of note in this region because her chief election rival withdrew just before the deadline for nominations. She was declared an uncontested winner in the national election to parliament even before the voting took place and became by default the first female parliamentarian not only in Bahrain but in the entire Gulf region. In Ms Al Gaood, we have a woman who attained fame and authority simply by throwing her hat

into the ring. However, by winning by default, a rare contingency impossible to plan for, she left no blueprint for a successful election strategy for other women to follow.

Arab Women as Role Models for Other Populations

Thus far we have seen that continuity (Najah Attar), celebrity (Buthaynah al-Nasr), nepotism (Jamilah Isma'il), and rare contingency (Latifah Al Gaood) are all factors that may limit the general influence of role models that are drawn too individualistically. There is, however, a middle ground between the individualist female role models discussed above and the strategic role models we discuss below, which is occupied by Arab women who are held up as role models for constituencies other than Arab women, typically Arab men and Westerners (men and women). These Arab females are not necessarily individualist on any of the criteria presented above, but neither can they be strategic for recruiting Arab women into positions of power because Arab women are not the primary audience.

For example, in a news brief from *Al Quds Al Arabi* on November 8, 2006, Abdel Beri Atwan,[4] the editor-in-chief and the first editor of a pan-Arab daily to have a woman serve as associate editor, holds up the courage of Arab-Palestinian women as a standard for Arab leaders to learn from. He excoriates Arab leaders for lacking the courage to fight the 2006 Israeli incursion into Gaza and praises the courage of the "faithful girls and ladies" in the Gaza city of Bayt Hanun who defiantly marched to a mosque and shouted "Allah is greatest, Allah is greatest" in solidarity with Gaza gunmen who were trapped by Israeli tanks. Some women were wounded and others killed in the mayhem. Atwan extols the women of Bayt Hanun for their "dignified uprising" and the unblinking courage with which they met Israeli bullets head on with their "faith-filled chests." These women, according to Atwan, were willing to sacrifice themselves to defend their land and religion, and he is reminded by the actions of these Gazan women of a past courage to fight Israeli aggression that he no longer recognizes in Arab leaders. He argues that the actions of the women from Bayt Hanun prove that "they are more manly and courageous than all the staff generals and commanders of the Arab armies, without exception." He complains

that Arab leaders are in command of billions of dollars' worth of weap-
onry, and yet have lost interest in Gaza and wash their hands of it. He
laments the fact that the Arab League used to call meetings during
times of crisis like this but now they will not even do that. Now, Atwan
regrets, everyone runs away from the problem. The President of Egypt
is on a tour of Central Asia. The King of Saudi Arabia is inspecting a
town on the Yemen border. The then Arab League Secretary General
Amr Musa has gone to Doha. And when these leaders are not running
away, Atwan complains, Arab governments distract themselves with
petty pursuits, such as fighting any small slight to their honor when-
ever Al Jazeera stings. The government of Tunisia had no time for
Gaza, but it did have time to close an embassy in Qatar in reaction to
an Al Jazeera report it did not like. The government of Jordan has no
time for Gaza, but it had time to recall its ambassador to Qatar for a
report it found unfavorable. Atwan presses his case with biting
contempt:

> Arab dignity shakes because a guest on a TV channel expressed
> opinions in a TV show that did not appeal to governments, but it
> completely disappears when Israel desecrates the honor of chaste
> women, kills the innocent by the tens, and blows up mosques and
> worship houses.

Atwan reserves his strongest vitriol for the first ladies of Arab coun-
tries. Comparing the rugged heroic women of Bayt Hanun with the
pampered and cosmetically-enhanced first ladies of Arab countries,
Atwan, his words dripping with a sarcasm that translation cannot
suppress, openly wonders how the first ladies reacted to the scenes of
these honorable women sacrificing themselves "if any reaction can
appear on such decorated faces."

A few days after Atwan's explosive remarks against Arab first ladies,
the latter found some space in the press for some low-key rebuttal. A
brief of an *Al Hayat* article of November 14, 2006 presents an inter-
view with HH Sheikha Sabeeka, the first lady of Bahrain, who was
serving a two-year term as President of the Arab Women Organization
(AWO), a coalition of Arab first ladies whose presidency rotates from
one first lady to another. The AWO was conceived out of the so-called

"Cairo Declaration" that emerged from the First Arab Women Summit called at the invitation of Egypt's first lady, Suzanne Mubarak. The organization officially came into existence in March 2003 and was about to hold its first biennial conference in Bahrain, with the first ladies of Egypt, Syria, Sudan, the Emirates, Lebanon, and Mauritania, and top representatives of the first ladies of the remaining Arab states, expected to attend.

In the interview, Sheikha Sabeeka noted that the Arab woman of today must negotiate "an insecure environment" and lacks "internal and external peace and security." As if in a rejoinder directed at Atwan on the alleged indifference and inaction of Arab first ladies to Gaza, the Sheikha makes special reference to AWO's concern for the deplorable circumstances of women "in Palestine and Iraq." According to Sheikha Sabeeka, a major concern of AWO is "changing the stereotype of Arab women in the west." She points to various plans her organization is developing to do just that, including visits to international universities, such as Cambridge, where Arab women can engage in dialogue with Western thinkers, opinion-leaders, and media to show that Arab women are more than what the West has pegged them to be. Although they show markedly different tones in their reaction to the Gaza crisis of 2006, Atwan and the first ladies he rebukes share one important point of similarity: they both employ Arab women as role models to teach lessons to audiences who are neither women nor Arabs.

Strategic Female Role Models

Let us now turn to strategic role models of Arab women. These are role models deployed with an interest in obtaining critical mass in the next generation. As Table 11.1 indicates, sixteen of the twenty-four "role model" news briefs (67%) focus on building a future critical mass of Arab women achievers. But what sort of future is to be mass produced for Arab women achievers? From our corpus of Arab news, two categories of future emerged. One is a future in which women are active in Islamic organizations that look inward and have little interaction with Western secularism and global development. The second is a future in which women participate in organizations that interact with the

secular West and seek to balance their religious heritage with global development. Both images of the future compete for the attention of Arab girls and women, with upwardly mobile girls and women as their prime targets.

Strategic Role Models Formed from Islamic Principles

Islamic movements for women, called piety movements in Egypt (Mahmood 2005), are expanding across the Middle East and Europe and are devoted to helping Arab women explore their identity in Islam without having to rely on male clerics or their male relatives to interpret that identity for them. Female Islamic movements meld into state activism (aka political Islam) when they join forces with male groups interested in putting pressure on state leaders to adhere more closely to the principles of Islam. Interviewing female Islamist activists from Hizbollah and the Egyptian Muslim Brotherhood, Abdel-Latif and Ottaway (2007) found that women often enter these male-dominant organizations at the periphery, carrying out charity and community work and outreach, and that over time their roles often evolve into more central roles of leadership shared with men.

Of the 178 news briefs in our corpus, one brief references the most well-developed organizational plan for passing the wisdom and achievements of one generation of Arab women to another, which would be the envy of the authors of the Arab Human Development Reports in terms of using female role models strategically to build critical mass. This plan builds its critical mass in the name of Islam, not globalization. The organization in question, reported in bare outline in a brief from *Al Hayat* of May 12, 2006, dateline Damascus, grew out of a secret Islamic women's society known as the Qubaisiate. The group is named after its founder, the Syrian sheikha, Munira al-Qubaisi (born 1933). The society stays underground because it is officially banned by the Syrian government, but members can identify one another by the distinctive way in which they tie their veils. They gather for meetings in homes to study the Qur'an, Hadith, Sunna and classical doctrines of Islam. Women are leaders of the movement and Syria has witnessed the rapid spread of Qubaisiate madrasas across greater Damascus and in pockets throughout the country.

The immediate focus of the *Al Hayat* brief is a recently released study on the Qubaisiate by Usamah al-Sayyid. His report overviews some of the basic teachings of Miss Munirah al-Qubaisi and other women who have influenced the organization, such as Amirah Jibril and Sahar Harbi from Lebanon, and Fadiyah al-Tabba from Jordan. The principals of the study had tried to interview Miss al-Qubaisi but she has avoided the public eye for years and now lives in quiet seclusion in a Damascus neighborhood protected by a small retinue of friends and followers. The study uncovered that two members of the Qubaisiate, Dr Samira al-Zayid and Su'ad Maybar, are reputable scholars of Islam. Al-Zayid (1987) has authored a six-volume work called *Al-Jami on the Prophet's Life*, and Maybar (Maybar n.d.) authored the book *Monotheism in the Koran and the Prophet's Tradition.*[5] In light of the growing power of the Islamist movement in Syria, the Syrian government has taken some preliminary steps to acknowledge the Qubaisiate and declare it a legal organization. The Syrian government's reasons for this show of support are based on two impulses that live in tension. The first impulse is to accept that political Islam (viz., the striving for a pure Islamic state) is worthy of public recognition and deserves mainstream attention. The second impulse is to recognize that political Islam poses a threat to state security. That the Qubaisiate deserves public recognition and that its members constitute a threat to government security are not ideas that can be harmonized but, for the Syrian government, they do make for a marriage of convenience. By making the Qubaisiate a more open and legitimate group, the Syrian government also makes it easier for the Qubaisiate to be monitored. As one Syrian official put it, having the Qubaisiate "[hold] classes in private homes is terrifying," because they are beyond the reach of the government's monitoring equipment.

Nothing in the brief directly captures the organizational inventiveness that the Qubaisiate uses to build a critical mass of girls spiritually enlightened in Islam from one generation to the next. However, that inventiveness is easy to access in English through background research. It is described in a *New York Times* report (Zoepf 2006) that appeared a little over three months after the *Al Hayat* article and describes the explosion of madrasas for girls in Syria. It estimates that some eighty female madrasas are now run in Damascus, educating 75,000 women

and girls; about half the madrasas belonging to the Qubaisiate. To show the intense competition between globalization and Islamic movements for the hearts and minds of Arab women, Zoepf quotes Muhammad al-Habash, both a lawyer and a Muslim cleric, who states that, before the rise of Islamist movements in Syria in the 1980s, we were all told we needed "to leave Islam behind to find our futures." But now, with the rise of movements centered on Islamic spirituality, the future for many Syrians has become the glorious past. "These days," al-Habash says, "most people in Syria will tell you that 'My history is Islamic history.'"

The Qubaisiate employs elaborate recruiting rituals to attract new recruits and finely worked-out fashion codes, as intricate as academic regalia, that indicate the women's advancement as they progress in knowledge and spirituality. Leaders of the Qubaisiate selectively target girls from the ages of five up and from the most well-to-do and well-connected families. From the families that are less wealthy and influential, they admit girls with high academic marks. Like the admissions strategy of an elite US university, this strategy ensures that an invitation to join the Qubaisiate will be seen as prestigious. It is also the best recruitment strategy for expanding membership and growing financial resources to fund the Qubaisiate's activities. This well-to-do core membership gives the Qubaisiate the resources to recruit a wider range of girls and women across the age and class spectrum. A girl thought to be interested is taken to a meeting where she is addressed by the Sheikha on religious subjects and then invited to ask questions. She will see girls surrounding her who have tied their veils by instruction so as to leave "a puff of fabric" (Zoepf 2006) under their chin, the signature of a Qubaisiate woman. Different scarf colors denote different levels of achievement in Islamic knowledge and spirituality: white for new members, black for the most advanced and navy blue for intermediate levels.

Zoepf goes on to explain how women play a strategic role in the Syrian Islamist movement and especially as it connects with state activism. Unlike men, women are harder for the state to detain or jail without causing a public uproar. When the government cracks down on men, it looks strong and powerful. When it cracks down on women, it looks weak, bullying and, worst of all, "fearful of Islam." To hold the

allegiance of various grassroots constituencies, all state governments in the Arab regions must radiate a strong commitment to Islam. To appear to turn one's back on Islam can be ruinous to the image of the power-holder and Arab power-holders are all too ready to capitulate to Islamist movement interests when necessary in order to avoid sending this message. When he was in power (1971–2000), Syrian President Hafez Assad banned headscarves from public schools. With the Islamist movement growing in power in Syria, his son, Bashar, lifted the ban and reduced the number of hours students needed to study Baath Party ideology, availing them of more time to pray in the mosque if they so wished.

The government strategy of accommodating Islamic movements both to curry favor with and keep tabs on them is hardly unique to Syria. It is a central theme in an *Al Hayat* brief from Egypt (December, 30, 2005). A veiled woman, Aicha Abdelhadi, is appointed Minister of Labor. She is a pioneer, the "first veiled Egyptian woman" to have a place in an Egyptian cabinet. Mubarak needed this "first" for public relations more than to make history. According to the brief, the Mubarak government was regularly accused by the Muslim Brotherhood of "fearing Islam" and the word on the street was that he desperately needed a veiled woman in his cabinet to rebut this fear. Abdelhadi, though veiled, is hardly a beacon of Islamic activism. She is a longtime careerist whose working life, as a veiled professional, goes back to the Nasser regime, where she started in 1959 working in a governmental pharmaceutical company as a union activist. She rose through the union ranks and was eventually elected president of the committee for working Arab women in the International Labour Organization (ILO). She is not a devotee of Islamic movements, but she did have the veil going for her and, for the Mubarak government, the veil was enough. As the brief hints, Mubarak was down one "religious" woman in his administration and so he chose a woman with a veil. Mubarak had learned about the importance of the veil the hard way. He had earlier chosen an unveiled religious woman, Dr Zeinab Rodwan, as one of the ten MPs the Constitution allowed him to appoint. Dr Rodwan had majored in Islamic studies and Mubarak had felt sure that her background would satisfy his Islamist constituencies. Unfortunately for Mubarak, Rodwan's not wearing the veil only

fueled speculation among these audiences that Mubarak was afraid of Islam. The appointment of Aicha Abdelhadi, a non-devout woman with a veil, was a sure sign he was not afraid of the veil.

Islamic vs. Globalization Principles as Competing Strategic Role Models and Recruitment Strategies for Achievement-minded Arab Girls

Three points surface from this brief excursion into Islamic movements and the recruitment of achievement-minded Arab girls. First, the Qubaisiate relies on advanced organizational and networking principles to build, sustain and empower a critical mass of Syrian women in Islamic knowledge and spirituality from one generation to the next. The intellectuals behind the Arab Human Development Reports can only envy what the Qubaisiate have accomplished by way of organizing women through strategic role models.

Second, globalization and Islamization differ in ideology but not in organizational methods and strategies. They differ in the desired future they project for the Arab region. Rather than seeking partnership with the West, the Qubaisiate imagine an Arab region that is so under threat of having its indigenous Muslim identity and culture obliterated by the legacy of colonialism and its post-colonial aftermath that the restoration of Arab identity and culture must be the top priority, a priority it embraces and helps organize across Arab borders.

Third, like so many women growing up in traditional societies outside the West in an age of global media, Arab women are "caught between East and West" (Ibrosheva 2007) on hundreds of choices in their daily lives. Their identity is now one of hybrids as they construct their sense of self across geopolitical fault-lines (Al-Malki 2003). They look West to understand the possibilities that exist for individual expression and freedom. They look East to keep their roots strong in family, tradition, and religion. The most extreme expression of a rootedness in Islam in the Islamist agenda is a pure Islamic state, a theocratic vision of governmental organization such as Iran attempted in the 1979 revolution but that no Arab government in North Africa or the Middle East has achieved. The vision of Islamic theocracy in Iran has been more despotic than democratic, violating a

sacred point of Islam: that the believer's free will be respected (Ishlahi 1992). The very feasibility of a pure Islamic state is the subject of much current debate and controversy. Fatah (2008) calls the Islamic state a "tragic illusion." An-Na im (2008) notes that there are so many competing strands of Islam that any practical Islamic state would need to be secular and pluralist, like Western states, in order to guarantee that no single group of believers could unfairly impose their will on other groups. March (2009) argues that one can find some strands of liberal/tolerant thinking in medieval Islamic doctrine that would suggest the philosophical possibility of an Islamic state based on liberal-democratic principles. However, to make his argument practical would require all current believers to voluntarily support these strands of thinking in classical doctrine and to ignore all contravening strands, an unlikely possibility (Hamoudi 2009). The point to take away here is that most political Islamists are unified by their dissatisfaction with current Muslim/Arab governments, which they believe to be too "secular" and out of touch with, if not in fear of, Islamic teaching. However, they are far from unified about what they can agree on, what the practical realities of a true Islamic state would be, and how it would govern.

To sum up, Arab women, caught in the vortex of the competing ideologies of Islamization and globalization, are the prime recruiting targets for both movements. Globalization specialists who cover the Arab world know that the gender empowerment deficit is the largest and most challenging human resource deficit standing in the way of Arab economies reaching their full potential. Specialists in Islam know that Arab women are the sacred keepers of home, family and tradition and if Arab women turn away from the project of restoring an Arab cultural identity that has been fractured by colonialism and the post-colonial era, the Arab identity will forever remain incoherent. One way to define a Muslim/Arab woman who "wants it all," we were told in one interview, is to understand a woman who is open to the call of both ideologies and who does not wish to foreclose either future. For part of the day, she seeks modernism and for the other part home/family/tradition/Islam, and she chooses to live her life one day at a time, each day forgetting that she is supposed to choose.

Strategic Role Models for Global Development

The intellectuals behind the Arab Human Development Reports imagine an Arab region that maintains its own traditional identity and culture but nonetheless competes head-to-head economically, politically, and culturally with the likes of North America, Europe, and China. They understand the importance of female development from a global perspective and not just from an Arab perspective. They are well read on research that shows women to be a vital asset to any economy wishing to compete into the twenty-first century. They understand that economies of this century will not be able to compete if they keep half their potential workforce at home (Chamlou 2004; Kristof & WuDunn 2009). They also understand that women bring more than just numbers. They bring increasingly *preferred* numbers with which to develop an economy on a global stage (Wittenberg-Cox & Maitland 2008). Women are becoming an ever growing part of the world's skilled labor market, an ever growing part of the world's purchasers, and an ever growing part of the preferred group that manufacturers worldwide wish to sell to.

Let us now turn to news briefs that address the strategic development of critical masses of Arab females for global development. While we found sixteen such stories (Table 11.1), we shall focus on the four that seemed most directly to imply the existence of networks of women strategically poised to help future generations of women to rise through the ranks. Imagine a young woman of estimable achievement who is educated and employed in a reputable profession connected to the worldwide economy, devoted to a set of principles that undergird her professional credentials, and endowed with the courage to uphold her professional standards even when it might be most unpopular and uncomfortable for her to do so. Such a woman of achievement, who can easily inspire young achievement-minded women seeking a global future to follow her path (page 110) and to admire her capability, appeared in an *Al Hayat* brief from March 29, 2006. She is the Saudi lawyer, Reem Al Habib. Reem was twenty-nine years old at the time of the brief with a freshly minted diploma from Harvard law school, where she graduated with honors. At the invitation of Raghad, the daughter of the notorious Saddam Hussein, Reem has just decided to

join his defense team, which can hardly have been a popular move for a Saudi national. But Reem is committed to the rule of law, and its protections, to her mind, must apply even to a murderous dictator. Asked to explain why she would want to defend such a man, Reem answers that her decision is purely personal and represents no political agenda. All she can bring to the case are her professional standards of fairness and her professional expertise in the law of international courts: "I felt I could bring justice in this case." She claims to be "facing a difficult mission," by which most would expect her to mean the geopolitical dissonance of a Saudi woman defending the Iraqi dictator. But Reem is a lawyer through and through and her focus is solely on the case: "I have to familiarize myself with the facts and developments of the case so far and build a generic vision that would help guarantee my client's rights." One can appreciate from this simple transaction why Reem graduated with honors from Harvard. Many would think that Saddam's atrocities make the law too good for him, but Reem understands that if Saddam does not deserve protection under the law, no one does. She comes across as a principled human being and an exceptional lawyer who will inspire many female attorneys after her.

In a second brief we looked at earlier, from *Al Hayat* on June 7, 2006 (page 122), we saw women celebrating the precedent-setting appointment in Bahrain of Muna Jassim Muhammad Al-Kawari to the supreme civil court. We identified this woman in chapter 7 as a woman of pride. After paying her obligatory and, it appears, heartfelt homage to the King of Bahrain, Sheikh Hamad Bin Isa al-Khalifa, Al-Kawari offers further strategic insight into why new generations of Bahraini women will be entering the judiciary in the near future. It is because, she says, there is a critical mass of young Bahraini women who are now sharing experiences and ambitions similar to her own. They are being groomed in the district attorney's office and looking ahead to ambitious futures, just as she had. These waves of young women, she is quick to point out, share the career thrust and trajectory that launched her.

A third brief, from *Al Hayat*, December 29, 2005, references a woman, Nadia Bakhraji, whom we met in chapter 9 (page 158) when citing examples of employed women. Nadia, an engineer, was elected to the board of a Saudi engineering association. She says that one of

her main goals on the board will be to convince Saudi females who currently work as engineers outside the country, many her former classmates, to return home and make their living in the Kingdom. Nadia confesses that, as a young engineer just starting out sixteen years before, she was tempted many times to accept jobs abroad and chose not to. She confesses that she faced "difficulties" working in the Kingdom and now, with her new position on the board, she is sensitive to these recruitment challenges and wants to make the Kingdom the employer of choice for its native daughters who seek careers as engineers. With her background, Nadia is perfectly placed to ensure the building up of a critical mass of new female engineers trained within the Kingdom and to draw back a significant number of Saudi female engineers from the Saudi diaspora.

A fourth and final brief from *Elaph*, dated October 20, 2005, highlights the vast networks of Saudi female entrepreneurs that we have encountered twice before, first in chapter 7 (pages 106–07) when meeting women of initiative planning conferences, forums, workshops, and other strategic gatherings, and then again in chapter 9 (page 158) when meeting working women. Now we meet these women again in a different guise – as links in a vast chain of female networks seeking to build critical masses of female know-how and empowerment through strategic organization. These chains of self-propagating female networks are what researchers from the World Bank call "Women helping Women" networks (Chamlou & Yared 2005, 62; Chamlou, 2008), which are considered engines for building female capacity in the Middle East. Chamlou and Yared (2005) compile a country-by-country listing of organizations designed to construct Arab "Women helping Women" networks. Some of the major players include the UN Economic and Social Commission for Western Asia (ESCSWA), Arab Women Connect (AWC), the Center of Arab Women for Training and Research (CAWTAR), and the Arab International Women's Forum (AIWF).

The AIWF, a non-profit organization based in London, occupies a unique place in the Arab world as the main organization committed to showcasing female Arab entrepreneurs on a world stage and putting Arab female entrepreneurs in conversation with women's business forums across the globe. Founded in 2001 by Haifa Fahoum Al Kaylani,

AIWF partners with powerful international organizations such as the World Bank, the European Commission, the European Parliament, and the Commonwealth Business Council. It is affiliated with corporations such as Shell, PepsiCo, Merrill Lynch, IBM, and PricewaterhouseCoopers – entities that understand the importance of developing Arab women for top positions in multinationals.

Despite Western preconceptions, business for Arab female entrepreneurs is booming and the advent of micro-credit has caused an explosion of enterprises set up by Arab women. In 2005, the World Bank estimated that there were some 22,724 female micro-entrepreneurs in Egypt, 8,335 in Jordan, 4,216 in Lebanon, and 32,354 in Morocco (Chamlou & Yared 2005, 47). The AIWF is represented on councils and conferences of the World Economic Forum, the US-Arab Economic Forum, the Council of Europe, and the Arab Financial Forum. Recognizing the interdependence of financial power and political power, the AIWF held a conference in June 2008 in Washington DC in association with the World Bank on "Realizing the potential of Arab Women in the private and public sectors" (AIWF 2008, 1).

The AIWF has also played a key role in book publishing projects that introduce to an international readership Arab female entrepreneurs who provide role models for a rising generation of Arab women.[6] One such project is a handsome coffee-table-sized book crafted by the famed photographer/author Jacqueline Hassink (2008). The book features thirty-six successful female entrepreneurs from nineteen Arab countries/territories (including Palestine and Iraq). To demonstrate that Arab women entrepreneurs can succeed outside the home without forfeiting their duties in the home, Hassink takes a glossy color photograph of each woman's boardroom and family dining room. Interested to show off these women as strategic role models who can be replicated given the appropriate environmental support, Hassink points out in the introduction that most were well-educated and enjoyed the full support of their families. A belief in female equality is also essential. As Al Kaylani mentions in her foreword: "These women – and so many unsung others – are part of a larger movement towards greater equality in the Arab world" (Hassink 2008, 8). As we shall see below, the assumption of female equality has been borne out in Western research

as a fundamental pivot for female advancement. Al Kaylani harbors no illusions about how much has been accomplished and how much remains to be done. She recognizes that the Arab women featured are still exceptions. They represent the "face of what can be" and indicate that behind them are "the faces of millions of other women who, as yet, have no voice." She has a long term vision and will not be robbed of hope. She looks forward to an "upcoming generation" of Arab women whose success will come from their "ambition," their "access to education and skills," and "to women" featured in the book, "who forged the way for them" (Hassink 2008, 8).

Conclusion

In this chapter, we have considered some basic relationships established in the literature between female aspiration, achievement, and role models. The literature suggests that female achievement spurs aspiration and that female role models can inspire achievement. The inspiration of female role models can work both at the individual and organizational/strategic level. At the organizational/strategic level, role models are not only inspiring but replicable. Strategic role models for Arab women serve different ideologies. Islamic role models call women to take a more active role in their religion. Secular role models call them to take a more active role in the global economy. These different networks of female role models compete for the attention of achievement-minded Arab women. There are many shrill "clash of civilization" (Lewis 1990, 2002a, 2002b; Huntington 1996) voices in both East and West that seek to drive an irremovable wedge between globalization and global Islam. Most common thinking about the networks conceives them as absolutist and mutually incompatible, but there remains room for uncommon thinking that can render them less incompatible through compromise if not through principle. The promise of compromise comes not from the intellectuals but from the many Arab women who already forge these compromises in hundreds of quiet ways in their daily lives, the women who, with one ear to the globe and another to their family and religion, seek hybrid identities. They wear Western clothing under their *abayas*, rely on Facebook and Twitter, seek educational opportunity and economic advancement in a

gender equal society, yearn for freedom and human rights, and want to remain respectful Muslim women (Krahe 2011). They want a place on the world stage with their religion visible and respected. These women already combine global and Islamic networks through hundreds of private negotiations, so it seems outlandish to think that, as a matter of principle, these networks can never cross. We need instead superior theoretical frameworks and principles that build upon the lives of these hybrids where the networks already cross. And we need to explore the role men can play in helping them cross successfully. We will begin to glimpse some of these frameworks and principles in chapter 14.

12: *Barriers to Empowerment*

Were woman to 'unsex' themselves by claiming equality with men, they would become the most hateful, heathen and disgusting of beings and would surely perish without male protection.

Queen Victoria (recorded in Victoria's journals 1870, cited in Sutton 2004)

We still think of a powerful man as a born leader and a powerful woman as an anomaly.

Margaret Atwood (cited in Hengen & Thomson 2007, 336)

There is a place in hell reserved for women who do not help other women.

Madeleine K. Albright (cited in Pyke 2008)[1]

In the previous chapter, we focused on news briefs about Arab women who have achieved some level of empowerment. Empowerment lies over the development rainbow and we examined some Arab women role models who have risen to empowered positions and inspire younger generations to follow in their path. In this chapter, we focus on empowerment as a process and a struggle and we review the news briefs in our corpus that illustrate some of the substantial barriers that stand in the way of Arab women, and women worldwide, attaining empowerment.

The world's workforce contains males and females and women cannot rise to the top without competing against men as well as women. The organizational strategy of the Qubaisiate works as well as it does, in part, because it does not seek to compete in a man's world. Women serve Islamic groups best in roles that are parallel with men's roles and non-overlapping. Islamic groups look East but not West. By contrast, the Arab woman who looks to globalization as an answer for her life,

or at least for her work-life, will need to compete both Westwards and Eastwards. Rising in a man's world is a challenge for woman across the world. What does the literature have to say about it?

The Male and Female Contributions to
Good Leadership/Management

Whereas there is much moral rhetoric in the US about the importance of increasing gender diversity in leadership positions, there were, until recently, no hard empirical data to show that gender diversity leads directly to an organization's greater productivity or profitability (Braun Consulting 2004). But in 2008, Cristian Dezsö of the University of Maryland and David Gaddis Ross of Columbia University (Dezsö & Ross 2008) were able to provide the first evidence that having women at senior management levels is, on average, good for business and indisputably advantageous for specific kinds of businesses. The researchers noted that a glass ceiling has traditionally hampered American women from entering the senior management of American business. According to the ExecuComp database of Standard & Poor's, less than 500 of the largest 1,500 US firms in 2006 had promoted even one woman to their senior management. Only thirty had a female CEO. Prominent female CEOs in America are so rare that they count as minor celebrities and after their stint in the boardroom, often run for elective office; examples are Meg Whitman at eBay and Carly Fiorina at Hewlett-Packard. According to the ExecuComp database, only 3% of Fortune 500 CEOs in America were women in 2006, with little increase noted by the end of 2011.

Dezsö and Ross wanted to know whether companies who fail to include women in their senior management are hurting themselves. To answer this question, they studied the 1,500 largest US firms and tracked various performance metrics of each firm, such as its return on assets, its return on equity, and its annual sales over a fourteen-year period (1992–2006). The researchers compared these metrics with the percentage of women holding senior management positions in the firm concerned and found that having women in senior management, even one woman, was positively correlated with higher numbers on these metrics. Put a woman on your senior management team, they

found, and, on average, your business will do better. What about making a woman the CEO of your organization? Dezsö and Ross found that, for companies with a woman CEO, the positive correlation, curiously, did not hold. They have no definitive explanation for this finding, but conjecture that there may be something special about the CEO position – the need to be tough and an inflexible "bad cop" perhaps – that neutralizes whatever overall benefit a woman may bring to that position.

So women in senior management roles, though not as CEOs, help the bottom line of a company. But do they help all companies equally? Are there some companies that female senior managers are less likely to help? And are there companies that female senior managers are more likely to help? Breaking their data down further, Dezsö and Ross found that female managers benefit a company most when the company puts a strong emphasis on knowledge and innovation, and fosters a democratic and participatory rather than autocratic culture of decision-making. These findings mesh well with the research on group intelligence cited in chapter 6. On average, women have higher group intelligence than men (Woolsey et. al. 2010) and are better able to lead teams by encouraging respect, listening, and participation – ingredients that bring out the best in team members when weighing information in order to make decisions. When a company's bottom line requires an open decision-making environment with democratic give-and-take, adding women with high group intelligence, Dezsö and Ross found, yields positive outcomes. However, women's special skills of group intelligence do not add value to the older male-dominated industrial and manufacturing sectors – ship-building, steel-making, mining, heavy manufacturing, construction – where a lone male boss needs only to bark orders to a labor force with the physical size and skill to carry out his orders (Pollack 1999; Kindlon & Thompson 2000; Snow 2011). James MacGregor Burns (2004), the famous historian of leadership, noted that the old leadership model of command and control, with a single boss controlling all the decision-making power, is now obsolete. In the new information economy, where expertise is distributed and team decision-making is vital, the leadership model must be, in Burns's word, "transformational," with organizations needing constantly to reinvent (transform) themselves not only to keep

pace with the incessant flow of ideas and innovations but to get a step ahead of the competition. This requires a transformational leader who can convene team members with diverse knowledge and lead the team to decisions that are both time-critical and democratic. Women, not surprisingly, as Burns notes, are well-equipped to fill roles as transformational leaders.

Dezsö and Ross's research complements older studies of leadership that had found that the best management practices combine stereotypically male and female characteristics (Fondas 1997). Good managers are found to "initiate structure" and to show "consideration." Initiating structure is the stereotypical male trait of taking command, assigning roles, allocating tasks, and monitoring performance. Initiating structure conjures up the image of the leader as bold commander, take-charge decision-maker – the leader as decisive father. Consideration is the stereotypical female trait of making sure everyone is accounted for and on board, and no one is left behind, and that the organizational climate is welcoming, open, friendly, participatory, and accommodates individual difference. Consideration conjures the image of the leader as helper, supporter, and listener – the leader as the nurturing mother.

The literature suggests that one cannot be an effective leader without the capacity to incorporate both gender roles into one's leadership repertoire. In a comprehensive meta-analysis of seventeen prior research studies conducted to find out the qualities of effective male and female managers, Dobbins and Platz (1986) found that prior findings converged on one central truth about effective male and effective female leaders: to be effective both "male and female leaders exhibit equal amounts of initiating structure and consideration." This central truth means that the best leaders must know and apply the repertoires of both stereotypical males and stereotypical females. If you want to be an effective leader, you must know how to bring group intelligence to the decision-making (female stereotype). But you must also understand there remain contexts in the life of a manager when the buck stops only with you and, in these contexts, you must accept sole responsibility for the decision-making and communicate your decisions for others to follow without mincing words (male stereotype).

The best leaders combine the stereotypical repertoires of both sexes. That is the consensus on the research on leadership. Yet other research

has found that women as well as men in the West have cultural biases – blindspots – that make it hard for them to perceive or acknowledge the female contributions to leadership. The traditional bias that a leader is a crusty "captain of his ship" turns out to be hard to kill. In an ingenious study designed to expose these blindspots, John Johanson asked males and females to rate ten laser-scanned impressionistic faces (five male-like, five female-like) on six dimensions: masculinity, femininity, androgyny, structure-initiating, consideration-giving, and leadership qualities. Females as well as males in his study consistently ranked the male-like faces as high in masculinity, structure-giving, and leadership, and low in femininity, androgyny, and consideration. Females as well as males in his study consistently ranked the female-like faces as high in femininity, androgyny, and consideration, and low in masculinity and leadership. Both his male and female subjects were blind to seeing consideration for others (empathy) as an important ingredient of leadership. Such cultural blindspots, Johanson concluded, encourage societies across the globe to "think manager-think male" (Johanson 2008, 788; see also Schein 2001). Such thinking, and blindspots, are constantly reinforced in the language practices of men and women in the workplace.

In her 1995 book that helped define the subject, Georgetown linguist Deborah Tannen found in her study of male and female language in the workplace, *Talking from 9 to 5*, that women's talk from 9 to 5 tended to focus on community, inclusion, and good feelings. Women tended to sacrifice their own image as nose-to-the-grindstone workers to make others look good. Men's talk from 9 to 5, by contrast, focused on status-seeking, status confirmation, and competitive gamesmanship. Both male and female discourses, Tannen argued, are vital to the life of the organization ("Both styles make sense and are equally valid in themselves, though the difference in styles can cause trouble in interaction" [Tannen 1995, 23]). Trouble may ignite, for example, when men interpret women from their language practices as unambitious and women interpret men from theirs as destructive of the office esprit-de-corps. In a later study, *Gendered Talk at Work*, similar in spirit to Tannen's, Janet Holmes of Victoria University of Wellington and Project Director of the Wellington Language in the Workplace Project (LWP) relied on LWP's archive of thousands of transcriptions

of male and female conversations and interviews across a variety of worksites to conduct her investigation of language and gender differences in workplace practices. Among other studies, she examined the different ways in which men and women told stories on the job. Her findings were similar to Tannen's. She found that men tended to tell stories about themselves that put them in strong agent, problem-solving roles, solicitous of credit; while the stories women told tended to put them in more self-effacing roles that cast less spotlight on themselves and more on the "face needs" (Holmes 2006, 188) of their listeners.

Cultural blindspots also affect and compromise research on gender. Ely and Padavic (2007) reviewed twenty years of research on gender difference in organizations and concluded that a substantial number of studies were based on erroneous assumptions, such as the assumption that the leadership qualities of men and women are based on genetics and early socialization and that these gender differences can be studied apart from organizational culture. The problem with such research, according to Ely and Padavic, is that it often evaluates a woman as a poor leader only because she is put in charge of an organization dominated by male biases about leadership. Unless the woman seeks to emulate a male in every aspect of her job and so forfeits any advantages of her gender, the organizational culture will already have defined her as a poor cultural fit. And research on female leaders in organizations that overlook this bias will, according to Ely and Padavic, wrongly blame the woman for failing on her responsibilities to the firm. Such hidden bias and double-binds haunt women managers in organizational life, and run so deep and in so many tangled directions that Eagley and Carli, writing for the Harvard Business School Press in *Through the Labyrinth* (2007), have argued that we had best retire the word "glass ceiling" and replace it with the word "labyrinth."

Cultural Blindspots and the Importance of Critical Mass

In the previous chapter, we noted that achievement spawns aspiration and that strategic role models that build critical mass can help inspire achievement. But in the context of the present discussion, it is important to understand that strategic role models and the critical mass they

build, serve an additional function. They can help to repair cultural blindspots and enforce new ways of seeing that go against the cultural grain. They can call into question the biases that make people think male when they think leader. At the same time, women can enforce these new ways of seeing only if they have the numbers necessary to make the truth enforceable as well as apparent.

Male leaders have many unconscious reasons for focusing attention on their maleness and its contribution to leadership. Female leaders have a counter-bias. Given the need for both gender traits in leadership, the best way to ensure that both get their due attention is to balance the bias demographically. The balance, moreover, must be in rank and not just in numbers. Investigating the power of demography, Ely (1995) found that bringing in large numbers of women at lower ranks does not change the dominant culture of a male organization. The act of bringing women into visible and parallel positions of leadership with men must, according to other research, be developed within a firm as an active recruitment policy (Calás & Smircich 2009; Calás, Smircich & Bourne 2009).

Can Feminism Matter?

The research just cited indicates that qualified women rise best among men when they rise together. There is strength in numbers as well as in power. But are women really so united? Do they really have such an all for one and one for all spirit? Can they summon the numbers to form a critical mass of their own? In defining female political solidarity, Scholz (2009) notes that, in order for it to be effective, the strength of connections within the female circle must exceed the strength of the females' external allegiances. Female solidarity strengthens when internal connections are stronger than external connections. Can we call strong connections between women who wish to rise among men in the workplace "feminism"? Can we call strong connections between strong Muslim Arab women who wish to rise among men in the workplace "Islamic feminism" (Wadud 1999; Barlas 2002)? The answer is not obvious because the word "feminism" has come to mean many different things, both good and bad, to many generations, races and classes of women, East and West. In the third world, "feminist" is

often a discredited term, used to reference Western women of 1960s vintage social thinking who seek, naively and paternalistically, to "rescue" the women of the developing world (Abu-Lughod 2002; Mohanty 2003). "Feminist" has also become a discredited word for many Western women born in the 1970s and later, who associate the term narrowly with various negative and polarizing stereotypes, from man-hating lesbians to sociopathic sharks who make family subservient to ruthless career advancement (Kamen 1991). But, despite being held in disfavor in both East and West, has the term lost all constructive meaning?

Henderson-Green and Stewart (1994) were interested in this question and conducted a study to see whether one core idea of feminism (solidarity among women) still had some functional meaning among a subpopulation of eighteen- to twenty-two–year-old American women. They administered a battery of surveys to see whether the women who self-identified as "feminists" held a group identity stronger than woman who self-identified only as "women." Because of the varied and negative connotations of "feminist" just discussed, they found, predictably, that virtually all the women in their sample strongly identified as "women" and a much smaller percentage identified as "feminists." However, this much smaller percentage of self-identified feminists shared much in common that the larger group did not. Among the larger population who identified themselves as "women" and not "feminists," there was no shared consciousness that women shared a common fate, no common acknowledgement of sexism as a problem, no shared sense that societal well-being depended on the well-being and advancement of women as a group, and no shared sense that women were in need of organization and collective action to pursue common concerns and interests and to fight common injustices. By contrast, among the smaller population of women who identified as "feminists," there was a much stronger shared political vision, one that aligned closely to some of Downing and Roush's (1985) categories of feminist awareness – anger aroused by the sexism that they had directly encountered, a sense that sexist attitudes must be regulated if not reduced, a sense of the common fate of women, and a sense that the development of society and the development of women are interwoven.

Half of the story to be learned from this research is that women who identify as "feminists" can still rally themselves toward a common goal. That is the positive half, the half that leaves hope for a brand of "feminism" still helpful for an Arab woman who wants to rise with masses of other women in a man's world. We can see some of these positive aspects of "feminist consciousness" arising whenever women, even Saudi women, speak openly and honestly about cultural barriers that discriminate against them as a sex. Social change depends on direct and candid speech. Feelings of anger/resistance and insistence, the emotional and tonal building blocks of social activism, motivate such speech. It should not be surprising that the attitudes reported in some of the news briefs we examined in chapters 6 and 7, as revealed in the angry and insistent voices of Arab women, may go further toward social empowerment. One example is the brief from *Asharq Al Awsat*, August 15, 2005. We have already considered the Saudi professional women referred to in this brief three times: first to hear their anger (chapter 6) (page 82) then to hear the insistence in their voices (chapter 7) (page 127) and then to take note of the way they took it upon themselves to judge some segregation practices as discriminatory (chapter 9) (page 175). Now, we want to consider their collective consciousness and whether it qualifies as a feminist consciousness. The women quoted in this brief suggest that, when sexual equality and culture conflict, culture must bend in favor of equality. This is precisely the root thinking that the Western research reviewed above identifies as "feminist." However, although we may in principle therefore call their collective consciousness a "feminist" consciousness, it is more important (should the "f" word cause offense) to realize that it is, at base, what Michelle Bachelet, Executive Director of the United Nations Entity for Gender Equality and the Empowerment of Women (UN Women 2011) calls a "stick-together" attitude that can hold on to gains and survive setbacks for women by making the common fate of women and the equality of the sexes two central principles.

The other half of the story is the negative half, the tendency for women to be divided against themselves. Women cannot create the critical mass necessary to have societal impact if they are divided from one another. Is there research that can shed light on this negative

aspect? Research relevant to this problem is explored in an area of social psychology known as social dominance theory (Sidanius & Pratto 1999). Social dominance theory says that all collectives produce internal hierarchies. Some members live in the penthouse. Others live in the basement. A corollary of social dominance theory is called ideological asymmetry, which says that the more an individual believes she belongs to a socially dominant group and values the dominance her group membership accords her, the stronger her attitudes will be in promoting a within-group bias of superiority and rejecting outgroups as inferior. In simpler English, this means that the more you believe a group to which you belong has high status, the more you are likely to show solidarity with members of that group and the more likely you are to keep your distance from those who do not belong to it. In line with the predictions of this theory, Nelson, Shanahan, and Olivetti (1997) found that males who scored highest on a social dominance questionnaire, who believe males have higher status than females, were also most opposed to the idea that women were equal to men. Anti-feminist men, the researchers found, rely heavily on social dominance thinking when they make judgments about the equality of women and men. They perceive that women are inferior *because* they believe, as men, they are the superior sex. Heaven (1999) in a related study found similar judgments among anti-feminist males.

By way of contrast, Nelson, Shanahan, and Olivetti (1997) found that women did not use social dominance thinking when they made judgments about the equality of women and men. Their study included self-identified anti-feminists, non-feminists, and feminists. Despite the negative stereotype of the feminist as a man-hating Amazon who believes women are the dominant sex, no woman in any of Nelson, Shanahan, and Olivetti's self-identified groups scored highly on the social dominance questionnaire. In other words, none, not even the self-described feminists, believed that women had an intrinsically higher status than men. However, anti-feminists, non-feminists, and feminists did hold different beliefs about the equality of women and men as a political value. Feminists saw equality with men as vital to their core political beliefs. This put them in a stable coalition with other women with the same core beliefs who wanted to rise in a world of men. Non-feminists saw equality with men as relatively important

but were worried that equality, carried too far, would strip them of the traditional protections they enjoyed under cultural beliefs of inequality. This put them in a much less stable coalition with other like-minded women trying to rise together in a man's world. Anti-feminists saw equality as a hostile threat to their traditional protections as women and wanted none of it. However, this made it effectively impossible for anti-feminists to build common cause with one another in order to correct the gender injustice they might experience as individuals.

These findings suggest that "feminism" (by whatever name) can be a strategic principle for the organization and coalition-building of females seeking to rise collectively in a world of males on a platform of equality. The research suggests that using the term "feminism" is not really important. What counts is the strategic principle behind the word – the principle that Arab women are willing to stick together in solidarity as equals to men, even though that platform may become, at times, culturally strained and uncomfortable. As we see below, all meaningful efforts towards the strategic development of Arab women for economic and global development involve rough sailing against individuals and organizations that assume that women are not the equals of men.

Cultural Barriers to Equality

Strategies of female development for globalization rely on helping women rise together in a world of men on the basis of their equality with them. Equality is important within these strategies of development as both a logistical and a moral principle. Without equality, there is no basis for women to remain in the coalitions they need to form with other women *to* create the critical mass *to* create the elimination of cultural blindspots *to* create the societal change that is necessary for female development, which in turn is necessary for global development. These multi-step logistics provide crucial support to a strategy of female development. The moral dimensions of equality are also essential for establishing true democracy, not just for women but for men as well. A society built on the rule of democracy and protected by the inalienable rights of individuals is one where one's right to democratic equality cannot be stripped away or forfeited in any circumstances.

This moral principle is a catalyst to the logistical principle. If women know that their equality with men is an inalienable right protected by law, their coalitions to rise together in a world of men will be more secure. But this security depends upon the rule of law being consistently applied to enforce gender equality.

Such consistent enforcement of gender equality is, unhappily, not secure in any region of the world. Even in countries such as Qatar, which invest heavily in female development, and where women outperform men in secondary and post-secondary graduation rates (Chamlou 2004), enforcement of the laws protecting the rights of women is deficient. Article 34 of the Qatari constitution stipulates that "All citizens are equal in general rights and duties" and article 35 states that "All people are equal before the law. There shall be no discrimination on account of sex, origin, language, or religion." However, this is belied by a recent survey on domestic violence in Qatar that sampled 2,787 female students at Qatar University, the national university of Qatar, which enrolls a wide cross-section of women. Of the sample, 2,366 were Qatari nationals, 4.4% of the total population of Qatari women aged fifteen to sixty-four, and 421 were non-Qataris, .4% of non-Qatari females in Qatar across the same age range. The survey found that 23% of the sample of Qatari women and 22% of the non-Qatari women reported being victims of domestic violence (beatings, marital rape, harassment, humiliation, insults) either definitively or to some extent. Yet the study found a serious lack of legislation to protect victims of abuse (Al-Ghanim 2009).

The authors of the Arab Human Development Reports understood that reforming human development efforts in the Arab world required major reforms for Arab women. They understood that the knowledge, freedom, and gender deficits in Arab regions were different aspects of the same problem. Without knowledge assets, a region forfeits it greatest opportunity to develop a diverse and sustainable economy. Without freedom and rights, there are no societal organs to guarantee large segments of the disenfranchised the opportunity and a secure means to develop and contribute their talents. Without a specific focus on women, there is no way to guarantee that the region's largest and most talented disenfranchised group, namely its women, will not be left behind.

One special challenge for Arab governments – as the 2011 revolts made abundantly clear – is that they are far from Western-style democ- racies with a transparent rule of law and open elections of the highest officers. This makes it all the harder to put in place gender equality practices that can be securely enforced, and to motivate ordinary citi- zens to expect accountability from their leaders. A September 20, 2005 *Asharq Al Awsat* brief of an opinion piece written by Hamad al-Majed makes this point in scathing terms. Al-Majed laments that Arab presi- dential elections are "absurd plays" that reveal that Arabs have a greater affinity for oppression than for freedom. He notes that what makes "Arabs look stupid in front of the real democracies" is the insistence of their leaders on winning in elections by margins of 99% to 1%. Is it not time, he deadpans, for these leaders to get better consultants so their margins of victory will not exceed 50% or 60%? He notes that one Arab leader did turn to Western consultants for help, only to be given the advice that he should shed his necktie before making speeches. But al-Majed does not lay sole blame at the feet of Arab leaders, because, as he sees it, Arab societies get the leaders they deserve through the "malignant disease", as he calls the people's "gullibility . . . to oppression." He sees this gullibility running "deep in the structure of the Arab societies, starting with homes, going through schools, and ending at the institutions of the public and private sectors and the intellectual groups and parties." This gullibility translates into the belief that if I am humiliated enough, I will obey and if my leader does the humiliating, his power will seem to me to be even more rightly held, his decision-making impeccable and beyond reproach.

Al-Majed puts the case harshly but it resonates with enough truth to make the authors of the Arab Human Development Reports know that the bright future they project for Arab women requires cultural change as a basis for political change. The authors of the 2005 report, focused on women, use the word "culture" 134 times in their report and in a prominent section the authors insist on Arab women enjoying a "culture of equality" with men (*Arab Human Development Report 2005*, 223).

The authors further understood that a culture of equality is not attained solely by the establishment of women's equality to men. It also includes the sovereign's equality with his people. In the constitu- tional democracies of the West, rights are extended through a

constitution that guarantees them. The sovereign cannot confer or rescind them. In the constitutional monarchies and authoritarian regimes of the Arab region, the culture of equality is guaranteed through the beneficence of a sovereign. Recall from chapter 8 the *Elaph* brief of July 27, 2006 (page 131) and the *Asharq Al Awsat* brief of August 3, 2006 (page 171), both of which offer a glowing first year progress report on King Abdullah's record on behalf of Saudi women against very strong conservative counter-pressures. Were King Abdullah to cave in to conservative forces, the women who have benefited from his policies would forfeit their protections. They are dependent on his good will, and were his policies to be withdrawn, their rights would follow. As enlightened a champion for female rights as King Abdullah may be, what he does for women in the Kingdom depends on his decision-making, not theirs. The women in turn rely on his benevolence without being able to rely on any independent rights of their own. If Saudi women could claim rights in a universal human rights sense, his kindness and their gratitude would be irrelevant to their rise.

Despite these gaps in the Saudi human rights record, Saudi women are not insulated from universal human rights movements. The brief of an *Asharq Al Awsat* article on November 30, 2005 covers Dr Lubna al-Ansari leading the first delegation of the Saudi National Human Rights Association (SNHRA) on a visit to the human rights center in Denmark. Dr al-Ansari is quoted in the brief as seeking "technical cooperation" between the SNHRA and the center and learning from the Danish center's established "expertise." She acknowledges the "cultural differences" between "us and them" but claims that "the mechanisms for dealing with human rights are the same everywhere; these matters do not differ."

However, cultural practices do matter in terms of the enforcement of human rights agreements – and no region cites "culture" as a reason for not falling in line with human rights principles more than Arab regions. Arab countries are notorious for perpetrating what Mayer (1995) calls the "new world hypocrisy" of signing universal human rights agreements with much fanfare without removing any of the cultural barriers needed to enforce them. Arab governments practice their hypocrisy, according to Mayer, by signing the

agreements and afterward inserting their "reservations" based on a broad reference to "Shari'a." These reservations have the effect of nullifying what they have signed. This, at least, is the considered opinion of a leading expert in both Western and Shari'a law (Mayer 1995) and the more recent opinion of an external expert, Dima Dabbous-Sensenig, the Acting Director for the Institute for Women's Studies in the Arab World (IWSAW) at the Lebanese American University in Beirut, who was commissioned by the Division for the Advancement of Women (DAW) in the United Nations Department of Economic and Social Affairs (DESA) to conduct a ten-year review and appraisal of the progress Arab-Muslim countries have made fulfilling the terms of two UN-sponsored agreements that most signed (Dabbous-Sensenig 2005).

The first of these agreements is the Convention on the Elimination of All Forms of Discrimination against Women (CEDAW), a universal "bill of rights" for women that requires all signatories to abolish all laws that are inconsistent with women's equality with men. The second arose from the Fourth World Conference on Women, and is better known as the Beijing Declaration and Platform for Action (Beijing Declaration 1995). Prominent in the Beijing Platform Mission Statement (1995) is that "Equality between women and men is a matter of human rights and a condition for social justice and is also a necessary and fundamental prerequisite for equality, development and peace." The Beijing Platform stresses the universal interest of women in equality and reinforces the Western social science we have reviewed, which deduces that women can rise in a world of men only by "working together and in partnership with men towards the common goal of gender equality around the world" (see item 3 of the Beijing mission statement). The Beijing Platform goes on to say that it "respects and values the full diversity of women's situations and conditions and recognizes that some women face particular barriers to their empowerment." However, any country that signs up to CEDAW is expected to remove all such barriers.

To date, all the Arab countries have ratified CEDAW, with Qatar being one of the last, ratifying it on April 26, 2009. The UAE ratified CEDAW in 2004, but openly acknowledged that its policies toward women were not at the time of its signing in compliance with CEDAW

and promised that they would be revised to comply. All other Arab countries became signatories with reservations, indicating that they accepted the broad framework of CEDAW but refused to accept some clauses because of religious considerations. Dabbous-Sensenig (2005) reports that most Arab countries balk at article 2, which she finds "paradoxical" because article 2 "condemns discrimination against women in all its forms," and is at the heart of CEDAW. Arab countries also balk at article 29, which assumes that any county's reservations with regard to article 2 are temporary and need to be removed. They balk at that restriction because they want the wiggle room to embrace as a permanent position the seemingly contradictory ideas that they champion non-discrimination by sex while at the same time refusing to condemn discrimination by sex. They also balk at article 16, which guarantees that the citizenship of children may pass through either the father or the mother, because most patrilineal Arab countries want to restrict the child to inheriting only the father's citizenship. Dabbous-Sensenig (2005) references her home country, Lebanon, to illustrate what is at issue here. Lebanon has fifteen different religious courts that apply the personal status codes of its many denominations to govern marriage, and each denomination takes different positions on domestic violence, marital rape, divorce, and honor crimes. Some personal status laws require the wife to "submit" to the husband but not the reverse. While Article 7 of the Lebanese constitution asserts the "equality" of men and women, there are no prohibitions against gender discrimination. The Lebanese Penal Code stipulates punishments twice as harsh for female adultery as for male adultery. Male adultery is defined as taking place with the lover in the marital home, while female adultery can take place anywhere. A husband convicted for killing an adulterous wife can plead extenuating circumstances, while a wife convicted for killing an adulterous husband cannot.

Dabbous-Sensenig concludes that there exists a "unified pattern of behavior" (2005, 9) in Arab countries supporting women's inequality to men. In the last ten years, there have been, she concedes, some pleasant surprises for Arab women, such as a more equal personal status code for women in Morocco, the passage of *khula*[2] in Egypt, which, at least ostensibly, made it easier for Egyptian women to apply for divorce, and a newly promulgated law giving Kuwaiti women the

right to vote and run in elections. But these are modest gains, states Dabbous-Sensenig, in the overall picture of the challenges still facing Arab women. Arab countries, as she sees it, have by and large not performed well in ensuring their women the equality protections prescribed by various international human rights treaties.

In chapter 8, we heard high praise for King Abdullah's enlightened attitudes toward Saudi women. What does Dabbous-Sensenig have to say about the state of females in Saudi Arabia? It continues to be, in her words, "the most repressive Arab regime as far as women are concerned," and has made "only modest gains" (2005, 6) in women's education, employment, and in the softening of some segregation practices.

Let us reflect for a moment on the striking tonal difference between the high-minded and hopeful language of the Arab Human Development Reports and the scathing documents of human rights monitors such as Dabbous-Sensenig. The Arab Human Development Reports show off the Arab intellectuals' interest to join the major economies of the twenty-first century. That interest, as a matter of urgent necessity, must include the Arab woman. Yet, if she is to be included, she must have equality with men so that she can rise together with other women in a world of men. Cultural barriers must be removed in order for her to achieve this equality and authors of the Arab Human Development Reports are not afraid to say so and to call for cultural reform. Nevertheless, these reports do remain restrained, if not timid, in speci-fying with crystal clarity the cultural eggs that need to be broken to prepare the omelet of true female equality in the Arab region. These reports are inclusive to a fault. They accommodate a Western/interna-tional notion of women's equality, necessary for promoting economic development inclusive of women, as well as a "religious" understand-ing of equality, embodied in King Fahad's paternal assertion that women are owed special care because "Islam honors women." The reports carry a powerful and optimistic long-term vision that is uplift-ing and admirable and leaves no one offended.

The worry is whether they have enough short-term realism to be impatient with a vision that may never touch ground and will sit on shelves ignored for decades to come. The idealism reflected in such reports also surfaces in some of the news briefs, such as one from an *Al*

Quds Al Arabi article of May 26, 2006 out of Kuwait, which proudly declares victory for Gulf women as if the struggle for women were over and all that remains is the celebration. The brief notes that the Gulf is now witnessing the "unique phenomenon" of "women break-ing the chains." Development for women has become the Gulf's new competitive sport. The brief asserts happily that the Gulf has develop-ment fever with women at the center, and that the Gulf states are all in competition with each other over whose women are reaching highest and advancing farthest. "If Omani women were the first to enter the electoral arena and occupy seats in the parliament . . . their Kuwaiti sisters are about to catch up with them . . . the same could be said about the Qatari and the Bahraini women." Repeating the findings of the *Arab Human Development Report 2002* on the democracy deficit in the Arab region, the brief recounts that Kuwait had been a "dimin-ished democracy" before democracy was "open to women" and now democracy has "two wings" to fly on. It then directly cites the Arab Human Development Reports, parroting their language about how the "absence of women's efficient participation in society alongside men" had been found to be behind "the current retardation and down-fall in the region."

Widely traveled and educated, Gulf women have been exposed first-hand to societies where equal opportunity, freedom of expres-sion, the rule of law, and an independent judiciary are taken for granted, but the brief seems to want to stretch the implications of this to an unrealistic degree. Exposure to these Western principles in one lifetime is a good thing but it certainly cannot, in one generation, or even several, export a century of modernist/democratic thought to Arab regions. Nor would it be desirable to see the traffic going in only one direction. The brief is replete with hopeful messages that are too often expressed as realities achieved rather than monumental strug-gles ahead. Have all the chains truly been broken for Gulf women? Are they now holding the power they want, making the difference they want? Has democracy finally arrived? Hardly. The brief mimics some of the official and officious language of development to say all the right things, but mouthing them will not necessarily make them true. Public relations is not cold journalism.

The brief boasts that women in Kuwait have just entered into "full

political participation" as voters and candidates in the municipal and parliamentary elections. In 2006, the full political participation of women turned out to be not kind to women when their participation in elections was found to be relatively "safe" for status quo interests because the large majority of (conservative) females were found to use their new voting power to reinforce, rather than overturn, existing anti-women stereotypes. An inquiry into the 2006 Kuwaiti elections, in which all female candidates failed to be elected, revealed that women voters in Kuwait were more conservative than the men. Kuwaiti female voters used their new-found power of the vote to strengthen the hand of anti-female Islamist parties. An expert observer of Middle East politics for the Carnegie Endowment for International Peace and George Washington University, Nathan Brown (2008) predicted that electoral reform in Kuwait was likely to make the terrain worse for female candidates for the foreseeable future because the various voting blocs, be they tribal, sectarian, or ideological, were likely to concentrate their votes on candidates who supported their pet local issues and who were good bets to win. Neither of these voting preferences, Brown argued, boded well for female candidates in Kuwait.

That said, female initiative can pay off and prove analysts wrong, even one as seasoned as Brown. As we saw in chapter 6 when discussing the Kuwait elections of 2009, four women did triumph. Rola Dashti, with a PhD from Johns Hopkins in Population Economics and a tireless commitment to gender parity in the Middle East, was one of them and she had been among the first group of women to lobby the Kuwaiti government for the voting franchise in 2005. Dashti stressed to her fellow Kuwaitis that change for the better could come only if they spoke with a united voice. Her campaign slogan was "Let us try to vote for Kuwait this time; Kuwait is our only protection and our only future, nothing else" (Thaindian News 2009). Dashti's triumph and that of her three female colleagues suggests that, while the language of global development may suffer from too much blanket optimism and too little willingness to confront the harsh cultural realities, breakthroughs that can provide momentum for more change are still possible. The Arab Human Development Reports are guilty of unbridled and unrealistic optimism, but that does not justify the conclusion that no optimism is warranted.

By contrast, documents such as Dabbous-Sensenig's review, that track how the Arab world fares (poorly) in enforcing various universal rights treaties for women are unsparing in citing the failure of Arab leaders to change their cultures in favor of female equality. These documents make clear that the harsh cultural realities are unremitting and can be enervating. They expose the seemingly never-ending labyrinths of patriarchy within Arab culture that put Arab women in one double bind after another. They can become so deafeningly negative that one can lose hope of any positive long-term vision at all. If we are not alert, this discourse is capable of reviving the myth that the Arab woman needs to be saved from her own culture, which simply replaces any serious long-term vision for Arab regions with a Western supremacist fantasy. Human rights reports exposing the hypocrisy of Arab governments are unyielding in their pessimism. But 2011 has signaled that the time when Arab governments could be smug about their hold on power and their lack of responsiveness to their citizens is over. That fact alone predicts a new generation of human rights reports that will see more room for democratic accountability in Arab lands and more reasons to think that Arab women can be the chief beneficiaries of that accountability.

What we have, it appears, are different cultures of equality confronting Muslim Arab women. On almost any issue where they can make active choices, they can look out to the international community or inward to Islam for answers. They can base their equality on universal human rights, seeking to rise together in a world of men. Or they can base it on the faith that their leaders are good to women because "Islam is good to women." Whose vision of the future will they choose?

No voice currently recruiting active Muslim Arab women to its cause has a complete or satisfying message. On the one hand, the voices of global development make too much of rational economic projections at the expense of historical and cultural practices that keep the Arab future firmly rooted in the Arab past. The ambitious Arab female is not willing to leave her culture behind for the sake of narrow careerism, wealth, and economic development. She rejects change for the sake of change. On the other hand, the voices of cultural Islam, for their part, do not consistently repudiate cultural patriarchy, and this leaves the same Arab female untrusting of cultural stability as well.

The majority of Muslim Arab women strategic role models heed the call of globalization and Islam not as an either-or, but a necessary both-and, recognizing their future as hybrids – cosmopolitans who seek to bend the forces of globalization to Islam and Islam to globalization. Currently, these forces, at least as discourses, seem at war with one another, but the reality is that they talk past each other. Separately, both try to recruit ambitious Arab women because they both know they cannot succeed without them. However, as we have said, many Muslim-Arab strategic role models do not want to be forced into a rigid choice. They want modernity and globalization but rooted in a value system that is not biased to Western values and does not exclude Islamic values. However, there is currently no language capable of embracing both Islamic and Western vocabularies at the base of globalization's underlying value system. Were we to replicate this concept-based census of women in Arab news a decade hence, we would hope and expect to find the languages of globalization and some of the core values at its root (Islamic and Western values) better accommodated and integrated than they are now under an umbrella of mutual respect. Perhaps this integration of values will come about because a generation of imaginative and resourceful Arab women, who live both value systems in their daily lives, will have insisted on their formal integration and, as a consequence, helped to pave the way for themselves and their daughters.

This formal integration is hard. Arab women do not face one monolithic choice between globalization and Islam. They face thousands of small choices between these cultures every day. Hybridity across the modern and Islamic tradition is the norm rather than the exception for many Arab women. They often have a foot in both worlds and the challenge is not to foreswear one identity for the other but to take reflective ownership over the complex hybrid identities they have already tacitly accepted. We do not mean to suggest that such a process will be easy, eliminate patriarchy, or heal divisions between women, but if it is managed with good will, it could move the dialogue to a newer and more honest level, acknowledging that what divides Arab women from themselves, from their patriarchal cultures, and from the West is less the proverbial clash of civilizations than an internal clash of the civilizations residing within them. Robin Wright, a veteran

American reporter who has covered the Middle East for almost forty years, has recently published a chronicle of the youth movements sweeping Islamic lands, including all twenty-two Arab countries. Whether these new youth movements are about overthrowing tyrants, or repudiating violence in the name of religion, Wright finds that the aims behind them "are about pluralism" (Wright 2011, 11), about forging a "peaceful coexistence of different tastes, walks of life, ethnicities, religions and schools of thought" (Wright 2011, 90).[3] We shall also see that the Arab female's struggle for more pluralized identities lies not with women alone. Men must get involved as well, and we discuss their involvement further, when we venture into the inner recesses of patriarchy in chapter 14.

Conclusion

In the previous chapter, we saw that female achievement shapes aspiration and that role models can inspire achievement. In this chapter, we have seen how this simple picture of female empowerment is challenged by cultural blindspots that fail to see women as leaders and prevent women from rising to powerful positions in the critical mass necessary for societal change. These problems challenge not only Arab women, but women around the globe. The research suggests that women may have blind spots as much as men about their female capacities. Women are often divided among themselves and their divisions are an impediment to their rise. While "feminism" is a controversial word in both East and West, research suggests that women who behave collectively to pursue a better future for themselves and their daughters create the optimal conditions for rising together in a world of men under assumptions of equality. Whether this inclination toward collective behavior is called feminism or not makes no difference to its effectiveness as a strategy of organization and coalition-building among women, and the building of critical mass. Females must be united to create the critical mass necessary to remedy the blind spots of males and their patriarchal filters.

These considerations raise cultural arguments about women's struggle to empowerment. Arab women are caught in the cross-hairs of these arguments from both East and West. Arab Development reports

tend to underplay the barrier of culture for Arab women. They too easily associate the rising economic empowerment of Arab women with a hoped-for social and political empowerment, and tend to pay lip service to cultural change without acknowledging the cultural forces of patriarchy an Arab woman must overcome in order to rise as a cultural agent. Human rights accounts from the West tend to overplay the restrictions of Arab cultures on women, sometimes going so far as to condemn Arab societies as irredeemably patriarchal and revive Western colonial myths. We have suggested that the logistics of empowerment for Arab women require reconciling the grains of truth in both discourses – a mammoth project sure to occupy the rising generation of Arab women. But, as we show in chapter 14, it is a project they must conduct not only among themselves but also with the active involvement of men.

13: Ranking Empowerment

WHAT MAKES A READER OF NEWS JUDGE A WOMAN TO BE EMPOWERED?

The ground covered in the previous two chapters bears witness to Arab women who leverage their achievement into empowerment. Chapter 11 focused on Arab women who have attained such empowerment. Chapter 12 focused on the cultural forces that make such attainments a struggle for women around the world, including Arab women. We now want to return to the question about female activeness that we raised in chapter 10, but this time focusing on the three concepts indicated in chapters 11 and 12 as central for judging female empowerment – achievement, authority, and pioneering. Can we rank these empowerment concepts according to their relative importance to overall impressions of female activeness?

To answer this question, we returned to the fifty-seven news briefs that left our reader with dominant impressions of "active Arab women" (see chapter 10). We then ran multiple analysis of variance (MANOVA), as in chapter 10, to understand how well the categories of achievement, authority and pioneering accounted for our reader's dominant impressions of active women. The results are displayed in Table 13.1 (see below).

This shows that Arab female pioneers were the strongest indicator of our reader's overall impression of activeness ($F = 4.43$; $p < .039$). We found this result unsurprising but also suspect. It is unsurprising because our reader had plenty of briefs to read through that presented "firsts" for Arab women. As we saw when we discussed female pioneeers in chapter 11, our designated reader could read about a *first* woman judge in Bahrain, a *first* parliamentary seat for a woman in Bahrain, the *first* Kuwait elections in which women participated, the *first* female

Saudi TV announcer, the *first* veiled labor minister in Egypt, the *first* female vice president in the Syrian cabinet, and the *first* female to run for the presidency of Yemen.

Concept of Empowerment	P-value for identifying the relationship between the empowerment concept (on the left) and a dominant impression of Arab female activity as judged by a human reader
Female Pioneering	F = 4.43; p < .039*
Female Achievement	F = 4.29; p < .041*
Female Authority	F = 1.90; p < .170

*= significant at the .05 level

Table 13.1. How different "empowerment" concepts differentially contribute to dominant impressions of Arab female activity. The table presents MANOVA analyses of the fifty-seven briefs our reader judged to put Arab women in dominant active frames. These results are suggestive of how various "empowerment" concepts we have discussed (chapters 11 and 12) may contribute to a dominant active frame. For example, briefs mentioning female pioneering and achievement appear most central to our reader's "gut" judgment of activeness, while female authority is much less so.

Everywhere in the Arab world, but particularly in the Gulf, women seem to be breaking new ground, setting new precedents, reaching new heights. The language of female precedent-setting has become a trope in Arab news. Taken on the surface, without deeper cultural knowledge to question it, our reader would have had no choice but to take these "firsts" through into gut judgments of dominant frames of Arab female activeness. What our reader could not have known is that, while the language of "firsts for women" may record true milestones for Arab women, it has also become a commonplace language that Arab governments rely on to sell the idea that their policies towards women are enlightened. Kaufer and Al-Malki have chronicled this phenomenon in their study of the reportage of Saudi women pioneers as depicted in both Western and Arab media (Kaufer & Al-Malki 2009). Analyzing in depth a small but carefully constructed sample of thirty-two articles on Saudi female pioneers, sixteen from Western

media and sixteen from Arab media, they found that Arab news tended to depict Saudi female pioneers in short public relations releases with no critical context. Western media, on the other hand, were more inclined to fill in this critical context and when they did, they sometimes found that the female pioneering took place against a wider background of female repression. One such Western article, written by Megan K. Stack of the *Los Angeles Times* (Stack 2007), noted that Rajaa Alsanea, the acclaimed young author of the novel *Girls of Riyadh*, and the first Saudi woman to write an international best-seller, had her book banned by the Saudi government. Similarly, an unattributed article in *The Economist*, published April 24, 2008, mentions Saudi Arabia's "first-ever" graduating class of female lawyers, but then notes that there are no opportunities for female law graduates to practice law in the Kingdom (cited in Kaufer & Al-Malki 2009).

Even if a woman's "first" in an Arab country is a legitimate push forward, it may be met with a stronger push back. Our reader, for example, had built a dominant active impression of Buthaynah al-Nasr, a woman we encountered before (chapter 8, page 138) to illustrate the importance to women of educational credentialing for breaking into new areas of employment, and again in chapter 11 (page 198) to explain how the story focused on her (celebrity) appearance more than on her credentials and that she may have been a token "first" to give the impression that government policies toward women were more enlightened than was in fact the case. We now note that female pioneers may face a pushback that dominates the story more than their advance. One can hardly fault our reader for thinking al-Nasr's "first" was a decisive step forward, but the story nevertheless devotes more words to describing the conservative backlash against her appearance, with al-Nasr responding to the reaction to her first appearance on air with more disbelief than pride: "I had not expected the clamour that accompanied my appearance as the first Saudi announcer in the channel. However, I was astonished by the fact that my appearance on television at that moment agitated many sections of the Saudi society."

Under the banner of pioneering, an Arab female may be more pawn than pioneer. We have already told the story (chapter 11) of Aicha Abdelhadi and her appointment as Egypt's Minister of Labor and the first veiled women to take a place in the cabinet. The *Al Hayat* reporter

covering the story (December 30, 2005) adds to the excitement of these events: "What is more important than those two matters is the break-through achieved by veiled women, who face obstacles in their attempts to occupy certain posts and positions because they wear the veil." But buried in the story is the information that her appointment "might not entail any message" for veiled women because she rose through the secular bureaucracy quietly and without distinction. And she was Mubarak's choice not because she was a trail-blazer but because she made it possible for him to send a message to the Muslim Brotherhood that he was not afraid of the veil. Because of the involvement in the public rela-tions machinery of many Arab governments, which would have been unknown to our reader, we have reason to be cautious about equating too quickly stories of "firsts" for Arab women with stories of empowerment.

Curiously, news briefs that presented Arab women holding authori-tative titles were not strong signals of female activeness (F = 1.90; p < .170). We were able to confirm this last finding through the textual record. Many of the reasons why Arab women of title appear in news is to point to the poor conditions of Arab women generally. The empowerment implicit in their title does not override the fact that they enter the news to champion the cause of women who lack empower-ment. A good example is the November 14, 2006 *Al Hayat* interview with Sheikha Sabeeka, first lady of Bahrain, who complains of the "insecure environment" and limited "internal and external peace and security" that plague Arab women. Another example we have referred to before is Iraqi Minister for Women's Affairs, Faten Abdul-Rahman Mahmud, who, in a brief from *Al Hayat* of August 15, 2006, uses her position of authority to complain that Iraqis participate alongside the American military in abuses perpetrated against Iraqi women. These are textual cases that confirm what our reader discovered – that Arab women of authority and power regularly appear in news briefs that leave an overall impression of female powerlessness.

Our reader also drew a dominant image of female powerlessness from briefs where women of authority use their power to divide women. Such is the case in a brief of an October 17, 2006 *Asharq Al Awsat* article from Egypt. A preacher, Sheikh Youssef Al-Badri, who sits on the Supreme Council for Islamic Affairs in Egypt, had filed a law suit against one Dr Su'ad Saleh, a professor of religious interpretation and former Dean of

Islamic and Arab affairs at Al-Azhar University for women, charging Dr Saleh with taking a hostile stance against any female apparel that completely covered the face. Dr Saleh had appeared on television with Sheikh Al-Badri and announced to viewers that she felt "disgusted" whenever she "sees a veiled woman." She denounced anyone "ignorant" enough to think that the face veil had anything to do with Islam. Dr Saleh conceded that the head scarf was a requirement of Islam, but not the face-covering, and she maintained that it was an imperative for Muslim women to show their faces.

Dr Saleh is clearly a woman of erudition and authority, but our reader nevertheless judged the overall story as conveying a dominant image of Arab women as passive and powerless. How can a story about a powerful woman give an impression of female powerlessness? The answer may lie in Amy Gutman's work on the role of identity politics and positive social change in a democracy (Gutman 2004). Extrapolating her theory to the 2008 US Presidential election, Gutman would argue that a female voter had a justifiable reason for voting for Hillary Clinton on the basis of identity politics, and an African-American voter had a justifiable reason for voting for Barack Obama for the same reason. Women and African-Americans in the US share common experiences of social discrimination and injustice. Insofar as these negative commonalities are identity-related, they can, according to Gutman, be relevant and even worthy reasons for supporting a candidate. Women can be reasonably assured that Hillary Clinton would fight for injustices they have directly experienced because Clinton is likely to have experienced them too. Blacks could be reasonably assured that Barack Obama would fight for similar reasons on behalf of African-Americans.

However, Gutman points out that there are limits on the value of identity politics and its capacity to serve democracies, maintaining that identity politics are valid instruments of democracy only insofar as they serve overriding democratic principles. Neither a woman candidate who supported the inequality of blacks nor a black candidate who supported the inequality of women would be furthering democratic equality overall. Nor, as in the case of Dr Saleh, would a woman in authority be pursuing democratic principles if her views disenfranchised large segments of women. Given her views, the mere

fact Dr Saleh is a woman with authority does not give her the right to hold authority over women. Her identity as an Arab female authority pales against the assault on freedom and religious tolerance she seeks to enforce on women through her authority. Her ascension to power, according to Gutman and apparently to our reader, could be interpreted as an overall loss of freedom for women more than an overall gain.

These considerations suggest that, of the triad of concepts associated with female empowerment, namely achievement, authority, and pioneering, female authority only weakly implies female empowerment. Titles of authority may be meaningless diplomas and women may be granted authoritative titles without true qualifications. They may also remain unprepared for and undeserving of their title, even if it does allow them to wield genuine power. We have seen that we must be very careful about linking female pioneering to female empowerment: "firsts" for women come and go and are easy to rig and manufacture for the sake of headlines and political expediency.

By contrast, it is female achievement that lies at the core of female empowerment. As Table 13.1 reveals, news briefs that showcase Arab female achievement were the second strongest signal for our reader's gut impression of activeness ($F = 4.29$; $p < .041$). When our reader sensed that female achievement was getting stage time in a brief, and that stage time was uncompromised by war or other countervailing pressures, she reliably built a dominant impression of female activity. The *Al Hayat* brief from March 29, 2006 about Reem Al Habib, the Harvard-trained lawyer retained to defend Saddam Hussein, serves as a primary example of a brief that puts Arab female achievement on display. Our reader's instincts are in line with the research literature: genuine achievement, first in school, and then beyond, has the most lasting benefit for women and the most long-term society-changing benefits for all.

In the previous chapter, we discussed how strategic role models inspire achievement. Female achievements provide the surest lynchpins for creating strategic role models. More than any concept we have discussed, achievement is best placed to inspire and pass down to younger generations through education and training. Women who know how to achieve will be impatient for change. Men with a raised

consciousness about women's development, and an acute understanding of the special role achievement can play in that development, are likely to become impatient along with them.

Conclusion

In this chapter, we have ranked the empowerment concepts of achievement, pioneering, and authority according to their contribution to a dominant impression of female activity. We have argued that achievement needs to be ranked as the core empowering notion, followed by pioneering, and authority. Women who strive to achieve do not all become empowered leaders, but, through a focus on achievement, they can work toward the mindset of leadership, which it is their right to develop. The psychologist who helped spearhead the positive psychology movement, Martin Seligman, has argued in a recent book (Seligman 2011) that the basis of happiness is flourishing and that flourishing rests on positive emotion, engagement, and finding meaning in life. According to Seligman, the factors that do the "heavy lifting" for flourishing are a life of achievement and of sharing with others. When women act as strategic models for other women, they combine these lives; they make their achievement the basis of their sharing with others. They have developed rare gifts through their achievements and they motivate others to acquire these gifts for themselves. They are women who, in Seligman's terms, have mastered the art of flourishing. From the evidence of our corpus of Arab news, achievement is the hallmark of empowerment, and learning to become a strategic role model is the hallmark of flourishing. But what are the hallmarks of female passivity in our corpus of Arab news? The remaining chapters take up this question.

14: Passivity

Men were made for war. Without it they wandered greyly about, getting under the feet of the women, who were trying to organize the really important things of life.

Alice Thomas Ellis, aka Anna Haycraft, English Writer and Essayist (1932–2005) (cited in St Peter 2010, 424)

A visitor from Mars could easily pick out the civilized nations. They have the best implements of war.

Herbert V. Prochnow (1897–1998). US Banker and author, contributed epigrams to the *Saturday Evening Post* and *Reader's Digest* (cited in Smith 2006, 441)

It'll be a great day when education gets all the money it wants and the Air Force has to hold a bake sale to buy bombers.

Author unknown (cited in Goebel 2008, 29)

In this and the remaining chapters, our focus shifts to the news briefs that depict the Arab woman within a dominantly passive cultural frame. It is a frame that keeps her fenced within set cultural boundaries, where decisions are made for her, where her agency is carried by the momentum of others, where she is spoken for more than she speaks, where she cedes her own potential for independent thinking to the thinking of others. This passive frame plays a part in the life of all people, not only women, and certainly not only Arab women. The error of Western media has historically been not simply that they have shown Arab women in a passive frame, but that they have *imprisoned* them within it. By freezing Arab female passivity into a passive icon/image bite, Western media have traditionally pinned

the Arab woman to one pole of the active-passive continuum and refused to set her free.

Just as active women measure themselves against passive boundaries, passive women, like the slave with a rising consciousness of freedom in Hegel's master-slave relationship (see Hegel 1967), understand that around the corner of every passive constraint is an opportunity to resist it with an active will. In an ideal scenario, every free person experiences life as a mix of making active choices, falling into choices already inherited, and resisting some of those inherited choices. Patriarchal cultures distort the balance for women by offering too few active choices, forcing too many passive choices, and restricting the resources available for turning passive choice into active choice (see chapter 7). However, such a characterization of patriarchy only restates the symptoms without elucidating the causes. Male-dominated cultures are resilient because the principles under which they operate are buried beneath so many layers of accepted practice that we typically cannot see what those principles are in order to call them out or critique them. Fortunately, one academic discipline, women's studies, has given priority to trying to unearth the hidden principles behind male dominant cultures and the reasons why these principles, left unseen and unattended, impose cultural defaults of male dominance and female passivity worldwide.

Theorizing Female Passivity Worldwide: The Contributions of Women's Studies

Although Arab female passivity has been iconicized for centuries in the West, it is only very recently that female passivity as a general construct has been theorized. That theorizing has been taking place in the discipline of women's studies and in the pages of *Signs*, the flagship academic journal of that discipline, published by the University of Chicago Press with its editorial office located at Rutgers University. Recently, its senior editor, Karen Alexander, and editor-in-chief, Mary E. Hawkesworth, anthologized a collection of articles from the journal that seek to present, from various perspectives, a theoretical treatment of female passivity (Alexander & Hawkesworth 2008). To anticipate the direction we shall be taking, let us pause for a moment to consider

the potential significance of these theorizations of passivity to our previous discussion.

In chapter 11, we saw that the voices of globalization and of Islam had not yet been reconciled within a general framework of female empowerment. The active woman who stakes her future on modernity seems, in principle, to turn her back on tradition, while the active woman who stakes her future on tradition seems, in principle, to turn her back on modernity. Nonetheless, we have noted that, as a matter of practice, Arab females mix tradition and modernity in hundreds of ways in their everyday practices. This mixing ensures that their reach as women extends Eastwards and Westwards simultaneously. We recognized that we were without deeper theories and principles to account for the possibilities of these path-crossings. Does the work in women's studies provide theories to account for these mixed pathways?

Not quite. What the work in women's studies shows is that even women with wing spans extending to East and West may remain severely limited in their freedoms in both directions. It is not that a woman's reaching to the West guarantees her freedom while her reaching to the East imposes constraints. That is far too simplistic a picture, for both trajectories are burdened by assumptions of patriarchy. For women's studies, modernity and tradition are not independent constructs, but interconnected options that have co-evolved historically. Both carry hidden assumptions of male dominance; and so neither choosing either modernity or tradition, nor negotiating between them, escapes patriarchy. Thus, if women are to win their freedom and autonomy in both East and West, they need to take on patriarchy itself. Alexander, Hawkesworth, and the contributors to their collection together articulate three major propositions that establish their framework:

1. Modernity is not always progressive towards women, and tradition is not always backward or reactive.

2. Tradition and modernity are mutually implicative concepts rather than mutually exclusive.

3. To think that modernity "corrects" the erasure of women in tradi-
tional cultures is a mistake. Both traditional and modern states
practice warcraft as part of their dominant statecraft and, within the
institutions that prepare for and execute war, women are left cultur-
ally erased.

The first proposition states that it is oversimplistic to think that
modernity and globalization are always women-friendly progressive
forces and that tradition implies holding women back. Alexander and
Hawkesworth's anthology contends that the tidy division of the
world into "the modern" and "the traditional" (aka "the backward")
is a division that serves the interests of modern champions of globali-
zation (mainly the US and European governments). Yet this tidy
division hides the inconvenient truth that the modernity/tradition
division is neither a tidy nor a hard distinction. Modern and tradi-
tional cultures, it turns out, are in alliance worldwide as well as in
conflict, and whether they mix as friends or adversaries is a matter of
circumstance. When, for example, the US subsidized Jihadist move-
ments fighting the Soviet Union in Afghanistan, forces of modernity
(the US) teamed with traditional fighters (the Mujahedeen) consid-
ered extremely backward when it came to the basic freedoms of
women in Afghanistan. Only after 9/11, and when it was in US policy
interests to do so did the George W. Bush Administration champion
the fight on behalf of Afghan women against a major sector of the
Mujahedeen warriors, the Taliban. Any blanket generalizations that
the forces of globalization and modernity necessarily champion the
advancement women are overdrawn (Alexander & Hawkesworth
2008, 4; Haq 2008).

The second proposition is that tradition and modernity are concepts
that are not so much opposed as mutually defining. Like active-passive,
they are also concepts that mutually define one another as the Ying-
Yang. And like mutually defining concepts, they overlap and blend in
endless ways. Modern organizations pride themselves on having family
leave policies that bow to traditional family priorities. And traditional
cultures, even female Islamic movements, have proven resourceful in
appropriating the modern ideals of individual empowerment to
advance the idea that they champion the development of women. In

Syria, we have seen how the Qubaisiate (chapter 11) have sophisticated rites and rituals that they claim develop and empower women within their religion. In Morocco, Islamic women's movements compete against neoliberal women's movements for state resources to help the government fight the war on terror. And these Islamic women's movements in Morocco have won significant public funds from the King of Morocco to help change the masculine culture of the mosque through the training of female clergy (Salime 2008). In Egypt, even Western feminists such as Judith Butler have been impressed by the way Islamic piety movements have empowered Egyptian women through a performance art that frees them to express their religion personally as part of a daily rite (Mahmood 2005). In sum, the language of female empowerment is not a language owned wholly by proponents of the modern/secular and the modern/global. Voices of religion and local tradition also rely on the language of modernity, individuality, and empowerment when they seek to persuade others (including Western audiences) that they are, within their own rites and customs, advancing the cause of women.

The third proposition requires confronting a common myth of modernist thought and exposing it for what it is. The myth is that modernity superseded traditional feudal societies by replacing fiefdoms that were constantly at war with nation-states committed to enduring states of peace. The myth allowed that modern nations were single-mindedly focused on peaceful economic development on behalf of their citizens, and that wars were only temporary aberrations from peace.[1] This meant that, in the nation-state, the economic planners and domestic policy-makers who were focused on peace were in the foreground, while their defense departments, focused on preparing for war, worked in the background. The primary focus of nation-states was ostensibly on the human development of their citizens. Their secondary focus was on the destruction of their enemies, but only as they were threatened and only as military force was justified for their self-preservation. Note well how this modernist narrative of peaceful development is exemplified in the Arab Human Development Reports reviewed in chapter 11. The reports assume that the state is at peace; that women are a vital part of the state's peace-time agenda; that women are under-utilized in that agenda;

and thus that women must assume a much larger role in the state's economic development.

However, in a bracing figure-ground reversal, Alexander and Hawkesworth's collection of articles contends that this long-held myth relating modernity and an irenic disposition is simply wrong, arguing that modernity has not transcended the belligerence and war of the feudal states but rather that belligerence and war still define the natural condition of modern statecraft. For Alexander and Hawkesworth and their contributors, warcraft is not restricted to active combat, casualties, and deaths, but includes the drawn-out cycle in which war is continuously anticipated, planned, executed, and recovered from. On this view, conditions of peace are simply the phases of warfare in which people tidy up and rebuild from a war no longer actively prosecuted – until, of course, the next war comes along. They argue that warcraft is not the antithesis of modern statecraft but the very foundation of it, and that peace is simply that stage of warcraft in which active hostilities recede into a dormant phase.

To make their case, Alexander and Hawkesworth quote a chilling statistic from Hardt and Negri (2004, 31): when we reached the new millennium in 2001, there were no fewer than "two thousand sustained arm conflicts on the face of the earth" (cited in Alexander and Hawkesworth 2008, 6). But even more impressive to Alexander and Hawkesworth than this statistic is the resilience of the modernist myth and the fact that we do not allow the ambience of war to deter us from believing that modern states experience war only as an unexpected departure from peace. Despite all evidence to the contrary, we cling ferociously to the myth that war is the exception, that modern diplomacy has the wherewithal to eliminate war, and that every new war we fight is entered into, subliminally at least, on the fantastical belief that *this* war, if well fought and won, can extinguish aggressive warfare once and for all. The myth met its apogee in August of 1914, when British author H.G. Wells, seeking to rally British involvement in World War I, published a number of articles in London newspapers that were collected into a book called *The War That Will End War*, and the title (along with its variant – "The War That Will End All Wars" – became a catchphrase of the British war effort (Wagar 2004). In America, presidents found they could not easily justify the necessity of war to the

American public if they could not argue, as Woodrow Wilson did for World War I, that the war "would make the world safe for democracy" (Jamieson 1990).

Once we recognize the lengths to which we go to maintain the modernist myth of war as a remote option (unless it is absolutely necessary to eliminate war!), it becomes easier to confront and jettison the myth and to acknowledge warcraft, if not always active hostilities, as a persistent aspect of modern nation states. It also becomes easier to appreciate the extent to which the political narratives of modern states rely on war narratives. As one looks over a map of the world, as Alexander and Hawkesworth point out, from the Americas to Europe, the Middle East, Africa and the Far East, one finds it hard to tell a story about the residents on each land mass without also telling a compelling story about how they are caught in the throes of continuous war narratives.

Like all narratives, war narratives have a setting, conflict, and resolution. The setting of the war narrative begins with disputed claims over land, governance, or sovereignty, which leads to tension and strife, followed by tense diplomacy. If the diplomats in the war narrative prove successful, the war narrative is aborted at this initial (setting) phase and does not transition, at least for the time being, to the open conflict stage. However, if diplomacy fails, the war narrative crescendos into active hostilities – coups, assassinations, incursions, armed combat, casualties, and mass deaths. War narratives that enter the active hostilities phase invariably at some point decrescendo back to a resolution or resting state, a truce or peace. Governments are either overthrown or defended. The leaders of the losing side are either exiled or criminally charged. Members of the losing populace are pardoned, detained, imprisoned, displaced, or resettled as refugees.

Unlike peace narratives, which do not exist as a well-defined genre, war narratives are so ubiquitous and recurrent that they form a compellingly stable literary form, with each cycle of a war narrative inhabited by its own limited set of verbs. On its early setting or diplomatic cycles, warcraft *holds talks*, *negotiates*, and *strongarms* adversaries in order to avoid violence. On its active hostilities or mobilization and militarization cycles, warcraft *unsettles*, *destabilizes*,

disrupts, dislodges, uproots, launches incursions, invades, bombs, kidnaps, maims, tortures, and *kills.* On its demilitarization and demobilization (aka resolution/peace) cycles, warcraft *repatriates* and *resettles refugees, buries* and *commemorates* the dead, *honors* the brave, *nurses* the wounded, *restores* calm, *clears* the devastation and *rebuilds* a battered infrastructure.

In chapter 11, we saw how empowering women for peaceful economic development is the concern of the Arab Human Development Reports. Those reports present a rosy picture of how Arab women can play a greater role in that development. However, in chapter 12, we suggested that the optimism of these reports may be overstated because they tend to ignore the harsh cultural realities of patriarchy that Arab women, and women worldwide, confront. The three propositions of women's studies introduced here help us understand more precisely how the Arab Human Development Reports miss the mark. They miss how women's priorities for social and economic development are pushed aside when statecraft is practiced as warcraft, when state narratives unfold as war narratives.

Under the principles of warcraft, the time-honored priorities of women – child welfare, education, and human development – are moved to the back burner. According to the myth of the modern state, war is undertaken reluctantly and only in the service of peace. But this contention cannot explain the build-up of perpetual war machines in modern states. Once the mask is lifted from the myth, the picture looks very different. It becomes easier to see that war narratives are not only alive and well but dominant in the corridors of the most powerful governments that pride themselves on modern rationality and peace priorities. In his book, *The Social Animal, New York Times* op-ed columnist David Brooks (2011) argues that US policy has failed time and again because it overestimates the importance of modernist thought (viz., conscious rational thought), and underestimates the latest neural research on the human brain, which has uncovered how our unconscious perceptions, feelings, and emotions contribute to our individual and collective beliefs and behaviors in ways that dwarf the contributions of our conscious thought. Brooks reports coming to realize that many of America's many failed policies, including suspect military adventures, have

arisen from the hubris of modernist thinking. What if American policy-makers, he mused, were forced to read and take seriously what scientists are learning in laboratories worldwide about human development through brain research? Brooks is not optimistic that this will happen anytime soon. He finds that the legislators who roam the corridors of the US Capitol building are too engaged in their own modernist hubris to listen to him. During his book tour, Brooks related that if he wanted to talk to US legislators about the latest stealth plane or smart bomb under development, he would be embraced as a significant gatherer of news. But he got a very different reception when he tried to talk to legislators about his avid reading of research in child development. One of his favorite studies dealt with testing four-year-old children and their impulse control with marshmallows! In a celebrated longitudinal experiment known as "the Marshmallow Experiment," Walter Mischel then of Stanford University (Shoda, Mischel & Peake 1990) gave four-year-olds a marshmallow and told them not to eat it until he returned with a second marshmallow. Once he returned, he told the children, they would be permitted to eat both marshmallows. Some determined four-year-olds summoned up the self-control to wait fifteen minutes for Mischel to return with the second marshmallow. Other four-year-olds squirmed and were tortured by the situation. They could not resist gobbling down the first marshmallow within thirty seconds of Mischel or his colleagues leaving the room. These differences were not terribly surprising. What was surprising is that Mischel tracked these children for the next thirty years and found major differences in their life prospects related to the will power they had mustered, or had failed to muster, on that fateful day when as four-year-olds they were administered marshmallows. The children in his study who had enough control to wait fifteen minutes for the second marshmallow grew up to score on average 210 points higher on their college SATs, had higher college completion rates, higher incomes, and lower incarceration and addiction rates than the children who wolfed down the first marshmallow within thirty seconds of Mischel's leaving the room.

Brooks was bowled over by the public policy implications of Mischel's study and by hundreds of other studies exploring the

mysteries of human development. Imagine the improvements to society, Brooks rhapsodized, if we could apply science to extend the impulse control of every child? What if it turned out that many of our failed policies turn on our current policy-makers being too impulsive to wait for that second marshmallow? Might we have a better society if we could adopt the marshmallow study at all stages of development to ensure that our leaders had the maturity to think beyond their impulses? What kind of federal funding might be available to bring these laboratory findings into practice to make sure our children, and future leaders, are developing into the best adults they can be? As he was researching and writing his book, Brooks threw these questions and curiosities out to policy-makers on Capitol Hill whom he covered on his regular beat as a political reporter. But as Brooks hilariously related in interview after interview on his book tour, when he raised the significance of the Marshmallow Study with legislators on the Hill, he would be treated like a loon or be told he belonged on women's daytime television.

Within war narratives, as Brooks found out, the heroes are overwhelmingly male and overwhelmingly focused on aggressive power rather than human development. The heroes are men in combat uniforms, on the march, in fighter planes, in the heat of battle, what Hamilton (2008, 137) has called "violent bodies." Women almost never appear as heroes in war narratives. Their appearances are reduced to the aggrieved faces of women assaulted, widowed, and displaced. In narratives of war, women are not violent bodies but bodies violated by violence (ibid.; White 2008).

The three propositions set out here significantly complicate the picture for women that we discussed in chapters 11 and 12. That may seem depressing and to some extent it is; but it also hopeful, for it clarifies the realistic challenges confronting women in constructive ways. Women may not be preternaturally passive. But in modern states that pursue war with greater sophistication than they pursue peace, women are more easily than men locked into passive roles. Women simply do not fare as well as men within war narratives.

Women in War Narratives

Nine further propositions from the women's studies literature elaborate the obstacles women face in gaining a positive footing within war narratives. The first is that women are the primary victims of war. As Alexander and Hawkesworth remark, "Contrary to stereotypes about war deaths that feature male combatants, women are the majority of casualties in war" (2008, 3). The vast majority of war victims, indirect as well as direct, are civilians and the vast majority of civilians victimized by war are women (Turpin 1998, cited in Alexander & Hawkesworth 2008, 3). War increases domestic and sexual violence against women. Women suffer at the hands of enemy combatants to be sure, but they also suffer at the hands of their husbands and allied combatants who are supposedly on "friendly" terms with them. War begets refugees living in impoverished and unsafe environmental conditions, and the displaced in question are predominantly female. The struggle for gender equality takes on special challenges for displaced populations. Females living under these conditions subject themselves to all manner of degradation, including prostitution, to feed their children. "The process of flight and displacement creates havoc with community structures and with cultural norms and traditions. Leadership structures, community coping mechanisms, and shared moral standards break down" (Buscher 2005, 21) in refugee communities. Women suffer most from situations of displacement because their domestic labor never stops and becomes more exhausting and harrowing under conditions of insufficient housing and food. According to a report by the Women's Commission on Refugee Women and Children (Buscher 2005), "women and men experience conflict, flight and displacement differently" (p. 21). Power relations become blurred, and men often lose their focus while women sharpen theirs. Losing their place as breadwinner and head of household, men often fall into depression, lethargy, and withdrawal. Women, used to putting their own needs after the needs of their husbands and children, have learned that depression in life-and-death circumstances is an indulgence they cannot afford. They fill vital roles in emergency decision-making, food distribution, and income generation programs. Such opportunities are mixed blessings, however, because, in return

for their competence under fire, women in refugee situations are asked to keep doing more with less.

Second, and relatedly, women are the invisible servants of war. When war steals funding away from health and service programs, women in war zones are expected, often for free, to "fill the gaps" (Alexander & Hawkesworth 2008, 3) by staffing phones, attending to the wounded, driving ambulances, and helping to reunite families.

Third, women are the unsung actors and behind-the-scenes heroes in warcraft. Women protest, clamor for peace, and join resistance movements. Women are much better "camouflage" warriors than men and so play an active role as "revolutionaries, militants, soldiers, spies and participants in the military industrial complex" (ibid.). And they fulfill these roles under horrific conditions that force them to play by men's rules at a high level of competence in order to survive. Denov and Gervais (2008) collected narratives of women who survived war in Sierra Leone's Revolutionary United Front (RUF). They were conscripted into the RUF and, to avoid beatings and sexual abuse, had to engage in extreme acts of violence to earn "promotions" within the RUF's bureaucracy. In order to escape going on violent missions, some women curried the favor of male decision-makers by cleaning, cooking, and extending other domestic services to them, including sexual entice-ments. However, the small proportion of women who did fight did so with a level of violence equal to if not exceeding that carried out by the men. Under life-and-death pressures, women will rise to meet unthink-able challenges, putting themselves at risk of sexually-transmitted disease if the need arises.[2] The fact that women play the part of unsung heroes in war narratives may seem to portray their role positively. But this is deceptive, because once their roles within war narratives are exposed, women may suffer dire consequences that they would prefer to avoid. The remaining propositions speak to this dilemma for women within war narratives.

Fourth, women are more likely than men to be ashamed of, suppress, and even lie about their war involvement. Men want their war medals and they want never to forget their war exploits. Women want to bury their memories and war involvement as quickly as possible. Women get less mileage from their involvement in war because that very involvement plays against the decorum they need to cultivate, and that

their husbands typically require them to cultivate, when situations normalize. By contrast, war involvement burnishes a male's masculinity. "Masculinist notions also serve as powerful tools for making men into soldiers because military forces encourage aggressiveness and competitiveness while censuring emotional expression and denouncing physically weak soldiers as effeminate" (White 2008, 70). Torture is hardly a badge of honor for men. But in rare cases it can still be worn as one. A man tortured for five years in a military prison camp, like John McCain in Vietnam, could become a war hero who writes best-selling memoirs and runs for the American presidency. A woman tortured under comparable conditions often becomes "damaged goods" when she returns to civilian life. Because they have less to gain by idealizing their war experience, women displaced in war tend to carry less sentimentalized images of the land they lost than their male counterparts, as Ahmetbeyzade (2008) found to be the case for Kurds living in exile in Turkey. Kurdish women, Ahmetbeyzade found, remember the violence of relocation from Kurdistan. Kurdish men remember the country's physical beauty and remain nostalgic for the homeland as a trophy to return for. It remains, of course, to be seen whether Ahmetbeyzade's findings for gender difference and war nostalgia hold up across other cases.

Fifth, even a female suicide bomber who *does* crave media attention for her identity politics, as a *female* martyr, is not taken as seriously as a male. Studying the media coverage of female suicide bombers in Palestine through film, fiction and academic reports, Naaman (2008) found that while media covers male suicide bombers as sincerely, if delusionally, driven by a cause, female bombers tended to be dismissed as acting out of personal frustrations such as infertility, or an unfaithful husband, or even as suffering from mental illness. Kotef and Amir (2008) further found that Israeli media in particular condemn a female suicide bomber by trying to masculinize her. The media give a female suicide bomber no coherent identity. She either enters the pursuit driven by personal demons without political significance, or she is a man in a female body.

Sixth, women are often the primary scapegoats when warcraft enters active hostilities. As we saw with news briefs from Iraq (chapter 8, page 141), men often use war as a pretext to police the morals of

women. Men also appeal to the "loose morals" argument to get away with extreme harassment and violence against women that would be harder to leave unpunished in normal times. Abdi (2008) has shown how, by taking advantage of the political upheavals in Somalia in the 1990s that saw family structures weakening, Islamists from the Sudan and Saudi Arabia were able to move into Somalia preaching that the lapsed morals of Somali women were to blame for the chaos. They contended that wearing hijab would be the only way for women to show repentance. While Somalia had no previous tradition of hijab, Somali women began to take it up for their own protection. When they refused, they were harassed on the streets, assaulted and some-times stoned.

Seventh, there is no guarantee that violence against women will subside or even stay at the same level when active hostilities subside. Violence against women is rampant even in times of peace, and the eruption of an active war simply gives men increased opportunities to commit their violence unchecked. When women are violated in the context of war, the press tends to blame the war, not the perpetrators. Rape and other forms of abuse against women are reported as the "collateral damage" of war. And the scapegoating of war as the culprit behind female abuse leaves the press free in times of peace to under-report female abuse on the premise that abuse without war lacks newsworthiness. War can provide a context of exoneration for men who abuse women. And peace may give abusive men the cover they need to increase their abuse without being reported. Hawkesworth (2008, 13), studying acts of violence against women in South Africa, notes that with the ending of apartheid and the withdrawal of press attention, violence against black women *increased*.

Eighth, women are the advertised beneficiaries of war, the "Helens" for whom a thousand ships are launched. Women are presented as the "embodiment of the nation that men seek to protect and defend" (Lorentzen & Turpin 1998, cited in Alexander & Hawkesworth 2008, 3). The irony is that the very warcraft often vigorously pursued purportedly for the protection of women turns women into society's least protected class.

Finally, and most pertinent to our analyses in the previous chapters and our analyses to come, rosy economic development reports

championing the advancement of women too commonly keep their eyes closed to the masculinized reality of culture. In doing so, the reports can gather dust because they plan for women's advancement in an idealized, mythical and modern "peaceful" state, where the priorities of women (on human and family development) are assigned more importance than they ever actually receive in the meager returns of a war-oriented state.

Until October 2000, there was little formal acknowledgement of the asymmetric consequences of war for women as compared with men. However, in that year the UN passed Security Council Resolution 1325, which specifically addressed the inequitable situation of women in war. The resolution required women's concerns to be taken into account at every phase of deliberation in the aftermath of armed conflict. The resolution was subjected to extensive review. Some analysts hailed it as a great step forward (Hill, Aboitiz & Peohlman-Doumbouya 2008) while others found it wanting because it did not guarantee women's direct participation and input (Farr 2008). Still others have proposed that international courts be established to create an "international framework of accountability" for those officially involved in the planning and execution of warcraft (Spees 2008, 200).

These solutions have merit, but as Samuelson (2008) has noted, their merit is conditional on the women having no qualms about going public with their stories. When we examined women driven by retributive anger (chapter 6), aspiration and drive (chapter 7), dreams of education (chapter 8), and gainful employment (chapter 9), we saw that women typically have no hesitancy in going on the record about the slights and indignities that hold them back. In these cases, by and large, their testimony is no cause for personal humiliation. By contrast, within narratives of war, the situation changes dramatically. Narratives of war create compromising and humiliating situations that often makes a woman prefer silence to the agony of public testimony. Samuelson has established an empirical case for this female preference for silence when he analyzes the case of Truth and Reconciliation hearings in South Africa following the dismantling of apartheid. He discovered that, for a black woman to testify that she had been harmed by apartheid, she effectively had to disclose

to the media that she was a victim of sexual violence. And he found that women, with justification, put under this media pressure were mortified by the prospect of such disclosures, for it made them the subject of gossip and unwanted prurient media attention. Though they had been victims and not perpetrators, the women knew their reputations would be permanently tainted through media exposure. In her novel, *David's Story* (2000), Zoe Wicomb traces the life of a proud female guerilla commander and her ordeal following her public testimony about her war experience. In excruciating detail, Wicomb makes clear through her art why no proud woman should ever agree to describe her experiences in war to a prurient public (cited in Samuelson 2008).

From women's studies has emerged a picture of women in war narratives caught in Gordian knots of culture. Within war narratives, a woman's position can become so terribly compromised that the retributive anger option of getting even – the option taken by the women we met in chapter 6 – may appear more crazy than courageous. It is true enough that, if she does not speak or act against the injustice dealt her, she is reduced to suffering in silence. However, if she does speak up in the name of justice, as the women driven by retributive anger in chapter 6 were willing to do, she risks extremes of ridicule and humiliation that, by any reckoning, can leave her permanently scarred and her situation much worse than before. She may, sadly and regrettably, find it easier to accommodate her suffering than to seek restitution for it.

Female Passivity: Are Muslim Countries a Special Offender?

Such degrading conditions of female passivity that reduce a woman to silence have been documented in one case study after another in a recent book by *New York Times* op-ed page writers and Pulitzer prize-winning journalists Nicholas D. Kristof and Sheryl WuDunn. Their book, *Half the Sky: Turning Oppression into Opportunity for Women Worldwide* (2009), puts a human face on female passivity. The women they document are not caught in the cross-fire of active hostilities. They are, however, trapped in societies with economies tilted toward warcraft, economies that assign a low priority to the

concerns of women's and children's health or nutrition and to their social or economic well-being.

Kristof and WuDunn introduce us to pregnant women like Prudence Lemokouno in Cameroon, who, denied access to prenatal care, suffered a rupture of the uterus when she went into labor. Her family had to bribe an indifferent doctor for help, only to find it was too late for her and her baby. Kristof and WuDunn walk readers through the progression of events that can transform an innocent pre-teen into a hardened drug-addicted teenage prostitute who may run away from her brothel many times, but who will unfailingly return to feed an overpowering drug addiction. They help readers understand how a girl could prudently "choose" dying in a brothel from HIV/AIDS over languishing in poverty and being tortured by withdrawal tremors. Kristof and WuDunn's book makes a major contribution to the understanding of how thorny the issue of volition can be in cases of female passivity (see the discussion on passive choice in chapter 7). The girls and women they chronicle all "chose" their lives to some degree, but against a set of alternatives so unappealing as to make the question of their capacity for authentic choice problematic.

Kristof and WuDunn include one controversial chapter entitled, "Is Islam Misogynistic?" Generally speaking, it vindicates Islam, but some of the phrasings imply that Islam prescribes female passivity systemically, as a matter of doctrine. They write: "Of the countries where women are held back and subjected to systematic abuses such as honor killings and genital cutting, a very large proportion are predominantly Muslim" (Kristof and WuDunn 2009, 130). In her review of the book for the *New York Times*, the renowned moral philosopher Martha Nussbaum (2009) praises it overall but criticizes the chapter on Islam as the weakest and least compelling. She accuses Kristof and WuDunn of fueling Islamophobic stereotypes, and argues that the offenses against women that dominate *Half the Sky* – maternal mortality and forced prostitution – are most prevalent in non-Muslim regions. While Nussbaum concedes that genital cutting and honor killing are more frequent in predominantly Muslim regions, she points out that the problem of maternal mortality, which gets considerably more attention in *Half the Sky*, is dominant in sub-Saharan Africa, where Muslims

are not a majority. And forced prostitution, which also gets more attention in *Half the Sky* than female circumcision and honor killing, is most prevalent in regions of South Asia (e.g., India, Thailand, and Cambodia), which are also predominantly non-Muslim. When it comes to the forced abortion of female fetuses, or the murder, starvation, or withholding of medical care from female infants, the major offenders are Singapore, Taiwan, South Korea, and China – all non-Muslim. So some of the worst offenses against women, Nussbaum concludes, have nothing to do with Islamic cultures. And some of the best practices on behalf of women cited in *Half the Sky*, Nussbaum notes, can be credited to Muslim cultures. For example, she finds that Kristof and WuDunn save warm praise for Muslim Bangladesh for its heavy investments in female welfare.[3] Kristof and WuDunn are clearly not Islamophobic and Nussbaum knows that, but she wants to make sure that Islamophobic readers can take no comfort from anything the authors of *Half the Sky* say, whether intentionally or inadvertently, about women in Islam.

Ranking Passivity in Arab News

We have described in chapter 10 how we recruited a reader to read all 178 news briefs in our corpus and provide "gut" responses about whether the story gave her an overall impression of Arab female activity or Arab female passivity. Using the sixty-two stories that produced an impression of Arab female passivity, we again ran multiple analyses of variance (MANOVA) to determine how the various factors linked to Arab female passivity through grounded theory ranked in contributing to our reader's gut impressions. Table 14.1 (see below) enumerates the rankings in descending order.

Our grounded analysis of the news briefs revealed that the passivity of Arab females could be linked to one or more of five factors: (1) fear/hostile threat; (2) patriarchy/misogyny; (3) poverty; (4) sadness/hopelessness; (5) illness/disease. As we can see in Table 14.1, all of these factors proved to have a statistically significant relationship to our reader's gut impression that a story conveyed Arab female passivity.

The distribution of these passivity factors in our corpus of Arab news is discussed below.

Concept of Passivity	P-value for identifying the relationship between the passive concept (on the left) and a dominant impression of Arab female passivity as judged by a human reader
Fear/Hostile Threat	(F = 24.39; p < 0.000)*
Patriarchy/Misogyny	(F = 13.93; p < 0.000)*
Poverty	(F = 11.38; p < .001)*
Sadness/Hopelessness	(F = 5.07; p < 0.081)*
Illness/Disease	(F = 4.41; p < 0.038)*

* = statistically significant at .05 level

Table 14.1. How different factors differentially contribute to impressions of Arab female passivity. The table presents MANOVA analyses of the sixty-two news briefs our reader judged formed a gut impression of Arab female passivity. These results are suggestive of how various factors uncovered in our grounded analysis may have differentially contributed to the judgment of Arab female passivity. For example, briefs mentioning female fear/hostile threat appear most central to the judgment of passivity, and briefs mentioning illness/disease, least so. However all the factors were statistically significant.

The contribution of fear/hostile threat to Arab female passivity

Arab women face fear/hostile threat in forty-four (24%) of the 179 briefs. Using the sixty-two summaries that our reader selected as conveying an overall impression of Arab female passivity, fear/hostile threat[4] proved the most significant factor contributing to that impression (F = 24.39; p < 0.000).

The contribution of patriarchy/misogyny to Arab female passivity

Arab women face fear/threat in forty (22%) of the 179 briefs. Employing the sixty-two briefs that elicited a gut impression of Arab female passivity, patriarchy/misogyny proved the second most significant contributory factor (F = 13.93; p < 0.000).

The contribution of poverty to Arab female passivity

Of the 179 news briefs, twenty-two (13%) depict Arab women living in poverty and squalor. On the basis of the sixty-two briefs that created a gut impression of Arab female passivity, this was the third most significant contributory factor ($F = 11.38$; $p < .001$).

The contribution of sadness/hopelessness to Arab female passivity

Of the 179 news briefs, twenty-two (13%) depict Arab women in states of sadness. In the sixty-two briefs that created a gut impression of Arab female passivity, sadness/hopelessness proved the fourth most significant contributory factor ($F = 5.02$; $p < 0.027$).

The contribution of illness/disease to Arab female passivity

Of the 179 news briefs, twenty (11%) make reference to Arab females living with illness/disease. In the sixty-two summaries that created a gut impression of Arab female passivity, this proved the fifth most significant contributory factor ($F = 4.41$; $p < 0.038$).

Curiously, no other factors contributed statistically to the overall impression of Arab female passivity, despite other obvious candidates. We had hypothesized that *repressive government* (either for women or for society generally) would be linked to female passivity, but this did not emerge as statistically relevant in our corpus ($F = 0.06$; $p < 0.80$). On the contrary, active Arab women in our corpus of Arab news appear frequently in news briefs where *repressive governments* are mentioned or implied. We may refer to Suzanne Mubarak's criticisms of the restrictions on the rights of women in Egypt (chapter 6), or Latifah Al Gaood's reports of her struggles as a new parliamentarian in Bahrain (chapter 6). Our reader labeled both these stories as "active," presumably because she focused her attention on these powerful women denouncing Egypt and Bahrain for their repressive environments for women. Similarly, *family/religious constraint* had seemed to us a likely candidate for contributing to an overall impression of female passivity. But again there was no statistical relation in our corpus between

conservative family traditions regarding women and female passivity ($F = 1.58$; $p < .211$). This is presumably because many briefs, like those about Saudi women car dealers, refer to activeness for an Arab woman within conservative family traditions rather than against them.

Because poverty and illness/disease are ubiquitous passive conditions for humans worldwide, not only for women in Arab territories, we decided to focus our analysis in the next three chapters on the three factors of fear/threat, patriarchy/misogyny, and sadness/hopelessness. In our coding study, we had divided female passivity under the categories of physical and psychological constraint (chapter 2). The categories of fear/threat, patriarchy/misogyny, and sadness/hopelessness cross that dividing line, as they may refer to women being constrained physically, psychologically, or both.

Building Counter-Stories to Reveal What the Passive Framing of Arab Women in Arab News Conceals

Before proceeding to the briefs conveying Arab female passivity in subsequent chapters (chapters 16–19), we note that our style of reporting on news briefs within a dominant female passive frame shifts perceptibly from the style of reporting on briefs within the active framing of previous chapters. Why would this be? Active framings for women in news tend to break dominant cultural stereotypes, while passive framings reinforce them. Just as it requires more conscious awareness and effort to resist gravity (climbing a mountain) than to accommodate it (resting in a chair), it requires more conscious awareness and effort to resist stereotypes than to reinforce them. In briefs framing Arab women within a dominant active frame, reporters who are pro-women are likely to understand that they are writing against the cultural inertia and must make a conscious effort to spotlight a female's active characteristics – her initiative, ambition, determination, and drive toward empowerment – in order to resist the status quo and promote social change. What do we mean by spotlighting a woman in a news brief? We mean granting her the placement required to make readers believe that the story not only includes her but is about her. The reporter of the news brief may spotlight her through strategic placements throughout the brief – in the headline, in the lead

paragraph, in the section headings, in the topic sentences, and at the beginning of sentences. Briefs with active framings and especially written by reporters with a pro-female bias, often, though not always, make a conscious effort to spotlight the women they reference in order to further a pro-women agenda. Spotlighting a woman is not a strict requirement for referencing her through an active framing, and a reporter may simply make passing reference to an active woman who remains buried in the story. Our point is, rather, that a reporter who wishes to feature female activeness in a story will know that the conventions of news writing that put females in headlines and topic sentences, and feature them as repeated grammatical subjects furnish a conventional way to cue readers that females are a main theme of the story.

News briefs with passive framings in our sample differ from briefs with active framings in two important respects. The first and most obvious is content. Briefs with active framings discuss a woman's anger, initiative, education, and other intermediate stages towards empowerment. Briefs with passive framings discuss a woman's fear/threat, her life under patriarchy, and her sadness/hopelessness. However, as we saw in chapter 10, these content divisions between active and passive framings are slippery and often collapse. As we saw in chapter 10, a reader may judge Iraqi girls in school as passive if they are living under a threat of war that obstructs their access to school, or, as we saw in chapter 13, a female who is praised as a pioneer may be satisfying a public relations opportunity for her government rather than empowering herself. Content an important indicator of passive vs. active framings, but because of the subtle interactions of content and context, it may be an unreliable indicator if it is studied apart from context.

The second difference between active and passive framing is the practice of highlighting itself. Spotlighting is a news reporting strategy and, as we saw above, it entails putting the focus of the story in prominent places – headlines, topic sentences, grammatical subjects. Spotlighting may often (but not always) have the effect of contributing an active element to the object spotlighted. That is to say, the more a brief spotlights seemingly "passive" females in a story, the greater the overlap between an active and a passive story framing. For example, a conservative reporter may seek to spotlight and praise a particular woman for advocating the subordinate status of women to men.

Aspects of the content indicate that the framing is passive. However, putting the woman in the spotlight suggests that the framing might also be active. The sole fact she has become the focus may indicate a certain cultural potency. Indeed, placing girls and women who are downtrodden, powerless, and ignored under the journalistic spotlight is one strategy for gaining acknowledgement of their human dignity, a first step down the long road to agency (Kristof & WuDunn 2009). The spotlight provides an inchoate agency of sorts for these girls and women, and has the power to provoke discussion about their challenges and, over time, seek ways to redress it. Conversely, keeping a woman out of the spotlight and buried in the minor detail of a news brief is a passive framing strategy. In the passive framing of Arab females in our briefs, Arab girls and women suffer fear/threat, patriarchy, and sadness/hopelessness. But, in addition, they typically suffer from the inattention of a writer who is focused on the dominant story line and who leaves the girls and women in the taken-for-granted detail and background of the story.

In chapter 3, we saw that the press most representative of the one hundred Arab media sources in our sample neither spotlight Arab women nor bury them in the background. They simply erase them from news. Erasure is the extreme form of framing women passively. Being written out of the spotlight is not as extreme as full erasure, but it nevertheless contributes to the perception of females being framed passively. We found that being written out of the spotlight was a paradigm for the passive framing of Arab females in our sample, making them conform to the assumption, by no means unique to Arab cultures, that hard news is about adult males. This is what Abbott calls a "normalized" assumption (Abbott 2002, 40), a default assumption that is very hard to displace. If we could construct a male voice defending the normalized assumption for females appearing in news, it might say: "If females are not featured in news, no offense to the females is intended. It is simply the way we write the news and have always done so. Why change?"

A moral philosopher from Michigan State University whose research lies at the intersection of identity, narrative theory, and feminism, Hilde Lindemann Nelson has produced some empirical evidence to indicate why change is necessary. Nelson has published a book-length study of the "damaged identities" that women suffer when the dominant culture

tells stories that relegate their own stories to the background and leave them unheard. For example, she followed a group of nurses working in a small city hospital in the US. They were part of a committee that had planned an annual "Nurse Recognition Day" within the hospital. Nelson observed that some nurses soon began to wonder why the doctors needed no "Doctor Recognition Day." This curious fact stirred some of the nurses to think that the very recognition day they had been planning with pride might be a sign of their subservient status (Nelson 2001, 2–3). This sobering realization prompted other nurses to recall episodes with doctors where the nurse tried tactfully to broach her own opinions about treatment care for the patient and the doctor was "abrupt" and told the nurse she was "emotionally overinvolved and professionally out of line" (ibid., 3). Sharing their stories, the nurses on the committee began to discuss whether some doctors had unfairly pigeon-holed nurses on the "touchy-feely" side of a "technical" vs. "touchy-feely" dichotomy (ibid., 3). Nurses, according to the stories of the doctors, led with their hearts; but doctors led with their brains and their technical education and were thus implicitly superior. The nurses recognized that the doctors had learned to tell these unflattering stories to one another and to others, but were careful in their story-telling to keep their stories shadowed in innuendo and fully deniable. The stories only leaked to the nurses in scraps that were hard to challenge and easy to discard or overlook. However, the nurses were reminded that they were the victims of these stories every time they received formal complaints from doctors (communicated through an official intermediary) for daring to challenge their authority on recommendations for patient care (ibid., 4–5). The nurses recognized that if they were to help themselves, they would need to circulate counter-stories to offset the stories (what Nelson calls "master-narratives" [ibid., 6]) that were commonly told about them. The nurses decided that their counter-stories would need to emphasize what brought them into nursing, their educational credentials, and how the knowledge of a nurse did not rank below that of a doctor but complemented it (ibid., 5–7). The nurses knew they would need to start rehearsing their counter-stories among themselves and then, to have impact, they would need to start circulating them throughout the hospital (ibid., 6).

Nelson discovered through these and other systematic observations

that if you find others telling stories about you that damage your identity, you had better learn to tell counter-stories that offer what she calls a "narrative repair" (ibid., 1) to the damage. She defines counter-stories as having four elements. First, they depict events factually. A counter-story cannot be effective if it does not respect the truth. Second, counter-stories select from the available facts to highlight some more than others. Any story requires a narrowed window of attention through which to lead readers from the beginning to the middle, and end. Counter-stories do not alter the facts of the original story; they only shift the narrowed focus of the story-telling so that information previously out of the spotlight comes into it. Third, counter-stories interpret the same facts as those in the original story in such as way as to tell a different story that may begin to redress historical mistreatment and promote the welfare and interests of those telling it (ibid., 11–13). Fourth, counter-stories reinforce one another and function as a unified force to resist dominant narratives (ibid., 14).

What makes a counter-story effective and how can its effectiveness be measured? Nelson defines effectiveness at three levels. First, is the counter-story effective in offering the oppressed group an alternative identity that it prefers to the dominant one? Will, for example, the nurses' counter-stories effectively change the way they think of themselves as nurses? Will it help repair their damaged identity? This first question Nelson calls the question of identity (ibid., 34). Second, will the counter-story persuade the wider culture to recognize and treat the oppressed differently? Will the doctors understand and accept the nurses' repaired identity through the stories they circulate? Will the doctors be able and willing to admit to the flaws in their own master narrative (about doctors and nurses) and be willing to stop telling it? In short, will the counter-story lead the oppressor to stop oppressing? This second question Nelson calls the question of oppression (ibid.). Third, does the counter-story create an action plan for the oppressed group's continuing resistance to the status quo and concrete paths towards change? Will the nurses' counter-story provide them with plans of action that can help them maintain their repaired identity over time and continue successfully to resist the master narrative they no longer want to be part of (ibid., 34–5)? This third question Nelson calls the question of resistance (ibid., 34).

In the news briefs we collected under a dominant passive framing, the women in the story, with a few exceptions, were not written into the spotlight. The briefs refer to Arab females, but were not meant to be about them or to explore their perspective. Were we to recount these briefs as they were written, the female angle would be lost and the representation in this book of Arab women in Arab news would be reduced to a compilation of dry and seemingly incidental information. But what if we were to read these news briefs against the grain in which they were written and construct a counter-story spotlighting the female angle? This is what we have attempted to do in chapters 16–19. We studied the original brief from the perspective from which it was first written. We then isolated all the embedded female elements and reconstructed the story into a counter-story, combining the female elements to build up a female perspective, and, finally, we reflected on how the female perspective converged with or diverged from the dominant perspective. This method approximates the method that the nurses in Nelson's study followed when they found that they were relegated to the background in the stories the doctors told, and determined to reconstruct these stories into counter-stories told from their own perspective. Constructing normalized stories into counter-stories is basic to research in cultural studies, woman's studies, human development, and other disciplines seeking to further the interests of social justice.[5] When you are searching for Arab women at the periphery of Arab news and seeking just representation for them, it is a method of choice.

Conclusion

In this chapter we have reviewed the major work from women's studies that has sought to theorize female passivity worldwide. We have seen that the myth of modern statehood presents peace and prosperity as the enduring norms of state life and war as a remote aberration. This myth undergirds the premises behind the Arab Human Development Reports discussed in chapter 11, but research in women's studies has shown its limitations. Contrary to the myth of modernism, modern states make warcraft and war priorities (human destruction over human development) a more central aspect of statecraft than is commonly

advertised, and the evidence suggests that, in these conditions, women often have reason to prefer erasure to visibility. The literature of women's studies has documented across many regions of the world how women suffer disproportionately within states that practice warcraft and within the war narratives resulting from that practice. The literature clarifies how modern development reports that make optimist predictions of the advancement of women may overestimate women's visibility and underestimate the cultural barriers that stand in the way of their empowerment. Kristof and WuDunn in their recent book put human faces on female passivity worldwide and offer many intimate portraits of females victimized in regions – and that is most regions – that place too little value on the priorities of women's health, nutrition, and social and economic well-being.

On balance, the literature from women's studies teaches us that the empowerment of women under conditions of gender equality cannot simply be an internal battle between women fighting over the codes of tradition vs. modernity. These codes, the literature suggests, are both tainted by masculine assumptions of gender inequality. The struggle for gender equality must confront the roots of patriarchy head on, and it must be a confrontation that brings men into the struggle. Women seeking gender equality need to put themselves in the awkward position David Brooks put himself in when he tried to divert the attention of powerful male legislators from military security to four-year-olds and marshmallows. Similarly, in order for their priorities to be noted, women seeking equality need to divert the attention of powerful men overseeing war industries from human destruction to human development. Women brave enough to divert attention in this fashion need to expect, true to form, that when they do this, they will be told, as was Brooks, that they belong on women's television and not in the "serious" world of policy that males reserve for themselves. Finally, such brave women need to learn to counter the typical male responses that Brooks heard in order to be able to awaken the men and raise their consciousness.

Through grounded analysis, we presented five factors that had a strong statistical relationship to the sixty-two news briefs that drew from our reader a strong gut reaction of Arab female passivity. The three most prominent were (1) fear/threat; (2) patriarchy/misogyny,

and (3) sadness/hopelessness. The remaining chapters describe Arab women in Arab news through the filter of these three factors. But they also describe passive Arab women as women who are seldom spotlighted in hard news. Most of the news briefs we review in chapters 16–19 keep the spotlight off the Arab female angle. Using the notion of "counter-story" explained above, we relied on a method of reclaiming the spotlight for Arab women so that readers might understand and reflect on the many female angles in Arab news that are there for the reading but seldom read.

15: Fear & Threat

THE GENESIS OF FEAR/THREAT AS A COMBINED CONCEPT

Fear/hostile threat is a concept that emerged from the news briefs through grounded theory and was found to strongly correlate with reader-based judgments of female passivity in our corpus. In this chapter, we explain this complex concept in more detail and give a country-by-country breakdown to show where Arab women experienced fear/threat in our corpus of Arab news.

Fear

Fear on its own means an anticipation of contingent future harm. According to our earlier findings, an active Arab woman has a future to claim. Chronic fear and threat force a woman to set this future aside and obsess about a future she wishes to avoid. Concepts signaling an active cultural frame, such as retributive anger, choice, capacity, initiative, drive and so on, work in concert to secure a woman's future. By contrast, fear, if it is great enough, is alone sufficient to disrupt that future and to cause it to fall under a cloud of uncertainty. Fear is not a monolithic emotion, however, and may range from mild to severe. Mild fear may be synonymous with caution, concern, wariness, or suspicion, while extreme fear may be referred to as anxiety, threat, horror, panic, dread, or terror. Fear may linger after the immediate stimulus arousing it and may return in the form of ongoing nightmares long after the stimulus has been removed. Fear may also be socially contagious, causing mass panic. What makes fear so gripping and disabling is that it presents a vivid negative future that one wants to avoid without knowing how to do so. When one attains certainty that a bad

future can be avoided, fear dissipates into relief. When one has certainty that a bad future cannot be avoided, fear settles into resignation, sadness, melancholy, hopelessness, or even depression.

A colorful description of the body in a state of severe fear was provided by Charles Darwin (2009, 81) in *The Expression of the Emotions in Man and Animals* (1872, 290; cited in Munger 2003, 221). Darwin noted that fear is typically preceded by "astonishment" and the arousal of the survival senses of sight and hearing. He and many novelists have recorded that, in fear, the eyes widen, the brows draw together, the lips stretch horizontally, the upper lip rises, the mouth parches and opens slightly, the muscles shiver, the heart beats quickly and violently, the skin perspires, and the hairs on the skin, like fur on a frightened cat, stand erect. There is an initial rush of paralysis, causing one to stand "like a statue motionless and breathless" (ibid.), but nevertheless, the muscles used for physical movement tighten and become oxygen-enriched, preparing for a fight-or-flight response. When we are in a relaxed state, we are controlled by parasympathetic nervous responses. Fear flips the switch from parasympathetic to sympathetic nervous responses, signaling an aroused and agitated state. Curiously enough, anger flips the same switch. So how do the physiological symptoms of fear differ from those of anger?

In a classic study, Albert F. Ax (1953) sought to answer this question. He measured the physiological responses of forty-three subjects, each of whom he put in states of both fear and anger.[1]

Ax's most important finding for our purposes was that, for people made angry, their heart rates, respiration rates and other physiological measures rose and fell in highly synchronized patterns, whereas for people made fearful, these same measures rose and fell independently, without synchronization. Ax reasoned that a person made angry activates various physiological response mechanisms that work together like a psychoactive drug – especially a stimulant – to shape a coordinated somatic response, whereas the body of a person made fearful does not work in harmony as a well-oiled fighting machine. Rather, a person experiencing fear finds clear-thinking and concentration challenging, is obsessed only with the vague aim of self-preservation, and is lucky if her body can support actions that remove her from harm's way long enough to survive the moment.

This finding is consistent with[2] the common political strategy of trying to mobilize an audience that has become distracted and immobilized by fear by making it angry. In his first inaugural address on March 4, 1933 at the height of the depression, Franklin Delano Roosevelt famously sought to motivate Americans out of what he called the "unjustified terror which paralyzes needed efforts to convert retreat into advance" by assuring them that "the only thing we have to fear is fear itself." After seeking to repudiate fear, he then went on to make the American public angry by blaming the bankers of America for their "stubbornness," "incompetence" and "unscrupulous" practices. With anger as their stimulant, Roosevelt called on the American public to reclaim a future supporting the "ancient truths" of civilization by heeding "social values more noble than monetary profit" (Roosevelt 1933). The strategy of seeking to replace an audience's fear by anger, its paralysis by activism, its future of pain by a future of fulfillment, are common strategies of leaders in American history.

From fear to fear/hostile threat

Fear may have its source either in the self or in the world. A person with high anxiety may say, "I feel anxious," and take a pill, and the fear is diminished. In this case, the person knows that the fear wells from within and there may be no outside agency imposing it from without. This is fear arising in the self. Fear that arises in the world assumes that the fear has an external agency. This is common in situations of risk, when statements such as "The odds are not in our favor" are frequently heard. In this, as in many cases of fear whose source is in the world, there may be no single external agency causing the fear. There may simply be random probabilities, as in gambling. Fear arising under the onset of threat, on the other hand, suggests that there is an external agency causing the fear that can be singled out and identified.

Threats posed by forces of nature, for example, give rise to fear with a specific external agency. A home owner building a house on the coast of the Gulf of Mexico faces the threat of hurricanes. Hurricanes, like most dangers arising from natural causes, can be predicted in advance and escaped, or their effects attenuated to some extent. Home owners have options for avoiding or reducing the risks. They may choose not

to build a sea-front home at all; they may choose to build it farther from the coast; they may choose to build it with more durable materials. All these choices are ways of planning to counter the threats of nature.

When threats come without hostile intent, we can counter-plan to avoid or diminish their negative consequences and they cannot counter-plan against us. Hostile threats, on the other hand, are threats that can be maneuvered to counter-plan against us. If we take steps to avoid them, the originator of the threat can take steps to put us back in harm's way. There are numerous briefs in our corpus of Arab news that describe hostile threats menacing fearful Arab women. These are threats that are deliberately engineered to keep Arab women in harm's way, even when they seek to escape harm. We noted in the previous chapter that forty-four of the 179 briefs included some mention of Arab women in states of fear from hostile threat. Table 15.1 gives a country breakdown of the briefs describing Arab women under fear/hostile threat.

Women with liberal-progressive agendas	Women with conservative agendas	Members of women-related activist organizations	Activists with unspecified politics	Activist leaders with unspecified politics	Women seeking to become religious role models
112 (13%)	3 (1%)	11 (1%)	28 (3%)	61 (7%)	7 (1%)

Table 15.1. Breakdown of the forty-four news briefs describing Arab women under fear/hostile threat per region/country. The nine stories from Palestine include four from Gaza, four from the West Bank and one that is general to all of Palestine. Note well that thirty of the forty-four stories take place in states/territories (Iraq, Palestine, Lebanon) that were war zones in 2005–2006.

Stories about women under fear/threat predictably follow the major war zones (Iraq, Palestine, Lebanon) along with repressive government crackdowns (Egypt) in the time period (2005–2006) of our sample. We do not have space in the next two chapters to review all forty-four briefs, but we do review those we believe are most relevant.

Conclusion

Fear/hostile threat is a complex concept and in this transitional chapter, we have shown how it can be derived from more basic concepts. We have also indicated its distribution in the corpus both inside and outside war zones. Because fear/hostile threats are characteristically different within and outside war zones, we now devote a chapter to each of these contexts. In the next chapter, we examine how fear/threat dominates coverage of Arab female passivity in the war zone states of Iraq, Palestine, and Lebanon. In the chapter following that, we turn to coverage of female passivity outside war zones.

16: Fear & Threat in War Zones

Before the local Serb warlord took Jasna away from her apartment to rape her on June 9, he told her not to cry. Jasna a Muslim schoolgirl would be safe with him. And so Jasna, who said she had never had a boyfriend, tried to stop crying as she was raped. According to the Bosnian government, more than 30,000 women have been raped in this former Yugoslav republic's nine-month-old war, with some of the victims as young as 12.

<div align="right">Zenica Bosnia (cited in Maass 1992)</div>

After every war, someone must clean up.

<div align="center">Wislawa Szymborska, Nobel-Prize Winning Polish Poet, born 1923.
Beginning lines of the poem "The End and the Beginning" (1993),
commonly thought to describe the role of women in the aftermath of war</div>

A UN official recently observed that "it is more dangerous to be a woman than a soldier in war" (Foroohar 2010, 44). The official was only partly exaggerating. At least soldiers have armor. In the aftermath of war, women are left to "tidy up," by leading efforts of healing, soothing, nursing, and teaching. But often the tidying up also comes in the form of bringing a perspective to war that refuses to idealize it or dwell on it, and insists on getting beyond it. On very rare occasions, if the war is horrific enough and knocks out enough of the male population, it may fall to women to get beyond war by seizing the reins of government from the men – as happened, remarkably, in Rwanda, after the 1994 genocide left 800,000 Tutsis and Hutus dead in three months. Seventy per cent of the remaining Rwandan population were women. By 2008, Rwanda had the largest percentage of females in powerful government positions in the world, with women occupying 56% of seats in parliament. No country has come to

illustrate the rule of women better than Rwanda. But, even here, there is controversy as to how well women leaders connect with average female citizens.[1]

Our corpus of Arab news confirms the truths that women suffer in war and are expected to do much of the tidying up after it. The suffering of women in war in our Arab corpus is not as ghastly as in Bosnia, and the tidying up is not as revolutionary as in Rwanda. But it is suffering and tidying up nonetheless. The news briefs show Arab women in active conflict zones in 2005–2006 living under the fear and hostile threat of war, and Arab women "cleaning up" by managing realistic perceptions of what war is and teaching others how to put war in perspective with a moral clarity that the men in news seldom show.

Fear and Hostile Threats in Iraq

The scholarship from the women's studies community referenced in chapter 14 suggests that women living under conditions of war are a paradigm for understanding female passivity on a global scale. It is therefore not surprising to discover that, when we generated grounded concepts representative of female passivity, and then studied the distribution of these concepts throughout our corpus, we found that the two hottest war zones of 2005–2006, namely Iraq and Palestine, were also the focus of news implying female passivity.

Hostile Threats Turned Violent:
Kidnap, Murder, and Iraqi Women

Research from women's studies, as we have seen, has called into question the simplistic picture that the forces of modernity and globalization are monolithically pro-women and that the forces of Islam and the East are monolithically anti-women. (Moallem [2005] is particularly enlightening on this point.) The capacity to commit violence against innocent women is alive and well both West and East.

The modern and Western contribution of fear/threat against women is illustrated in two briefs from Iraq on the treatment of Iraqi women by American soldiers. A news brief of an *Al Hayat* story from

June 1, 2006 recounts the "gruesome details" of the Haditha massacre in Iraq that had taken place months earlier, on the morning of November 19, 2005, and whose details were only then being leaked to the press. On that morning in the village of Haditha, US marines riding in a humvee ran into an IED (improvised explosive device) that blew up their humvee, killing the driver and wounding another soldier. The marines, according to their own testimony, believed they were under fire and identified four houses approximately 150 yards away as the source of the fire. They stormed the houses one by one. In the aftermath, fifteen unarmed Iraqis lay dead in their homes, including seven women and three children – the worst incidence of violence against Iraqi civilians by US soldiers. The brief recounts what took place in the first house[2] as related by Eman Waleed, a nine-year-old girl who survived the mayhem, along with her eight-year-old brother, Abdul Rahman, and her younger sister, Asia (sic), and who provided the only eyewitness testimony. She reported hearing a loud blast that shattered all the windows in her house. Her father did what he always did when his house came under threat. He retreated to his room in the front of the house, Qur'an in hand, to pray. The rest of the family, the mother, grandfather, grandmother, two brothers, two aunts and two uncles huddled in the living room to the rear. The Marines broke into the house and began shouting in English. They entered the front room where the father was praying. Eman testified, "We heard shots." The father fell immediately, dead. The Marines then entered the living room where the remaining family members were cowering. She recalls them shooting her grandfather in two bursts, first in the chest, then the head. They then fired on her grandmother. She and Abdul Rahman were hiding under some furniture but still within the Marines' line of fire. The adults hurled themselves forward to shield the children and were mown down by bullets. Eman's leg was hit by shrapnel and Abdul Rahman was hit in the shoulder. Jesse Macbeth, an ex-American soldier who had served in Iraq for almost a year and half and is quoted in the brief, reports being shocked by the massacre but not surprised: "It became clear to me later that the operation to liberate Iraq was in reality slaughtering Iraq." Video of the crime scene taken the day after showed no bullet holes outside the house. This finding called into question the Marines' account that they were under enemy fire, which

they had cited as justification for their assault. Further weakening their account was the condition of the dead women. The dead females were not combat ready. All were found in their nightclothes.[3]

The above description of the incidents at Haditha preserves the facts of the case as reported by the original *Al Hayat* news brief and other news sources, but with the Arab female angle brought out for emphasis. It provides a counter-story (see chapter 14) where the female connection has been spotlighted and so made easier for readers to isolate and judge. Once the female angle is isolated in the brief, it is readily apparent that the Iraqi women at Haditha were victims but not specifically targeted victims. They were part of the story's "collateral damage," but not in a way that showed any targeted prejudice against Arab women on account of their gender.

A more targeted assault against an Iraqi girl occurred on March 12, 2006, in the village of Yusufiyah, south of Baghdad and became known as the al-Mahmudiyah killings, al-Mahmudiyah being the nearest town. There, a fourteen-year-old girl, Abeer Qasim Hamza, was gang-raped and murdered, soon after the murder of her mother, father, and six-year-old sister. Five US Army soldiers of the 502nd Infantry Regiment were charged. By September 2009, all had pleaded guilty and two had been convicted. The soldier judged to be the primary culprit was sentenced to life in prison with no possibility of parole (BBC 2009b). A brief dated August 15, 2006, reports that Faten Abdul-Rahman Mahmud, the Iraqi minister for women's affairs, expressed her concern that the Americans would whitewash the killings. Mahmud's concern was to construct her own counter-story to make sure that the women's angle was not lost by either the American or Iraqi government. Mahmud is a woman we met earlier (page 125) in the context of her insistent pushing for Iraqi representation on a panel formed to investigate the charges of rape at al-Mahmudiyah. We revisit her now because, in addition to her forceful insistence that justice be served, the brief describes her expressing an "anxiety" on behalf of Iraqi women everywhere that in the Iraqi war zone the threat to female safety would not receive the full media attention it deserved. Mahmud accused the American government of granting the American soldiers legal immunity (which it did not do), which, she worried, would only increase the incidence of rape and further "arouse [the]

anxiety" of Iraqi women. Her concerns were exacerbated after General George Casey, then leader of the American effort in Iraq, had personally met with her and promised her that Iraqis would have representation in the investigations, only later to discover that the first session of the investigation had convened with only one representative from the Iraqi human rights commission in attendance, and this person was granted only "observer" status. Abdul Rahman emphasized that there were too many differences in "cultures and religious and moral values" between Americans and Iraqis to assume that justice could be fairly meted out by the Americans alone. To deny Iraqi representation, she is quoted as saying, is to commit "an assault against the honour of the Iraqis" and to put "all Iraqi females" under notice that they "are vulnerable to such an act."

Throughout 2005–2006, sectarian violence between Iraqi Sunnis and Shi'is produced a stream of stories about kidnappings and murders. Both factions engaged in reprisals and counter-reprisals to the kidnaps and murders of the other. A news brief from *Al Hayat* on January 20, 2006 suggests how highly prized women were by both sides as kidnap targets. Although the brief covers aspects of the practice of kidnapping women as a part of tactical warfare, it does not spotlight women and the fear/threat caused them at the center of the story. We offer an analysis of the original article that makes the female angle of fear/threat more visible and easier to assess.

Like women in most societies, Iraqi women are the central threads of Iraqi social fabric. There is thus no more effective way to rend the enemy's social fabric than to kidnap their women. The symbolism of the kidnapped woman is potent, as the brief explains, because to kidnap a woman is to deal a "blow to the heart of the social traditions that are considered the primary engine of the tribal Iraqi society." Rounds of female kidnappings caused tension in Iraqi society, and male tribal members threatened the life of anyone detaining their female kin.

In the hostilities in Iraq in 2005–2006, Iraqi women became a measure each side used for assessing their tactical advantage over the other. Each side required a reserve of kidnapped women from the other side as collateral for bargaining for the return of women it had lost, and seizing women for barter became a primary skirmishing strategy. The Iraqi government understood the tactical leverage of the

"kidnapped-woman" as well as the insurgents. In official communications, according to the brief, the government denounced the use of women for barter and declared the practice not only immoral but also ineffective. Gen. Ali Yassiri, chief of the Al-Najda police, is quoted in the *Al Hayat* brief as saying that the insurgents' female detainee system "has not succeeded in making the security forces relinquish their goal of ridding Iraq of terrorists and criminals." Yet, behind the scenes, the Iraqi government quietly imitated the very tactics it publicly deplored. Iraqi government forces routinely broke into the homes of insurgents and removed their women, often under the pretext of "arresting" them. The insurgents returned the favor by breaking into the homes of Iraqi officials and stealing their women. Such "women for women" warfare, the brief points out, "had become the primary weapon in the war between the insurgents and the government."

The Americans, also clued into kidnapped women as tactical leverage, were not above imitating the practice for their own advantage when the occasion called for it. To pursue Abu Musab Al-Zarqawi, the leader of the Iraqi Sunni insurgency and Iraq's most wanted criminal,[4] American forces kidnapped one of al-Zarqawi's female relatives in Ramadi. In retaliation, the insurgents declared open season on American female journalists. Shortly after, the Revenge Battalions group kidnapped American journalist Jill Caroll and threatened to kill her within seventy-two hours if their women were not released from detention.

Not all kidnapped women were powerless pawns. One kidnapping of a prominent Arab female took place in circumstances where there seems to be no counter-analysis that is exclusive to Arab females and fear/threat within war zones. An Arab woman with power is kidnapped, treated well, and released. Eight months after the story about Jill Caroll had run, on August 18, 2006, another *Al Hayat* brief appeared on the kidnapping of an Iraqi female parliamentarian and member of the Islamic Party of Iraq, thirty-year-old Taysir Al-Mashhadani. Al-Mashhadani claimed to have been held captive for two months before being released. According to her account, she had been kidnapped in the predominantly Shi'a area of northern Baghdad, al-Sha'ab, in early July. She described her captors as having descended on her without warning from civilian cars, wearing

civilian clothes. According to her account, they had intercepted her car and left her bodyguards too surprised to protect her. She later recounted that the kidnappers were surprisingly calm and gentle in their instructions to her: "Remain in your place Doctor Taysir until we take you somewhere safe." Over the course of her detention, she recalled, her captors kept her on the move, switching her from one house to another, in and out of at least five different houses in as many nights. In each house, a different group took custody of her, and she was questioned daily about her ideological alliances. She claimed to have been treated with respect and dignity throughout her captivity, and reported that her captors assured her that they were sensitive to the delicacies of kidnapping a woman. As the length of her detention was approaching two months, her captors informed her that she would be released the next day. No ransom was ever demanded and she assumed her release was part of a political negotiation to which she was not privy.

Sometimes it is not Iraqi women but their husbands who are the direct victims of kidnapping. Wives of kidnap victims endure additional pain and frustration if the government is implicated in the kidnapping because the wife's pleas for government help may only make matters worse for her husband. An *Al Quds Al Arabi* news brief of November 21, 2006 is a case in point. A recent Shi'i kidnapping of suspected Sunni leaders had left one official of the Ministry of Higher Education and Scientific Research and another from the Overseas Studies and Relations Department dead. The source of this story was one of the surviving kidnap victims, who had been released. He reported that the Shi'i kidnappers had first tried to confuse their victims by adopting Sunni nicknames such as Abu Omar and Othman and pretending they were Sunnis. This was intended to lull the victims into disclosing that they were members of the Sunni Islamic Party. Members of that party, once identified, were beaten with iron clubs, tortured, and often killed. Those Sunnis who could not be positively identified as members of the party were subjected to further interrogation. The interrogators were seasoned in the art of deception and in the teamwork necessary to keep the interrogated Sunnis confused and off balance. One would tell the victims they would eventually be released; another would come and threaten to beat them; a third would

intervene in the "good cop" role, making the victims think he was calling for their immediate release.

It is easy to see here how females can become invisible in the detail of the story. The female angle lies at the periphery that we now bring into the spotlight. The wife of one of the kidnap victims, a suspected member of the Islamic Party, was being held hostage by Mulla Sadr's Shi'ite army. The wife explained to the *Al Quds Al Arabi* reporter that she believed her husband was still alive, but that he suffered from high blood pressure and required medical care. She was fearful for his safety but also concerned that the Shi'a faction now in charge of the Iraqi government had been involved in the kidnapping. Were that the case, she knew her public pleas to the government for help might jeopardize her husband's life. The government had told her that she needed to keep her agony to herself. In defiance of this warning, the woman had decided to go on record with the *Al Quds Al Arabi* reporter about her fears, now of the government as well as the insurgency. As the brief frames it, the wife "added with jitteriness and fear that the current government had told her not to contact the media or make any statements."

Threats to Female Pharmacists in Iraq

Throughout 2005–2006, Iraq's professional and entrepreneurial class, an important bellwether of Iraq's social stability, was threatened by insurgents. There was a particular focus on pharmacists because the drugs they carried served a variety of purposes for a variety of markets. They could be sold on the open market to the highest bidder, or used to treat the wounded of all factions. And addicts had also recently shown themselves ready to arm themselves and steal drugs for their personal use. An *Al Hayat* brief from February 8, 2006 describes the plight of pharmacists in Iraq in the face of the rapidly deteriorating security situation. Asaad Burhan, a pharmacy owner, complained that he had been told he must surrender his pharmacy or have his throat cut. In the face of these threats, he closed his pharmacy, as did many of his peers. But, unlike many others, he lacked the money he needed to relocate to a hospital in Amman, Dubai, Damascus, or Cairo to continue his business. So he shut down the

pharmacy he owned in violent southern Baghdad and moved to the quieter remote neighborhood of Karada, where he continued to work as a pharmacist secretly, making sure he stayed off the dangerous streets and was home from work before sunset. Burhan could not explain exactly why pharmacists in general, and he in particular, were being targeted, but claimed that, bad as it had been for him, it had been worse for his female colleagues. In the brief, he mentions the female angle obliquely, by pointing out that the "female pharmacists . . . now remain inside their homes." But if we search for a counter-analysis to spotlight the females, we find that he was also saying something profound about how war was affecting male and female pharmacists differently. Women had shut down their pharmacies and did not dare leave their homes. Being at greater risk than men in conditions of such insecurity, the female pharmacists had lost more than their places of work. They had lost their careers and livelihoods.

Fleeing under Hostile Threat:
Iraqi Women Émigrés and Refugees

Another brief covers the mass exodus of the expert class. An *Al Quds Al Arabi* brief of January 24, 2006 features this worrisome "brain drain," including the exodus of one female émigré given peripheral mention. The brief reports that, since the fall of Baghdad in April 2003, some 1 million people had left Iraq and some 1,100 families were leaving each day for Jordan alone. Many of these emigrants had skills that were in demand in neighboring Arab countries. Skilled experts without Western passports were welcomed into Syria, Jordan, and Egypt, while those with Western passports, and often with degrees from American and European universities, emigrated to the West. The brief covers not only where the expert class were going but why they were leaving. Some report being targeted because they were prosperous Ba'thists with ties to the Saddam regime. Others had simply had enough of the endless kidnappings and extortion, and the police looking the other way. Omar Al Kabissi reported receiving a note demanding he leave the country within ten days. He took the note to the police, only to find himself accused of writing it. He left for Jordan days later. The brief cites a US AID From the American People (USAID) report[5] that

declared the security system of Iraq had been fractured into tense "power zones," one power zone "shared by gangsters committing robberies and murders," and another controlled by "the transitional Iraqi government" stationed in the Green Zone. Others suggested that insurgents were targeting Iraq's expert class in order to undermine Iraq's last hope of functioning as a single country. In that, these sources confessed, the insurgents appeared to be succeeding.

Baghdad's intellectual class was in flight. But just as worrisome was the fact that its student class was running for the exits as well. Students interviewed at Baghdad University reported that the security situation and shattered economy had persuaded them to leave Iraq immediately after their graduation, if not before.

Even Iraqis who had returned to Iraq with high hopes after the fall of Saddam were leaving, as well as others who had long prided themselves on being able to tough it out. They had endured one security threat after another, but the incessant run of threats had finally broken their will. The lone female émigré mentioned in the *Al Quds Al Arabi* brief fell into this category. She was identified only as a "lady" and was described as having witnessed "four wars" without once thinking of leaving Iraq. But now, defeated, she admitted that the situation had hit an "unbearable" rock bottom and that it had been a long time since she had felt safe in her country. Because of the security situation, her world had become increasingly small and confined, and she claimed she no longer felt safe anywhere, not even "in her own bedroom." In chapter 8, when describing Arab women and their education, we met Rim Mahmoud who had to leave school and was confined to her home when the tensions of war flared. The unnamed "lady" in the current brief teaches that when a home is no longer safe for an Arab female, nothing left in the country may be safe.

By 2007, the Iraqi war had produced an estimated 3.8 million refugees (Yaghmaian 2007). Women and children were the main victims. According to the Office of the United Nations High Commissioner for Refugees (UNHCR 2002) of the 43 million refugees worldwide, women and children bear the brunt of the trauma of refugee life. The most immediate concerns for refugees are security, sanitation, nutrition, health care, and access to services, followed by the maternal

concerns of protection from sexual violence, prenatal care, and the custodial, nutritional, and educational needs of their children. During the Iraq war, rafts of female refugees were displaced with their families from central Baghdad to camps outside the city. An *Asharq Al Awsat* brief from June 19, 2006 covers Nassir Al Ali's report of the diseases ravaging the Ajkok refugee camp near Baghdad. At the time, the Ajkok camp comprised more than 290 families who had been taken by force from central Baghdad. The camp lacked functioning sewers and potable water and these unsanitary conditions led to the spread of rickets, skin disease, and infections. Especially hard hit were the children. A woman who asked to be called Abu Mazen complained that the families were crowded together, literally living on top of one another, sometimes twenty in one tent. There were shortages of water, electricity, food, fuel, and sanitation. Um Zahra, a widow with two small children and no income, had fled Baghdad with her children after being threatened several times. She claimed that the camps had offered nothing to the families and any information to the contrary was government disinformation. The Ministry of Labor, whom she had contacted, had promised support for displaced families but she had later discovered their promises were empty. She acknowledged that health teams from the Ministry of Health had visited the camp a few times and examined some families. However, aside from administering some medications that eventually proved ineffective in treating the children, they had done nothing. The only aid to have made a difference, she went on, came from humanitarian organizations from Italy, Spain, and the United Arab Emirates Red Crescent. Independent corroboration showed that Um Zahra had not been exaggerating the problem. An official in the Emigrants Commission of the Council of the Baghdad governorate, contacted for the story, confirmed that the solutions being brought into the camps were no match for the problems.

Hostile Threats to Iraqi Women for their Alleged Lack of Piety

As we saw in chapter 14, current research in women's studies has found that women are often blamed when war breaks out. But why are women blamed? Across Muslim and many non-Muslim

countries, the honor of the woman is the honor of the family and a common litmus test for state strength and stability. The erosion of that strength and stability through war must be, according to a devious but persistent illogic, the doing of the women and so their sole responsibility and fault. Whether such premises are believed or used only as a convenient pretext to step up the oppression of women in war zones, extremists in war zones use such premises as justification for policing the morals of women at a rate and intensity higher than the "normal" surveillance of women they proudly practice in times of peace.[6]

An *Al Hayat* brief from May 12, 2006 establishes the context for such intensified harassment. The brief reports that Musab Al-Zarqawi, leader of Al-Qaeda in Iraq, and his supporters, were rampaging from neighborhood to neighborhood in Baghdad to annex them into what he called a "Muslim principality." Al-Qaeda in Iraq members saturated neighborhoods with fliers threatening the murder of any woman sighted without a head scarf. An *Al Hayat* brief of June 5, 2006 covering a story about the city of Ba'quba, just north-east of Baghdad in Diyala province, reported that women's beauty salons were being shut down after religious extremists circulated pamphlets banning cosmetics. Salima Najm, a salon owner, had to shut down her salon after receiving a death threat. Groups of armed men seeking to intimidate women made such salons one of their prime targets.

As we saw in two previous briefs in chapter 8, the religious police extended their activities to Baghdad's female students. One brief, from *Al Hayat* on May 24, 2006, described life for students during the end-of-year finals in the spring of 2006. There we met Rim Mahmoud, who braved the 2005–2006 academic year but who abandoned her spring examinations because it was no longer safe for girls to travel, especially without the veil. The other (*Al Hayat*, October 3, 2006) addressed the resumption of that life at the start of the new school year in the fall of 2006. There we met Sara, a junior studying philosophy, who thought it best to drop out for a year to wait for security to improve – but she waited for nothing, because the new school year saw the security situation worsen. Threats against women intensified, and families forced their daughters to remain home.

Marital Tensions under the Hostile Threat of Sectarian Division

Sectarian relations became so strained in Iraq in 2005–2006 that, even if a woman who married across sectarian lines managed to survive hostile threats, her marriage often did not. This phenomenon is documented in a December 4, 2006 brief from *Al Quds Al Arabi*. The exodus from Iraq in 2005–2006 had been massive. So too had been the relocation of the population along sectarian lines within Baghdad neighborhoods. Yearning for the "purity" of neighborhoods, Sunni dominated neighborhoods expelled their Shi'i minority to Shi'i regions, while Shi'is expelled their Sunni minority to Sunni regions. Expulsions were forced and frequently violent. The main narrative of the brief describes the plight of both Shi'a and Sunni families who had been evicted from one another's neighborhoods.

But the brief concludes in passing with a female angle that is poignant and potentially explosive. Um-Haidar, a mother of four, had a tale to tell which the brief cautions was "starting to spread in Baghdad and threatening to dismantle the social fabric in the city." It was about the rising rate of divorce caused by sectarian tensions. The strain within neighborhoods was spilling over into marital strains between couples who had married across the Sunni-Shi'a divide. Civil war had been waged across the country but now it was being waged within marriages, tearing them apart. Within families in which there were multiple mixed marriages, the sectarian dominos could fall quickly and one divorce based on sectarian difference might cause a cascade of divorces down the line. Um-Haidar hailed from a Sunni family that lived in the Sunni dominated Abu-Ghurayb area west of Baghdad. She had married a Shi'i friend who worked with her brothers. She had four children with her husband before the family moved to the Shi'i dominated Ur neighborhood to be closer to his parents. Her brother shortly thereafter married her husband's sister and they had three children. Pressured by his parents, her husband divorced Um-Haidar and took away their four children. This forced her brother to divorce his wife and wrest three children from her. Under the pressure of sectarian tensions, families disintegrated. Divorced Sunni and Shi'a men lost their wives. But only divorced Sunni and Shi'a women lost their children.

The Moral Clarity of Two Women's Fear

In the waning days of 2006, sectarian violence reached such proportions in Iraq and, to a much lesser extent, Lebanon, that Mshari Al-Zaydi, *Asharq Al Awsat*'s opinion page editor, was moved to write a long editorial, dateline December 18, decrying the way sectarianism had torn the fabric of Arab society and cowardly politicians were exacerbating the problem by denying it was so. Al-Zaydi wrote of the "flames of sectarian fire consuming our region" while hapless politicians close their eyes and say all is well. Despite the overthrow of the dictator and the authentic hope for a unified Iraq, sectarian divisions had stolen that hope. Al-Zaydi complained that it was too much to expect inept and craven politicians to tell the truth about sectarian strife when we are most in need of truth.

So on whom can we rely for the truth? Who can expose the cover-up and address the folly of the hatreds at their source? Al-Zaydi recommends we look to the "moving words" of two young Lebanese women recently published on December 11 in *Asharq Al Awsat*. The first is a Christian woman by the name of Patricia, a member of the March 14 alliance aimed at seeing the withdrawal of Syrian influence from Lebanon. Patricia's haunting fears open us to the gravity of the situation with new clarity. Living in East Beirut, Patricia reported that she now studiously avoided running into certain people, even friends, if she anticipated an uncomfortable difference of opinion with them across sectarian lines. She is quoted as saying: "I am worried that I would have to hear any provoking comments to which I would have to respond as I can no longer remain silent. People are fed up. I can now see the hatred in people's eyes in Beirut." The second woman is Muslim. Her name is Fadia and Al-Zaydi describes her as "a young Shi'i supporter of Hizbollah." Her religious beliefs may differ from Patricia's but what these women share are the clarifying fears of a situation that has gotten out of hand. Fadia too "expressed her fear of areas where residents are of mixed faiths, especially at night as you do not know what could happen between Hizbollah supporters and pro-government elements."

The female angle makes up only a small portion of a long editorial that takes a roll call of the major (male) players on both sides of

sectarian violence and dissects their motives, interests, egos, and intransigence. But even though Patricia and Fadia occupy only a modest part of the editorial, they emerge as the quiet heroines of Al-Zaydi's long narrative. Of the many men referenced in the brief, none can claim the clarity of these two women about one emotional truth of the situation on the ground. The men fantasize about the ultimate triumph of their particular sect and their imagination is freighted with too much ego to confront the costs (everyone loses) when hatreds collide. The two women in the story, no doubt representing the views of other women and men not depicted in the brief, have the moral clarity to frame the situation with the sobriety necessary to bring about resolution.

Fear and Hostile Threats in Palestine

Next to Iraq, the region in which the corpus reports Arab women in 2005–2006 as being most under hostile threat is Palestine. The source of this threat, unsurprisingly, is Israel and its policies.

Female Fears of Family Dislocation Policies in Israel

Suad Amiry, a Palestinian writer, studied architecture in Beirut, the UK and America. Her memoir, *Sharon and My Mother-in-Law: Ramallah Diaries* (2005) has been translated into eleven languages, and was joint winner[7] of the coveted Viareggio Prize. *Sharon and My Mother-in-Law* is a darkly funny account of Amiry's absurd, humorous, and painful experiences while living under occupation for nearly twenty years. Among many other stories, she recounts how she somehow managed to get her dog, Noah, an identity card when thousands of Palestinians, including herself, struggled in vain to obtain one. Noah had the credentials to enter Israel unobstructed but Amiry did not. She recounts an amusing tale when she drove with Noah to an Israeli checkpoint. Holding out Noah's ID card for entry, she argued with the Israeli soldier that she should be allowed to pass because she was, after all, Noah's driver.

Amiry recounts the challenges of living with her ninety-two-year-old mother-in-law during a forty-two day curfew. An *Asharq Al Awsat*

brief dated February 6, 2006 used the occasion of the publication of Amiry's book to focus attention on the consequences for Palestinian families of Israeli's family dislocation policies. Some background about these policies will put the importance of the story into perspective.

From the time of occupation in 1967, Israel has controlled the Palestinian population registry and retained the power to judge who is a Palestinian resident. Many Palestinian parents did not register their children, especially their daughters, as residents and these children, upon reaching the age of sixteen, were not able to persuade the Israeli government to issue them with identity cards. The card is necessary for applying to universities, opening bank accounts, securing a driver's license, marrying within Israel, and passing through checkpoints. Deprived of an identity card, a Palestinian's mobility is seriously constrained. As Amiry notes in her book, over 50,000 Palestinians are still waiting for their identity cards; some have been waiting for up to eleven years. And during their long wait, they cannot travel and are considered "illegal" in their own places of residence.[8]

Lowenstein, who researched Palestinian displacement issues in 2006, interviewed Adnan, a Palestinian man living in Gaza and married to an Algerian, Fatima. They had applied for Fatima's identity card a decade ago and still did not have it. Meanwhile, Fatima could not get a passport, and so could not leave Gaza, or if she did, might never be allowed back. According to B'Tselem, the Israeli information center for human rights in the occupied territories, Israel only considers granting new identity cards to Palestinians through its family unification program, which allows non-residents of Gaza and the West Bank (typically spouses of residents) to become permanent residents. When it processed requests through the family unification program, Israel was slow and miserly in granting identity cards. The Israeli Civil Administration justified its frugality by charging that the Palestinian Authority had long exceeded the quota allotted to it for family re-unification (B'Tselem 2008). However, as the brief suggests, there is something surreal about asking an Arab female, like Fatima, who has been living with her husband for over a decade, to come up with a reason as to why, to make her residence legal, she deserves to be "reunited" with him. From 2000 until 2006 the application process had become worse than surreal. It had become futile. From the second

intifada in September 2000 until 2006, Israel had frozen all family
unification requests.

B'Tselem (2008) documents cases like that of Raafat Abu Ra'iyeh, a
baker and resident of Tarqumya in the Hebron District, who was
detained up to four hours a day at checkpoints to and from work.
During times of crackdown, he sometimes sacrificed seeing his family
for months at a time, fearing deportation. Even so, Abu Ra'iyeh felt
lucky to be employed. Many without ID cards, such as Mu'az Abu
'Eid, could not find work. Many others, seeking to return to education,
could not do so. And still others, caught in the cross-hairs of the second
intifada in the midst of their schooling, could not pass the checkpoints
to attend school. Safa Fuqahaa, from the town of Tubas in the West
Bank, fell into this last category. She had begun nursing school in
Nablus. At the end of her second year, the second intifada erupted and
the Israeli army set up checkpoints between her home and Nablus,
which, without an ID card, she could not pass. Safa was thus forced out
of her school, compelled to halt her studies in midstream, and suffered
a "traumatic" experience because she was "one of the top students"
(B'Tselem 2008).

Palestinian women denied identity cards encounter devastating
setbacks to their prospects for marriage and child-raising. Without
IDs, they are at a severe disadvantage as marriage prospects. Ein
al-Beida told B'Tselem that once suitors heard she had no ID card,
they quickly disappeared. The lack of an ID card also made mother-
hood an unnerving experience. Intisar Abu 'Issa, a Palestinian mother
interviewed by B'Tselem, discovered to her horror that after her child
suffered catastrophic burns that required emergency medical help
abroad, she was denied permission to travel.

The February 6, 2006 *Asharq Al Awsat* brief on Palestinian family
dislocation notes that since the institution of the Palestinian Authority
after the Oslo accord in 1993, Israel had refused to register over 40,000
Palestinians with permanent resident status. Many Palestinians living
in the West Bank and Gaza rely for their residence on fragile visitor
visas, which they must regularly leave the country to renew. These
departures from the country are a constant challenge. An unnamed
mother whose adult daughter lives in Ramallah with an American pass-
port said that her daughter must return to the US four times a year just

to maintain her visitor status in the West Bank. Permanent residence means accepting a permanent itinerant status. The mother fears this permanent itinerant status will be passed on to her grandchildren. She said her daughter realized that the only way to give her children any kind of legitimate permanent resident status was to give birth in America. A birth in Palestine can sentence a child to permanent status as a nomad.

Palestinian family dislocation was further exacerbated on July 31, 2003 when the Knesset enacted the "Nationality and Entry into Israel Law (Temporary Order) – 2003." The law forbad the granting of Israeli residency or citizenship to any Palestinians from the 1967 Occupied Palestinian Territories who were married to an (Arab) Israeli citizen. Through a series of extensions, the law was still in effect in 2005. On July 27 2005, the Knesset voted to extend the law through March 31 2006. The *Asharq Al Awsat* brief appeared at a time of peak debate over the law, less than two months before the March 31 deadline and three months before the Israeli Supreme Court was scheduled to rule on the constitutionality of the law. On May 14 2006, in a close split decision of 6–5 Justices, the Court upheld the constitutionality of the law. Less than a year later, on March 21, 2007, the Knesset passed a stronger law that forbad residency or citizenship to the spouse of an Israeli Arab who was a resident or citizen of Lebanon, Syria, Iran or Iraq – states considered a threat to Israeli security (Adalah 2006).[9]

The *Asharq Al Awsat* February 6, 2006 brief complained that the Israeli government turned away with one hand what it offered with another. Taking a barrage of international criticism that its law committed discrimination against Arab families on the basis of national belonging, Israel had made gestures in 2006 to reopen applications for the family unification of Arab Israelis and their foreign spouses. But the terms of these gestures, so the brief asserts, sabotaged the seriousness of the gesture. One of the terms was that the man needed to be over the age of thirty-five and the woman over the age of twenty-five to apply for family unification. A couple both aged twenty-five would need for the man to age a decade to be united and the woman would need to count down a decade on her biological clock. Another proposed restriction was that the lag time between application and approval could last five years. A couple could do the math and see that they

would be lucky to be united in Israel while still in their child-bearing years. Ziad Al Houmari, from the Jerusalem Center of Social and Economic Rights and also quoted in the brief, added a third wrinkle. He notes that Israel exercises great discretion in annexing more land for Israel and rescinding the residency rights of Arab Israelis. He envisioned a nightmare scenario where a couple – in fact hundreds and thousands of couples, he fears – could make application for family unification within Israel and by the time they heard about approval, neither would have footing in Israel. These additional restrictions, so the brief contends, threaten the future of intact Palestinian families living in greater Israel. Palestinian women, the hub of their families, live at the hub of the threat.

Female Fears of Food Shortages in Gaza

On January 26, 2006, Hamas gained unexpected victories in Palestinian Legislative Council elections, putting an end to forty years of Fatah-PLO dominance over Palestinian leadership, and setting prospects of peace with Israel at a new low. Hamas spokespersons vowed never to recognize Israel or abandon the radical Palestinian call for the dismantling of the Jewish state. Wary of Hamas' radicalism, the US government froze aid to the Palestinian Authority, making it all but impossible to pay the salaries of the administrators of the Palestine Authority. Residents of Gaza were panicking about feared Israeli reprisals for putting Hamas in power.

In chapter 7 (page 124) we met Mahmoud Omar Hakoumi of Gaza and referred to his unnamed wife's insistence that he buy extra food stuffs for the family in anticipation of further strikes from Israel. We now revisit that same *Elaph* brief from February 28, 2006 from the perspective of Gazan women living in fear. The brief focuses on Palestinians making a run on the food markets in response to "Israel's threats" to close the crossings that supply Gaza. It notes that Gazans "fear shortages and price increases" in the event the markets shut down, and that their "great concern" is inciting panic-shopping to hoard necessities. The brief makes palpable the Gazans' fear and especially the heightened fear of Gazan women. It describes this fear as emanating in part from Hamas' victories in the legislative elections

and Tel Aviv's interest "to punish the Palestinian people" for electing Hamas. Hamas leaders are described as imploring Gazans to cease their "fear and worry." Yet the brief suggests that their reassurances are not working, and they are especially not working for the Gazan mothers who know that the words of Gazan leaders cannot feed and nourish their children. The brief reveals that "anxiety amongst some Palestinians remains high, especially amongst women who fear that their children will suffer from a shortage of milk and nutrition supplies."

A Wife's Fears during a Home Invasion

In March 2006, more than forty Qassam rockets fired from Gaza hailed down on the Southern Israeli city of Sderot. Rocket launches from Gaza increased steadily after that, reaching ninety firings into Israel in June. Israel retaliated by shelling the launch sites in Gaza. The Israeli Air Force began targeted assassinations of leaders of the Popular Resistance Committees, Islamic Jihad, Hamas and Fatah. On May 30, in a dawn raid on his Ramallah home, Israeli forces captured and arrested the deputy secretary-general of the Hamas-led Palestinian government, Aziz Kayed. An *Al Quds Al Arabi* brief published the next day, May 31, voices the fears and complaints of Kayed's wife. She describes how her house was encircled by soldiers before they broke in, and says that, once they had forced their way in, they searched the house for over an hour. They confiscated the memory card from her husband's computer, and seized a substantial sum of money that she and her husband had been saving for a new home. The soldiers, she complains, went to gratuitous and humiliating lengths to invade their privacy. She alleges that the soldiers interrupted their search midstream to view a family videotape on the family digital camera. She accuses the soldiers of being "brutal" with her husband. She pleaded with the soldiers that there were children in the bedrooms who "might be scared," but the soldiers paid no attention and stormed the room. They then hurriedly placed Kayed and his wife under arrest, and rushed the husband to an undisclosed location.

These briefs from Gaza offer minuscule counter-stories of what war looks like from the Arab female perspective. They remind us that men

must take to the fight or flee from it. Women are the legitimate witnesses of war who are allowed to keep one eye on the mayhem and the other on normalcy. They are not afraid to insist on food and sleep for their children when their worlds are caving in.

"Scared to Death" – Palestinian Schoolgirls' Fear of Assault by Israel Soldiers

In November 2005, just two months before Ariel Sharon's stroke and Hamas' unexpected victories, tensions between Israel and Palestine seemed to be abating slightly. Israel had recently opened the Rafah border, allowing Palestinians in Gaza passage into Egypt, and had promised to implement safe passage from Gaza to the West Bank. However, Hamas' missile-launchings into southern Sderot and then into the outskirts of Ashqelon soured Israel's overtures. That same month, a judgment was passed that shocked Palestinians and much of the world, including large segments of the Israeli public: an Israeli soldier who had been tried for killing an innocent Palestinian school-girl in 2004 by unloading rounds of bullets into her body was acquitted.

We met this girl in chapter 8 (page 146) when we noted the special importance of education for Arab females and the heartbreak when little girls innocent of politics and interested in learning are savaged. It is time to give this little girl a name; she was Iman Darweesh Al Hams. The final days of Iman's life had been days of heightened tension. On September 29, 2004, Qassam rockets launched from Gaza killed two Israeli children from Sderoth. Then twenty-seven more died, mostly Israelis on holiday, from multiple suicide attacks in Egyptian tourist hotels in Sinai. These acts catalyzed in early October the Israeli operation known as "Days of Repentance," which saw the Israeli army, by October 7, taking over a large portion of northern Gaza, leveling houses, and killing over eighty Palestinians. Four days later, on October 11, 2004, a Palestinian schoolgirl, Iman, was walking past an Israeli checkpoint on her way to school near a Palestinian refugee camp in the city of Khan Younis. Thinking she might be carrying a bomb, soldiers opened fire on the girl's legs to disable her. The girl, in school uniform, was hit in the leg and fell, bleeding, to the ground. In order to "'confirm

the kill,' a euphemism used by Israeli soldiers to describe killing a wounded Palestinian", the commander in charge approached the help-less girl and, ignoring the pleas of other soldiers that the girl was innocent, fired two bullets into her head at point blank range (Barghouti 2004). He then began walking back to his troops, but suddenly turned back on the girl and emptied his rifle into her. Soldiers found no weapons on the girl's body. Her schoolbag contained only her text-books. According to one eyewitness, Fuad Zourob, the girl, realizing she was under fire, dropped her bag and tried to run but fell. Zourob said, "One came close to the girl and started to shoot. He walked away, turned back and then shot her some more" (McGreal 2004). Dr Mohammed al-Hams, who autopsied the body, recovered at least seventeen bullets from the girl's chest, hands, arms, and legs. She had three bullets in her head (McGreal 2004). Despite the eyewitness testi-mony of the soldiers, the commander was cleared of unethical conduct by a military tribunal and suspended only for failing to manage good relations with his troops (BBC News 2004; Lynfield 2004). A docu-mentary on Israel's Channel 2 recovered and aired an audiotape of the communications between the soldiers at the time of the incident. The audio revealed that, far from representing a threat to the Israeli soldiers, they had accurately profiled the girl as around ten years old and "scared to death" (Lynfield 2004). The Israeli public raised a hue and cry over the injustice. In January 2005, the Public Committee against Torture in Israel requested that the Israeli High Court of Justice hand over the investigation to civilian authorities. The request was turned down in February (Sissons 2005).

On November 15, 2005, a military tribunal acquitted the commander. The Israeli army, deaf to public sentiment, promoted him to the rank of major and compensated him for his legal fees (McGreal 2005). A November 18, 2005 brief from *Al Quds Al Arabi* focuses on Iman Darweesh Al Hams's fear, her being "scared to death," as one of the angles of its story on the acquittal. The story quotes the acquitted defendant, elated by the ruling. He boasted that he would not hesitate "to do the whole thing over and over even if the child was three years old." Quoting from the audio transcripts of the Channel 2 documentary, the brief reports that the girl was mown down "despite the fact that his [the defendant's] colleagues warned

him that the child was scared to death and did not pose any danger
and was on her way to her school." The brief ends with a dark anti-
Semitic as well as anti-Zionist threat that Iman's tragedy will bear
"witness to the size of the terror which is practiced by the sons and
grandsons of the Holocaust."

Fear of Sexual Assault by Israeli Soldiers

During this same period of escalating tensions between Israelis and
Palestinians, articles appeared about Palestinian girls being exposed
to sexual harassment by Israeli soldiers. An *Asharq Al Awsat* brief
from March 20, 2006 covers a UN report that points the finger at
occupation soldiers and settlers for sexually harassing Palestinian
women. Released by the UN High Commissioner for Refugees, the
report mentions Palestinian women as "regularly exposed to threats"
whenever they pass military checkpoints in the West Bank. According
to the report, women at these checkpoints are often forced to strip in
front of their family members and they occasionally fall prey to sexual
violence by Israeli military soldiers and settlers. The Israeli press
uncovered that the Israeli Foreign Ministry had asked its Israeli
representative to petition the UN to expunge the incriminating
sections of the report.

Scared to Death without Family:
Fear of Giving Birth in an Israeli Prison

An underpublicized fact is that, from the second intifada in September
2000 to 2008, some 700 Palestinian women have been detained in
Israeli jails (Addameer 2009). The holding of Palestinian female pris-
oners in Israeli detention has become a common and expanding
practice. In September 2000, there were five Palestinian women in
Israeli jails. By 2004, that number had mushroomed to 120 (Addameer
2009). Monitoring the civil rights of these women has been an ongo-
ing concern for a special project sponsored by the United Nations
Development Fund for Women (UNIFEM) and known as the
Protection of Palestinian Female Prisoners and Detainees in Israeli
Prisons.[10] The goals of the project are to protect Palestinian women

in Israeli jails from abuse, shackling, beatings, overcrowding, lack of natural light, and poor dietary and hygienic standards. The goals are also to ensure these women adequate access to lawyers, family members, psychological and neonatal counseling, and continuing education.

Some of these women are young mothers and others are pregnant. The mothers have special concerns about their prenatal and neonatal health rights, and these concerns have grown into more formal questions of policy. Are the children born in prison better off with their mothers in prison or separated from them? Should the children even be allowed in the prison, or are they better off remaining in the care of relatives on the outside? An *Elaph* brief of May 12, 2006 explores these policy questions. The brief mentions that six of these detained women are young mothers between the ages of eighteen and twenty-two who attend to their children while in prison. Some of these mothers gave birth while in prison and the brief refers to four of them.

Mirvet Tah gave birth to her son Wael in 2002 and was released in 2005. Manal Ghanem was detained at the age of thirty while four months pregnant, on April 17, 2003, and sentenced to four years in prison. Not even six months into her term, in September 2003, Manal gave birth to her baby son, Noor. Now three years old, Noor had been removed from his mother just the day before the article appeared. Through her lawyer, Manal had tried to postpone the separation, but the Israeli military court rejected her argument. The separation of a child from its mother in prison causes heartbreak – not only for the mother, but for all the female prisoners who have come to know and "mother" the child themselves. The brief reports that a pall of sadness coursed through the prison cells when Noor's father came with his three sons to take Noor from Manal. The only note of encouragement was that Manal was expected to be released and reunited with Noor and her family in February 2007.

Issues about what happens to the child of an imprisoned mother become especially poignant when a woman's sentence is unexpectedly extended. Women can sometimes take drastic actions to maintain the custodial rights of an infant and sometimes they are effective. The third woman to be referred to is named Olyan. She gave birth to her daughter Itaf in February 2005 in Ramallah women's prison. In January

2006, the mother's detention was extended for another six months. Olyan went on a hunger strike to protest against the possibility that Itaf, now a toddler, would be taken from her. The prison administration agreed to let Olyan keep Itaf with her in prison.

The fourth and last of the women referred to who had given birth in prison is twenty-two-year-old Samar Sobeih, who was detained with her husband and imprisoned in September 2005. From the start of her incarceration, she informed the authorities that she was pregnant but they believed her only after conducting their own tests. Despite her fragile condition, she alleges that the authorities treated her harshly, sometimes interrogating her from dawn until after midnight. She accuses them of preventing her from meeting with her lawyers, her relatives, and even the Red Cross. Her son had been born by caesarian section without complications just a year before she was interviewed for the *Elaph* article, and had been transferred to a normal hospital room. However, Sobeih claims that, as a prisoner, she was chained to the birthing bed and kept under constant surveillance. Her guards refused her privacy, even in the bathroom. And even after giving birth, the living conditions were hardly optimal for a young baby. According to her account, she lives in a cockroach-infested cell with four other prisoners. The windows are constantly covered, blocking out the sunlight. Despite the squalid conditions, there is also a happy side to the story. She reports the pleasure of bearing a child in a prison full of women with impeccable mothering instincts. She notes with satisfaction that her son enjoys the doting attention of forty-eight mothers – the number of women prisoners in her section. And, of course, not even prison walls can deny a woman the rapture of any new mother. Sobeih exalts that she has "felt joy and optimism" about motherhood and she has richly enjoyed, even in prison, the special indulgences owed a new mother. She says she receives "special treatment" from her cellmates as they "bring her food and take care of her child." But Sobeih still reports fear of having to experience something as consequential as childbirth outside the normal family environment. She admits that she "was very scared" before her caesarian because "it was her first child and none of her family was near her."

Women Fearing Family Dissolution:
Divisions between Hamas and Fatah

The Israeli government and Israeli males are not the only source of threat for Palestinian women. The political split that began in 2006 between Hamas and Fatah also threatens family unity, as a May 30, 2006 brief from *Al Quds Al Arabi* makes clear. The brief indicates that the disputes between Hamas and Fatah have become personal in the most intimate way, tearing apart thousands of Palestinian families. Brothers within the same families are divided in their allegiances, and it has become possible to have one brother working for Fatah, another for Hamas, and a third for Islamic Jihad. Even well-placed families are not immune to these internal divisions. A case in point is the prominent Al Rajoub family, whose two brothers, Colonel Jibril and Minister Nayef, occupy prestigious positions in the leadership of Fatah and Hamas respectively. Another example is the household of the late hajji Abdullah, whose family live in a village east of Bethlehem in the southern West Bank. The Abdullah family consists of five sons, three of whom are politically active and are split across the Palestinian political spectrum. While age is sometimes said to soften political feelings, the three politically active brothers increase in radicalism as they increase in age. Ahmed, the oldest, is reputed to be a member of Islamic Jihad. He has been uncompromising with Israel on every front, and has spent most of his life in Israeli prisons. Mahmoud is the middle son and a devoted member of Hamas. The youngest of the political sons is Suleiman, a staunch supporter of Fatah. While the three brothers love and respect one another, family harmony evaporates when political topics are raised at the dining table. Ahmed routinely criticizes Mahmoud for not being hard-line enough against Israel. By entering the legislative elections, Hamas, he believes, capitulated to a Palestinian authority that had agreed to abide by the Oslo Accords. Mahmoud, quick to hold his ground with Ahmed, expresses his pride that Hamas was successful enough in the 2006 elections to represent the majority of the Palestinians. He believes that Hamas saved the Palestinian people from a feckless and corrupt Fatah, and that by blending ideological purity with pragmatics, Hamas offers the best hope for the Palestinian future. This back and forth of his older brothers causes

Suleiman to seethe. He curses his naïve brothers for nurturing the fantasy that the Palestinian people can thrive without sympathetic connections to the West.

Where are the women amidst these raucous family arguments? According to the brief, they are whisking their children and themselves out of the room to preserve family harmony. Each brother rules the political climate of his own household with an iron fist. Each has made his children disciplined believers in his own point of view and the children now imitate their fathers' hard lines. Each brother has taken steps to prevent his own home from becoming politically divided as the home of their birth has become. The brothers' wives, for their part, follow whatever their husbands believe, because they are "afraid of angering [their husbands]" and they work hard to suppress any notion that their political opinions could deviate from their husbands'. The grandmother, the mother of the brothers and Abdullah's widow, assigns herself a different role. She has learned to "curse the politics" that has splintered her household into three. The only political unity left to the family is when they talk about Israeli occupation. That is the only theme that, if only for fleeting moments, restores family harmony.

Fear and Hostile Threats in Lebanon

July 12, 2006 saw Israel's thirty-four-day incursion into Lebanon in what came to be known in Israel as the 2006 Israel-Hizbollah War and in Lebanon as the July War. The fear and hostile threat perceived by Lebanese women as reported in two news briefs involved the negative impact of the incursion on family safety, including the safety of the unborn. A brief from *Asharq Al Awsat* on July 18, 2006, just six days after the onset of hostilities, details the problem of the displacement of thousands of Beirut citizens as a result of Israeli air assaults. Gaby Khalil, an official of the Higher Relief Committee, estimated that roughly 5,000 Lebanese had been displaced, including many infants requiring milk and diapers. Education, a lifeline for Arab women (chapter 8), was among the first casualties of war (chapters 8 and 14). Across Beirut, school classrooms were converted into makeshift shelters. Firefighters, helpless against the bombs, made

themselves useful by spreading mattresses and blankets on the floors of the shelters. Hussein Aouda, aged seventy-one, could gauge how far the technology of Israeli warfare had advanced since the time of the Lebanese civil war in the late 1970s and early 1980s. Then, the destructive power of Israeli bombs had made him feel unsafe, but it was nothing like the feeling of terror he now experienced from the escalated firepower of current Israeli weaponry. He retained a vivid memory of how much the Lebanese people had suffered in past decades, and now wondered why the suffering had to be revisited. The story tells of many women who were also affected. A woman in her ninth month of pregnancy is found on a plastic chair in front of the school. She reports being "worried and afraid" for her unborn child. Another woman, Maryam Hows, explains how having bombs dropped on her house caused her to lose touch with her large family, who scattered in every direction during the mayhem. She spent an entire day and night searching the streets before she found all thirty-four members of her family, safe and unharmed.

Maryam Hows' search for her family members took place before Israel launched its ground war on July 23. On July 26, Israeli forces destroyed a UN observer post in the south of Lebanon, killing four UN observers stationed there. On July 30, Israeli bombs hit an apartment building in Qana, also in the southern region, killing twenty-eight civilians, many of whom were children. These and other assaults seemed to many Lebanese and world observers unusually violent and disproportionate acts of aggression (see, for example, Spyer 2008). An *Asharq Al Awsat* opinion piece of July 31 rages against Israel and compares Israeli attacks to Nazi atrocities. The brief then ramps up the accusations, charging the Israelis with using outlawed weapons that burn human muscle without showing any traces on the skin. It raises the alarm that the medical emergency in Lebanon was dire and growing worse by the moment. Refugee children were without medical supplies. Particularly vulnerable were pregnant women, as a gynecologist, Wisal Tanoush, quoted in the brief, explains. Tanoush claims that many pregnant Lebanese women were being infected by the use of non-sterile instruments in the delivery process. And the "tension and fear [had] caused many women to miscarry."

Conclusion

This chapter has related fear/threat stories found in our corpus of Arab news and their impact on Arab female passivity in war zones. Some of these briefs put the spotlight on Arab women but the majority leave women in the background and our task has been, as far as possible, to offer a counter-analysis of the brief with the spotlight squarely on the women. This strategy helps us see what normally remains unseen; it helps us reflect on the costs of keeping Arab women hidden in Arab news; and it offers us a bigger-picture assessment of the costs of the full erasure of women from news – which, from the evidence of our sample, is still practiced by the majority of Arab print media. A woman hidden can be found. A woman erased cannot.

Miscarriage may seem to be one of the minor problems that impact Arab women in war zones. And in comparison with murder, kidnapping, rape, physical violence and abuse, the loss of one's home and livelihood, and the fear of walking in the streets, there is an argument to be made that miscarriage may well be the mildest of what Arab women learn to endure in war. Nevertheless, the increased number of miscarriages in wartime should remind us that war zones do not only visit unusual hardships on women. By magnifying the usual hardships, they also do much worse. And if the women's studies research (chapter 14) is to be believed, they do even worse than that: they give the press a pretext to blame women's mistreatment on "war." And this pretext, perversely, provides a later justification for keeping female mistreatment out of the headlines when war subsides.

17: *Fear & Threat outside War Zones*

Society portrays [a] woman's body as something to fear and hide. Any flesh or curve shown is considered derogatory or rather a reason for man's carnal desires. The very word 'woman' is often [referred to] as a weaker sex, [so] a woman can always be subjected to what a man wants out of her. This [keeps her] on guard every time she walks alone and at the same time freak[ed out] at the slightest screech of the door.

<div align="right">(Supriya 2007 in reference to an Indian website)</div>

In this chapter, we turn to coverage of Arab female fear and sense of threat outside war zones. Although they are not the direct threats of war, the fears and threats Arab women experience outside war zones are just as real as those experienced in wartime. They may not often relate to the life-and-death situations that occur more frequently in war, but they nonetheless can and sometimes do amount to life-and-death issues for individual women and occasionally for women more widely. The only real difference between threats in and outside war zones is the difference of context. The fears and threats experienced by women in our corpus arise on urban streets, in cinemas, through email, and, not least, in the "comfort" of their own homes.

Fear and Hostile Threats in Jordan

Fear of Honor Killing in Jordan

An article from *Elaph* dated February 17, 2006 portrays the fear aroused in Jordanian women by the threat of honor killing. The headline is shocking: "Study: 90 % of women incarcerated because of threatened

honor killing." Jordanian prisons are known to shelter women seeking protection from their families. The families have issued a death sentence against them because they have had sexual relations outside marriage.[1] The offense is worse if it results in pregnancy or involves adultery, but the punishment is the same. Consent to consort with a man outside marriage is cause for death, but the woman need not have consented for the same judgment to be passed. Her family may turn on her even if a man, even a male relative, forcibly molests or rapes her. The honor of the family depends on the state of her body, not on her consciousness or her free consent. If her body alone is violated, her life must be sacrificed for the restoration of family honor. This emerged from a study led by Hoda Al Hamouri, whose research team interviewed forty women detained in Jordanian prisons. Demographically, the detained women were young (aged between eighteen and thirty-five), poorly educated, unemployed, single, and from families with low levels of education and income. Many of the detainees expressed fear as their release from jail would mean certain death at the hands of their brothers and fathers.

The *Elaph* brief puts the spotlight on Jordanian women jailed for their safety and the fact that, as women, they receive media attention, there may seem no need to search for a counter-story extending the female angle. However, the female angle to this story does remain eclipsed in the absence of answers to two further questions.

First, why is this happening in Jordan? The Arab press's focus on honor killing in Jordan may perplex a Westerner, who may consider Saudi Arabia, Yemen, and Sudan as more likely suspects. In the West, Jordan enjoys the image of a relatively liberal and West-friendly state, never included in the West's roll call of egregious women's rights offenders. Indeed, Jordan has achieved a reasonably liberal human rights record as far as women are concerned. Freedom House (2011a) reported that "Jordanian women enjoy equal rights with respect to their entitlement to health care, education, political participation, and employment," though the report does warn that "protection mechanisms for women victims of violence are inadequate." So where does honor killing fit in and where does Jordan stand in relation to this practice?

The frequency of honor killing is commonly believed to be related

to the existence of legal provisions and court attitudes that exempt the practice from being prosecuted in the same way as other murders. While honor killing has no legal sanction in most countries, in some countries, particularly Arab countries, it is protected by legal texts, the judicial interpretation of these texts and, often most important, by unwritten custom. Egypt's penal code has its Article 17, which grants judges discretion to reduce punishment in certain circumstances, including the circumstances of honor killings (Khafagy 2005). In 2009, President Assad rescinded Article 548 of the Syrian penal code, which sentenced a man convicted of honor killing to a maximum one-year prison term. The revised sentencing required a minimum two-year imprisonment. Syrian women activists remained cautious, but acknowledged it was "a small contribution to solving the problem" (BBC 2009c). The Moroccan penal code carries its Article 418, which concedes that men who defend their honor by killing or beating their wives or female relatives may be acting in extenuating circumstances (Nazir and Tomppert 2005). The US-based NGO Freedom House noted that while Article 418 remains on the books, the sentencing for committing an honor killing in Morocco has been equalized for both male and female perpetrators (Freedom House 2011b).

However, the most aggressive law upholding the legal legitimacy of honor killings is found in Jordan. Jordan's Article 340 of the criminal code asserts that "any man who kills or attacks his wife or any of his female relatives in the act of committing adultery or in an 'unlawful bed' benefits from a reduction in penalty" (Peratis 2004). The strong wording of the Jordanian law protects the unconditional right of the male to take premeditated action against his female relative. The wording of the law and the historical propensity of Jordanian families to carry out honor killings places Jordan, along with Pakistan, at the top of the list of Muslim countries most notorious for honor killings (Hassan & Welchman 2006). In addition, Jordan's juvenile law incentivizes families to permit sons under the age of majority to kill their sisters by allowing minors to be released with a clean criminal record at the age of eighteen. This means that a boy who kills his sister before he is eighteen can expect to resume a normal life when he reaches his eighteenth birthday.

In the 1990s, journalist Rana Husseini covered cases of honor

killings in Jordan for the English language *Jordan Times*. Her coverage drew media attention from CNN, which in turn mobilized civil organizations in Jordan to try to overturn Article 340 and to call for the Jordanian state to protect women under family death sentences (Hassan & Welchman 2006). In 1999, in response to international clamor for Article 340 to be rescinded, King Abdullah established a council to review gender inequalities and the council recommended the removal of Article 340. However, the Jordanian parliament twice failed to ratify the recommendation. In 2001, the king suspended parliament and during this suspension several laws were drafted to rescind Article 340. However, as soon as parliament was reconvened in 2003, it voted down these draft laws (Al Jazeera, September 7, 2003). Despite the parliament's action, Hassan and Welchman (2006) express the opinion that the existence of Article 340 has not been key to the prevalence of honor killings, and that rescinding it would not have the effect of eliminating this crime, as some believe. They argue that only international pressure has been effective in curbing the practice, and that the Jordanian courts, under that pressure, have taken a firmer stand against the practice.

Yet while world opinion has made the Jordanian courts more willing to prosecute the perpetrators of honor-killings, opposing conservative voices in Jordan have criticized foreign meddling in Jordan's internal affairs. An example is the release of Norma Khouri's *Forbidden Love* (2003), published as non-fiction, in which Khouri recounts how in the 1990s she lost her best friend in Jordan to an honor killing. It was later revealed that Khouri had not been living in Jordan during the years in question, and in fact had not resided in Jordan since her early youth. The exposure of the hoax strengthened the hand of conservative groups to smear foreign media and human rights organizations as out to malign Jordan unfairly.

The brief raises a second question that helps extend the female angle to the story. Why are threatened women being jailed when those who threaten their death remain free? There are no doubt many answers to this question but the one drawn from our research that seemed most compelling is the mystique that links honor killing with religion, honor, and the sanctity of family. American academics such as Phyllis Chesler (2009), Professor Emerita of Psychology and Women's

Studies at the College of Staten Island in New York City, add to this mystique when they go to great lengths to differentiate honor killings from domestic violence against women. Studying the details of fifty cases of honor killings committed in North America and Europe, Chesler found that a brother is a likely killer in an honor killing and an unlikely killer in an ordinary domestic violence case. She found that the ferocity of the killing is likely higher in an honor killing than in an "ordinary" case of domestic homicide. And she found other differences. But by focusing on the material differences of the crime scenes rather than the shared immorality of the crimes, there is the danger of imbuing honor killing with the same sense of mystique as those who defend it. The differences between prototypical cases of honor killing and prototypical cases of domestic violence may be enumerable, but they remain minor compared with their similarities as egregious violations of human rights. Muslim and Muslim/Arab women organizations worldwide who subscribe to gender equality by and large find no difficulty in classifying honor killing as a crime of domestic violence, albeit a particularly horrific one. They generally would not wrap the practice in an aura of mystique and would find regrettable the many attempts to link it with religion, thus supporting orientalist beliefs and Islamophobia. They see no connection between honor killing and religion and argue that the Islam they know and practice makes the honor of the family too important for the female to shoulder alone: "The Qur'an is explicit in its emphasis on the equality of women and men before God" (Muslim Women's League 2011).

However, if there is a danger of mystifying honor killing for the purpose of defending the practice or stereotyping Muslims, there is also the opposite danger of treating it as a horrible crime without cause. Researchers within Jordan have come to recognize that if the problem underlying honor killings is a violent expression of gender inequality, then the way to wipe out the practice in Jordan is to wipe out the conditions that feed that inequality. In a study sponsored by a European-Jordan partnership, a team of researchers opened the case files on ninety-one honor killings of women that went through the Jordanian courts between 2000 and 2009. Archives were made of the perpetrators' statements and the economic history of both perpetrators and victims. Thirty-one perpetrators were interviewed. The researchers discovered a geographical

pattern; more than half of honor killings in Jordan were concentrated in the central region, where more than half the country's poor lived. And while it had previously been thought that fluctuations in honor killings were most related to fluctuations in the social life of families and tribes, the researchers found that fluctuations in the economy were a better predictor. Even more importantly, from a human rights angle, the researchers found that the best predictors for being a victim of an honor killing in Jordan were inversely proportionate to predictors for female empowerment. The *less* education and meaningful employment a woman had, the *more* likely she was to be a victim of her family: 92% of the victims had been educated to only high school level or less; 82% were unemployed and those who were employed were working for low wages. On the basis of their sample of ninety-one cases, the researchers concluded that women's "lack of empowerment is a strong indicator of vulnerability" (Mansur 2009).

The researchers discovered that the male perpetrators were also victims on the human development scale: 76% of the killings were committed by a brother and 92% of those brothers had not graduated from college or university. In the competition for employment, the perpetrators lagged behind other Jordanian males. The perpetrator was three times more likely than the average Jordanian male to be unemployed. Two-thirds (66%) of the perpetrators and almost three-quarters (73%) of the victims could be classified as poor. Given that 13% of Jordanians in Jordan live below the poverty line, those families involved in honor killing, either as killers or as victims, make up a disproportionate number of that 13%. The researchers concluded that honor killing in Jordan should be classified as poor-on-poor crime. If we called it poverty-killing instead of honor-killing, so indicated Yusuf Mansur, who worked as an economist on the research team, we might mystify it less, stigmatize it more, and understand how the lives of the perpetrators are in need of economic development as much as the lives of their victims (ibid.). One hidden female angle to Jordanian women in protective custody is that the men who threaten them need help. When the men in the household have few societal resources to work with, the life chances for the girls and women are significantly diminished. The development of girls and women depends crucially on developing the boys and men in the household.

Fear and Hostile Threats in Iraq

Let us briefly turn to two stories that capture fear and hostile threats to Arab females in Iraq.

Fear of Honor-Killing as a Recruitment Tool for Suicide Bombers

The first story did not appear in our corpus of Arab news, which makes it an anomalous example for our study. Nonetheless, we think it worthy of a brief mention because it serves as a bridge from the current discussion of honor-killing to the topic of female suicide bombing that we take up more thematically in chapter 19. The story highlights how the fear of honor killing can be an incentive for recruiting women into suicide bombing. That fear, the story makes clear, can be powerful enough to recruit a woman into a war zone and certain death. An article from the BBC (2009a) reported on the detainment of fifty-one-year-old Samira Jassim who conspired with Sunni insurgents in the Diyala province. The insurgents would plot to have females raped and, after the rape, the news would be leaked to the families, some of whom would, according to plan, declare a death sentence on the rape victim. Distraught and reduced to the state of a hunted animal, the female became easy prey for Jassim, who would approach her target, befriend her, appoint herself a trusted counselor, and advise her that it would be more noble to die as a suicide bomber for the Sunni cause than at the hands of her brothers. According to a military spokesman quoted by the BBC report Jassim "had recruited 80 women to act as bombers, 28 of whom had gone on to launch attacks." The story here is about the evil perpetrated by a single woman. But the counter-story for us, introduced in chapter 12, is about the barrier that female divisiveness can create to female empowerment. Men recruit women into war on the basis of the adage that "no one suspects a woman," but women are not only the unsuspecting victims of men. Women like Jassim are also capable of acting stealthily against other women.

A Fear that Came True: Death of My Terrorist Husband

The fears of Arab women described in the cases related thus far lead readers to sympathize and to hope that their fears are not realized. An *Al Hayat* news brief from July 7, 2006 introduces us to a different example of female fear. It is the confirmed fear of one of the widows of Abu Musab al-Zarqawi, a native Jordanian and husband of three wives, who was alleged to be the leader of al-Qaeda in Iraq, and responsible for various bombings, beheadings, and attacks on civilian populations. Al-Zarqawi was killed on June 7, 2006 by American drone bombers while attending a meeting in an isolated safe house north of Baqubah. One of his wives and their child was also killed in the blast. Um Muhammad, one of the surviving widows and also a native of Jordan, was described as confiding in an Internet forum that she had "feared for her husband's life and warned him about remaining in Iraq but that he had refused to betray his religion" or give up his zealous hatred for the American occupation. As the brief describes it, his wife had asked her husband at the last Adha feast[2] whether he would sacrifice a sheep. He is rumored to have replied that he would prefer to sacrifice an American soldier so that "I can please God by slaughtering him." But the brief also makes clear that he knew Iraq would be his last stand and that he would die on Iraqi soil. In an interview with an Italian newspaper, the brief goes on, his wife claimed that she had urged her husband to leave Iraq out of concern for his safety, but he had adamantly refused, claiming that he faced victory or martyrdom and then confiding that "martyrdom is next for me."

If there is a female counter-story here, it can probably be pulled out by asking the question, "why is this news?" And the answer seems to be that widows are effective media vehicles for exposing a human side in famous – or infamous – husbands that may have not been accessible to the outside world while they were alive. Terrorists cause an unsettling future for others. The power of their image depends on keeping hidden their own human worries and vulnerabilities. The widow recalling them constructs a more human version of events that she is best qualified to deliver. Much of the world will remember a terrorist. But she will mourn a husband.

Fear and Hostile Threat in Jordan

Horror as an Escape from Terrorism: Why a Jordanian Girl Prefers Scary Movies

Sometimes Arab women may choose fictional terrors as an escape from non-fictional fears. In addition to being unsympathetic, female fear may also be self-induced, lighthearted and even a recreational sport. We find an example in an *Al Quds* brief from August 29, 2006 that reports on a craze among Amman girls to prefer horror films to romantic movies. The brief features eighteen-year old Diala, a wisp of a girl, no more than 110 pounds, standing with "confidence and coquetry" in the company of five young men at the entrance of a movie theatre waiting to purchase a ticket for the midnight showing of a horror movie. Dressed up for the occasion and speaking with an American-English accent, Diala voices her sniffy indifference to romantic Hollywood movies, and dismisses them as having become as "dull and boring" as Egyptian romantic fare. The predictable hug and kiss and the romantic movie is over! The horror movie, by contrast, is unpredictable and keeps the audience in suspense, at least for a while. Diala rallies her companions to expect some real excitement tonight. They hope the movie they watch will be as unpredictable in suspense and gory as the real-life videos that Al-Zarqawi has been producing in Iraq. Diala has seen the "massacre," the "slaughtering," and the "blood and head-chopping" in the cinéma verité of Iraq. She now wants to experience it in recreational art, where she and her friends can gleefully yell at the appropriate moment as each scene crescendos to new heights of revulsion. The *Al Quds* reporter had not pitched this story to an editor but stumbled into it at the movie house and could not resist trying to figure out what was going on with Diala, her friends, and perhaps her generation in Amman. In response to whether she likes love stories, Diala replies that neither she nor her girlfriends do. But she does allow that they might be a good salve for older housewives suffering from boredom in their marriages. Asked whether she likes action movies, she replies no, because they could be violent and inspire others to violence. The surprised reporter, then asks, "You reject action movies because they instigate violence and you enjoy horror movies which are

full of violence?" But Diala has a quick and insightful reply: Grownups in Jordan get their horror stories every day in their newscasts, which they cannot control. Diala and her friends want to control the horror in their lives. They want to watch the horror that suits them and turn off the horror on TV. The horror movie proves a good fear substitute for a fear they would rather not think about. This profound question answered, the reporter turns his questioning to the lighthearted: What about romance with a boy during the horror movie? Diala is direct about that being a non-starter. No boy has a chance of touching or stealing a kiss from her. Any boy who would try is immoral and she would not think of befriending anyone like that. After all, she has her ethics and traditions to uphold and they forbid flirtation. "We have all come to watch a movie," she says matter of factly, "and just that."

As indicated, the reporter had not planned this story but fell into it after running into a girl as bright and articulate as Diala, with the gift of knowing how to speak for her generation as well as for herself. If there is a further female angle here, a female counter-story to pull out, it is a reinforcement of how girls and women often make the best witnesses of war whether the war is coming to them live or through media.

Fear and Hostile Threats in Egypt

Female Journalists Sexually Harassed under Mubarak

In 1995, the Samir Kassir[3] Award was established by the European Commission to honor journalists covering the Middle East with the best opinion or investigative article on the rule of law, human rights, or freedom of expression. The first winner of the Samir Kassir Award went to Dina Darwich for her article "Plumes contre biceps" (Pens against Biceps; Darwich 2006), originally published in French in the Egyptian weekly, *Al-Ahram Hebdo*, on January 10, 2006.

In her award-winning article, Darwich asserted that 2005 had been "one of the worst years of freedom of expression in Egypt," with some fifty journalists having become victims of violence. She predicted that if 2004 had been the year of journalist kidnappings, such as those of Reda Hilal and Abdul-Halim Qandil, 2005 would be known as the year

of frightening female journalists away from stories the government considered too sensitive. To make her point, she reviewed the case of twenty-four-year-old journalist Asmaa Heriz, writing for *Al-Karama* weekly magazine, who was taking photographs exposing evidence of election fraud in Cairo when four men accosted her. One covered her mouth to prevent her from screaming while others overpowered her and pushed her into a car. "I found myself in a dark office where a man began to interrogate me. He took my camera and started looking at the pictures" (Darwich 2005). The man seized her papers, her CDs and her mobile phone. A member of state security, the man thrust a document onto a table, as it turned out a confession of wrongdoing, that he demanded Heriz should sign. She refused. She was escorted down a dark corridor where two heavily-built women beat her. She lost consciousness and when she came to, the security officer said that he never wanted to see her byline in the newspapers again. He advised her to get married and never return to work.

Darwich also chronicles the case of another female journalist, Nawal Ali, frightened off a story by the use of violence. Ali was beaten and had her clothes torn off. Darwich reports on two other female journalists working for the opposition paper *Al-Dostur*, Chaïmaa Abul-Kheir and Abir Al-Askari, both of whom were beaten up when trying to cover demonstrations against the Mubarak government. A security officer grabbed Abul-Kheir by the hair and ordered two women security officers to beat her up and tear off her clothes. A group of youngsters working for the government circled Al-Askari and slapped her across her body.

2006 would prove no healthier a year for female journalists in Egypt than 2005. It was especially unkind to Abir Al-Askari. An *Al Quds Al Arabi* brief from May 12, 2006 reported on the harassment Al-Askari had suffered at the hands of Mubarak's police. Covering a demonstration against the government in the downtown area of Cairo, Al-Askari found herself facing a circle of six police officers and soldiers, closing in on her. She was subdued with kicks and slaps. They took her to the police station where the beating continued. They ripped her clothes and threw her out of the station, threatening to do worse if she dared show her face again in the downtown area. Half naked and with two soldiers in pursuit, she pleaded for a prayer rug from a shop owner to cover herself.

What went wrong with Egypt's relationship to its press in 2005–2006? To answer this question, we first must note that whatever went wrong was a sharp departure from venerable traditions of Egyptian journalism.[4]

Despite the richly diverse press environment, press freedom in Egypt suffered setbacks in 2005 as never before. A Paris-based NGO, *Reporters without Borders*, compiles an annual worldwide Press Freedom Index (available at http://en.rsf.org/press-freedom-index), based on surveys sent to editors and correspondents worldwide. In the 2003 Press Freedom Index, Egypt ranked 110th out of the 166 countries studied. In 2004, former *Wall Street Journal* reporter, Steven J. Glain, who had covered the Middle East for that newspaper referred to Egypt in his retrospective as the "towering dwarf" and volunteered that: "Nowhere in the Arab world is the gap between rhetoric and reality as great as in Egypt. The country is officially democratic, but election results are routinely manipulated and dissent stifled, sometimes brutally" (Glain 2004, 242). By 2005, Egypt had dropped precipitously in the Press Freedom Index to 143rd out of 167.

What happened? On July 26, 2006, a panel of experts at George Washington University debated that very question (Hanley 2006). Experts agreed that seismic forces were driving the Mubarak government and the Egyptian press further apart. The Mubarak government relied on the language of democracy and counter-terrorism to secure greater control over the press. Yet the press, even the state-run press Mubarak traditionally controlled, was feeling unprecedented global pressures to assert its independence. Let us consider the Mubarak government and the press in turn, and how in 2005 they were headed on a collision course.

First, the Mubarak government. Under the guise of counter-terror measures, the Mubarak government began crackdowns in 2005, first on opposition parties, then on the judiciary and, finally, on journalists. Under the guise of democratic measures, Mubarak called on the parliament to amend Article 76 of the constitution to allow multiple-candidate elections for president in time for the upcoming 2006 election. The parliament approved this amendment by referendum in May 2005. But the amendment was such a

transparent ruse that public demonstrations were scheduled to protest it. On May 25, 2005, what came to be memorialized as "Black Referendum Day," young women and men demonstrated before the Cairo press syndicate and the judge's club. The government was prepared for the demonstrators with a brutal show of force that administered harsh physical attacks on men. But girls and women were singled out for sexual as well as physical assault. Some female bloggers in the crowd who were beaten would remember the hardening of their resolve that day to step up their blogging to fight state oppression. "I was beaten, assaulted and watched other female journalists being molested by state security's plain-clothes thugs, as the officers stood by in approving silence," Nora Younis, a well-known Egyptian blogger, rights activist, and a 2008 winner of the Human Rights First Award, told Rania Al Malky, then Deputy and now Chief Editor of *The Daily News Egypt*. Younis told Al Malky that after her physical ordeal, her blogging against state oppression became "more determined" (Al Malky 2007). For his part, Mubarak would impose new anti-terrorist laws that would further weaken civil liberties in Egypt (Asser 2007) and deepen divisions between the government and the press.

Let us now turn to the journalists and the collision with the government from their side of the tracks. In order to remain competitive, even state-controlled presses like *Al-Ahram* knew they were expected to cross red lines to uncover the news. Since the Al Jazeera revolution in 1995, when satellite channels first broke free of the terrestrial influence of governments, and Arab viewers could for the first time see their leaders cross-examined and held to account on live programs (El-Nawawy & Iskandar 2002; Alterman 2005; Sakr 2005; Zayani 2005; Cherribi 2006; Lynch 2006), Arab audiences have become increasingly sophisticated at separating news and state propaganda. New generations of journalists entered the profession understanding that the satellite channels had brought prestige, power, visibility, and income to those well-trained in objective journalism, but this meant that government-run media, despite their hope to control the news, also found themselves needing to promote editorial independence as a way of staying competitive (Radsch 2007).

The Rise of Female Bloggers in Egypt

With the lines sharply drawn between the Egyptian government and the press, blogging emerged as a method for journalists and citizen-bloggers to tell their counter-stories with a reduced risk[5] of ending up jailed or bloodied. Blogging was also a means of raising awareness of difficult subjects in a way that was not possible in mainstream news (Otterman 2007), including in the two briefs (1.1%) in our 2005–2006 corpus that cover Egyptian female bloggers. Neither brief delves into the phenomenon of female blogging, the demographics of female bloggers in Egypt or the lessons learned as female bloggers learned to manage communication across gender lines when males posted responses to their writings. This additional information is necessary, we shall see, to fill in a narrative from the Egyptian female bloggers of 2006 to the events of Tahrir Square in January-February 2011.

Research about blogging drawn from social scientists on the Arab (Lynch 2007) and Egyptian (Al Malky 2007; Otterman 2007; Radsch 2008) blogospheres supports the idea that blogging and mainstream journalism can be birds of a feather. Bloggers with a journalistic ethic are committed to accurate and timely reporting to establish an informative window on the world. At the same time, the blogger has no organizational hierarchy to answer to. Blogs for this reason blur the boundary between public and private expression and between the spectator of news and the newsmaker. They constitute citizen-driven journalism with an individual rather than an organizational voice, though with the potential to effect institutional change without the constraints of institutional structure (Shirky 2008).

Egyptian women played a defining role in the development of the Egyptian blogosphere. According to Arab Blogosphere demographer Bruce Etling and his colleagues (2010), Egyptian female bloggers fall demographically into a cluster they call "Egyptian Youth" bloggers. This demographic includes the densest concentration of female bloggers across all Arab territories and about half of all Egyptian bloggers. Egyptian females within this profile constitute one of the youngest Arab female blogging populations across all Arab territories with half between the ages of 18–24 (Etling et al. 2010, 1236). Compared with other blogging subpopulations within Egypt,[6] female bloggers within

Etling's Egyptian Youth category tend to support Western culture and values more than the other categories of Egyptian bloggers, and to discuss a broader range of topics on their blogs than other categories of Egyptian bloggers – topics such as single life, family life, Palestine, poetry, literature, art, political rights, women's rights, hijab, and feminism.

We might ask how elite is the subpopulation of Egyptian females who find their way to blogging within this demographic of Egyptian Youth? Very elite, it appears, but still with the critical mass numbers to create a societal impact with their blogging. The odds of a random Egyptian female making it to this demographic are low. With a population of 79 million people, Egypt has an Internet penetration of only 15% (Open Net Initiative 2009) and a total population of bloggers who represent only .003% of the overall population (Otterman 2007). It is difficult for a random Egyptian woman to beat these odds and make it into blogging; at the very least, she needs a family with means and an investment in her education and achievement. If she passes these filters, the chances of holding her own against a male elite become reasonably higher. Egyptian female bloggers represented in Etling's demographic of Egyptian Youth constitute roughly 30% of all Internet users in Egypt, which, as Otterman notes, is a startling statistic in a country where only 24% of the women work,[7] only 44% can read and the average age at which women marry is twenty-four. Among the subpopulations within Egypt who are literate and schooled, Egyptian women tend to hold their own with men in educational achievement, particularly in the arts and social sciences where female students since 1999 have graduated in larger numbers than males (Otterman 2007). Given the high unemployment rate among Egyptian women and their educational attainments, Otterman paints a picture of a young and educated Egyptian female blogger who has quite a lot to say and the time to say it.

Because of their educational achievement and because of the time they had available, Egyptian women were faster in creating the Egyptian blogosphere than Egyptian men. As Otterman tells it (citing Alaa Seif Al Islam, who collects statistics on the Egyptian blogosphere), in the first phase of the Egyptian blogosphere, Egyptian women hosted 70% of the blogs. Men's participation has steadily increased since then

and, as of 2009, women's share of blog hosting was about 50% or slightly less (Etling et al. 2010, 17). Perhaps most significantly for our purposes, Otterman found that blogs are a space in their lives where Egyptian women of this Egyptian Youth demographic have come to expect gender equality with men. And this expectation led to female bloggers hosting blog discussions for a mixed readership that would be unthinkable in face-to-face Egyptian society. The discussions topics often entered sensitive issues about love, dating, homosexuality, feminism, sexual discrimination, virginity and more – all taboo topics in face-to-face mixed company.

In light of the uncensored and new patterns of mixed-gender interaction supported by Arab blogs, Western journalists and researchers discovered that Egyptian blogs were becoming an indispensable trove for monitoring the level of self-censorship in the mainstream Egyptian press and tapping the undercurrent of social and political feeling in Egyptian society that mainstream news dared not touch (Eid 2006; Al Malky 2007). Western media researchers began to understand that blogs created new forms of social engagement both within the Arab world (Ulrich 2009) and as bridges linking the Arab world to the outside (Lynch 2007). Prominent among these new forms of social engagement were the voices of young Egyptian women bloggers, who could be read and heard threatening gender restrictions and state dictatorships across Arab lands as never before, and, not least, becoming accustomed and adept in cyberspace, if not physical space, relating to males as equals. It was a portent of the Arab Spring to come.

But there would be more portents before 2011. Sexual assaults on the streets of Cairo and their cover-up by the government and mainstream media during the Eid season of 2006 impelled a rising generation of young Egyptian female bloggers to believe that the gender-equality they felt a right to expect on-line was a right they should expect off-line as well.

The realities of cyberspace and physical space could not have been more different for Egyptian female bloggers in the fall of 2006. On-line, Egyptian women bloggers were learning to manage gender relations with the males who read and replied to their blog posts. Sharon Otterman, who spent eighteen months in Cairo studying

Egyptian women and political reform, discovered that Egyptian men were avid readers of female blogs. It is typical for female bloggers to find they have as many men reading their posts as women. It gives men clues about "what is going in our minds," one prominent female blogger told her (Otterman 2007).

A female blogger who spoke out for gender equality had to get used to attacks from some of her aggressive male readers eager to test her mettle. Their attacks seem to be launched in some cases to test her cool and stamina. Would she break down or stand firm in the face of criticism? The attacks would charge her with being a man-hater, a feminist, a lesbian, an abortion lover, a disgrace to Islam, and so on. Women readers were not passive either. They could hold their own with the men in launching criticisms of the host's postings if they were so inclined, and her women readers often proved especially good at attacking the aggressive males in order to defend the host. Without face or voice cues, it was sometimes hard for the female blogger to tell whether the criticisms of her and her views on gender equality were delivered in jest, half jest, or utter seriousness. But ultimately, dealing with these ambiguities, which manifest off-line as well as on, female bloggers received indispensable training in the art of leading discussions on sensitive topics with groups that included men. Over time, Egyptian female bloggers learned to take the heat, and assert their positions, field the criticism, rebut, qualify, compromise, concede, and roll with the punches as appropriate. Egyptian females often started blogging to practice self-expression, but managing the community feedback and monitoring the community with their superior group intelligence (chapter 6) helped make them seasoned leaders. Wahda Tania, a thirty-one-year-old woman who blogs anonymously, argued from her own experience as a blogger: "The Internet is a great tool to teach people how to express themselves and how to fight for their ideas" (quoted in Otterman 2007).

Through their individualized leadership training as blog hosts, Egyptian female bloggers often recognized the need and desire to learn from one another. They found they could use cyberspace to organize themselves as well as organizing their individual blog communities. On September 9, 2006, they practiced one of the key tenets of

feminism as an organizing principle (chapter 12) – there is strength in numbers. On that date, some 200 female bloggers linked to a single site of solidarity to share their ideas about feminism and femininity (Otterman 2007).

On-line, Egyptian female bloggers were becoming adept and increasingly comfortable about talking to men about everything under the sun. They were gaining invaluable practice at learning to lead mixed groups through tough discussions. Through the circumspect use of words, outside of harm's way, they learned to think through their positions on sexual discrimination, and to speak candidly with both males and females about the humiliating costs of being treated like a cheapened sexual object. Otterman found that female blogs were opening up the topic of sexual discrimination to male audiences and making sexual harassment a social issue for which men had to share responsibility, rather than just a "woman's problem."

Through patient reflection about sexual harassment in cyberspace and in mixed company, many female bloggers discovered that the men in their blogs could take responsibility for their behavior toward women and did not need to be accommodated. And the discovery that men in cyberspace could and would take responsibility for their treatment of women made female bloggers increasingly impatient with the boys and men on the streets who could not or would not.

Sexual Assaults in the Streets of Cairo

Female Egyptian bloggers were developing new communities and confidence in cyberspace about gender equality. But off-line, in the physical world, life seemed to be going in the opposite direction. On the streets, Egyptian women were suffering waves of harassment and the police were not protecting them. By the fall of 2006, it became sorely apparent that the Egyptian government was not the only threat against Egyptian women. Youth gangs were stalking women in downtown Cairo. They prowled together in packs, targeting random women. Their modus operandi had become a signature. Targeting their victim, they first surrounded her, cursed her, stripped her, and then proceeded to mass rape her. They cared nothing about the age of the woman, whether she was a mother accompanied by children,

or whether she wore hijab. These are the observations of Nabil Sharaf-Eddine, an Egyptian liberal, writing for *Elaph* in October 30, 2006. A translation of Sharaf-Eddine's article made it into our corpus of briefs. In the brief, Sharaf-Eddine describes how difficult it had become for the press and the public to grasp the problem. Sharaf-Eddine observes that, if the crimes taking place on downtown streets were set in a best-selling novel, the city would be outraged and single-minded about bringing the culprits to justice. But this was real life and the Egyptian government and public were crippled by apathy. Worse yet, the mainstream press would not touch the story, thinking it would be taken as a criticism of the police and the government. Sharaf-Eddine confessed that he found the story only in blogs and at first could not believe what he was reading. Only after checking other sources did he accept its credibility. He headed downtown to see for himself. In a seedy neighborhood, he saw roaming youths in packs, ranging in age from twelve to thirty, moving with a "herd mentality" and cursing at the tops of their voices. Suddenly, rising through the din, Sharaf-Eddine could hear a lone female voice making a sickening cry for help. Passers-by averted their eyes and looked clinically distracted, as if reluctant viewers of a film on primitive cultures. Sharaf-Eddine credits a female activist and blogger, identified only as "Radwa", with helping to put him on to the story. On her blog, Radwa, an eyewitness to one rape, had reported how stunned she was to see eleven- and twelve-year-old old boys encouraging each other to participate in the rape of a mother holding on for dear life to the hands of her three small daughters. Sharaf-Eddine was also able to find shop owners, policemen, and others who had witnessed similar events but who had remained too shocked to describe what they had seen, much less explain or react to it. Sharaf-Eddine could do nothing himself but comment on the "crassness amidst official and popular passiveness as if nothing unusual was taking place." He wondered whether something terrible was lurking within the Egyptian psyche that allowed these events to pass and whether Egypt's current indifference to evil would mean something far worse for the country down the road.

The Awakening of Egyptian Female Bloggers:
Prelude to an Arab Spring

On October 25, 2006, the same week the *Elaph* brief appeared, Malek Mostafa made a post on his blog called "Downtown's Sexual Rabies" (Al Malky 2007). The blog entry gave an eye-witness account of the mayhem downtown and backed it up with pictures. The post drew 60,000 readers and soon Mostafa and two of his colleagues were using their blogs to expose other incidents of sexual harassment around Cairo that the government was not acknowledging and the mainstream press was not covering. Even when presented with the facts of the sexual crimes, the Egyptian police would refuse to file formal complaints, swatting away the request with an excuse that made no effort to be credible: "[It] would reflect badly on their peers" (Al Malky 2007). Despite the public proof in cyberspace, the sexual assaults on the physical streets of Cairo were ignored by the official Arab press, including Al Jazeera.

Mainstream press coverage of the harassment did not commence until Nawara Negm, an outspoken journalist and critic, invited onto a local television program to comment on Ramadan television shows, abruptly changed her agenda and started talking openly on air about the crimes of sexual harassment on Cairo streets and the proof of their existence in the blogosphere. The show's host, Mona El Shazly, went to the neighborhood crime scenes to verify the incidents and the neighbors were able to verify almost all of them for her. Once the attacks had been confirmed by mainstream media, the Egyptian police smugly and disingenuously defended their inaction on the grounds that no formal complaints had ever been filed (Al Malky 2007).

These incidents, chronicled by Al Malky, afforded the female bloggers of Egypt a case study of how the instruments of new media, such as blogs, and later Facebook and Twitter, were powerful weapons for circulating counter-stories capturing experience from a female lens that the world could witness and learn to retell. Nora Younis, the blogger we met above interviewed by Al Malky, suggested that her blogs and those of her female colleagues ended a longstanding silence about the experience of women in mainstream news.

> When it comes to this particular issue – a sort of skeleton in our closet – it's impossible to deny that it [the Eid assaults on women] happened because thousands of women experience it every day. The bloggers came out victorious in this particular credibility battle. (ibid.)

Nora and other female bloggers in Egypt had become emboldened to think that government stories based on lies were no match for their counter-stories so long as the truth and a blog or Facebook account was at hand. Young Egyptian female bloggers were arming for the Arab Spring of 2011.

Egyptian Woman after Mubarak

In his coverage of the rapes on Cairo streets, Sharaf-Eddine, as we saw above, wondered "whether Egypt's current indifference to evil would mean something far worse for the country down the road." Down the road, in this case, depending on one's political perspective, may have meant Friday, February 11, 2011, the day demonstrators massed in Tahrir Square for the eighteenth consecutive day and, networked through YouTube, Facebook, and Twitter, forced Hosni Mubarak from power. These events were outside our 2005–2007 corpus, of course, but they are extensions of themes already discussed and so are relevant to pursue here. The events at Tahrir Square merit our attention not simply because of the Arab coverage but also because of the important contrasts in the angle adopted by Arab and Western media on a case of female molestation.

Many around the world celebrated the events of Tahrir Square as a dawning of democracy in Egypt, but in America, the UK, and much of the West, this feel-good story competed uncomfortably with the vicious assault on Lara Logan, Chief Foreign Correspondent of CBS News, who had returned to Cairo that day to cover the breaking events for the news show *60 Minutes*. On the evening of February 11, CBS put out a terse statement on the CBS News website, indicating that, in the crush in Tahrir Square, Logan had become separated from her crew and surrounded by a "dangerous element," and had "suffered a brutal and sustained sexual assault and beating." She was rescued, the

announcement went on, "by a group of women and an estimated twenty Egyptian soldiers." In the October 30, 2006 Cairo rape story, the modus operandi of the gangs was to target, surround, strip, and then rape. In the Logan case, the modus operandi was similar but for the last phase; a report in the *Sunday Times* (London) (Colvin, February 2011) said that Logan was targeted, surrounded, stripped, pinched, slapped, and beaten by poles though not raped.

Logan's traumatic ordeal provided sectors of the Western media with endless opportunities to display their misogyny and Islamophobia. Message boards lit up across America with accusations that an "attractive blonde woman" such as Logan should have known better than to report from an Islamic country. A micro-blogger at New York University, Nir Rosen, tweeted that Logan was a "warmonger" who had learned firsthand what it was like to be treated as a woman in an Arab country: "Look, she was probably groped like thousands of other women." Rosen came under fierce public attack and was forced to resign his position. The conservative pundit Debbie Schlussel, who often targets the American Muslim community, wrote: "Lara Logan was among the chief cheerleaders of this 'revolution' by animals . . . Now she knows what Islamic revolution is really all about" (*Daily Mail* 2011). Anti-Muslim media tended to label Logan's attackers as "protestors," leaving the impression that the people responsible for the violent rampage against Logan were the same core who had planned the initial occupation of Tahrir Square. One of dozens of Western bloggers, for example, conflating the protestors and those assaulting Logan, asserted that the assault on Logan "tells us quite a bit about some (many?) of the protesters in Egypt" (Dennis 2001). The problem with this cross-reference is that the core who had planned the Tahrir Square revolt – the so-called April 6 group – had carefully schooled themselves in the non-violent tactics of the Serbian pro-democracy movement that had overthrown Slobodan Milosevic (PBS Frontline 2011b).

For mainstream Western media sources who did not conflate the non-violent protestors and the rampaging gangs, the events of February 11, 2011 tended to split into two clashing stories about women. One was the optimistic story of young women revolutionaries participating in the fall of Mubarak and the dawning of a new age of democracy and gender equality in Egypt. The second was the stereotypical colonial

story that wondered aloud, in light of Logan's ordeal, whether Arab male culture was capable of respecting the dignity of women and thus capable of true democratic governance.

Some Western reporting combined these clashing stories, diluting both. An example is an article published on February 16, 2011 by *USA Today* (Fordham 2011) headlined "Uprising Energizes Egyptian Women." The story, written by staff reporter Alice Fordham, leaves the gate with the first story about women and crosses the finish line with the second. Fordham begins by noting that, having had to suffer leers, catcalls, unwanted touching, and workplace prejudices, a coalition of young revolutionary women were finally feeling breezes of gender equality. For eighteen days, they had bonded with one another and with revolutionary men as equals in Tahrir Square. A woman named Rifaat is quoted as saying, "In Tahrir, I really didn't feel there was segregation. Women came on their own; they didn't feel they needed a chaperone, which is unusual at a big event with people from outside your social group." After several other quotations from women who swore by the new gender equality they found at Tahrir Square, Fordham tacks on a negative note about the Logan assault at the end of her story. To provide context for her abrupt shift, she claims that some Egyptian women reported being groped in Tahrir Square. So ending her story on a dark note was an attempt not to contradict the ebullient testimony of the women who found gender equality at Tahrir Square, but rather to seek journalistic balance. She wanted her readers to know that Tahrir Square had been an uplifting and liberating experience for many Egyptian women but not all, and that fact should put women on notice that removing Mubarak would not remove sexism as quickly or easily as some women at Tahrir Square might hope.

Let us now turn to the coverage of these conflicting stories about women – the women of Tahrir Square and the assault on Lara Logan – as provided by two quality news organizations – Public Broadcasting Service (PBS) in America and Al Jazeera-English in Qatar. Both services avoided combining the stories. Within three days of each other, both media ran extended pieces on the positive role the women of Tahrir Square played in the Egyptian uprising. Al Jazeera profiled four female activists: twenty-six-year-old Asmaa Mahfouz, twenty-four-year-old Mona Seif, twenty-four-year-old Gigi Ibrahim, and

thirty-three-year-old Salma El Tarzi (Al Jazeera English 2001). PBS's *Frontline* focused only on Ibrahim, running a piece called "Gigi's revolution" (PBS Frontline 2011a).

PBS's coverage of Gigi focused primarily on her battles with her upper-class Cairo family to live the life of an activist and venture to Tahrir Square. Al Jazeera's coverage of the women revolutionaries was considerably more in-depth. Among other things, it confirmed the positive story that Fordham had found. The four women revolutionaries had indeed discovered gender equality in Tahrir Square they had never before experienced in Egyptian society. Mona Seif told Al Jazeera: "I have never felt as at peace and as safe as I did during those days in Tahrir. There was a sense of coexistence that overcame all of the problems that usually happen – whether religious or gender based." Gigi Ibrahim seconded the motion: "During the 18 days neither I nor any of my friends were harassed. I slept in Tahrir with five men around me that I didn't know and I was safe." Salma El Tarzi added her voice to the chorus: "Something changed in the dynamic between men and women in Tahrir. When the men saw that women were fighting in the front line that changed their perception of us and we were all united. We were all Egyptians now The general view of women changed for many. Not a single case of sexual harassment happened during the protests up until the last day when Mubarak stepped down. That is a big change for Egypt."

Fordham's story balancing the sweetness of the Tahrir experience for women and the bitterness of the Logan experience would suggest that Al Jazeera's uplifting stories of the women revolutionaries at Tahrir were authentic but incomplete. Some women in Tahrir Square were groped. Logan was brutally assaulted. Where was Al Jazeera with the darker side of the story for women? The Al Jazeera story did indeed capture the darker side. But, unlike Fordham's article, it clarified the fact that the inspiring and the depressing stories for women were not concurrent stories. They in fact were separated by a clear time-line. On the day of Mubarak's resignation and ensuing celebration, the same day Logan was assaulted, the women revolutionaries in Al Jazeera's story experienced an "opening up" of Tahrir Square to the broader Egyptian society. These elements may have hated Mubarak for the miserable economy and the rampant corruption, but they were

not "political" elements with the non-violent training of the original April 6 core. They were not necessarily friends of democracy and they were almost certainly not proponents of gender equality. Once these broader elements of Egyptian society poured into Tahrir, the women revolutionaries, as reported in the Al Jazeera story, saw the spirit of Tahrir dissipating before their eyes. As Mona Seif explained to Al Jazeera, "the moment Tahrir opened up, we saw a lot of people that were not there before and there were reports of females being harassed." Seif continued, "There was one Egypt inside Tahrir and another Egypt outside" and on the day Mubarak resigned and Logan was attacked, the Egypt on the outside overwhelmed Tahrir Square. As Gigi Ibrahim put it: "But that [the gender equality of Tahrir] changed on the day Mubarak stepped down. The type of people who came then were not interested in the revolution. They were there to take pictures. They came for the carnival atmosphere."

By conflating the non-violent protesters and the rampaging marauders, many Western sources licensed the inference that the marauders were somehow one with the protesters. However, the Al Jazeera story makes clear that the young women and men protesters never for a moment imagined they represented anyone but themselves. They knew they had yet to change the heart and mind of the wider Egypt. Their vision was to build an oasis of democracy and gender-equality within Tahrir first and then work to spread what they had built. As Mona Seif explained to Al Jazeera: "We will transfer the spirit of the square to the rest of the country . . . the spirit of the revolution has empowered us to spread the feeling we established wider and wider. The revolution is not overWe have to continue. This is where the real hard work beginsRebuilding Egypt is going to be tough." And Salma El Tarzi added: "Tahrir Square became our mini model of how democracy should be."

What about PBS and Al Jazeera on the coverage of the Logan assault? As we mentioned above, PBS to its credit never tried to combine the story of the women revolutionaries at Tahrir and the assault on Lara Logan. It covered the Logan story separately through the lens of sexual harassment in Egypt (PBS NewsHour 2011a). Unlike more sensationalist Western media, PBS carefully side-stepped the Islamophobic premise that a single horrific crime perpetrated against

one female reporter could taint a whole movement that had inspired so many of Egypt's youth. At the same time, PBS did operate from the premise that the Logan incident required a fuller account of sexual discrimination practices in Egypt. Here is the script that Margaret Warner, the PBS presenter, reads from to negotiate the delicate transition between Tahrir Square, Lara Logan, and sexual discrimination:

> The vivid scenes from Tahrir Square showed women working side by side with men, demanding reforms and the ouster of President Mubarak. But on the night of his resignation, in the square, there was an ugly reminder of another side of Egyptian life: a physical and sexual assault on CBS correspondent Lara Logan. She was eventually rescued from her male attackers by Egyptian women and soldiers. The attack on Logan unleashed a torrent of articles about the culture of sexual intimidation experienced by many Egyptian women. In a 2008 survey, 83 percent of Egyptian women in Cairo said they had been sexually harassed. (ibid.)

Notice that the script is careful to make Tahrir Square the location of the incident but not its determining context or cause. The script prevents the incident from besmirching the meaning of Tahrir Square. It simply reminds us of sexual harassment and its prevalence in Egyptian society.

How did Al Jazeera cover the Logan incident? The answer is that it did not. Al Jazeera's non-coverage left Western pundits exasperated. Dozens of Western media sources accused Al Jazeera of going AWOL on the story, neglecting its fundamental journalistic responsibilities. Carolyn Forsyth, a blogger for OpenSalon, was typical when she headlined her blog of February 17, 2011 "Al Jazeera shocks with disappointing coverage of Lara Logan" (Forsythe 2011). One week past the incident and Al Jazeera had delivered not a word about Lara Logan. Then more days passed. Silence from Al Jazeera. Logan was assaulted on February 11, 2001. A search of Al Jazeera's English website on the key words "Lara Logan" two weeks later, on Friday February 25 still brought not a single hit. Al Jazeera, it was clear, had taken a moratorium on Logan coverage, a principled stand of zero coverage – "sorry, simply not news for us."

However, if we reflect on Al Jazeera's coverage of the Egyptian women involved in the revolutionary movement carefully, we can build a reasonable case for why the editors at Al Jazeera might have classified the Logan incident as a random local crime with no news-worthy connection to the wider significance of Tahrir Square or Mubarak's transition. After all, Al Jazeera's coverage of the revolution-ary women made clear that, by the day of Logan's assault, the distinctive thing about Tahrir Square was that it was where Egyptians chose to mass to mark Mubarak's resignation. It was no longer hallowed ground for principles of democracy and gender equality. Those principles had been worked through by the protestors over their eighteen-day pilgrimage at Tahrir and they were now seeking to export them across Egypt. The protestors understood that by February 11, Egypt had changed forever. Yet they also understood that they were still at the beginning of change, and for all practical purposes, Egypt had not changed at all. On February 11, 2011, Tahrir Square still reflected the psyche of which Sharaf-Eddine had reminded us in October of 2006. Egypt still contained elements perpetrating random violence against women. Given these considerations, Logan's assault was news of a terrible sexual molestation, but no more important as international news than the random assault on a Cairo street reported in Arab news on October 30, 2006. And yet to publicize Logan's story would be to risk combining the stories and inviting the inference, as so many Western media tried to do, that Logan's assault was a sign of a flawed democracy movement. As anyone who supported the democracy movement understood, Logan's assault was a sign of the challenge ahead for a democratic movement only weeks old. To blame the move-ment for Lara Logan would be akin to blaming President Obama for the federal deficit on his first day of office. Logan was simply not part of the story. That, apparently, was the stand of Al Jazeera.

Other Arab media, published in Arabic, did mention Lara Logan in passing. A prime example is a story by Sabri Hasaneen from *Elaph* that ran on February 19, 2011. The story replicated and elaborated Al Jazeera's coverage of the women at Tahrir Square, and explained how, from January 25 until February 18, Tahrir Square was a remarkably successful experiment in gender equality among a rising generation of Egyptian men and women. Translated into English, the article was

headlined "The Revolution Saves 83 percent of Egyptian Women from Sexual Harassment." The piece states that men and women were encamped at close quarters, with ample opportunities for sexual harassment, but none took place. Women slept in transparent plastic tents not far from men and never felt unsafe, against all the previous logic. Rania Majdi, a pharmacist quoted in the story who dared to wear modern clothes to the Square, brought with her a reluctant father who was sure his daughter was setting herself up for harassment or worse. But after witnessing the bonds of respect that had developed between the sexes on the square, the father gave Rania his blessing to provide medical support. Another woman, a member of the January 25 coalition, Marwa Jum'a, told Hasaneen that she experienced no male harassment on the Square but plenty of male chivalry. Jum'a's job was to collect garbage on the Square and at one point when she was bending to lift some off the ground, she inadvertently exposed the small of her back. The next thing Jum'a could remember was a young woman was rushing up to her holding a long shirt. The woman explained that after seeing Jum'a's back exposed, her brother went into a shop, bought her a longer shirt and bade his sister run it over to her to protect her modesty. Jum'a asked the young women if she could thank her brother directly for his kindness, but the brother demurred, not wanting to cause her any further embarrassment. Another act of chivalrous kindness occurred when thugs abducted three revolutionary women and headed them in the direction of a roof top, intending to rape them. A group of male revolutionaries immediately overpowered the thugs, asserting that they were not about to let harm come to women who were their equals (Hasaneen 2011).

Legal activist and manager of the Egyptian Center for Women's Rights (ECWR), Nahed Shehata, was also in the Square and included in the *Elaph* story. Only a month earlier, ECWR had released information, broadcast globally, stating that, in Egypt, 83% of Egyptian women and 98% of foreign women reported being victims of physical or verbal sexual assault. The report found that more than half of Egyptian women reported sexual harassment a daily occurrence of life for them and that the women interviewed for the report did not by and large think that modest Islamic dress deterred harassment (ECWR survey results cited in Jacoby 2011). Shehata explained to the *Elaph*

reporter that the ennui of Egyptian society had left Egyptians feeling so alienated and oppressed in their own country that they had learned to turn on one another, especially men on women. They had lost the moral compass that had once reminded them that every human life is a center of sacredness and honor and had substituted instead an apathetic "who cares" attitude about their fellow citizens. The January 25 revolution was a decisive repudiation of these enervating attitudes and an insistence that Egyptians awake to the fact that Egypt belonged to them. Mubarak had done his best to keep the citizens of Egypt divided by class, religion, and gender. Now was the time for Egyptians to unite and reclaim ownership.

The revolutionaries on the square were well aware that their behavior had to transcend Egyptian society or the meaning of the movement would be lost. And channeling the meaning of the movement beyond Tahrir Square would be the only way to awaken an Egyptian society that had been so beaten down by autocracy and corruption that it had lost its sense of religious honor and optimism for the future. The *Elaph* piece ends with the Logan case. Waleed Mahjoub, a member of the January 25 coalition, asserts that the regime's people were the likely culprits. He extends an apology to Logan, saying that she was supporting the revolutionaries and none of them had the slightest motivation to harm her. Indeed, they had every motivation imaginable to keep her safe, as Logan's attack could not have been more perfectly scripted to dilute the meaning of the January 25 revolution. As CBS news reported, all Logan wanted after her attack was privacy for herself and her family. Compared with Western media, Arab media must be credited with doing more to respect her wishes.

Can Arab Women Living in Fear Reclaim their Future?

Fear, one dominant emotion underlying passivity, changes Arab women's hope for the future they want to pursue into obsession about a future they want to avoid. The cases reviewed in this chapter and the previous one indicate that Arab female fear often originates from external threats that are real: threats from war, poverty, exclusion from education, and the violent behavior of men. In the big picture, women cannot set aside their fears unilaterally. In order to do so, they need the

cooperation of men. And even when women have that cooperation, they need to worry about maintaining it. Women with strong and supportive male family members and mentors often lose their male networks under conditions of war, economic uncertainty, and other social disruptions.

Conclusion

This chapter has examined the stories in our corpus that discuss Arab females under hostile threat outside of war zones. We have witnessed Jordanian-based stories of honor killings, the wife of a terrorist who feared the death of her husband, and even a girl who scares herself silly in horror movies to find insulation from the horror in news. We have seen female journalists and bloggers in Egypt, such as Nora Younis, who were beaten for reporting the truth. We have read about Egyptian women raped in the streets of downtown Cairo and updated that story with the assault on a non-Arab woman (Lara Logan) in Tahrir Square in 2011.

In previous chapters we asked whether Arab women can rise in a world of men. In this chapter we have asked whether they can rise collectively against fear, especially outside war zones. We considered the research question of whether rhetoric – mere words – can transform an audience's state of fear into more active and optimistic impulses of anger and hope and have discussed the current literature in the psychology of the emotions that confirms that words can change emotional states, and redirect habitual fear into more positive emotions and outlooks. And we have indicated how this research provides a basis on which leaders can build their efforts to dissipate Arab women's fear where they live.

18: Uncommon Stories of Patriarchy/Misogyny

The world is made by man—for man alone. I, who have lived as a man among men, realize it. I, who have talked with men as a man, know it.

Cora Anderson (1914), on why it was easier for her to make a living as a male impersonator than as a woman

As if more reminders were needed that it's a man's world

Anonymous

Fear is not fate. The one redeeming aspect of fear is that it may be acute and short-lived rather than chronic. Although fear may exist as a long-term condition, the majority of briefs we have considered thus far have brought us in contact with fear as a by-product of the acute circumstances of war, state and political hegemony, and domestic violence. These experiences of fear may ebb and flow over time. Wars come to a truce. Waves of state violence may subside. Bad leaders are on occasion overthrown or die and, once in a while, replaced with better ones. And even as we saw in the case of *khula* divorce (chapter 7), destitute women are willing to risk homelessness to escape constant beatings from abusive husbands.

In the stories to follow in this and the next chapter, we confront female passivity as the by-product of more settled and less volatile cultural conditions of patriarchy/misogyny (this chapter) or sadness/hopelessness (chapter 19). In this chapter, we focus on women living under accepted, but nonetheless flagrant, conditions of inequality with men (patriarchy), with these conditions often powered by the implicit or explicit belief that women, as the inferior sex, deserve to be held in contempt (misogyny). In chapter 14, we reported that forty (22%) of the 179 briefs showed at least some traces of Arab females suffering at the hands of a culturally accepted *patriarchy/misogyny*. Table 18.1 presents a country-by-country breakdown of coverage of such women across our corpus.

Pan Arab	Iraq	Palestine	Egypt	Saudi Arabia	Morocco	Bahrain	Other*
2	9	7	7	5	4	2	1 each

* = Lebanon, Jordan, Tunisia, Yemen

Table 18.1. Breakdown of the forty briefs describing Arab women living under conditions of patriarchy/misogyny by region/country. The seven stories from Palestine include one from Gaza, three from the West Bank, and three general to Palestine.

We do not analyze all of these stories here because many refer to ground we have already covered. We have already considered many common examples of patriarchy that correlated with concepts featured in previous chapters. For example, we have looked at the myriad ways in which females lead more restricted lives than males within the culturally passive frames of capability and choice (chapter 7, page 113). We may recall Amal, who stepped outside the "safety" zone of female professions by choosing engineering over teaching. She later regretted her choice after becoming pregnant. Her guilt at returning to a more "female-appropriate" profession was conditioned on the cultural premise that only women, not men, must restrict their work choices to make a family possible.[1] We saw how Saudi women (page 106) faced limited scholarship opportunities because of their restricted freedom of movement[2] and how prominent men dismiss the idea of women serving on the Saudi Shura Council as "absolutely out of the question."[3] And when it comes to testifying as an expert witness before that Council, Saudi women can be recognized for their expertise if that expertise is confined to their experience as women. Finally, the same chapter brought us in contact with Mshari Al-Zaydis (pages 118–20), a public figure who advocated more free speech and less religion in the Arab public sphere, but who still took for granted that a wife who dared take a political stand independent of her husband violated sacred Islamic doctrine. And in chapters 8 and 9, we reviewed stories (pages 164–65) that uncovered how Saudi men and brothers make the final decision about a woman's type and brand of car even if it is the wife, sister, or daughter's money that pays for it.[4] Stories like these are only

the tip of the iceberg of the paternalistic functioning of patriarchal cultures, leaving the men to make the decisions. When it comes to decisions that are "for her own good," the female is better off, according to the premises of cultural paternalism, delegating the decision-making to her male guardians.

In the previous two chapters, we have seen how Arab women in and outside of war zones are the special targets of blame, abuse, forced marriage, sectarian divorce, kidnapping, and even murder. War restricts female mobility, and, as we saw in chapter 16, female pharmacists can lose their livelihood when that happens.[5] Other stories in our corpus affirm that in reported cases of human rights abuses, males are disproportionately the abusers and females disproportionately the victims. For example, a study reported in a September 2006 news brief from *Asharq Al Awsat*, found that 40% of human rights complaints from Saudi Arabia stemmed from domestic violence abuses reported by females.[6]

Patriarchy runs deep across world cultures, not just Arab culture, and reading about restrictions on women both inside and outside the home is an unhappy and, unfortunately, recurring theme. For the remainder of this chapter, we focus on only a handful of stories in our corpus that addressed manifestations of patriarchy and misogyny that were unalloyed with other categories already featured, or best featured in their own right under the composite category of patriarchy/misogyny.

Patriarchy/Misogyny in the Pan Arab World

Arab Women Complicit in Patriarchy

The most insidious stereotype about patriarchy/misogyny is that it is practiced exclusively by men. Yet women are among its most ardent defenders. Islamic feminists, as we have seen, believe in the teachings of the Qur'an shed of the patriarchal assumptions so often used to interpret it. Feminists in Muslim countries tend to garner the majority of press attention and it is often negative. Yet large populations of Islamic women shielded from media scrutiny defend both the Qur'an *and* its overtly patriarchal interpretations. Such women defend the status

quo and pounce on women who dare insinuate that a Muslim woman's life is facing challenges.

An *Elaph* brief of June 29, 2006 from regular columnist Hani Nakshabandi caricatures in a tone of rebuke women who pick on other women. Nakshabandi, a Muslim, a champion of female equality and by many accounts an Islamic feminist, complains that whenever he defends the rights of women to Arab/Gulf audiences, the most vocal hecklers he must face down are the women. In attacking patriarchy, he complains, the women in his audiences mistakenly think he is attacking Islam. The female responses to his message are so predictable, trite, and knee-jerk that he can rehearse them in his sleep. All Nakshabandi needs to say to an audience is that "women live without rights," and at least one female heckler will shout back, as if on cue, that "Islam has given Muslim women more rights than any women in history" and that Islam placed the full "responsibility and burden" on the man so as to leave women "glorified." The heckler will then recite stories from the Qur'an in rapid fire from memory while cradling the Qur'an in her hands as a symbol of her knowledge and devoutness. All Nakshabandi needs to say to an audience is that "women live in a kind of slavery" to trigger some women into screaming back that Islam forbids slavery. All he needs to say is that women have had their wills stolen from them for some agitated women in the audience to cry out that Islam "created a free will for women." Nakshabandi wants it known that he can "appreciate women's pride in their Islam," but he cannot fathom why their pride should shield them from the harsh realities facing women in today's world. Islam may have given women unprecedented rights, but it did not mark the end of the history of women's development. He speculates that some "satanic ability" must have been used on women in his audiences to brainwash them into thinking otherwise. And as he sees it, "it is the largest brain washing operation that mankind has known." Nakshabandi explains that, if he could, he would eagerly share the opinion that the number of Muslim women so brainwashed is very small. But alas he cannot agree. He suggests that there are significant numbers of brainwashed women who fit this profile in the Gulf and many more who fit it less openly in other Arab regions. He maintains that the situation for women worsened after Islam not because of

Islam but because men over time failed to live up to the responsibilities for women that Islam assigned them. Yet, rather than learning from their mistakes, rather than admitting they had fallen short of the high standards of Islamic teaching regarding reverence for women, men found a way to excuse their failure by reinterpreting their religion and allowing for the projection of darker motives onto their faith. The "strange thing" he finds is that "women accepted this." They agreed to play the victim's role, perhaps reluctantly at first, but now with relish.

Patriarchy/Misogyny in Iraq

Women as Second-class Citizens in Iraq

As we have seen in chapter 16, the targeting of women in war zones is a common occurrence in our corpus of Arab news. Arab women coming together in war zones to challenge openly the patriarchy that targets them is much less common. An *Asharq Al Awsat* brief of May 3, 2006 covered a conference of Iraqi women beginning to take up the challenge. The article by Salam Jihad reported that, after three years of war, Iraqi women still face an intolerable human rights and security situation. Jihad was relaying the conclusions of the first conference for women held in Najaf governorate. Four speakers from that conference are briefly quoted. Deputy culture minister Jaber Al Jabiri averred that Iraqi women "have suffered the most from traditions and customs that have aimed at making them a second class citizen." He suggested that these traditions and customs affecting Iraqi women negatively "need polishing." Sawsan Al Barak, a women's rights activist and the next speaker, said that women remain figureheads in political participation, filling mandatory seats of parliament as required by law, but having no legitimate claim to primary seats or administrative posts. She went on to say that these accepted practices lead to a "paralysis" that keeps women from active roles in society. Akila Al Dahan, an MP in the Iraqi parliament and the third speaker, is quoted as saying that the deteriorating security situation in Iraq was hurting women most. Finally, Hind Alouch, a lawyer and the last speaker, confirmed that the personal status laws affecting women negatively in marriage, divorce,

and inheritance were applied inconsistently and arbitrarily across different Muslim sects and proposed that women would benefit significantly from more uniformity in the definition and enforcement of these laws.

The Double Standard of "Pleasure Marriages" in Shi'i Iraq

On the very same day, the same newspaper covered a peculiar story about a car bomb tip-off in the Amin district of Baghdad. The tip resulted in an Opel Hummer being destroyed, the owner arrested, and a woman fleeing from the scene. Seconds after the tip arrived, police and commandos from the Ministry of Interior and the Iraqi army arrived on the scene to close the streets and quarantine the car. They could find no explosives in the car, but they were determined to find a bomb. So they split the tires, broke the glass, and stripped the car down to its chassis. Minutes later, the owner of the car accompanied by a woman, appeared. Shocked by the skeletal frame that used to be his car, the owner asked the police who had done this to his property. Before he could finish his question, the police arrested him. The woman with him fled from the scene and the brief reports that she was "forced to flee" because he had told the police he had just married her by *muta'a*, the Shi'i Muslim tradition known as pleasure marriage or temporary marriage.

The brief focuses on the car and the security situation. Why had the police destroyed the car after discovering it was unarmed? One policeman responded with a "blame the victim" response. He said: "Is it not enough that the bomb threat caused a state of panic among the citizens and forced shopkeepers to leave their shops and escape." And what about the traffic tie-ups caused by closing down the streets. Why should not the owner of the car be punished? The policeman remonstrated that his punishment had not been severe enough. Witnesses on the scene brought more mixed reactions. Some thought that the actions of the police were justified in the name of security, even if the property of innocents had been harmed. Others believed the police overreacted. The security services, they said, are paid to protect life and property, not to destroy property and assault property-owners in the name of protecting their safety. Still others diverted attention from

the issue by suggesting that American security forces had behaved far worse than the Iraqi police that night.

However, the story within the story that is of greatest interest with regard to the female angle is why the woman fled the scene. Some background helps in the search for an answer. The high cost of Arab marriage, as well as rising unemployment and economic difficulties in Arab regions, have caused the increasing incidence of unconventional marriages, variously called 'urf, muta'a and messyar. Couples typically hide these marriages from their families, and the secrecy puts the woman at a disadvantage because she is unable to negotiate the terms of the union. A woman in a conservative society who accepts such a marital relationship puts herself at greater risk than the man. If the relationship is exposed, she faces the cultural opprobrium of the prostitute. The relationship is generally controlled by the man and he can end or deny it (Rashad, Osman & Roudi-Fahimi 2005).

Urf marriages have no official contract, which makes legal disputes that might arise between the couple difficult to negotiate. There are no official records but in 1998, there were an estimated 10,000 cases of contested paternity as a result of urf marriages (Rashad, Osman & Roudi-Fahimi 2005). In muta'a (pleasure or temporary marriage), which is practiced by the Shi'as in southern Lebanon and Iraq, couples specify in their marriage contract the date upon which the marriage is to end. Messyar ("dropping by"), mainly practiced in the Gulf countries, is an arrangement in which a man is not obligated financially and where the woman remains in her own house and the marital agreement is that the husband will "drop by" to see her. Because males under Islam can marry multiple spouses and females cannot, a married man discovered accompanying a female who is not his wife has a cultural advantage when the relationship is exposed. The man can always claim he is with a newly betrothed wife and if the woman is married he can deny she ever told him. The man has a first-line of defense and a backup to explain why he is where he is. The culture offers the woman no first-line defense and no backup. She is likely to drift into legal limbo and disgrace as a result of her involvement (ibid.). To return to our story, the man accompanying the woman back to his wrecked car had a story to tell the police about his involvement with her that could get him off the hook. The woman did not. She had no alternative but to flee in disgrace.

Patriarchy/Misogyny in Saudi Arabia

Why Terrorism is "Man's Work"

Stories about Saudi Arabian women from mideastwire.com offer the Western reader much to read that breaks the stereotype of Saudi Arabia as a misogynous country. As mentioned earlier (chapter 9), of the 339 briefs from September 2005 to June 2007 that the indexers at mideastwire.com classified as "women's" stories, the single largest cluster (twenty-seven briefs) was about Saudi women in business (Kaufer & Al-Malki 2009). Nevertheless, mideastwire.com also provides ample numbers of briefs that fit Western stereotypes. An *Asharq Al Awsat* brief from April 20, 2006, features a question and answer interview with Saudi Interior Minister Major General Mansour Al-Turki. The interview is long and wide-ranging and covers many aspects of Saudi society. Four questions dealt specifically with the status of women in the Kingdom. One question asked Al-Turki about the detention of Saudi women in various criminal investigations. Al-Turki replied that women were responsible for the crimes they committed and could not be pardoned by religious or state laws. However, in the case of detaining women for routine questioning, the majority, he insisted, were released immediately and those who were not were held in protective custody somewhere outside the police station. The children of the women were immediately handed over to their relatives and guardians.

A second question asked about the ban on women driving in the Kingdom and why the ban existed. Al-Turki denied that security was a reason for the ban, but then ducked the question further by citing that it was outside his jurisdiction, as he worked for the executive authority while the issue of women driving falls under the authority of the legislature. Al-Turki did, however, hint that an overturn of the ban was inevitable and that society should "prepare for such a practice."

A third question asked about the ceilings for women working in the military. Currently, Saudi women are confined to the rank of staff sergeant and Al-Turki was asked whether women could become officers. He failed to answer the question directly but did allow that as women had become more directly involved in crime and security

threats, it had become more important to bring women into law enforcement. Whether they might take on more responsibilities and rise in the ranks in security enforcement he did not say, but hinted vaguely that if women's role in law enforcement changed, the changes would certainly be reflected in their responsibilities and rank. As a follow-up, he was asked whether he personally supported women developing careers in the security field. He answered that there was a strong desire for it and in some cases, such as in the interrogation of female suspects, it was a necessity.

A fourth question explored the involvement of Saudi women in terrorist attacks, such as the al-Khalidiya attack. Al-Turki was asked about the extent of the problem and why women were getting involved. In a back-handed defense that left Saudi women stereotyped more than flattered, he said: "I can assert that a woman's role in supporting terrorism may be [involuntary] as women usually fall under the control of their husbands." Al-Turki defended Saudi women involved in terrorist acts because, as he saw it, they would only engage in such attacks at the behest of their husbands. As a brief follow-up to this question, he was asked to comment on the statements of Sheikh Mohamed Al Nejeemi, who has spoken of women who "encourage their sons to take part in jihad (holy war) in Saudi Arabia." Must this too be the result of a wife's devotion to her husband? Minister Al-Turki acknowledged that some Saudi women were led by their own extremist ideologies and not necessarily those of their husbands, but he "reassured" his questioner that terrorism was the jurisdiction of men and in eastern societies men were simply "more prepared" to participate in it. Terrorism, Al-Turki reasoned, is essentially "man's work" and the best policy for keeping women out of terrorism, apparently, is monitoring the man she weds.

Stigmatizing Female Drug Addiction

Drug addiction is unbecoming in the Kingdom but for women it is taboo. For Saudi males, addiction is an acknowledged problem that is seen to deserve treatment solutions. For Saudi females, it is an unforgivable disgrace that goes unacknowledged and often untreated. Thus reports an *Asharq* brief from February 27, 2006 in which regular

columnist Mohammed Al-Jazairy reports coming across a prostitution ring of female university students run by a non-Saudi. The pimp would get the girls addicted to drugs and force them into prostitution to subsidize their habit. Once addicted, their fate was sealed. The girls had no recourse to treatment, even if they sought it. As female drug addicts have no recognized existence, no units in Saudi hospitals can admit them as addicts. They can be admitted only as cases of mental illness. "Female addicts are taken . . . to psychiatric units," according to Dr Mohamed Shaweesh, Director of the Jeddah branch of Amal Hospital who is quoted in the piece. For a Saudi woman to be classified as mentally ill is somehow more face-saving than for her to have to admit to a physical addiction. Shaweesh goes on to comment that Saudi society is "unmerciful towards female addicts" and it remains unforgiving even if the woman miraculously finds ways to overcome her addiction and begin life afresh. Unlike in the West, where American First Lady Betty Ford could be feted for admitting her alcoholism and conquering it, there are no rewards for a Saudi woman who admits to an addiction and overcomes it. A Saudi man may be respected for owning up to his habit and beating it. He can turn his imperfections into a badge of honor, but a Saudi woman is not permitted to leverage her imperfections this way. Her fight against addiction must proceed in strict isolation and privacy. Shaweesh observes that even private hospitals are not allowed to extend treatment to female addicts and female addicts with good family connections desperate for treatment can get help only under conditions of extreme secrecy.

Al-Jazairy reviews the case of Reem, a Saudi teenager who chose prostitution rather than admitting her drug habit to her parents. Reem eventually did reach out to her family and her family forgave her and supported her very private treatment. Now an undergraduate, she was looking forward to her wedding in two weeks' time. Reem, like Shaweesh, and like Al-Jazairy, was baffled as to why the Kingdom sees honor and compassion in a man seeking help for addiction and only shame and disgrace in a woman reaching out for the identical medical help. The male drug addict who fights his addiction and recovers is restored in full by society. Al-Jazairy pleads, on the authority of Islam, that equal benefits should be granted to Saudi women addicts so they may "return to the right path."

Ask the Groom, Ignore the Bride

An *Asharq Al Awsat* brief from May 17, 2006 made reference to two columns written in that same week by regular columnist Hussein Shobokshi. Shobokshi notes the "tragedy" as well as the folly of issuing nonsensical fatwas in the name of Islam. One column noted that an Imam was fired in a Saudi city simply for delivering his Friday sermon from his laptop computer. Shobokshi recalls other "innovations" that clerics once stupidly sought to ban in the name of Islam: "telegraphs, cars, bikes, watches, radios, televisions, airplanes, the English language, the Internet, and camera-enabled mobile phones." A second column, more pertinent to the female angle, notes that the majority of marriage officials in the Kingdom do not bother to ask the bride if she consents to the marriage. Her consent is apparently unimportant and would cause social embarrassment to herself and her family. Marriage officials, out of custom and decorum, look only to her male guardians for consent. Shobokshi laments that clerics too often overlook the true spirit of Islam with regard to women's rights in favor of the pre-Islamic subordination of women that Islam overthrew. These baseless and absurd edicts, he goes on, have seriously threatened the perception of Islam as a fair, "glorious" and "tolerant" religion.

Patriarchy/Misogyny in Palestine

Discrimination against Palestinian Women on the Job

An *Al Hayat* article of November 16, 2006 reviews the workplace discriminations faced by women working for the Palestinian Authority (PA). We visited these Palestinian women in chapter 9 as one of the few examples in our corpus of Arab news revealing the everyday conditions of Arab women on the job. Our focus now is the patriarchy/misogyny that the women in the PA endure on the job. The article reports a survey of Palestine women working for the PA that showed that 82% could not afford health care for their families; 73% do not have health insurance to cover themselves; 60% cannot afford medicine; 67% must keep their food purchases to necessities; 75% cannot afford reading material for themselves or their children; and 71% had

had to suspend all entertainment purchases. Despite steady rises in men's salaries in the PA, only a tiny percentage of women (6%) had seen increases. According to the survey, 86% of women working for the PA felt consumed by anxiety and worry, which negatively impacted their families and especially their children.

Patriarchy/Misogyny in Yemen

Yemeni Government Supports Human Sex Trafficking

The website of the US Department of State defines sex trafficking as a commercial sex act induced by force, fraud, or coercion upon a person younger than eighteen. Victims of sex trafficking may be male or female but the majority are young females. The common ways of luring girls and women into the sex trade include promises of employment and marriage, and get-rich-quick schemes put forward by unscrupulous strangers and sometimes treacherous family members and friends. Common ways of keeping girls and women in the sex trade are for the traffickers to threaten, starve, confine, beat, addict, and rape their victims as a way of conditioning them to comply.

According to the 2009 Department of State Report on Human Trafficking (United States Department of State 2009), Yemen is an egregious offender in the trafficking of women and children: Yemeni children are trafficked across the northern border into Saudi Arabia or to the Yemeni cities of Aden and Sana'a. Unconfirmed estimates suggest that ten Yemeni children are trafficked into Saudi Arabia every day. Young boys are brought in from the countryside for work in the cities as street beggars, vendors, and unskilled labor. Girls and women, trafficked as sex workers, are frequently routed from the countryside of Ethiopia, Somalia, and the Philippines into Yemen. According to the State Department report, some females trafficked to Saudi Arabia from Yemen are sexually molested before reaching the Kingdom, and others after. Yemeni girls are also trafficked within Yemen. A study by the International Programme on the Elimination of Child Labour (IPEC) found that girls as young as fifteen are exploited for commercial sex in hotels, casinos, and bars in the governorates of Mahweet, Aden and Taiz (United States Department of State 2009). Al-Alaya

and al-Kibsi recently reported on the practice of Saudi male tourists visiting Yemen, contracting a temporary marriage with a Yemeni girl, bringing the girl back to Saudi Arabia, and then abandoning her on the streets. Her abandonment forces the girl into prostitution to survive (al-Alaya & al-Kibsi 2009).

According to the 2009 US Department of State report, the government of Yemen does not comply with minimum standards for the elimination of trafficking, though it currently claims to be making efforts to do so (Ismail 2009). But how earnest are these efforts? A brief from *Al Quds*, dated September 8, 2005, reported that a local human rights organization had uncovered that the government of Yemen issues "dancer" licenses to prostitutes to give them legal cover when they consort with Saudi tourists. The brief closes with the startling news that the male pimps are unrelenting and despicable but the female pimps are worse. A female pimp, it claims, is more likely than a male to take all her female prostitutes' earnings and leave them emotionally drained and destitute. This is an unexpected and especially sordid case of women divided against women.

Patriarchy/Misogyny in Egypt

Restricting the Meaning of the Veil

We have seen that the veil comes with many societal meanings.[7] One of the goals of patriarchy is to restrict the veil to meanings that accommodate male control and fantasy and to eschew meanings that women control. A controversy over the meaning of the veil arose around the appearance in Egypt of the movie *Ouija* in which the star actress, Menna Shalabi, playing a university student, wears hijab during an undercover rendezvous with a male student in his apartment. According to an *Elaph* brief of January 19, 2006, religious scholars attacked the film because the script appeared to have turned hijab into a sacrilegious symbol that brought every woman who wore it under suspicion. The director, Khaled Youssef countered that the film was exploring the motives in his characters' minds and whether a woman's face was exposed or not was tangential to the expression of these motives. He further pointed out that men were susceptible to the same motivations

and no one was paying attention to the religious meaning of their clothing. Consequently, his film, he argued in his defense, was more a case of art imitating life than art stepping across forbidden cultural lines. The director had invited the General Adviser of the Muslim Brotherhood to attend a showing with him, but he had not replied to the invitation. Religious conservatives, like the General Adviser, often present their own strong opinions about what the veil means and blame women for violating their interpretations without consulting women themselves about the variety of interpretations that motivate them. As we saw in chapter 8, many educated women who value education and open-mindedness understand that they can define the meaning of the veil as much as the culture defines it for them. This was the complicated reality that Youssef wanted to bring to the screen. Yet conservative forces turn the veil into a rigid signifier, dismiss the individual woman's active choice (chapter 7), and categorize the woman as a violator should her apparel enter into situations that do not meet preconceived conceptions of "appropriate" behavior for a religious woman.

Conclusion

Patriarchy may seem to stem from men's failure to listen to women with an open mind. If this were the case, normal courses in listening skills for men might be all that is needed. Unfortunately, bringing an end to patriarchy involves more than opening the ears and mind of a male to a female. It requires overhauling the fundamental patterns of thought of the male once his ears and mind are opened up, and changing the general character of men so that they are able to listen and take in what they hear in an enlightened way. This cannot be achieved simply by the presentation of a motivational lecture. What is needed is a sustained development strategy for men – no less comprehensive a strategy than current global development strategies for women.

19: Sadness & Hopelessness

WOMEN WHO HAVE LOST THEIR FUTURE

Female passivity may arise in women feeling sadness or loss, or that they are lost, isolated, and deprived of hope. Unlike fear, caused by a negative future looming over a woman as a worrying possibility, female sadness and hopelessness arise when the negative descends upon her as a cloud of certainty. In sadness and hopelessness, a darkness may descend that will not lift. The darkness may be especially stubborn if it is caused by outside forces that are beyond her control to change. Such sadness may lead to a variety of negative outcomes, from psychological withdrawal, defeat, melancholy, depression, and retreat to irrational and even pathological actions. Some have come to analyze female suicide bombing as a symptom of profound sadness/hopelessness (Skaine 2006) and that is how we analyze it here.

In chapter 14, we reported that twenty-two (13%) of the 179 news briefs showed at least some traces of Arab women suffering sadness/hopelessness. Table 19.1 gives a region and country breakdown.

Pan Arab	Palestine	Saudi Arabia	Iraq	Egypt	Lebanon
1	8	5	3	3	2

Table 19.1. Breakdown of the twenty-two news briefs describing Arab women living in sadness/hopelessness per region/country. The eight stories from Palestine include four from Gaza, three from the West Bank and one general to Palestine.

As in previous chapters, we cover here only a subset of these twenty-two briefs, selecting those that least replicate ground already covered

by focusing on examples of Arab female sadness/hopelessness that overlap least with passive concepts discussed in previous chapters.

Female Sadness in Palestine

More stories of female passivity involved with sadness or hopelessness in Arab news coverage of 2005–2006 come out of Palestine than from any other country represented in the sample, and over half (thirteen out of twenty-two) of the stories we classified under the concept of sadness/hopelessness come from Palestine, Iraq, and Lebanon. As we saw in chapter 16, these countries were the major theaters of war in that period.

The Sense of Loss and the Female Suicide Bomber

As we reviewed briefly in chapter 14 (page 355–57), double standards tend to be used when judging female and male suicide bombers. Mainstream media assign little credit to suicide bombing. They judge it, justifiably, as an action that is unfortunate and morally fraught, if not deplorable and condemnable. Nonetheless, they seldom deny the male suicide bomber the minimal courtesy of linking his actions to acts of political expression. When men blow themselves up, their political motives, however misguided, are typically not questioned and their personal lives are consigned to the fine print of footnotes.

Mainstream media, by and large, do not extend the same courtesies to the female suicide bomber, but tend to assume that no woman with a good family, home life, or future would have the political will to take her own life. Mia Bloom, an expert on the subject of female suicide bombing, opens her book *Dying to Kill: The Allure of Female Suicide Bombing*, by holding up this popular belief to critical examination: "How bad must your life be if you think it is better to be a sacrifice than to live, have a family, and be a productive member of society?" (Bloom 2005, 1). According to Rosemarie Skaine, author of *Female Suicide Bombers*, mainstream media tend to present the public's belief that women are drawn to suicide bombing for "personal and emotional" reasons (Skaine 2006, 34), that their actions are shaped by "personal circumstances" (ibid., 41), and that they are driven by motives and

levels of distress that are "personal" (63). In the public imagination, female suicide bombing represents for these women a personal nadir, a failed private life as a woman, and perhaps a psychotic break that allows them to avoid the shame of their personal failure. As the bombing is thought to result from her life situation as a woman, the media consider it justifiable to open up her private life and make public sport of unearthing the failures that might have triggered her murderous intent. But focusing on the woman's "private life" overlooks the "real causes" (Skaine 2006, 167), which, according to Skaine, are no less political than the man's.

The myth of the scorned woman turned vengeful killer is as old as Greek tragedy and Euripides' character, Medea, who murdered her children to exact revenge on a husband who had betrayed her. The Medea myth promulgates one of the oldest and most disquieting ideas about female violence, linking ancient Greece to the present day: while women are on average less violent than men, the Medea myth teaches that there is nothing more deadly than an enraged woman. According to the myth, women are slower to vengeance than men because they have longer fuses and greater requirements for the harm to affect them personally, at the core of their being, before it provokes a violent reaction. A man may be quicker to violence because, for him, it need not be personal. A man can file violence under "professional duty" and claim it is "nothing personal" when he kills a combatant in war. In the Medea myth, a woman does not classify violence and is incapable of doing so. It suggests that a woman cannot be aroused to acts of violence unless her heart is broken, but once that happens there is no stopping her. A violent woman, in the myth, brings unimaginable passion to her fury, which makes it more frightening than a man's and much deadlier because it is not expected from a woman. In the myth, women come to violence slowly, but when the violence erupts, it does so with volcanic force; and because no one can predict female violence until it is too late, it is associated with deep cunning, stealth, and subterfuge. The English playwright and poet William Congreve (1670-1729) brought all these elements of the Medea myth together in the only tragedy he ever wrote, *The Mourning Bride* (1697) and in one of the only lines he is ever remembered for writing when his character, Zara, intones: "Heaven has no rage like love to hatred turned, nor hell a fury like a

woman scorned" (Act 3, Scene 8). Popularized, these lines survived the centuries as: "Hell hath no fury like a woman scorned".

No political leader understood the potency of the Medea myth and its tactical advantages in fighting asymmetric warfare better than President Yasser Arafat. At the start of the second Intifada, on January 27, 2000, Arafat addressed 1,000 Palestinian women in Ramallah, and told them that they held a special place in his "army of roses" because only recruits within this army could crush Israeli tanks from behind the shields of female propriety and delicacy. Previous to Arafat's speech, there had been no feminized version of the masculine form of the word for martyr, *shahid*. In that speech, Arafat introduced the feminized *shahida* (Skaine 2006, 132). The concept of a female suicide bomber within Palestine was born that day and it led to a rash of female suicide bombings in the first two years of the second Intifada (2000-2002).

Arafat understood the tactical advantages a female suicide bomber brings to warfare. But what would motivate a female suicide bomber to enlist and martyr herself in the first place? As previously hinted, searching for personal explanations behind female suicide bombing has become a preoccupation in the West. Enthralled with the Medea myth, the media seek to ferret out failings in the bomber's personal life that might account for her actions. Fortunately, there are now many research centers worldwide that are looking beyond the myth to the science behind female suicide bombing. Research centers in Israel, Europe, and the United States have all sought to work out an effective profile for the female suicide bomber, and over the years a number have been proposed. If the profile drawn by the Israeli government is taken as representative, the extent to which such profiles have overcome the gender biases of the Medea myth remains unclear.

The Israeli Ministry of Foreign Affairs (2003; cited in Brym & Araj 2006) created a profile of female suicide bombers in Palestine that cited three motives that drive the female bomber. The first, which has stood up over time, is that female bombers act as they do because they are legitimated by religious and political leaders. Arafat's original legitimation of the practice is an example, as is the legitimation by leaders of Hamas. The spiritual head of Hamas, Sheikh Ahmed Yassin, an advocate of political Islam, was quoted in an August 2001 interview

as saying that, in the right circumstances, Islam permits females to take up violence against foreign aggressors, and that he personally granted permission to Palestinian women to launch suicide attacks within Israel. In every recorded instance of female suicide bombing, the evidence shows that female suicide bombers felt they were justified in their actions by a higher authority.

A second motive, one that has not stood the test of time, is the so-called socio-economic motive (Brym & Araj 2006), the belief that female (and to a large extent male) suicide bombers are driven by economic hardship, infertility, failure in school and on the job, a poor family life, and low social standing. This theory was given new life by the fact that a prominent female bomber in 2006 was a university student struggling to pay tuition fees. A brief from *Asharq Al Awsat* on April 28, 2006 presented its own research to test the theory that female suicide bombers were struggling financially and socially. Several of the families of fifteen Palestinian suicide bombers since 2000 were interviewed, including those of four well-publicized female bombers all of whom blew themselves up in 2002: Wafa Idris, a nurse from Amari refugee camp near Ramallah (died January 27, 2002); Dareen Abu Aisha, a university student from Nablus (died February 27, 2002); Ayat Akhras (died March 29, 2002), a high school student from the Dehaishe camp, and Andalib Taqatiqah (died April 12, 2002) from Gaza. As a result of the interviews, the newspaper concluded that the socio-economic theory was simply wrong. The majority of young Palestinian suicide bombers had an upper-middle-class back-ground, and even those who were struggling financially were actively involved in school with good academic records and plans for a pros-perous future. The female law student, Hanadi Jaradat, who blew herself up at the age of twenty-nine in Haifa on October 4, 2003, belonged to a wealthy family, had been doing well in law school, and was just weeks from graduating.

Other briefs in our corpus provide initial support for a third motive cited by the Israeli ministry, which suggests that a female suicide bomber may be young, impressionable, and sometimes romantically involved with a man already recruited for suicide bombing. An *Asharq Al Awsat* brief from August 31, 2005 reminds readers that female suicide bombers are often extremely young – still highly impressionable

teenagers – and easily exploitable by religious extremists. The brief, from Morocco, details how King Mohammed VI pardoned two sixteen-year-old twins, Iman and Sanaa Al-Ghuraisi, who fell into collusion with a sophisticated extremist group. The group was skilled at commandeering the passions of idealistic Moroccan teenagers, and helping divert their legitimate sympathies toward Palestine into deadly projects. King Mohammed saw the girls as victims of such manipulative tactics and exonerated them.

Less than a year later, on May 15, 2006, an *Al Hayat* brief covered a young Iraqi girl, Sajida Al-Rishawi, described by her lawyer as "easily led." Al-Rishawi was on trial in Jordan for attempted suicide bombing. The girl had entered into a marriage with a prospective male suicide bomber, although it is not clear whether she knew this at the time they were married. The couple drove to Amman and hid out in a Radisson hotel where he dressed her in a suicide belt and left her to detonate herself. She later testified that she had received no training in how to use the belt and had not even understood that the belt contained explosives. She testified that when she finally realized to her horror what the belt was, she immediately removed it, hailed a cab to the house of some Jordanians she knew, notified the police, and gave herself up for arrest there.

These examples speak to the possible relevance of the third motive cited in the Israeli ministry's 2003 profile of female suicide bombers. However, it is often empirically ambiguous because it conflates her own intention (she fell in love with a man who turned her heart to murderous ideas) with her dependency (she fell in love with a man who set her on a path to murder). Sajida Al-Rishawi's case history as a would-be suicide bomber illustrates the ambiguity. Was Al-Rishawi working as a knowing accomplice of her husband, or was she a trusting and duped victim of a male companion out to take advantage of her? Could the lure of a fanatical man fill her own heart with murderous thoughts, or did it only significantly heighten her risk of finding an explosive belt around her torso for reasons she could not explain or defend? Many young women are impressionable and interested in romance and so likely to fall prey to this third motive insofar as it speaks of dependency. This motive is thus ineffective in screening the population of young women who might turn to bombing, and in

predicting when being impressionable and in love may carry over to a willingness to die for the beloved.

This third motive is flawed in an even more fundamental way. It does not adequately circumscribe the population of female suicide bombers. Although some bombers are young and impressionable, many others are not (Brym & Araj 2006), and the third motive cannot therefore account either for the young female bombers reported to be in healthy relationships with men or contentedly unattached, or for the female suicide bombers who are decidedly not young, callow, idealistic, or blinded by love. Some female bombers and bombing suspects have been experienced women in their late twenties and older who had become hardened to violence and mayhem. Almost a year to the day after King Mohammed pardoned the Al-Ghuraisi twins, the Moroccan police uncovered a major terrorist plot hatched by the radical Ansar Al-Mahdi sect. Fifty-six were arrested, including four women. A September 1, 2006 brief from *Al Quds* reports that Moroccan police were especially wary of the women because two were the wives of pilots with Morocco's national airline and one had contact with the wife of a slain al-Qaeda operative who had allegedly planned the Madrid bombings of 2004. It is hard to imagine relating these suspect women to a "young, impressionable, love-struck, and misled" profile.

Despite efforts to jettison myth for science, the Israeli ministry's profile still seems caught in the mythic thinking that (Arab) women capable of extreme violence must therefore be victims of personal disturbance and distress that dilutes the meaning of their action as political expression. The problem with this and many other female profiles of suicide bombing is they perpetuate an unjustified asymmetry between male and female bombers. They assume that men are driven by public purpose, even if through indefensible methods. They assume, by contrast, that only humiliating personal failure can incite a woman to wanton violence. When a man blows himself up, we witness public purpose gone wrong; when a woman blows herself up, we witness the most desperate and loathsome primal reverberations of private shortcoming.

Many sympathetic to the Palestinian cause acknowledge that the methods of male suicide bombers are pathological and indefensible, yet nonetheless insist that the motivations are political and worthy of a

legitimate hearing (Brym & Araj 2006).[1] The failure to distinguish motivation and method for female bombers with the same consistency constitutes a blind spot in many Western and Israeli-based profiles. When profiles demonize not only the female bomber's methods, but her motivations, they imply, contrary to plausible fact, that the motivations have no political relevance when it comes to curbing the methods. However, addressing the motivations of the female bombers as serious political expression, just like the males', is precisely on point for addressing their methods.

On the evidence of our corpus and only from that evidence, we arrived at a conclusion somewhat different from the Israeli profile.[2] We saw little evidence that female suicide bombers are driven by the Medea myth of failed personal relationships, but rather by a profound sense of loss with clear political overtones. The actions taken by the female suicide bomber in the briefs we read are tied to political restitution no less than the acts of a male suicide bomber. There is complete symmetry between male and female suicide bombers on this point. Our corpus did not contain enough examples of male suicide bombers to take the case further with the males. But as far as the female bombers are concerned, their political expression is tied to loss and mourning. Unlike mainstream activists stricken by loss, female bombers do not mourn their loss through accepted methods of grieving and then pursue restitution through independent political means. They do not wait out a grieving period and only then angrily summon justice for retribution (chapter 6). Female bombers rather feel authorized to take justice into their own hands to avenge their loss. To do so, they turn sorrow into a political act and squeeze politics into a single momentous act of causing grief as restitution for suffering it. It is certainly a perverse, deplorable, and criminal act of political expression. On moral grounds, it is a failed act, but we need not open up a woman's personal life and go on a witch-hunt for extraneous failure to know that.[3]

To see this account of female suicide bombing in action, let us consider some news briefs. An April 28, 2005 *Asharq Al Awsat* brief supports this linkage of female suicide bombing, loss and the redirection of this loss into the seeking of political restitution. It reports on a series of interviews with families of suicide bombers, female as well as male. Family members testify that their relatives who became bombers

all shared experiences of profound loss. On their way to becoming bombers, the females in question all redirected their loss into feelings of political motivation mixed with obsessive and murderous methods.

Indeed, the female bombers profiled all exhibited an anger that bears an uncanny resemblance to the second phase of the Kubler-Ross (1969) five-stage model of coping with a devastating loss. The first phase is denial; the second is anger. The person exiting the denial phase stops saying "This is not happening to me," because she realizes it is. But with that realization comes a new set of angry questions such as "Why me?" and, more sinister, "Who is to blame for this?". As we shall see below, suicide bombers from Palestine often place the blame on feckless Arab leaders who cannot confront Israel with one voice. Although the *Asharq Al Awsat* brief does not delve deeply into the background of Hanadi Jaradat, her life circumstances are typical of the female suicide bomber in Palestine.

Jaradat was twenty-one when her fiancé was killed by Israeli security forces. Shortly after that tragedy, the day before her brother was to be married, she witnessed him and her cousin being shot dead in her home, targeted by Israeli soldiers (Regular 2003). Similar loss overwhelmed two other well-publicized female bombers that the April 28 *Asharq Al Awsat* brief covers. Ayat Al-Akhras had first been radicalized after she lived through the imprisonment of her older brother during the first Intifada in 1987. She was radicalized again during the second Intifada after members of her family had been wounded and killed. She blew herself up entering a supermarket in Jerusalem, killing a guard and a seventeen-year-old Israeli girl, Rachel Levy, who resembled Al-Akhras and shared her physical beauty. In response to whether there was a socio-economic motive to Ayat's actions, her mother responded in the negative. The mother explained that her daughter had been an accomplished student, having earned top grades in her tests just days before the suicide bombing. She was college-bound and headed toward a promising career and family life. She was engaged to be married to a wonderful man, had no financial worries, "did not hate life and was not frustrated . . . She had even chosen the names of her future children with her fiancé Hussein Al-Qassas."

Yet Al-Akhras's neighbors could vividly remember the event that triggered her decision to bring her life to a close at the age of eighteen.

It was March 8, 2002, just three weeks before she carried out her attack, that her close friend and neighbor, Isa Zacaria Faraj, had been struck and killed by a stray Israeli bullet while holding his infant son. An eyewitness described it thus: "As we rushed to save Faraj, Ayat was crying and screaming hysterically from the roof top of her house." Al-Akhras's sense of loss quickly escalated into anger, and it was anger targeted against Arab leaders for their inability to stand up to Israel. Like many Palestinian suicide bombers, Al-Akhras made a video in which she declared that she had to make the ultimate sacrifice for Palestine because Arab leaders could not: " I say to the Arab leaders, stop sleeping. Stop failing to fulfill your duty. Shame on the Arab armies who are sitting and watching the girls of Palestine fight while they are asleep" (Hammer 2002).

In the Kubler-Ross model of loss, denial and anger eventually transition into bargaining, depression, and acceptance. In bargaining, the person suffering loss knows she is dealing with forces she cannot control and looks for ways to negotiate with them. In depression, she runs up against the limits of bargaining and comes to a sobering certainty that the loss hanging over her is permanent and beyond negotiation. In acceptance, this certainty turns from a negative to a positive as she accommodates the loss, and even embraces it, as a natural part of life.

Although the psychology of suicide bombing is complex, and multifaceted, and a comprehensive analysis is well beyond our scope here, it is useful as a starting point to consider suicide bombing as a deviation from the Kubler-Ross model of loss that rejects the lapse of time normally required to transition from the earlier to the later stages and instead allows loss, denial, anger, and acceptance to implode in a single moment. Experienced in normal time, the phases of loss proceed at their own pace and cannot be controlled by the consciousness of the griever, but in the case of a suicide bomber, the phases of loss are experienced all at once. Anger, loss, depression, acceptance, compensation, and the execution of justice descend on the bomber's thinking all at once. No longer her master, death stands guard as the watchful servant of the suicide bomber. In dying, she lives for that timeless yet infinitesimal moment when she conquers death by making it serve her own ends.

Rolling back time to the morning of April 12, 2002 in the Gaza city of Bayt Fajar, the April 28 *Asharq Al Awsat* brief follows a third female bomber as she awakens to the last morning of her life. She is twenty-two-year-old Andalib Taqatiqah. Her family, from a lower-class economic background, were still sleeping, having stayed up late the night before listening to the news about the Israeli re-occupation of Palestinian cities. Andalib brewed tea for herself and her brother Ahmad, whom she heard stirring. Making his way to the kitchen, Ahmad watched his sister retire to the courtyard to drink her tea. It was the last any family member would ever see of Andalib. Sometime between that last eyewitness glimpse to the end of her short life, Andalib somehow managed to suit herself up with explosives, slip through several Israeli military checkpoints into West Jerusalem, and, finally, blow herself up. While Andalib's family struggled economically, her sister, Abeer, did not need treatises about economic class struggle to explain why Andalib did what she did. She knew that her sister had been emotionally distraught over the Israeli "massacres of Jenin, Nablus, Ramallah, and the sieges of the Al Mahd church."

Interviewing the families of these female as well as male suicide bombers, the brief comes to the following conclusions: Suicide bombers in Palestine distort their political motivations by committing acts that are pathological and murderous. Their political motives, however, are not pathological. They are born of overwhelming grief and the desire for political restitution. Their actions may be condemned, but in order to bring an end to such actions it is necessary to take their motivation with the utmost seriousness. It is appropriate to deduce that female suicide bombers feel a sense of deep personal connection and loss, but to think that they, unlike men, are somehow ruled only by personal pathology is to deny their political agency.

From the perspective of gender equality and media coverage, we have cited scholarship that finds a discrepancy in mainstream media, which tend to cover male suicide bombers for their political motives and females for their personal ones. This is an example of gender inequality in media but a limiting one from a human rights perspective. However, paradoxically, a chimerical gender equality can be found in some Arab media such as Hamas TV (Women Against Shariah 2011) and al Manar TV (Jorisch 2004), which dangle in front of

impressionable Arab girl viewers images of martyred female suicide bombers glorified on a footing equal with men. As Rapheal Israeli notes in his study of Palestinian women turning to suicide bombing, "self-immolating young women are glorified posthumously" while there seems no change in the fortunes of living Palestinian women (cited in Skaine 2006, 168). Most Arab women we have met over these chapters would be repulsed at the thought that martyrdom is the price a woman must pay for full equality. They would prefer to see equality as a right guaranteed the living, regardless of gender. If a woman must die to be equal to a man, there is something profoundly wrong with our theory of gender equality.

A Young Girl Becomes the Icon of Palestinian Sadness

For a short while, she would become the world's icon of Palestinian distress. Her name is Huda Ghalia and she was just twelve at the time. It was June 9, 2006. Huda's family were enjoying a summer outing on a beautiful, sunlit Friday afternoon on the Beit Lahiya beach bordering the shores of the Mediterranean. She was with her parents and her dozen siblings. Suddenly, the Israeli military began to shell the beach. Shelling was nothing new. According to the UN Office for the Coordination of Humanitarian Affairs, Israel had fired 7,599 artillery shells at Gaza from April to June 20, in response to 479 Qassam missiles shot from Gaza into Israel over the same time period. However, the human carnage that began with the shelling that June 9 *was* new. Over the next eleven days, from June 9 to June 20, thirty-one Palestinians were killed in Gaza, including ten children. The fatalities included seven members of the Ghalia family (Karmi 2006). Photographer Zakariah Abu Harbeed arrived on the scene just in time to capture the aftermath. The seven members of Huda's family who lay dead, were her father, one of his two wives, and five of Huda's siblings. Most of Harbeed's photographs were too graphic to make the airwaves, but one (available at http://www.viiphoto.com/detailStory.php?news_id=586) was to become iconic and would win Harbeed two photojournalism awards. Huda is caught sobbing by the body of her fallen father and the agony seared on her face became an icon of Palestinian grief. It was not unlike the horrific image that had helped ignite the second Intifada

in 2000, Talal Abu Rahma's film of the terrified twelve-year-old Mohammad al-Dura in Gaza who died in cross-fire in his father's arms (McCarthy 2007).

Interviewed by *The Guardian* newspaper of London, Harbeed recalls that he had not wanted to get too close to the carnage, but then recognized that in the image of Huda, he could capture for posterity "some life coming out of this death" (ibid.), especially as it was believed that Huda was the sole survivor and would face a life on her own wondering why of all her family, only she had been spared. Huda's image, as emblem of the lone phoenix to rise from the ashes, was also a rare opportunity, Harbeed thought, to unify Palestinian resilience and resolve. Huda's photograph made her an instant celebrity, and she was photographed in individual sittings with Sheikh Al-Nahyan, Deputy Prime Minister of the UAE, Palestinian President Abbas of Fatah, and Prime Minister Ismail Haniyeh of Hamas (ibid.).

However, the response to Huda's image as a symbol of Palestinian unity and resolve never lived up to its hoped-for potential for two reasons. First, the photograph hid details that made its symbolism less dramatic. Early reports that Huda had lost all her family members proved false. She was not an orphan and had a number of surviving family members in Gaza with whom she could continue her life there. Second, President Abbas refused to take full advantage of the image. He was aware that the photograph held public relations potential for Hamas, Islamic Jihad, and his own Fatah, and that it offered a rare opportunity to unify the Palestinian factions. However, he did not rise to the occasion and, as a result, disappointed many Palestinian leaders who hoped the photograph would help the divided Palestinian factions close ranks. Some Palestinian leaders implored the UN Security Council to convene, condemn and investigate the massacre through an international investigation commission like that formed for Darfur (ibid.). President Abbas condemned the incident and called for an investigation, but he did not push for formal emergency measures, disappointing many.

Among the ranks of the disappointed was *Al Quds* editor-in-chief Abdel-Beri Atwan. In an *Al Quds* brief from June 12, 2006, Atwan noted that the Israeli forces "have committed yet another massacre in the Gaza Strip last Friday, one that has claimed the lives of an entire

family, including children in their first months of age." "Young Huda," he writes, echoing the inaccuracy of the early reporting, "was the only survivor." He notes with contempt that Huda's death "moved the rocks at the beach," but "failed to move" the hard hearts of Arab leaders. Three days after Atwan's brief appeared, and after it had emerged that Huda had many surviving family members, an *Al Hayat* brief of June 15 reports that Sheikh Hamdan Bin Zayed Al-Nahyan, the deputy prime minister of the United Arab Emirates, had phoned Mahmud Abbas and expressed his desire to help Huda's family financially.

The Guardian's investigation (McCarthy 2007) found that the attention showered on Huda became a mixed blessing for the Ghalia family, and for a time caused much tension and strain. Huda's injuries were less serious than those of other family members and some of them, surviving grave wounds with grace, had arguably more reason than Huda to be celebrated. Her younger brother, Adham, aged ten, who suffered shrapnel wounds to his stomach and mouth, and was eventually transferred to the US for treatment, would have been a worthy icon. So too would Huda's two older sisters, Amani and Ayhaam, who were the most seriously injured, and one of Huda's uncles, thirty-three-year-old Hassan, the younger brother of Ali, her dead father. Huda may have become an archetypal icon of suffering for Palestine, but she was arguably not the best icon of suffering even within her own family. The designation of icon went only to Huda because of a photographer's lucky timing and on-the-spot artistic judgment. Only Huda received an international outpouring of concern and good wishes, and when she traveled with her family, only Huda would receive VIP treatment. The initial headlines sainted Huda as an orphan now needing to go it alone. The surviving members of her family were erased from the story as long as possible to feed a publicity machine that required the truth to remain hidden.

These family tensions turned out to be short-lived because various Arab organizations ultimately stepped up with funds for the whole family. Hamas agreed to pay for the children's education. A Qatar charity paid for adaptations to the family home to make it handicapped accessible and to the house of the eldest daughter, Amani, mother of two, who had lost most of her left arm in the attacks. President Abbas

provided another £1,000 for medical expenses and the UAE offered money to help with further home renovations.

Under the radar, one of the family's greatest benefactors was the Israeli medical establishment and, in particular, the Assaf Harofeh Medical Center near Ramla. There, Israeli doctors and medical teams worked tirelessly to make meaningful lives possible for the worse injured of the Ghalia family: Amani, Uncle Hassan and especially Ayhaam. Hassan comments that he found the Israeli medical team, staff, and patients in the hospital "welcoming." Israeli patients who shared the facilities at Assaf Harofeh with the Ghalia injured extended emotional support to all the surviving Ghalia family members in their long recovery (ibid.). Huda the iconic gradually morphed into Huda the ironic. The visual symbol of Palestinian suffering in Gaza suffered *least* of all her surviving family members. In the iconic image, Israeli war technology is the villain, but in the reality on the ground, Israeli medical technology was a hero. Those who suffered most in Huda's family, outside the headlines, and in dire need of excellent medical care, received it from advances in Israeli medicine, the merciful face of Israeli technology. Huda's case illustrates the tensions between the media's need for simple icons and image bites to push sales, and the ironies and deeper reflection that unleash the contradictions that complicate the indelibility of the frozen images.

Huda's story is well and good, but what is the counter-story about Arab women that emerges from it? Images are enthralling because they present us with big ideas. We started this book by noting that the media bombard us with images and one of the images circulating in the West for centuries has been that of the Arab woman. Once we seek to study her, we tend to freeze her image, much as the media sought to freeze Huda's sadness. Freezing helps the idea sit still for us and offers the tantalizing possibility that we can understand the Arab woman by cutting out all the non-essential background. In order to understand her, we pretend we can set aside everything non-Arab and everything non-female and that her essence will then reveal itself. Our coding study in Part I was based partly on the hope that, if we could throw the right categories at her discrete appearances in Arab news, the categories that stuck would help us construct a more accurate image than that arrived at by Western social science studies of pre-Internet Western media.

Our coding study did find an image of Arab women in Arab news more balanced than the image uncovered in pre-Internet Western news, but in the final analysis our coding study was still the replacement of one frozen image (a passive Arab woman) by another (an active and passive Arab woman). We did not leave stereotypes behind, but rather found evidence for a fairer stereotype. Stories and counter-stories and the theoretical frameworks that support their telling – the focus of Part II – provide a deeper set of analytical tools for puncturing stereotypes and arriving at the more complex truth. Truth and understanding in general come from puncturing the façade of big ideas and reflecting on what we learn when the façade crumbles. But, as we found with Huda, the more honest learning produced by this analytical story-telling is often a random mixture of modest detail that ruins the big theory we had wanted the image to confirm; the analytical story-telling resists replacing the fallen big image with another big image. Huda's symbolism as the face of Palestinian suffering is a big idea. The story of her making routine trips to a welcoming Israeli hospital to watch her relatives convalesce is the small uncomfortable detail that robs the big idea of its energy – and truth. It replaces the big idea only with much smaller truths about the contradictions of the human condition.

And the same disappointments arising from big-idea thinking are true for studying the Arab woman in general. If we pursue her as one big idea, we shall never find her. We can find her only in thousands of glimpses, and only in the stories and counter-stories she tells and that are told about her. The glimpses, in turn, necessarily implicate her with non-Arabs and non-women, and with Arabs and women in a global context. Despite the temptations to think otherwise, we can never find her by demarcating her as a category apart. The advances of social science methodologies have enabled the construction of more rigorously derived and fairer images, and the more compelling the images we build, the more we learn when they puncture under the pressure of analytical story-telling. We shall find the Arab woman, as we found Huda, by puncturing one dominant stereotype of her after another and learning each time we discover she is more than each stereotype had pegged her to be.

The Feigned "Sadness" of the Mother of a Slain Martyr

Ten days after the *Al Hayat* brief reporting on aid to Huda's family, on June 25, 2006, Gilad Shalit, a nineteen-year-old member of an Israeli tank crew, was captured close to the border on the Israeli side and taken into Gaza. A small band of Palestinians had burrowed an underground tunnel stretching one-third of a mile from Gaza across the Israeli border. The Palestinians passed by barriers, evaded lookout posts and watchtowers, and cut their way through razor wire in order to carry out the kidnapping. Equipped with grenades, automatic rifles, and anti-tank missiles, they killed two Israeli soldiers, incapacitated four more, and incurred two fatalities of their own – two young Army of Islam recruits, Hamed Rantisi and Mohammed Farwana. The Army of Islam, the Popular Resistance Committees (PRC), and the Al-Qassam Brigades, the military arm of Hamas, all took credit for the kidnapping. Shalit's bloody uniform was left behind, which convinced Israeli intelligence he had been injured – how badly they did not know. A surveillance camera caught grainy images of Shalit wrapped in a blanket and lifted through an opening cut in the fence dividing Gaza from Israel.

Israel's retaliation for the Shalit kidnapping was swift and merciless. The Israeli military launched sortie after sortie on Gaza without letup. Within months of Shalit's abduction, over 1,000 Gazans were dead. At the time we write this in April, 2011, Israel still seeks Shalit's release, and Palestinian leaders still use him in bargaining for the freedom of hundreds of imprisoned Palestinians. In 2008, there were an estimated 9,000 Palestinians in prison in Israel, including about seventy women and more than 300 children, with half of the children imprisoned for throwing stones (Toomey 2008).

Christine Toomey, an investigative reporter for the *The Times* (London), went to Gaza on the second anniversary of Shalit's capture to learn more about his whereabouts, his treatment, and the circumstances in which prisoner releases were negotiated between Israelis and Palestinians. Far from the staid and formal world of international diplomacy, Toomey discovered that negotiations for prisoner exchange between Israel and Palestine are conducted in a dark, seedy, and dangerous netherworld whose primary victims are the prisoners' families. The

hopes of these families are raised and dashed on a daily basis and manip-
ulated by remote interests they can barely understand.

The families of the dead are left only with their grief. Toomey
tracked down the mothers of the two Palestinian gunmen who lost
their lives in the abduction of Shalit, and she found a night and day
difference in their response to their loss. Mariam Rantisi, mother of
Hamed, was proud of her son's martyrdom and bitter that Shalit was
still alive. "If I had my way," she says, "I would kill Shalit." Mariam
states proudly, "We are a family of fighters. I hope all my sons become
martyrs to liberate Palestine." Ahlam Farwana, mother of Mohammed,
brought an entirely different tone to her interview with Toomey. She
reports being saddened and shocked beyond words to discover that her
son was involved in such activities. She had no knowledge of his
involvement until his death and insists that, had she known, she would
have tried to stop him. She knew Mohammed only as her calm and
good son. It came as a complete and disappointing shock to her, she
remarks, to discover his secret life, and discovering it posthumously
intensified the pain, adding deception to loss. When men from the
Army of Islam knocked on her door to let her know her son was a
martyr, Ahlam says, she cursed them for wasting her son's life and told
them they should never darken her door again.

Was Ahlam a credible source? Toomey came to think not. When
Toomey came to interview Ahlam in her home, she spotted a Taliban-
looking man standing on one of Ahlam's balconies, apparently keeping
watch. When the man abruptly picked up his cell phone to make a call,
Toomey's driver told her they should make a quick exit. When in the
car, the driver told her that the man's long hair, beard, and clothing
indicated he was a member of the Army of Islam, the very organization
Ahlam claimed to have rejected. Toomey notes she immediately
dismissed Ahlam as a reliable witness, and she was right to do so.

For a very different Ahlam appears in an *Al Quds* brief of June 22,
2006, which summarizes an Arabic report on the festive mood of
Gazans over the Shalit kidnapping. They are reported in the brief as
being fearful of Israeli reprisals, which they knew were sure to come,
and did. But for the immediate moment, the mood was joyous. In the
Al Quds brief, Ahlam is reported as passing out candy in front of her
home to celebrate the abduction of Shalit and the martyrdom of her

son, and she was using Huda Ghalia as a symbol of Palestinian grief and oppression. Ahlam wailed that little Huda's cries of sadness reached out across the world, and many heard and responded to those cries, including her beloved son Mohammed, who gave his life to relieve her pain.

In this Gazan community, to be the mother of a martyr is an honor almost as high as the honor of the martyr himself. Ahlam was the woman of honor at the celebration. Mohammed was the man of the moment and Ahlam gave birth to Mohammad. For Ahlam, the occasion was a spiritual wedding and she was the mother of the groom. She toasted the groom with these words:

> Today, I celebrate the marriage of my son with the most precious thing in life, Allah. People should come and congratulate me on the martyrdom of my son Mohammad. I offered what is dearest to my heart and God. I am completely satisfied and honest in what I am saying.

Ahlam knew Mohammad had committed his life to this moment of destiny. She recalls once asking him if she could find a bride for him, but he declined and asked Ahlam for her forgiveness, which she apparently gave. Both accepted the fact that Mohammad's life would not be ordinary.

Ahlam feigned her sadness to mislead a Western journalist. She knew how to respond to her son's death as she thought a Westerner would expect her to respond. In actuality, she greeted her son's death with pride more than horror. However, we would not want to claim that Ahlam's celebratory response to her son's death was free of sadness. There is sadness in honor even as there is sadness in grief, but sadness in honor does not seek pity while sadness in grief does. The only Arab woman that was supposed to be pitied at this celebration was little Huda, the icon of Palestinian sadness. Ahlam, as it turned out, was willing to brave the loss of a son to avenge a Palestinian icon of loss. One wonders how this celebration and the chain of events leading up to it would have been altered had that photographer not captured Huda's image and had the facts about the Ghalia family been reported accurately from the start.

Coming to Terms with the Loss of Land and Property in Gaza

Sadness and hopelessness may result from the loss of property through war, as well as from the loss of loved ones. When people are dispossessed of their land and have no confirmation of what has happened to it, the initial phase of denial in Kubler-Ross's model of loss is likely to extend for an excruciating length of time. When people cannot see their loss, they are likely to deny the experience of loss. Only when they are allowed back onto their property and have to confront the visual reality of cherished possessions eviscerated is denial likely to transition into later phases (anger, negotiation, depression and acceptance). An *Al Quds* brief from August 8, 2006 devotes itself to this transitioning stage of loss after Israeli troops withdrew from Gaza and Gazans were able for the first time to see what had become of their land and belongings. Gazans who had fled the village of Al-Shawka and sheltered in public facilities returned to witness first-hand what had happened.

The brief mentions that Gazans were "shocked by the size of the devastation in their homes and agricultural lands," spread over hundreds of acres. Abu Khaled, an Al-Shawka farmer, was found sitting on top of his olive trees, which had been crushed by Israeli bulldozers. The olives were to have been his income for the next month. Israeli armored vehicles had destroyed the farm's irrigation system and water well. The female angle surfaces when Abu Khaled points out his neighbor Karina, in her fifties, out scavenging for food among the debris and ruins. During the incursion, Karina and her family sought refuge at a school in a nearby village. During her stay there, she had wept uncontrollably and spared whatever energy she could muster between her crying to curse Arab leaders for allowing this to happen. She feared for her home, which she had come to cherish "as her own child," and in which she, her husband, and her adult sons had invested their lives. When the Israelis withdrew, she returned to the plot where her home once stood and stared at her worst nightmare. Through tears, she offered confident assurance to no one in particular that her family would rebuild the house and hold on to the land.

It is difficult in our view to draw out a counter-story with a female angle that departs significantly from the narration of the original story.

The woman shows sadness, and resolve to rebuild her home and, presumably, had her husband or sons caught the reporter's attention that day, they would have shown a similar sadness and resolve. There is a definite human angle of pathos to the story but not, on the face of it, a suppressed female angle that has been denied full expression.

Female Sadness in Iraq

Violence in Anbar Creates "Sad Cultures" for Women

In chapter 14, we reviewed some of the literature from women's studies that documents the tendency to blame women for war. An *Al Hayat* brief of May 4, 2006 extends this theme further, into the realm of sadness. It reports on how war zones may create melancholic and subdued regions, emotionally depressed enough to tamp down even the happiest of occasions into subdued rituals.

The brief quotes twenty-five-year-old Leila who cannot recall one display of joy or celebration at her wedding except perhaps for the smile on her mother's face that she caught momentarily through her mother's tears. All the festive trappings of weddings across Anbar province have been "whittled down" to their bare bones and buried under an avalanche of death and violence. Marwan Al-Kubeisi, who lives in the village of Baghdadi near Haditha, explains that the absence of security and stability, and the high rate of deaths and detainees have simply created a "sad culture" throughout the region.

The brief also pulls in other voices who attest that the sadness is also enforced by religious extremists who use the chaos of war to ban all the traditions that the populace once used to mark joy and celebration: traditional folk dances, songs, and chants. Some report that girls are quitting school not only because of the collapse of security but also because of the resurrection of ancient tribal customs that see an educated woman as threatening the natural and social order. As we have seen in previous chapters, a woman's close male relatives, particularly her father, may have a huge say in how she views and values education. A girl identified only as Khansaa, aged fifteen, tells how her father was gunned down by American troops. He had championed Khansaa's education, but without her father's authority and guidance

to count on, Khansaa was forced to marry a religious cleric in Fallujah old enough to be her grandfather. The loss of her father was the loss of her future.

This brief, or at least our presentation of it to spotlight the female angle, reveals both the importance of male networks to the female and the fragility of her own networks, particularly when she relies exclusively on kin. An advantage of education is that it provides females with networks of adult mentors that can expand on and at times stand in for the adult networks in the family. The challenge is that this advantage does not become active until girls are well into education – and the right kind of education. Poor schools with unqualified teachers offer few opportunities for expanding networks. At the age of fifteen, Khansaa had not built up the traction outside the home to enable her to save herself after her father's death.

Searching for a Husband's Remains

As Khansaa found out the hard way, war whittles down a woman's male networks. In chapter 16, we saw the harrowing effects of sectarian violence in Iraq and its contribution to women's fear. An *Asharq Al Awsat* brief from April 5, 2006 explores the effects of such violence on women's sadness. The brief places us at Bab al-Mozam near the Ministry of Health in Baghdad and describes a queue of dozens of persons in front of the gate who had come to inquire about their loved ones at the forensic medicine department. The department houses the official morgue, run by the Iraqi Ministry of Health. Hundreds of corpses may arrive here every day but no official figures are published.[4] The dead arrive so fast that the morgue refuses to accept corpses if they come without tags verifying that death occurred in an Iraqi hospital. In other words, the morgue will not accept bodies found in gutters, sewers, rivers, bridges, canals, or dustbins. The number of dead dying outside hospitals is so much larger than those dying within them that a guard warns the gathering crowd that they should wait only if they have first searched the streets for their loved ones and are sure they are not there.

Awatef Hassan, a thirty-seven-year-old mother of three from an upper-class neighborhood of Baghdad, was also in the queue. Her

husband had been kidnapped more than two weeks before. She had learned from eyewitnesses that he had been on his way to pick up his car from the mechanic when two cars pulled up. Seven armed men jumped out and forced him into one of the cars. The day after the kidnapping, the kidnappers asked for a ransom of $250,000. She negotiated it down to $80,000 and the kidnappers agreed. She dropped the money off for them, but her husband was never returned and she was sure she was now the victim of two losses – her husband and her savings. She had looked for him in alleyways and trash bins, but had not found him. Now she was waiting in line for her last chance to claim all that was left for her – his remains.

Female Sadness in Saudi Arabia

Factors Intensifying a Mother's Sadness When Her Son Dies

We met this unnamed Saudi mother in chapter 7 when we discussed the special insistence of a Saudi mother who had pleaded with her son, Khaled, to return home from the battlefront in Iraq (page 124). Khaled had deceived his parents and joined the Jihad in Iraq without their knowledge or permission. In chapter 7, we contrasted Khaled mother's behavior with the behavior of his father, Abdul-Rahman Al-Khalidi. Khaled's mother, we may recall, never stopped speaking to Khaled long after his father had given up on him. Khaled's father, however, never stopped speaking about Khaled on behalf of the family after Khaled was killed, while his mother is now too devastated to ever mention her dead son in public.

Now we contrast Khaled's mother and father again, but this time in the way they expressed their sadness in the wake of Khaled's death. The father grieved because Khaled went to Iraq to fight without parental permission perhaps even more than he grieved over his son's death. As the brief puts it, "Al-Khalidi expressed his sorrow that his son went to Iraq without his parents' permission." To a Western reader, Khaled's father may seem grossly insensitive to grieve the loss of his authority more than the loss of his son's life. However, the brief notes that there is compelling religious doctrine behind Khaled's thinking. The brief quotes a religious authority, the Chief Judge of the

Dawmat-Al-Jandal court, and Imam and spokesman of the Al-Dreiwish mosque, one Sheikh Issa Bin Ibrahime Al-Dreiwish, as saying that even Jihad must await the proper conditions and if these conditions are not satisfied, Muslims must be willing to wait before acting. One of these sacred conditions, the Sheikh noted, is that it is permitted for young men to fight only if they have gained the full consent of the Imam and then the parents or guardians. "If the Imam agrees then comes the permission of the parents."

The Sheikh pointed out that it was his practice always to inform young men hungry for battle of their sacred obligations to obtain the permission of their parents. If the parents did not grant it, according to the Sheikh, the young man should remain at home. In this light, the father's sorrow over his son's defiance may seem more sympathetic. The son had the religious obligation not to go to war and he defied his obligations. Now he is dead. Why grieve over his death when one can praise the religion that would have saved him and lay the blame only on the human failing that he disobeyed his religion?

The mother was enduring an entirely different experience of sadness. The father described the mother as "passing through a terrible emotional state" as she felt "extremely pained and sad at the death of our eldest son." The father suggested that the mother's sadness over her son's death was harder for her to cope with than his sadness over the son's disobedience. His sadness focused on the loss of his authority. Her sadness focused on the death itself. Why were there these two different foci of sadness?

Research in the cognitive structure of emotions may hold some answers. In their book, *The Cognitive Structure of Emotions*, Ortony, Clore and Collins (1988) make the case that our emotions arise from cognitive appraisals – positive and negative judgments – of situations. Within situations, we can judge objects, agents, and events. We judge objects by their properties, agents by their actions, and events by their consequences. Appraisals of objects consist of judging some objects as evoking pleasure (e.g., roses) and others displeasure (e.g., rats). Appraisals of agents correspond to judging actions they take and assume responsibility for that give pleasure (e.g., Sue paid me a compliment) and displeasure (e.g., Tom criticized me). Appraisals of events correspond to judging events that we approve of and would like to see

recur (e.g., catching your flight on time) and events we disapprove of and would like never to revisit (e.g., missing your flight).

Emotions may strengthen or diminish in intensity on the basis of the perceived forcefulness or mildness by which assessments are made. The emotion of disappointment arises because we build high hopes for the future that are dashed, but disappointment may occur in varying degrees of intensity depending on how high our hopes were, the effort we had expended to achieve them, our perceived probability of achieving them, and so on. If we pay for lottery tickets and do not win the lottery, we should not be too disappointed so long as we recognize how low the odds were. If we expect to be first in the cafeteria line for lunch by coming at noon sharp and find we are second in line, we should not be very disappointed because the loss incurred by being second in line rather than first is very small. By contrast, if we have spent four years preparing to compete for a Rhodes Scholarship and only make runner-up, we might be crushed by disappointment as a result of working so hard for so long and coming so close with nothing to show for it.

Within the Ortony, Clore, and Collins framework, sadness arises as a feeling of distress in reaction to an object. The death of a child is distressing and sad. Khaled's mother is described as making this assessment of the situation. But Khaled's father is described as making a different assessment of the death of his son: he says he is sorrowful over his son's disobedience. This means that Abdul-Rahman Al-Khalidi appraises his son Khaled as an agent taking actions, bearing responsibilities, and reaping consequences of which he disapproves. As an agent, Khaled left for Iraq and fought against his parent's will and his defiance has reaped consequences – his death – that affect the parents negatively. According to the predictions of the Ortony, Clore and Collins framework, Al-Khalidi would feel justified in responding to his son's death with anger and blame for Khaled's lack of respect. The fact that the Imam agreed that Khaled had acted contrary to his religion by failing to gain parental consent can only intensify Al-Khalidi's anger. Had consent of the parents not been a condition of Jihad, both Khaled's father and his mother might have taken some measure of pride for being the parents of a martyr, like proud Ahlam, whom we met above, who derived both pride and honor as the mother of a hero, and passed out sweets from her doorstep in celebration of her martyred son.

Khaled's father, were he able to feel the pride of Ahlam, might find his anger partly dissipated. Khaled's mother, knowing she could be hailed as the mother of a martyr and a community saint, might find her sadness less heavy. However, as the brief makes clear, Khaled acted against religious Jihad and violated its authority. His parents could take no consolation in his martyrdom even if they wanted to. The emotional cushion available to Ahlam was not available to Khaled's parents.

Khaled's mother as a consequence was deprived of one potential opportunity to bring some relief to her sadness. She lost another opportunity to relieve her sadness because she had worked so relentlessly on the phone to persuade her son to come home. Like the runner-up for the Rhodes Scholarship, whose disappointment increases with the effort expended, Khaled's mother had never abandoned hope that Khaled would stop defying his parents and his religion and come home. She worked persistently to keep faith in him as a good son capable of obedience and respect. Acting as the good son would have kept him alive and that was her goal. Unlike the father who stopped talking to his son when he began holding him responsible for disobedience, the mother refused to let blame stand in the way of family unity. She sought to persuade Khaled to act positively for the sake of his future. The fact that, after so much repeated effort, she could not persuade him, and that he could not stop acting as he did, and could not stay alive, would, within the Ortony, Clore and Collins framework explain the heightening of her hurt, disappointment, and sadness at his death.

Female Sadness in Egypt

The Aggrieved Mother of a Political Detainee

On April 19, 2006, the State Security Investigations (SSI), Egypt's domestic intelligence agency, announced the arrest of twenty-two suspected members of an extremist group allegedly plotting to bomb civilian targets around Cairo. The extremist group called themselves al-Taifa al-Mansura or "The Victorious Sect." The SSI reported that those arrested had confessed to terrorist plotting and that Egypt could

breathe a sigh of relief that its anti-terrorist forces were on the alert on behalf of Egypt's civilian population.

However, all was not as it seemed. The arrests were carried out in suspicious circumstances. A Human Rights Watch investigation released eighteen months later discovered that the suspects were arrested not in April 2006 but much earlier, in February and March. Further, their "confessions" had been extracted by use of torture, including beating with sticks, electric shocks to the genitals, round-the-clock blindfolding, and suspending suspects from the top of an open door while handcuffed. The Human Rights Watch investigation concluded that the twenty-two suspects may have committed no "crimes" other than sporting long beards and religious garb and that the very name "Victorious Sect," may well have been an invention of the SSI. Those interviewed in the report suggested that the SSI's motives for the arrests were to mobilize public support for the continuation of the Emergency Law and to promote the SSI's own vital importance to Egyptian security (Sifton 2007, 59).

Long before the Human Rights Watch investigation became public, the Egyptian judiciary suspected something was afoot in the prosecutions of the defendants. The courts refused to pursue prosecutions, despite the confessions, and, by September 2006, a team of judges had ordered all the defendants to be released. Defiant, the SSI suppressed the release order and, citing Egypt's Emergency Law, obtained new detention orders for the defendants.

An *Al Hayat* brief of April 21, 2006 covered the story just as it was breaking, at the time the arrests were first announced, and without knowledge of the human rights irregularities that were later to surface. The *Al Hayat* brief takes a human interest angle, focusing on the families of those arrested as they appeared before the district attorney to learn about the fate of their loved ones. The families claimed that they had only learned of the charges through the media.

The mother of one of the detainees was found and interviewed. The unidentified *Al Hayat* reporter had not been seeking her out, but had met her when he went to the home of one of the detainees in the case, twenty-seven-year-old Mohammad Ahmad Saiid, the owner of a printing press. The reporter found there "a small apartment with the door closed and the lights off." The reporter knocked on the door several

times and for a while no one answered. Finally the door opened and
the reporter came face to face with an old woman holding a walking
stick, clutching a photograph of her son and "crying intensely." She
told the reporter that she had been a widow for ten years. Mohammad
was her only son and she had been living alone since his arrest three
months earlier. Mohammad's late father's sole wish in life was to live
long enough to see Mohammad fulfill his dreams. The father had run
a small shop where he sold drinks and Mohammad had taken it over
upon his death. Everything had been fine, according to Mohammad's
mother, until the day a group of "bearded men came and sat with him
in the shop." The woman said the bearded men persuaded Mohammad
to dress in Islamic robes and let his beard grow. They also persuaded
him to change his business into a printing shop with a printing press.
Buried in the brief is that the mother may have inadvertently helped
the courts and later Human Rights Watch break the case. She testified
that her son had been detained for three months, dating his arrest back
to January 2006 and contradicting the official account of the Egyptian
SSI. Although she did not realize it at the time, Mohammad's mother
may have been guaranteeing justice for her son by agreeing to share
her sadness with a reporter, and providing the first scrap of evidence
that the SSI account was not true.

We could not find what had happened to Mohammad Ahmad Saiid.
Did he remain in detention or was he released? Did the fall of the
Mubarak government change his status? We certainly hope so. The
strongest counter-angle of the story is parental more than maternal. It
indicates how dictatorships can capriciously rob mothers (and fathers)
of their brightest hope – the future of their children. The Mubarak
government was busy arresting young men because Egypt had been
experiencing the demographic peaking of its youth. Modern Egypt has
never been younger than it is today: 28% of the population are aged
between fifteen and twenty-nine (*The Washington Post* 2011). This
youth bulge is not restricted to Egypt but permeates Arab territories
where the bulge between fifteen and twenty-nine is "the largest youth
cohort in the Middle East's modern history (Dhillon and Yousef 2009,
1). This is the age group that is crystallizing its dreams for the future,
seeking education and work experience to make that future come true,
and finding its dreams shattered by a sluggish economy, high

unemployment, corruption, political stagnation, police-state security crackdowns, and a rising cost of living. The Arab Spring in Egypt and other Arab lands is first and foremost a youth movement (Wright 2011), and parents and grandparents of the youth bulge who created the Arab Spring in Egypt rejoiced with their children and for their children's future to see a dictator topple. But one dictator's fall is just that. Like Mohammad's mother, Egypt's parents are still waiting to see what will happen to their children.

"Sad" about Flunking her Final Exam Essay Criticizing Bush

Egypt's war on terror created a human rights record so deeply troubled that it made the checkered "war on terror" record of the George W. Bush administration seem by comparison a model of civic virtue. At the end of the school year in Cairo in June 2006, Egypt's *Al Wafd* newspaper, one of Egypt's opposition reformist newspapers, reported that a thirteen-year-old female student from the Sharbin secondary school, Ala' Faraj Mujahed, was being failed on her end-of-term Arabic-language test because her essay had attacked the policies of the Bush administration (see Walls 2006). Worse, the Undersecretary of the Ministry of Education at al-Daqahliyya ruled that Ala' was not only being failed in her Arab language test that year but would be banned from taking the exam the following year. The Undersecretary accused Ala' of working with foreign interests against Egyptian security. For her insubordination and other alleged violations, Ala' was put through three separate security interrogations.

The story created a hue and cry across the Middle East. Khaled Salam, editor of the Muslim Brotherhood's official English website based in London, wrote that the Egyptian Ministry of Education had blown Ala''s essay out of proportion. According to Salam, Bush himself would have seen Ala''s essay as a fair expression of free speech. And Salam knew what he was talking about. He knew that Bush has already reacted to thousands of Ala's with diplomacy and not punishment. He knew that New Jersey high school students had organized a "mock trial for George W. Bush for committing war crimes." And he knew that the students were never punished and George Bush

never blinked. Bush had learned to control his dissenters by swatting them away like flies. To control hecklers in his audience, Bush's tactic was to look toward the hecklers, toss them a salute of respect, and simply announce triumphantly to the general audience that this was "free speech in action." The audience would then give Bush a rousing ovation of affection that drowned out the hecklers. Ala''s essay, Salam claimed, was a responsible expression of a subjective viewpoint. Furthermore, it was no more a threat to Egyptian national security than a pesky heckler at a Bush speech. Salam urged President Bush to send a letter of solidarity to Ala' and let her know that America stood by her (Salam 2006).

In its early fumbling efforts at damage control, the People's Assembly gave a vote of confidence to the Minister of Education in al-Daqahli-yya who had authorized the decision to fail Ala' and the additional punishments. International criticism of the Egyptian ministry swept in so ferociously and from so many corners of the world that the People's Assembly shifted course. The Assembly knew it had inherited a problem that was spiraling out of control, and contemplated rescind-ing its vote of confidence and ousting the minister. An *Al Quds Al Arabi* brief of June 28, 2006 reports on these unfolding developments. A wide consensus was emerging that the Minister of Education had exceeded his authority.

In her first statement since the matter became public, Ala' commented that she was "very sad" because she had hoped that the minister would offer her justice and that so far had not happened. The daughter of a humble cotton gin worker who denied any special inter-est in politics, Ala' added that, in retrospect, she had come to regret what she had written. She said she had never imagined her essay would make her a security threat.

Muslim Brotherhood members of the People's Assembly demanded that Ala''s essay be re-evaluated. The Muslim Brotherhood in Egypt, however, is not the Muslim Brotherhood in London. Khaled Salam, a London-based member, knew the West well enough to know that George W. Bush would have sided with Ala' against the Egyptian ministry. The Muslim Brotherhood in Egypt underestimated Bush and cast him as a partner in crime with the Mubarak government. Hamdi Hassan, a Brotherhood spokesperson, stated that what

happened to Ala' "was shameful, whereby a child was being pursued to please Bush."

Might there be a deeper female angle to this story? Would the story have had just as strong an impact had Ala' been a boy? It is impossible to say with certainty and defending counterfactuals in history is always a risky enterprise. Nonetheless, there is some reason to believe that the fact that Ala' was a girl was instrumental in igniting the controversy. Of all the demographics used to symbolize his war on terror in Afghanistan and Iraq, George W. Bush had made the plight of Muslim girls and women his rallying icon for the war, the symbol of a rescue that was worthy of the payment of American treasure and American lives. Just days after the 9/11 attacks, George and Laura Bush exploited media images of oppressed Afghan girls as part of the Bush Administration's justification for bombing Afghanistan (Hesford 2005). And in a risible act of cultural tone-deafness, in 2005, Bush sent his Communications Director, Karen Hughes, to Saudi Arabia to assure Saudi women that soon they would be permitted to drive. The Saudi women challenged Hughes and told her they were actually very happy as they were (Kaplan 2005). Despite the Bush Administration's blindspots in prosecuting the war on terror, the Bush Administration had no better ally than Hosni Mubarak. In his last days in power, when world opinion had withdrawn support from the Egyptian President, Dick Cheney, Bush's Vice President and the architect of America's war on terror praised Mubarak as a "good friend" of the United States and its foreign policy (Savage 2011). The Mubarak government would have known that the Bush Administration had made Muslim women and girls their icons of the war effect; and that special iconic status had been assigned to little veiled girls in school, learning from books with smiles on their faces. An incident showcasing an Egyptian schoolgirl displaying ungratefulness to Bush could be seen as a flagrant slap-in-the-face to Bush's sacred emblem of the "Muslim schoolgirl" with potential to damage Egyptian-US relations. Had the incident involved a boy, it may have been met with the same overreaction by Egyptian officials, but the clash of geopolitical symbols would not have been as pointed or stark.

Female Sadness in Lebanon

Reliving 1982 in 2006: One Grandmother's Sad Nostalgia

According to casualty statistics, the 1982 Israeli invasion of Lebanon was estimated to have cost the lives of almost 18,000 Lebanese and wounded 30,000 (Collelo 1987), to say nothing of the thousands of Lebanese families who fled for their lives. Understandably, the Lebanese who survived that war never wanted to imagine revisiting that scale of social upheaval in their lifetimes. They would tell their children and grandchildren born after 1982, and more broadly after the Lebanese war between 1975–1990, what they had endured, hoping it would never be relived. The summer of 2006 dashed that hope and gave those who could remember 1982 a painful reacquaintance with the Lebanon they had known twenty-four years before. Those who were children in 1982 were now parents and they found themselves taking the same frantic actions with their children they remembered their parents taking with them. A July 26, 2006 brief from *Asharq Al Awsat*'s reporter Caroline Akoum captures this angle of the war from the Lebanese perspective. She notes that for many fathers fleeing with children on their backs, history is repeating itself. They can remember as if it were yesterday their fathers carrying them in flight on their backs. The brief, appearing just days into the 2006 conflict, finds Lebanese families, even on the run, keeping their radios tuned from dawn to midnight to listen for news of a cease-fire. News is hard to come by, though, because of Israel's bombing of television antennas and power outages. It was just like 1982. The children who are displaced now experience the reality of what they had only heard in the stories told them on the laps of their parents and grandparents. Like 1982, they cheer when they hear about Lebanese missiles firing into Israel. But this happiness is short-lived compared to the "grief and anger" they suffer because of the disruption to their lives. Fourteen-year-old Alaa Hashem was awaiting the results of his primary school exams when his family went on the run. Now he did not know which should command his attention – his studies or the security situation that could cost his father his job and his family its economic safety net.

The female angle in the brief appears when it introduces a grand-mother who never thought she would have to relive "the stories of the last century" that she used to tell her grandchildren. She had wanted to bury these stories in the twentieth century. Now she realizes her grandchildren will be able to tell them firsthand to their grandchildren. Faded legends of the past, she ruefully understood, would become the reopened wounds of living memory for her grandchildren. The worst parts of the past were infecting the future.

Conclusion

An Arab woman infused with sadness recurs as a theme in our corpus with many variations. She is part of a psychological profile of female suicide bombers. She is an icon and ironic marker of Palestinian suffer-ing. She is the symbol of an undercover warrior whose grief masks vengeance against the West. Her tears forge special bonds with her children, husband, grandchildren, and property during times of war when these precious commodities are subject to loss. Her sadness symbolizes the political hardships she and her children face. She may even become sad when she finds herself at the center of a clash of symbols, as Ala' Faraj Mujahed found herself in when she did not behave like the Muslim schoolgirl that Bush had in mind when he funded Mubarak to fight the war on terror. In a nutshell, the sadness of Arab women in our corpus reflects symptoms, signs, barometers – in short, ways of feeling that invite a search for causes; but an Arab woman's sadness also reflects subterfuge and tactical weaponry, ways of feeling that invite a search for motives. In Arab news, Arab women use their sadness and are used by it for all these purposes.

Concluding Statement

THE JOURNEY FROM CODING TO CANVASSING
AND THE JOURNEY AHEAD

This book was presented in two parts with each raising different questions and yielding different answers. Part I asked whether depictions of Arab women in Arab news would be similar or different from those that have historically been studied by researchers into Western media. We wanted to know whether Arab women were represented less stereotypically and with more balance in Arab news. We found they were. To a large degree, we can credit technological advances for these findings. The English-speaking reader's access to foreign news via the Internet is leaps and bounds ahead of where it was during the pre-Internet era, when the Western studies that formed our external reference group were conducted. Before digital media services became mainstream outlets for international news, Arab women's voices in Western news remained exotic and mysterious, muzzled under captions and voice-overs. In Arab news now available to the English-speaking reader, the voices of Arab women are routinely available as sources that help construct the news that affects them.

Part II sought to find out what we would learn if we could canvass and take a concept-based census of the Arab women we had anonymously counted in Part I. What concepts did they exemplify, what brought them into the news, and what could we make of their status when compared with that of women in other regions? To answer these questions, we turned to grounded theory, statistical text-analysis, background research to understand why they had appeared in news, and the existing scholarship on gender and human rights, in order to

benchmark the lives of these Arab women against the lives of women who have been studied worldwide. In this part, we found that female achievement plays a special role in empowering women in Arab regions and around the globe. We found that the fears of women, threats against them, misogyny, and despair, especially but not exclusively in war zones, account for female disempowerment in Arab regions and elsewhere.

When considering the situation of women worldwide, the role of feminism remains controversial, but the idea of gender equality as a social value and aspiration for economic development is much less disputed. It is impossible to sustain the argument that one sex is less deserving of rights and opportunities than the other, although many may still try to do so. Even in Saudi Arabia, the bastion of social conservatism in the Arab world, women are learning how to use "equality" principles in Qur'anic teaching to disarm men and women who espouse gender inequality as a public good. Maureen Dowd, the feminist op-ed columnist of the *The New York Times*, interviewed a resourceful Saudi woman, identified only as Sarah, who defiantly did not cover her hair. Frequently remonstrated with by the religious police, she has learned to reply in a dignified, respectful and yet matter-of-fact manner to her male harassers: "You really shouldn't be looking in the first place . . . Islam argues that men should be keeping their gaze down." Says Sarah, "if you know how to do it properly," you can hold your own with anyone (Dowd 2010). Such active women who know their own minds represent a growing proportion of modern Arab women. They have some similarities with Western feminists, but blend assertiveness with respect for tradition and religion. They are open to modernity but with a deference to tradition and their cultural/religious heritage that makes them invest in a slow-developing modernity, which they seek to integrate steadily but judiciously into their lives. As Dowd observes, "it is feminism played in adagio."

By contrast, Arab women who are pulled under by a negative current in theaters of war, sites of social and ethnic conflict, and hotspots of political hegemony and economic instability, are, like women elsewhere in similar situations, a different story. They typically lack the emotional and financial resources, positive support systems, and access to quality education and meaningful employment that are necessary to

compete with men and make the argument for equality with men. In many cases, they need outside assistance in order to understand that the argument for equality is available for them to make, and is, indeed, their sacred human right.

We have seen that active and passive are not mutually exclusive cultural frames and that it is problematic to employ one extreme or the other of the active-passive spectrum as an uncritical and static label. Each frame comprises a surplus of variables that mix and match in the life of any individual, whether or not they are Arab or female. Nonetheless, we have discovered from our corpus and from outside research that women worldwide benefit from cultural stability, supportive networks, and self-determination with respect to their futures. These variables tilt the statistical balance in favor of experiencing life through active frames. Conditions of war and social instability, patriarchal networks, fear, threats, poverty, and ill-health tilt the odds toward experiencing life through passive frames, but, even then, active and passive intertwine in endless combinations in a woman's life. No autobiography of an accomplished Arab woman fails to record her many struggles; and few autobiographies of Arab women in desperate straits are completely empty on positive moments that offer glimmers of hope for a more productive life (Shaaban 1988/1991, 1995; Abu-Lughod 1993; Sasson 1993, 1994, 2000; Mernissi 1994, 2001; Golley 2003; Lewis 1996, 2004; Ahmed 1999; Mikhail 2004; Makdisi 2005; Dahmash-Jarrah 2005; Heath 2008).

We have also seen how an understanding of the emotions plays a vital role in supporting a woman's aspiration to equality. Women who seek to redress past injustice through anger/resistance toward the status quo build a strategic resource for identity and self-determination. Fear, by contrast, substitutes a woman's self-determined future with one imposed on her by external threats. Excessive sadness may deplete her capacity to plan ahead by making her exhaust her resources counting her losses rather than her assets. To combat these challenges, Arab women, along with women worldwide, require new leverage points in the form of economic and human resources to lift them up.

Micro-finance – the forging of local families and neighborhoods into capital-raising economic networks – has been touted as a broad solution for women globally. Kristof and WuDunn (2009) make it

their number one formula for helping women hold up "half the sky." Entrepreneurism, as organizations like the Arab International Women's Forum (AIWF) well understand, is a central component of human development. However, human development is more than entrepreneurism. Living a life fulfilling one's aspirations through achievement amounts to more than becoming an employer and meeting a payroll. It is certainly true that, for women to become more economically self-sufficient, they must understand finance and business as generations of women before them have not. However, no principle of gender development can succeed if it assumes that each gender must grow into self-sufficiency apart from the other. Gender development means each sex must be able to count on the other as a basic human resource for building societies together. During a recent roundtable address in Cairo on the subject of "Women in Democratic Transition: The Pathway to Democracy," UN Women Executive Director, Michelle Bachelet, reinforced this point when she insisted: "We will continue supporting women's organizations, but they have to work on identifying women's rights champions that are men" (UN Women 2011). From time immemorial, women have provided the key human resource for men's advancement. The question of the twenty-first century is whether men can, and will, rise to the occasion on behalf of women.

Katrin Bennhold, among others, thinks this role shift is both timely and necessary. Bennhold holds two degrees from the London School of Economics and writes for the *International Herald Tribune* and its parent newspaper, *The New York Times*. She is best known for her coverage of the challenges of integrating Muslim immigrants into the suburbs of France and won a fellowship from the American Institute for Contemporary German Studies at Johns Hopkins University to conduct research comparing Muslim immigration policies in Europe and America. Bennhold, an economist, has peered into the future of female development and discovered that a sorely overlooked factor is men. Men are nowhere to be found in most discussions of gender equality and they need to be recruited into the discussion (Bennhold 2010).

Men played roles in older forms of feminism but they were not helpful roles. Bennhold notes that feminism in her mother's

generation in the 1960s had consisted in women beating down the doors to gain entry into a man's world. Men on the whole were divided between two character types of that day, neither ideal. There were the anonymous males who were quietly resistant, if not outspoken and hostile, to women joining their world. There were also the zealous female-supportive males – the overprotective male guardians – who could be counted on to give their wives and daughters help and connections without thinking to give them independence. These were the two male character types Bennhold's mother inherited in the Germany of 1965 when she found herself the only female studying engineering in her college classes. Bennhold confronted the legacy of the first male character type starkly when she realized her engineering school had no female toilets. She confronted the second male type when a concerned professor told her she had better find a smart husband to help her pass the rigorous curriculum. Men either offered women no help or too much. Each male type reinforced in different ways the underlying presumption that women were incapable of succeeding in the world of men.

Bennhold now sees a revolution taking place in the twenty-first century, with a rising generation of men increasingly embracing the idea of living side-by-side with women as equals. Men are increasingly seeking friendship and colleagueship with women without domination. She proposes that this shift is taking place as a result of very long-range changes in the global economy. Boys are now failing in school at an alarmingly higher rate than girls. The worldwide economic crisis has rattled to the core any idea that there is a secure world of male employment for women to covet. The world that used to guarantee boys manufacturing and heavy industry jobs that girls did not compete for has gone for the foreseeable future. Now the majority of professional jobs worldwide require sitting still, hunkering over information, and having a long attention span, and, from first grade on, girls are markedly better than boys at these requirements (Pollack 1999; Kindlon & Thompson 2000). Major publications have recently run cover stories on "The Death of Macho" (Salam 2009) and "The End of Men" (Rosin 2010), both announcing that there is no longer a world of secure male employment for women to envy. In March, 2011, the number one best-selling book in America on gender studies was

Dan Abrams' *Man Down*, which cited hard research showing that women are better in the classroom, have superior hygiene, superior memories, are more risk averse and, overall, superior investors, take better care of patients and clients, vote more regularly, drive more responsibly, have sturdier immune systems, and live longer than men (Abrams 2011).

Yet, as men have lost a world of inequality they once relied on, women are still seeking to get a foothold in a world of equality they have known only in their imagination. The rising new generation of Arab women, symbolized by the women in Tahrir Square, are becoming impatient to see their dream realized. This multi-cultural, global Arab woman is well represented by Dalia Ziada, a female activist during the Arab spring, whom Robin Wright presents in the following words:

> The mix – the pink hejabis and the globalized Internet world – is what makes this generation one of the most dynamic forces in the current social and political upheavals. After pledging her commitment to Allah, Ziada described herself on her blog as "a mix of Shakespeare's Brutus with his internal conflict of choosing between satisfying the selfishness of the people he loves or protecting his beloved country against them, Dickens's Pip with his great expectations and unlimited ambition, and Austen's Elizabeth with her proven self-confidence and pride. (Wright 2011, 147–8)

The quest of ambitious globally-minded women like Ziada is fraught with risks, Bennhold cautions, because even though women now compete and even outpace men as never before in classrooms and some occupations, they are still playing catch-up. And, as they catch up, they are typically on the receiving end of a backlash. Less than a month after their victory in Tahrir Square, the women among the leaders of the democratic revolt in Egypt sought to celebrate their new freedoms on International Women's Day, March 8, 2011, in what was to be a Million Woman March. Only 300 women attended that afternoon – but that was not the biggest disappointment of the day. The women had begun their march in high spirits behind a column of supportive men supporting them. The escorts were soon outflanked and outnumbered by swarms of enraged men out to teach the upstart women a

lesson. Hecklers cried out that a woman could never be president in a democratic Egypt. They were met with loud shouts that women should have no role in writing a new constitution, and they were accused of hijacking the revolution by focusing it on women rather than democracy. And then the situation deteriorated further and they were subjected to physical harassment. The women were punched, pinched, kicked and groped until they fled. As the *Washington Post* reported, "Gone, organizers said, was the spirit of equality and cooperation between the sexes that marked most of the historic mass gatherings in the square" (Leiby 2011). Two weeks later, it was revealed that about nineteen of the young female protestors in Tahrir Square in post-Mubarak Egypt had been arrested, detained, poked with electronic prods if they dared speak, subjected to virginity tests carried out by men, and threatened with prosecution for prostitution (Kristof 2011). Days later, the military posted a Facebook message promising to investigate these allegations, but the message was later deleted (Gray 2011). Such backlashes explain why Arab women, like women everywhere, can sometimes feel they are receding even as they are advancing.

Women are bonded through the biology of reproduction, Bennhold notes, and these bonds have led to many female-only initiatives among working women, including women-only networks, workshops and even conferences on challenges facing women in the workplace. Bennhold concedes that these initiatives may be good for exchanging "tips and [boosting] morale," but by excluding men from the solution, Bennhold believes, women are not helping their cause. Their access to power typically requires the help of men, and by side-stepping men, she fears, women may be inadvertently force-fitting males into the old character types that kept women down. Bennhold quotes Avivah Wittenberg-Cox, chief executive of a gender management consultancy, who writes that, as women, "We've got to wake up . . . and start focusing on the guys." Bennhold agrees, and asserts that: "Basically, guys are the more effective feminists because other guys are more likely to listen to them" (Bennhold 2010).

But the development of women does not need just any guys. The "guys" must be men of accomplishment, learning, and influence over other men. Bennhold's own examples confirm this point to be true for Norway, the country ranking first on the World Economic Forum's

gender gap index. All women's gains in that country relied on finding champions in and forming coalitions with powerful networks of men. Male legislators were needed to pass quotas to require companies to reserve at least 40% of their boardroom seats for women. An effective male prime minister who was willing to champion paternity leave policies accounts for why Norwegian women have the option of returning to the workforce while their husbands tend to the children. Men developing themselves under the aegis of gender equality can be the best hope not only for women but for boys in search of strong male role models. As Bennhold concludes, "The last frontier of women's liberation may well be men's liberation."

In the meantime, women are progressing worldwide, but progress is not smooth or uniform. A recent article headed "The Burqa Revolution" (Foroohar 2010) reports that more women hold elected office than ever before. From 1995, the year of the Fourth World Conference on Women in Beijing, to 2009, the percentage of women holding parliamentary office rose from 11.3% to 18.8%.[1] Educational and employment levels for girls are also at unprecedented highs. In China, Foroohar reports, 20% of all entrepreneurs are women and 73% of Russian businesses employ at least one woman on their senior management team. On the other hand, women in conflict zones continue to suffer disproportionately. Nonetheless, as the 2011 Arab uprisings came to attest, blogs and micro blogs, cell phones, and social networking websites have given women unparalleled opportunities to air their views and organize as never before without risking their safety.

As Foroohar suggests, however, these gains are not coming about because the Beijing accords have succeeded, but rather because of women's frustration at the delay in their implementation. Girls are now enrolled in universities at a higher rate than men in both the developing and developed world (ibid., 45). In the next ten years, the majority of new earned income worldwide will be earned by women (ibid.). Young women, with this new clout, are less interested in waiting around for the previous generation to have prepared the way for them, and will seize what they can get when they can. They will not want to sacrifice the cultural importance of being women, but they will not see anything lady-like in waiting patiently for their turn only for the sake of complying with another generation's sense of decorum.

Western readers who subscribe to foreign news services can learn all this and much more. On balance, they will learn that the Arab woman has come a long way from age-old Western image bites, when her voice was silenced in favor of captions and voices speaking for her. They will learn that Arab women have independent and impatient voices with which they can chart their own lives. They will also learn that too many Arab women, like too many women worldwide, are still seen and not heard, even though their voices are worth listening to. The UN estimates that, even without special mandates to do so, females will reach political parity with males worldwide by the end of the twenty-first century (ibid.). Given the glimpse of Arab women afforded by our corpus, Arab women will not sit still waiting for that deadline. They have achieved too much, let us think and let us also hope, to be deterred by the challenges ahead.

Appendix 1: Final Coding Scheme [Part I]

Dimension 1: Power/Viewpoint

[*Power coding – Editorial viewpoint*]

Active-positive: The coded female is referenced in an active context; the writer/translator indicates a positive stance toward her active behavior.

Active-negative: The coded female is referenced in an active context; the writer/translator indicates a negative stance toward her active behavior.

Active-neutral: The coded female is referenced in an active context; the writer/translator offers no detectable commentary about her active behavior.

Passive-positive: The coded female is referenced in a passive context; the writer/translator indicates a positive stance toward her passive behavior.

Passive-negative: The coded female is referenced in a passive context; the writer/translator indicates a negative stance toward her passive behavior.

Passive-neutral: The coded female is referenced in a passive context; the writer/translator offers no detectable commentary on her passive behavior.

Negative-negative: The coded female is referenced in a negative context; the writer/translator indicates a negative stance toward her negative behavior.

Negative-neutral: The coded female is referenced in a negative context; the writer/translator offers no detectable commentary on her negative behavior.

Neutral-neutral: The coded female is referenced in a neutral context; the writer/translator offers no detectable commentary on her neutral behavior.

Non-Arab: The coded female is not Arab.

Dimension 2: Occupational Status

Child: The coded female is a young child.

Student: The coded female is referenced specifically as attending school, ranging from elementary levels to university.

Unemployed: The coded female is referenced as unemployed.

Employed: The coded female is referenced as employed, but with no detail about the nature of her employment.

Non-professional worker: The coded female is referenced as employed in a position that does not require educational qualifications.

Professional worker: The coded female is specifically referenced as employed in a position that requires educational qualifications.

Candidate for Office: The coded female is referenced as a candidate for elected office, but not a current office-holder.

Office-holder: The coded female is referenced as an office-holder either in government or in an organization.

Unclear: The translated article summary does not provide any information about the coded female's occupational status.

Non-Arab: The coded female is not Arab.

Dimension 3: Personal Status

Unmarried: The coded female is specifically referenced as unmarried.

Married: The coded female is specifically referenced as married.

Divorced: The coded female is specifically referenced as divorced.

Widowed: The coded female is specifically referenced as widowed.

Remarried: The coded female is specifically referenced as remarried.

Mother: The coded female is referenced as having children, with no mention of her marital status. If her marital status is mentioned, code the reference as married.

Unclear: The brief provides none of the above information.

Non-Arab: The coded female is not Arab.

Dimension 4: Social Status

Girl living at home: The coded female is referenced only as young, unmarried, and living with her family.

Student: The coded female is referenced specifically as attending school, ranging from elementary levels to university.

Wife/homemaker: The coded female is referenced only in the context of marriage or domestic practices.

Employed: The coded female is referenced as being employed in some capacity, professional or otherwise.

Normative ideal/stereotype: The coded female is referenced only in the context of her desire to behave as a religious role model of Islam, with no specified interest in making a public agenda statement about her religious practice.

Activist: The coded female is referenced as an activist for a cause distinct from women-related issues. The coded female is not in a leadership position within her cause.

Activist/leader: The coded female is referenced as a leader within an activist organization unrelated to women's issues. This includes women in public office who advocate for specific causes.

Member of activist organization: The coded female is referenced as an activist

dealing with women's issues, but without a clear indication of her stance on women's issues.

Activist/leader liberal: The coded female is referenced as a liberal activist or liberal activist leader within the context of women's issues.

Activist/leader conservative: The coded female is referenced as a conservative activist or conservative activist leader within the context of women's issues.

Unclear: The translated article summary does not provide any information about the coded female's cultural status.

Non-Arab: The coded female is not Arab.

Appendix 2: Index of Translated News Briefs Referenced

(In chronological order)

Index of Al Hayat Briefs

Index of Al Quds Al Arabi Briefs

Index of Asharq Al Awsat Briefs

Index of Elaph Briefs

Acknowledgements

In the process of writing this book, we have incurred many debts. Amal Al-Malki would like to thank her husband, Slimane, and her family whose love and support made writing this book possible. David Kaufer would like to thank his colleagues and students at Carnegie Mellon University, Pittsburgh, and Carnegie Mellon University in Qatar for many stimulating discussions about this research. He would like to thank Barbara, Aaron, and Mollie for their continuing support. Suguru Ishizaki would like to thank his family and the Department of English at Carnegie Mellon University for their support. Kira Dreher wishes to thank her husband, Jeffrey Squires, and her family for their continual support and tremendous encouragement.

Finally, we collectively wish to thank Qatar Foundation and the Qatar National Research Fund (QNRF), who in part sponsored this research under grant 29–6–7–9 to Amal Al-Malki and David Kaufer, principal investigators. We also wish to thank the following people who gave generously of their time to help shape this project in its formative stages: Muna Nashashibi and Sharif Nashashibi of Arab Media Watch, Naomi Sakr of the University of Westminster, Dena Matar of the School of Oriental and African Studies (SOAS), Abdul-Bari Atwan, Editor-in-Chief of *Al Quds Al Arabi*, and Haifa Fahoum Al Kaylani, Founder and Chairwoman of the Arab International Women's Forum. We would like to thank the editors at Bloomsbury Publishing and Bloomsbury Qatar Foundation Publishing in Qatar, especially Andy Smart, Anne Renahan, and Carol Rowe, whose tough and incisive editing improved the manuscript immeasurably. We would like to thank Nicholas Noe, Editor-of-Chief of mideastwire.com, on whose database of news briefs our research was based. We would also like to

thank Ethan Pullman, research librarian at Carnegie Mellon University in Pittsburgh, for help in tracking down remote sources published in Arabic. Most of all, we would like to thank Sheikha Moza Bint Nasser, to whom this book is dedicated, for her steadfast vision and tireless efforts on behalf of the empowerment of Arab women and women worldwide.

Notes

Preface

1 Although comprehensive across 100 Arab media sources, our survey focused on Arab news presented in the format of Arab newspapers and news websites rather than radio or television. For more on these sampling restrictions, see the Introduction.
2 This striking finding is subject to the sampling restrictions described in the above note and the discussion in chapter 3.

Introduction

1 The reader will see in chapter 3 how this assumption was significantly refined and narrowed in our actual study.
2 http://www.openarab.net/en/node/321.
3 Ibid.
4 The best quantitative computer-based coding tools available and relevant for our purposes (e.g., Hart 2001) tag text but do not allow the open-ended concept development and 'messy' [variable length] coding units that such development requires. The best qualitative coding tools (Nisus, Nvivo) allow for open concept development and messy coding, but not for maintaining the tight numerical associations needed for robust statistical analysis. Our text-analysis strategy sought the best bridge between quantitative and qualitative analysis. In addition to tagging content using messy coding and relating it to higher-level concepts and themes, text-analysis software of the type we used allowed us to maintain the associations between the textual tags and the higher level concepts so that all could be exported into a statistical package for further analysis.
5 Especially the assumption that mideastwire.com was systematically sampling from the wide variety of briefs coming out of Arab media.

1: Searching for Arab Females in Arab News

1 The Western stereotype of oppressed Arab women often turns on this slippage of Arab and Muslim identities in the stereotyping of populations being studied. For one representative example, see Eltantawy's 2007 study of US newspaper representations of Muslim and Arab women post-9/11.

2 Or delivered to subscribers within a week of the appearance of the original story.

3 Egyptian studies of Egyptian women in media have looked at Arab women speaking in their native tongue. However, the majority of these studies have concentrated on the language and character roles of women in TV soap operas and other "women's media," in which women are playing stereotypical cultural roles. See Allam 2008.

4 Arab women are hardly the only victim of image bites, which are growing ever more common in media use (Grabe & Bucy 2009, 271). And, as we have just argued, image bites are highly susceptible to media manipulation. To counteract the power of image bites of Arab women in the West, there has been within recent years a spate of publications on Arab women history, literature, autobiography and "as-told-to" genres, written in English by or in the voice of Arab women (Shaaban 1988, 1995; Abu-Lughod 1993; Sasson 1993, 1994, 2000; Mernissi 1994, 2001; Golley 2003; Lewis 1996, 2004; Ahmed 1999; Mikhail 2004; Makdisi 2005; Dahmash-Jarrah 2005; Heath 2008).

5 Given that almost half the images were from Israel, it seems surprising that 63% of the women in the photographs were veiled. Wilkins does not address this detail per se, but it seems apparent that the photographs taken within Israel disproportionately represent Arab women living within Israel. Whereas Wilkins does not explain whether any screening process was used to restrict "Middle Eastern" women to Muslim women, she does cite (p. 58) historical evidence from *The New York Times* to explain why so many of those pictured are veiled: "Since the Palestinian uprising got under way, Islamic fundamentalism and its rituals have become a rallying point in the fight against Israel. In the Israeli-occupied territories of Gaza and the West Bank, where few women used to cover their heads, it has become rare to see bareheaded women (*New York Times*, August 22, 1991, p. 4).

6 Bielsa and Bassnett (2009, chapter 2) complain that the important role translation plays in this disembedding process has been largely ignored by the leading cultural theorists on globalization. After reviewing the work of leading theorists such as Scott Lash and John Urry (1994), Arjun Appadurai (1996), and Manuel Castells (2000a, b), Bielsa and Bassnett conclude that, despite differences, these theorists equate globalization with transnational flows that place a high premium on the smooth flow of money, commodities, information and images running seamlessly and without interruption in the service of global capitalism (Bielsa & Bassnett 2009, 22). As Bielsa and Bassnett (2009, 25) see it, these cultural theories of globalization seek to conceal the turbulence of translation by romanticizing globalization as a politics-free "universal digital language" that produces instantaneous cross-cultural intelligibility. They counter-argue that a truer and more honest cultural account of globalization needs to pay attention to the ideological labor of the translator who negotiates the counterflows – the political sensitivities, disharmonies, conflicts, cultural blindspots, asymmetric power relations – that could expose the hidden faultlines of cross-cultural understandings and interests. And they seek to show the extent to which the disruptions and dislocations caused by the asymmetries of globalization are hidden from view when the cultural

tensions that attend translation are hidden from view. For example, Bielsa and Bassnett (2009, 102) recount the none-too-surprising fact that when news must be translated for cultures with little background in the realities of the events being reported, translators must add additional background information that readers of the native culture would take for granted. But there are more surprising lessons to be learned about how translations are tailored to the ideological predispositions of the target consumers. Bielsa and Bassnett (2009, 104) report that on the occasion of Ronald Reagan's funeral on July 11, 2004, the original English article reporting on the event for one news agency prominently hails Reagan in the headline for "winning the Cold War" and mentions in the first paragraph that he was "the Great Liberator" from Soviet communism. However, the Spanish and French translations of that English article changed the headline to focus on the dignitaries in attendance rather than on the accomplishments of the late American president. The Spanish version eliminates "the Great Liberator" from the first paragraph and buries it in the twelfth paragraph, as part of a quotation attributed to Margaret Thatcher. The Spanish translation thus summarily strikes this presidential accomplishment ("Great Liberator") from the official language of the deceased Reagan and demotes it to a private reflection of his close friend and partisan ally, Thatcher. In these and several other examples, Bielsa and Bassnett (2009, chapter 5) show that translators make hidden cultural adjustments to suppress counter-ideologies that would upset the expectations of the target readers.

Even more disruptive to the appearance of world news as a smooth, seamless flow is the realization that some languages, notably English, dominate others in the global flow. Bielsa and Bassnett (2009, 113) point out that London-based Reuters translates all its source English articles into other languages but translates no articles originating from alternative languages into English. This means that, through Reuters' asymmetric model, Anglophone cultures can push their version of news to the non-Anglophone world but Anglophones are guaranteed to remain well-insulated from news filtered through a non-Anglophone cultural lens. By way of contrast to Reuters, the Inter Press Service (IPS) news agency, founded in 1964 by the Italian-Argentinean economist Roberto Savio, took on the mission to create news that can further the aims of global development and that actively seeks to reduce the gaps between the have and have-not nations. For this mission, IPS knew it had to politicize globalization rather than romanticize it and this commitment required, in turn, an open acknowledgement of the power of translation to expose as well as hide competing political interests. The IPS aligns itself with Babels, an organization that affirms the right of everyone to express themselves on matters of global interest in the language of his or her choosing. IPS provides on its website news stories in thirteen languages (Bielsa & Bassnett 2009, 110-11), all of which can make their way back to the global decision-makers in English. Bielsa and Bassnett sympathize deeply with the IPS project and see it as a model for other news agencies to adopt.

7 In Arab media, this disruption is widely known as the Al Jazeera effect. (See Lynch 2006; Seib 2008).

8 Rather than agents of empire, IPS's new generations of journalists and translators must be fair-minded intercultural interpreters who can make readers feel like insiders within whatever foreign context news is breaking. The journalists and translators under this new definition must do more than report and translate events from the elite's talking points. They must be skilled at explaining local culture to their readers and teaching them respect for difference so as to enlarge reader sympathies (Bielsa and Bassnett 2009).

9 To be fair, American journalism was handcuffed because the Bush administration, with some justification, censored channels of information about the war on terror. The globalization of news across satellites makes the news of any country, in principle, the news of every country. This, in turn, makes governments more cautious about the information they dispense to their own national press in times of war. As the Bush administration began to plan the war on terror in Afghanistan and Iraq (Woodward 2004; Gordon & Trainor 2006; Ricks 2006), American journalists were given little hard information to report or analyze, making it difficult to criticize the unknown details of a war initiative that attracted wide popular support within America (Volkmer 2002).

10 Mideastwire.com is one of two major translation services of news from the Middle East. The other is MEMRI (Middle East Media Research Institute). Mideastwire.com translates stories that are much wider in range than MEMRI. Run by Israelis, MEMRI tends to focus on Islamic extremism and fundamentalism and is extremely controversial in the Arab world (Whitaker 2002).

11 Personal communication with Nicholas Noe, July 2007.

12 Though designed independently of Skalli's study, our study was designed to take a wider-lens view of female representations in reporting across news throughout the Arab Middle East and North Africa.

13 We also need to acknowledge the rise of a non-commercial women's media that is concerned with the political imbalance of women in media and focuses on female activism and rights rather than consumerism. See Dougherty, 2008.

14 See note 8.

15 This meant we filtered out the following fourteen country codes from our sample of news briefs: Afghanistan, Australia, Belgium, Bosnia & Herzegovina, France, Germany, Iran, Kyrgyzstan, Netherlands, Pakistan, South Africa, Turkey, United Kingdom, United States. In addition, we filtered out one regional code covering a span of countries, namely Europe.

16 The twenty Arab countries included in our sample were Algeria, Bahrain, Egypt, Iraq, Jordan, Kuwait, Lebanon, Libya, Mauritania, Morocco, Oman, Palestine, Qatar, Saudi Arabia, Somalia, Sudan, Syria, Tunisia, United Arab Emirates and Yemen. Our sample left out only two Arab League member states (see http://en.wikipedia.org/wiki/Arab_League), namely Djibouti and Comoros. Djibouti is on the Horn of Africa, on the strait of Bab El Mandeb, with Yemen to the north-east on the other side of the strait. Comoros is an island nation of archipelagos off the coast of Africa, close to Madagascar. Other listings of Arab countries and territories (e.g., http://en.wikipedia.org/wiki/List_of_Arab_countries_by_population) designate a twenty-third Arab

territory, namely Western Sahara, bordering Morocco and Mauritania in the Maghreb (or Arab West). Home to about 500,000 people, Western Sahara (formerly Spanish Sahara) has struggled with Morocco for autonomy since the 1970s. Guerilla war was waged for independence until the UN brokered a peace in 1991. A UN referendum to resolve the status of Western Sahara has been continuously deferred.

17 Counting the number of media sources in our corpus was not an exact science because mideastwire.com had its own proprietary system for labeling sources and many labels we had to work with were non-standard, including in-house labels (e.g., mideastwire.com [as news source]), generics (e.g., Newspaper-Middle East; Radio-Middle East; TV Middle East) or ciphers (e.g., Unknown) and each of these non-standard labels may or may not have overlapped with uniquely specified media sources. We had no independent way of reconciling specific and non-specific labels to ensure there was no duplicate counting. Furthermore, because mideastwire.com used proprietary methods of labeling media sources, we had to make our best estimates of what several of the non-specific labels meant. The media sources indexed by mideastwire.com in our sample, ordered in descending order (most to least) of the number of female keywords used, and interpreted by us when the label was non-specific, were the following: Asharq Al Awsat, Sayidaty, Al Hayat, Al Watan, Elaph, Al Quds Al Arabi, Al Mar'a al-Arabiya, Al Arabiya.net, Zahrat Al Khaleej, Newspaper — Middle East (=label for an Arab newspaper that mideasstwire.com does not typically index), As Safir, Laha, Al Jazeera (narrative stories from the Al Jazeera website), Al Wasat, Ad Dustour, Al Khaleej, mideastwire.com (=label for a translation that may draw from multiple news sources), Institute for War and Peace Reporting, Al Raya, Al Manar, Al Ayyam, Al Seyassah, TV-Middle East (=label for translations based on a composite of television coverage), Agencies (=label for translations based on a composite of news agencies not regularly translated), Akhbar Al Khaleej, Al Ahram, Al Ghad, An Nahar, Al Ittihad, Al Bayan, Al Sharqiyah, Lebanese News Agency, Al Mustaqbal, Al-Jazirah, Ma'an News Agency, Al Wafd, Al Ayyam, Yemen, Al Hayat al Jadidah, Abrar, Al Quds, Fairuz International, As Sabah, Unknown (=label for source that could not be identified), Mena, Palestinian Information Center, Teshreen, Al Arabiya TV, Al Hasnaa, El Khabar, WAFA PNA, Ad Diyyar, Al Balad, Al Qabas, Liberté, Al Zaman, Yemen Observer, Al Mara'a Al Yaum, Al Hayat English, Ramattan News Agency, Al Ra'y, Al Akhbar Lebanon, Gulf Daily News, Kingdom of Saudi Arabia TV1, Siyasat-e Ruz, Lebanese Broadcasting Channel, El Watan, Shahrazad, Al Fourat, Izz-al-Din al-Qassam Brigades website, Khabat, Resalat, Al Akhbar, Al-Risalah, Dunya Al Watan, E'temad, MAP, Saudi Gazette, Voice of Israel, Al Thawrah, Islamic Jihad Movement, The Media Line, VoIRI, Al Manar Palestine, Algerian Radio, Champress, Palestinian Sat TV, Radio – Middle East (=label for composite of radio broadcasts), SABA, Al Baath, Al Bayyinah, Al Intiqad, Al Mada, Al Mutamar, Al-Arab al-Yawm, Asharq Al Awsat English, As-Sabah, Channel 2 Jerusalem, Hawlati, Izz-al-Din al-Qassam Brigades, Ma'ariv, Quds Press Agency, and SPA news agency.

18 Of course, verifying a female reference in news from an Arab country does not guarantee that the female referenced is Arab. The sample delivered from mideastwire.com contained hundreds of references to women who were western and non-Arab, such as Condoleezza Rice; and women who were non-western and non-Arab (e.g., women who were Iranian, Turkish, Pakistani, etc.). We thus required for our coding scheme options for an NA (non-Arab) coding for women in Arab news who were not Arab. See chapter 4 and Appendix 1 for overviews of the coding scheme. Our coding study in Part I only required we deal with briefs from Arab countries that had at least one verifiable female mention. If the female mentioned was not Arab, we could code for it and report it as a separate category. Our qualitative analysis in Part II required that we deal only with briefs whose references included only *Arab* women. Hence, when we turned to our qualitative analysis in Part II, we made sure to eliminate all briefs that contained one or multiple references to non-Arab women. This is why the news briefs analyzed decreased from 237 to 178 when we moved from our coding study of Part I to our more open-ended canvassing study of Part II.

2: Thinking Through a Coding Scheme

1 The verb 'keep' may be either transitive (she kept the gown) or intransitive (he keeps watch). We explore only its intransitive application in the present example.

2 Technically speaking, Hariman calls this style "realist" because of a focus on concrete action. Yet he offers Machiavelli as the prototype practitioner of this style.

3 Testing our category of strong speech acts, for example, our coding team read an article in our corpus describing Fatima Al-Tisan, an attendee at a conference on higher education. The subject under discussion was a controversial university admissions policy and Al-Tisan is described as "discussing requirements for admission." The question before our research group was: Is the verb phrase "discussing requirements for admission" a strong speech action? It is surely volitional, real and affirmative, but it lacked uninterrupted and completed action. One member of our group suggested that when one is discussing something, there is no indication of the discussion reaching a conclusion, much less a decisive conclusion, much less a conclusion effecting change. These were grounds for not categorizing "discussing requirements for admission" as a strong speech act. However, others in our group argued that if the press is citing a person for discussing requirements for admission, there is some implication that she is a discussion leader, particularly in the context of a conference on higher education. This implication suggests a certain influence over other discussants and thus a strong speech act.

We came across another article in which the wife of the king of Bahrain, Sheikha Sabeeka Bin-Ibrahim Al-Khalifa, is described as having undertaken three actions with low levels of transitivity: "announced," "expressed the hope," and "asserted." "Announced" and "asserted" were strong speech acts, which we found repeatedly across briefs in our sample.

But what about "expressed the hope"? Clearly, were a person reported as having "hoped" for something, it would neither be a strong speech action nor a speech action at all. It would simply be a report of a private mental state about a positive wished-for state of affairs. However, "expressing a hope" transforms hoping into a public speech act and one requires considerable standing to have one's expressed mental states covered by media. We referred back to the Hopper and Thompson eight categories of transitivity and discovered that "express the hope" exhibits the transitive properties of uninterrupted, completed, volitional, and affirmative. The sole transitivity property it lacks in comparison to the speech acts we had confidently classified as "strong speech acts" was realism. When you express a hope, you have not made a real change but simply projected one for the future. We thus understood why "express the hope" had initially raised our suspicions about its standing as a strong speech act. Nonetheless, after realizing how much overlap "express the hope" enjoyed with the strong speech acts about which we were more confident, we agreed to include it.

We also classified the verb "stressed" as a strong speech action in an article where an Arab woman in the news, reacting to a murder and rape case, "stressed that what took place was 'murder and rape with prior intentions and meditations, nothing but the death penalty can suffice'." Stressing a point is foremost volitional and affirmative, but also completed and uninterrupted. In this case, as in others, classifying the verb as a strong speech action depends on the entire verb phrase in which it is embedded. Should a woman be described as *stressing* that "she can't cope," then the stressing action becomes private and sad, far from an act of institutional activity in any realm. The private act casts off its sense of volition and affirmation. But in the present article context of stressing a point about a heinous crime, the stressing action comes across as strong and decisive and projecting outward toward the world.

4 This tacit authorization can always be explicitly overridden, of course.

5 We could extend this thinking over many pages. When the reporter describes her as "indicating" something, she is presented as an active and reliable source of the story. When the reporter describes her as "confirming" something, she is represented as an active source authority with the qualifications to verify information that has heretofore lacked verification. When the reporter describes her as "clarifying" something, she is assumed to hold the authority to issue statements whose clarity is judged vital; or to be a spokesperson for groups who hold that authority. When the reporter describes her as "deciding" something, she is established as carrying the authority to enter into and make decisions worth press coverage. When the reporter describes her as "advising" someone on some topic, she is portrayed as one who commands access, trust, and influence over persons with rank or office who seek her counsel. When the reporter describes her as "assuring" someone of something, she is painted as having the ear of worthy persons who entrust their job performance or personal well-being to her positive feedback. When the reporter describes her as "agreeing to" something, she is depicted as an insider to important negotiations and contracts whose completion depends upon your free volition.

6 These quotes are taken from a mideastwire.com brief of an Asharq Al Awsat article of March 6, 2006, headlined ""UN report: occupation soldiers and settlers sexually harass Palestinians."

7 A skeptic might object that our treatment of the first measure for defining the active-passive distinction, transitivity, is biased toward Western languages and thinking. We respond by pointing out that the principles determining transitivity show up in languages around the world and Hopper and Thompson's analysis includes many such language groups. We can also reply that there is substantial psychological evidence that the active-passive continuum is a central organizing cognitive principle of language across cultures. Over 50 years ago, the inventor of the semantic differential scale, the psychologist Charles Osgood discovered that the active-passive continuum is one of three fundamental and cross-language building-blocks that help human language users sort the lexicon that lies at the intersection of descriptive and evaluative language. In their classic 1957 study, Osgood and his colleagues asked 100 college students to evaluate where 20 random concepts (*lady, boulder, sin, father, lake, symphony, Russian, feather, me, fire, baby, fraud, God, patriot, tornado, sword, mother, statue, cop, America*) fell along a seven-item scale of 50 word-pairs (e.g., *slow/fast, good/bad*), with each pair lying at the extremes of a scale (Osgood, Suci & Tannenbaum 1957: 35–43). Students were instructed to mark 1 on the scale if slow, mark 7 on the scale if fast and 2–6 if anywhere in between. Each student was thus asked to judge a 'lady' as falling along a seven point scale between *slow* and *fast*, between *good* and *bad*, and so on across 50 word scales. After all the students made all their selections on all the concepts, each scale of word-pairs had 2,000 (100 students x 20 concepts) separate responses. Each of the 2,000 responses for any one scale could be correlated with the 2,000 responses of any one of the 49 other scales. This produced an enormous correlation matrix, which was then simplified through the data reduction technique known as factor analysis. Impressively, despite the enormous number of correlations, Osgood and his colleagues found that 50% of all the correlation variations could be explained by reducing the data to three simple continua: positive-negative; potent-impotent, and active-passive. They found that the students made implicit use of the positive-negative continuum in their mental lexicon to place the following English words at opposite poles of the scale: *good/bad, beautiful/ugly, sweet/sour, clean/dirty, tasty/distasteful, valuable/worthless, kind/cruel, pleasant/unpleasant, sweet/bitter, happy/sad, sacred/profane, nice/awful, fragrant/foul, honest/dishonest, and fair/unfair.* He found that the students made implicit use of the potent-impotent continuum in their mental lexicon to separate word pairs like *large/small, strong/weak, heavy/light, and thick/thin, hard/soft, brave/cowardly.* And Osgood and his colleagues found that students made implicit use of the active-passive continuum in their mental lexicon to separate English pairs like *active/passive, fast/slow, hot/cold* and *sharp/dull.* In another study with bilingual Japanese and Korean students, they found that the students made the same judgments, producing the same factor hierarchy, featuring the central importance of the same three continua, and they made the same judgments, regardless of whether they made their judgments in English or in their mother tongue

(ibid.168–78). This finding further suggests that these three continua, including the active-passive continuum, are fundamental to the psychological organization not only of English, but also of other languages. Following on the work of Heise (1979), we intended to extend Osgood's active-passive semantic continuum to open-ended verbal data as a means of analyzing levels of activity/passivity in texts of all kinds, including language-based media and, as in our present study, the activity-passivity levels of Arab women in Arab news briefs.

3: The Coding Scheme and Experimental Sample

1 When independent readers can produce judgments of active and passive behavior in news that is highly convergent, we say that the coding scheme has achieved a high degree of inter-coder (or more conventionally called inter-rater) reliability. We can also say that the coding scheme has been verified.

2 See Osgood, Suci & Tannenbaum 1957.

3 In translations, we could also assign the attitude to the translator.

4 We eliminated as possible codings negative/positive, which means that a woman is described as engaged in negative behavior and the editorial slant toward the action is positive. Viewpoints that could not be discerned as carrying a positive or negative bias were scored as neutral.

5 See note 6 below.

6 The Cohen Kappas on each dimension is as follows: Dimension 1: 0.755287009; Dimension 2: 0.762232296; Dimension 3: 0.956440804; Dimension 4: 0.918854652. Landis and Koch (1977) define a "substantial" range of agreement as lying between .61 and .80 and they consider above .8 to be "almost perfect" agreement. Fleiss (1981) considers .75 to be "excellent" agreement. Consequently, we achieved very high substantial or excellent agreement.

7 By agreement, female pronouns such as "she" and "her" were not part of the original keyword search that mideastwire.com used to locate briefs for us. It made no sense to them or to our research to have pronouns as search terms. Because of the high frequency of pronouns in English, mideastwire.com would have had to share most of their database of briefs with us, which, as proprietary intellectual property, they understandably could not do. From our perspective, accepting all the briefs in their database that contained female pronouns would have inundated us with more stories than we had the capacity to read and interpret. Consequently, our agreement did not include pronouns as key words. Nonetheless, because of the importance of female pronouns as keywords within briefs acquired through less frequent female keywords, we proceeded independently to identify the female pronouns "she", "her," "hers," and "herself" in all the articles we received under our license.

8 Writers resort to pronouns to maintain established topics that already reside in the short-term memory of readers (Givon 1979). Thus, pronouns are required for the narrative development of individual characters.

9 One simple way of measuring the extent to which a media source elaborates stories about females as unique individuals as opposed to simply mentioning gendered categories or gendered labels is to compute the

ratio of occurrences of "she" and "woman" per media source. A media source that is efficient in elaborating stories about specific women should have a high ratio of "she" to "woman." The four pan-Arab sources in our sample all had a high "she" to "woman" ratio. The highest was Al-Quds, with a ratio of 4.24 (386/91), followed by Elaph (3.87; 310/180), Asharq Al Awsat (3.5; 881/249) and Al Hayat (3.42; 665/194). We assumed that a women's publication, like Sayidaty, which elaborates stories about a specific woman or women in virtually every article, would have a substantially higher "she" to "woman" ratio and that was in fact the case in our sample, where Sayidaty had a ratio of almost 7:1; (6.82; 1017/149).

10 We ran concordances for "she" and "woman" across the news briefs in our experimental sample to verify these statements. See also note 8.

11 Based on the challenges facing translators of radio and TV news. See Introduction.

12 Our 2005–2006 sample of Al Jazeera contained forty-four (less than 3%) of the 1,496 briefs in our sample. As stated in the Introduction, Al Jazeera television, like all Arab television and radio, is under-represented in our sample. The majority of Al Jazeera briefs come from the Al-Jazeera website.

13 The sample we received from mideastwire.com was found to be heavily skewed toward liberal-reformist and internationally-focused pan-Arab media sources. In addition to the six media sources already mentioned (Al Hayat, Asharq Al Awsat, Al Quds, Elaph, Sayidaty, Al Watan) the three media sources next most represented in our corpus were As Safir, a left-leaning Lebanese daily with a pan-Arab reach that describes itself as the "The Newspaper of the Arab World in Lebanon," and the web sites of the two prominent satellite networks from the Gulf, alArabiya.net, and alJazeera.net. Taken together, these nine media sources accounted for 62% (1,256) of the briefs in our corpus of 2,014 Arab news briefs from over one hundred sources. Since we had no access to mideastwire.com's full database (with or without female references) of news briefs for 2005–2006, we could not calculate the precise extent to which female references are monopolized by the liberal pan-Arab press for that news service. Caution should therefore be exercised about making conclusive inferences either way without carrying out similar research using other Arab news databases as they become available in English or Arabic.

14 See note 10. This is a major assumption and probably not true in any rigorous sense. In a more perfect design, the translations and the media sources would both have been randomized before we drew our female sample.

15 Thanks to the work of Sakr (2007), we designed our study from the start with the knowledge that the media source itself, as an institution, an ownership structure, and a corporate entity with investors to please, and a preferred reader demographic to satisfy in order to attract advertisers, all play a role in shaping the content of a media source. The media source is thus an important variable shaping content and we wanted to make sure our original sample contained a wide enough array of media sources to ensure our study could generalize across Arab media sources and not be restricted to one in particular. Given the skewing of our sample to liberal pan-Arab media, replication will be needed to see how well our

findings hold up across other databases drawn from Arab media. See note 12 above.

16 Yet it remains a truth that could be dependent on the one database of Arab news we used. As previously mentioned, replications of this sampling on other databases must be conducted in order to test the robustness of this finding. See also notes 12 and 14 above.

17 And in addition, we identified the pronoun "they" and had a human editor isolate occurrences of it that referenced only females. See note 7 above.

18 It is more complicated than this, of course, for translations. There is also the perspective of the news institution and of the translator who works for that institution. It was beyond the scope of our study to delve into these additional perspectives.

4: Results of the Coding Study

1 While we had limited our sample to news briefs within Arab countries with at least one female reference, there were still briefs where the females referenced were not Arab (e.g. Condoleezza Rice).

2 This cosmopolitan factor may also explain the very few occurrences of a category we called Passive-traditional (or P-traditional for short). This category was designed to capture aspects of passivity associated with time-honored tradition and religious obligations in the family that the woman would not take as restraining. Of the 888 pronoun mentions we coded, we found only one (0.11%) instance of such positive passivity.

5: Females up Close

1 Grounded theory was originally developed jointly by Barney Glaser and Anselm Strauss (1967). Glaser and Strauss had an eventual parting of the ways with Glaser's notion of grounded theory stressing the induction and discovery of categories and theory while Strauss emphasized theory vali-dation. The approach we took toward grounded theory follows Glaser's school of thought.

2 These open-ended methods of grounded theory include the "open-writ-ing" form of coding and the overly selective "field-note" and "memo" forms of coding prescribed in grounded theory (Glaser 1992).

3 DocuScope is a software tool for computer-aided rhetorical analysis. DocuScope provides an interactive environment for tagging textual data through linguistic patterns in a pre-defined dictionary. The current pre-defined dictionary contains more than forty-four million patterns of English, including individual words and multi-word language strings that we have collected through incremental coding and testing of hundreds of texts from dozens of genres. DocuScope's dictionary authoring environ-ment allows researchers to create their own special-purpose and customizable dictionaries suitable to the genres and contexts of the textual data (in this case, Arab news briefs) at hand. Users can build small (containing dozens or hundreds of language patterns) or massively large (containing millions of language patterns) customized dictionaries for coding textual data. Finally, a visualization environment for moving

between the aggregate text of interest and its component language patterns makes it straightforward to author, in a relatively short time, customized dictionaries that are consistently classified over hundreds and thousands of word and phrasal patterns. Unlike most text-analysis programs (e.g., Hart 2001, Stone et al. 1966) that recognize only single words, the built-in pattern-matcher underlying the DocuScope environment has the ability to match passages of language of any arbitrary length. Qualitative researchers rightly understand that many of the most explanatory elements of a text can span different segments (e.g., words, phrases, clauses, and paragraphs) and may overlap so profoundly as to make the attainment of human coding reliability a practical impossibility. We designed the DocuScope environment so that the committed qualitative analyst of language would not have to choose between the richness and interpretive flexibility of qualitative analysis and the systematicity of quantitative analysis.

4 Early into our canvassing (Part II) analysis, it became clear that our categories of negative and neutral did not merit further analysis. The dominant categories for negative behavior in our relatively few codings of negative (see Table 4.1 above) resulted from (typically Palestinian) women imprisoned or involved in female suicide bombing. Further background research revealed that the women involved in these alleged "negative" behaviors were caught in a briar patch of political and sociological issues that made the reduction of their behaviors to the one-dimensional judgment of "negative" untenable (see chapter 19). We also realized that our codings of women exercising neutral behavior – exercising personal judgments, concerns, statements, and so forth – had been useful in the coding study (Part I) for accommodating a loose-fitting miscellany of behaviors that did not fit the tighter categories of active and passive. However, further background research convinced us that this category of neutrality held little theoretical interest for the more open-ended canvassing of Arab women we undertook for Part II. We thus focused in Part II only on the two categories of active and passive. However, as we explain in the text, we now thought of active and passive as inter-dependent cultural frames rather than rigid linguistic dichotomies.

6: Anger & Resistance

1 Roberts' translation appears on-line at http://www2.iastate.edu/~honeyl/Rhetoric/index.html and http://classics.mit.edu/Aristotle/rhetoric.1.i.html.
2 In *Understanding Anger Disorders*, DiGiuseppe and Tafrate distinguish dysfunctional and functional anger. On the dysfunctional side is rage. Rage is thought to release neuro-chemical responses that create feelings of intense hostility, clouded thinking, and an incapacity for planning. Rage is thought to be an irrational step beyond normal anger and in the classic literature on anger, the hostility of rage is partitioned off from predatory aggression, the latter known to require sustained planning and cognitive focus (DiGiuseppe & Tafrate 2007, 239–54). English also divides with some degree of precision the language of hostile but non-aggressive rage (livid, combative, fiery, fed-up, exasperated, fuming, huffy, vitriolic) from the language of predatory aggression that is thought

to require the foreplanning of retributive anger (vengeful, vindictive, revenge-seeking, punitive, predatory, armed and dangerous, retribution-seeking, justice-seeking,). Recent events, however, have complicated the dichotomy between retributive anger and rage. The shootings at Columbine Colorado in April, 1999 caused researchers on anger and aggression (Bushman & Anderson 2001) to rethink this rage/predatory dichotomy because the perpetrators of those crimes appeared to exhibit both aggressive planning and rage. In the year Bushman and Anderson's article appeared asking whether it was now time to pull the plug on the hostile vs. aggression dichotomy, 9/11 occurred, which cemented the idea that persons with rage can also be capable of planned aggression.

It also cemented the idea for Bernard Lewis, the Princeton emeritus historian, whose erudition on the Middle East has influenced the thinking of American presidents since the Eisenhower administration. Some of Lewis' theories, crystallized across many books, were popularized in a 1990 *Atlantic Monthly* article entitled "The Roots of Muslim Rage" (Lewis, 1990), and later in his 2002 book entitled *What Went Wrong? The Clash between Islam and Modernity in the Middle East* (Lewis, 2002b). Lewis's article does not refer to the causes of 9/11 but to what went wrong with Islam's historical relationship to the West. Lewis's answer is detailed and multi-faceted, but a brief brief suffices here: At the peak of Islam's worldwide power and influence, prior to the Western Enlightenment, Muslim countries rightly saw themselves at the scientific and cultural center of the world, surrounded by unbelieving barbarians. To the east were polytheists who were mostly weak and divided. To the north and west was the rival monotheistic system of Christendom. Lewis views the historical rivalry between Islamdom and Christendom as a "Clash of Civilizations," a phrase popularized by Huntington (1996) that Bernard Lewis is credited as coining first (Hirsh 2004). For the first millennium of their rivalry, according to Lewis, Islam had the upper hand. For the past 300 years, since the rise of European colonialism in Asia and Africa, Islam has been on the retreat. Lewis describes the Muslim decline as the suffering of one psychological defeat after another, as Muslims tried variously and failed variously to emulate Western political assemblies, factories, and other organizational structures and strategies (Lewis 1990). Failure led to anger and blame, as Lewis explains:

> When you become aware that something is going wrong and you say "What went wrong?", there are two ways you can follow up. One is what I have just described: in effect, to say "What did we do wrong?", and that leads to "How do we put it right?" The other response when you are aware that things are going wrong is "Who did this to us?" And that leads into a twilight world of neurotic fantasies and conspiracy theories. This has also been a line much followed by some people, though by no means all, in the Islamic world. (Lewis 1990)

The latter response, insofar as it has been amplified by influential and media-savvy voices in Muslim lands, precipitates a culture of rage, a deep-seated disposition that "turns every disagreement into a problem and makes every problem insoluble" (Lewis 1990). "What Went Wrong"

chronicles what in Lewis' view is the chronic Muslim disinclination to
learn from, adjust to, or integrate with the West. To illustrate this lack of
interest in integration, Lewis cites the fifteenth-century Moroccan jurist
al-Wansharisi who, reminiscent of the Mohammad cartoon controversy
in Denmark in 2006, pondered whether Muslims could live a pious life as
a minority in a Christian land practicing religious tolerance.
Al-Wansharisi's response was an emphatic no. If such a government
practiced true tolerance, al-Wansharisi reasoned, "the danger of apostasy
[would only be] greater" (Lewis 2002b, 39). Lewis notes that, as inheri-
tors of the Old and New Testaments, Muslims felt they could dismiss
anything in those previous monotheisms that had not survived into their
own (Lewis 2002b, 36). As a result of their reluctance to exercise intercul-
tural curiosity, adapt, or integrate, Muslims found it difficult, according
to Lewis, to reconcile two incompatible views: their faith in the inherent
superiority of Islam and the Muslim reality of living in a subaltern rela-
tionship to cultures of the West. Needless to say, Lewis' views are very
controversial but are taken as articles of faith among the American and
European right wing. To test the influence of Lewis's thinking on the
news reporting of the Danish cartoon controversy of 2006, Kaufer and
Al-Malki (2008) sampled fifty-six English news articles covering that
controversy and representing media sources in America, Europe, the
Middle East and Asia. They reviewed the controversy in depth and deter-
mined that two sides of the story were not only possible but could be
well-supported. The "Danish" side of the story was that vengeful Arabs
were thin-skinned about religious parody, intolerant of free speech in a
free society, and were now stirring up hostile behavior against fearful
Danes. The "Arab" side of the story was that an angry right-wing Danish
government was out to make life miserable for fearful law-abiding Arabs
by baiting them with brazen assaults on their religion (not unlike the
Nazi Kristallnacht against German Jews) and pursuing an aggressive state
plan to deport substantial segments of the Arab population in Denmark.
Kaufer and Al-Malki coded the fifty-six articles for evidence of anger and
fear responses and for just who (European or Arab) was represented in
the article as angry and who (European or Arab) as fearful. They found
that the English-language world press took up the Danish side of the
story, representing Arabs overwhelmingly as the aggressors and the
Danes as the victims. Kaufer and Al-Malki submitted their research to
the Arab Media Watch website where it has attracted many readers. But
when earlier submitted to refereed social science journals in Europe,
their research received the response, "There's nothing new about these
findings. Everyone knows that media worldwide stereotype Arabs as irra-
tionally angry and aggressive."

3 The five stages are passive acceptance, revelation, embeddedness–emana-
tion, synthesis, and active commitment. Passive acceptance refers to the
stereotype of Western women of the 1950s and the Western stereotype
of the Arab woman today. Women in this stereotype accept their lot in
life, subordinate to men and embrace traditional gender roles. According
to Downing and Roush (1985), women experiencing a feminist identity
consistently report a second "slap of cold water to the face" phase,
encountering events that woke them up to a patriarchal system they

found unacceptable. This revelation period, according to the researchers, is marked by "anger" associated with feelings of betrayal. It is a sweeping, generalized and uncontrollable anger, characterized by simmering rage more than cold strategy. The phase after revelation is what Downing and Roush call embeddedness–emanation, where the woman seeks retreat into female networks to vent her anger and loss of trust in males. Over time, this phase sublimates into a fourth "synthesis" phase where women learn to classify men across the wide variation of attitudes men can hold and behaviors they can exhibit toward patriarchy. They learn to sniff out men who reject patriarchy, who practice gender equality in deed, and they recruit these men as allies, friends, mentors and husbands. They learn in parallel to size up men who practice patriarchy as obstacles to avoid or confront. These women have not lost their anger from the revelation stage but have learned to channel it into a concept approximating what we call anger/resistance in this chapter. Their rage sublimates, focuses, and matures into a quiet pragmatic righteousness for change. Some, but not all, women, Downing and Roush hypothesize, enter a fifth activist phase, characterized by organized political action to combat cultural sexism and patriarchy. With the devaluation of the "feminist" label since the 1960s, some recent research (Erchull et al. 2009) has shown that US women in their twenties identify with feminism less strongly, but when they do, they take Downing and Roush's synthesis phase as their phase one.

4 As a pattern detected in the surface stream of texts, anger/resistance combines words related to anger (e.g., wrath, anger, aggression), resistance (e.g., resist, oppose, counter), negative value terms to resist (e.g., injustice, slavery, oppression) and positive value terms to embrace (e.g., justice, freedom, liberty).

5 Suzanne Mubarak, as it happened, had a mixed record on human rights. She received a master's degree in sociology from the American University in Cairo with a thesis on poverty in the Egyptian slums. Her thesis supervisor was Saad Eddin Ibrahim, who is a distinguished scholar and human rights activist who formed the Arab Organization of Human Rights. For his achievements, Ibrahim was awarded the Ion Ratiu Democracy Lecture Prize at the Woodrow Wilson International Center for Scholars in 2006. Despite his work on behalf of human rights and his ties to Suzanne Mubarak, he was jailed by the Mubarak government for three years for defaming Egypt's image abroad. Asked to explain how the First Lady could have turned her back on her advisor simply for doing what he did -- criticizing human rights violations -- Ibrahim just laughed and said, "Power isolates you from reality. I think that like her husband, she became cut off, she forgot what she saw in her fieldwork among the people of Egypt" (Remnick 2011).

6 Women's involvement in elections is often a sign of the overall capabilities of women in society, capabilities we discuss at length in chapters 7–13. This is certainly the case in wealthy Kuwait and Bahrain, where literacy and graduation rates for women hover among the highest in the Arab world. Yet in Arab countries overall, the link between female participation in elections and female literacy and education is not as sturdy as one might expect – especially in countries that impose strong female

quotas. Yemen, with a symbolic court-ordered 30% female representa-
tion in elective government (Jarhum 2007), has seen dozens of women
run in local council and parliamentary elections and even boasts two
female parliamentarians, although two in three women in Yemen are
illiterate and Yemen is at the bottom of the world gender gap index
(Hackman 2011). Quotas for women, whether mandated or symbolic,
may raise the political standing of women but, as in the case of Yemen,
they may also mask the deeper conditions that prevent women from actu-
ally attaining that status.

7: Aspiration & Drive

1 According to the Qur'an [4:4], the man or the man's family is enjoined to
pay a 'dowry' to the bride as part of the contract to marriage.

8: Education

1 One of the many reasons we coupled the analysis of our sample with
consideration of international literature on gender and its many sub-
literatures, was to locate discrepancies between issues involving girls and
women discussed in Arab news with issues discussed in Western journal-
ism. Same-sex education was one issue that struck us as unrepresented in
our 2005–2006 corpus of Arab briefs compared to the attention it received
in Western journalism in the same years. We haven't made a formal study
of this discrepancy, however, and just leave it as an observation.

9: Employment

1 It became part of Cambridge University in 1948.
2 Prior to this issue, in 1971, *Ms. Magazine* had appeared as a "one-shot"
insert in New York Magazine. The debut issue appearing in spring 1972
was the first stand-alone issue of the magazine and it contained essays by
feminists from all walks of life, including the essay of Tillmon's. Three
months later, in July 1972, the first regular issue of *Ms. Magazine* hit
newsstands.
3 See the third quotation at the head of the chapter.
4 As mentioned in chapter 1, we did not limit our analysis to mideastwire.
com's classification of its news stories.
5 Most early (circa 1881) historical occurrences of "out-and-about" in the
English language pertained to returning to activity after recovering from
illness. Based on the quotations in the Oxford English Dictionary (OED),
this usage applied to women as well as men. The only historical quotation
of "out-and-about" the OED gives to mean "social-networking for advance-
ment" applies to a man, a 1991 reference by Z. Edgell in the publication
Times like These, xviii. 107. "He was out and about struggling for recogni-
tion, involving himself in activities that would further his political career."
See the on-line OED reference for "out-and-about"; retrieved March 16,
2011 at http://www.oed.com/view/Entry/133395?redirectedFrom=out%20
and%20about#eid33105372.

6 More crudely put, if we could give Josephine Joe's networks without turning her into Joe, would Josephine advance as well as Joe? Or must Josephine become Joe in order to enjoy Joe's networking advantage?

7 For older references on female employment in the Middle East that are still not dated, see Hijab (1988) and Moghadam (1995).

8 A copy of the Saudi constitution, adopted March 1992, can be found at http://www.servat.unibe.ch/icl/sa00000_.html.

10: Ranking Activeness

1 Strictly speaking, so-called "active" concepts may participate in dominant passive frames and vice versa.

2 Pride and choice-making appeared too infrequently to be included in the statistical analysis in this chapter. In chapter 7, we have defined drive as a combination of pride, insistence, and initiative. Because of the unavailability of material indicating pride and choice-making for the analysis of this chapter, the definition of drive we have applied in the present chapter is a combination of insistence, initiative, education, and employment.

3 We must hasten to add that these findings, while interesting, are representative only of the corpus of Arab news we studied. Other corpuses might yield entirely different results. More studies on other samples are needed to arrive at a more definitive conclusion as to what constitutes the most relevant combination of factors for predicting high levels of activity for Arab women.

11: Empowerment

1 News briefs focusing on Arab female capability fall into this category. See chapter 7.

2 News briefs focusing on Arab female drive fall into this category, which is a combination of the concepts of a woman's insistence, initiative, education, and employment. See chapters 8 and 9.

3 We do not have evidence of this influence through citation patterns. We simply observe that the Arab Human Development Reports are uncannily in line with the findings of this research.

4 As background research for this book, we interviewed Mr Atwan and his associate editor at the *Al Quds* offices in London in June 2008. One of Mr Atwan's many claims to fame in his remarkable life is that he spent two days in an Afghanistan cave interviewing Bin Laden, which he chronicles in his book, *The Secret History of Al-Qaeda* (Atwan 2006; 2008). He published his rise from Palestinian refugee camps to the front page in his autobiography even more recently (Atwan 2009).

5 Bibliographic information about Su'ad Maybar's book could not be validated, even after searching the Arab Union Catalog extensively in both Arabic and English and the Central and Digital Libraries of Al-Azhar University. The authors wish to thank Ethan Pullman, the Humanities Librarian at Carnegie Mellon for his assistance in tracking down these references.

6 As part of the research for this book, we interviewed Haifa Fahoum Al Kaylani at the AIWF main office in London in June 2008.

12: Barriers to Empowerment

1 Albright was asked, "What advice do you have for women who want respect from their male colleagues? Albright answered, "Women have to be active listeners and interrupters—but when you interrupt, you have to know what you are talking about. I also think it is important for women to help one another. I have a saying: "There's a special place in hell for women who don't.""

2 In chapter 7 under "passive choice" we saw, and shall see again in chapter 18, the darker interpretation of the *khula* law in Egypt that shows it to be less pro-woman.

3 Quoting Iranian presidential candidate Mir Hossein Mousavi.

14: Passivity

1 According to the modern narrative about nations and their development, war and what Hobbes called the "constant potentiality" of war (Hobbes' *Leviathan*, cited in Alexander & Hawkesworth 2008, 6) are but inconvenient and short-lived distractions amidst enduring states of peace and calm among nations.

2 Unfortunately, because these women are classified as armed combatants, international law denies them refugee status and they often end up living in squalid conditions with the HIV/AIDS virus (Farr 2008).

3 In a later op-ed about Bangladesh, Kristof writes: "Consider Bangladesh. After it split off from Pakistan, Bangladesh began to educate girls in a way that Pakistan has never done. The educated women staffed an emerging garment industry and civil society, and those educated women are one reason Bangladesh is today far more stable than Pakistan" (Kristof 2010).

4 To detect fear in a news brief, our text-mining algorithm relied on a predefined dictionary of words suggestive of fear (see Kaufer et al. 2004).

5 Nor is the method of counter-stories unique to the present day. In 1841, the American abolitionist Frederick Douglass (1841) delivered a speech to the Plymouth County Anti-Slavery Society in Massachusetts entitled "The Church and Prejudice." As one can guess, the speech was about the subtle racism of the American church. Douglass recounted a story of his own church in New Bedford, Massachusetts, where a young lady during a service "fell into a trance" and, after awakening, declared she had been to Heaven. As Douglass recalls, "Her friends were all anxious to know what and whom she had seen there." So the young lady volunteered what she remembered. But Douglass then went on to describe a "good old lady whose curiosity went beyond that of all the others." The old lady asked the girl simply whether she had seen "any black folks in heaven." The young woman, "after some hesitation," Douglass told his audience, replied "Oh! I didn't go into the kitchen!" Douglass concluded: "Thus you see, my hearers, this prejudice goes even into the church of God." But Douglass clearly knew he was talking to an audience of abolitionists already well-practiced in reconstructing stories of naïve white racism into counter-stories of racial injustice. For the majority of Americans in 1841, the young lady's reply would likely have given no cause for unease. Kitchen work and fieldwork were part of the

normalized background of the slave economy in the Southern US. Most Americans of 1841, like the innocent but racist young lady, would simply have no idea of the "kitchen" Douglass had experienced as a slave; yet Douglas was confident he could build a counter-story of that kitchen from the slave perspective that could raise the awareness of his white audience. And so, three years later, he published his first autobiography, *The Narrative of the Life of Frederick Douglass: An American Slave* (1845). There, Douglass had more space in which to reconstruct the normalized stories of white Americans into never-before-told counter-stories of black oppression in order to "undermine and reverse a system of power relations" (O'Meally 2003, xxvi).

15: Fear & Threat

1 In order to induce fear, the experimenter deceived the subject by not revealing that the experiment was intended to induce fear and record the subject's physiological response, and saying instead that its aim was to collect harmless physiological data. In order to do this, the experimenter revealed, he would need to hook the subject's little finger to a wire. At this point, the experimenter announced that he would start collecting data from the subject and then, almost immediately, the subject felt a mild electric shock to his finger. It was not sharp enough to cause pain but it was definitely intended to alarm the subject. The experimenter pretended that the electric shock had been a terrible "accident"; he expressed surprise and regret and apologized to the subject for the "mistake." The experimenter begged the subject to proceed with the experiment and offered assurance that the mistake would not happen again. Then, deviously, the experimenter "accidentally" shocked the subject's little finger a second time. After apologizing again, the experimenter, his face now heavy with concern, checked the wiring and blurted out in a startled voice that the wire was connected to a dangerous high-voltage short circuit. These dramatic deceptions put the subject under a heightened state of alarm and allowed Ax to record the subject's physiological responses while in a fearful state.

In order to induce anger, the experimenter pretended that the subject would be undergoing a polygraph test. The subject was told that the polygraph had to be administered by a specially trained operator, but that the usual operator had called in sick and, as a last resort, the experimenter had called in a substitute operator who had previously been fired for incompetence and a poor attitude. The substitute operator then entered the room and pretended to start the polygraph test by hooking the subject up to the polygraph. During the first few minutes of the test, the operator criticized the subject for failing to sit still and cooperate with instructions. This play-acting created the conditions for Ax to record the subject's physiological responses in an angered state. Ax assessed each subject in each state using seven physiological measures: (1) heart rate, (2) ballistocardiogram, (3) respiration rate, (4) face temperature, (5) hand temperature, (6) skin conductance, and (7) integrated muscle potential.

2 Although Ax himself would not have seen this consistency. See Chapter 16 for an explanation.

16: Fear & Threat in War Zones

1 The post-war record of Rwandan women in leadership roles has been mixed for the women of Rwanda. Women in the Rwandan Parliament helped to pass laws against domestic and gender-based violence and in favor of women's property rights, but they also reduced maternity leave for women by half. One female constituent bitterly complained that the female leaders of Rwanda "are not answerable to women" (Moore 2010).

2 Our account of this brief relied on the coverage provided in *Time Magazine* to fill in background (McGirk 2006).

3 Only one soldier involved in the Haditha killings remains on trial and, as of July 2011, his trial on a charge of manslaughter remains indefinitely postponed. The remaining soldiers charged were acquitted with no finding of guilt in 2007 and 2008. See Wikipedia. Haditha Killings/Charges Dropped.

4 He was killed later that year by American bombs.

5 United States Agency for International Development. The USAID provided weekly reports on the reconstruction of Iraq during 2006. The reports are on-line at http://www.usaid.gov/index.html. However, we could not pinpoint any of the reports written around the time referred to in the *Al Quds Al Arabi* article.

6 An alternative account is that the oppression of women does not objectively rise in war zones. Rather, it is press coverage of female oppression that increases, which heightens the subjective impression of females being oppressed in war zones. These alternative interpretations are beyond the scope of the present discussion.

7 The joint winner was Manuela Dviri, an Israeli writer whose son was the innocent victim of a Hezbollah rocket.

8 Writing for *Forced Migration Review*, the official journal of the Oxford Refugee Studies Centre, Lowenstein (2006) found case after case of abuse of Palestinians who had lived in the West Bank and Gaza for decades, were even married to residents, and were still treated as unprocessed refugees.

9 Adalah stands for The Legal Center for Arab Minority Rights in Israel.

10 The organization is also known as Aseerat (www.aseerat.ps/en-index.php).

17: Fear & Threat outside War Zones

1 Tracy Wilkinson (2000) reported for the *Los Angeles Times* that Jordanian girls have been victims of honor killing for flirting.

2 The feast, part of the Eid al Adha or the Festival of Sacrifice, re-enacts Ibrahim's obedience by sacrificing a cow or ram, a third of which is donated to the poor. The feast symbolizes obedience to Allah and generosity.

3 Samir Kassir was born in 1960 in Beirut. In 1980, he began a career in journalism, publishing news and commentary in leading news outlets, including Lebanon's leading *An-Nahar* daily, the pan-Arab *Al Hayat*, and the Lebanese francophone daily *L'Orient-Le Jour*. In 1990, he earned a

PhD in modern history from the Sorbonne in Paris and just two years later published his first book. By 1995, he had begun writing a weekly editorial in *An-Nahar*'s Friday edition, which was drawing considerable attention because of his criticism of Syria's presence in Lebanon. On June 2, 2005, he was leaving his Beirut home and starting his car when a bomb exploded. His murderers have never been found (Reporters Without Borders 2009).

4 Egypt had for years enjoyed one of the freest presses in the Middle East. Freedom House publishes an annual report, *Freedom of the Press*, which measures the freedom and editorial independence of the press across every nation and territory of the globe. There is no fully free press in the Middle East, but the 2009 report rated the press of Israel, Kuwait, Lebanon and Egypt as at least "partly free." Every other press in the Middle East and North Africa was rated "not free" (Freedom House 2009). With a regional press that dates back to the 1920s (Adel Iskandar, quoted in Hanley 2006) and an independent, diverse, politically-active, and literary avant-garde press that dates back to the 1960s (Kendall 2006), Egypt can boast among the longest, proudest, and most thriving press traditions in the Middle East. The print press dominates Egyptian journalism in terms of sheer numbers, with more than 500 newspapers, and more independent carriers than other media (Radsch 2007). Since the 1990s, the Egyptian press has exploded not only in size but also in diversity. There are the three major outlets, *Al-Ahram*, *Al-Akhbar*, and *Al-Gomhuria*, which are well-funded mouthpieces of the government. Among these powerhouses, *Al-Ahram* is the oldest, and the second oldest in all of Egypt, founded in 1875, and is the newspaper with the widest circulation in Egypt. It features writers from diverse walks of life, such as Naguib Mahfouz, winner of the Nobel Prize in Literature in 1988. Beyond these government-run presses, there are rafts of smaller independent and oppositional presses that often operate on a shoestring. They can be generally divided under two categories: the sensationalist presses motivated by profit, and niche opposition presses that typically wield no political influence but give a voice to selective constituencies of Egyptian readers that would otherwise go unheard (Iskandar, cited in Hanley 2006). The most persistent of these small opposition presses, which had constantly nipped at the heels of the former Mubarak government, is *Al-Dostour*, founded in December 1995. To side-step Egypt's restrictive publication laws, *Al Dostour* publishes from Cyprus. The Mubarak government suspended the paper from operation in 1998 when it published statements from Islamic groups that were considered inflammatory. *Al Dostour* resumed publication in March 2005 and immediately returned to its criticism of the Mubarak government, Mubarak, and his family. In October 2010 its then editor, Ibrahim Eissa, was fired under alleged government pressure.

The most influential of these independent presses is *Al-Masry Al-Youm*, first published in 2005 under the founding editorship of the former *Cairo Times* editor Hisham Kassem. The paper introduced a hard and objective news alternative to the many sensationalist opposition presses and very quickly after its launch began competing

head-to-head with *Al-Ahram* as the national paper of record. It rivaled the editorial range and depth of *Al-Ahram* while crossing the red lines that *Al-Ahram* was required to respect. It attracted a new generation of journalists, including women, who were interested in establishing their credentials as journalists more than cheering for the government (Grant 2008).

5 We are not saying that blogging against the state in Egypt is safe. We are simply saying that bloggers have been safer than print journalists because their work does not require the same level of physical exposure. The Mubarak administration jailed pro-democracy bloggers in Egypt. But as Al Malky (2007) has said: "There appears to be a consensus, even among political bloggers and the most vocal human rights advocates, that the arrested bloggers were not targeted for the content of their blogs." They were targeted for what they did on the streets or in widely circulating texts.

6 This includes the Muslim Brotherhood Cluster, the Egyptian Islamic Cluster, the Secular Reformist Cluster, and the Wider Opposition Cluster. For details, see Etling (2010, 1232–1233).

7 Which is half the employment rate for males, still abysmally low (Otterman 2007).

18: Uncommon Stories of Patriarchy/Misogyny

1 This cultural premise is hardly exclusive to Arab regions.

2 Dr Islam Khujah made this criticism, which is referenced in chapter 7 (page 106).

3 Dr Abdul Rahman al-Sughayyar made this remark, referenced in chapter 7 (page 113).

4 Maha Al-Hassan and car dealerships in Saudi Arabia are discussed in chapters 8 and 9.

5 *Al Hayat*, February 8, 2006, "Pharmacists in Iraq: Between the threats of the militants and the addicts," discussed in chapter 16. Arab women sometimes see their restricted job prospects during war as a form of employment discrimination. An *Asharq Al Awsat* brief from April 21, 2006 explains that, before 2003, Iraqi women held 60% of the mostly low-paid positions in the government bureaucracy. Men were motivated to look for employment outside the government for better pay. However, in 2003 with the onset of the Iraqi war, the brief reports that "women became less lucky than men in finding jobs and especially in governmental circles." The *Asharq Al Awsat* reporter interviewed "specialists" in employment patterns in Iraq who denied that women were being discriminated against. The employment experts explained that during wartime there is a strong demand for security specialists including police, military, and guards. These jobs go mainly to men. The experts contended that for women it was different. They "prefer to remain at home rather than work and go out, because of the dangers of it." And, according to the experts, during times of social unrest, fear for their daughters is an overriding concern for families. The experts are quoted as saying: "[F]amilies were scared for their daughters which

is [a] prominent [fear] in our society [which] holds on to traditions and norms." But at least one unnamed Iraqi woman begged to differ with this assessment. She is identified in the brief as a graduate from the Faculty of Education at Baghdad University. She claims she wants to work in her field as a teacher but she either knows, or accepts, or is told (the brief does not make clear) that "she cannot move about like a man or work in dangerous fields including services and security." Still, she did not believe that she was being treated fairly; nor did she believe that the government of Iraq was practicing gender equality in hiring. She concluded that "governmental institutions need to look into this problem and place a formula (*sic*) to secure opportunities for women that are equal to men."

6 Again, this cultural premise is not exclusive to the Arab world.

7 See the discussion of the brief from the December 1, 2006 edition of *Asharq Al Awsat* in chapters 8 and 9 (page 143–44).

19: Sadness & Hopelessness

1 Pape, O'Rourke and McDermit (2010) make a similar argument for Chechen female suicide bombers. They argue that such women are motivated by the Russian occupation more than by personal deficiency or even global jihad.

2 We do not claim to have carried out an exhaustive survey of these profiles. And what we propose here is based only on the evidence of our immediate corpus, which involves only female bombers. We did not have enough cases of male suicide bombers in our corpus to propose an analysis for male bombers.

3 It should be noted that we frame female suicide bombing, as suicide bombing in general, from an unapologetic counter-terrorist perspective. This view of suicide bombing is controversial and there are apparently ways of framing the practice from more sympathetic perspectives. For example, Brunner (2007) critiques both Bloom (2005) and Skaine (2006) for framing the subject of female suicide bombers from a counter-terrorist perspective.

4 Curious to know the official number of bodies coming in each day, the *Asharq Al Awsat* reporter phoned the Iraqi Ministry of Health spokesman, Qasim Yahya, for an answer. He said he was not at liberty to disclose the number. After more persistence from the reporter, Yahya finally acknowledged that he was under orders from Parliament not to say. He did allow that not only the number of corpses, but the way they arrived at the morgue, was a matter of "politics" and he had nothing to do with politics.

Concluding Statement

1 Women's increasing participation in government derives from state-imposed quotas more than from a new-found confidence in women leaders (see Foroohar 2010).

Appendix 2

1 This headline does not reflect the story content as it should. It would be more accurate to read it as: " ... abandon romantic movies in favor of horror movies."

2 "Suzanne" is the more common spelling and we use that spelling in the text.

3 The brief relies on an unusual spelling. In the text, we use a more common spelling, "Menna Shalabi."

Bibliography

Abbott, A. 1988. *The System of Professions: An Essay on the Division of Expert Labor*. Chicago IL: University of Chicago Press.

Abbott, N.P. 2002. *The Cambridge Introduction to Narrative*. Cambridge. Cambridge University Press.

Abdel-Latif, O., and M. Ottaway. 2007. Women in Islamist movements: Toward an Islamist model of women's activism. Carnegie Paper, July. http://carnegieendowment.org/2007/07/10/women-in-islamist-movements-toward-islamist-model-of-women-s-activism/4xu (accessed August 26, 2011).

Abdi, C.M. 2008. Convergence of civil war and the religious right: Reimagining Somali women. In *War and Terror: Feminist Perspectives*, ed. K. Alexander and M. Hawkesworth, 279–306. Chicago IL and London: University of Chicago Press.

Abouzeid, L. 1989. *Year of the Elephant: A Moroccan Woman's Journey Toward Independence*, trans. B. Parmenter. Austin: Texas Center for Middle Eastern Studies, University of Texas at Austin.

Abrams, D. 2011. *Man Down: Proof Beyond a Reasonable Doubt that Women are Better*. New York: Abrams Image Press.

Abu-Lughod, L. 1993. *Writing Women's Worlds: Bedouin Stories*. Berkeley: University of California Press.

Abu-Lughod, L. 2002. Do Muslim women really need saving? Anthropological reflections on cultural relativism and its others. *American Anthropologist* 104, no. 3: 783–90.

Abu Odeh, L. 1993. Post-colonial feminism and the veil: Thinking the difference. *Feminist Review* 43: 26–37.

Adalah. n.d. Ban on family unification. *Adalah*. http://www.adalah.org/eng/famunif.php (accessed on October 1, 2011).

Adameer. 2009. Palestinian women in Israeli prisons. *Adameer Prisoners' Support and Human Rights Organization*. http://addameer.info/?p=551 (accessed October 5, 2011).

Agwa, A. 2000. The Image of Women Portrayed in the Egyptian Movies Broadcast on Channel One on the Egyptian TV. Cairo: Mass Communication Department, Research Report. Cairo University.

Ahelbarra, H. 2009a. Kuwait elects first women MPs. Al-Jazeera/English, May 17. http://english.aljazeera.net/news/middleeast/2009/05/200951713 38473416.html (accessed February 27, 2011).

Ahelbarra, H. 2009b. Kuwait votes for women and change (video). Al-Jazeera/English. http://english.aljazeera.net/news/middleeast/2009/05/2009517 11368608195.html (accessed February 27, 2011).

Ahmed, L. 1992. *Women and Gender in Islam: Historical Roots of a Modern Debate*. New Haven CT: Yale University Press.

Ahmed, L. 1999. *A Border Passage: From Cairo to America – A Woman's Journey*. New York: Farrar, Straus & Giroux.

Ahmed, L. 2011. *A Quiet Revolution*. New Haven CT: Yale University Press.

Ahmetbeyzade, C. 2008. Negotiating silences in the so-called low intensity war: The making of the Kurdish diaspora in Istanbul. In *War and Terror: Feminist Perspectives*, ed. K. Alexander and M. Hawkesworth, 255–78. Chicago IL and London: University of Chicago Press.

al-Alaya, Z., and M. al-Kibsi. 2009. Tourism marriage drives Yemeni girls to prostitution, report. *Yemen Observer*, August 13. http://www.yobserver. com/front-page/10017061.html (accessed August 26, 2011).

Al Awadi, B., H. Al Mubarak, and A. Al Attawi. 2009. Women's rights in the Kuwaiti personal status law and Bahraini Shari'a judicial rulings. Manama: Freedom House. http://www.familylaw-khaleej.org/media/document/ WRAG-THEO-ENGLISH.pdf (accessed February 28, 2011).

Alexander, K., and M.E. Hawkesworth, eds. 2008. *War and Terror: Feminist Perspectives*. Chicago IL: University of Chicago Press.

al-Ghanim, K.A. 2009. Violence against women in Qatari society. *Journal of Middle East Women's Studies* 5, no. 1: 80–93.

Ali, N. and D. Minoui. 2010. *I am Nujood, Age 10 and Divorced*. New York: Three Rivers Press.

Al Jazeera. (2003). Jordan quashes 'honour crimes' law. *Al Jazeera*, September 7. http://english.aljazeera.net/archive/2003/09/2008410102158508644. html (accessed October 5, 2011).

Allam, R. 2008. Countering the negative image of Arab women in the Arab media: Toward a "pan Arab eye." Media Watch Project. Policy Brief 15. Washington DC: Middle East Institute. http://www.mei.edu/Portals/0/ Publications/countering-negative-image-arab-women-arab-media.pdf (accessed October 5, 2011).

Allied Media. 2010a. Al-Hayat Arabic daily newspaper. http://www.allied-media.com/Arab-American/al_hayat.htm (accessed February 23, 2011).

Allied Media. 2010b. Al Quds Al Arabi. http://www.allied-media.com/Arab-American/al_quds_al_arabi.htm (accessed February 23, 2011).

Allied Media. 2010c. Asharq al-Awsat. http://www.allied-media.com/Arab-American/asharq.htm (accessed February 23, 2011).

Alloula, M. 1986. *The Colonial Harem*. Minneapolis: University of Minnesota Press.

Al-Malki, A. 2003. Tradition and modernity in post-colonial novels. Diss. School of Oriental and African Studies (SOAS). University of London.

Al Malky, R.A. 2007. Blogging for reform: The case of Egypt. *Arab Media and Society* 1. http://www.arabmediasociety.com/?article=12 (accessed August 14, 2011).

AlMunajjed, M. 1997. *Women in Saudi Arabia Today*. London: MacMillan.

Al-Nafjan, E. 2008. Prominent Saudis: Dr Mohammed Al Zulfa. *Saudiwoman's Weblog*, June 26. http://saudiwoman.wordpress.com/2008/06/26/promi-nent-saudis-dr-mohammed-al-zulfa/ (accessed August 26, 2011).

Al-Qazzaz, A. 1983. The treatment of Arabs in US social studies textbooks. In *Split Vision: The Portrayal of Arabs in the American Media*, ed. E. Ghareeb, 381–90. Washington DC: American-Arab Affairs Council.

Alterman, J.B. 2005. Afterword. Arab media studies: Some methodological considerations. In *The Al-Jazeera Phenomenon: Critical Perspectives on New Arab Media*, ed. M. Zayani, pp. 203–8. Boulder: Paradigm.

Altorki, S. 2000. Concept and practice of citizenship in Saudi Arabia. In *Gender and Citizenship in the Middle East*, ed. S. Joseph, 215–37. New York: Syracuse University Press.

Amiry, S. 2006. *Sharon and My Mother-in-Law: Ramallah Diaries*. New York: Anchor.

Anderson, C. 1914, May 15. Man-woman says man out in the world is a hunter of women. *Day Book of Chicago*, 3, No. 194. n.p.

An-Na im, A.A. 2008. *Islam and the Secular State: Negotiating the Future of Sharia*. Cambridge MA: Harvard University Press.

Appadurai, A. 1996. *Modernity at Large: Cultural Dimensions of Globalization*. Minneapolis: University of Minnesota.

Arab Fund for Economic and Social Development. 2005. The mismatch between educational achievement and the Arab labor market with a gender perspective. In *Arab Women and Economic Development*, ed. H. Handoussa, 141–74. Cairo: Arab Fund for Economic and Social Development.

Arab Human Development Report. 2002. *Creating Opportunities for New Generations*. UN Development Program. Arab Fund for Economic and Social Development. Arab Gulf Program for UN Development Organizations. http://www.arab-hdr.org/publications/other/ahdr/ahdr2002e.pdf (accessed January 18, 2010).

Arab Human Development Report. 2003. *Building a Knowledge Society*. UN Development Program. http://www.arab-hdr.org/publications/other/ahdr/ahdr2003e.pdf (accessed January 18, 2010).

Arab Human Development Report. 2004. *Towards Freedom in the Arab World*. UN Development Program. http://www.arab-hdr.org/publications/other/ahdr/ahdr2004e.pdf (accessed January 18, 2010).

Arab Human Development Report. 2005. *Towards the Rise of Women in the Arab World*. UN Development Program. http://hdr.undp.org/en/reports/regional-reports/arabstates/RBAS_ahdr2005_EN.pdf (accessed January 18, 2010).

Arab International Women's Forum (AIWF). 2008. *Newsletter*, Summer. London: AIWF.

Arab News. 2011. Homepage. *Arab News*. Saudi Research & Publishing Company. http://www.arabnews.com/ (accessed October 4, 2011).

Arab Press Network. 2009. *Elaph*: The number one on-line newspaper in the Arab world. http://www.arabpressnetwork.org/articlesv2.php?id=3002 (accessed February 23, 2011).

Aristotle. 2004. *Rhetoric*. Trans. W.R. Roberts. New York: Dover. Available at http://www2.iastate.edu/~honeyl/Rhetoric/index.html (accessed July 20, 2011).

Asser, M. 2007. Egypt: A permanent emergency. BBC News, March 27. http://news.bbc.co.uk/2/hi/middle_east/6481909.stm (accessed August 26, 2011).

Atwan, A.B. 2006/2008. *The Secret History of al Qaeda*. London: Saqi Books.

Atwan, A.B. 2009. *A Country of Words: A Palestinian Journey from the Refugee Camp to the Front Page*. London: Saqi Books.

Ax, A.F. 1953. The physiological differentiation between fear and anger in humans. *Psychosomatic Medicine* 15, no. 5: 434–42.

Azzi, I. 2011. Cairo leaders: Suzanne Mubarak held women back. *WeNews*, February 17. http://www.womensenews.org/story/the-world/110216/ cairo-leaders-suzanne-mubarak-held-women-back (accessed February 23, 2011).

Bailey, D., and G. Tawadros. 2003. *Veil: Veiling, Representation and Contemporary Art*. Cambridge MA: MIT Press.

Baker, M. 2006. *Translation and Conflict: A Narrative Account*. London: Routledge.

Baldry, A.P., and P.J. Thibault. 2006. *Multimodal Transcription and Text Analysis*. Oakville CT: Equinox Publishing.

Barghouti, O. 2004. The killing of Iman al-Hams: Executing another child in Rafah. *CounterPunch*, October 25. http://www.counterpunch.org/2004/ 10/25/executing-another-child-in-rafah/ (accessed August 26, 2011).

Barlas, A. 2002. *"Believing Women" in Islam: Unreading Patriarchal Interpretations of the Qur'an*. Austin: University of Texas Press.

Barthel, D., and P. Mule. 1992. The return to the veil: Individual autonomy vs. social esteem. *Sociological Forum* 7, no. 2: 323–32.

Bassnett, S. 2002. *Translation Studies*. 3rd ed. London: Routledge.

BBC. 2004. Gaza girl death officer cleared. BBC News, October 15. http:// news.bbc.co.uk/go/pr/fr/-/1/hi/world/middle_east/3748054.stm (accessed August 26, 2011).

BBC. 2009a. Iraq's "female bomber recruiter." BBC News, February 4. http:/ /news.bbc.co.uk/1/hi/7869570.stm (accessed August 26, 2011).

BBC. 2009b. US soldier spared death penalty. BBC News, May 21. http:// news.bbc.co.uk/2/hi/americas/8062705.stm (accessed August 26, 2011).

BBC. 2009c. "Syria Amends Honour Killing Law. BBC News, July 2. http:// news.bbc.co.uk/2/hi/8130639.stm (accessed August 26, 2011).

Beijing Declaration. 1995. Beijing Declaration and Platform for Action. United Nations Department of Economic and Social Affairs (DESA) Division for the Advancement of Women (DAW). http://www.un.org/womenwatch/ daw/beijing/pdf/BDPfA%20E.pdf (accessed August 26, 2011).

Beijing Platform Mission Statement. 1995. United Nations Fourth World Conference on Women: Platform for Action. http://www.un.org/women-watch/daw/beijing/platform/plat1.htm#statement (accessed August 26, 2011).

Benhadid, F. 2005. Gender and globalization: Human rights, property rela-tions, and economic opportunities. In *Arab Women and Economic Development*, ed. H. Handoussa, 99–119. Cairo: Arab Fund for Economic and Social Development.

Bennhold, K. 2010. The female factor: Feminism of the future relies on men. *New York Times*, June 22. http://www.nytimes.com/2010/06/23/world/ europe/23iht-letter.html?adxnnl=1&adxnnlx=1277283824– XC5yGpLKFF1BUZKpgk64IA (accessed June 23, 2010).

Bialik, C. 2010. Beyond poll's bottom line. *Wall Street Journal Blog*, September 24. http://blogs.wsj.com/numbersguy/beyond-polls-bottom-line-995/ (accessed February 23, 2011).

Bielsa, E., and S. Bassnett. 2009. *Translation in Global News*. London: Routledge.

Blackwood, R.E. 1983. The content of news photos: Roles portrayed by men and women. *Journalism Quarterly* 60: 710–14.

Blau, P.M. 1977. *Inequality and Heterogeneity*. New York: Free Press.

Bloom, M. 2005. *Dying To Kill: The Allure of Suicide Terror*. New York: Columbia University Press.

Botman, S. 1999. *Engendering Citizenship in Egypt*. New York: Columbia University Press.

Bower, J.L., and C.M. Christensen, 1995. Disruptive Technologies: Catching the Wave. *Harvard Business Review* 73, no. 1: 43–53.

Braun Consulting 2004. Lack of measurable evidence . http://www.braun-consulting.com/bcg/newsletters/winter2004/winter20042.html#sub6 (accessed August 26, 2011).

Britt, L., and D. Heise. 2000. From shame to pride in identity politics. In *Self, Identity, and Social Movements*, ed. T.J.O. Stryker and R.W.S. White, 222–68. Minneapolis: University of Minnesota Press.

Brizendine, L. 2006. *The Female Brain*. New York: Broadway Books.

Brooks, D. 2011. *The Social Animal: The Hidden Sources of Love, Character, and Achievement*. New York: Random House.

Brown, N. 2008. What is at stake in Kuwait's parliamentary elections? *Carnegie Endowment for International Peace*, May 7. http://www.carnegieendowment.org/publications/index.cfm?fa=view&id=20098 (accessed August 26, 2011).

Brown, N. 2009. Kuwait's democracy experiment on the line. *Foreign Policy*, March 19. http://lynch.foreignpolicy.com/posts/2009/03/19/kuwaits_democracy_experiment_on_the_line (accessed February 27, 2011).

Brunner, C. 2007. Occidentalism meets the female suicide bomber: A critical reflection of recent terrorism debates: A review essay. *Signs* 32, no. 4: 957–71. http://www.jstor.org/stable/pdfplus/10.1086/512490.pdf?acceptTC=true (accessed August 13, 2011).

Brym, R., & B. Araj. 2006. Suicide bombing as strategy and interaction: The case of the second intifada. *Social Forces* 84, no. 4, 1969–86.

B'Tselem. 2008. Israel refuses to issue ID cards to unregistered Palestinians. www.btselem.org/english/Family_Separation/20080529_Unregistered_persons.asp (accessed August 26, 2011).

Bullock, K. 2002. *Rethinking Muslim Women and the Veil: Challenging Historical and Modern Stereotypes*. London: International Institute on Islamic Thought.

Burns, J.M. 2004. *Transforming Leadership*. New York: Grove Press.

Burt, R.S. 1992 *Structural Holes: The Social Structure of Competition*. Cambridge MA: Harvard University Press.

Buscher, D. 2005. Masculinities: Male roles and male involvement in the promotion of gender equality: A resource packet, ed. D. Quick. New York: Women's Commission for Refugee Women and Children.http://www.unicef.org/emerg/files/male_roles.pdf (accessed September 30, 2011).

Bushman, B.J., and C.A. Anderson. 2001. Is it time to pull the plug on the hostile versus instrumental aggression dichotomy. *Psychological Review* 108: 273–9.

Byrne, R. 1988. *The 1911 Best Things Anybody Ever Said*. New York: Random House. 272.

Cahn, N. 2000. The power of caretaking. *Yale Journal of Law and Feminism*. 177: 214–223.

Calás, M.B., and L. Smircich. 2009. Feminist perspectives on gender in

organizational research. In *The Sage Handbook of Organizational Research Methods*, ed. C. Buchanan and A. Bryman, 246–69. Thousand Oaks CA: Sage.

Calás, M.B., L. Smircich, and K.A. Bourne. 2009. Extending the boundaries: Reframing "entrepreneurship as social change" through feminist perspectives. *Academy of Management Review* 34, no. 3: 552–69.

Calvert, J.R., and A.S. Al-Shetaiwi. 2002. Exploring the mismatch between skills and jobs for women in Saudi Arabia in technical and vocational areas: The views of Saudi Arabian private sector business managers. *International Journal of Training and Development* 6, no. 2: 112–24.

Cancian, F. 1987. *Love in America*. Cambridge: Cambridge University Press.

Castells, M. 2000a. *The Information Age*. Vol. 1: *The Rise of the Network Society*. Oxford: Blackwell.

Castells, M. 2000b. *The Information Age*. Vol. 2: *Economy, Society, Culture*. Oxford: Blackwell.

CBS. 2011. CBS News' Lara Logan assaulted during Egyptian protests. CBS News, February 15. http://www.cbsnews.com/stories/2011/02/15/60minutes/main20032070.shtml (accessed February 23, 2011).

CEDAW. 1979. Conference for the Elimination of All Forms of Discrimination Against Women. http://www.un.org/womenwatch/daw/cedaw/ (accessed August 26, 2011).

Center of Arab Women for Training and Research (CAWTAR). 2001. Gender and globalization: Economic participation of Arab women. Tunis: CAWTAR and United Nations Development Programme.

Center of Arab Women for Training and Research (CAWTAR). 2006. *Arab Women Development Report: Arab Women and the Media: Analytic Survey for Women Research Studies from 1995–2005*.Tunis: CAWTAR and United Nations Development Programme.

Chamberlin, A. 2006. *A History of Women's Seclusion in the Middle East: The Veil in the Looking Glass*. Binghamton NY: Haworth Press.

Chamlou, N. 2004. *Gender and Development in the Middle East and North Africa: Women in the Public Sphere*. MENA Development Report. Washington DC: World Bank. http://siteresources.worldbank.org/INTMENA/Publications/20262206/genderoverview.pdf (accessed August 26, 2011).

Chamlou, N. 2008. *The Environment for Women's Entrepreneurship in the Middle East and North Africa*. Washington DC: World Bank.

Chamlou, N., and B.K. Yared. 2005. Women entrepreneurs in the Middle East and North Africa: Building on solid beginnings. In *Arab Women and Economic Development*, ed. H. Handoussa, 43–74. Cairo: Arab Fund for Economic and Social Development.

Chan'ad Bahraini. 2006. Women's rights in Bahrain. *Chan'ad Bahraini*, December 19. http://chanad.weblogs.us/?p=516 (accessed March 1, 2011).

Charmaz, K. 2006. *Constructing Grounded Theory: A Practical Guide Through Qualitative Analysis*. Thousand Oaks CA: Sage.

Cherribi, S. 2006. From Baghdad to Paris: Al-Jazeera and the veil. *Harvard Journal of Press/Politics* 11, no. 2: 121–38.

Chesler, P. 2009. Are honor killings simply domestic violence? *Middle East Quarterly* 16, no. 2: 61–9. http://www.meforum.org/2067/are-honor-killings-simply-domestic-violence (accessed August 11, 2011).

Chow, I.H., and C.I. Ng. 2007. Does the gender of the manager affect who he/she networks with? *Journal of Applied Business Research* 23: 50–61.

Christensen, C.M. 1997. *The Innovator's Dilemma: The Revolutionary Book that Will Change the Way You Do Business* New York: Perseus.

Christensen, C.M., and M. Raynor. 2003. *The Innovator's Solution: Creating and Sustaining Successful Growth*. Cambridge MA: Harvard Business School Press.

CIA. 2007. World Factbook. https://www.cia.gov/library/publications/the-world-factbook/index.html.

Clarke, A. 2005. *Situational Analysis: Grounded Theory after the Postmodern Turn*. Thousand Oaks CA: Sage.

Cohen, J. 1960. A coefficient of agreement for nominal scales. *Educational and Psychological Measurement* 20: 37–46.

Collelo, T. ed. 1987. Lebanon: The siege of Beirut. *Country Studies Series*. Federal Research Division of the Library of Congress. http://www.country-data.com/cgi-bin/query/r-8077.html (accessed October 3, 2011).

Collins, R. 1979. *The Credential Society*. New York: Academic Press.

Colvin, M. 2011. Mob stripped and beat TV reporter with poles. *Sunday Times*, February 20. http://www.theaustralian.com.au/news/world/mob-stripped-and-beat-tv-reporter-in-cairos-tahrir-square-it-has-emerged/story-e6frg6so-1226008941002 (accessed October 5, 2011).

Congreve, William. 2008. *The Mourning Bride*. London: Dodo Press.

Constitution. 1992. Saudi Arabia – Constitution. http://www.servat.unibe.ch/icl/sa00000_.html (accessed January 18, 2010).

Corder, J., and C.W. Stephan 1984. Females' combination of work and family roles: adolescents' aspirations. *Journal of Marriage and the Family* 46, no. 2: 391–402.

Dabbous-Sensenig, D. October 31, 2005. Incorporating an Arab-Muslim perspective in the re-assessment of the implementation of the Beijing Platform for Action. United Nations Department of Economic and Social Affairs (DESA) Division for the Advancement of Women (DAW). www.un.org/womenwatch/daw/meetings/consult/10–review/EP9.pdf (accessed August 26, 2011).

Dahmash-Jarrah, S. 2005. *Arab Voices Speak to American Hearts*. Tampa FL: Olive Branch Books.

Daily Mail. 2011. "No one told her to go there." Now female pundit lays into Egypt sex attack victim Laura Logan and "animal" protestors. *Daily Mail*, February 18. http://www.dailymail.co.uk/news/article-1357957/Lara-Logan-attack-Debbie-Schlussel-Nir-Rosen-criticise-CBS-correspondent.html (accessed February 25, 2011).

Danzinger, N. 1983. Sex-related differences in the aspirations of high school students. *Sex Roles* 9: 683–94.

Darwich, D. 2006. Pens against biceps. http://www.prixsamirkassir.org/contest7–ENG.htm (accessed August 26, 2011).

Darwin, C. 2009. *The Expression of the Emotions in Man and Animals*. Penguin Classics. London: Penguin. (1st ed. 1872).

Davidson C. and K. Coates Ulrichsen 2010. Bahrain on the edge. *Open Democracy*, October 19. http://www.opendemocracy.net/christopher-davidson-kristian-coates-ulrichsen/bahrain-on-edge (accessed August 26, 2011).

Davies, S.E. 1866/1988. *The Higher Education of Women. A Classic Victorian Argument for the Equal Education of Women.* Introduction by Janet Howarth. London: Hambledon Press. http://books.google.com/books?id=JoxnAHrf zrMC&pg=PR7&dq=Sarah+Emily+Davies+the+higher+education+of+wo men&hl=en&ei=yqwtTo7MNofDgQemr6itCw&sa=X&oi=book_result& ct=result&resnum=2&ved=0CC4Q6AEwAQ#v=onepage&q&f=false (accessed July 25, 2011).

Dennis, S. February 17, 2011. Lara Logan's "assault": What this says about the Egyptian protesters and the American media. *America's Watchtower,* February 17. http://americaswatchtower.com/2011/02/17/lara-logans-assault-what-this-says-about-the-egyptian-protesters-and-the-american-media/ (accessed February 24, 2011).

Denov, M., and C. Gervais. 2008. Negotiating (in)security: Agency, resistance, and resourcefulness among girls formerly associated with Sierra Leone's Revolutionary United Front. In *War and Terror: Feminist Perspectives,* ed. K. Alexander and M.E. Hawkesworth, 35–60. Chicago IL: University of Chicago Press.

Dezsö, C.L., and D.G. Ross. 2008. Does female representation in top management improve firm performance? A Panel Data Investigation. Robert H. Smith School Research Paper No. RHS 06–104. http://ssrn.com/ abstract=1088182 (accessed August 26, 2011).

Dhillon, N. and T. Yousef, eds. 2009. *Generation in Waiting: The Unfulfilled Promise of Young People in the Middle East.* Washington DC: Brookings Institution.

DiGiuseppe, R., and R.C. Tafrate. 2007. *Understanding Anger Disorders.* New York: Oxford University Press.

Dobbins, G.H., and S.J. Platz. 1986. Sex differences in leadership: How real are they? *Academy of Management* 11, no. 1: 118–27.

Dougherty, A. 2008. The intersections of women centered media: Funding and the struggle for our human rights. *Global Media Journal.* 7, no. 13. http://lass.calumet.purdue.edu/cca/gmj/fa08/gmj-fa08–dougherty.htm (accessed October 5, 2011).

Douglass, F. 1841. "The Church and prejudice." Speech delivered November 4, 1841 at the Plymouth County Anti-Slavery Society in Massachusetts. http://www.greatamericandocuments.com/speeches/douglass-church-prejudice.html (accessed August 26, 2011).

Douglass, F. 1845. *The Narrative of the Life of Frederick Douglass: An American Slave.* Repr. New York: Barnes & Noble, 2003. http://www.gutenberg. org/catalog/world/readfile?fk_files=2163547 (accessed August 7, 2011).

Dowd, M. 2010. Driving Ms. Saudi. *New York Times,* March 14. http://www. nytimes.com/2010/03/14/opinion/14dowd.html?hp (accessed March 14, 2010).

Downing N., and K. Roush. 1985. From passive acceptance to active commitment. A model of feminist identity development for women. *The Counseling Psychologist* 13, no. 4: 695–709.

Doyle, L. 2001. *The Surrendered Wife: A Practical Guide to Finding Intimacy.* New York: Simon & Schuster.

Dunne, M. 2010. Interview with Dr Rola Dashti, Member of the Kuwaiti Parliament. *Arab Reform Bulletin,* March 9. http://www.carnegieendow-ment.org/arb/?fa=show&article=40316 (accessed March 1, 2011).

Dunnell, P.A., and L. Bakken. 1991. Gifted high school students' attitudes toward careers and sex roles. *Roeper Review* 13, no. 4: 198–202.

Duval, S. 1998. New veils and new voices: Islamist women's groups in Egypt. In *Women and Islamization: Contemporary Dimensions of Discourse on Gender Relations*, ed. K. Ask and M. Tjomstand, 45–72. Oxford: Berg.

Eagley, A., and L. Carli. 2007. *Through the Labyrinth: The Truth About How Women Become Leaders*. Cambridge MA: Harvard Business School Press.

Economist. 2008. Our women must be protected. *The Economist*, April 24. http://www.economist.com/node/11090113 (accessed August 26, 2011).

Eid, G. 2006. Implacable adversaries: Arab governments and the Internet. http://old.openarab.net/en/node/346 (accessed August 26, 2011).

Eisler, R.T. 1995. *Sacred Pleasure: Sex, Myth, and the Politics of the Body*. New York: HarperOne.

El-Guindi, F. 1999. *Veil: Modesty, Privacy and Resistance*. New York: Berg.

El-Hadidy, M. 1977. *An Analytical Research on the Image of Women in Egyptian Movies*. Technical Report. Cairo: Mass Communication Department, Cairo University.

El-Nawawy, M., and A. Iskandar. 2002. *Al-Jazeera: How the Free Arab News Network Scooped the World and Changed the Middle East*. Cambridge MA: Westview.

Eltantawy, N.M. 2007. US newspaper representation of Muslim and Arab women post 9/11. PhD Diss. Georgia State University.

Ely, R.J. 1995. The power in demography: Women's social constructions of gender identity at work. *Academy of Management Journal* 38, no. 3: 589–634.

Ely, R.J, and I. Padavic. 2007. A feminist analysis of organizational research on sex differences. *Academy of Management Review* 32, no. 4: 1121–43.

Engels, F. 1972. *The Origin of the Family, Private Property, and the State*, ed. E.B. Leacock. New York: International Publishers (first published 1884).

England, A. 2009. Kuwait: Stymied by political infighting. *Financial Times*, April 15. http://www.ft.com/intl/cms/s/0/69015160–29d0–11de-9e56–00144feabdc0.html (accessed October 5, 2011).

Erchull, M.J., M. Liss, K.A. Wilson, L. Bateman, A. Peterson, and C.E. Sanchez. 2009. The Feminist identity development model: Relevant for young women today? *Sex Roles* 60: 832–42.

Esposito, J., and D. Mogahed. 2008. *Who Speaks for Islam? What a Billion Muslims Really Think*. New York: Gallup Press.

Etling, B., J. Kelly, R. Faris, and J. Palfrey. 2010. Mapping the Arabic blogosphere: Politics and dissent online. *New Media and Society*. 12: 1225–42.

Falah, G.-W. 2005. The visual representation of Muslim/Arab women in daily newspapers in the United States. In *Geographies of Muslim Women*, ed. G.W. Falah and C. Nagel, 300–22. New York: Guilford Press.

Farr, V. 2008. A. Notes toward a gendered understanding of mixed-population movements and security sector reform after conflict. In *War and Terror: Feminist Perspectives*, ed. K. Alexander and M.E. Hawkesworth, 223–30. Chicago IL: University of Chicago Press.

Fatah, T. 2008. *Chasing a Mirage: The Tragic Illusion of an Islamic State*. New York: Wiley.

Felder, D., and M. Vuollo. (August 2008). Qatari women in the workforce. Rand-Qatar Policy Institute Working Paper. http://www.rand.org/pubs/working_papers/2008/RAND_WR612.pdf (accessed August 26, 2011).

Feldman, D.C., W.R. Folks, and W.H. Turnley. 1999. Mentor-protégé diversity and its impact on international internship experiences. *Journal of Organizational Behavior* 20: 597–611.

Feldman, R., and J. Sanger. 2006. *The Text Mining Handbook: Advanced Approaches in Analyzing Unstructured Data*. Cambridge: Cambridge University Press.

Fischer, C.S., and S.J. Oliker. 1983. A research note on friendship, gender, and the life cycle. *Social Forces* 62: 124–33.

Fish, S. 1982. *Is There a Text in This Class? The Authority of Interpretative Communities*. Cambridge MA: Harvard University Press.

Fleiss, J.L. 1981. *Statistical Methods for Rates and Proportions*. 2nd ed. New York: John Wiley.

Fondas, N. 1997. Feminization unveiled: Management qualities in contemporary writings. *Academy of Management Review* 22 no. 1: 257–82.

Fordham, A. 2011. Uprising energizes Egyptian women. *USA Today*, February 16. http://www.usatoday.com/news/world/2011-02-16-egyptwomen_N.htm (accessed February 23, 2011).

Foroohar, R. 2010. The burqa revolution. *Newsweek*. April 26, 44–5.

Forsythe, C. 2011. Al Jazeera shocks with disappointing coverage of Laura Logan. *OpenSalon*, February 18. http://open.salon.com/blog/catherine_forsythe/2011/02/18/al_jazeera_shocks_with_disappointing_lara_logan_coverage (accessed February 18, 2011).

Fox, L.H., and W.Z. Zimmerman. 1985. Gifted women. In *The Psychology of Gifted Children*, ed. J. Freeman, 219–43. New York: Wiley.

Frankel, M. 2010. Social sensitivity trumps IQ in group intelligence. *New Scientist*, October 1. http://www.newscientist.com/article/dn19530-social-sensitivity-trumps-iq-in-group-intelligence.html (accessed July 20, 2011).

Freebase. 2010. *Al Hayat Newspaper*. http://www.freebase.com/view/en/al-hayat_newspaper (accessed February 23, 2011).

Freedom House. 2009. Freedom of the press 2009. http://www.unhcr.org/refworld/country,,FREEHOU,,JOR,,4b27420b28,0.html (accessed October 2, 2011).

Freedom House. 2011a. Jordan. http://www.freedomhouse.org/template.cfm?page=174 (accessed August 11, 2011).

Freedom House. 2011b. Morocco. http://www.freedomhouse.org/template.cfm?page=178 (accessed August 26, 2011).

Friedman, M., ed. 2005. *Women and Citizenship*. Oxford: Oxford University Press.

Friedman, T. 2011. This is just the start. *New York Times*, March 1. http://www.nytimes.com/2011/03/02/opinion/02friedman.html (accessed August 27, 2011).

Gal, S. 2002. A Semiotics of the Public/Private Distinction. *differences* 13, no. 1: 77–95.

Garcia, B. 2011. Global crisis exposed weaknesses, but Kuwaiti economy doing well. *Kuwait Times*, February 2. http://www.kuwaittimes.net/read_news.php?newsid=MTY1Mzc3NjMz (accessed February 27, 2011[no longer available]).

Geisler, C. 2004. *Analyzing Streams of Language: Twelve Steps to the Systematic Coding of Text, Talk, and Other Verbal Data*. New York: Pearson Longman.

Gere, A.R. 1997. *Intimate Practices: Literacy and Cultural Work in US Women's Clubs, 1880–1920*. Urbana: University of Illinois.

Giddens, A. 1991. *The Consequences of Modernity*. Cambridge: Polity Press.

Gilman, C.P. 1898. *Women and Economics*. Boston: Small, Maynard & Co. http://digital.library.upenn.edu/women/gilman/economics/economics.html (accessed August 27, 2011).

Givon, T. 1979. *On Understanding Grammar*. New York: Academic Press.

Glain, S.J. 2004. *Mullahs, Merchants, and Militants: The Economic Collapse of the Arab World*. New York: St Martin's Press.

Glaser, B. 1992. *Basics of Grounded Theory Analysis*. Mill Valley CA: Sociology Press.

Glaser, D., and A. Strauss. 1967. *Discovery of Grounded Theory. Strategies for Qualitative Research*. Mill Valley CA: Sociology Press.

Global Media Monitoring Project. 2005. Who makes the news?. http://www.whomakesthenews.org/gmmp-background.html (accessed August 27, 2011).

Goebel, J. 2008. *Reimagining Education: What We Teach, How We Teach and the Systems in which we Teach*. n.p.: Lulu.

Golley, N.A.-H. 2003. *Reading Arab Women's Autobiographies*. Austin: University of Texas Press.

Gordon, M.R., and B.E. Trainor. 2006. *Cobra II: The Inside Story of the Invasion and Occupation of Iraq*. New York: Vintage.

Grabe, M.E., and E.P. Bucy. 2009. *Image Bite Politics*. New York: Oxford University Press.

Graham-Brown, S. 1988. *Images of Women: The Portrayal of Women in Photography of the Middle East 1860–1950*. London: Quartet Books.

Granovetter, M.S. 1973. The strength of weak ties. *American Journal of Sociology* 78: 1360–80.

Grant, D. 2008. From "decorative democracy" to journalistic potency: Egyptian print media today and tomorrow. *Arab-West Report* 19, no. 2. http://arabwestreport.info/year-2008/week-19/2–decorative-democracy-journalistic-potency-egyptian-print-media-today-and (accessed October 2, 2011).

Gray, J. 2011. Egypt military clouds women's early freedoms. WeNews, April 1. http://www.womensenews.org/story/the-world/110331/egypt-military-clouds-womens-early-freedoms (accessed April 2, 2011).

Greenberg, G., and P. Gottchalk. 2008. *Islamophobia*. London: Rowman and Littlefield.

Gutman, A. 2004. *Identity in Democracy*. Princeton NJ: Princeton University Press.

Hackman, A. 2011. A woman leading change in Yemen. Common Ground News Service, March 1. http://www.commongroundnews.org/article.php?id=29365&lan=en&sp=0 (accessed March 2, 2011).

Haddad, Y.Y. 2007. The post 9/11 hijab as icon. *Sociology of Religion* 68, no. 3: 253–67.

Hameed, K.T. 2006. Stop paying lip-service to rights for women. *Gulf Daily News*, July 9. http://www.gulf-daily-news.com/NewsDetails.aspx?storyid=148760 (accessed February 28, 2009).

Hamilton, C. 2008. Political violence and body language in life stories of women ETA activists. In *War and Terror: Feminist Perspectives*, ed. K.

Alexander and M.E. Hawkesworth, 137–60. Chicago IL: University of Chicago Press.

Hammer, J. 2002. How two lives met in death. *Newsweek*, April 15, 18–25. http://www.thedailybeast.com/newsweek/2002/04/14/how-two-lives-met-in-death.html (accessed August 12, 2011).

Hammoud, H. 2005. Illiteracy in the Arab world. UNESCO report. http:// portal.unesco.org/education/en/files/43573/11315363751Hammoud,_ H.doc/Hammoud,%2BH.doc (accessed January 18, 2010).

Hamoud, S. 2011. Amidst chaos, don't forget Bahraini women. Common Ground News Service, February 22.http://www.commongroundnews.org/ article.php?id=29330&lan=en&sid=2&sp=0&isNew= (accessed February 28, 2011).

Hamoudi, H.A. 2009. Venice conference on Islamic law. *Islamic Law in Our Times*. http://muslimlawprof.org/2009/09/19/venice-conference-on-islamic-law.aspx (accessed August 27, 2011).

Handoussa, H., ed. 2005. *Arab Women and Economic Development*. Arab Fund for Social and Economic Development.

Hanley, D.C. 2006. Paradox of the free press in Egypt *Washington Report on Middle East Affairs* 25, no. 8, November. http://www.wrmea.com/compo-nent/content/article/287–2006–november/6209–waging-peace-paradox-of-the-free-press-in-egypt.html (accessed August 27, 2011).

Haq, F. 2008. Militarism and motherhood: The women of the Lashkar-i-Tayyabia in Pakistan. In *War and Terror: Feminist Perspectives*, ed. K. Alexander and M.E. Hawkesworth, 307–30. Chicago IL: University of Chicago Press.

Haque, M. 1995. Elements of cross-cultural communication and the Middle East. In *The US Media and the Middle East: Image and Perception*, ed. Y.R. Kamalipour, 17–25. Westport CT: Praeger.

Hariman, R. 1995. *Political Style: The Artistry of Power*. Chicago IL: University of Chicago Press.

Harris. F. 1910. *Montes the Matador and Other Stories*. New York: Mitchell Kennerly.

Hart R. 2001. Redeveloping diction: Theoretical considerations. In *Theory, Method and Practice of Computer Content Analysis*, ed. M. West, 43–60. New York: Ablex.

Hasaneen, S. 2011. The revolution saves 83% of Egyptian women from sexual harrassment: A consensus that freedom oppression was its cause. *Elaph. com*, February 19. http://www.elaph.com/Web/news/2011/2/633031. html?entry=articlemostvisitedtoday (accessed on October 5, 2011).

Hashem, M. 1995. Coverage of Arabs in two leading US newsmagazines: Time and Newsweek In *The US Media and the Middle East: Image and Perception*, ed. Y.R. Kamalipour, 156–62. Westport CT: Praeger.

Hassan, R.A., and L. Welchman. 2006. Changing the rules? Developments on "crimes of honor" in Jordan. In *Honour: Crimes, Paradigms and Violence against Women*, ed. L. Welchman and S. Hossain, 199–209. London: Zed Books.

Hassink, J. 2008. *Domains of Influence: Arab Women Business Leaders*. London: I.B. Tauris.

Hatim, B., and I. Mason. 1990. *Discourse and the Translator*. New York: Longman.

Hawkesworth, M. 2008. War as a mode of reproduction: Feminist analytics. In *War and Terror: Feminist Perspectives*, ed. K. Alexander and M.E. Hawkesworth, 1–34. Chicago IL: University of Chicago Press.

Hawley, P. 1972. Perceptions of male models of femininity related to career choice. *Journal of Counseling Psychology* 19, no. 4: 308–13.

Hay, C.A., and L. Bakken. 1991. Gifted sixth-grade girls: Similarities and differences in attitudes among gifted girls, nongifted peers, and their mothers. *Roeper Review* 13: 158–60.

Hayward, S. 2004. *Women Leading.* New York: Macmillan Palgrave.

Heath, J., ed. 2008. *The Veil: Women Writers on its History, Lore, and Politics.* Berkeley: University of California Press.

Heaven, P.C.L. 1999. Attitudes toward women's rights: Relationships with social dominance orientation and political group identities. *Sex Roles* 41, no. (7/8): 605–14.

Hegel, G.W.F. 1807/1967. *Phenomenology of Mind,* Trans. J.B. Baillie. London: Harper & Row.

Hegstrom, P. 2004. *Angry Men and the Women Who Love them. Breaking the Cycle of Physical and Emotional Abuse.* Kansas City MO: Beacon Hill Press.

Heise, D. 1979. *Understanding Events: Affect and the Construction of Social Action.* Cambridge: Cambridge University Press.

Henderson-Green, D.H., and A.J. Stewart. 1994. Women or feminists? Assessing women's group consciousness. *Sex Roles* 31, no. (9/10), 505–16.

Hengen, S.E. and A. Thomson. 2007. *Margaret Atwood: A Reference Guide.* Plymouth: Scarecrow Press. 336.

Hesford, W.S. 2005. Kairos and the geopolitical rhetorics of global sex work and video advocacy. In *Just Advocacy? Women's Human Rights, Transnational Feminisms, and the Politics of Representation*, ed. W.S. Hesford and W. Kozol, 146–72. New Brunswick NJ: Rutgers University Press.

Hijab, N. 1988. *Womanpower: The Arab Debate on Women at Work.* Cambridge: Cambridge University Press.

Hill, F., M. Aboitiz, and S. Poehlman-Doumbouya. 2008. Nongovernmental organizations' role in the buildup and implementation of Security Council Resolution 1325. In *War and Terror: Feminist Perspectives*, ed. K. Alexander and M.E. Hawkesworth, 207–22. Chicago IL: University of Chicago Press.

Hirsh, M. 2004. Bernard Lewis revisited. What if Islam isn't an obstacle to democracy in the Middle East but the secret to achieving it? *Washington Monthly* 36, no. 11 (November). http://www.washingtonmonthly.com/features/2004/0411.hirsh.html (accessed August 27, 2011).

Holmes, J. 2006. *Gendered Talk at Work: Constructing Social Identity through Workplace Interaction.* Malden MA: Blackwell.

Hoodfar, H. 1997. The veil in their minds and on our heads: Veiling practices and Muslim women. In *The Politics of Culture in the Shadow of Capital*, ed. L. Lowe and D. Lloyd, 248–79. Durham NC: Duke University Press.

Hopper, P., and S.A. Thompson 1980. Transitivity in grammar and discourse. *Language* 56: 251–99.

Hosseini, K. 2007. *A Thousand Splendid Suns.* New York: Riverhead/Penguin.

Howarth, J. 1988. Introduction. In: Emily Davies, *The Higher Education of Women (1866): A Classic Victorian Argument for the education of women*, vii-xlvi. London: Hambledon Press. http://books.google.com/books?id=Joxn AHrfzrMC&pg=PR7&dq=howarth+sarah+emily+davies&hl=en&ei=jiuc

TcnwNor5ca7ape4F&sa=X&oi=book_result&ct=result&resnum=1&ved=oCCgQ6AEwAA#v=onepage&q&f=false (accessed April 6, 2011).

Human Rights Watch. 2004. Honor crimes under Jordanian law. http://www.hrw.org/node/12141/section/5 (accessed August 27, 2011).

Human Rights Watch. 2005. Promoting impunity: The Israeli military's failure to investigate wrongdoing. *Human Rights Watch* 17, no. 7. http://www.hrw.org/en/reports/2005/06/21/promoting-impunity (accessed August 27, 2011).

Huntington, S.P. 1996. *The Clash of Civilizations and the Remaking of World Order*. New York: Touchstone.

Hurlbert, J.S. 1991. Social circle and job satisfaction. *Work and Occupation* 18: 415–30.

Ibarra, H. 1993. Personal networks of women and minorities in management: A conceptual framework, *Academy of Management Review* 18: 56–87.

Ibarra, H. 1997. Paying an alternative route: Gender differences in managerial networks. *Social Psychology Quarterly* 60: 91–102.

Ibrosheva, E. 2007. Caught between East and West? Portrayals of gender in Bulgarian television advertisements. *Sex Roles* 57: 409–18.

Initiative for an Open Arab Internet. 2009. www.elaph.com.Network for Human Rights Information. http://old.openarab.net/en/node/321 (accessed October 6, 2009).

International Press Service. n.d. *Women in the News: The Gender Wire*. International Press Service. http://ipsnews.net/genderwire/ (accessed October 3, 2011).

Ishizaki, S. 2009. Toward a unified theory of visual-verbal strategies in communication design. In *IEEE International Professional Communication Conference*, 1–9. Waikiki HI: IEEE. http://www.computer.org/portal/web/csdl/doi/10.1109/IPCC.2009.5208706 (accessed April 2, 2011).

Ishizaki S. and D. Kaufer. Forthcoming. The docuscope text analysis and visualization environment. In *Applied Natural Language Processing and Content Analysis: Identification, Investigation, and Resolution*, ed. P. McCarthy and C. Boonthum.

Ishlahi, S.D. 1992. Islam at a Glance: Concept and Meaning. http://muslim-canada.org/islamglance_conceptandmeaning.html (October 2, 2011).

Isma'il, I. 2011. Article on Muslim Brotherhood website advocates transportation for women only. Middle East Media Research Institute Dispatch 3711, March 29. http://www.memri.org/report/en/0/0/0/0/0/0/5143.htm (accessed March 30, 2011).

Ismail. S. 2009. Yemen child trafficking to increase in Ramadan. *Yemen Times*, August 20. http://www.yementimes.com/DefaultDET.aspx?i=1287&p=view&a=1 (accessed August 9, 2011).

Israeli Ministry of Foreign Affairs. 2003. The role of Palestinian women in suicide terrorism. http://www.mfa.gov.il/MFA/MFAArchive/2000_2009/2003/1/The%20Role%20of%20Palestinian%20Women%20in%20Suicide%20Terrorism (accessed August 27, 2011).

Jackson, C. 2010. Elaph, most respected electronic daily in the Arab world, says 58% readers object to building mosque at Ground Zero. *Monterey Bay Forum*, September 20. http://freedomok.net/2010/09/elaph-most-respected-electronic-daily-in-the-arab-world-says-58–readers-object-to-building-mosque-at-ground-zero/ (accessed February 23, 2011).

Jacoby, J. 2011. No rights for women, no freedom in a nation. *Boston Globe*, February 20. http://articles.boston.com/2011-02-20/bostonglobe/29341639 _1_sexual-harassment-egyptian-center-egyptian-women (accessed August 23, 2011).

Jamieson, K.H. 1990. *Eloquence in an Electronic Age: The Transformation of Political Speechmaking*. Oxford: Oxford University Press.

Jamsheer, G. 2006. Women in Bahrain and the struggle against artificial reforms. Address to the House of Lords on December 18. http://www. wluml.org/sites/wluml.org/files/Bahraini%20activist%20Ghada%20 Jamsheer%27s%20speech%20to%20the%20House%20of%20 Lords%202006.pdf (accessed February 28, 2011).

Janardhan, N. 2005. In the Gulf, women are not women's best friends. *The Daily Star*, January 20. http://dailystar.com.lb/article.asp?edition_id=10& categ_id=5&article_id=16064# (accessed August 27, 2011).

Jarhum, R. 2007. Women demand 30% quota in nominations. *Yemen Times*, November 22. http://www.yementimes.com/DefaultDET.aspx?i=1105&p= report&a=1 (accessed April 21, 2011 [no longer available]).

Jarrar, S.A. 1983. The treatment of Arabs in US social studies textbooks: Research findings and recommendations. In *Split Vision: The Portrayal of Arabs in the American Media*, ed. E. Ghareeb, 381–90. Washington DC: American-Arab Affairs Council.

Johanson, J.C. 2008. Perceptions of femininity in leadership: Modern trend or classic component? *Sex Roles* 58: 784–9.

Jorisch, A. 2004. *Beacon of Hatred*. Washington DC: Washington Institute for Near East Policy.

Kahf, M. 1999. *Western Representations of the Muslim Woman: From Termagant to Odalisque*. Austin: University of Texas Press.

Kamalipour, Y.R., ed. 1995. *The US Media and the Middle East: Image and Perception*. Westport CT: Praeger.

Kamen, P. 1991. *Feminist Fatale: Voices from Twentysomething Generation Explore Future Women's Movement*. New York: Plume.

Kanter, R.M. 1977. *Men and Women of the Corporation*. New York: Basic Books.

Kaplan, F. 2005. Karen Hughes: Stay home! *Slate*, September 29. http:// www.slate.com/id/2127102/ (accessed August 13, 2011).

Kaplan, S. 2011. The plight of young males. *Harvard Business Review Blogs*, March 9. http://blogs.hbr.org/cs/2011/03/the_plight_of_young_males. html (accessed October 5, 2011).

Karim, K.H. 2002. Making sense of the "Islamic peril": Journalism as cultural practice In *Journalism after September 11*, ed. B. Zelizer and S. Allan, 101–16. New York: Routledge.

Karmi, O. 2006. Gaza in the vise. *Middle East Report Online*, July 11. http:// www.merip.org/mero/mero071106 (accessed August 27, 2011).

Karsten, M.F. 1994. *Management and Gender: Issues and Attitudes*. Westport CT: Quorum Books.

Katz, Y., and T. Lazaroff. 2008. Goldwasser, Regev to be laid to rest after 2 uncertain years. *Jerusalem Post*, July 16. http://www.jpost.com/Israel/ Article.aspx?id=107799 (accessed August 27, 2011).

Kaufer, D., and A. Al-Malki. 2008. Muslim rage, Western fear, and the clash of civilizations: Stereotypic constructions in the world press's coverage of

the Danish cartoon controversy of 2006. http://www.cmu.edu/hss/english/research/arab_women/world_press_coverage_of_danish_cartoon_controversy.doc (accessed October 3, 2011).

Kaufer, D., A.M. Al-Malki. 2009. A "first" for Saudi women: Arab/West representations of female trendsetters in Saudi Arabia. *Journal of Arab and Muslim Women Media Research* 2:, no. 1–2: 113–33.

Kaufer, D., and K. Carley. 1993. *Communication at a Distance*. Mahwah NJ: Lawrence Erlbaum.

Kaufer, D., C. Geisler, S. Ishizaki, and P. Vlachos. 2005. Computer-support for genre analysis and discovery. In *Ambient Intelligence for Scientific Discovery*, ed. Y. Cai, 129–51. New York: Springer.

Kaufer, D., and R. Hariman. 2008. A corpus analysis evaluating Hariman's theory of political styles. *Text & Talk* 28, no. 4: 475–500.

Kaufer D., and S. Ishizaki. 2006. A corpus study of canned letters: Mining the latent rhetorical proficiencies marketed to writers in a hurry and non-writers. *IEEE Transactions of Professional Communication* 49, no. 3: 254–66.

Kaufer, D., S. Ishizaki, B. Butler, and J. Collins. 2004. *The Power of Words: Unveiling the Speaker and Writer's Hidden Craft*. Mahwah NJ: Lawrence Erlbaum.

Kendall, E. 2006. *Literature, Journalism and the Avant-Garde: Intersection in Egypt*. London: Routledge.

Khafagy, F. 2005.Honour killing in Egypt. http://www.un.org/womenwatch/daw/egm/vaw-gp-2005/docs/experts/khafagy.honorcrimes.pdf (accessed August 10, 2011).

Khan, M.W. 2004. *Woman between Islam and Western Society*. New Delhi: Goodword Books.

Khouri, N. 2003. *Forbidden Love*. New York: Doubleday.

Kindlon, D., and M. Thompson. 2000. *Raising Cain: Protecting the emotional life of boys*. New York: Ballantine Books.

King, A., and A. Hill. 1993. *Women's Education in Developing Countries: Barriers, Benefits, and Policies*. A World Bank Book. Baltimore MD: John Hopkins Press.

Kotef, H., and M. Amir. 2008. (En)gendering checkpoints: Checkpoint watch and the repercussions of intervention. In *War and Terror: Feminist Perspectives*, ed. K. Alexander and M. Hawkesworth, 161–84. Chicago IL: University of Chicago Press.

Kozma, L. 1999. Remembrance of things past: Leila Abouzeid and Moroccan national history. *Social Politics* 6, no. 3: 388–406.

Krahe, D. 2011. Visions of female identity in the new Egypt. *Spiegel Online International*, April 1. http://www.spiegel.de/international/world/0,1518,754250,00.html (accessed April 2, 2011).

Kress, G., and T. van Leeuwen. 2001. *Multimodal Discourse: The Modes and Media of Contemporary Communication*. London: Arnold.

Kristof, N.D. 2010. Divorced before puberty. *New York Times*, March 3. http://www.nytimes.com/2010/03/04/opinion/04kristof.html (accessed August 27, 2011).

Kristof, N.D. 2011. Freedom's painful price. *New York Times*, March 28. http://www.nytimes.com/2011/03/27/opinion/27kristof.html?hp (accessed March 28, 2011).

Kristof, N.D., and S. WuDunn. 2009. *Half the Sky: Turning Oppression into Opportunity for Women Worldwide.* New York: Knopf.

Kübler-Ross, E. 1969. *On Death and Dying.* New York: Simon & Schuster.

Laguardia, C. , 2006. E-views and reviews: Hot off the MideastWire. *Library Journal,* August 15. http://www.libraryjournal.com/article/CA6359871. html& (accessed August 27, 2011).

Landis, J.R., and G.G. Koch. 1977. The measurement of observer agreement for categorical data. *Biometrics* 33: 159–74.

Lash, S., and J. Urry. 1994. *Economies of Signs and Space.* London: Sage.

Leary, T. 1996. *What Does Woman Want?* New York: New Falcon Publications.

Lee, V., and A.S. Bryk. 1986. The effects of single-sex secondary schools on student achievement and attitudes. *Journal of Educational Psychology* 78, no. 5: 381–95.

Leiby, R. 2011. Women's rights marchers in Cairo report sexual assaults by angry mob. *Washington Post,* March 9. http://www.washingtonpost.com/ wp-dyn/content/article/2011/03/08/AR2011030805540.html (accessed March 10, 2011).

Lendenmann, G.N. 1983. Arab stereotyping in contemporary political cartoons. In *Split Vision: The Portrayal of Arabs in the American Media,* ed. E. Ghareeb, 374–8. Washington DC: American-Arab Affairs Council.

Lerner, J.S., and L.Z. Tiedens. 2006. Portrait of the angry decision maker: How appraisal tendencies shape anger's influence on cognition. *Journal of Behavioral Decision Making* 19: 115–37.

Levine, S.B. 2010. The truth will set you free...But first it will piss you off. *Encore Careers,* October 31. http://www.encore.org/learn/truth-will-set-you-free (accessed October 6, 2011).

Lewis, B. 1990. The roots of Muslim rage. *The Atlantic,* September. http:// www.theatlantic.com/doc/prem/199009/muslim-rage (accessed August 27, 2011).

Lewis, B. 2002a. What went wrong? *The Atlantic,* January. http://www.theatlantic.com/doc/prem/200201/lewis (accessed August 27, 2011).

Lewis, B. 2002b. *What Went Wrong? The Clash between Islam and Modernity in the Middle East.* New York: Oxford University Press.

Lewis, R. 1996. *Gendering Orientalism: Race, Femininity and Representation.* London: Routledge.

Lewis, R. 2004. *Rethinking Orientalism. Women, Travel and the Ottoman Harem.* London: I.B. Tauris.

Lindquist, K.A., and L.F. Barrett. 2008. Constructing emotion: The experience of fear as a conceptual act. *Psychological Science* 19, no. 9: 898–903.

Lindquist, K.A., L.F. Barrett, E. Bliss-Moreau, and J.A. Russell. 2006. Language and the perception of emotion. *Emotion* 6, no. 1: 125–38.

Lippman, W. 1997/1922. *Public Opinion.* New York: Free Press.

Litvak, P., J.S. Lerner, L.Z. Tiedens, and K. Shonk. 2009. Fuel in the fire: How anger impacts judgment and decision making. In *The Handbook of Anger,* ed. M. Potegal, 287–310. New York: Springer.

Lobban, R., and E.W. Fernea, eds. 1998. *Middle Eastern Women and the Invisible Economy.* Gainesville: University of Florida Press.

Lorentzen, L., and J.E. Turpin, eds. 2008. *The Women and War Reader.* New York: New York University Press.

Lowenstein, J. 2006. Identity and movement control in the OPT. *Forced Migration Review* 26: 24–5.

Luebke, B.F. 1989. Out of focus: Images of women and men in newspaper photographs. *Sex Roles* 20: 121–33.

Lynch, M. 2006. *Voices of the New Arab Public*. New York: Columbia University Press.

Lynch, M. 2007. Blogging the new Arab public. *Arab Media and Society* 1, no. 1: 1–29.

Lynch M. 2009. Arabs watching the Israeli elections. *Foreign Policy*, February 10. http://lynch.foreignpolicy.com/posts/2009/02/10/arabs_watching_the_israeli_elections (accessed April 4, 2010).

Lynfield, B. 2004. Israeli army under fire after killing girl. *Christian Science Monitor*, November 26. http://www.csmonitor.com/2004/1126/p07s01-wome.html (accessed August 27, 2011).

Maass, P. 1992. The rapes in Bosnia: A Muslim's schoolgirl's account. *Washington Post*, December 27. http://genocideinvisegrad.wordpress.com/2008/11/29/the-rapes-in-bosnia-a-muslim-schoolgirls-account/ (accessed August 7, 2011).

Mabro, J., ed. 1991. *Veiled Half-Truths: Western Travellers' Perceptions of Middle Eastern Women*. London and New York: I.B. Tauris.

Macleod, S. 2006. Ghada Jamsheer: Activist. *Time Magazine*, May 14. http://www.time.com/time/magazine/article/0,9171,1193998,00.html (accessed March 1, 2011).

Mahmood, S. 2005. *Politics of Piety: The Islamic Revival and the Feminist Project*. Princeton NJ: Princeton University Press.

Makdisi, J.S. 2005. *Teta, Mother, and Me: Three Generations of Arab Women*. New York: Norton.

Malaysia Star. 2006. Bahrain woman elected UN General Assembly president. *The Star*, June 9. http://thestar.com.my/news/story.asp?file=/2006/6/9/apworld/20060609085540&sec=apworld (accessed February 26, 2011).

'Malika'. 2009. One step forward. two steps back: Women's rights in Kuwait. *Muslim Media Watch*, October 26. http://muslimahmediawatch.org/2009/10/one-step-forward-two-steps-back-womens-rights-in-kuwait/ (accessed February 28, 2011).

Mansur, S. 2009. The economics of honour crimes. *Jordan Times*. October 6. http://www.jordantimes.com/?news=20487 (accessed August 11, 2011).

March, A. 2009. *Islam and Liberal Citizenship: The Search for an Overlapping Consensus*. New York: Oxford University Press.

Marsden, P.V. 1987. Core discussion networks of Americans. *American Sociological Review* 52: 122–31.

Maybar, S. n.d. 'Aqīdat al-tawhīd min al-Kitāb wa-al-sunnah [Monotheism in the Koran and the Prophet's Tradition]. Damascus: Matba' at al-Ṣabāh.

Mayer, A.E. 1995. Rhetorical strategies and official policies on women's rights: The merits and drawbacks of the new world hypocrisy In *Faith and Freedom: Women's Human Rights in the Muslim World*, ed. M. Afkhami, 104–34. New York: Syracuse University Press.

McCarthy, R. 2007. Huda Ghalia: "I try to forget – but I can't." *The Guardian*, March 27. http://www.guardian.co.uk/world/2007/mar/17/israelandthepalestinians.rorymccarthy (accessed July 15, 2010).

McChesney, R.W. 2002. September 11 and the structural limitations of US journalism. In *Journalism after September 11*, ed. B. Zelizer and S. Allen, 91–100. London: Routledge.

McGirk, T. 2006. Collateral damage or civilian massacre in Haditha. *Time Magazine*, March 19. http://www.time.com/time/world/article/0,8599, 1174649-3,00.html (accessed August 27, 2011).

McGreal, C. 2004. A schoolgirl riddled with bullets. And no one is to blame. *The Guardian*, October 21. http://www.guardian.co.uk/world/2004/oct/21/schoolsworldwide.israel (accessed August 1, 2010).

McKee, M. 2009. Kuwait: Victory for women's rights. *Women Living Under Muslim Laws*. http://www.wluml.org/node/5658 (accessed February 28, 2011).

Mellor, N. 2005. *The Making of Arab News*. Oxford: Rowman & Littlefield.

Mernissi, F. 1987. *Beyond the Veil: Male-Female Dynamics in Modern Muslim Society* Rev. ed. Bloomington: Indiana University Press.

Mernissi, F. 1994. *Dreams of Trespass: Tales of a Harem Girlhood*. Reading MA: Addison-Wesley Publishing Company.

Mernissi, F. 2001. *Scheherazade Goes West*. New York: Washington Square Press.

Michalak, L. 1988. Cruel and unusual: Negative images of Arabs in American popular culture. *ADC Research Institute*, Paper No. 15.

Mikhail, M.N. 2004. *Seen and Heard: A Century of Arab Women in Literature and Culture*. Northhampton MA: Interlink Publishing Group.

Mill, J.S, 1997. *The Subjection of Women*. Mineola NY: Dover Thrift Editions.

Miller, S.H. 1975. The content of news photos: Women's and men's roles. *Journalism Quarterly* 52: 70–5.

Milne, D. 2002. The beautiful soul: From Hegel to Beckett. *Diacritics* 32, no. 1: 63–82.

Minic, R. 2008. What makes an issue a "Woman's Hour" issue? *Feminist Media Studies* 8, no. 3: 301–15.

Mishra, V.M. 1979. News from the Middle East in five US media. *Journalism Quarterly* 56, no. 2: 374–8.

Moallem, M. 2005. *Between Warrior Brother and Veiled Sister*. Berkeley: University of California Press.

Moghadam, V.M. 1995. The political economy of female employment in the Arab region. In *Gender and Development in the Arab World*, ed. N.F. Khoury and V.M. Moghadam, 6–34. London: Zed Books.

Moghadam, V.M. 2005. Women's economic participation in the Middle East: What difference has the neoliberal policy made? *Journal of Middle Eastern Women's Studies*. 1, no. 1: 110–146.

Mohanty, C.T. 2003. *Feminism without Borders: Decolonizing Theory, Practicing Solidarity*. Durham NC: Duke University Press.

Moore, G. 1990. Structural determinants of men's and women's personal networks. *American Sociological Review* 55: 726–35.

Moore, J. 2010. Global leadership: In Rwanda, women run the show. *Christian Science Monitor*, November 15. http://www.csmonitor.com/World/Global-Issues/2010/1113/Global-leadership-In-Rwanda-women-run-the-show (accessed August 26, 2011).

Morrison, A.M., R.P. White, and E. Van Velsor. 1987. *Breaking the Glass Ceiling: Can Women Reach the Top of America's Largest Corporations?* Reading, MA: Addison-Wesley.

Munger, M. 2003. *The History of Psychology*. New York: Oxford University Press.

Murray, A.F., and P. Farmer. 2008. *From Outrage to Courage: Women Taking Action*. Monroe ME: Common Courage Press.

Muslim Women's League. 2011. Islamic perspective on "honor killings." http://www.mwlusa.org/topics/violence&harrassment/hk.html (accessed August 24, 2011).

Naaman, D. 2008. Unruly daughters to mother nation: A Palestinian and an Israeli first person films. *Hypatia* 23:2. 17–32.

Naib, F. 2011. Women of the revolution: Egyptian women describe the spirit of Tahrir and the hope that the equality they found there will live on. Al Jazeera/English, February 19. http://english.aljazeera.net/indepth/features/2011/02/2011217134411934738.html (accessed August 26, 2011).

Nacos, B.L., and O. Torres-Reyna. 2007. *Fueling Our Fears: Stereotyping, Media Coverage, and Public Opinion of Muslim Americans*. Lanham MD: Rowman & Littlefield.

Navasky, V. 2002. Foreword. In *Journalism after September 11*, ed. B. Zelizer and S. Allen, xiii–xvii. London: Routledge.

Nazir, S., and L. Tomppert, eds. 2005. *Women's Rights in the Middle East and North Africa: Citizenship and Justice*. Lanham NJ: Rowman & Littlefield.

Nelson, H.L. 2001. *Damaged Identities, Narrative Repair*. Ithaca NY: Cornell University Press.

Nelson, L.J., S.B. Shanahan, and J. Olivetti. 1997. Power, empowerment, and equality: Evidence for the motives of feminists, nonfeminists, and antifeminists. *Sex Roles* 37, no 3/4: 227–49.

Noe, N. 2007. *Voice of Hezbollah: The Statements of Sayyid Hassan Nasrallah*. London and New York: Verso.

Noe, N. 2008. *Re-Imagining the Lebanon Track: Toward a New US Policy*. New York: Century Foundation.

Nomani, A. n.d. Hijab chic. How retailers are marketing to fashion conscious Muslim women. Allied Media. http://www.allied-media.com/AM/Hijab_Chic.html (accessed March 22, 2011).

Novacovich, J. 1995. *Fiction Writer's Workshop*. Cincinnati: Story Press.

Neuendorf, K. 2002. The Content Analysis Guidebook. Thousand Oaks, CA: Sage.

Nussbaum, M. 2000. *Women and Human Development: The Capabilities Approach*. Cambridge: Cambridge University Press.

Nussbaum, M. 2009. Seeing women's rights as a key to countries' progress (review of N.Kristof and S.WuDunn, *Half the Sky: Turning Oppression Into Opportunity for Women Worldwide*). *New York Times*, September 7. http://www.nytimes.com/2009/09/08/books/08nussbaum.html (accessed August 15, 2010).

Oakley, J. 2000. Gender-based barriers to senior management positions: Understanding the scarcity of female CEOs. *Journal of Business Ethics* 27, no. 4: 321–34.

Oakley, T. 2009. *From Attention to Meaning: Explorations in Semiotics, Linguistics and Rhetoric*. Bern: Peter Lang.

Odeh, L.A. 1993. Post-colonial feminism and the veil: Thinking the difference. *Feminist Review* 43: 26–37.

O'Halloran, K., and B. Smith. 2011. *Multimodal Studies: Exploring Issues and Domains. Routledge Studies in Multimodality*. New York and London: Routledge.

O'Meally, R. 2003. Introduction. Crossing over: Frederick Douglass's run for freedom. In F. Douglass, *Narrative of the Life of Frederick Douglass, an American Slave, Written by Himself*, xiii–xxxiii. New York: Barnes and Noble.

Open Net Initiative. 2009. Internet filtering in Egypt. http://opennet.net/sites/opennet.net/files/ONI_Egypt_2009.pdf (accessed August 11, 2011).

Ortony, A., G.L. Clore, and A. Collins. 1988. *The Cognitive Structure of Emotions*. Cambridge: Cambridge University Press.

Osgood, C., G. Suci, and P. Tannenbaum. 1957. *The Measurement of Meaning*. Urbana: University of Illinois.

Otterman, S. 2007. Publicizing the private: Egyptian women bloggers speak out. *Arab Media and Society* 1. http://www.arabmediasociety.com/?article=13 (accessed August 29, 2011).

Palmer, A.W. 1995. The Arab image in newspaper political cartoons. In *The US Media and the Middle East*, ed. Y.R. Kamalipour, 140–50. Westport CT: Praeger.

Pape, R., L. O'Rourke, and J. McDermit. 2010. What makes Chechen women so dangerous? *New York Times*, March 30 http://www.nytimes.com/2010/03/31/opinion/31pape.html?ref=opinion (accessed March 30, 2010).

PBS Frontline. 2011a. Gigi's revolution. PBS Frontline, February 15. http://www.pbs.org/wgbh/pages/frontline/revolution-in-cairo/video-gigis-revolution/ (accessed August 12, 2011).

PBS Frontline. 2011b. Revolution in Cairo. PBS Frontline, February 22. http://www.pbs.org/wgbh/pages/frontline/revolution-in-cairo/?utm_campaign=homepage&utm_medium=proglist&utm_source=proglist (accessed February 24, 2011).

PBS NewsHour. 2011. For Egypt's women, harassment remains part of daily life. PBS NewsHour February 21. http://www.pbs.org/newshour/bb/world/jan-june11/egyptwomen_02–21.html (accessed August 29, 2011).

Peninsula. 2011. Women power in Yemen. *The Peninsula*, April 17. http://www.thepeninsulaqatar.com/qatar/149235–women-power-in-yemen.html (accessed April 21, 2011).

Peratis, K. 2004. Honor crimes under Jordanian law. http://www.hrw.org/node/12141/section/5 (accessed August 27, 2011).

Pollack, W. 1999. *Rescuing Our Sons from the Myths of Boyhood*. New York: Owl Books.

Pyke, S. 2008. 10 questions for Madeleine Albright. *Time Magazine*, January 10. http://www.time.com/time/magazine/article/0,9171,1702358,00.html (accessed January 11, 2012).

Radsch, C.C. 2007. Speaking truth to power: The changing role of journalism in Egypt: Paper presented at the annual meeting of the International Studies Association 48th Annual Convention, Chicago IL, February 28, 2007. http://citation.allacademic.com/meta/p_mla_apa_research_citation/1/8/0/2/8/pages180287/p180287–1.php (accessed August 29, 2011).

Radsch, C.C. 2008. Core to commonplace: The evolution of Egypt's blogosphere. *Arab Media and Society*, 6. http://www.arabmediasociety.com/?article=692 (accessed August 29, 2011).

Ragins, B.R. and J.L. Cotton. 1991. Easier said than done: gender differences in perceived barriers to gaining a mentor. *Academy of Management Journal* 34, no. 4: 939–51.

Ragins, B.R., and T.A. Scandura. 1994. Gender differences in expected outcomes of mentoring relationships, *Academy of Management Journal* 37: 957–71.

Ragins, B.R., B. Townsend, and M. Mattis. 1998. Gender gap in the executive suite: CEOs and female executives report on breaking the glass ceiling. *Academy of Management Executive* 12, no. 1: 28–42.

Rashad, H., M. Osman, and F. Roudi-Fahimi. 2005. Marriage in the Arab World. Population Reference Bureau. http://www.prb.org/pdf05/ MarriageInArabWorld_Eng.pdf (accessed August 29, 2011).

Read, J.G., and J.P. Bartkowski. 2000. To veil or not to veil? A case study of identity negotiation among Muslim women in Austin, Texas. *Gender and Society* 14: 395–417.

Regular, A. 2003. Profile of the Haifa suicide bomber. *Haaretz*, October 5. http://www.haaretz.com/hasen/pages/ShArt.jhtml?itemNo=346913&cont rassID=1&subContrassID=1&sbSubContrassID=0&listSrc=Y accessed October 3, 2011).

Reis, S. 1987. Understanding the special needs of gifted females. *Gifted Child Quarterly* 31, no. 2: 83–9.

Remnick, D. 2011. Judgment days. *New Yorker*, February 14, 37–8.

Renzulli, L., H. Aldrich, and J. Moody. 2000. Family matters: Gender, networks, and entrepreneurial outcomes. *Social Forces* 79: 523–46.

Reporters Without Borders, 2003. Press freedom index 2003. *Reporters Without Borders.* http://en.rsf.org/spip.php?page=classement&id_rubrique= 551 (accessed October 5, 2011).

Reporters Without Borders. 2009. French investigation at standstill four years after journalist Samir Kassir's murder. *Reporters Without Borders*, June 2. http://en.rsf.org/lebanon-french-investigation-at-standstill-02–06– 2009, 33246. html (accessed August 27, 2011).

Ricks, T.E. 2006. *Fiasco: The American Military Adventure in Iraq*. New York: Penguin.

Riffe, D., S. Lacy, and F.G. Fico. 2005. *Analyzing Media Messages: Using Content Analysis in Research*. Mahwah NJ: Lawrence Erlbaum.

Rizk, S. 1988. *The Image of Women as Portrayed in the Women's Programs in the Radio*. Cairo: Egyptian-Anglo Library.

Rizzo, H., A.-H. Abdel-Latif, and K. Meyer. 2007. The relationship between gender equality and democracy: A comparison of Arab Versus non-Arab Muslim societies. *Sociology* 41, no. 6: 1151–70.

Roosevelt, F.D. 1933. First inaugural address. http://historymatters.gmu. edu/d/5057/ (accessed August 6,2011).

Rosin, H. 2010. The end of men. *Atlantic Magazine*, July/August. http://www. theatlantic.com/magazine/archive/2010/07/the-end-of-men/8135/2/ (accessed August 29, 2011).

Ross, M., and S. Collier. 2010. *The Complete Guide to Self-Publishing: Everything You Need to Know to Write*. New York: Adams Media.

Roy, K.C., H.C. Blomqvist, and C. Clark. 2008. *Institutions and Gender Empowerment in the Global Economy, Part I*. New York: World Scientific.

Rugh, W. 2003. *Arab Mass Media: Newspapers, Radio, and Television in Arab Politics*. Westport CT: Praeger.

Sabbagh, S., ed. 1996. *Arab Women: Between Defiance and Restraint*. New York: Interlink Publishing Group.

Sabh, M. 2005. Economic reform policies and their effect on the status of women in Arab countries. In *Arab Women and Economic Development*, ed. H. Handoussa, 121–140. Cairo: Arab Fund for Social and Economic Development.

Said, E. 1979. *Orientalism*. New York: Vintage Books.

Said, N. 2005. An affordable translation service from the Arabic language press. *The Electronic Intifada*, October 23. http://electronicintifada.net/v2/article4266.shtml (accessed August 29, 2011).

Sakr, N. 2005. Women, development and Al Jazeera. In *The Al-Jazeera Phenomenon: Critical Perspectives on New Arab Media*, ed. M. Zayani, 127–50). Boulder CO: Paradigm.

Salam, N. 2007. *Arab Television Today*. London: I.B. Tauris.

Salam, K. 2000. Ikhwanophobia reaches a new level *Ikhwanweb*, June 25. http://www.ikhwanweb.com/article.php?id=4070 (accessed August 29, 2011).

Salam, R. 2009. The death of macho. *Foreign Policy*, August 29. http://www.foreignpolicy.com/articles/2009/06/18/the_death_of_macho (accessed March 6, 2011).

Salime, Z. 2008. "The War on terrorism:" Appropriation and subversion by Moroccan women. In *War and Terror: Feminist Perspectives*, ed. K. Alexander and M. Hawkesworth, 415–38. Chicago IL: University of Chicago Press.

Samuelson, M. 2008. The disfigured body of the female guerilla: (De)militarization, sexual violence, and redomestication in Zoe Wicomb's *David's Story*. In In *War and Terror: Feminist Perspectives*, ed. K. Alexander and M. Hawkesworth, 89–112. Chicago IL: University of Chicago Press.

Sasson, J. 1993. *Princess*. New York: Bantam.

Sasson, J. 1994. *Daughters of Arabia*. New York: Bantam.

Sasson, J. 2000. *Desert Royal*. New York: Bantam.

Savage, C. 2011. Cheney has kind words for Mubarak. *New York Times*, February 6. http://thecaucus.blogs.nytimes.com/2011/02/06/cheney-has-kind-words-for-mubarak-as-friend-to-u-s/ (accessed August 13, 2011).

Schein, V.E. 2001. A global look at psychological barriers to women's progress in management. *Journal of Social Issues* 57: 675–88.

Schick, I.C. 1990. Representing Middle Eastern women: Feminism and colonial discourse. *Feminist Studies* 16, no. 2: 345–81.

Schiff, S. 2010. *Cleopatra: A Life*. New York: Little Brown.

Scholz, S.J. 2009. Feminist political solidarity. In *Feminist Ethics and Social and Political Philosophy: Theorizing the Non-Ideal*, ed. L. Tessman, 205–222. Dordrecht: Springer Netherlands.

Scott, J.W. 2007. *The Politics of the Veil*. Princeton NJ: Princeton University Press.

Searle, J. 1969. *Speech Acts*. New York: Cambridge University Press.

Seib, P. 2008. *The Al Jazeera Effect: How the New Global Media are Reshaping World Politics*. Washington DC: Potomac Books.

Seligman, M. 2011. *Flourish: A Visionary New Understanding of Happiness and Well-being*. New York: Simon & Schuster.

Sen, A. 1993. *Commodities and Capabilities*. Oxford: Oxford University Press.

Shaaban, B. 1988/1991. *Both Right And Left Handed: Arab Women Talk about Their Lives*. Bloomington: Indiana University Press.

Shaaban, B. 1995. The muted voices of women interpreters. In *Faith and*

Freedom: Women's Human Rights in the Muslim World, ed. M. Afkhami, 61–77. New York: Syracuse University Press.

Shaheen, J.G. 1983. The Arab image in American mass media. In *Split Vision: The Portrayal of Arabs in the American Media*, ed. E. Ghareeb, 327–36. Washington DC: American-Arab Affairs Council.

Shapiro, D., and J.E. Crowley. 1982. Aspirations and expectations of youth in the United States: Part 2. Employment activity. *Youth and Society* 14: 33–58.

Sherr, L. *Failure is Impossible: Susan B. Anthony in Her Own Words.* New York: Times Books. 48.

Shirazi, F. 2001. *The Veil Unveiled: The Hijab in Modern Culture.* Gainsville: University of Florida Press.

Shirky, C. 2008. *Here Comes Everybody: The Power of Organizing Without Organizations.* New York: Penguin.

Shmaysani, M. 2008. Sayyed Nasrallah: Achievement dedicated to all Lebanon. *Al-Manar TV*, July 2. http://www.liveleak.com/view?i=7fa_1215131207 (accessed August 29, 2011).

Shmurak, C.B. 1998. *Voices of Hope: Adolescent Girls at Single Sex and Coeducational Schools.* Bern: Peter Lang.

Shoda, Y., W. Mischel, and P.K. Peake. 1990. Predicting adolescent cognitive and self-regulatory competencies from preschool delay of gratification: Identifying diagnostic conditions. *Developmental Psychology* 26, no. 6: 978–86.

Sidanius J., and F. Pratto. 1999. *Social Dominance: An Intergroup Theory of Social Hierarchy and Oppression.* Cambridge: Cambridge University Press.

Sifton, J. 2007. Anatomy of a state security case: The "victorious sect" arrests. *Human Rights Watch* 19, no. 9e (December 11) (accessed August 27, 2011).

Sissons, M. 2005. Promoting impunity: The Israeli military's failure to investigate wrongdoing. *Human Rights Watch.* 17, no 7E. http://www.hrw.org/reports/2005/iopt0605/1.htm#_ftnref7 (accessed October 5, 2011).

Skaine, R. 2006. *Female Suicide Bombers.* Jefferson NC: McFarland and Company.

Skalli, L. 2011. Constructing Arab female leadership lessons from the Moroccan media. *Gender and Society* 25: 473–95.

Smalley, B., ed. 2007. *Middle East and North Africa Media Guide 2007.* Dubai: Media Source.

Smith, A. 2006. *Why We War: The Human Investment in Slaughter and the Possibilities of Peace.* n.p.: Lulu.

Snow, K. 2011. Women now the backbone of American economy. MSNBC, April 4. http://www.msnbc.msn.com/id/41914274/ns/business-us-business/t/women-now-backbone-american-economy/#.ToyrvXP2JmB (accessed October 5, 2011).

Spees, P. 2008. Women's Advocacy in the creation of the International Criminal Court: Changing the landscapes of justice and power. In *War and Terror: Feminist Perspectives*, ed. K. Alexander and M.E. Hawkesworth, 185–206. Chicago IL: University of Chicago Press.

Spivak, G.C. 1988. Can the subaltern speak? In *Marxism and the Interpretation of Culture*, ed. C. Nelson and L. Grossberg, 271–313. Urbana and Chicago: University of Illinois Press.

Spyer, J. 2008. Lebanon 2006: Unfinished war. *Middle East Review of International Affairs* 12, no. 1: 3 (accessed August 29, 2011).

St. Peter, A. 2010. *The Greatest Quotations of All Time*. Bloomington IN: Xilibris.

Stack, M.K. 2007. A veiled eye view of Saudi segregation. *Los Angeles Times*, June 6. http://articles.latimes.com/2007/jun/06/world/fg-women6 (accessed January 18, 2010).

Stanton, E.C. 1854. Elizabeth Cady Stanton's address to the New York Legislature. http://www.milestonedocuments.com/documents/view/eliza-beth-cady-stantons-address-to-the-new-york-legislature/ (accessed February 23, 2011).

Stasz, C., E. Eide, and P. Martorell. 2007. *Post-Secondary Education in Qatar: Employer Priorities in Demand, Student Choice, and Options for Policy*. Doha: RAND Corporation. http://www.rand.org/pubs/monographs/MG644/ (accessed August 29, 2011).

Stevens, C., L.A. Puchtell, S. Ryu, and J.T. Mortimer. 1992. Adolescent work and boys' and girls' orientations to the future. *Sociological Quarterly* 33, no. 2: 153–69.

Stone P., D. Dunphy, M. Smith, and D. Ogilvie. 1966. *The General Inquirer: A Computer Approach to Content Analysis*. Cambridge MA: MIT Press.

Suleiman, M.W. 1965. An evaluation of the Middle East news coverage in seven American newspapers. July-December, 1956. *Middle East Forum* 41, no. 2: 9–30.

Supreme Council of Women. 2009. His Majesty the King endorses the first part of family law. *Bahraini Women* 52: 5. http://www.scw.gov.bh/media/pdf/Newsletter-Issue52–EN.pdf (accessed March 1, 2011).

Supriya, S. 2007. What women fear? Do men realize these hidden fears of fair sex? *OneIndia Living*. http://living.oneindia.in/relationship/2007/what-women-fear.html (accessed April 5, 2011).

Sutton, G. 2004. The failure of feminism. http://www.renewamerica.com/columns/sutton/040302 (accessed July 30, 2011).

Symborska, W. 1993. The end and the beginning. http://www.panhala.net/Archive/The_End_and_the_Beginning.html (accessed August 8, 2011).

Tannen, D. 1995. *Talking from 9 to 5: Men and Women at Work*. New York: HarperCollins.

Tarlo, E. 2010. *Visibly Muslim: Fashion, Politics, Faith*. New York: Berg.

Terry, J. 1971. A content analysis of American newspapers. In *The Arab World: From Nationalism to Revolution*, ed. A. Jabara and J. Terry, 94–113. Wilmette IL: Medina University Press International.

Thaindian News. 2009. Rola Dashti: First woman Parliamentarian of Kuwait. *Thaindian News*, May 18. http://www.thaindian.com/newsportal/politics/rola-dashti-first-woman-parliamentarian-of-kuwait_100193959.html (accessed August 29, 2011).

Tillmon, J. 1972. Welfare is a women's issue. *Ms. Magazine*. http://www.msmagazine.com/spring2002/tillmon.asp (accessed August 29, 2011).

Toomey, C. 2008. On the trail of Gilad Shalit, the lost soldier. *The Sunday Times*, September 14. http://www.timesonline.co.uk/tol/news/world/middle_east/article4723995.ece (accessed August 29, 2011).

Tuchman, G. 1978. The symbolic annihilation of women by the mass media. In *Hearth and Home: Images of Women in the Mass Media*, ed. G. Tuchman,

A.K. Daniels and J.W. Benet, 186–215. New York: Oxford University Press.

Turpin, J.E., ed. 1998. *The Women and War Reader*. New York: New York University Press.

Tyre, P. 2006. The trouble with boys. *Newsweek*, January 30,. http://www.newsweek.com/2006/01/29/the-trouble-with-boys.html (accessed March 7, 2011).

Ulrich, B. 2009. Historicizing Arab blogs: Reflections on the transmission of ideas and information in Middle Eastern history. *Arab Media and Society* 8. http://www.arabmediasociety.com/?article=711 (accessed August 29, 2011).

Ulrich, L. 2007. *Well-Behaved Women Seldom Make History*. New York: Knopf.

UNHCR. 2002. The world of refugee women at a glance. *Refugees* 1, no. 126: 7. http://www.unhcr.org/3cb5508b2.html (accessed August 7, 2011).

UN-Women. 2011. Bachelet addresses challenges, provides recommendations for pathway to democracy in Egypt. *UN-Women*, March 25. http://www.unwomen.org/2011/03/bachelet-addresses-challenges-provides-recommendations-for-pathway-to-democracy-in-egypt/ (accessed August 29, 2011).

UN-Women. 2000. Facts and figures on VAW. http://www.unifem.org/gender_issues/violence_against_women/facts_figures.php?page=4 (accessed August 29, 2011).

United States Department of State. 2009. Trafficking in persons report 2009: Yemen 2009. June 16. http://www.unhcr.org/refworld/docid/4a4214802d.html (accessed 5 November 2009).

Valanka, A. 2011. Kuwait at 50. Embittered by regional politics, Kuwait looks inward. *The Majalla*, February 9. http://www.majalla.com/en/Features/article254962.ece (accessed February 27, 2011).

Vivian, B. 1999. The veil and the visible. *Western Journal of Communication* 63: 115–39.

Volkmer, I. 2002. Journalism and political crises in the global network society. In *Journalism after September 11*, ed. B. Zelizer and S. Allen, 235–46. London: Routledge.

Wadud, A. 1999. *Qur'an and Woman: Rereading the Sacred Text from a Woman's Perspective*. New York: Oxford University Press.

Wagar, W. 2004. *H.G. Wells: Traversing Time*. Middletown CT: Wesleyan University Press.

Waisbord, S. 2002. Journalism, risk, and patriotism. In *Journalism after September 11*, ed. B. Zelizer and S. Allen, 201–19. London: Routledge.

Wall, J., K. Covell, and P. MacIntyre. 1999. Implications of social supports for adolescents' education and career aspirations. *Canadian Journal of Behavioural Science/Revue canadienne des sciences du comportement* 31, no. 2: 63–71.

Walls, S.C. 2006. Candid US memo on Iraq, Egyptian dissent. MSNBC, July 26. http://www.msnbc.msn.com/id/13484966/ns/world_news-mideastn_africa// (accessed August 29, 2011).

Washington Post. 2011. Youth movement [in Arab countries]. http://www.washingtonpost.com/wp-srv/special/world/middle-east-youth-population/ (accessed August 11, 2011).

Wasielewski, P.L. 1985. The emotional basis of charisma. *Symbolic Interaction* 8:, no. 2: 207–22.

Watson, C.M., T. Quatman, and E. Edler. 2002. Career aspirations of adolescent girls: Effects of achievement level, grade, and single-sex school environment. *Sex Roles* 46, no. 9–10: 323–35.

Whitaker, B. 2002. Selective memri. *The Guardian*, August 12. http://www.guardian.co.uk/world/2002/aug/12/worlddispatch.brianwhitaker (accessed August 29, 2011).

White, A. 2008. All the men are fighting for freedom, all the women are mourning their men, but some of us carried guns: A raced-gendered analysis of Fanon's psychological perspectives on war. In *War and Terror: Feminist Perspectives*, ed. K. Alexander and M.E. Hawkesworth, 61–88. Chicago IL: University of Chicago Press.

Wildman, S.M. 1996. *Privilege Revealed. How Invisible Preference Undermines America*. New York: New York University Press.

Wilkins, K.G. 1995. Middle Eastern women in Western eyes: A study of US press photographs of Middle Eastern women. In *The US Media and the Middle East*, ed. Y.R. Kamalipour, 51–61. Westport CT: Praeger.

Wilkinson, T. 2000. Activists seek end to Jordan's "honor" killings. *Los Angeles Times*, March 11. http://articles.latimes.com/2000/mar/11/news/mn-7680 (accessed August 29, 2011).

Wicomb, Z. 2000. *David's Story*. Cape Town: Kwela Books.

Wittenberg-Cox, A., and A. Maitland. 2008. *Why Women Mean Business*. San Francisco: John Wiley & Sons.

Wollstonecraft, M. 1997. *The Vindications: The Rights of Men and The Rights of Woman*, ed. D.L. Macdonald and K. Scherf. Toronto: Broadview Literary Texts (first published 1792).

Women Against Shariah. 2011. Hamas TV extols female suicide bombers. *Women Against Shariah*, May 19. http://womenagainstshariah.blogspot.com/2011/05/hamas-tv-extols-female-palestinian.html (accessed August 12, 2011).

Women Gateway. 2010. Al Ruwai asks rival to stick to law. *Women Gateway*, September 23. http://www.womengateway.com/enwg/News/2010/Sep/Al+Ruwai+asks+rival.htm (accessed March 1, 2011).

Woodward, R. 2004. *Plan of Attack*. New York: Simon and Schuster.

Woolsey, A., C. Chabris, A. Pentland, N. Hashmi, and T. Malone. 2010. Evidence for a collective intelligence factor in the performance of human groups. *Science* 330, 686–8.http://www.sciencemag.org/content/330/6004/686.full (accessed August 29, 2011).

World Education. 2011. Girls' and women's educational initiative. http://www.worlded.org/WEIInternet/gwe/index.cfm (accessed 24 July, 2011).

Wright, R. 2011. *Rock the Casbah: Rage and Rebellion across the Islamic World*. New York: Simon and Schuster.

Yaghmaian, B. 2007. Refugees are an overlooked casualty of Iraq war. *USA Today*, February 7. http://www.usatoday.com/news/opinion/editorials/2007-02-06-opcom_x.htm (accessed August 29, 2011).

Yegenoglu, M. 1988. *Colonial Fantasies: Towards a Feminist Reading of Orientalism*. Cambridge: Cambridge University Press.

Zakaria, F. 2010. The Jihad against the Jihadis. *Newsweek*, 22 February, pp. 26–32.

Zayid, S. 1987. *al-Ja mi' fi al-si rah al-Nabawi yah*. [Damascus]: S. al-Zayid.

Zayani, M. 2005. Introduction: Al-Jazeera and the vicissitudes of the new

Arab mediascape. In *The Al-Jazeera Phenomenon: Critical Perspectives on New Arab Media*, ed. M. Zayani, 1–46. Boulder CO: Paradigm.

Zoepf, K. 2006. Islamic revival in Syria is led by women. *New York Times*, August 29. http://www.nytimes.com/2006/08/29/world/middleeast/29syria.html?_r=2&oref=slogin (accessed August 29, 2011).

Index

women's studies, xviii, 244–245,
250, 253, 258, 268–69, 277,
286, 304, 369
*Year of the Elephant; A Moroccan
Woman's Journey Toward
Independence* (Abouzeid), 138

Yemen, 24, 76, 81, 103, 107–08,
135–36, 140, 173–74, 176, 187,
199, 237, 306, 336, 346–47,
406n16, 407n17, 418n6
Youtube, 325